El Greco

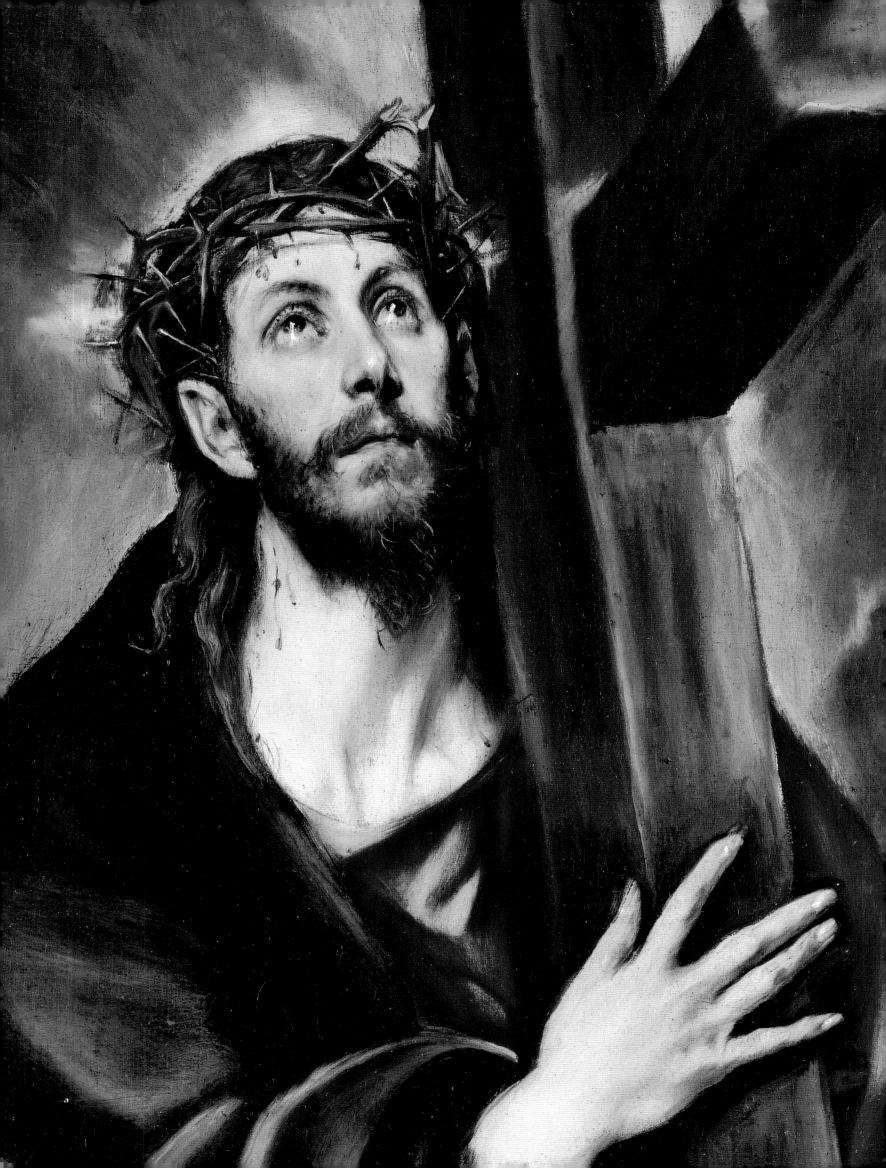

El Greco

ESSAYS
David Davies and John H. Elliott

CATALOGUE ENTRIES
Xavier Bray, Keith Christiansen, Gabriele Finaldi
with contributions by
Marcus Burke and Lois Oliver

CATALOGUE EDITED BY
David Davies

National Gallery Company, London

DISTRIBUTED BY YALE UNIVERSITY PRESS

This book was published to accompany the exhibition
El Greco held at The Metropolitan Museum of Art, New York,
from 7 October 2003 to 11 January 2004, and at
The National Gallery, London, from 11 February to 23 May 2004.

The exhibition was supported by GlaxoSmithKline in London

It was organised by The Metropolitan Museum of Art, New York,
and The National Gallery, London

First published in Great Britain in 2003 by
National Gallery Company Limited
St Vincent House
30 Orange Street
London WC2H 7HH
www.nationalgallery.co.uk

ISBN 1 85709 938 9 paperback 525470
ISBN 1 85709 933 8 hardback 525469

British Library Cataloguing-in-Publication Data
A catalogue record is available from the British Library

Library of Congress Catalog Card Number 2003105497

PUBLISHER Kate Bell
PROJECT EDITOR Tom Windross
EDITOR Paul Holberton
DESIGNER Philip Lewis
PICTURE RESEARCHERS Xenia Corcoran and Kim Klehmet
PRODUCTION Jane Hyne and Penny Le Tissier
EDITORIAL ASSISTANCE Jane Ace, Rebeka Cohen and Jan Green

Printed and bound in Italy by Conti Tipocolor

All measurements give height before width, then depth where necessary.

FRONT COVER/JACKET *The Opening of the Fifth Seal* (*The Vision of Saint John*)
(detail), 1608–14 (cat. 60)
FRONTISPIECE *Christ carrying the Cross* (detail), 1580s (cat. 32)
PAGE 6 *Saint Sebastian* (detail), about 1577–8 (cat. 24)
PAGE 8 *Saint Jerome as a Scholar* (detail), about 1600–14 (cat. 50)
PAGES 12–13 *The Purification of the Temple* (detail), about 1600 (cat. 8)
PAGES 16–17 *The Annunciation* (detail), about 1597–1600 (cat. 40)

Contents

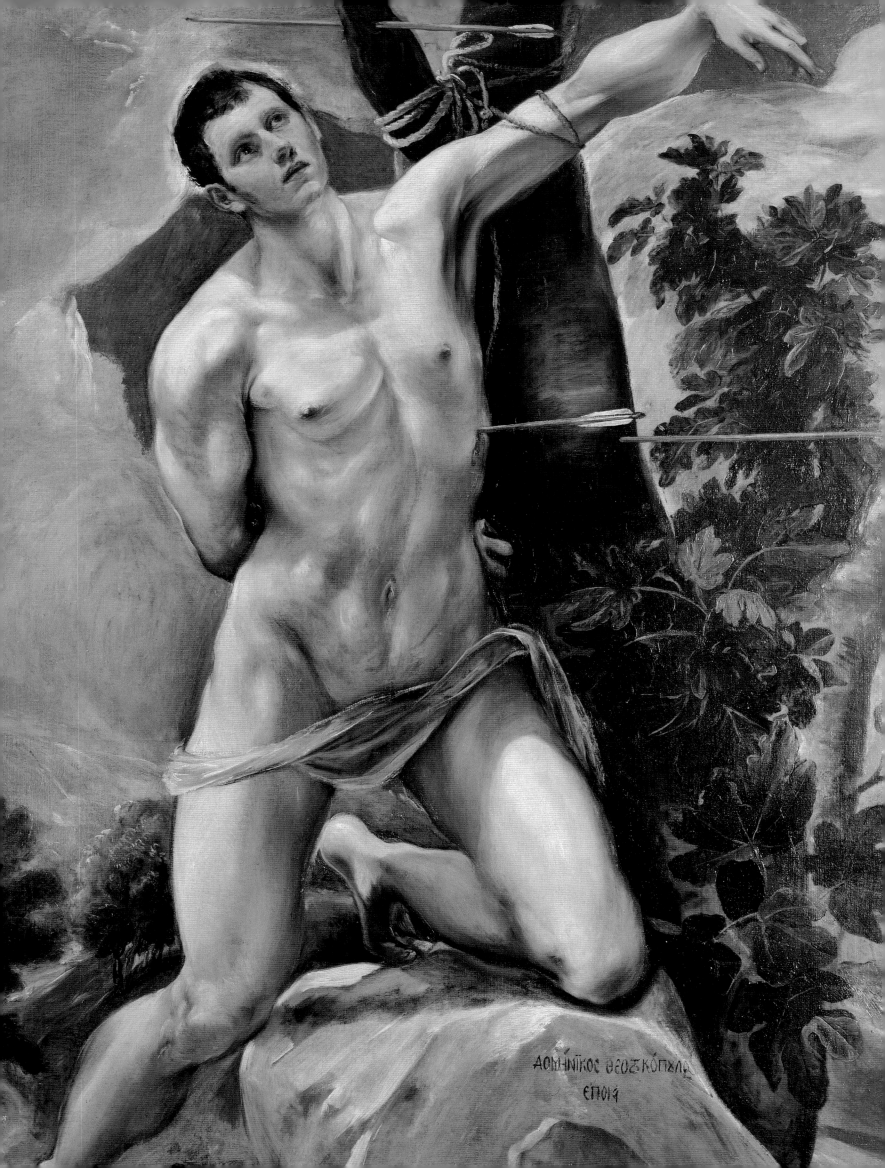

ΔΟΜΗΝΙΚΟΣ ΘΕΟΤΚΟΠΥΛΟΣ
ΕΠΟΙ4

Sponsor's Foreword

GLAXOSMITHKLINE is proud to be sponsoring *El Greco*, an unprecedented collection of work that shows the full scope and breadth of the achievement of this unique and distinctive artist.

El Greco is the latest in a series of landmark exhibitions that GSK has supported in recent years, which includes *American Sublime* and *William Blake* at Tate Britain, *Grinling Gibbons and the Art of Carving* at the V&A, and here at the National Gallery, *Spanish Still Life* and most recently, *Art in the Making: Underdrawings in Renaissance Paintings*. Our partnerships with Britain's galleries and museums are built on a shared commitment to excellence, innovation and access. We are also committed to supporting arts projects that involve the participation of young people from an early age. Through our support we hope to encourage new audiences and ask those already familiar with the arts to take a fresh look.

Themes of discovery and innovation are fundamental to a research-based company like GSK. With his uniquely recognisable style and dramatic use of light and colour, El Greco is, perhaps, one of the most distinctive and recognisable artists of all time. However, after a long period of neglect after his death, he was rediscovered by painters of the late nineteenth and early twentieth centuries, including Manet and Picasso. This exhibition shows the full range of El Greco's subjects and the development of his style and artistic ideas; it includes not only his most famous pieces but also some of his less well-known work, including portraiture, landscapes and sculpture. We hope that you will leave the collection having rediscovered El Greco, with a greater understanding of the breadth of his artistic achievement, imaginative power and visual sophistication.

Please enjoy the exhibition.

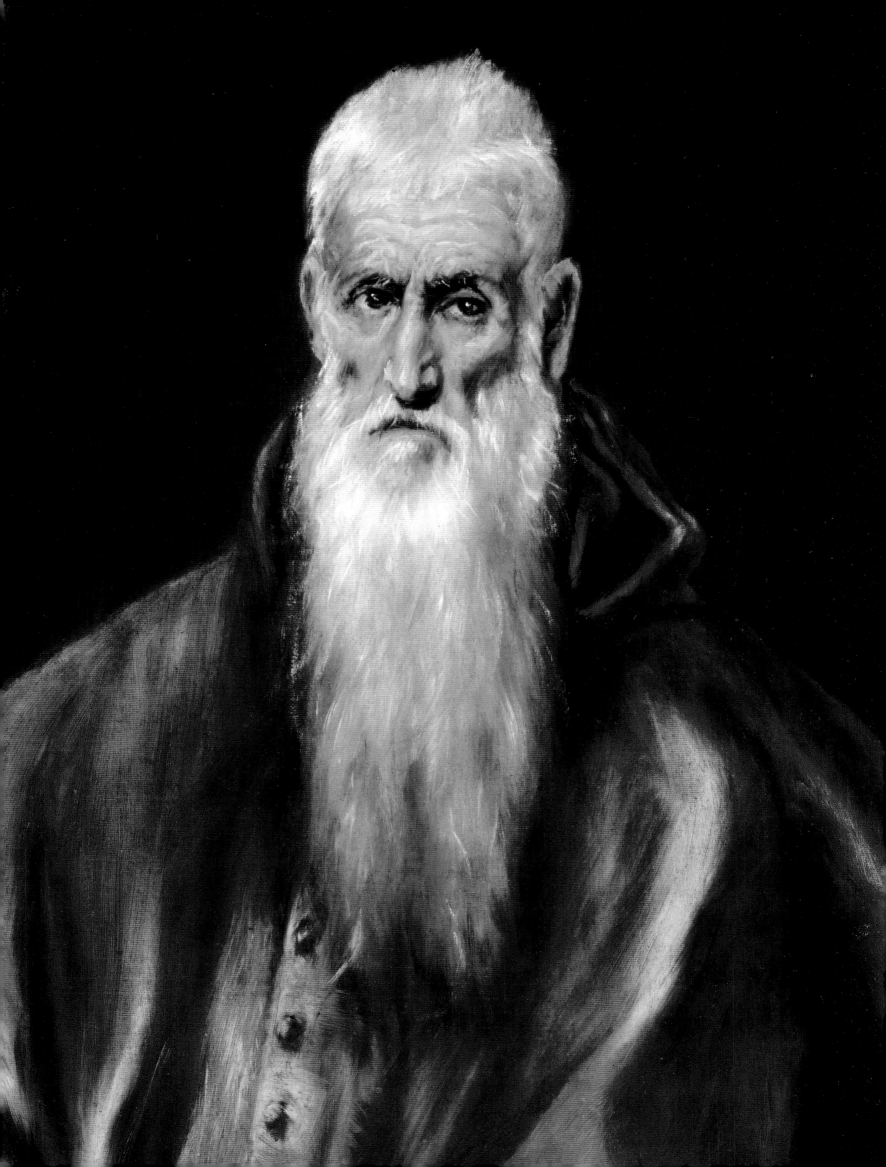

Directors' Foreword

EL GRECO is one of the few old master painters who enjoys widespread popularity. Like Vermeer, Piero della Francesca and Botticelli, he was rescued from obscurity by an avid group of nineteenth-century collectors, critics and artists to become one of the select members of the modern pantheon of great painters. Indeed, he has sometimes seemed *the* proto-modern painter – an artist who, in the words of the French critic Paul Mantz, writing in 1844, 'even in his extravagance always demonstrates his great feeling for art'.

Delacroix owned a reduced copy of El Greco's *Disrobing of Christ* similar to the one exhibited here (cat. 21; the critic Théophile Gautier thought El Greco's work resembled Delacroix's), and John Singer Sargent, a great admirer of El Greco, purchased a version of *Saint Martin and the Beggar* (cat. 38). Cézanne copied the portrait of *A Lady in a Fur Wrap* (cat. 73), which had been the most popular of the handful of El Greco's works displayed in Louis-Philippe's celebrated Galerie Espagnole in 1838. Manet was reserved in his judgement: like so many artists and critics before him, he found El Greco's work '*bizarre*' but his portraits '*fort beaux*' – a verdict with which his hero Velázquez would have concurred.

British collectors and writers also played a leading role in his 'rediscovery'. Two nineteenth-century art historians with a fascination for Spanish painting, Richard Ford and William Stirling (later Sir William Stirling-Maxwell), were instrumental in returning El Greco to the public eye, even though they expressed reservations; Stirling described him as an 'artist who alternated between reason and delirium'. As late as 1919, the British public's understanding of the artist had not caught up with this critical change, and when the National Gallery in London acquired the *Agony in the Garden* (fig. 45), there was an outcry. Typically, it was the critic and painter Roger Fry who raised his voice in defence of the Gallery's then Director, Sir Charles Holmes, hailing the acquisition as a major coup and the artistic equivalent of an 'electric shock' for the public. Fry saw quite clearly the modernist features in El Greco's work, commenting in a letter written to Vanessa Bell in 1917 on the 'purposeful distortion and pulling of planes that you get in Greco and Cézanne'. (The Metropolitan Museum acquired its first El Greco in 1905, the year before Fry began a two-year curatorship.)

During the crucial period Picasso was working on that keystone of modern painting, the *Demoiselles d'Avignon* (1907), he visited his friend Ignacio Zuloaga in his studio in Paris and studied El Greco's *Opening of the Fifth Seal* (cat. 60), which left an indelible impression. For Picasso, too, El Greco was both the quintessential Spaniard and a precursor of Cézanne and Cubism. Franz Marc and the members of the Blue Rider group admired El Greco as a painter who 'felt the *mystical inner construction*' of life: someone whose art stood as a rejection of the materialist culture of bourgeois society.

The twentieth-century view of El Greco is encapsulated in a widely read essay published in 1950 by Aldous Huxley: 'In looking at any of the great compositions of El Greco's maturity we must always remember that the intention of the artist was neither to imitate Nature nor to tell a story with dramatic verisimilitude. Like the Post-Impressionists three centuries later, El Greco used natural objects as the raw material out of which, by a process of calculated distortion, he might create his own world of pictorial forms in pictorial space under pictorial illumination. Within this private universe he situated his religious subject matter, using it as a vehicle for expressing what he wanted to say about life.' (It is worth mentioning that the famous, but baseless notion that El Greco was astigmatic, famously put forward in a pamphlet in 1914, was soundly rejected by Sargent, who rightly related the artist's 'exaggeration of elegance' to sixteenth-century issues of style.)

One of the purposes of an exhibition such as the present one is the opportunity it provides to test the image – or rather images – we have of El Greco and his art against the works themselves: to try to see him on his own, rather than our, terms. In this exhibition every effort has been made to secure a body of paintings that presents El Greco's achievement in the fullest manner possible.

The last two decades have brought a number of refinements to our knowledge of the artist. For one thing, we can now identify a small group of icons he painted in his native Crete (or Candia, as it was then known), prior to his move to Venice in 1567. These works remind us of the Neoplatonic, non-naturalistic basis of El Greco's art, before he set about transforming himself into a disciple of Titian and an avid student of Tintoretto,

Veronese and Jacopo Bassano. We also possess El Greco's copies, with the artist's annotations in the margins, of the architectural treatise by Vitruvius and of Vasari's *Lives*. The opinions he voices must be read against the works, but also understood in the context of late sixteenth-century debates about the nature and function of art.

El Greco was in Rome from 1570 to 1576, but the contacts he established with other artists remain nebulous: our firmest guide to his response to what he saw are the paintings, of which an exemplary group is included in the exhibition. What can be said is that, despite a letter of introduction to the powerful Farnese family, his paintings seem to have met with no more success in Rome than they had in Venice. He received no major commissions, and his work was confined to modestly scaled devotional paintings and portraits. El Greco reputedly criticised Michelangelo's abilities as a painter – an opinion that would have generated little confidence in his abilities and offended the Roman art establishment (Michelangelo had died in 1564, but his prestige in Rome was undiminished).

These were not auspicious beginnings for his career in Spain, where he moved in 1576. In Madrid, his bid for royal patronage from Philip II failed. (For his austere retreat at El Escorial, Philip wanted clearly decipherable pictures that advertised his orthodoxy, not paintings that celebrated artistic genius.) Only in Toledo, where he received two major commissions (see cat. 17–20, 38–9), did El Greco meet with the success an artist of his calibre might have expected. It was in this ancient city, which El Greco immortalised in one of the most celebrated landscapes in Western art (cat. 66), that he found, at last, a sympathetic circle of intellectual friends and patrons and forged a highly profitable career. In Toledo he became the artist we have come to admire, and we need hardly be surprised to learn from his contemporary, Francisco de Pisa – whose portrait he may have painted (cat. 82) – that, then as now, no visitor to the city failed to go to the church of Santo Tomé to admire *The Burial of the Count of Orgaz* (fig. 17).

Toledo may have been far removed from the artistic ferment of Rome, but it was no bastion against the forces – cultural as well as artistic – that were to shape the art of the seventeenth century. It is all too easy to treat El Greco's achievement in isolation, as though it were an art outside its time – an art waiting to be discovered by the modern era. It comes as something of a shock to realise that, when El Greco died in 1614, Caravaggio and Annibale Carracci – the creators of the new Baroque style – had been buried for four and five years, respectively. Ribera was already active in Rome, and one of Caravaggio's most individual followers, Juan Bautista Maino, was busy in Toledo itself (as had been the great still-life painter Juan Sánchez Cotán). In 1611 Velázquez, the presiding genius of seventeenth-century Spain, was apprenticed to Francisco Pacheco in Seville. It is enough to mention these figures to realise that in important respects El Greco's art belonged to the past, not the future – to the world of Mannerism, with its emphasis on the artist's imagination rather than the imitation of nature.

Pacheco, whose curriculum of study formed the young Velázquez, visited El Greco in his studio in Toledo in 1611 and recorded seeing the plaster, wax and clay figures from which El Greco worked. He did not approve of this method, which El Greco had doubtless learned from Tintoretto in Venice: Pacheco advocated a real human figure rather than something modelled in clay. It is thus not surprising that El Greco's pupil Luis Tristán abandoned his master's esoteric Mannerist style for Caravaggesque naturalism. And yet, although he disapproved of the extreme distortions of El Greco's late religious paintings, Pacheco could not deny El Greco's place among the great painters, 'for we see some works by his hand so plastic and so alive (in his characteristic style) that they equal the art of the very best'. He may have had in mind El Greco's portraits, which Velázquez also prized so highly.

Paradoxically, it is precisely the most extravagant flights of El Greco's fertile imagination – works in which the figures are elongated beyond credibility and their forms dematerialised by a flickering brushwork – that are most prized today (they form the core of this exhibition). In the present age of secularism, this is nothing short of miraculous. However, in his indispensable study of the profound changes of taste, fashion and collecting in nineteenth-century France and England – *Rediscoveries in Art* – Francis Haskell reminded us 'the real "discoveries" that occurred between about 1790 and 1870 were not so much of

Orcagna or Rembrandt, Vermeer or El Greco, Botticelli, Piero della Francesca or Louis Le Nain, as of a multitude of contrasting qualities each apparently divorced from those associations (of religion or of a certain concept of art itself) that were once thought to be indissolubly linked to them'.

Much of the scholarship of the last century has aimed to reverse this divorce of El Greco's art from its context – to counter the myth of El Greco the proto-modern. This exhibition – the most comprehensive and focused ever devoted to the artist – has particularly benefited from the scholarship generated by the ground-breaking show mounted in 1982 at the Museo Nacional del Prado in Madrid, the National Gallery, Washington, the Toledo Museum of Art and the Dallas Museum of Art, and the symposia organised by Nicos Hadjinicolaou in Crete in 1990, 1995 and 1999. Other important exhibitions – in Madrid, Rome and Athens in 1999–2000, and in Vienna in 2001 – have further sharpened our vision of the artist. The results of these ambitious undertakings can be found in the catalogue of the present exhibition. However, it is important to note that this catalogue is not a mere summary of current scholarship: it presents a particular interpretation of the artist's life and work. David Davies, the author of the essays on the artist and the guest curator, is a lifelong student of El Greco, and it is his vision that has shaped the exhibition – both the selection of works and the catalogue. He has been assisted by Gabriele Finaldi, formerly of the National Gallery and now Associate Director at the Museo Nacional del Prado, Xavier Bray at the National Gallery in London, and Keith Christiansen at the Metropolitan Museum. To them and to Sir John Elliott, who has addressed the historical background, we extend our heartfelt thanks.

El Greco's achievement was various, and David Davies has chosen to group the paintings thematically as well as chronologically. Thus, El Greco's pictures of *The Purification of the Temple* (cat. 6–9), though painted at different times, are shown together so as to bring into sharper focus his shifting emphasis. Similarly, his portraits – the finest selection ever brought together – are treated separately, as are his allegorical and mythological works. This kind of division is certainly in keeping with the artistic theory of El Greco's day, which applied different standards of decorum and naturalism to these different kinds of painting. That we have been able to gather such a distinguished body of works is entirely due to the generosity of numerous institutions and individuals and their commitment to this project. We are especially grateful to the museums and collectors in Spain and in North America – so rich in El Greco holdings – for agreeing to part with their works for this occasion.

At the Metropolitan Museum *El Greco* follows the exhibition *Manet/Velázquez: The French Taste for Spanish Painting* and joins a distinguished series of monographic exhibitions devoted to the great masters of Spanish art: *Zurbarán* in 1987, *Velázquez* in 1989–90 and *Ribera* in 1992. It also uniquely celebrates the taste for El Greco among New York collectors, foremost among whom are the Havemeyers. It was Mrs H.O. Havemeyer who bequeathed to the museum *The View of Toledo* and the portrait of *A Cardinal (probably Cardinal Niño de Guevara)*. The Metropolitan Museum would like to recognise the outstanding generosity of the Iris and B. Gerald Cantor Foundation for its sponsorship of *El Greco* in New York, and for its enduring support throughout the years. In London we extend very grateful thanks to GlaxoSmithKline, both for their long-term support of the National Gallery, and for their sponsorship of *El Greco*.

Philippe de Montebello
DIRECTOR, THE METROPOLITAN MUSEUM OF ART, NEW YORK

Charles Saumarez Smith
DIRECTOR, THE NATIONAL GALLERY, LONDON

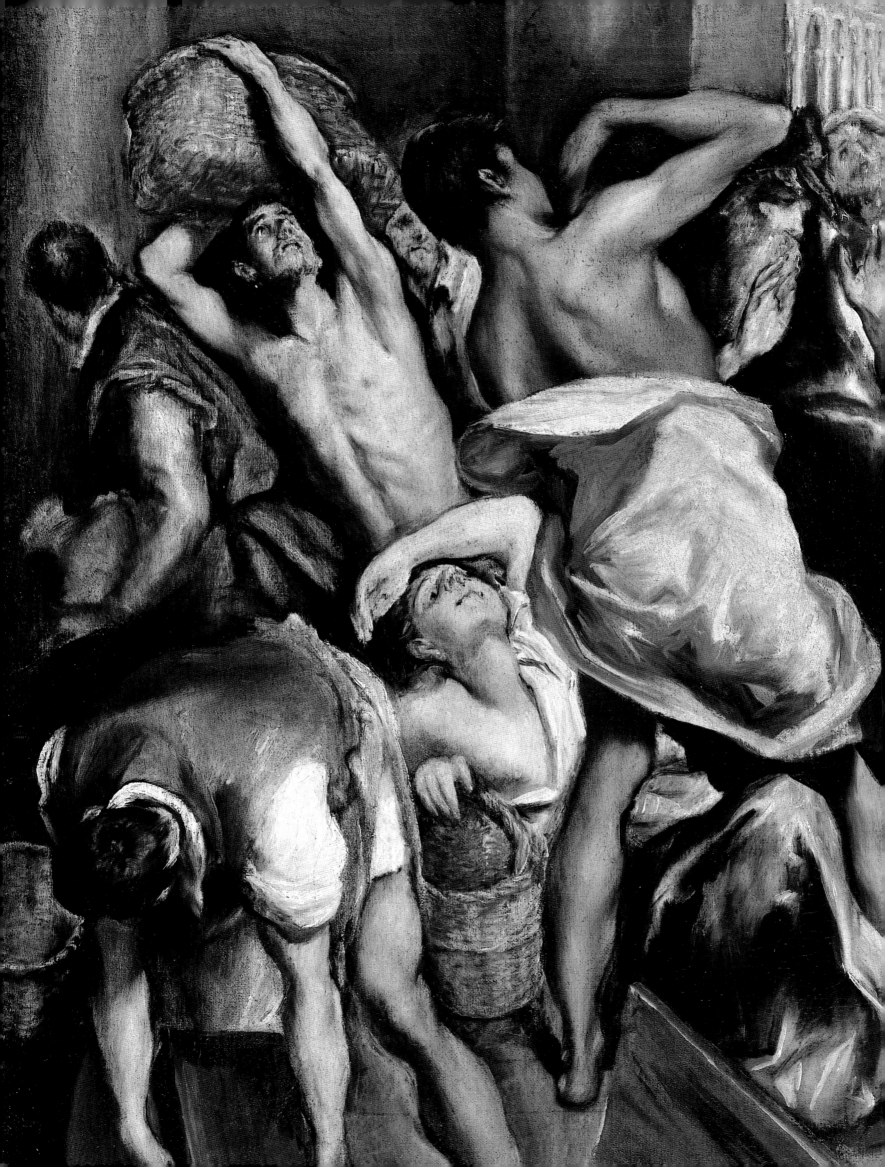

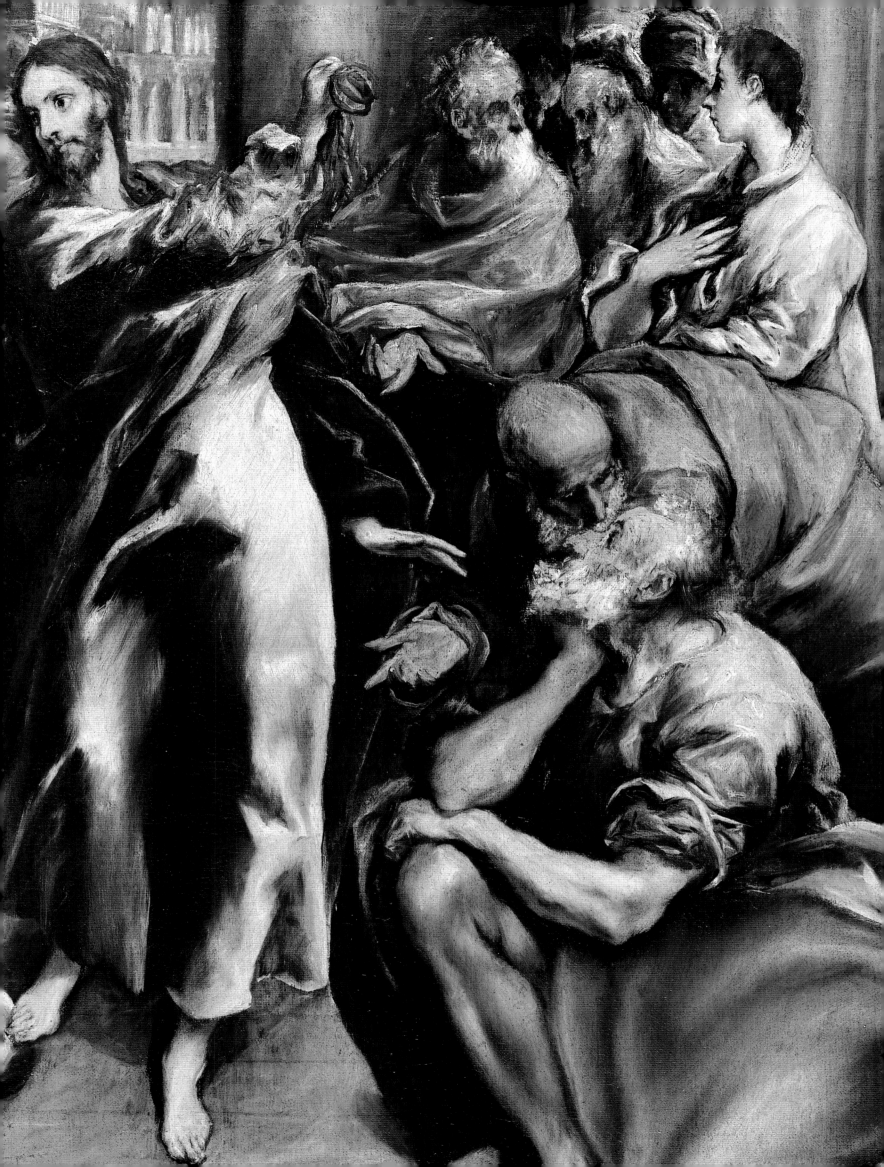

Acknowledgements

I wish to express my gratitude to Neil MacGregor for having invited me to curate this exhibition, and to dedicate it to a dear, mutual friend, Enriqueta Harris Frankfort, the 'doyenne' of scholars of Spanish Art.

My intention has been to examine El Greco's œuvre in its historical context – religious, philosophical, political and social – in order to appreciate its function, estimate its meaning for a contemporary audience, and assess the artist's developing response. Professor Sir John Elliott's essay is an eloquent introduction to that context.

Accordingly, the paintings have been arranged thematically and in chronological order. Thereby one is made acutely aware of the radical changes in the style of El Greco's religious paintings, for example, from a post-Byzantine idiom in Crete, to a Renaissance one in Italy, and to that in Toledo which he fashioned in response to the ethos of its religious life, and which reached a glorious climax in his late paintings. Compounded uniquely of Mannerist and Byzantine elements, his highly personal, conceptual style is characterised by elongated figures and abstract form, light and colour. As such, forms are denuded of mass and texture, light is bleached white and colours are pure. All is quickened – the figures assume flame-like shapes – and illuminated – the intense colours sparkle, and the incandescent light spurts fitfully. Perceived in its devotional and liturgical contexts, the meaning of El Greco's mystical imagery is clear, as it obviously was for his contemporaries.

Moreover, since he sought the essence of the religious drama – the spirit rather than the letter of the law – his paintings have a universal appeal. Their relevance is not confined to boundaries of time and space. Thus it is hoped that this exhibition will not only contribute to a better understanding of his art but also excite us and illuminate our vision.

To achieve this end, I have had the good fortune to have had the support and collaboration of Gabriele Finaldi, Keith Christiansen and Xavier Bray. Brimful with enthusiasm and mental energy, they, too, have journeyed abroad and engaged in complex, and sometimes frustrating, negotiations to secure loans. Significantly, it is they, together with the participation of Lois Oliver and Marcus Burke, who have compiled the catalogue entries. With intellectual acuity and visual sensitivity they have addressed established statements and made new observations about the chronology, iconography and style of El Greco's paintings. It has been a pleasure and a privilege to have worked with scholars endowed with such critical and instinctive discernment.

In my own work on El Greco, I owe a very special debt of gratitude to the following scholars, past and present: Enriqueta Frankfort, Anthony Blunt, Sir Ellis Waterhouse, Gregorio de Andrés, Ángel García Gómez and Ronald Cueto. Their instruction and scholarship have been a source of inspiration, and their support inestimable. I also wish to acknowledge the help of José Álvarez Lopera, Rocío Arnáez, Fernando Bouza, John Bury, Maria Calì, Fernando Checa, Peter Cobb, Walter Cockle, Maria Constantoudaki-Kitromilides, Gareth Alban Davies, Edmund Fryde, Consuelo García, R. L. Gapper, Nigel Glendinning, E. H. Gombrich, Lydie Hadermann-Misguich, Nicos Hadjinicolaou, Anne Halpern, Pamela Izzard, Marianne Joannides, Ludmilla Kagané, Gordon Kinder, Marina Lambraki-Plaka, Elizabeth McGrath, Jack Millar, Scott Nisbett, Terence O'Reilly, Alexander A. Parker, José Manuel Pita Andrade, Robert Pring-Mill, Margaret Ann Rees, Ruth Rubinstein, Michael Screech, Robert Sharples, Philip Troutman, Ronald Truman, Jennifer Vanim, John Varey, Maria Vassilaki, Zahira Veliz and John White.

In connection with the securing of loans for the exhibition, my colleagues and I are especially grateful to José Buces Aguado, who has given unstinted help, and has travelled to Toledo and Cadiz on our behalf, and to Zita Konialidis, who was instrumental in the negotiations over the loan of the Syros icon. In addition, we are deeply grateful to the following:

Ángel Alonso, Rafael Alonso, José Álvarez Lópera, William Nash Ambler, Christopher Atkins, Andaleeb Banta, Ronni Baer, Andrea Bayer, Joaquín de la Bellacasa, Sylvain Bellenger, David Alan Brown, Ignacio Cano, José Capa Eiriz, James N. Carder, Javier Carrión Barcaizlegui, Emilio Cassinello, Patrizia Cavazzini, Michael Clarke, César Conde, Philip Conisbee, His Excellency Miguel Ángel Cortés, Jean-Pierre Cuzin, Sabina De Cavi, David Djaoui, His Eminence Metropolitan Dorotheos of Syros,

Rev. Padre Luís García Donas, Carmen García Frías, Rafael García Serrano, José Carlos García Solano, Pierre Geal, Condesa de Gendulain, Luis and Samyra Irastorza, Olaf Koester, Athena Konialidis, Alastair Laing, Marina Lambraki-Plaka, Enrique Pareja López, Rev. Padre D. José Luis Pérez de la Roza, Carol Lekarew, Patrick Lenaghan, John Lishawa, Tomàs Llorens, Mercedes Llorente, Luis Fernando Londaíz y Mencos, Marques de Eslava, Jose Pepe de la Mano, María del Mar Borobia, Juan March, Fernando Marías, Guillermo Martínez-Correcher, Alvaro Martínez Novillo, Pilar Mencos y del Arco, José Milicua, His Eminence Cardinal Cormac Murphy-O'Connor, Enrique Ojeda, Consolación Pastor, Gonzalo del Puerto, Paloma Renard, Joseph Rishel, Deborah Roldan, Leticia Ruiz Gómez, Francis Russell, Almudena Sánchez, P. Juan Pedro Sánchez Gamero, Ángel Sáncho, Eléna Santiago, George Shackelford, Pilar Sedano, María Rosa Suárez Zuloaga, His Excellency The Marqués de Tamarón, Spanish Ambassador to the Court of Saint James, José Manuel Tofiño Pérez, Ana Trias, Dacía de Viejo, His Excellency Sr. D. Álvaro Fernández Villaverde y Silva, The Duque de San Carlos, Richard de Willermin, Isabel Zamora, Miguel Zugaza Miranda.

Finally, we wish to thank, wholeheartedly, the Exhibitions and Publications Departments, and the catalogue's editor, Paul Holberton, and designer, Philip Lewis, for their zealous commitment to the project. Their enthusiasm and efficiency have been exemplary, and they have shown remarkable composure in the face of the late agreement of loans, as well as the delayed submission of some essays, as I am well aware. The success of the exhibition will owe much to their sterling efforts. DD

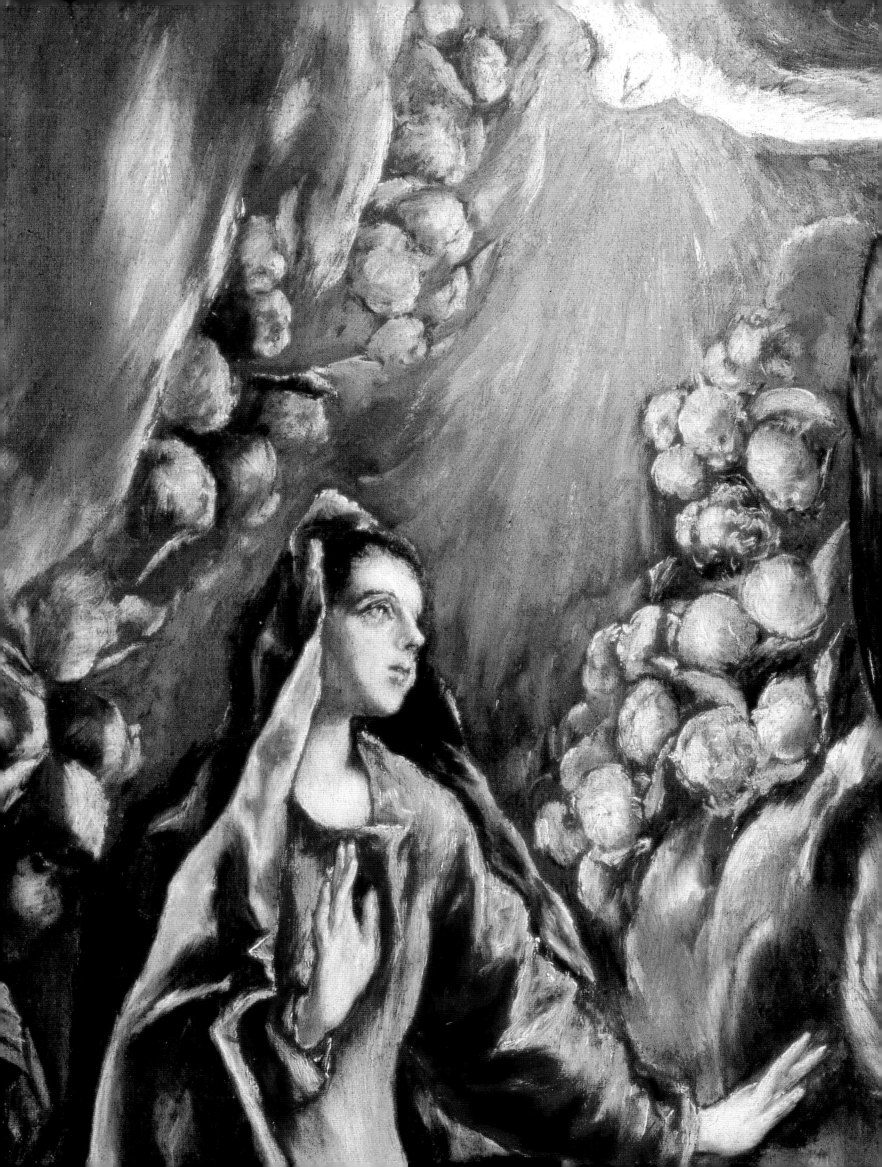

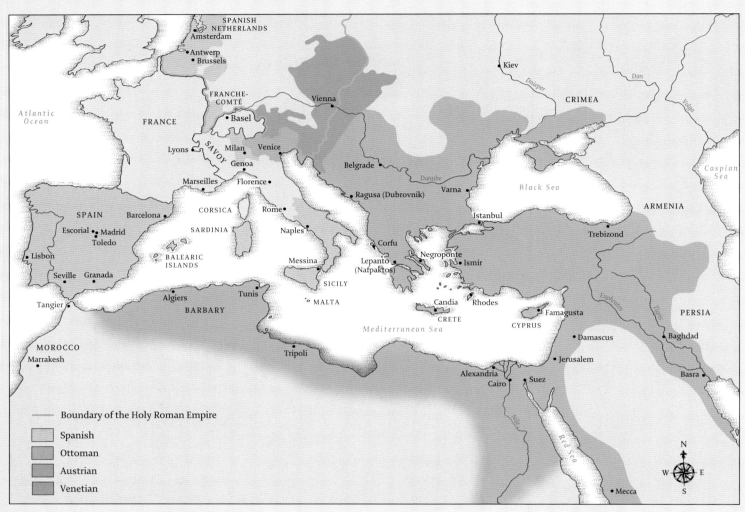

Fig. 1 Mediterranean empires at the end of the sixteenth century

Boundary of the Holy Roman Empire

Spanish

Ottoman

Austrian

Venetian

El Greco's Mediterranean:
The Encounter of Civilisations

THE MEDITERRANEAN WORLD of the sixteenth century –
the world of El Greco – was a world in which three civilisations
coexisted, interacted and clashed: the Latin West; the Greek
Orthodox East; and the civilisation of Islam (fig. 1). As a Cretan,
and hence a subject of the Republic of Venice, Domenikos
Theotokopoulos, known as El Greco (1541–1614), belonged both to
the Greek East and to Latin Christendom. He and his generation
lived much of their lives in the shadow of confrontation
between Christendom and Islam.

More than a month's sailing time from Venice,[1] Crete,
a Venetian colony since 1211, was, by the sixteenth century,
an exposed Christian outpost in an eastern Mediterranean
dominated by the Ottoman empire from its capital at Istanbul,
the former Constantinople. Its Greek Orthodox inhabitants,
citizens of the Byzantine empire until the island passed into
the hands of the Venetians, had continued to look towards
Constantinople as their spiritual home until it fell to the
Ottoman Turks in 1453. Clinging tenaciously to their Greek
culture in the face of a repressive Venetian regime, they
engaged in periodic insurrections against Venetian rule, and

fiercely resisted Venetian attempts to impose upon them the
measures agreed at the Council of Florence in 1439 to end
the schism between the Greek and Latin churches. By the
later fifteenth century, however, the growing threat from the
Turks would begin to force on Venice a reassessment of its
policies, including its religious policy, towards a resentful
colonial population.

If the peasants, extracting a meagre living from the stony
soil, remained implacably opposed to their Venetian feudal
lords, in the towns at least the once sharp divisions between
colonists and colonised were gradually being blurred. Inter-
marriage at all levels of society had brought the two communities
closer, and the Venetian ruling élite, which had accepted the old
Cretan nobility into its ranks, was assimilating the Greek
language, Greek dress and Greek ways.

Urban life came to reflect the new prosperity of an island
that reaped increasing benefits from its participation in Venice's
expanding maritime and commercial empire, exporting olive
oil, salt and raisins and serving as a staging-post for Venetian
shipping. Cretan families sent their sons to study at Padua

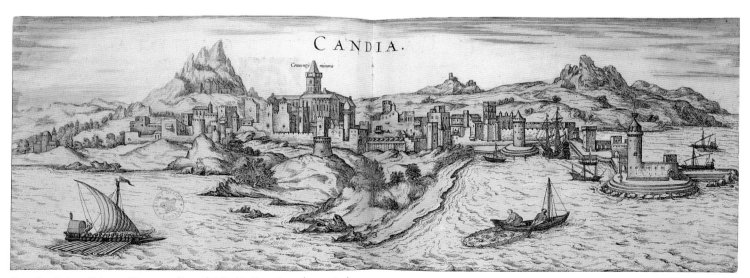

Fig. 2 **Candia** from *Civitates orbis terrarum* (II, p. 53). Edited by Georg Braun (1541–1642)
6 volumes, published 1572–1617. The British Library, London, Maps C29E1

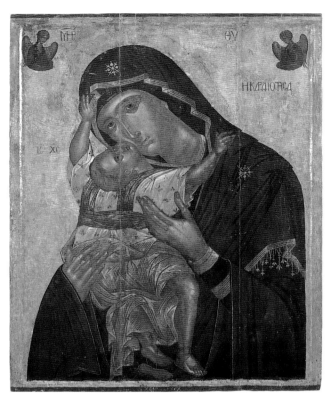

Fig. 3 Angelos Akotantos (active around 1500–1550)
The Virgin Kardiotissa, fifteenth century
Tempera and leaf on panel, 121 × 96.5 cm
Byzantine and Christian Museum, Athens, inv. τ1582

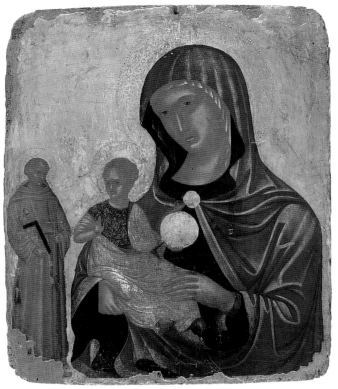

Fig. 4 Attributed to Nikolaos Tsafouris (died before 1501)
The Virgin 'Madre della Consolazione' and Saint Francis of Assisi, late fifteenth century
Tempera and leaf on panel, 60 × 52 cm
Byzantine and Christian Museum, Athens, inv. τ233

University on the Venetian mainland, and Cretan cultural life began to respond to the Renaissance breezes blowing from Venice – a Renaissance which itself was indebted to the Greek refugees who had fled to the West after the fall of Constantinople. Venetian-style buildings and *piazze* began to change the face of the old Byzantine towns, and notably of the island's capital, Candia (fig. 2; the modern-day Iraklion), which by the later Middle Ages had given its name to the island as a whole. Gradually, in the late fifteenth and early sixteenth centuries, Greek East and Latin West were blending to create a distinctive Venetian-Cretan culture.[2]

It was in the city of Candia (so named after El Khandak, the defensive ditch built by the Arabs during their occupation of Crete during the tenth and eleventh centuries) that Domenikos Theotokopoulos was born in 1541, a member of one of those local families which had prospered as a result of service to the Venetian state. His father, Georgios Theotokopoulos, was a tax-farmer with shipping and trading interests, and his elder brother Manoussos would follow in their father's steps.[3] The family is thought to have been Greek Orthodox, but by the mid-sixteenth century Venice's more relaxed religious policy had dispelled many of the old tensions between the Greek and Latin cults. In the new, more tolerant climate of religious co-existence, the adherents of the two faiths would frequent each other's churches, while both communities would participate in the innumerable religious processions that enlivened the street life of Candia and the island's other towns, celebrating their shared devotion to the Virgin Mary and Saint Francis.[4]

Another bridge between the two religious worlds was provided by the portable icon. Cretan workshops of the later fifteenth and early sixteenth centuries enjoyed a flourishing trade in these sacred images, both for the home market and for export to Venice and the eastern Mediterranean. A distinctive school of Cretan icon-painting had by now emerged, producing works of a hybrid character, in which Byzantine traditions (fig. 3) were modified by western influences brought to the island by Venetian prints and paintings or by returning artists (fig. 4).[5] His obvious artistic talents qualified the young Domenikos Theotokopoulos for training in the workshop of a local icon-painter, and by 1563 he was publicly known as a master in the art of painting icons and tempera panels. At this stage of his career, and for someone of his ambitions, a move from the provincial society of Crete to the cultural metropolis of Venice would have offered irresistible attractions. Many of his compatriots had made the same move before him, lured by the greater economic and social opportunities to be found in the city that prided itself on being the Queen of the Adriatic, the head of a great maritime empire.

When El Greco moved to Venice in 1567, possibly making use of his family's contacts in the city, he was confronted not only

by a heritage of overwhelming visual and architectural beauty, but also by living artists whose style was far removed from that of the Cretan icon-painters with their carefully modelled figures set against brilliant gold backgrounds. During his three years in Venice, where he seems to have worked and studied on his own, he gradually assimilated the lessons to be learnt from the artists of the Venetian Renaissance about colour, perspective and the technique of painting in oils. In particular, the two greatest living masters, Titian and Tintoretto, were to have a transforming impact on his work.[6] Those three years of residence in Venice, so fruitful for El Greco's personal development, were, however, years of impending crisis for the Republic and its empire – a crisis in which his family in Crete would be fatally engulfed.

The city, with a population of some 170,000,[7] had acquired its prosperity, and built up its maritime empire, through skilful exploitation of its geographical position as a meeting-point and centre of exchange between Greek East and Latin West.[8] It had survived both the opening by the Portuguese of an overseas route to the spices of the East and the replacement of the Byzantine empire by that of the Ottoman Turks. It was as much in the interest of the Turks as of the Venetians to maintain the flow of trade, but the Ottomans had developed into a formidable naval power, posing a major threat to Christian lands and shipping in the eastern and central Mediterranean. The thrust of Venetian diplomacy was to protect the Republic's territorial and commercial interests by staying on good terms with the Ottoman Sultan, Sulaiman the Magnificent, and, following Sulaiman's death in 1566, with his successor Selim II.

By the middle years of the sixteenth century Venice, although it maintained a substantial fleet, had become a pygmy in a Mediterranean world dominated by two opposing giants. An expanding Ottoman empire lay to its east, and to its west lay the Spanish monarchy and empire, of which the government passed in 1556 from Charles V to Philip II. In both the Spanish and the Ottoman empires memories ran deep. The presence on Spanish soil of a large population of Moorish descent, the Moriscos – left behind in the peninsula after the completion of its reconquest by Christian forces in 1492, and only nominally converted to Christianity – was a persistent reminder of the centuries of hostility between Christendom and Islam. The legacy of religious hatred was compounded by the clash of territorial interests along the North African coast, and by endless skirmishes on the sea and along the shores of the Mediterranean as the Turks and their North African allies attacked Christian shipping and raided Christian villages while corsairs from Spain and Italy responded in kind.

As the two empires moved towards their decisive confrontation, it required all the skills of Venetian diplomacy to steer a course between them. But in 1565 the Turkish fleet besieged Malta. The eventual raising of the siege of Malta, following the arrival of the Spanish fleet, made it clear that only Spain had the capacity and the resources to protect the central Mediterranean against Ottoman assaults. Having failed at Malta, the Turks, under their new sultan, would sooner or later seek their revenge elsewhere, and the Venetian colonies of Cyprus and Crete were the most obvious targets for an attacking fleet. After thirty years of peace, the Venetians still clung to the hope that their territories would be immune from attack,[9] but in July 1570 Turkish forces invaded Cyprus and laid siege to Famagusta. In Spain at the same time, Don John of Austria, bastard son of Charles V and half-brother of Philip II, was in the final stages of crushing a revolt of the Moriscos of Granada after almost two years of savage guerrilla warfare in the Alpujarra mountains.

Pius V, the most austere of Counter-Reformation popes, saw this as the moment for realising his long-cherished dream of organising an alliance of Christian powers against the forces of Islam. Struggling to save Famagusta, the Venetian republic set aside its objections to a military confrontation with the Ottoman empire and an alliance with Spain. After protracted negotiations a Holy League was agreed on 20 May 1571. By the terms of the League, Spain, Venice and the papacy were to join forces in a campaign against the Turks, with Spain contributing half the funds, troops and ships, the Venetians a third and the pope a sixth.

By this time El Greco had been in Rome for several months. He had arrived there in the autumn of 1570, bringing with him works he had painted in Venice. The celebrated Croatian miniature painter Giulio Clovio, impressed by his skill, recommended him

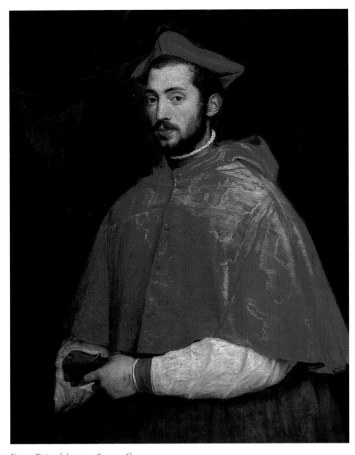

Fig. 5 Titian (about 1487–1576)
Cardinal Alessandro Farnese, 1545–6
Oil on canvas, 93 × 73 cm
Museo Nazionale di Capodimonte, Naples

to Cardinal Alessandro Farnese (1520–1589), the rich and cultivated grandson of Pope Paul III and the greatest Roman patron of artists and men of letters of the age (fig. 5).[10] The Palazzo Farnese, in which El Greco was initially to be given accommodation, had been completed and extensively remodelled by Michelangelo. The great Florentine had died six years earlier, but his powerful presence was inescapable for El Greco as he walked the streets and visited St Peter's and other city churches. Cardinal Farnese, protector and patron of the Jesuits, and builder of their mother church of the Gesù, carried over into the more dogmatic age of the Counter-Reformation the values and concerns of Renaissance humanism, and favoured in his artistic tastes a judicious blending of the old and the new. In coming into contact with the cardinal's intellectual circle under the leadership of his humanist librarian Fulvio Orsini, El Greco therefore found himself once again in a crucible in which different worlds met and fused – in this instance the worlds of Renaissance humanism, pagan antiquity and Catholic Reformation spirituality, as defined by the decrees promulgated by the Council of Trent on its conclusion in 1563.

The Farnese circle was much frequented by Spaniards, whose presence in the city, in large and growing numbers, was one of its most striking features in the later sixteenth century. In 1582 it was alleged that there were 30,000 of them – clerics, lawyers and merchants, together with artisans and notaries to meet their various needs. If true, this would mean that they represented nearly a quarter of Rome's estimated population of 115,000.[11] Spanish influence, indeed, was all-pervasive in the Rome of the Counter-Reformation papacy. There was a constant coming and going between Madrid and the papal court. Philip II, like Charles V before him, needed a compliant papacy to support his global interests, and approve his ceaseless requests for taxes and financial support from the wealthy Spanish church. The Spanish ambassador to the Holy See was therefore a dominant figure in the life of the city, distributing pensions to the cardinals, including Cardinal Farnese, to ensure on each papal death the election of a new pontiff favourable to Spain. While Philip II pursued policies which in his eyes were invariably in the best interests of the Church, a judiciously managed patronage system kept the papacy in line.

In the early summer of 1571, Spain, the papacy and the normally recalcitrant Venetians were at last united against a common enemy. Vast preparations were now under way, and on 7 October the combined allied fleets, under the supreme command of Don John of Austria, met and defeated the Ottoman fleet in Greek waters at Lepanto (present-day Nafpaktos) in the Corinthian Gulf. It was an extraordinary triumph for Christian arms. Of the Ottoman fleet of some three hundred ships, 127 were captured by the forces of the Holy League, and the Turks lost 30,000 men, as against Christian losses of fifteen to twenty ships and perhaps 8000 men.[12] In Venice, where the news of the victory arrived on 19 October, the doge and Signoria went at once to St Mark's, where mass was sung with the *Te Deum Laudamus*. In Rome, where the news was received on 22 October, an elated Pius V and his cardinals gave thanks in St Peter's, and triumphal arches bearing the names of Philip II, the pope and Venice were erected in the streets.[13] As the news spread across Europe the rejoicings were everywhere repeated, and in Toledo, where again a *Te Deum* was celebrated in the great cathedral, Philip II endowed an annual procession to commemorate the victory in perpetuity (figs. 6 and 7).[14]

While the psychological impact of the victory was enormous, bringing a vast sense of relief to a Christendom which had long felt beleaguered by Islam, its aftermath proved in many respects a sad disappointment. Pius V and Don John of Austria dreamed of a crusade which would see Christian banners flying from the towers of Istanbul and Jerusalem. Greek copyists, poring over their codices in Spain, dreamed of the liberation of their homeland from the Turks.[15] But the Venetians were interested only in the fate of Cyprus, which they finally surrendered to the Turks in 1573 in return for peace, and Spain's attention was being diverted from the Mediterranean by its struggle with the Dutch. For Philip II the challenge of Islam was beginning to take second place to the Protestant challenge emanating from the Netherlands, England and France. For its part the Ottoman empire was becoming increasingly absorbed in developments on its Persian front. As a result, the two empires began to disengage, and the great war in the Mediterranean dwindled into a stand-off characterised by corsair attacks and small-scale naval skirmishes.

The dreams of lesser men than the pope and John of Austria were also doomed to disappointment. Among them was El Greco's elder brother, Manoussos, who arrived in Venice in October 1571 in the wake of Lepanto to request four armed galleys to launch attacks on Turkish shipping. His enterprise, however, went awry when he made the mistake of attacking a merchant vessel which turned out to be sailing under a Ragusan flag, and carrying supplies for the Venetian fleet. Arrested by the Venetian authorities and unable to pay his debts at a time of depression on the island, he was forced to sell all his property. Years later he would join his younger brother in Toledo, where he died in 1604.[16]

In Rome, El Greco himself was faring little better. Disappointed of Farnese patronage,[17] he secured admission in 1572 to the painter's guild, the Accademia di San Luca, which allowed him to set up his own studio, but he failed to obtain major commissions, and his prickly temperament and outlandish opinions did not help to smooth his path.[18] Once again he decided to try his luck elsewhere, this time with Titian's royal patron, Philip II of Spain. By October 1576 he was to be found in Madrid.

He was probably hoping to join the Italian artists who were being recruited to work on the decoration of Philip II's monastery–palace of El Escorial, of which the foundation stone had been laid thirteen years earlier, in 1563.[19] Work had now begun on the great basilica at the centre of the monumental complex, and a whole series of *retablos*, or altarpieces, would be needed for its chapels and altars.[20] His first documented activity, however, was in Toledo, and here he was to remain. For all his efforts, he would never win the favour of the king. In *The Adoration of the Name of Jesus* (fig. 8, detail of cat. 22), apparently painted in commemoration of Lepanto, he would portray Philip at prayer, alongside his Holy League allies, the pope and the doge.[21] Although he eventually managed to secure a commission for the Escorial, *The Martyrdom of Saint Maurice* (fig. 16, p. 53), his picture apparently failed to conform to Tridentine notions of religious propriety, and was deemed unsuitable for the basilica. No further royal commissions were to come his way.[22]

Failing to find employment at the Escorial or with the court in Madrid, he had to make do for the time being with Toledo, the city which had lost out to Madrid when, in 1561, Philip II

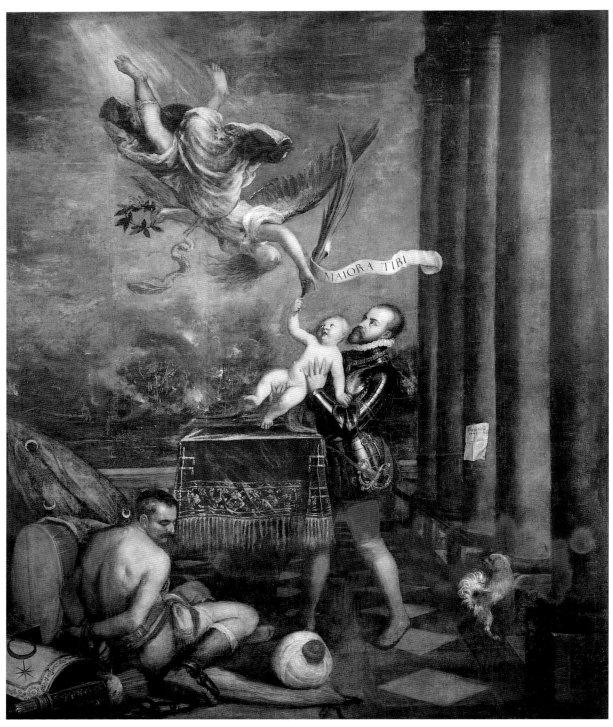

Fig. 6 Titian (about 1487–1576)
Philip II offering Don Fernando to Victory
(Allegory of the Battle of Lepanto), before 1575
Oil on canvas, 325 × 274 cm
Museo Nacional del Prado, Madrid, inv. 431

OPPOSITE
Fig. 7 Paolo Veronese (probably 1528–1588)
Allegory of the Battle of Lepanto, about 1572
Oil on canvas, 169 × 137 cm
Gallerie dell'Accademia, Venice

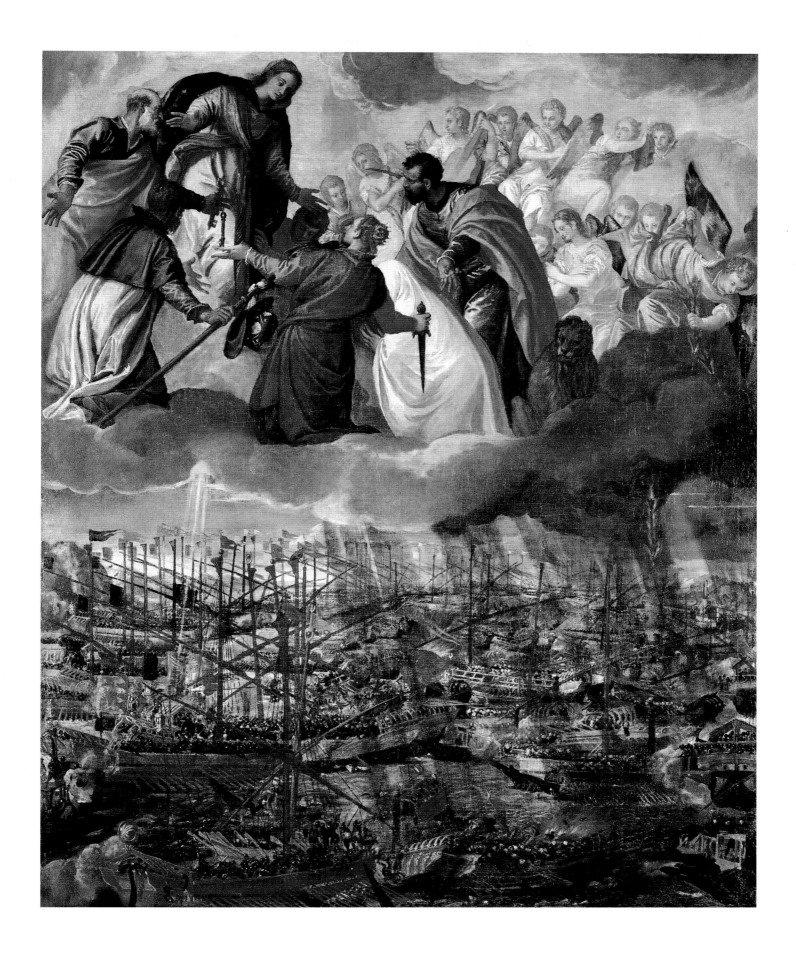

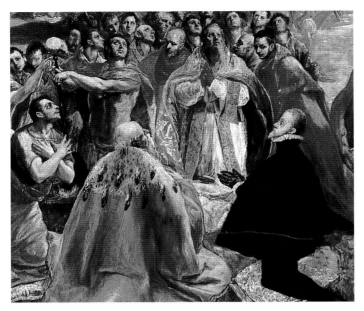

Fig. 8 Detail of cat. 22

decided that the inconveniences of an itinerant court were so great that the time had come to find a permanent location for the seat of government. Among its other disadvantages, Toledo (figs. 9 and 10), perched high above the river Tagus, was a city of steep and narrow streets, and offered little scope for expansion.[23]

All the indications are that El Greco went to Toledo as a result of the friendship he had struck up in Rome with Luis de Castilla, who had gravitated into the Farnese circle on his arrival in the city in 1570.[24] Luis, the illegitimate son of Don Diego de Castilla, dean of the Toledo Cathedral chapter, was well placed to obtain commissions for El Greco in his native city. In the event, Don Diego commissioned him to paint not only *The Disrobing of Christ* (see cat. 21) for the cathedral vestiary – on which he was already at work in early July 1577 – but also eight canvases for the main and side altars of a new church to be constructed for the convent of Santo Domingo el Antiguo (see cat. 17–20). These were the first commissions in a Spanish career that was to see the artist working in Toledo for the rest of his life.[25]

Although he had made the acquaintance of Spaniards in Rome, nothing would quite have prepared El Greco for the Spain of Philip II, where artists were still looked down upon as no more than artisans. It is significant that he was known in Spain as 'the Greek' in its Italian form, 'Greco' – the name by which he had been known in Italy – rather than in its Spanish form (which would have been 'El Griego'), as might have been expected once he had settled in Castile. The parish register of Santo Tomé in Toledo records his death in 1614 under the name of 'Dominico Greco',[26] but he himself, even in his last years, was still signing his pictures in cursive Greek letters either with his

initials or else as *Domenikos Theotokopoulos* in full. Although he had learnt enough Spanish by 1582 to be able to act as an interpreter in a case before the Inquisition involving a fellow Greek accused of Islamic practices,[27] he remained, in Spain, as elsewhere, something of an outsider, a native of Candia to the end.

The Spain of the 1570s was still basking in the afterglow of Lepanto, and Philip II was the most powerful monarch in Christendom. In 1580, on the extinction of its native royal line, the kingdom of Portugal would be added to his dominions, and the combined Spanish and Portuguese empires stretched around the globe. Vast quantities of silver were flowing in to Seville each year from Spain's viceroyalties of Mexico and Peru and, in the nervous eyes of her enemies or her uneasy allies, the Spain of Philip II was on the road to universal monarchy.[28] But problems were accumulating for Philip, not least in northern Europe, where the Dutch rebels were consolidating their position, and Elizabethan England was proving to be an increasingly aggressive and formidable power on the high seas.

Castile, the heart of Spain's monarchy and empire, saw itself as the Lord's chosen nation and the champion of His cause. But, to retain divine favour, its religious orthodoxy must be impeccable. Philip II had been prompt to announce his acceptance of the Tridentine decrees, and strenuous efforts were made to raise the educational standards of the clergy, improve the morals and spiritual awareness of the lay population, and standardise devotional practices to conform to the new criteria. The religious orders were to be the active instruments of this Catholic reformation, while an intrusive Inquisition vetted books for any expression of heretical propositions and maintained a network of informers on the lookout for any hint of religious deviation.[29]

Spiritual confidence was therefore accompanied by a deeply defensive mentality which detected enemies at every turn. At the beginning of Philip's reign, 'Lutheran' cells had been discovered and eradicated in Valladolid and Seville, and nobody was safe, not even the primate of Spain. In 1558 the Archbishop of Toledo, the Dominican friar Bartolomé Carranza, was arrested by the Inquisition on the charge of promulgating

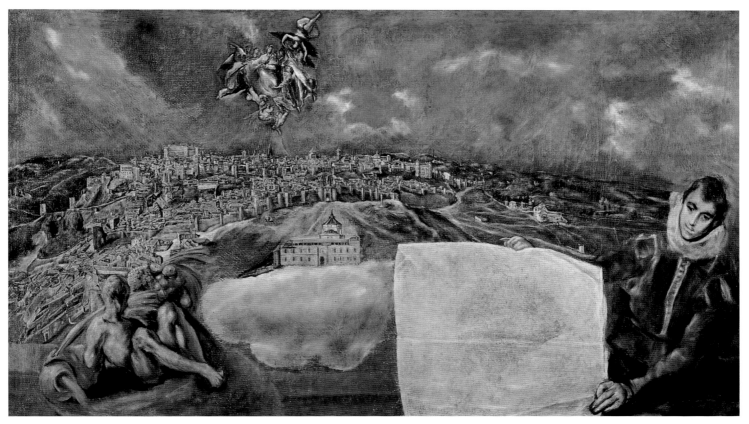

Fig. 9 El Greco
View and Plan of Toledo, about 1610
Oil on canvas, 132 × 228 cm
Museo de El Greco, Toledo

heresies in a book of commentaries on the Catechism. Carranza's orthodoxy was defended before the Inquisition by a distinguished group of supporters, including Don Diego de Castilla, who described him as 'an excellent prelate', and who, as dean of the chapter, was effectively in charge of Toledo Cathedral during the archbishop's long imprisonment. Carranza died in Rome in 1576, the year before El Greco's arrival in Toledo, having abjured sixteen suspect propositions, but without being able to return to his see.[30] In the absence of an archbishop the cause of ecclesiastical reform in the archdiocese lagged, and it was left to his successor, the Inquisitor General Gaspar de Quiroga, to push ahead with the work of Counter-Reformation, although he, too, was largely an absentee, spending most of his time at court.[31]

The religious purity of Spain was seen to be threatened not only by Protestants whose heresies infiltrated into the peninsula through subversive literature, but also by the activities of Moors and alleged crypto-Jews. The subjugation of the rebellious Moriscos of Granada in 1570 had been followed by their dispersal through Castile, a move which only served to exacerbate the problem by spreading northwards the presumed contagion of Islamic beliefs and practices and creating new pockets of

a largely unassimilated ethnic group in Castilian cities like Toledo. Some forty years later, in 1609–11, the government of Philip's son and successor, Philip III, adopted a radical solution to the festering Morisco question by expelling from Spain the entire Morisco population, some 300,000 strong.[32]

Once the internal threat from Protestantism had been eradicated, the taint of 'judaising' had moved to the top of the Inquisition's list of concerns. Practising Jews had been expelled from Spain in 1492, but many had converted to Christianity both before and at the time of the expulsion. Unlike the Moriscos, who usually held lowly occupations, many of these Jews' descendants, the so-called *conversos* or 'new' Christians, occupied important positions both in Church and state. In the sixteenth century in Toledo *conversos* were to be found in the flourishing merchant community, in the cathedral chapter and on the city council.[33] But in 1547, against strong opposition from Diego de Castilla, Cardinal-Archbishop Silíceo pushed through the cathedral chapter a statute of '*limpieza de sangre*' (purity of blood), excluding from ecclesiastical offices and benefices anyone with a trace of Jewish lineage over four generations. In 1566 the crown imposed a similar statute on the Toledo city council.[34]

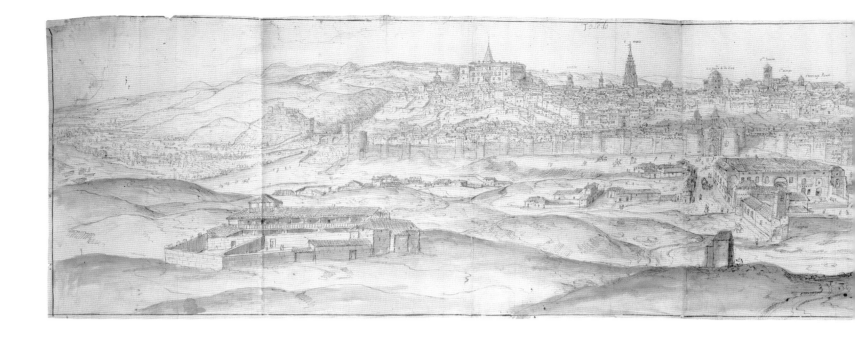

While many descendants of converted Jews succeeded in concealing their family origins by the use of forged genealogies, change of surname and extensive bribery, the spread of *limpieza* statutes in the Castile of Philip II inevitably heightened tensions in a society where the authorities were obsessively preoccupied with the purity and preservation of the faith. In a religious climate characterised by repression, growing dogmatism and an insistence on conformity, humanist scholarship found itself under pressure, heterodox opinions went underground, and highly charged spiritual energy, like that of Saint Teresa – herself of Jewish ancestry – was not only channelled into public and private devotion, acts of charity, and religious reform, but also found an outlet in the upsurge of mystical writing that was to be one of the glories of the age.

There is no evidence that El Greco himself had any contact with these mystical currents or was affected by their influence, but the city in which he had taken up residence was at the centre of the Spanish Counter-Reformation. Now that the court had moved to Madrid, Toledo, with a population of some 60,000 inhabitants, was heavily dominated by its ecclesiastical establishment, although it retained a strong artisan base, consisting primarily of silk and other textile workers. The 1591 census recorded 739 secular clergy and 1942 members of the religious orders, of whom 1399 were women.[35] The cathedral alone, with forty canons, had a staff of almost six hundred.[36] The Church was ubiquitous in this city, and members of the civic élite, who were proud of the Roman and imperial heritage of their native city and keen to modernise and beautify its public buildings, were no less concerned to found and adorn churches, chapels

and convents which would help to win them a place in Heaven and perpetuate their memory on earth.

As an itinerant foreign artist in search of employment El Greco, therefore, had chosen his city well, even if he had done so more by accident than design. Above all, Toledo offered the promise of patronage, not only of the clergy but also of an educated civic élite. Patrons, or potential patrons, naturally wanted altarpieces for their churches and chapels and religious pictures for private devotion, and a number of them, too, wanted their portraits painted. However, while religion was all-pervasive in late sixteenth-century Toledo, and shaped the character and direction of El Greco's artistic production, the nature and extent of his own religious commitment are difficult to determine. The demand for devotional works and altarpieces meant that there was ample scope for a skilled and accommodating artist, but El Greco, as his Italian career had already suggested and his Spanish career was to confirm, was the least accommodating of men. With unconventional and vehemently expressed views about the visual arts, and an exalted opinion of the artist's calling and his own personal worth, he was quick to engage in litigation and antagonise his patrons. In spite of this, he received enough commissions for altarpieces to keep his studio working, and gradually built up a circle of discerning clients and admirers who appreciated his artistic genius and were prepared to pay for paintings that defied conventional tastes.[37]

These included some of the most learned and intelligent members of Toledo's élite – not only clerics but also merchants, lawyers and professors in the city's university of Santa Catalina.

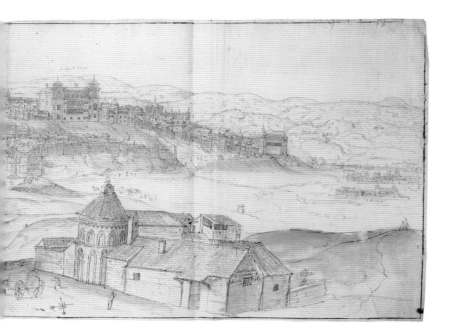

The city could boast several distinguished scholars with classical, philological and historical interests, and there was a particular enthusiasm at this time for the collecting and editing of Greek texts, especially those relating to the early Church councils – a subject of keen interest in a city whose church enjoyed ecclesiastical primacy in Spain, and which was to be the seat of a reforming provincial council in 1582. A number of Greeks were living in Toledo in El Greco's time, some of whom found part-time employment transcribing these texts. Among them was a fellow-Cretan, Antonio Calosinás, brought back for this purpose from the Council of Trent by two of Toledo's most distinguished citizens, the brothers Antonio and Diego de Covarrubias, both of them royal councillors.[38] Antonio de Covarrubias, who was later to become a canon of the cathedral and *maestrescuela* or rector of the university, was to be El Greco's closest known friend.[39]

It was among such people – scholars, collectors and connoisseurs – that this proud foreigner seems to have felt most at home. His intellectual approach to the arts made their company congenial to him, while they admired his virtuosity. As they sang his praises, so his fame began to spread. This in turn won him new commissions, but the money was never sufficient to pay for the opulent life-style to which he felt himself entitled, and which included paid musicians to entertain him at his meals.[40] But conspicuous consumption was nothing unusual in the Spain of Philip II and Philip III (1598–1621). It was not only individuals, but the whole country, that lived beyond its means. Yet at least during El Greco's lifetime Toledo remained a prosperous city. It was in the two or three decades following

his death in 1614 that its population began to dwindle and its industries to decline.[41]

Toledo may not have been what El Greco had in mind as his final destination when he left Candia on his westward journey, but, as a second best to the courts of popes and kings, the city had its compensations. His travels had brought him to the very heart of Counter-Reformation Spain, to a country and a city with the spiritual energy and material resources to provide an environment that gave him a degree of acceptance, and sufficient employment to provide him with a living. Above all, it offered him the opportunity and the stimulus to resolve with supreme originality the artistic problems arising from the personal encounter of a painter formed in the Greek tradition with the art and artists of the Latin West. In Toledo, as in Rome, the worlds of classical scholarship and Counter-Reformation spirituality met and interacted. In Toledo, as in Venice and his native Candia, Christianity was brought face to face with the potentially galvanising presence of rival traditions and survivals, both Jewish and Moorish. Here, in the imperial city of Toledo, at the conclusion of his long journey through the kaleidoscopic worlds of the sixteenth-century Mediterranean, the uniquely personal world of El Greco at last fell into place.

OVERLEAF
The Burial of the Count of Orgaz (Gonzalo Ruiz of Toledo, Senor Orgaz) (detail), 1586–8 (fig. 17)

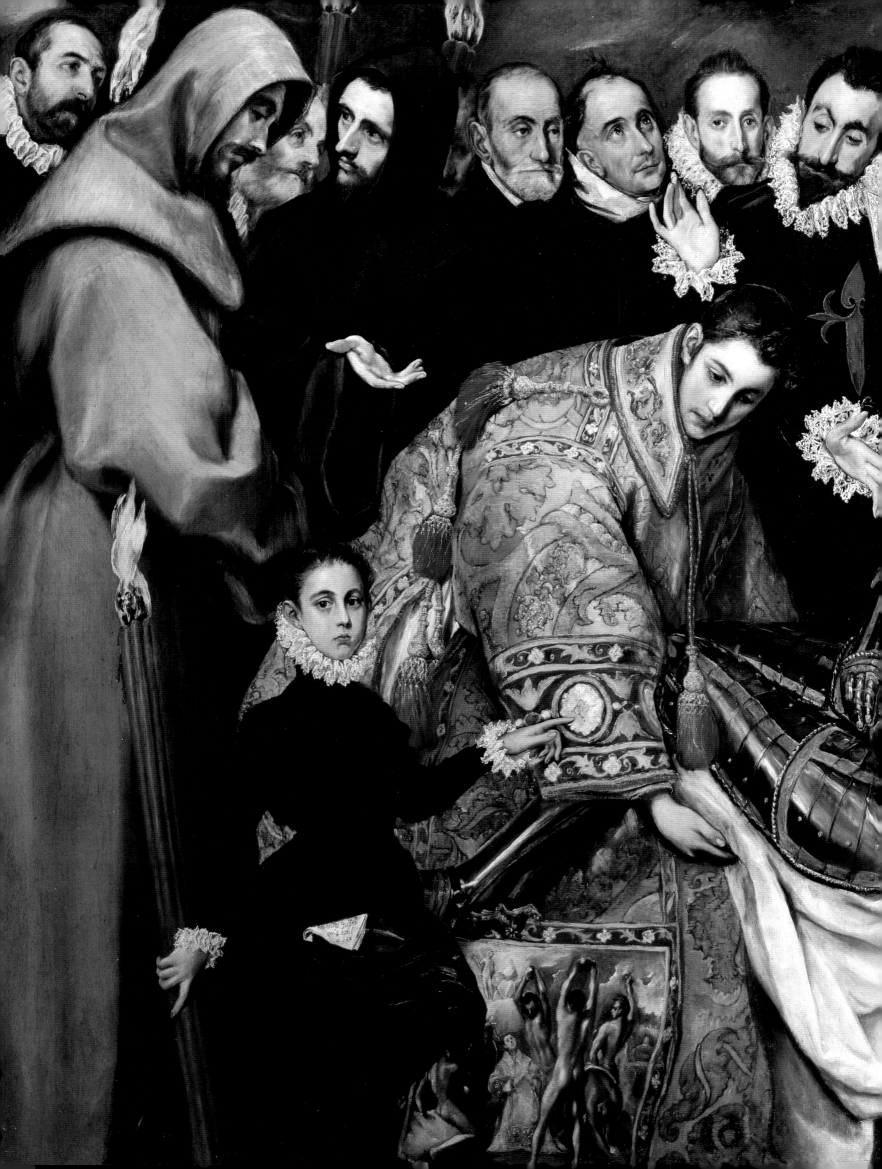

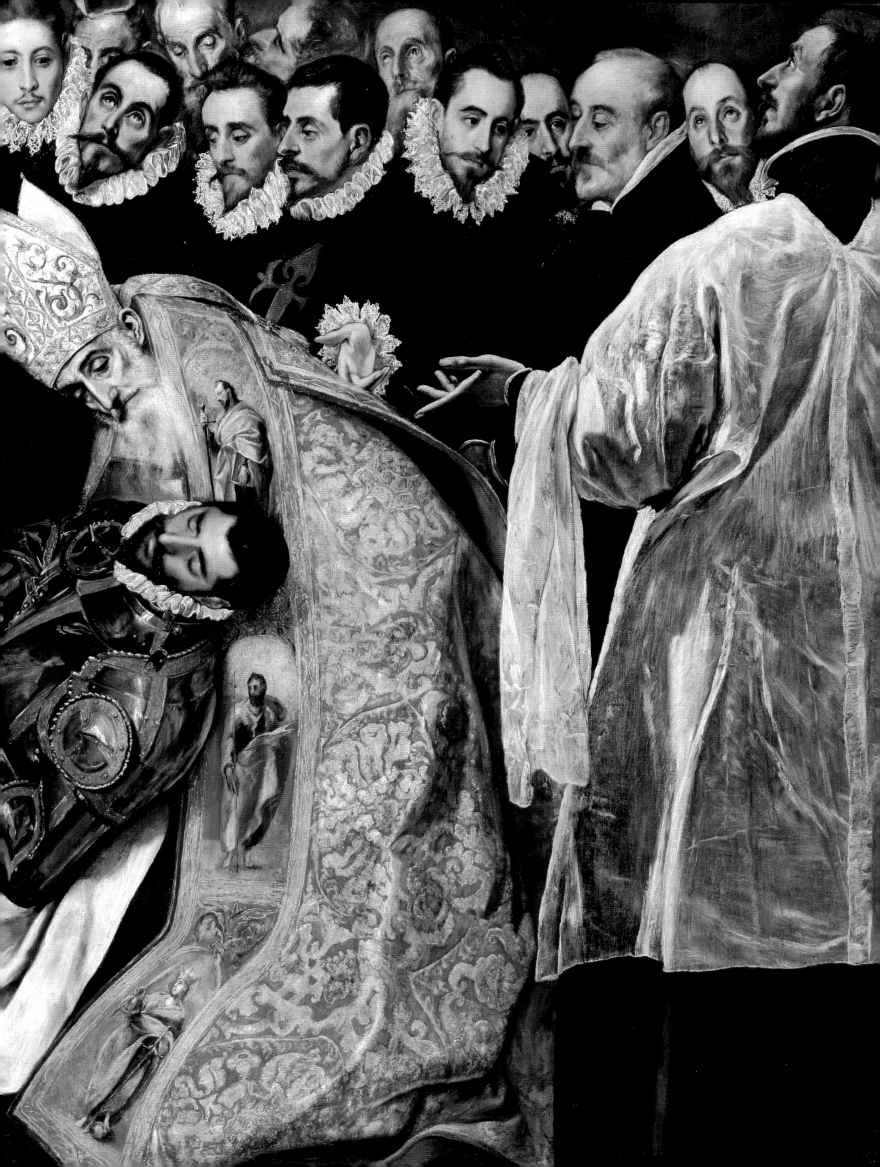

Chronology

The softest brush ever to give soul to a panel, life to canvas
LUIS DE GONGORA Y ARGOTE, sonnet – *A Funeral Lament to El Greco* (1627)

CRETE

1541 According to his own testimony, Domenikos Theotokopoulos (known as El Greco) was born in Candia (now Iraklion), the capital of Crete, then a possession of the Venetian Republic. In a document dated 31 October 1606 the artist gave his age as 65. In 1582, acting as interpreter in the trial of a Greek boy in Toledo, he stated that he was a native of the 'town of Candia'. El Greco's father, Georgios Theotokopoulos, was a tax collector for the Venetian state with trading and shipping interests, and the artist's elder brother Manoussos (1531–1604) followed in his father's footsteps.

First session of the **1545**
Council of Trent

Ignatius Loyola's **1548**
Spiritual Exercises
published

Philip II proclaimed **1556**
king of Spain

Bartolomé Carranza **1558**
(1503–1576) appointed
Archbishop of Toledo

Spanish court moved **1561**
from Toledo to Madrid

Last session of the **1563** On 28 September the Duke of Candia
Council of Trent issued a warning to Balestra and his son Constantine to stop harassing 'Manoussos
Work begins on and Domenikos Theotokopouli' and their
Philip II's monastery– families, or face six months' imprisonment.
palace at El Escorial The document is the first to record Domenikos as a master painter.

1566 On 6 June El Greco acted as a witness in the sale of a house, signing himself as *maistro Menegos Theotokópoulos, sgourafos* (Master Domenikos Theotokopoulos, master painter).

1566 On 5 November El Greco was named as a representative in the mediation of a dispute against the Venetian patrician Luca Miani (1535–1593), who bore the honorary title of Camerlengo of the Serenissima in Candia from 1561 to 1564.

On 26 December El Greco obtained permission to sell 'a *Passion of Christ* executed on a gold background' (now lost) in a lottery. A day later two artists, including the well-known Cretan icon-painter Georgios Klontzas (1540–1608) assessed its value, setting a high price of 70 ducats.

VENICE

1567 Although there are no documents to prove it, El Greco probably left for Venice during the spring or summer of 1567. Ships could generally only sail from Crete between May and October, when the weather was favourable.

1568 A letter written on 18 August shows that El Greco was living in Venice. It records that he gave a series of drawings to Manolis Dakypris, to give to the Cretan cartographer Giorgio Sideris called Calapodas. The famous manuscript-painter Giulio Clovio (1498–1578) later described El Greco as a follower of Titian ('*discepolo di Titiano*'). The work of Titian and of other Venetian artists, in particular Jacopo Tintoretto and Jacopo Bassano, had a profound influence on El Greco.

ROME

Andrea Palladio's **1570** In 1570 El Greco travelled to Rome, probably
I Quattro Libri via Padua, Verona, Parma, Bologna, Florence
dell'Architettura and Siena: later, when in Spain, he made
published marginal notes in his copy of Vasari's *Lives* reflecting the art he had seen in those places. For example, he contradicted Vasari's views on the artist Felice Brusasorci, whose work he must have seen in Verona. He especially

1570 admired Correggio and Parmigianino, describing the figure of the Magdalen in Correggio's *Virgin and Child with Saints Jerome and Mary Magdalen* (Galeria Nazionale, Parma) as 'the most singular figure in all of painting'. This picture hung in its original location, the Church of San Antonio Abale, Parma, until 1712. El Greco also had lavish praise for Correggio's painting in the dome of the city's cathedral.

By November El Greco was in Rome and had made contact with Giulio Clovio. In a letter dated 16 November Clovio recommended the 'young Candiot, a follower of Titian' to his patron Cardinal Alessandro Farnese, singling out for special praise a self-portrait which had 'astonished all of these painters of Rome', and asking him to place the artist under his protection and give him temporary lodging in the Palazzo Farnese. There, El Greco came into contact with Fulvio Orsini (1529–1600), a humanist and librarian of the Palazzo Farnese, who was to become one of his chief patrons (see cat. 10, 70). It was perhaps through Pedro Chacón, a close friend of Orsini, that El Greco met the Spanish churchman Luis de Castilla; Castilla met Chacón in Rome in the summer of 1571 and remained there until 1575. He became one of El Greco's closest friends. The Italian painter Federico Zuccaro (c. 1541–1609) was also in Rome from 1570 to 1574 and the two artists may have met there. At some point Zuccaro's 1568 edition of Vasari's *Lives* passed to El Greco; he may have been given it in Rome or when Zuccaro visited Toledo in 1586.

On 7 October the Turks were defeated at the Battle of Lepanto by the combined forces of Spain, Venice and the Papacy (the Holy League) led by Philip II's half-brother, Don John of Austria

1571 In late October Manoussos Theotokopoulos, El Greco's elder brother, arrived in Venice and requested permission to engage in piracy against the Turks.

1572 On 6 July El Greco wrote to Cardinal Farnese to protest about being thrown out of his palace in Rome: 'I did not deserve to be thrown out and sent away in such a manner, as I had committed no fault' ('*neanco meritava senza colpa mia esserne poi scacciato et mandato via di questa sorte*'). The reasons for the incident are unknown. However, in a letter to his master dated 18 July the cardinal's majordomo mentioned in passing that '*pittore Greco*' (presumably El Greco) was working on the decoration of the Hall of Hercules in the Farnese villa at Caprarola, outside Rome. Although there is no trace of El Greco's hand in the fresco cycle, which was under the supervision of Jacopo Bertoia (1544–1573?), it appears that he may still have been serving the Farnese.

On 18 September El Greco was admitted to the Guild of San Luca on paying an entrance fee of 2 *scudi*. He registered as a painter under the name 'Dominico Greco', our first record of the artist calling himself by this name. By the end of this year he had opened a workshop, and was assisted there by the Sienese painter Lattanzio Bonastri da Lucignano (c. 1550–c. 1590). This suggests that El Greco wished to settle in Rome and make a career as an Italianised painter.

1574 It was around this year that the Italian painter Francesco Prevoste (c. 1528–1607) entered El Greco's studio; he continued to work with El Greco for the rest of his life.

Plague in Rome **1575** On 14 May Vincenzo Anastagi, Knight of Malta, was appointed to the office of Sergente Maggiore of the Castel Sant'Angelo at Rome. El Greco's portrait of *Vincenzo Anastagi* (fig. 56, p. 252) was painted to commemorate this.

MADRID

1576 By 1576 El Greco was in Spain. He is listed in the records of the Royal Almoner, where he appealed for financial aid on 21 October ('año 1576. 21 de Octubre Dimo [Domenikos] Griego'). The anecdote related by Giulio Mancini (1568–1630) in *Alcune considerazione* (1621), that El Greco had to flee Rome after angering the painters of the city by criticising Michelangelo's *Last Judgment*, may be apocryphal. He perhaps hoped for work in connection with Philip II's great project, the monastery of San Lorenzo at El Escorial. Around this time he received the commission for *The Adoration of the Name of Jesus* (see cat. 22, 23) from the king. El Greco was probably also attracted to Spain by the promise of commissions in Toledo for the cathedral and for the church of Santo Domingo el Antiguo (see cat. 17–20).

Plague in Venice. Titian was among the dead

Death of Bartolomé Carranza, Archbishop of Toledo, following seventeen years in prison under investigation by the Inquisition

TOLEDO

1577 On 2 July El Greco received a payment on account for the *Disrobing of Christ* (see cat. 21) commissioned through Diego de Castilla, dean of the canons of Toledo Cathedral. On 8 August Diego de Castilla and El Greco signed a contract for the painter to provide eight pictures for the new church of Santo Domingo el Antiguo, six for the main altar and one each for two side altars (see cat. 17–20). El Greco was expected to design the altarpiece for the finished works, as he did for almost all of his subsequent large commissions (in other cases he also planned the frames and the accompanying scuptures). *The Assumption of the Virgin* (fig. 12, p. 49) for Santo Domingo el Antiguo was signed and dated later that year.

Gaspar de Quiroga (1512–1594) appointed Archbishop of Toledo. Start of a food shortage in Toledo that continued until 1579

1578 Birth of El Greco's son, named Jorge Manuel after El Greco's father and brother. El Greco never married Jorge's mother, Jerónima de las Cuevas.

1579 On 15 June, following the completion of *The Disrobing of Christ* (see cat. 21) for Toledo Cathedral, El Greco and the cathedral lawyer, Canon García de Loaisa Girón, met before a notary to determine the price of the painting. The valuation led to the first of a series of legal disputes that became a feature of almost

1579 all El Greco's important commissions. In July El Greco's agent set the value at a high 900 ducats. The cathedral's representatives, Nicolás de Vergara the younger, master architect to the cathedral, and Luis de Velasco, a painter also employed by the cathedral, set the value at a mere 227 ducats. In addition they raised objections about certain improprieties: first that some of the heads in the crowd were placed above that of Christ; secondly the three Maries who appeared in the lower left were not mentioned in the Gospel text. On 23 July an arbitrator set the price at 317 ducats, but acknowledged that the painting was one of the best he had ever seen. On the theological questions he deferred to the Church authorities. El Greco decided not to deliver the painting until he was satisfied with the price.

The church of Santo Domingo el Antiguo was dedicated on 22 September, by which time all of El Greco's paintings there were finished and installed. On 23 September Loaisa Girón appeared before the magistrate of Toledo and argued that since El Greco had come to Toledo to paint the altarpieces of Santo Domingo he would soon be leaving now they were completed. He requested, therefore, that El Greco should deliver the disputed *Disrobing of Christ* to the cathedral immediately as security against the 150 ducat advance, and insisted that the artist should correct the 'errors' in the picture. El Greco was defiant, demanding that he be paid before altering or delivering the picture. He also refused to answer a question about his reasons for coming to Toledo, asserting that he was under no obligation to do so.

1580 On 25 April, Philip II ordered the Prior of the Escorial to provide El Greco with materials, 'especially ultramarine', to enable him to carry out the commission 'made some time ago' for *The Martyrdom of Saint Maurice* (fig. 16, p. 53) for one of the chapels of the church of the Escorial. On 11 May El Greco and his chief assistant Francisco Prevoste (who had accompanied him from Italy) received a 200 ducat advance for the painting, and on 2 September they received a further 200 ducats.

1581 On 8 December the dispute over *The Disrobing of Christ* was finally resolved, El Greco accepting a payment of 200 ducats which brought the total to 350 ducats – much less than his earlier demands, and only slightly more than the 317 stipulated by the arbitrator. However, it appears that El Greco was not forced to make any changes to the work, as the three Maries still appear in their original position.

Completion of the monastery at El Escorial

Death of Saint Teresa of Ávila (1515–1582)

1582 Between May and December El Greco acted as an interpreter at nine court hearings for a seventeen-year-old Athenian servant, Micael Rizo Calcandil, who was accused of heresy by the Inquisition in Toledo. The boy was found to be innocent.

On 16 November, El Greco delivered *The Martyrdom of Saint Maurice* to the Escorial in person. The intervention of an arbitrator was again required, who set the price at 800 ducats. The king did not like the painting and ordered it to be removed. A replacement was commissioned from the arbitrator, the Italian painter Diego de Rómulo Cincinnato, whose version still hangs at El Escorial in the chapel of Saint Maurice. This marked the end to El Greco's hopes of a court appointment.

1584 El Greco received a small payment for designing a frame for *The Disrobing of Christ*.

1585 On 9 July El Greco signed a contract with the new warden of Toledo Cathedral, Juan Bautista Pérez, to build the frame he had designed for *The Disrobing of Christ*. The contract specified a gilt wood frame with sculptural decoration. The frame is lost, but the carved and painted relief sculpture from the altarpiece, of *The Virgin presenting the Chasuble to Saint Ildefonso* (see fig. 37, p. 124), is still in the cathedral.

On 10 September El Greco signed a lease to rent three apartments, including the spacious royal quarters, in the ancient palace of the Marqués de Villena. The palace (now destroyed) was on part of the site now occupied by the Paseo del Tránsito. El Greco continued to live there until at least 1590, and again from 1604 onwards.

1586 The Italian painter Federico Zuccaro visited Toledo in about 1586; this may have been when he gave El Greco his 1568 edition of Vasari's *Lives*, which El Greco annotated.

On 18 March 1586 El Greco was commissioned to paint *The Burial of the Count of Orgaz* (fig. 17, p. 54) for the parish church of Santo Tomé. The contract stated that it was to be completed by Christmas of the same year and included a description of the subject: '[The artist] agrees to paint a picture that goes from the top of the arch to the bottom. The painting is to be done on canvas down to the epitaph. Below the epitaph there is to be a fresco in which the sepulchre is painted. On the canvas he is to paint the scene in which the parish priest and other clerics were saying the office, for the burial Don Gonzalo de Ruiz, Lord of Orgaz, when Saint Augustine and Saint Stephen descended to bury the body of this gentleman, one holding the head, the other the feet and placing him in the sepulchre. Around the scene should be many people who are looking at it, and above all this, there is to be an open sky showing the glory [of Heaven].'

1587 Early in the year, the frame for *The Disrobing of Christ* was completed; and on 20 February it was evaluated without incident at just over 570 ducats.

On 26 April the relics of Leocadia, an important Toledan saint, were brought into Toledo and enshrined in the cathedral. To mark the occasion, the councillors of the city commissioned decorated wooden arches to be erected along the route of the triumphal procession. El Greco provided two arches (now lost), decorated with wooden sculpture painted to imitate marble and with monochromatic paintings depicting scenes from the life of the saint.

| | 1588 | By spring 1588 *The Burial of the Count of Orgaz* was finished. There was a dispute over the price and Dr Pedro Salazar de Mendoza, a canon of Toledo cathedral, agreed to act as arbitrator. The first set of appraisers put the value at 1200 ducats, a sum that the priest Núñez (who happened to be El Greco's parish priest) regarded as exorbitant and he petitioned the archbishop's council for a reduction. A second appraisal was arranged, which set the value at 1600 ducats. Núñez asked that this second appraisal be set aside. On 30 May the archbishop's council decided that the first appraisal should be allowed to stand and ordered the church to pay El Greco 1200 ducats within nine days. El Greco appealed against the council's decision to the papal nuncio in Madrid, but retreated in the face of the threat of a lengthy and expensive legal dispute, finally agreeing to accept the settlement. |

Left margin entry: Defeat of the Spanish Armada — 1588

By spring 1588 *The Burial of the Count of Orgaz* was finished. There was a dispute over the price and Dr Pedro Salazar de Mendoza, a canon of Toledo cathedral, agreed to act as arbitrator. The first set of appraisers put the value at 1200 ducats, a sum that the priest Núñez (who happened to be El Greco's parish priest) regarded as exorbitant and he petitioned the archbishop's council for a reduction. A second appraisal was arranged, which set the value at 1600 ducats. Núñez asked that this second appraisal be set aside. On 30 May the archbishop's council decided that the first appraisal should be allowed to stand and ordered the church to pay El Greco 1200 ducats within nine days. El Greco appealed against the council's decision to the papal nuncio in Madrid, but retreated in the face of the threat of a lengthy and expensive legal dispute, finally agreeing to accept the settlement.

A document of 1 July records that El Greco and Prevoste sent paintings of Saint Peter and Saint Francis to agents in Seville, Jerónimo González and Pedro López de Párraga, possibly for export to the Americas.

1589 On 27 December El Greco signed a contract to confirm that he would continue to pay rent for his apartments in the palace of the Marqués de Villena. The document describes him as a resident ('*vecino*') of Toledo.

Death of Saint John of the Cross (1542–1591)

1591 On 14 February El Greco received a commission for the paintings of the high altar of the church of San Andrés in Talavera la Vieja, Toledo province. According to the contract there was to be a 'coronation of Our Lady in a heavenly glory, in which there should be painted the blessed saints John the Baptist and Dominic with the rosary and Saint Anthony and Saints Sebastian and John the Evangelist and other saints which said Dominico [El Greco] deems suitable for the decoration and proper appearance of said retable . . . in the lower part of said retable there is to be . . . the figure of Saint Joseph, and at the left side, there should be the figure of Saint Andrew, with their attributes, done with the brush on canvas affixed to panels'. In the final

1591 paintings (Museo de Santa Cruz, Toledo) El Greco substituted Peter for Joseph. He received 300 ducats for the work, which was completed by the summer and must have been executed largely by assistants.

On 26 November El Greco gave Prevoste permission to act on his behalf in discussions relating to a commission for an altarpiece for the Hieronymite monastery at Guadalupe.

Death of the Venetian painter Jacopo Bassano (1510–1592)

1592

Death of the Venetian painter Jacopo Tintoretto (1518–1594)

1594

Death of Gaspar de Quiroga, Archbishop of Toledo (1512–1594)

Alberto, Archduke of Austria, appointed Archbishop of Toledo

1595 On 28 August El Greco received a commission for a tabernacle in the church of the Hospital of Saint John the Baptist (also known as the Tavera Hospital), Toledo, through Pedro Salazar de Mendoza, the canon of Toledo Cathedral who had acted as the arbitrator during the dispute over *The Burial of the Count of Orgaz* in 1588. Mendoza appears to have become a friend of the artist: the inventory made at the time of his death lists six paintings apparently by El Greco.

1596 Between 17 and 21 December El Greco signed various documents for a contract with the Royal Council of Castile for the retable and paintings for the high altar of the church of the Augustinian Colegio de Doña María de Aragón, Madrid, dedicated to Our Lady of the Incarnation (see cat. 40–2). The college was a foundation of Doña María (died 1593), lady-in-waiting to Philip II's fourth wife. According to the contract El Greco was to receive advances totalling 2000 ducats against a final price to be determined by appraisal.

1597 On 16 April El Greco received the commission, which had been under discussion since 1591, for the high altar of the Hieronymite monastery at Guadalupe. The contract stipulated the impressive sum of 16,000 ducats. For reasons yet to be discovered El Greco never executed the work.

A document dated 24 May records El Greco and Prevoste again sending works to agents in Seville for sale.

On 9 November 1597 El Greco signed a contract with Dr Martín Ramírez de Zayas, professor of theology at the University of Toledo, to paint three altarpieces for his private family chapel of Saint Joseph, Toledo (see cat. 38, 39).

Death of Philip II; Philip III proclaimed King of Spain **1598** El Greco obtained an injunction against the estate of Doña Maria de Aragón for 1000 ducats he was owed as part of the 2000 ducat advance agreed in 1596.

Birth of Diego Velázquez (1599–1660) **1599** In June the injunction against the estate of Doña Maria de Aragón was lifted, presumably because El Greco wished to see an amicable resolution to the dispute.

Bernardo de Sandoval y Rojas appointed Archbishop of Toledo On 13 December the paintings for the Capilla de San José, Toledo, were valued. After an initial challenge to the valuation, Dr Ramírez agreed to pay the full price of 2850 ducats. Of that sum 636 was to be paid direct to creditors; 136 to a linen merchant who probably supplied material for canvases, and 500 ducats to the famous still-life painter Juan Sánchez Cotán (1560–1627) for a claim not specified.

1600 On 12 July the paintings for the Colegio de Doña María de Aragón were finally transported from Toledo to Madrid. In August they were assessed by two court painters, Juan Pantoja de la Cruz (c. 1553–1608), acting for the college and Bartolomé Carducho (c. 1560–1608), for El Greco. El Greco was to receive nearly 6000 ducats for the paintings, retable designs and sculptures.

1600 On 12 December Luis Pantoja Portocarrero acknowledged receipt of rent from El Greco, indicating that the artist had moved to new lodgings, away from the palace of the Marqués de Villena. The exact location of this property in Toledo is unknown.

Spanish Court moved to Valladolid **1601** In June, following problems with the payment for the paintings for the Colegío de Doña María de Aragón, El Greco's agent attempted to collect 500 ducats directly from the tax collector in Illescas, who owed this amount to the estate.

Peter Paul Rubens sent as an ambassador to the Spanish court, where he remained from May until the end of the year **1603** On 7 January El Greco and Jorge Manuel acted as witnesses to a document issued by Fray Sabba of the Order of Saint Basil, Macedonia, granting Demetrio Zuqui, a Greek resident in Toledo, permission to raise funds in the bishopric of Cuenca in order to free six friars of the monastery of Santa María de Yberia from the Turks.

On 3 February El Greco received a payment for the Saint Bernardino altarpiece for the Franciscan college dedicated to the saint (now Museo de El Greco, Toledo). The receipt informs us that the total price for the work was about 275 ducats. The final payment was made on 10 September 1604.

From this year Jorge Manuel appears in documents as his father's assistant and business partner for the first time. On 7 April, Jorge Manuel was authorised to inspect the proposal for a new altarpiece for the Hospital de la Caridad, Illescas (see cat. 48). On 18 June, 'domingo griejo y xorje mannel, pintores' received the commission for the hospital. The commission included the decoration of the whole chapel, including the design for the retable and the provision of sculptures as well as paintings of *The Madonna of Charity, Coronation of the Virgin, Annunciation* and *Nativity*. El Greco agreed that the final appraisal would be made by the hospital's own nominees. The contract stipulated that the altarpiece should be in place by 31 August 1604, the festival day of the church. On 20 August 1603 El Greco received an advance of 1200 *reales* (about 109 ducats) for the work.

1603 On 17 September Jorge Manuel received a commission on El Greco's behalf to build the altarpiece of the Chapel of Our Lady of the Fields in Talavera de la Reina. This may never have been executed.

In 1603, the artist Luis Tristán de Escamilla (c. 1585–1624) entered El Greco's studio as an apprentice, remaining there until 1606. He was a close friend of El Greco's son, and El Greco's most talented pupil, becoming the leading painter in Toledo after El Greco's death.

On 25 December 1603 Manoussos, a Greek resident in Toledo (probably the artist's brother, Manoussos Theotokopoulos) was named as an executor in the will of Thomasso Trechello, a Greek Cypriot living in Toledo.

1604 El Greco's first grandchild, Gabriel, son of Jorge Manuel and his first wife Alfonsa de los Morales, was baptised on 24 March. Dr Gregorio de Angulo, a councillor of Toledo, acted as godfather.

On 5 August El Greco returned to live in the palace of the Marqués de Villena, renting twenty-four rooms including the main hall. He remained there for the rest of his life.

On 22 October Manoussos petitioned for a licence to raise money in order to save Greek compatriots from the Turks. On 13 December a Manuel Griego (possibly El Greco's brother), was recorded in the book of the deceased in El Greco's parish church of Santo Tomé, close by the artist's home.

Part one of *Don Quixote* published

1605 On 24 March Jorge Manuel presented his architectural designs for the Corral de Comedias to Toledo council. He was given a silver fountain pen worth 140 ducats as thanks for his plans. The theatre was destroyed in a fire in 1630.

The work at the Hospital de la Caridad, Illescas, was completed by 4 August, when the hospital's assessors recommended the low price of 2430 ducats. This marked the start of bitter and lengthy litigation, with Dr Gregorio de Angulo acting as El Greco's lawyer. A second valuation took place on

1605 20 September, setting a price of 4437 ducats. On 19 November the hospital issued a bill of complaints, saying the work had not been completed by the agreed date (31 August 1604). On 14 December 1605 El Greco petitioned the archbishop's council, noting 'the delay continues to cause me much damage and loss'. The archbishop's council supported El Greco throughout the dispute, but the case carried beyond the archbishop's council to the royal chancellery in Valladolid and to the papal nuncio in Madrid.

Spanish Court returned to Madrid

1606 On 26 January there was a third valuation of the work at Illescas, setting a price of just over 4835 ducats. In March the archbishop's council threatened the confiscation of hospital property to pay the debt to El Greco. In connection with the Illescas commission, El Greco successfully contested payment of tax, arguing that he practised painting as a liberal art. This was the first time that an artist had received exemption from taxation in Spain. His case was quoted by the artist Vicente Carducho (c. 1570–1638) in *Diálogos de la Pintura* (1629), which argued that painting was a liberal art.

On 25 August Dr Gregorio de Angulo's uncle, Juan Bautista de Ubeda, a parish representative, and his brother, a local merchant, commissioned El Greco and Jorge Manuel to execute an altarpiece for their family chapel in the parish church of San Ginés, Toledo, for which they would be paid 1000 *reales* (about 90 ducats).

On 7 November Jorge Manuel received a commission on El Greco's behalf for the main altarpiece and side altarpieces for the parish church of San Martín de Montálban in Lugar Nuevo.

The commission for an altarpiece in the private chapel of Isabel de Oballe, Toledo, was awarded to the Italian artist Alessandro Semini (died 1607).

1607 On 17 March 1607 the Illescas pictures were valued at 2093 ducats. Although this was less than the original valuation, El Greco agreed to accept.

1607 On 29 April Prevoste was granted power of attorney for El Greco. This is his last appearance in documents.

On 29 May Jorge Manuel was granted power of attorney for El Greco, confirming his predominant rôle in the workshop.

On 28 November, following the death of Semini, Dr Gregorio de Angulo and the juror Juan Langayo were appointed to find an artist to take over the work on the unfinished Oballe Chapel altarpiece. On 11 December El Greco was given the commission to complete it, incorporating some changes, including making the altarpiece taller, replacing the frescoed decorations with oil paintings on canvas and placing a framed scene of the *Visitation* on the ceiling (see cat. 55-8). On Angulo's recommendation the city council voted to accept El Greco's proposal, and to pay him 1200 *escudos* (about 1280 ducats), as recorded in a document of 12 December 1607. The artist received a generous advance of 400 ducats.

1608 On 13 August El Greco stated that the work on the Oballe Chapel altarpiece was much advanced, but not finished.

On 16 November El Greco received his last large altarpiece commission, for three altars in the Tavera Hospital (the Hospital of Saint John the Baptist), Toledo, where he had been commissioned to design a tabernacle in 1595. The contract, signed on 16 November by El Greco and his friend Pedro Salazar de Mendoza, was for the main and side altars. The artist was granted a five-year schedule of advances of 1000 ducats per annum. The paintings that El Greco contributed include *The Baptism* (fig. 20, p. 58) and *The Annunciation* (Collección Santander, Madrid) both finished by Jorge Manuel after his death, and *The Opening of the Fifth Seal* (see cat. 60). An indication of the rest of the original iconographic programme given to El Greco is provided by the contract signed on 23 April 1635 by the painter Félix Castelló, who was to provide new altarpieces for the main and side altars. As well as a *Baptism* (for the main altar) and a *Vision of the Apocalypse* and *Annunciation* (for the side altars), he was also asked to provide

1608 two smaller pieces – *The Beheading of Saint John* and *Saint John Preaching in the Wilderness*.

Death of the Italian painter Annibale Carracci (1560–1609)

1609 Around 1609 El Greco painted the portrait of *Fray Hortensio Félix Paravicino* (see cat. 81).

Death of the Italian painter Michelangelo Merisi da Caravaggio (1571–1610)

1610

1611 In 1611 the Spanish writer and painter Francisco Pacheco (1564–1644) visited El Greco in Toledo; he would later recall the visit in *Arte de la pintura* (published posthumously in 1649).

On 12 August, having fallen two years behind in their rent, El Greco and Jorge Manuel had to negotiate a postponement of the back payment with the agents of the Marqués of Villena. At the same time they signed a lease on the property for a further twelve months.

On 19 November, following the death of Philip II's widow, Margarita de Austria, the councillors of Toledo commissioned El Greco and Jorge Manuel to provide a monument for the funerary celebrations in Toledo Cathedral ordered by Philip III. The monument was praised in a sonnet by Paravicino.

1612 On 26 August El Greco and Jorge Manuel purchased a family burial vault in the church of Santo Domingo el Antiguo, Toledo. In payment El Greco was to build the altar and retable at his own expense. It was for this chapel that he painted *The Adoration of the Shepherds* (see cat. 62).

Sometime in this year Jorge Manuel was appointed director of the building of Toledo town hall.

1613 On 17 April El Greco stated that the work for the Oballe Chapel was complete and requested a valuation, but only in March 1615, after his father's death, was Jorge Manuel able to declare that 'the altarpiece and the rest of the work of the Chapel of

1613 Isabel de Oballe which my father was contracted to do is finished and the said altar in place'.

Jorge Manuel travelled to El Escorial to show his architectural drawings to Philip III.

1614 In a document dated 31 March, El Greco, 'confined to his bed', affirmed his catholic faith. 'Unable to make a will', he gave power of attorney to Jorge Manuel Theotokopoulos, 'my son and of Doña Jerónima de las Cuevas, who is a person of honesty and virtue', to make his testament, arrange his burial, and pay his debts. He made Jorge Manuel his universal heir, and named as his executors his old friend Luis de Castilla, dean of Cuenca Cathedral and Fray Domingo Banegas, a Dominican monk in San Pedro Mártir.

On 7 April El Greco died. The entry in the Book of Burials of the parish of Santo Tomé reads: 'Dominico Greco, On the seventh [of April] Dominico Greco died, made no will. Received the sacraments, was buried in Sto Domingo el Antiguo, gave mass.' In the funeral procession, members of the Brotherhood of Our Lady of Sorrows from the monastery of San Pedro Mártir and members of the Brotherhood of Charity accompanied the priests of Santo Tomé. A sung mass was performed before El Greco's great *Assumption* in Santo Domingo el Antiguo, and three more followed on successive days. Ten masses were said at San Pedro Mártir and in the Santísima Trinidad, where the artist's friend Fray Hortensio Félix Paravicino may have officiated. In the following months Jorge Manuel ordered one hundred masses for the soul of his father, divided between Santo Tomé and Santo Domingo el Antiguo.

The inventory of El Greco's possessions made by his son Jorge Manuel on 7 July 1614 included the following items in his studio: 3 easels, ('*tres bancos de pintor*'), some colours ('*algunos colores*'), 143 paintings, mostly finished, but with a few merely primed canvases, four painted as far as the chiaroscuro design, and some 'unfinished' paintings including works for the Hospital of Saint John the Baptist. There were also

1614 fifteen plaster models and thirty in clay and wax; twenty-seven books in Greek, including philosophy and poetry, the Old and New Testaments, the writings of the Church Fathers and the proceedings of the Council of Trent; sixty-seven books in Italian, seventeen in Spanish and nineteen on architecture; 150 drawings; thirty plans (probably for altarpieces); and 200 prints. Jorge Manuel, his first wife Alfonsa de los Morales and their ten-year-old son Gabriel continued to live in El Greco's housee.

1615 Part two of *Don Quixote* published

1617 On 17 November Jorge Manuel's first wife Alfonsa de los Morales died.

1618 The church of San Torcuato, designed by Jorge Manuel, was completed. Only the portal survives today.

1619 Following a disagreement over the payment for the burial chapel at Santo Domingo el Antiguo (El Greco's *Adoration of the Shepherds* had been valued at only 2300 *reales* (about 209 ducats), 1200 *reales* short of the price agreed for the chapel), Jorge Manuel purchased another burial chapel in San Torcuato on 18 February. Jorge Manuel agreed to move El Greco's remains from Santo Domingo el Antiguo to San Torcuato.

1620 Fernando de Austria appointed Archbishop of Toledo

1621 On 28 June Jorge Manuel was named Master of Works (official architect) to Toledo town council. His duties included building and designing temporary architecture for festivals. That spring he and Luis Tristán were awarded the important commission to design the catafalque for the funeral ceremonies of Philip III in Toledo Cathedral.

On 7 August, on the occasion of Jorge Manuel's marriage to his second wife, Doña Gregoria de Guzmán, a second inventory of El Greco's possessions was made.

1622 In 1622 Jorge Manuel's son Gabriel Morales entered an Augustinian monastery, and Jorge Manuel agreed to make a monument for the monastery for Holy Week.

On 18 April the authorities of the Hospital of Saint John the Baptist attempted to imprison Jorge Manuel, claiming that he had refused to complete the work commissioned by the hospital. According to Jorge Manuel he had not been paid for the work he had done. The hospital authorities seized possessions from Jorge Manuel, including 100 paintings.

1623 On 18 May representatives of the Hospital of Saint John the Baptist returned, taking the altars by force and moving them to the hospital.

Completion of the main chapel of Santa Clara, designed by Jorge Manuel.

1624 On 17 July the authorities of the Hospital of Saint John the Baptist had another order issued for Jorge Manuel's arrest and on 2 September more possessions were seized, including furniture and the rest of the high altar for the hospital. Jorge Manuel continued to insist that he had not yet been paid for the work already completed.

An inventory of the paintings in the hospital made in 1624 indicates that *The Annunciation* was by then in place on the left-hand altar, with the *Baptism* installed on the right-hand altar. The hospital also had other paintings 'lent' by Jorge Manuel to decorate the chapel while he completed the commissioned altarpieces, including *Saint John the Baptist with a Lamb*, *Saint Philip*, two landscapes and twelve small *Apostles*.

1624 On 26 September the hospital authorities complained that El Greco's original design for the retable (agreed in 1608) was at fault because it would not fit the semi-circular apse.

On 24 October the completed parts of the altar were valued at 11,002 ducats and the hospital authorities were accused of damaging the altar when they seized it. They rejected the valuation, stating that even 2000 ducats would be excessive.

1625 On 18 February Jorge Manuel agreed to redesign the high altar of the Hospital of Saint John the Baptist.

On 10 March Jorge Manuel was appointed Master Builder of Toledo Cathedral. That year he submitted plans for the completion of the dome of the Mozárabe Chapel.

1628 In 1628 Jorge Manuel submitted new designs for the Ochavo in Toledo Cathedral, but it was decided to continue with the original plans.

On 22 September the new parts for the high altar of the Hospital of Saint John the Baptist were valued at 675 ducats.

1630 The dispute with the Hospital of Saint John the Baptist continued, with Jorge Manuel locking parts of the altar in the crypt and refusing to hand over the keys. On 19 April his third wife, Isabel de Villegas, stated that she did not have the keys, either, and that her husband was in Granada.

1631 Death of Jorge Manuel Theotokopoulos, buried on 29 March. Litigation between the Hospital of Saint John the Baptist and his heirs continued.

OVERLEAF
The Adoration of the Name of Jesus (detail), late 1570s (cat. 23)

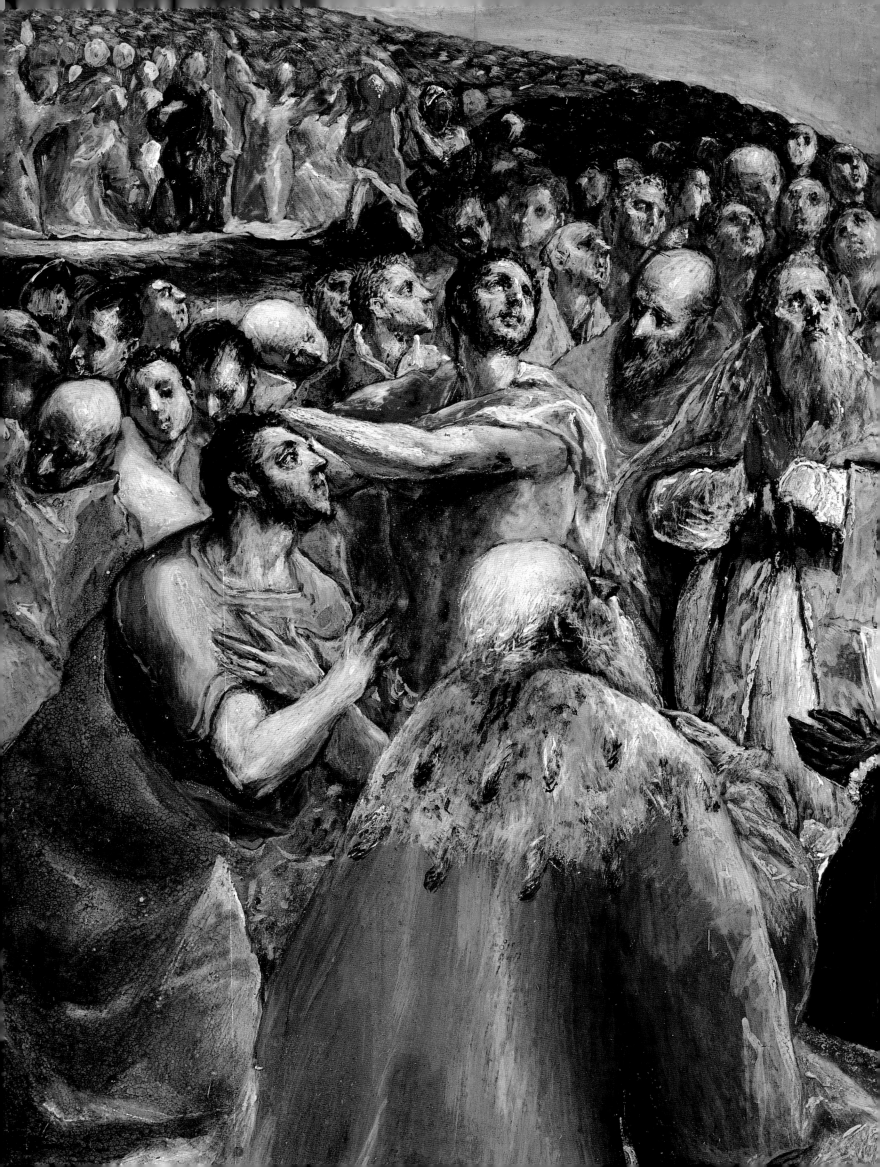

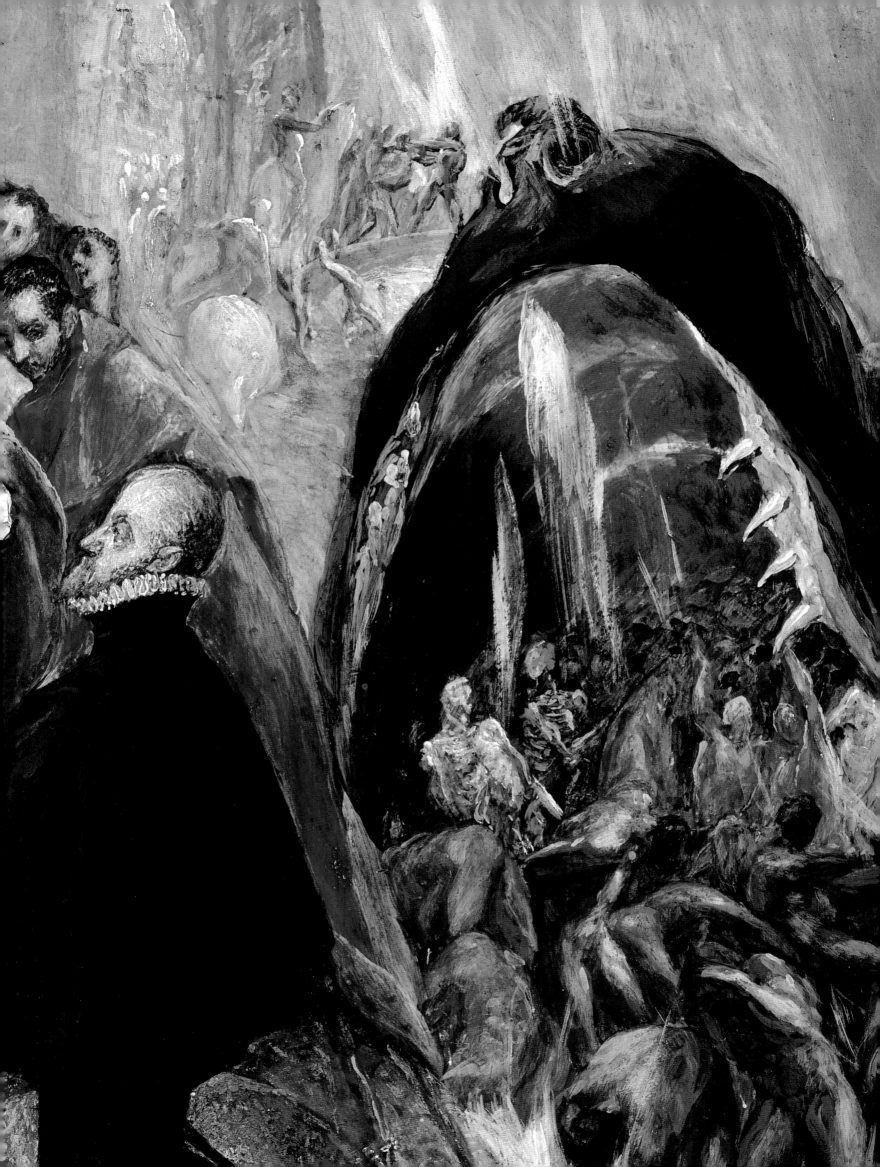

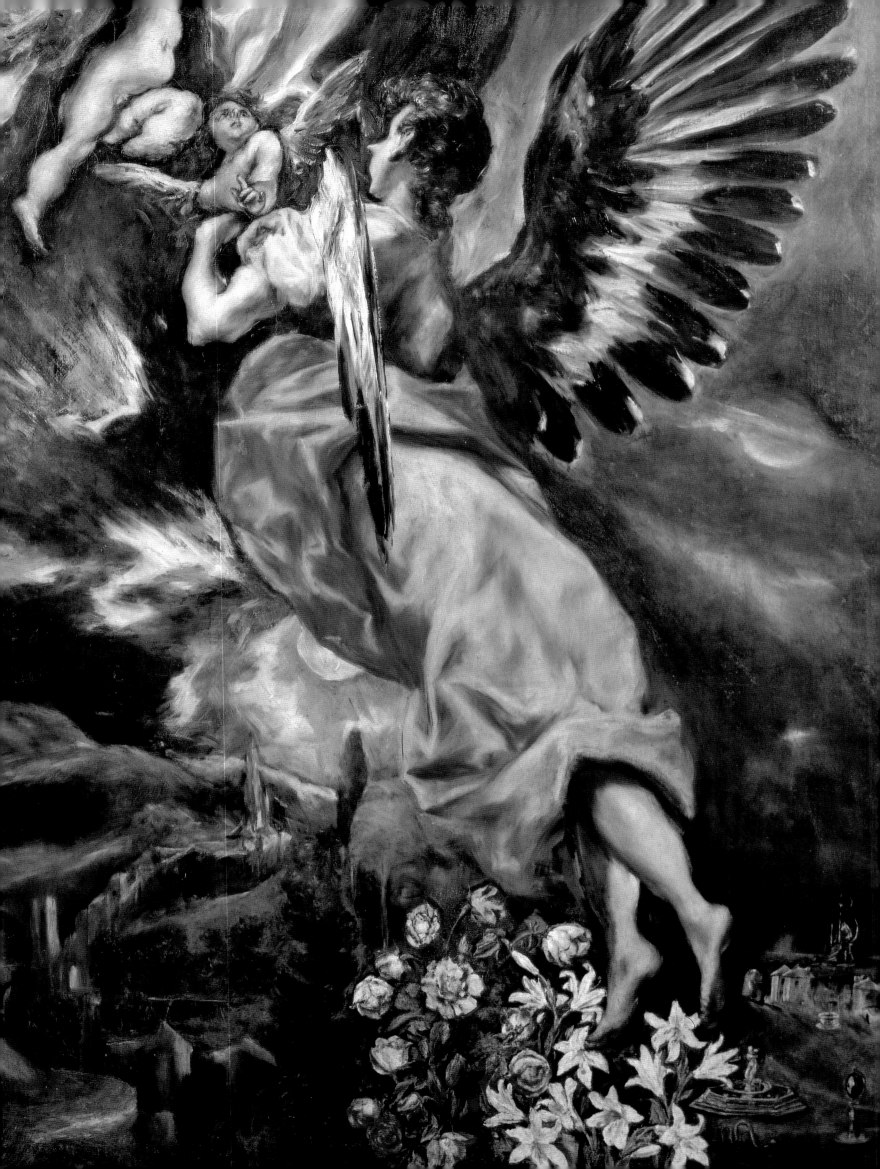

El Greco's Religious Art:
The Illumination and Quickening of the Spirit

Creta le dió la vida, y los pinceles Toledo . . .
Crete gave him life, and Toledo his brushes . . .[1]

El Greco's Stylistic Development

DOMENIKOS THEOTOKOPOULOS, in his native Crete, was trained in the prevailing local post-Byzantine style,[2] and, though he subsequently adapted and 'transformed' what he had learned on moving to Italy, this background remained fundamental to him – he continued to sign his work in Greek, for instance – and it almost certainly influenced the unique style that he forged in the later part of his career in Spain.[3] The contemporary post-Byzantine style in which he was trained is typified by one of the few works surviving from his Cretan period, the icon of *The Dormition of the Virgin* (cat. 1).[4] In such art there is no concern with optical observation, either empirical or scientific. Its purpose is to convey the transcendental world of the figures represented, rather than natural phenomena as perceived by the senses. Figures tend to be two-dimensional, elongated and uniform in size and proportion. The reliance on stereotypes may suggest a lack of imagination, but it also reveals a conscious lack of interest in individualisation. It is not a matter of who the figures are but what they are.

Like bodies, draperies are dematerialised. Their form and pattern may be distinctive, but their texture cannot be discerned. Similarly, the highlights on draperies bear little relationship to the fold structure or to any source of natural light. Instead, these reflected lights appear to emanate from within the form. They are pure white and bright. They suggest divine illumination. Colours, too, are saturated and brilliant. Natural elements have been abstracted from them so that the radiance of coloured light evokes not the material world but the transcendental. The effect is heightened by the gold background, which reflects light and denies space. In the dimly lit interior of a church, the light from the flickering candles is thus reflected and transformed to evoke the lustrous Heavenly Jerusalem described in Revelation 21.

Yet there is evidence of a subtly unconventional approach to Byzantine sacred imagery on El Greco's part. In *The Dormition* Christ is not depicted in a rigid, upright position, as in many contemporary icons of the subject. Instead He leans over His mother and tenderly gathers her soul. The bier is placed at an angle and, likewise, the disciples, as they surround it, are not shown in strict profile or frontal positions. The gestures and poses of the disciples are also varied and animated. The drawing of the angels in grisaille is astonishingly fluent. The Virgin in Heaven is in a *contrapposto* pose and the angel at the left is gracefully contorted into a *figura serpentinata*. The buildings at either side are lit from the same direction. All these stylistic factors, together with the elegant candelabrum ornamented with semi-nude females at the base of the image, point to El Greco's study of Italian Renaissance sources, notably prints.[5]

Probably soon after his arrival in Venice (at some time between January and August 1568) El Greco painted the Modena Triptych (fig. 11). Here he adapts Renaissance principles of representation to a small-scale triptych of a post-Byzantine design common in the Venetian empire. As the wings of the triptych are opened in succession, the sequence of images reveals the state of Man before the Fall to his restoration to a state of Grace through Christ. It begins with *Adam and Eve*, followed by *The Annunciation, The Adoration of the Shepherds, The Baptism of Christ*, and reaches a climax in *The Coronation of the Christian Knight*, in which Christ, the second Adam and the 'Sun of Justice' (Malachi 4: 2) bestows the 'Crown of Justice' (2 Timothy 4: 8). The inclusion of a view of Mount Sinai, at the back of the triptych, complements this spiritual progress. The view refers not only to the intercessory rôle of Saint Catherine (patron of the monastery at Sinai) but also to the need for man to persist in his spiritual pilgrimage on earth.[6]

El Greco is here attempting three-dimensional form, proportion, gesture and facial expression, as well as perspective and naturalistic effects of light and colour. He again uses prints to aid him to solve the ensuing problems. The central image of Christ crowning the Christian Knight is derived, essentially, from two anonymous, probably Italian, mid-sixteenth-century

Fig. 11 El Greco
The Modena Triptych, 1568
Tempera on panel,
centre panel 37 × 23.8 cm
side panels 24 × 18 cm
Galleria Estense, Modena

woodcuts, one depicting *The Coronation of a Christian Knight* and the other *The Last Judgment*.[7] El Greco has copied the shape of Christ's body without convincingly conveying its three-dimensional form or anatomical structure. Light and shade create dramatic contrasts but they do not articulate the different planes of the body. Moreover, the weight of Christ's body is not supported correctly by his left leg. In fact, his legs do not relate properly to his body. The awkwardness of the pose, the disjointed members and the lack of harmony in their proportional relationships reveal that El Greco had to overcome serious stylistic problems before attaining to a Renaissance ideal of form. Nevertheless, there is clear evidence of his potential to energise an image through rhythmic outlines and to signal its meaning through colour. The reds and yellows in the other scenes culminate here in a vivid chromatic climax. Flaming reds, oranges and bright yellows symbolise, in Apocalyptic imagery, the almighty destruction of the sinful and the glorious triumph of the faithful.

El Greco's striving to improve his *disegno* is evident from the style of his *Pietà* in Philadelphia (cat. 14), which is in marked contrast to that of the Modena Triptych. Here he has turned to the art of Michelangelo, notably the *Pietà* that is now in the Museo dell' Opera del Duomo in Florence (fig. 32, p. 108). Since the marble was then in Antonio Bandini's collection in Rome,[8] it is likely that El Greco's version was painted soon after his arrival there in 1570. It is not known whether he saw the original or a copy, such as an engraving.[9]

His response to Michelangelo's *Pietà* is highly imaginative. He has adopted the sense of scale, even though the panel is small (29 × 20 cm), the pyramidal design, the muscular form of Christ and certain elements of his pose. He is also acutely aware of its devotional function. Michelangelo, instead of presenting Christ as a horizontal form resting on the lap of his mother, had turned his figure into a vertical, thereby exposing fully the suffering Christ to the faithful. As the pathetic, lifeless Christ sinks to the ground, the pyramidal form, with Nicodemus at its apex, directs the eyes and the mind of the faithful heavenwards to invoke the intercession of Christ for the soul of Michelangelo, for this was originally intended to be placed above his tomb.[10] El Greco has substituted for Nicodemus the Virgin, the prime

intercessor between man and Christ, and emphasised her significance by showing her in silhouette, above the horizon. He vividly conveys her anguish, eliciting an empathetic response from the viewer. The tilted, elliptical shape formed by the arms of Christ and one of the Maries in Michelangelo's sculpture is levelled and transformed into a buoyant one in El Greco's composition. The body of Christ is animated by the counterthrust of his legs. As his head tilts to the right, the Virgin turns her gaze to the left, to the three crosses on the stark hill of Calvary. From there, the horizon dips down to the right, in opposition to the clouds that billow upwards to the left. In this barren, inhospitable landscape the sacrificial victim and mourners suffer in isolation. Yet the redemptive significance of Christ's sacrifice is also manifest in El Greco's image. An elemental energy infuses all the forms. Swirling rhythms, brilliant light and vibrating primary and complementary colours not only evoke the turmoil of suffering but also herald triumph over death.

El Greco's increasing concern with a more naturalistic representation during his years in Italy is clearly discerned in his series of *Christ healing the Blind* (cat. 4, 5) and of *The Purification of the Temple* (cat. 6–9). Unusually, El Greco painted the latter subject as an independent composition, whereas in the past it had formed part of a series of the life of Christ.[11] this may have been a symptom of his ambition to paint a painting following the principles outlined by the humanist architect Leon Battista Alberti in *On Painting* (1435–6):

> Though variety is pleasing in any story [*historia*], a picture in which the attitudes and movements of the bodies differ very much among themselves is most pleasing of all. So let there be some visible full-face with their hands turned upwards and fingers raised, and resting on one foot; others should have their faces turned away, their arms by their sides, and feet together, and each one of them should have his own particular flexions and movements. Others should be seated, or resting on bended knee, or almost lying down. If suitable, let some be naked, and let others stand around, who are half-way between the two, part clothed and part naked.[12]

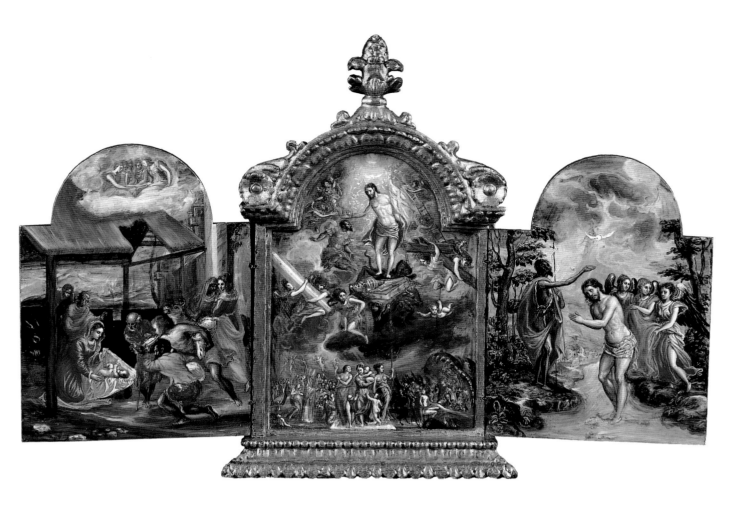

Certainly, in his earliest version of *The Purification* (cat. 6) El Greco makes a bold but abortive attempt to assimilate and emulate the achievements of High Renaissance painters. The design resembles that of Michelangelo's drawings of the subject.[13] Many of the figures are derived from Michelangelo, Raphael and Titian.[14] The rhythmic outlines of the forms suggest the influence of Tintoretto, while the iridescent colours and flickering highlights are reminiscent of both Tintoretto and Bassano. In painting the staged background, both here and in the Minneapolis version (cat. 7), El Greco has ingeniously included a variety of civic buildings, such as a Venetian palace, which correspond to the architect Sebastiano Serlio's stage design for tragedy, in the second of his *Five Books of Architecture*, published in 1545. However, the composition of the painting is loosely organised, the treatment of space confused, the drawing imprecise and the painting is overloaded with iconographic paraphernalia.

Under the impact of the works in Rome of Michelangelo and Raphael, El Greco's painting of the second version of *The Purification* (cat. 7) reveals a more ordered design. Space is better articulated, and the structure of forms is more accurately rendered. El Greco's sensibility to colour and his handling of paint – the use of glazes, scumbles and impasto swept over a fairly coarsely woven canvas – are a debt to the further training he received in Venice, reportedly in Titian's workshop.

This naturalistic style reaches its climax in his earliest works in Toledo, the altarpieces for Santo Domingo el Antiguo (1577–79; see cat. 17–20) and *The Disrobing of Christ* ('El Espolio') for the vestry of Toledo Cathedral (see fig. 15; see cat. 21). In the main chapel of the conventual church of Santo Domingo, seemingly for the first time, he was required to co-ordinate painting, sculpture and architecture on a large scale. For the architectural frame of the high altarpiece he adapted Italian designs for church façades (such as Vignola's unexecuted design for the façade of the Gesù in Rome and Serlio's design for a church) and for portals (specifically the distant portal in Serlio's stage design for tragedy). He imposed on the ornate native 'Plateresque' tradition a modern Renaissance grandeur, a processional order and a triumphal clarity. This grandeur and clarity is echoed in the central canvas, *The Assumption of the Virgin* (fig. 12), in which

the symmetry of the design is sustained by colour. Primary colours – the yellow light and the red and blue drapery of the Virgin – accentuate the central axis. Complementary greens are placed at the lower margins. Pink, yellow and purplish grey are balanced diagonally across the surface. The chromatic brilliance of such effects is enhanced by the bright light shining on broad areas of form. Forms are three-dimensional, sharply delineated and aligned with others in different spatial planes so that all appear to be fused into the surface plane, thus creating the illusion that they project into the space of the beholder. The illusion is heightened by relating the gaze of the Virgin and the direction of light in the painting to the source of real light in the chancel, streaming down from the windows above.

Above *The Assumption*, God the Father holds His dead Son in His arms (fig. 14). The composition derives from Dürer's woodcut of *The Trinity* (1511), either directly or via Federico Zuccaro's free copy of it.[15] The pose of Christ is based again on that in Michelangelo's *Pietà* (fig. 32, p. 108), but in reverse. It also seems to reflect the influence of Taddeo Zuccaro's *Dead Christ supported by Angels*, especially in the treatment of the torso and the inclination of the head.[16] However, as in Michelangelo's *Pietà*, the legs bent at the knee convey more convincingly the dead weight of Christ's slumped body. In comparison with El Greco's earlier extant works painted in Italy, the sense of scale is monumental. The outline of the figure is clearly delineated, the form is three-dimensional and the surface is as smooth as marble. The musculature, and the reversed Z-shaped pose, convey strength and grace.

In the side altarpiece of *The Resurrection* (fig. 13) the figure of Christ is idealised in the same manner as in *The Trinity*, that is, it is based on a studied imitation of exemplary works of art (it derives, ultimately, from the *Apollo* Belvedere) rather than a literal copying of nature. Rotating on its vertical axis, and perfectly balanced, the figure manifests the fluent grace that characterises the dead Christ in *The Trinity*. The painting rests directly on the altar and, in the left foreground, Saint Ildefonso is shown half-length, wearing priest's vestments, and with hand on breast and eyes upturned to the figure of Christ. He is on the same eye-level as, and consequently would have mirrored, the real priest standing at the altar. Thus the saint

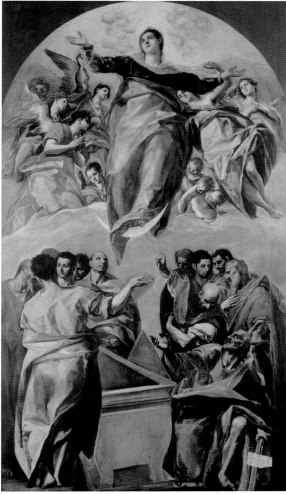

Fig. 12 El Greco
The Assumption of the Virgin, signed and dated 1577
Oil on canvas, 401 × 229 cm
The Art Institute of Chicago, Illinois
Gift of Nancy Atwood Sprague in memory of
Albert Arnold Sprague, 1906.99

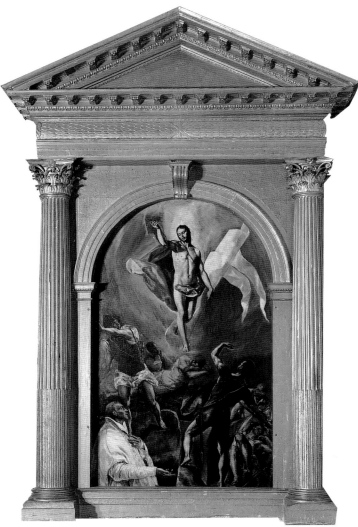

Fig. 13 El Greco
The Resurrection, 1577–9
Oil on canvas, 210 × 128 cm
Church of Santo Domingo el Antiguo, Toledo

acts as an intercessor, and provides a stepping stone from the physical to the divine. He is a witness to the triumph of the Resurrection, as the priest is a witness to the real presence of the Risen Christ in the consecrated bread and wine on the altar.

This desire to convince the beholder that he is a witness to a real event is conspicuous in *The Disrobing of Christ* (fig. 15; see cat. 21). El Greco appeals to the senses, recalling the meditative exercises encountered in spiritual writings, notably those of the founder of the Jesuits, Ignatius Loyola. One can hear the raucous clamour of the crowd and the crunching noise of the bradawl as a hole is bored in the cross, smell the foul sweat of the executioners, touch the cold, polished steel of the armour, and taste the bitterness in Christ's mouth. El Greco creates convincing three-dimensional forms by means of precise drawing and smoother handling of paint. They are conceived from a close viewpoint and compressed, like cut-outs, into such a shallow

space as to suggest high-relief polychrome sculpture. The beholder is face to face with a rough and rowdy, jostling crowd while the executioner bores a hole in the cross, which seems to lie at the feet of the beholder. By contrast, Christ's facial expression and gestures poignantly recall the words that He spoke on the Cross: 'Father, forgive them; for they know not what they do' (Luke 23: 34). The claustrophobic space, with its grim foreboding of death, is relieved by the calm majesty of Christ. His physical power is expressed by the scale and centrality of His body. But it is colour rather than drawing or design which reveals His divinity. The blood-red robe, intensified by the adjacent yellows, gleams like a jewel, reassuring the celebrant of the triumph of Christ, and preparing him to repeat that sacrifice in a bloodless manner on the altar in the celebration of Mass.

In spite of El Greco's achievement, his representation of the divine in these terms did not seem to satisfy him as he grew

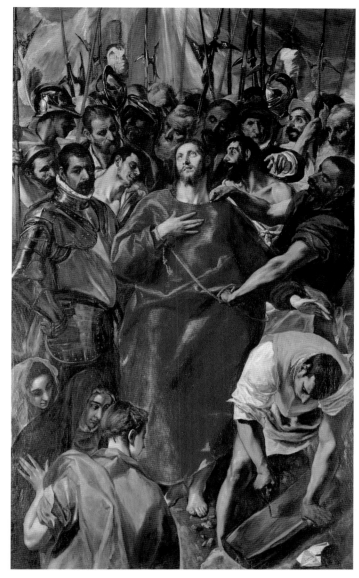

Fig. 15 El Greco
The Disrobing of Christ ('El Espolio'), 1577–9
Oil on canvas, 285 × 173 cm
Sacristy, Toledo Cathedral

older. The naturalistic element is gradually extracted to reveal the spiritual. Thus the decade of the 1580s is witness to a remarkable change in style. Figures are increasingly two-dimensional, elongated and slender. Transitions from light to dark are distinct. Colours are more expressive and less descriptive. Renaissance rules of perspective and proportion are gradually abandoned. It is an aesthetic not based on the observation of natural phenomena, but conceived in the mind.

An important work in this development is *The Martyrdom of Saint Maurice* (fig. 16), which was commissioned by Philip II in 1580, or earlier, for an altar in the royal monastery of El Escorial. As opposed to *The Disrobing* and conventional depictions of martyrdom in which the scene of suffering is placed immediately before the viewer, here it is relegated to the margin and seen in the middle distance. In the foreground, Saint Maurice and his companions appear instead to discourse on sacrifice and salvation. As in a Socratic dialogue, death has no sting. With a classical gesture (*adlocutio*) Saint Maurice exhorts the idea of martyrdom, which is triumphantly heralded by angels making music and holding palms and wreaths of victory. To formalise this idea, El Greco has abandoned the single, unified action of *The Disrobing*, and condensed the beginning, middle and end of the saint's story into one frame. He has also rejected an appeal to the senses. Rather than forceful and immediate, the figures are elongated and graceful, posed and detached. Likewise the blood red of Christ's garment in *The Disrobing* has been forsaken for delicate shades of pale blue, yellow, green and crimson. The physicality of suffering has been transcended by the glorification of martyrdom. In accord with this conceptual approach, the painting is adorned with conceits. For example, the flowers in the foreground signify the 'flowers of sanctity' (*flos sanctorum*) that is, the martyrs. Yet the sophistication and artifice of this imagery, reflective more of the artistic climate of Florence and Rome than of Venice, was out of tune with the notions of decorum that were rigidly upheld by Philip II. The painting was rejected.

Nevertheless, in Toledo, El Greco continued to explore and refine this imagery, as in *The Crucifixion* (cat. 25), which was also an altarpiece. The donors are naturalistically portrayed at the base of the painting, again on the same eye-level as a real priest

Fig. 16 El Greco
The Martyrdom of Saint Maurice, 1580–2
Oil on canvas, 448 × 301 cm
Monasterio de San Lorenzo de El Escorial,
Patrimonio Nacional

standing at the altar and celebrating Mass. Their images serve
to remind the celebrant to commemorate them in the canon of
the Mass. Thus the device of a stepping-stone from the physical
to the transcendental is repeated. Here, however, the represen-
tation of the latter in terms of the former has been abandoned.
The figure of Christ is more two-dimensional and elongated.
Although nailed to the cross, His body is seized by a powerful,
rhythmic energy. It is enhanced by the zigzag pattern of the
clouds and by the dramatic contrasts of tone. It is revealing
that the pose of Christ, alive on the cross, is ultimately derived
from a drawing of the same subject by Michelangelo (fig. 40,
p. 132), who had presented it to the celebrated spiritual reformer
Vittoria Colonna.[17] Whereas Michelangelo stresses the physical
suffering of Christ – He twists in agony on the cross, his chest
heaving with pain – to elicit an empathetic response from
Vittoria Colonna, El Greco has attempted to transcend this
appeal to the senses. The donors are not witness to a corporeal
vision, as is Saint Ildefonso in *The Resurrection* (fig. 13). Instead,
they contemplate in their mind's eye the spiritual significance
of Christ's sacrifice. Precedents for this striking contrast between
the naturalistic depiction of donors and the symbolic represen-
tation of the heavenly prototype existed in the tradition of
Byzantine icon-painting.[18]

El Greco's most famous representation of the relationship
between Heaven and earth is *The Burial of the Count of Orgaz*
(1586–8; fig. 17). In the lower half there is a realistic representa-
tion of a burial service with contemporary mourners. Their
physical individuality is emphasised by their different physical
forms, the variety of their facial and gestural expressions, and
the different textures of armour, cope, surplice, habit and civilian
dress – the richly embroidered vestments of Saints Stephen
and Augustine, the count's damascened armour glinting in the
gloom and reflecting the head of Saint Stephen in the breast-
plate, and the diaphanous surplice of the priest. The illusion
is heightened by the inclusion of contemporary Toledans as
mourners. It is a medieval mystery played in modern dress and
possibly at night.[19] Above their heads, an angel spirals heaven-
wards bearing the soul of the count, in the insubstantial form
of a child, to face its private judgment. The celestial vision is
characterised by a pronounced elongation and flattening of the

figures and the schematic treatment of clouds and drapery,
which are reduced to almost two-dimensional patterns. The
heavenly figures, together with the clouds, are subsumed by
a powerful rhythm that bears no relation to the forces of nature.
Light is exceedingly bright and white, and emanates from
Christ. It cascades down on to the glacial clouds and flashes
across the zigzag folds of drapery. No longer the embodiment
of physical beauty, strength and grace, as in *The Resurrection*,
Christ is now conceived as a radiance of light. He is the Sun of
Justice. His light is not the light of day, indeed there is no time
of day, for this is the plenitude of time.

Increasingly, El Greco was now concerned with visualising
the transcendental rather than the terrestrial. He rejected a
literal interpretation of sacred subjects and sought to express
their spiritual significance not only in the subject-matter but
also in the style of his painting. His forms are dematerialised
and elongated, colours are pure and brilliant, light is incandes-
cent and fitful, and space is undefined and often dark and void.
In certain altarpieces (see cat. 39, 55), El Greco systematically
effects a visual ascent from figures or forms at the base of the
painting that constitute natural phenomena and are perceived
through the senses to those above that have been conceived in
the mind through reason and faith, and that are dematerialised
– rising through the spiritual hierarchy or 'chain of being' and
rendering the visual process complementary to that of the
spiritual. In this manner, El Greco figuratively expresses the
yearning for the love of God through purging the senses,
dispelling the darkness of ignorance, and illuminating and
elevating the spirit. As such, his art conforms to the mystical
imagery of the Bible, devotional treatises, the Breviary and the
Missal. It becomes the function of El Greco's imagery to evoke,
in the mind's eye, holy persons who are illuminated, quickened
and elevated in a state of Grace, and thus to illuminate the
mind of the Christian faithful to their spiritual significance and
inspire its ascent to God.

This aspect of El Greco's style is developed in the 1590s. He
seems to represent not the physical body but the soul or spirit
that forms the body. Clearly, he makes no reference to the life
model. Instead the figures probably reflect the clay models
that El Greco is known to have made in order to compose his

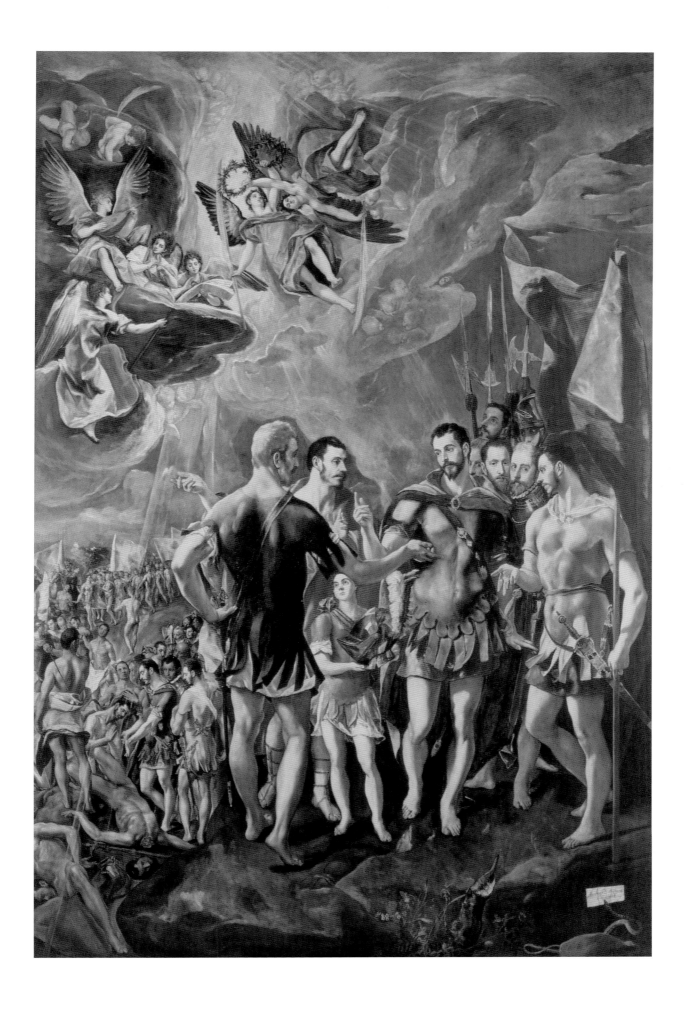

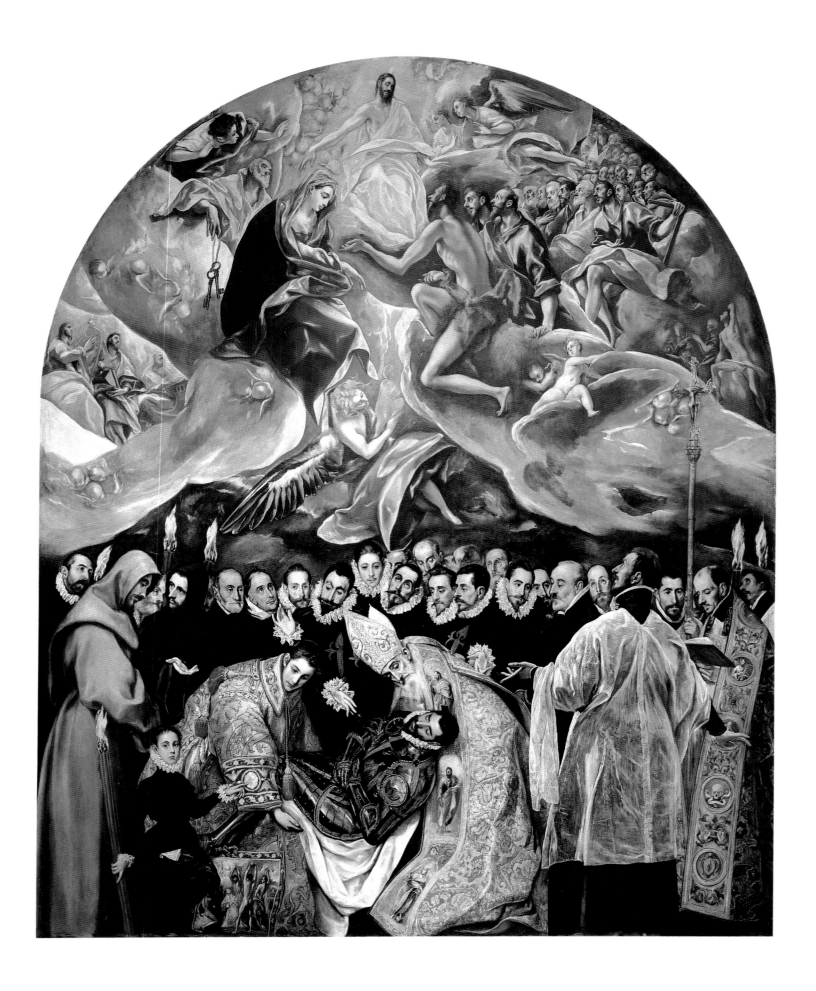

Fig. 17 El Greco
The Burial of the Count of Orgaz
(Gonzalo Ruiz of Toledo, Senor Orgaz), 1586–8
Oil on canvas, 480 × 360 cm
Parish Church of Santo Tomé, Toledo

paintings, following the practice of Pontormo and Tintoretto before him.[20] In the inventory of his possessions twenty models in plaster and thirty in clay and wax were listed.[21] Francisco Pacheco, too, recorded that El Greco had shown him clay models that he had made for use in his works.[22] Angels in aerial poses that he must have studied in such models recur in his paintings: for example the angel at the top in *Saint Joseph and the Christ Child* in the Capilla de San José in Toledo (fig. 46) recurs at a different angle at top left in *The Adoration of the Shepherds* in Bucharest and again at top right among the Virgin and angels in the *View and Plan of Toledo* (fig. 9) and finally top left in *The Adoration of the Shepherds* (cat. 62).[23] The elongation of the figures with their relatively small heads becomes more exaggerated, so that they assume flame-like shapes. The figure of Christ in *The Resurrection* (cat. 42) exemplifies this pheno-menon. In addition, the figures' verticality is accentuated by the reflections of light, which taper upwards irrespective of the configuration of the forms. In contrast to figures painted by artists such as Parmigianino, Tintoretto and Barocci, El Greco's are much more two-dimensional and consistently aligned close to the picture-plane. They no longer revolve around an axis, as in *The Resurrection* in Santo Domingo el Antiguo. They bear no relationship to the *figura serpentinata*. Instead, they are quickened and subsumed by powerful, energising rhythms. Significantly, they are dematerialised and ascetic in appearance. The Mannerist aesthetic of graceful beauty has been forsaken.

Neither the figures' proportions nor their relationship of figures to space are measured: space is either suppressed or invisible in darkness. Nor is there any indication of place. In contrast to El Greco's work for a Cretan cartographer and his painting of a topographical *View and Plan of Toledo* (fig. 9), the settings in his religious pictures are remarkable for their symbolic character. Toledo is sometimes represented (see cat. 38, 55), but only figures allegorically, as the stepping-stone to a higher world.

Just as there is no sense of definable space, so there is no sense of the time of day. The temporal has been forsaken for the eternal. Likewise, there is no light of day. The light in his religious paintings emanates from within the divine. El Greco dispenses with the natural interrelationship of light and dark.

Cast shadows are rare in his paintings. Atmospheric pheno-mena have been abstracted. Instead, light is the antithesis of darkness. Light never penetrates it, but dispels it. Thus there is light and darkness in his paintings, but there is seldom day and night. Witness the unreal, undefined darkness of the back-grounds in *The Burial of the Count of Orgaz*, (fig. 17), *The Baptism of Christ* (fig. 20) and the late *Crucifixion* in the Prado (fig. 21). Here, darkness is symbolic. It corresponds to the imagery of Scripture and the liturgy: 'In him was life, and the life was the light of men, And the light shineth in darkness, and the darkness did not comprehend it' (John 1: 4–5).

El Greco's concept of light, which bears no relationship to the observation of natural phenomena, is complemented by his colour. Colours are pure, luminous and juxtaposed to create vibrant effects. The optical range of tone and hue in a form, which is determined by its shape, texture and the intensity and colour of the light, is scarcely evident in El Greco's religious works after the late 1590s. There is no attempt to convey either the artificial cadencies of shot colour, as in Roman and Florentine Mannerism, or the optical illusion of a form in space through colour modelling, as in Titian's late work. Here it is instructive to compare the first-hand observations of the aged Titian at work by Palma Giovane and of El Greco at work by Pacheco in 1611. According to Palma, Titian used 'brushes laden with colours, sometimes of a pure red earth – which he used, so to speak, for a middle tone – and at other times of white lead; and with the same brush tinted with red, black and yellow he formed a highlight'.[24] By contrast Pacheco recorded that El Greco retouched his painting to make 'the colours distinct and separate'.[25] As opposed to Titian's practice of building up in many layers of different colours, El Greco, as microscopic exami-nation has revealed (fig. 18), added glazes of the same colour one above the other in order to create the distinctive depth and luminosity of his painting – in effect, like stained glass.

These various stylistic characteristics are evidence of El Greco's conceptual approach to painting, manifest in his *Annunciation* (1596–1600; fig. 19), which originally formed the central compart-ment of a large altarpiece in the Augustinian Colegio de Doña María de Aragón in Madrid (see further cat. 40–2). At the bottom of the canvas, the terrestrial world is barely indicated by the

steps, sewing-basket and rose-bush in flames. The flames are rendered so naturalistically that they would probably have appeared to mirror the real candle flames burning on the altar during the celebration of Mass. But above and beyond El Greco has distorted light, colour and form. Indeed, all the forms are in a state of flux. The grand rhythm of the wings of Gabriel and the Holy Spirit quicken the drama. Garments of crystalline blue, crimson and yellow-green vibrate against the blue-grey void. Incandescent light is reflected off the figures with such intensity that each seems to be its own source of light. None is circumscribed by time or place. Corporeality is abstracted to symbolise their spiritual being.

In El Greco's very latest works, the brushwork is more vigorous; light is bleached white and fitful; colours are pure, luminous and vibrant – they glow with unearthly beauty; figures are more elongated, dematerialised and dynamically charged. There is a new spiritual energy. This is wondrously conveyed in El Greco's decorative scheme for the Oballe Chapel in San Vicente (see cat. 55–8). Above, in the vault, there was to be *The Visitation* (cat. 58). Its inclusion was a reference to the foundress, Isabel de Oballe; its position was undoubtedly El Greco's invention. The subject of the altarpiece was *The Virgin of the Immaculate Conception* (cat. 55). At the bottom of the canvas there is a cluster of naturalistically painted lilies and roses (symbols of the Virgin). They are to the right of centre, presumably to avoid being masked by the crucifix of the tabernacle on the altar. Illusionistically, they would have mirrored real flowers

Fig. 18 El Greco
Cross section from Gabriel's dress, detail from **The Annunciation** (fig. 19)

which were probably placed on the altar during her feast-days. From the realm of the naturalistic flowers, heavenly beings flare upwards illuminating the dark night. Amidst the flickering light of the candles on the altar and the clouds of incense, they would have appeared to soar to the real light from the window and to the heavenly sphere above, where, in *The Visitation*, the two celestial bodies are fused in a burst of incandescent, metaphysical light. Such visionary imagery recalls the mystical poetry of Saint John of the Cross:

> *¡Oh lámparas de fuego,*
> *en cuyos resplandores*
> *las profundas cavernas del sentido,*
> *que estaba oscuro y ciego,*
> *con extraños primores*
> *calor y luz dan junto a su querido!*

> O lamps of burning fire
> In whose translucent glow
> The mind's profoundest caverns shine with splendour
> Before in blindness and obscure,
> With unearthly beauty now
> Regale their love with heat and light together.[26]

The viewer may continue his ascent until perhaps ultimately attaining union with God.

This mystical process is described by Saint John of the Cross:

> . . . with respect to the remembrance and adoration and esteem of images, which the Catholic Church sets before us . . . they [images] will ever assist it [the soul] to union with God, allowing the soul to soar upwards [when God grants it that favour] from the superficial image to the living God, forgetting every creature and everything that belongs to creatures.[27]

The same response is encountered in the poetry of the Augustinian Fray Luis de León. In his *Ode to Salinas*, he recalls how, at the sound of Salinas's organ music, his soul was transported beyond the world of the senses to that of the spirit, where he comprehended the music of the spheres and experienced a divine harmony, the source of which was God Himself.[28]

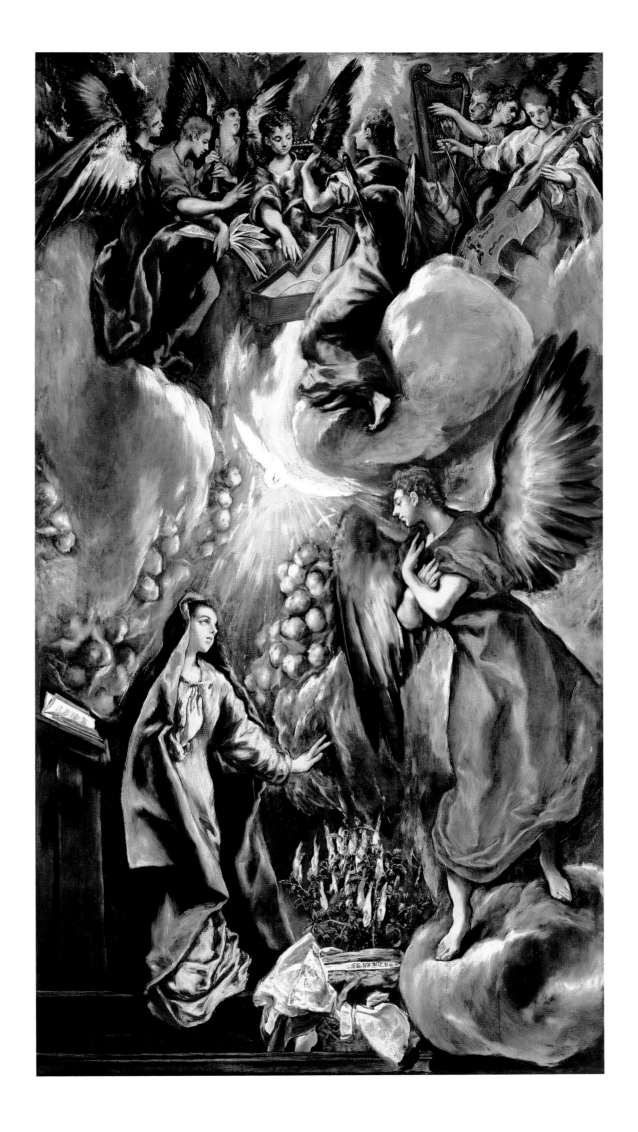

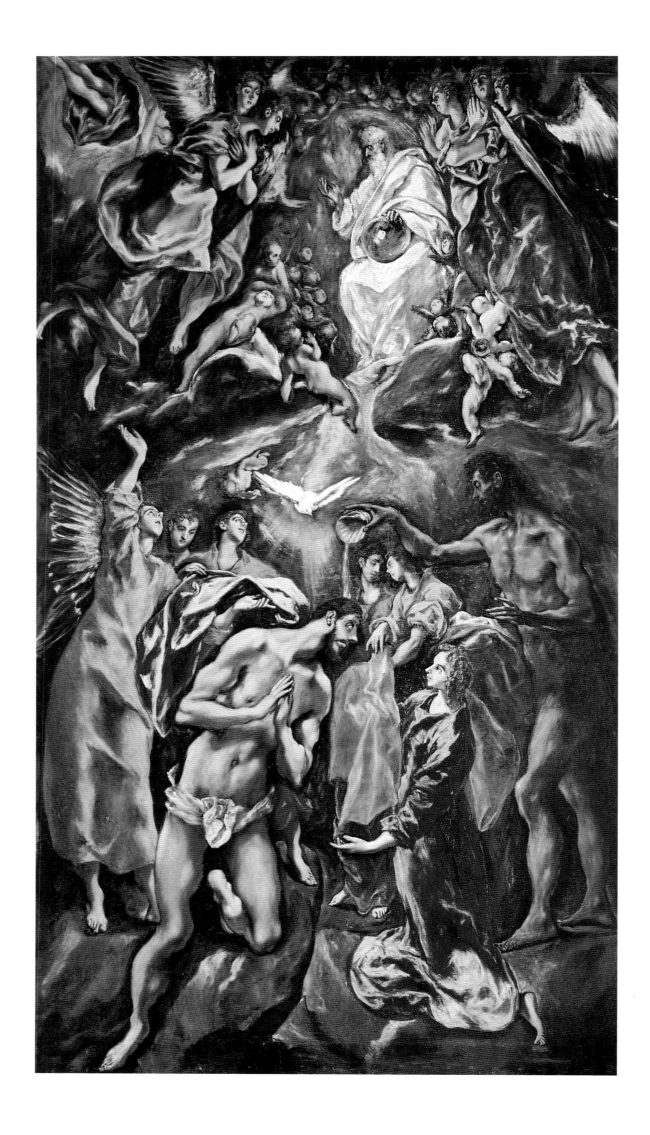

Fig. 20 El Greco
The Baptism of Christ, 1608–28
Oil on canvas, 330 × 211 cm
Tavera Hospital (Church of the Hospital of
Saint John the Baptist), Toledo

The Spirit of the Catholic Reformation

To appreciate the course of El Greco's stylistic development, especially the remarkable transformation of his religious art during his time in the ecclesiastical capital of Spain, it is essential to have some understanding of the religious context in which it flowered. El Greco lived in a time of theological renewal and zealous spiritual reform. Toledo in particular, the see of the primate of Spain, presented at the time of his arrival a scene of intense religious activity. The city was a crucible of reform. Its printing presses turned out tracts on the spiritual life and it was pullulating with convents. Already in 1537 it had been described as a city 'where the sanctity of the Church automatically invites him [a Catholic] to live in a saintly manner! Over and above the great number of the clergy and the multitude of monasteries of all the religious orders . . . there are confraternities of the devout in this city so numerous that one would think that all such organisations in all of Spain had gathered for a convention in Toledo.'[29] It was propitious that in the year after El Greco's arrival in Spain, 1576,[30] Gaspar de Quiroga was appointed Archbishop. Like his predecessor, Bartolomé Carranza, he pursued a policy that reflected the best ideals of the Counter-Reformation.

It was Christian belief that, after the Fall, man needed to be redeemed, or restored to his proper place in the cosmic hierarchy. This could be achieved only through the bestowal of God's grace, which had been merited by the self-sacrifice of His Son, Jesus Christ, dying on the cross. Traditionally it was supposed that, by choosing a Christian life of prayer and good works, and by recourse to the Sacraments of the Church, the individual could earn Grace, redemption from Original Sin and hopefully a place in Heaven. By contrast Protestants believed that, after the Fall, man had lost his free will and was radically corrupted by Original Sin. His redemption, or 'justification', depended solely on faith in God's mercy. Good works and prayer made no difference: they were not instrumental in the economy of Justification. Martin Luther is reported to have said that a good man will perform good works, but good works will not make a good man. Conversely, man no longer had to fear being punished in Purgatory for his temporal sins. Protestant reformers inveighed against the belief in Purgatory. They believed that Christ was the sole mediator between God and man, and that

the invocation of the Virgin and saints to intercede for man through Christ was irrelevant. Likewise, the petitioning of priests and religious to pray for the faithful served no purpose. Accordingly, the rôle of nuns, friars and monks, who exemplified faith and good works through their self-sacrifice and continuous prayer, was annulled.

The Protestants also dismissed the sacraments of Confirmation, Penance, Marriage, Extreme Unction and Order. Thus the ecclesiastical institution of the Catholic Church was undermined. Theirs was a priesthood of the laity. Even more challenging was their attitude towards the Eucharist and its liturgical celebration in the Mass. They denied that the sacrifice of Christ on Calvary was bloodlessly re-enacted on the altar. They rejected the belief that the bread and wine that was co-mingled with water were transubstantiated at the consecration into the real flesh and blood of Christ, thus mysteriously making real His glorified presence. It followed that the tradition of revering the host, placing it in a special receptacle, such as the tabernacle, and displaying it in a monstrance was also cast aside.

The special benefits deriving from this fountain of Grace and bestowed on the communicants and on those, such as donors, named in either the Commemoration of the Living or the Commemoration of the Departed, or in Masses for the Dead, were now also denied by the Reformers. Similarly, the tradition of linking donations, such as chapels or altarpieces, to the saying of Masses, often in perpetuity for the souls of the departed, was also repudiated.

Since the Protestant reformers dismissed the special sanctity of the Mass, the central act of Catholic worship, they reduced the rites of the Church. The supernatural rôle of the priest, as a sacramental channel of Grace, to consecrate, to offer the sacrificial victim to God the Father, and to administer the sacrament of the Eucharist, was also censured by the Reformers. The austerity of Protestant worship is clearly evident in contemporary paintings of Dutch church interiors. What is also apparent is that the focus of attention is on the minister delivering a sermon, as opposed to earlier, fifteenth-century representations in which the elevation of the host is the central event. Protestants maintained that the word of God was revealed only in the Bible, and ignored the authority of conciliar decisions

and the writings of the Church Fathers and Doctors of the Church. The Bible was to be made available to all the literate by being translated into the vernacular. However, in spreading the word of God, the use of images was generally avoided. Luther permitted images relating to the Sacraments of Baptism (The Baptism of Christ) and Eucharist (The Last Supper),[31] but Calvin and the Church of England rejected all religious images because they believed that they encouraged idolatry.[32]

These Protestant refutations were staunchly countered and condemned in the canons and decrees of the Council of Trent. The Council denied that Man had lost his free will after the Fall,[33] and claimed that, after Baptism, he could hope to be the recipient of God's Grace as a result of his faith and of his actions. The Council upheld the traditional seven Sacraments – Baptism, Confirmation, Eucharist, Penance (or Confession), Extreme Unction, Marriage and Order (the last two mutually exclusive) – as channels of Grace from God. The real presence of Christ in the Eucharist, liturgically activated in the Mass, was re-affirmed,[34] and the sacramental rôle of the priest maintained.[35] Belief in Purgatory and the intercessory rôle of the Virgin and saints between man and Christ was re-asserted.[36] Significantly, sacred imagery was justified in the context of this invocation of the saints. Veneration was not idolatrous because it was referred to the prototype represented in the image. Further, the Council of Trent vigorously encouraged spiritual reform of the individual as intrinsic to Catholic worship. It gave authoritative support to the quest for the spiritual life, not merely to those in orders but also to the Catholic faithful at large.

In Spain, the striving after spiritual renovation had already begun during the reign of Isabella and Ferdinand (1479–1504). Inspired by the re-conquest of Christian Spain from the Moors, it had been fostered notably by Jiménez de Cisneros, Archbishop of Toledo (1435–1517). Here the ideas of Erasmus of Rotterdam (c. 1466–1536) provided a powerful stimulus.[37] Although, by the mid-sixteenth century, the Erasmian movement had lost favour and some of his writings had been banned,[38] the zeal for the spiritual reform of the individual lost nothing of its intensity in Spain, especially in the new and reformed religious orders. In the last four decades of the sixteenth century, it found magnificent expression in the spiritual

writings of Luis de León, Luis de Granada, Saint John of the Cross and Saint Teresa of Ávila.[39] Their 'imitation of Christ' was characterised, essentially, by a rejection of the carnal life and a yearning for the spiritual. 'Set your affections on things above, not on things on the earth' (Saint Paul to the Colossians 3: 2) was their clarion call. With the apostolic fervour of Saint Paul reverberating in their sermons and writings, the spiritual reformers pursued this ideal by putting 'on charity, which is the bond of perfectness' (Colossians 3: 14). Their acts of charity were undertaken not merely for the benefit of others, nor for the accumulation of justice for themselves, but wholeheartedly for Christ.

In the quest for deliverance from sin and restoration to communion with God, the spiritual reformers thrived upon the devout use of the Sacraments, especially the Eucharist. At Baptism they had received sanctifying Grace, whereby the guilt of Original Sin was remitted and the gifts of faith, hope and charity infused. Grace that had been subsequently lost could be retrieved through the Sacrament of Penance. However, it was in the celebration of the Mass that their union with Christ was consummated, and the bonds with the mystic body of Christ further strengthened. Adoration of the Holy Eucharist heightened their fervour for the crucified and resurrected Christ, who was present in the Sacrament. Telling images are those of Saint John of Ávila praying before a crucifix that is suspended in a chalice, full to the brim with blood,[40] and Saint Teresa's visions in which 'almost invariably the Lord showed himself to me in his resurrection body, and it was thus, too, that I saw him in the host'.[41] Thus the narrative cycle of Christ's life was subordinated to the specifically salvific, to the achievement of salvation. Scenes of his infancy, passion and resurrection, rather than of his ministry, predominated in Catholic prayers and writings.

Devotion to Christ was made manifest not only in corporate works of mercy but also in repentance, asceticism and prayer. The repentance of sins prepared the individual to receive Christ. The denial of self, 'the taking up of the cross', enabled the individual to reject the material life that prevented him from following Christ. The encouragement of the abnegation of the flesh was accompanied by a desire to pray in the wilderness, in imitation of Christ. For example, Luis de Granada's

letters to Bartolomé Carranza, recommend a retreat into the 'yermo', the spiritual wilderness.[42] Prayer, especially mental prayer, provided the individual with the means of conversing with Christ, and of sharing the suffering and joy of Christ. Two basic forms of prayer were distinguished, vocal, such as the Lord's Prayer, and mental. Mental prayer, the 'ascent of the mind to God', embraced first meditation and then contemplation. In practice, these two stages were not necessarily rigidly separated, nor were they in strict sequence, nor was contemplation an inevitable consequence of meditation, although it was zealously desired. Meditation involved the application of the senses in order to imagine, for example, the size of the garden at Gethsemane, or the physical suffering experienced by Christ on the cross. In contemplation, the higher form of mental prayer, the spiritual reformers would seek to transcend the physical world, and hope to attain through Grace a union of the soul with Christ. Initially they would attempt to purge their minds of physical images since these would prevent them from attaining that state of quiet which was more spiritual, and in which they hoped to receive infusion and illumination from supernatural sources. Subsequently their understanding might be illuminated with supernatural light. Beforehand they would be in a state of blindness and darkness – the despair of the 'dark night of the soul' (Saint John of the Cross).[43] Then, possibly, God would make his presence felt to them and their souls would experience mystic union with God. Mystic writers could find no words to express this union adequately, yet common to their reminiscences were images of the flame and a brilliance of light and colour, as in the poem 'The Living Flame of Love' of Saint John of the Cross.[44]

Much of the method and poetic imagery of the mystic writers in Spain was derived from the mystic treatises of Pseudo-Dionysius the Areopagite. Since he claimed to be the Dionysius who, according to Acts, converted to Christianity after hearing Saint Paul preach at the Areopagus in Athens, subsequently to become (as Saint Denis) the patron saint of France, his writings had apostolic authority and exerted a great influence on both Eastern and Western medieval mystical theology. They became known in the West through the Latin translation of John Scotus Erigena.[45] Both Saints Thomas Aquinas and Bonaventure, for example, referred to him in their writings on mental prayer.[46] In Spain, the spiritual writers were profoundly influenced by his treatises, especially his *Mystic Theology*.[47]

Pseudo-Dionysius conceived the illumination of the soul in terms of light metaphysics. God the Father is described as 'the Father of Lights', the 'one Source of Light for everything which is illuminated'. Jesus is described as 'the Light of the Father, the Real, the True, "Which lighteth every man that cometh into the world, by Whom we have access to the Father", the Origin of Light'. Light emanates from God as a 'divine procession of radiance'. It is imparted to angels and transmitted from one to the other in descending order, that is, through the celestial hierarchy. Celestial members of the hierarchy are compared to 'bright and spotless mirrors which receive the Ray of the Supreme Deity . . . and being mystically filled with the Gift of Light, it pours it forth again abundantly, according to the Divine Law, upon those below itself'. Eventually divine light spiritually illuminates the mind of Man. He, in turn, with the help of angels, can ascend the hierarchy from the physical to the divine. Initially he needs to contemplate the physical world, which will provide a stepping stone to the divine:

> For the mind can by no means be directed to the spiritual presentation and contemplation of the Celestial Hierarchies unless it use the material guidance suited to it, accounting those beauties which are seen to be images of the hidden beauty, the sweet incense a symbol of spiritual dispensation, and the earthly lights a figure of the immaterial enlightenment.[48]

The search for the spiritual life and the quest for the mystic union of the soul with God through contemplative prayer were profoundly indebted to Neoplatonic thought, and formed the cornerstone of the fabric of spiritual reform in Spain.

It is essential to note that El Greco's commitment to the Catholic faith was unambiguous. On his death bed, making his testament, he affirmed, in conformity with Catholic practice:

> I believe and confess in all that which the Holy Mother Church of Rome believes and confesses and in the mystery

of the Holy Trinity in whose faith and belief I profess to live and die as a good faithful Catholic Christian.[49]

Furthermore, he contracted to be buried in the Cistercian convent of Santo Domingo el Antiguo and provide both altar and an altarpiece for the chapel, which shows that he wished to be commemorated in masses celebrated at the altar and hoped that prayers would be said by the nuns for his soul after death. The subject of the altarpiece, *The Adoration of the Shepherds* (cat. 62), implied belief in the intercession of the Virgin, through Christ, for the bestowal of Grace from God for the benefit of his soul. The Mother of God, in Greek Theotokos, was the equivalent of El Greco's name saint (his surname was Theotokopoulos), and it is conceivable that the humbly adoring shepherd in the foreground is a self-portrait of the artist (see cat. 75).[50]

Counter-Reformation Themes in El Greco's Art

The subject-matter of El Greco's religious art, whether as a result of his own choice or that of his patrons, clearly reflects the tenets and principles of the Council of Trent, modified by the influence of the spiritual reform movements. In it those doctrines which were refuted by the Protestants and re-affirmed by the Council of Trent feature large,[51] together with an emphasis on doctrine rather than narrative. El Greco's imposing image of *Saint Jerome as a Scholar* (cat. 50), visualised as the personification of wisdom, asceticism and authority, embodies the Tridentine insistence on the authority of the Vulgate, that is, the Latin version of the Bible by Saint Jerome – as opposed to vernacular translations sponsored by the Protestants. The importance of faith and good works in Man's Justification is clearly expressed in El Greco's representation of the saints. Subjects include martyrdom – *Saint Sebastian* (cat. 24); *The Martyrdom of Saint Maurice* (fig. 16); charity – *Saint Martin and the Beggar* (cat. 38); and especially prayer and personal contrition. The fervent desire of the spiritual reformers to encourage personal contrition, as well as absolution or forgiveness through the Sacrament of Penance, is reflected in the many commissions that El Greco received to illustrate saints in

penitence. Some outstanding examples are Saint Mary Magdalen (cat. 26), Saint Peter (cat. 27) and Saint Jerome (*Saint Jerome in Penitence*, National Gallery of Art, Washington, DC). El Greco related the subject of repentance to mortification and prayer. He portrays these saints as sorrowful and ascetic, and depicts them in the austere setting of the wilderness ('*yermo*'), in solitude, and in attitudes of prayer. Vividly he evokes the opening words of the Penitential Psalm (50 in the Vulgate): '*Miserere mei Deus*' (Have mercy upon me, O God).

In his innumerable paintings of Saint Francis (see cat. 45–7) El Greco never shows the saint performing miracles, but depicts him in prayer, usually before a crucifix, and in a bare wilderness. At his side there is frequently a skull, the symbol of the transience of earthly life. He is emaciated and in a coarse habit, reminiscent of the asceticism of the Desert Fathers and, in particular, that of the Francisan Recollects.[52] It is, however, most pointedly in his representations of Saint Dominic in prayer (see cat. 33) that El Greco reflects the attitudes of Spanish spiritual reformers. In the second half of the sixteenth century there was an acrimonious dispute within the Dominican Order concerning 'good works'. The supporters of Bartolomé Carranza, the former archbishop of Toledo, maintained the primacy of mental prayer and penance. Their opponents insisted on the traditional Dominican activities of preaching, scholarship and education.[53] Surely, El Greco's painting is the standard of those Dominicans who supported Carranza.

The Burial of the Count of Orgaz (see fig. 17) is a different kind of manifesto of Tridentine doctrine.[54] According to the story, as a reward for his benefactions particularly to the Augustinian convent dedicated to Saint Stephen, at the burial of the count both Saint Augustine and Saint Stephen miraculously appeared and lowered his body into the tomb. The soul of the count is taken heavenwards by an angel to face the judgment of Christ. In contrast to Luther's view, the salvation of the soul of the count is not assured. Consequently, the soul has to face its private judgement, in which, with the intercession of the Virgin and the other saints, and thanks to its 'good works', it hopes to attain 'the crown of justice'. To emphasise the moral of this medieval miracle, El Greco introduced contemporary witnesses

in modern dress, among them a young boy who, like a chorus figure, points to the dead count (in contemporary armour) and, by implication, exhorts the beholder to imitate the faith and good works of this Christian Knight.

Specific references are also made to the Sacraments in El Greco's art. Baptism is signalled by *The Baptism of Christ* (fig. 20). Penance (as well as personal contrition) is signified by images of Saints Peter, Mary Magdalen and Jerome in penitence. Order is referred to in *The Burial of the Count of Orgaz* (fig. 17), in which the celebrant, accompanied by deacons, reads the Office for the Dead.[55] The series of Apostles (cat. 51–3), which may have been for a sacristy,[56] again makes manifest the Tridentine re-affirmation of the Sacrament of Order. Viewed by the priest as he prepared to celebrate Mass, these images would have reminded him 'that this [Sacrament of the Eucharist] was instituted by the same Lord our Saviour, and that to the Apostles and their successors in the priesthood was given the power of consecrating, offering and administering His body and blood'.[57]

A significant figure recalling the sacrament of Order was the local saint, Ildefonso (died 667), a former archbishop of Toledo who had written a defence of the perpetual virginity of the Virgin Mary, *De Virginitate Beatae Mariae*, and on whom, as a reward, the Virgin bestowed a chasuble. In *The Resurrection of Christ* in Santo Domingo el Antiguo, Saint Ildefonso is represented as a celebrant in Easter vestments, and again in a relief made by El Greco which accompanies *The Disrobing of Christ* (fig. 15), originally in the vestry of Toledo Cathedral. As the celebrating priest donned the liturgical vestments, *The Disrobing* would have put him vividly in mind of the sacrifice of the Mass that he was to celebrate. The fifteenth-century mystic Thomas à Kempis had written that it was 'in order that he [fallen Man] might be clad in a robe of righteousness, and might be made an heir of everlasting life, that Thou didst submit to be deprived of Thy clothing...'.[58] Symbolically, Saint Ildefonso is being clad in the robe of righteousness as a reward for his faith and good works.

Since the celebration of the Eucharist in the Mass is the central act of Catholic worship, there is scarcely any dogma that does not relate to it.[59] The sacrifice of Christ on Calvary merited Grace from God, by means of which those who responded with

faith and good works were potential recipients of Grace and hopeful for salvation. In many altarpieces, El Greco refers to this sacrificial aspect with subtle ingenuity. For example, in his scheme of chapel decoration in Santo Domingo el Antiguo, *Saint John the Baptist* (cat. 18) is shown looking and pointing downwards, whereas he is traditionally represented pointing to the Lamb which he holds in his other arm. In fact, he is pointing at the altar, thereby referring to the sacrifice of the 'Lamb of God ... who taketh away the sin of the world' (John 1: 29). For the attic of the high altarpiece, El Greco painted *The Trinity* (fig. 14). In this liturgical context, God the Father's acceptance of the sacrificial victim is the climax of the drama of sacrifice and salvation. The prayer of the celebrant, 'Humbly we beseech thee, Almighty God, to command that by the hands of thy holy Angel, this our sacrifice be uplifted to thine Altar on high', has been answered. El Greco's intention to reveal the drama of sacrifice and salvation, which is re-enacted in the celebration of the Mass, is also evident in the *Crucifixion* from the Colegio de Doña María de Aragón (fig. 21). El Greco has depicted a profusion of blood. Blood gushes out of Christ's side, it is collected in the open palms of the angels, and is mopped up by Saint Mary Magdalen at the foot of the cross. The image of blood is enhanced by the predominant colour of red within the picture. Yet Christ is depicted in an idealised form. There is no hint of physical suffering. Indeed, the angels in the sky are exultant because Man will be redeemed through the blood of Christ.

The theme of sacrifice and salvation is repeated in *Saint Joseph and the Christ Child* (Capilla de San José, Toledo; see fig. 46, p. 160; cat. 29–31). El Greco's treatment is a far cry from that, for instance, of Murillo (1665–6; Museo de Bellas Artes, Seville). Whereas the latter depicts Saint Joseph with his traditional attribute of the rod in bloom, El Greco substitutes a shepherd's crook. Saint Joseph protects the Lamb of God, whose garment is blood-red and whose sacrifice is re-enacted during the celebration of the Mass. Moreover, as a result of his 'good works', the saint is crowned with the victor's laurel. As an example for contemporary reformers, Saint Joseph is shown emaciated, barefoot or 'discalced', and against the background of Toledo.

The doctrine that the saints can be invoked to intercede with Christ was robustly re-affirmed in the Twenty-fifth Session of

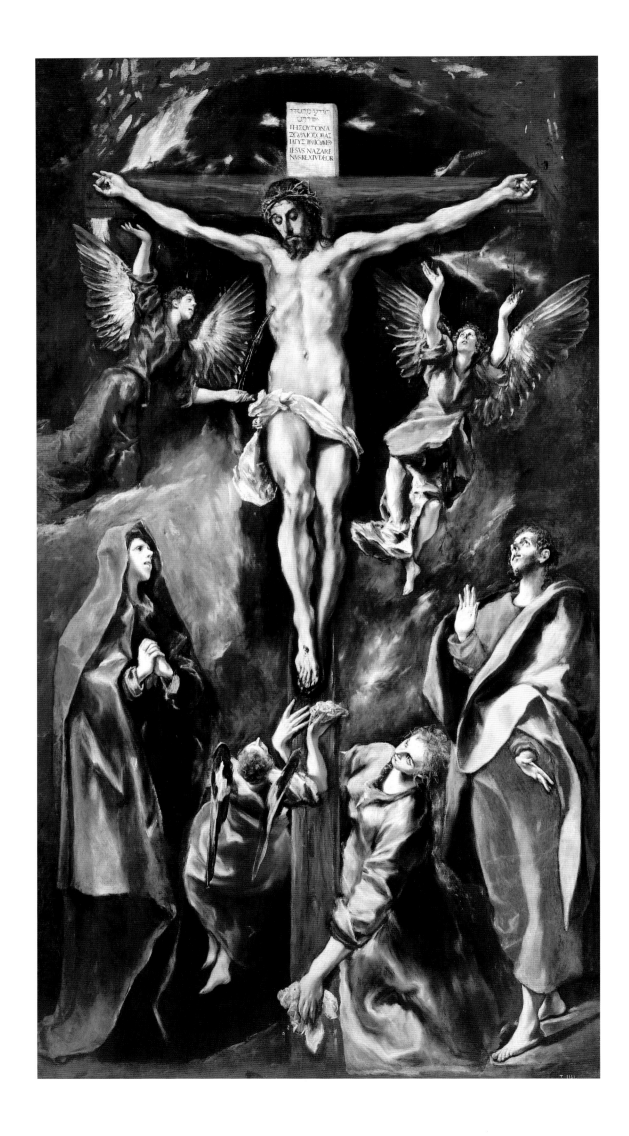

the Council of Trent. Among the saints, the Virgin is pre-eminent. Special veneration (*hyperdulia*) is paid to her because she was the Mother of God, and the prime intercessor between Man and Christ. Since her rôle had been denied by the Protestants, the Catholic Church responded by extolling her special status and her good works. She is shown as the special recipient of Grace (The Annunciation) and the mother of God (The Nativity, The Holy Family, The Adoration of the Shepherds). To signify her love, the ideal virtue of protection and mediation, she is depicted as the exemplar of charity (Madonna of Charity), the affectionate mother of the infant Jesus (The Holy Family), the anguished *Stabat Mater* on Calvary (The Crucifixion) and the mother who grieves over her dead son in her lap (*Pietà*). As a reward for her faith and good works she is assumed into Heaven with her body preserved from corruption (The Assumption of the Virgin), and crowned by God (The Coronation of the Virgin). Although the Council of Trent refrained from making any decision about her conception in the decree concerning Original Sin, she was referred to as the 'immaculate Virgin Mary, the mother of God'.[60] In Spain, in particular, the cult of the Immaculate Conception of the Virgin in the womb of her mother, Saint Anne, was held dear (see cat. 55). (Later, it came to be known as 'the darling dogma of the Spaniards'.) [61]

Following the Tridentine emphasis on the redemptive and salvific rôle of Christ, the principal subjects selected from the life of Christ are the Infancy (also involving the Virgin), Passion (Agony in the Garden, Christ carrying the Cross, Veronica, Disrobing, Crucifixion, *Pietà*) and Resurrection. El Greco himself was continually preoccupied with the spiritual significance of Christ's life: he seeks to resolve the fundamental question not who is Christ but what is Christ. This is evident if one compares his *Christ carrying the Cross* (cat. 32) with Titian's version of the subject (fig. 22). Titian vividly conveys the intense, physical suffering experienced by Christ as he is bowed down by the weight of the cross. The beholder is encouraged to meditate on the physical realism of the scene and empathise with Christ. In El Greco's version, in contrast, Christ looks serene and triumphant. He gazes not at the viewer to elicit sympathy but heavenwards to direct the mind to God. The cross is weightless; his long tapering fingers seem to caress

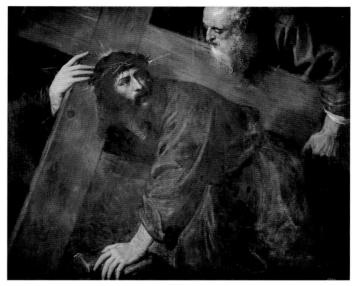

Fig. 22 Titian (about 1487–1576)
Christ carrying the Cross (Christ and the Cyrenian), about 1565
Oil on canvas, 98 × 116 cm
Museo Nacional del Prado, Madrid, inv. 439

rather than to grasp it. His crimson robe is not blood-stained or muddied, but glows royally. El Greco's interpretation recalls the Gospel text of Matthew 16: 24: 'If you wish to come after me, deny yourself and take up your cross and follow me.' One is reminded of Erasmus's words:

> Christ has told everyone that whoever does not take up his own cross and follow in his footsteps is not worthy of Him. Dying with Christ as far as the flesh is concerned means nothing to you if living by His spirit means nothing.[62]

It is to the spirit, not the senses, that El Greco's image is designed to appeal. Thus, although the subject-matter of El Greco's religious pictures is orthodox and in accord with the theological decrees of the Council of Trent, one can also discern certain emphases which reflect the specific ideals of the spiritual reformers.

As far as commissioned works, at least, were concerned, the choice of subject would not have been a matter for the artist, although he might have been consulted, since he was certainly familiar with sacred literature.[63] When it came to treatment of the subject, however, he inevitably played a greater rôle. In

certain commissions for which a contract exists, such as *The Burial of the Count of Orgaz*, it would seem that El Greco himself was responsible for introducing additional features, such as contemporaries in modern dress, the soul of the count, and the appearance of Philip II among the Church Triumphant as a member of the City of God.[64] It is conceivable that some of these may have resulted from a discussion between the artist and Andrés Núñez de Madrid, the parish priest of Santo Tomé, but it is unlikely, since they conform to pictorial traditions. Criticism of his iconographic innovations suggests that he must have been responsible for their invention. The chapter of the Cathedral, for example, complained that he had included the three Maries and placed soldiers at a higher level than Christ in *The Disrobing of Christ* (see cat. 21); *The Martyrdom of Saint Maurice* (fig. 16) was rejected by Philip II probably because El Greco had displaced the scene of martyrdom to the background and possibly because he had included contemporary portraits; at Illescas the confraternity objected to his inclusion of a portrait of his son and of companions wearing large ruffs, deemed indecorous. Responsibility for the interpretation of the subject – the emphasis on the spiritual – is a still more complex issue. Undoubtedly it was primarily the rôle of the clergy and the religious orders to promote and dictate the spiritual life. Nevertheless, the evolution of his treatment in a series of paintings such as that of *The Purification of the Temple* (cat. 6–9) demonstrates a high degree of personal involvement in the iconography.[65] El Greco's capacities in this regard should not be underestimated. The men with whom he was associated and the books in his library are evidence that he was steeped in the religious, and also secular, thought of his time.

El Greco's Intellectual Milieu

'Dominico Greco was a great philosopher, acute in his remarks, and he wrote on painting, sculpture and architecture', recorded Francisco Pacheco in his *Arte de la Pintura*, published posthumously in Seville in 1649.[66] Pacheco, who had visited El Greco in Toledo in 1611, was the erudite master of Velázquez, and an authoritative witness. However, he was not a kindred spirit. He found that El Greco made statements that were paradoxical and contrary to received opinion.[67] He did not uphold the orthodox view, echoing Aristotle, that the artist should follow precepts.[68] He spoke of Michelangelo with little appreciation, saying that he was a good man but 'did not know how to paint'.[69] El Greco, wrote Pacheco, was 'singular in everything, as he was in painting'.[70]

El Greco's intellectual capacity and interests are also evident from the company he kept both in Italy and in Spain.[71] Little is known of his circumstances after leaving his native Crete and arriving in Venice in 1568. From November or December 1570 to July 1572, however, having moved to Rome, he lived in the Farnese Palace under the protection of Cardinal Alessandro Farnese.[72] The cardinal was described as one who 'has always favoured every "virtuoso" and every rare intellect';[73] he was a great patron of religious and secular art and architecture, and an avid collector.[74] El Greco painted for him works such as *Boy blowing on an Ember* (cat. 63), which was the re-creation of a lost work of ancient art described by Pliny the Elder, and *Christ healing the Blind* (cat. 5), which signified, at that time, the enlightening of the ignorant or heretic by the Catholic Church. However, El Greco's association with the Cardinal was short-lived. He was accused of some grave misdemeanour, he claimed unjustly, and was abruptly discharged from the Cardinal's service in July 1572.[75] It is conceivable that the cause of his fall from favour was his supposed condemnation of Michelangelo's *Last Judgment*.[76]

In spite of his dismissal, El Greco must have benefited from the intellectual milieu in the Palace. Among the residents was the distinguished canon and librarian Fulvio Orsini. He owned El Greco's portrait of their mutual friend the celebrated miniaturist *Giulio Clovio* (cat. 70) and five other portraits (four were probably miniatures) that are now lost, and El Greco's *View of Mount Sinai* (probably cat. 10).[77] Orsini's collection also included works attributed to Giorgione and Titian, twenty drawings by Michelangelo[78] and sixteen paintings and drawings believed to be by Raphael.[79] He was curator of the cardinal's collection of classical antiquities,[80] and the author of *Images et elogia vivorum illustrium et eruditorum* (Images and discourses in honour of famous and learned men [of antiquity]), published in 1570.[81] His renown as an epigrapher was reflected in his collaboration with the eminent Spanish scholar Antonio Agustín on his *De*

legibus et senatus consultis (On Roman laws and decrees) of 1583.[82] Orsini bequeathed some of his Greek and Latin books to his executor Orazio Lancellotti,[83] who may have been a patron of El Greco.[84] Other residents of the Farnese Palace included Matteos Devaris, who translated into Greek the canons and decrees of the Council of Trent, an edition of which is recorded among El Greco's books, and Pedro Chacón, the Toledan employed to reform the Julian calendar and to bring out a new edition of the Septuagint, that is, the Greek version of the Hebrew Old Testament, in collaboration with Fulvio Orsini and others. Chacón spoke Greek fluently, was well versed in musical theory and was a mathematician.[85] In the Farnese Palace the presence is also recorded of Cardinal Granvelle, a leading patron and confidant of Philip II. He relates that on one occasion, when he was in the company of Orsini and Chacón in the loggia of the palace, they observed a goldfinch's nest and discussed at length this phenomenon of nature.[86]

In Toledo an early patron of El Greco was Diego de Castilla, the dean of Toledo Cathedral, a supporter of Saint Teresa[87] and an outspoken defender of Bartolomé Carranza, the former archbishop of Toledo, who had been imprisoned, ostensibly for Erasmian tendencies.[88] Both Diego de Castilla and his illegitimate son, Luis de Castilla, the dean of Cuenca Cathedral, were El Greco's close friends.[89] Diego de Castilla had been the executor of the will of Juan de Vergara,[90] who was a distinguished classical scholar and who had been lauded by Erasmus, with whom he had corresponded.[91] Luis de Castilla was a scholar of repute and a bibliophile; he had met Chacón in Rome,[92] and inherited some of his manuscripts.[93] Subsequently he came into the possession of the corpus of letters written by Erasmus to Vergara, bequeathed to him by Alvar Gómez de Castro,[94] who held the chair of Rhetoric and Greek at the University of Toledo from 1549 until his death in 1580.[95] Gómez de Castro had acclaimed the fame of El Greco in a letter written to Cardinal Quiroga, Archbishop of Toledo, and had composed the inscription in the church of Santo Tomé about the miraculous burial of the Count of Orgaz above which, some years later, El Greco's painting would be hung.[96] Gómez de Castro was also an admirer of Michelangelo's spiritual mentor, Vittoria Colonna, and an intimate friend of the Castillas and of Antonio de Covarrubias, whose portrait El Greco painted (cat. 77).[97] Antonio had been appointed rector of the University of Toledo. He was a Hellenist of distinction: the great scholar Justus Lipsius acclaimed him as '*Oh gran luminaria de Espana*',[98] and El Greco himself praised his 'eloquence and Ciceronian elegance and perfect knowledge of Greek'.[99] Although there is no trace of Covarrubias's commentary on the eight books of Aristotle's *Politics*, some of the Greek codices which he possessed do survive.[100] To El Greco he bequeathed his extensively annotated copy of the works of Xenophon.[101]

Others associated with El Greco included the poet and court preacher Fray Hortensio Paravicino (cat. 81),[102] Jerónimo de Cevallos, jurist and patron of the Discalced Franciscan convent in Toledo (cat. 83),[103] and Cardinal Archbishop Gaspar de Quiroga, primate of Spain.[104] His approval was required for the painting of *The Burial of the Count of Orgaz*.[105] Quiroga actively promoted the reform of the Church, and, significantly, in 1584 authorised the publication of an *Index Librorum Expurgatorum* (Index of expurgated books), which was essentially a salvage operation of the works of Erasmus.[106] His sympathy with scholars is shown not only by his protection of those accused of Judaism[107] but also by his assistance to the eminent classical scholar Andrés Schott,[108] who succeeded Gómez de Castro as the professor of Rhetoric and Greek at the University of Toledo. His chair was next occupied by Pedro Pantino,[109] and just as Schott received support from Quiroga, Pantino received support from García de Loaisa.[110] This Toledan canon was involved in the contractual negotiations over El Greco's *Disrobing of Christ* (fig. 15; see cat. 21), he was the owner of a version of El Greco's *Boy blowing on an Ember* (see cat. 63) and he was later to succeed Quiroga as primate of Spain. His library contained the most important collection of Greek codices in Spain.[111] It is interesting to note that, in Spain, two contemporary copyists of Greek manuscripts – Antonio Calosinás and Nicolás de la Torre – hailed from Crete.[112]

El Greco was also acquainted with the historian Pedro Salazar de Mendoza, who was administrator of the Tavera Hospital, for which El Greco devised and partly executed the altarpieces for the church (see cat. 60); the poet and lawyer Dr Gregorio Angulo;[113] the erudite Dr Rodrigo de la Fuente;[114] and the Augustinian Diego de Zúñiga or Stunica, who wrote a

treatise on dialectic, rhetoric, physics and metaphysics (Toledo 1597).[115] In addition, the learned Pedro Laso de la Vega, Conde de los Arcos, commissioned several major works from El Greco;[116] he provided surety when El Greco was commissioned to paint the high altarpiece for the Augustinian Colegio de Doña María de Aragón (see cat. 40–2) and with his wife, Mariana de Mendoza, the elder daughter of the Conde de Orgaz, commissioned El Greco to paint his novel, heraldic plan of Camaldolensian Hermitages (cat. 44).[117]

During considerable periods of his sojourn in Toledo (1585–90 and 1604–10), El Greco rented apartments in the Villena palace, which belonged to the Pacheco family. Some members of that family played an active role in the spiritual reform movements, for example, the contemporary Marquesa was an enthusiastic supporter of Saint Teresa and acquainted with Saint John of the Cross. [118] These grandees certainly admired the work of El Greco because in their palace at Escalona were recorded pictures of *Saint Mary Magdalen in Penitence*, *Saints John the Baptist* and *John the Evangelist*, and one which included two Franciscan saints, presumably Saint Francis and Brother Leo (see cat. 46).[119] Again, Martín Ramírez, who commissioned El Greco to decorate the Capilla de San José (see cat. 38, 39) was called 'mi Martinico' by Saint Teresa.[120] An illustrious collector and, possibly, patron of the art of El Greco was Saint John of Ribera, Archbishop and Viceroy of Valencia. According to an inventory of 1611, there were four pictures in his collection that are now accepted as the work of El Greco.[121]

A telling reminder of El Greco's association with men of learning is the occasion when, on his death-bed, he signed a power of attorney enabling his son to make his will.[122] Two of the witnesses were Greek compatriots, Costantino Focas (or Sofías), professor of Greek in Madrid, and Dr Diógenes Parramonlio (or Paranomaris), later to occupy the prestigious chair of Greek at Salamanca.[123] Even where El Greco did not find favour, his art and learning were recognised: Fray José de Sigüenza, the librarian of the monastery of El Escorial, for which El Greco had painted his rejected altarpiece of *The Martyrdom of Saint Maurice* (fig. 16), relates that the picture 'pleases few, although they say that there is much artistry in it and that its author knows a lot. . .'.[124]

El Greco the Painter Philosopher

El Greco's interests in theology, liturgy and hagiography, combined with philosophy, history and literature, are reflected by the inventory of his library. He owned in Greek the Old and New Testaments, the *Canons and Decrees of the Council of Trent*, the Early Christian *Apostolic Constitutions*, as well as the works of Saint Justin Martyr, Saints Basil and Chrystostom, and Pseudo-Dionysius the Areopagite.[125] Among the books on philosophy there figured two copies, in Greek of Aristotle's *Politics* and one of his *Physics*, and a commentary on Aristotle's *On the Soul* by the sixth-century Christian John Philoponus. Although no works by Plato or the Neoplatonists are recorded in the inventory,[126] there are books listed which reflect the profound influence of Platonism.[127]

These books must have deepened El Greco's understanding of both Aristotelianism and Platonism, and of their relevance to Christian thought. The contents of his library and his association with men who ardently supported the reform of the Catholic Church, and who were profoundly interested in the philosophy, literature and history of the classical world, presupposes that El Greco had the intellectual capacity to comprehend their ideas and that he shared at least some of their enthusiasms.

The treatises on painting, sculpture and architecture to which Pacheco refers are lost,[128] but further important evidence has been discovered which vividly conveys El Greco's ideas, at least at one particular period of his development. This is the annotations on his copies of Vasari's *Lives of the Most Eminent Painters, Sculptors and Architects* (Florence 1568)[129] and Daniele Barbaro's edition of Vitruvius' *Ten Books on Architecture* (Venice 1556).[130] It becomes clear that El Greco held trenchant opinions about style and the nature of art and architecture. He lauded the Venetians for their skill as colourists and scorned the Florentines for upholding the primacy of draughtsmanship. Vasari, in particular, was the butt of vitriolic comments.

One must remember that El Greco's remarks relate to the statements of the author (or editor), and are not necessarily a complete exposition of his ideas. There is no reference, for example, to his attitude towards religion or religious imagery.[131] It is also not known when these annotations were made. El Greco's copy of Vasari's *Lives* had previously been owned and

annotated by a contemporary Italian painter, Federico Zuccaro (1540/41–1609).[132] El Greco may have obtained it either in Rome or in Toledo: Federico was working in Rome in 1570, the year of El Greco's arrival in the eternal city, then departed for France and the Netherlands in 1574. El Greco and Federico had a common supporter in the minaturist Giulio Clovio, who had recommended both of them, on different occasions, to Cardinal Alessandro Farnese.[133] Furthermore, since the pose of Christ in El Greco's *Trinity* (1577–79; fig. 14) is closely related to that in earlier representations of *The Dead Christ with Angels* by Federico and his elder brother Taddeo, some form of communication between El Greco and Federico in Italy seems likely.[134] Alternatively, El Greco may have come into possession of the book in Toledo, since Federico, who was engaged in the decoration of the monastery of El Escorial from December 1585 to December 1588, visited the former imperial city in 1586.[135] In any case, since El Greco wrote his annotations on both books in a mixture of Italian and Castilian, it is evident that they were done in Spain. From the macaronic nature of their language, as well as from internal evidence, it would certainly appear that they were written before he had fully developed his true 'Spanish' style.[136]

The foundation of El Greco's artistic theory was the premise that painting is a liberal art and not a mechanical craft. It reflected the ethos of the 'Renaissance' artist, encapsulated in Alberti's dictum that the painter should 'be learned in all the liberal arts',[137] recalling Vitruvius' prescription that the architect should be 'instructed in geometry, know much history, have followed the philosophers with attention, understand music, have some knowledge of medicine, know the opinions of the jurists, and be acquainted with astronomy and the theory of the heavens'.[138] It is on this very passage that El Greco comments approvingly:

I find that of everything that Vitruvius has written, the way of seeing outside the limits of architecture is the one that reveals the real truth and even if he had not written anything, this understanding is what illuminates more.[139]

The liberal artist is regarded as one who is engaged in intellectual problems.[140] The solving of such difficulties reveals the inventive capacity and intellectual facility of the artist.

Vitruvius had written: 'Invention . . . is the solving of intricate problems and the discovery of new principles by means of brilliancy and versatility.'[141] To this can be related the terms *difficoltà* and *facilità* prevalent in Italian sixteenth-century theoretical treatises.[142] El Greco wrote: 'The art that presents us with more difficulties is the most agreeable and therefore the most intellectual',[143] and 'Eminent men are those who, in any art form, make difficulties appear easy.'[144]

But the solution of such problems was only a means to an end. The artist's objective was, ideally, to reveal universal or first principles, that is, the concepts that underlie and unite forms, as opposed to the specific or particular. El Greco affirms this aim:

Painting is the only art that can judge everything: form, colour. Its aim is the invention of everything. In sum, painting has a position of prudence . . . because painting is so universal it becomes speculative, it never lacks the scope of speculation, because there is always something to discover, even in mediocrity and obscurity one can appreciate it and can imitate it.[145]

In seeking universals in the God-given world, El Greco, like all liberal artists, imitated Nature, since Nature generated the universal principles inherent in the natural world. The phrase 'art imitates Nature' is derived from Aristotle's *Physics*,[146] in which Aristotle defined Nature not as the outward world of created things, but as the creative force, the productive principle of the universe.[147] The process of artistic creation was analogous. The sculptor, for example, imitates Nature because his artistic conception (form) is applied to bronze (matter) to create a bronze sculpture. Moreover, what is imperfect or incomplete in the natural world can be corrected or perfected in art through the intellect. Accordingly, art imitates the creative capacity of Nature to realise the typical or universal from among the particulars of natural phenomena, and this is not the same as the literal reproduction of the natural world. It is not synonymous with modern notions of 'naturalistic' art.

According to Aristotle, knowledge of forms could be gained through the observation and selection of natural phenomena, in which form and matter were integral. In contrast, as El Greco's art progressed, he painted pictures in which all the subject,

except perhaps for a few terrestrial stepping-stones in the foreground, is irradiated and de-materialised. Such pictorial imagery seems now to reflect a Platonic or Neoplatonic understanding of the world and its relationship to God.[148] Plato had posited the view that there were two worlds, one of the senses that was in a state of flux, subject to growth and decay, and another of incorporeal forms. Plato had supposed that knowledge of the latter world could only be glimpsed by the philosopher during life, and was perfectly accessible only before birth or after death, when the soul is released from the body and returns to its origin – the incorporeal world of forms.

In spite of Plato's opinion that poetry (and painting, by implication) was once-removed from the natural world, some upholders of the Platonic tradition, such as Cicero, did maintain that art could serve to recollect the ideal forms. In defining the ideal orator, he wrote:

> This ideal cannot be perceived by the eye or ear, nor by any of the senses, but we can nevertheless grasp it by the mind and the imagination. For example, in the case of the statues of Phidias . . . [he] did not look at any person whom he was using as a model, but in his own mind there dwelt a surpassing vision of beauty. . . . These patterns of things are called . . . ideas by Plato.[149]

Apparently for the first time, an artist's vision is explicitly linked with Plato's forms.

In the third century AD Plotinus, a Neoplatonist, drew upon this tradition in his exposition on pagan theology (*The Enneads*). He returned to Plato's dualism, but claimed that the soul could achieve a glimpse of the world of forms not only by reason but by going outside itself in a state of extasis, which was a vision of the true reality. Significantly, he also argued, contrary to Plato:

> Still the arts are not to be slighted on the ground that they create by imitation of natural objects . . . we must recognise that they [artists] give no bare reproduction of the thing seen but go back to the Reason-Principles from which nature itself derives . . . they are holders of beauty and add where nature is lacking. Thus Phidias wrought the Zeus [of Olympia] upon no model among things of sense but by

apprehending what form Zeus must take if he chose to become manifest to sight.[150]

Yet Plotinus also claimed that, initially, the soul is able to use the truth of the senses to recollect the truth of the forms. Nevertheless, to attain that inner vision, that knowledge of universals, he exclaims 'cut away everything' and 'act as does the creator of a statue . . . cut away all that is excessive'.[151] Thus the function of the artist is perceived as abstracting matter to reveal universals in order to raise the mind to the archetype.

Developing the ideas of Plotinus in a Christian context, Pseudo-Dionysius the Areopagite (believed to be contemporary with Saint Paul, but actually an early sixth-century writer) evolved in still more detail the means of ascent towards the forms. He elaborated a hierarchical ascent from the natural world towards a transcendental vision of God. Again in opposition to Plato, he recognised no dichotomy between the natural world and the divine, using art as a metaphor to explain how

> . . . we attain to true vision and knowledge . . . by the abstraction of the essence of all things; even as those who, carving a statue out of marble, abstract or remove all the surrounding material that hinders the vision which the marble conceals and, by that abstraction, bring to light the hidden beauty.[152]

Dionysius's Neoplatonism provided a framework for all those seeking the reality of the spirit behind the world of appearances, in particular for mystics in their elaboration of contemplative prayer. As we have seen, El Greco had works by Dionysius in his library, and they would have reinforced the attitude towards images of which he would certainly have been aware by virtue of his training in post-Byzantine painting.[153] Not in the same style, but analogously, using abstraction and avoiding literal illusionism, the artist diverts the mind to the spiritual essence, the form. El Greco makes clear that his heavenly figures are not members of the material world.

Specifically, El Greco seized upon the metaphor of light, which is recurrent in Pseudo-Dionysius and re-appears in the writings of the Spanish mystics. The purity and brightness of light that are found in his later paintings (see above, pp. 55–8)

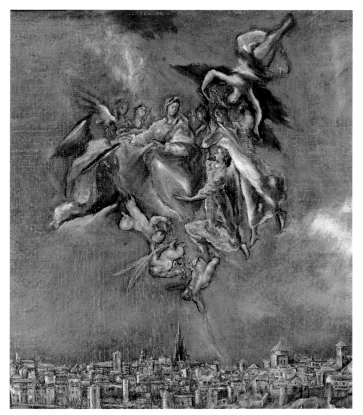

Fig. 23 Detail of fig. 9

are intended to symbolise the emanation and reflection of divine light which, spiritually, will illuminate the viewer. A significant clue to El Greco's conscious use of light in a metaphorical, spiritual sense is provided by the inscription on his *View and Plan of Toledo* (fig. 9). In the sky, the Virgin and angels are seen holding the chasuble which will be awarded to Saint Ildefonso for his devotion (fig. 23). The saint is in the Cathedral of Toledo, barely discernible on the horizon. The supernatural size and scintillating appearance of the Virgin and angels are explained in the inscription on the painting:

> Also in the story of Our Lady who gives the chasuble to Saint Ildefonso, for their adornment and in order to make the figures large I have availed myself of the fact that they are celestial bodies as we can see in the case of lights which, seen from afar, appear large however small they may be.

The statement concerning 'lights' refers to the phenomenon that at night and at a distance it is not possible to distinguish between the source of light and its radiance – an optical fact observed by the medieval naturalist John Pecham:

> [Firelight] appears larger from afar, since the distance makes it impossible to distinguish between the flame and the intense light near the flame, and so they are perceived by the eye undividedly as though a single great light.[154]

Pecham also 'called attention to the parallel between the radiation of visible light and divine illumination of the intellect'.[155]

El Greco's incandescent light is complemented by his pure, luminous, vibrant colours, unlike those of any other artist, and diametrically opposed to the different colours with which Titian modelled form in his mature work. These otherworldly colours recall the gem-like glitter of the Heavenly Jerusalem described by Saint John (Revelation 21). In the same tenor, El Greco's attenuated, flame-like figures spiral upwards as if to another realm.

The fact that metaphysical light and abstracted form are intrinsic to *The Adoration of the Shepherds* (cat. 62) which El Greco painted for his sepulchre[156] reveals unequivocally that the mystical imagery of his late style was personal to him and Neoplatonic in nature. Yet, despite his profound interest in spirituality,[157] El Greco's use of light and of abstracted form does not imply that he was himself a mystic, or was representing his own mystic experience. His paintings are representations of biblical and hagiographical subjects,[158] and it was their subject-matter that the faithful meditated upon in order to draw closer to God. It was by means of the mystical style in which he presented this imagery that El Greco excited the minds of the faithful to the contemplation of 'those most sublime things'.[159] Within the narrow, vertical format of an altarpiece frame, the ritualistic imagery evokes a mystical ascent – like the rungs of Jacob's Ladder – from the corporeal world to the celestial.

> For now we see through a glass darkly; but then face to face.
> Paul, I Corinthians 13: 12

To El Greco and the spiritual reformers life was a pilgrimage; its quest was the City of God.

OVERLEAF Detail of cat. 33

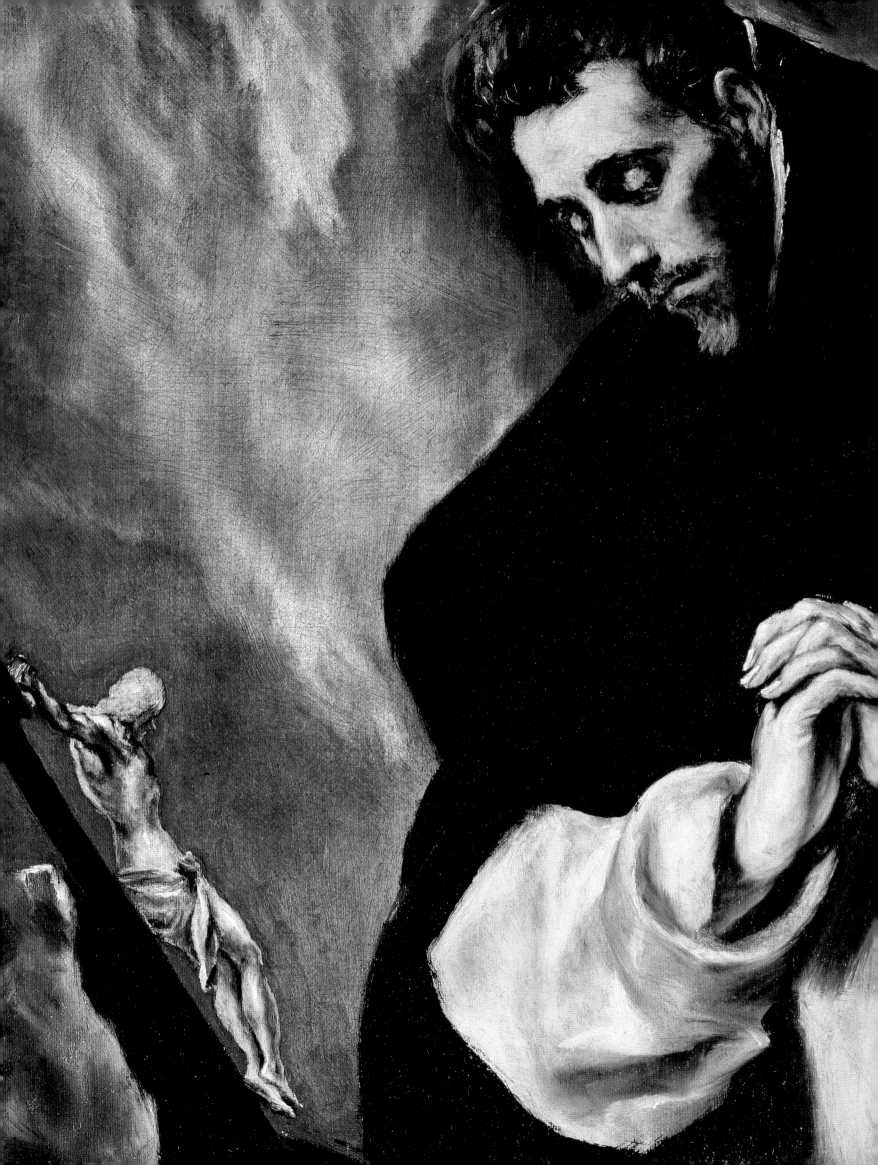

Catalogue

1 The Dormition of the Virgin, before 1567

Tempera and gold on panel, 61.4 × 45 cm

Signed on the base of the central candelabrum
ΔΟΜΗΝΙΚΟΣ ΘΕΟΤΟΚΌΠΟΥΛΟC Ὁ ΔΕΤΞΑC
(Domenikos Theotokopoulos realised); in the upper section
Ἡ ΚΟΊΜΗCΙC ΤΗC ΘΕΟ [ΤΌΚ]ΟΥ (The Dormition of the Virgin)

Holy Cathedral of the Dormition of the Virgin, Ermoupolis, Syros

The discovery by Mastorópoulos in 1983 of El Greco's signature on this icon constituted a significant advance in the understanding of the artist's early career and formation. In both its iconography and technique the painting demonstrates the artist's origins and training in the traditions of post-Byzantine painting, while at the same time testifying to his receptiveness to Italian visual sources. It has become the touchstone for the attribution of other works to El Greco's Cretan years. The icon, which retains its function as a cult object in the Church of the Dormition of the Virgin on the island of Syros in the Aegean Sea south-east of Athens, conforms closely to the established pattern for this subject (fig. 24), which was very common in the Orthodox Church in which El Greco may have been raised. There are also, however, interesting interpolations, some of which are probably the artist's own.

The Virgin is shown recumbent on a bier with the Apostles gathered around for her exequies. Saint Peter, on the left, holds a thurible to incense her body and there are church elders in priestly vestments bearing liturgical books with funerary orations. There are also other devout men and women present. Christ appears in the centre of the composition leaning towards the Virgin and receiving her soul in the form of an infant wrapped in swaddling bands. The natural character of his pose and gesture differs from that of traditional representations, in which he is shown standing upright. Above, the Virgin is being assumed into Heaven, surrounded by angels. She wears a crown on her head and rests her feet on a crescent moon, imagery alluding to the Woman of the Apocalypse (Revelation 12). To her left is the Apostle Thomas, who was absent at her funeral; he kneels in homage and receives her girdle as a token of her bodily assumption into Heaven. The Apostles are seen again on banks of clouds to left and right.

The dove of the Holy Spirit, which is shown in naturalistic foreshortening and is the source of the light that fills the golden mandorla in the centre of the scene, is not part of the established iconography of the Dormition of the Virgin. The elaborate poses of some of the angels in the upper register of the icon suggest that El Greco was following Italian Mannerist prototypes, and the classicising candelabrum in the foreground adorned with nude female figures is perhaps based on an Italian print. By including his signature on this object El Greco was drawing attention to his creative talent: icons are very rarely signed, and the particular form of wording that he employed here – which reappears on the 1577 *Assumption of the Virgin* (fig. 12, p. 49)– seems to contain intentional antiquarian allusions, since according to Lucian (two volumes of whose works El Greco owned in Toledo), Phidias, the ancient Greek sculptor, signed his works in this way. These various character-istics seem to testify to an artist who is ambitious and has humanistic aspirations. GF

Fig. 24 Circle of Andreas Ritzos
The Dormition of the Virgin, last quarter of the fifteenth century
Tempera on panel
85 × 54.5 cm
Hellenic Institute of Byzantine and Post-Byzantine Studies, Venice

PROVENANCE

Possibly from the Monastery of the Holy Mountain of the Dormition of the Virgin on the island of Psará in the Aegean, and perhaps brought to Syros during the Greek Revolution in 1824

ESSENTIAL BIBLIOGRAPHY

Mastorópoulos 1983; London 1987, pp. 190–1; Chatzidakis 1990, pp. 142–5; Iraklion 1990, no. 1 (entry by M. Acheimastou-Potamianou); Constantoudaki-Kitromilidis in Madrid-Rome-Athens 1999–2000, pp. 89–90; no. 1 (entry by G. Mastorópoulos)

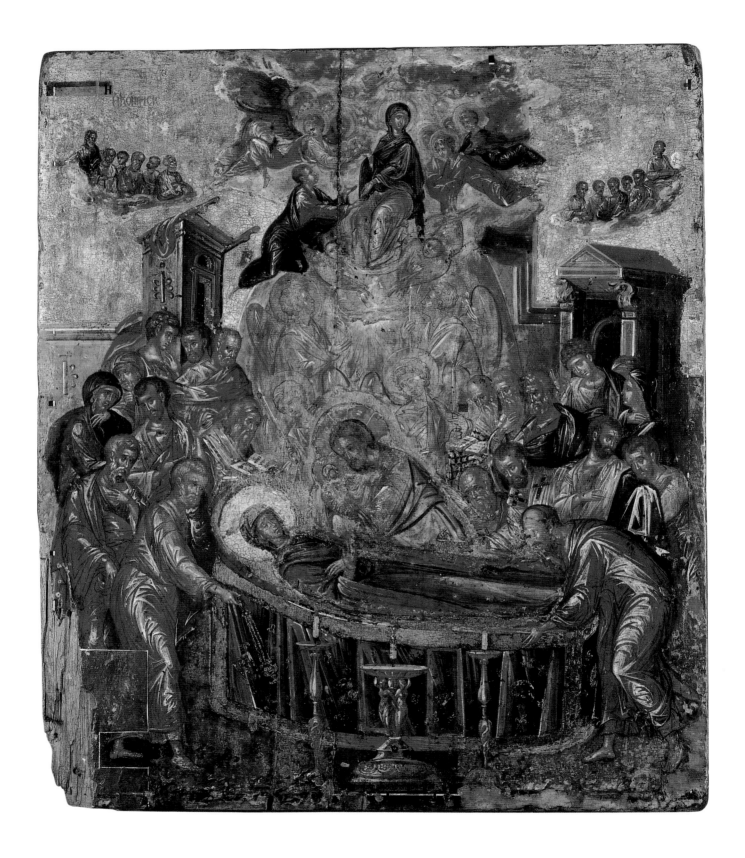

2 Saint Luke painting the Virgin and Child, before 1567

Tempera and gold on canvas attached to panel, 41.6 × 33 cm

Signed in the area of the stool under the easel
ΧΕΙΡ ΔΟΜΗΝΙΚΟΥ (hand of Domenikos)

Benaki Museum, Athens, inv. 11296

PROVENANCE

Acquired by the diplomat and writer
Dimitrios Sicilianos, probably in the
early 1920s, either in Athens or in
Iraklion; donated by him to the
Benaki Museum in 1956

ESSENTIAL BIBLIOGRAPHY

Iraklion 1990, no. 2 (entry by
M. Constantoudaki-Kitromilidis);
Constantoudaki-Kitromilidis 1995,
pp. 103–6; Cormack 1997, pp. 43, 46, 48,
57, 220–1; Madrid-Rome-Athens
1999–2000, no. 2 (entry by M.
Constantoudaki-Kitromilidis);
Vienna 2001, no. 1 (entry by M.
Constantoudaki-Kitromilidis);
Constantoudaki-Kitromilidis 2002

Together with the icon of *The Dormition* at Syros
(cat. 1), this is one of El Greco's earliest works, painted
while he was a master in Crete. It has suffered serious
losses but much of the paint surface remains intact
and legible. It shows the Evangelist Saint Luke, tradi-
tionally both a physician and a painter, in the act of
painting the icon of *The Virgin Hodigitria*, patron and
protector of Constantinople. The icon shows the
Virgin and Child against a gold background bearing
the inscriptions in red *MP..* (Mother of God) and
IC XC (Jesus Christ). It rests on a three-legged easel;
underneath it is a stool with a box of pigments,
a small circular container and a tablet. The saint
himself sits on a elegant chair holding a shell or
small palette in his left hand and in his right a fine
brush, with which he applies the last touches to the
icon. An angel descends from above with a laurel
wreath to crown the painter and a white scroll
inscribed with the words *.[EI]AN EIKO[N]A Y.*
(He created the divine image).

The earliest surviving Byzantine depictions of
Saint Luke as a painter date from the eleventh
century, although the imagery is older. It appears
to have been adopted after the period of Iconoclasm
(725–842) in order to invest the practice of icon-
making with greater authority. Several images of
the Virgin and Child are attributed to Saint Luke,
including the *Hodigitria*: his authorship guaranteed
their antiquity and orthodoxy. Saint Luke was
adopted as the patron saint of painters; during the
course of the fifteenth and sixteenth centuries
painters' guilds and academies of art dedicated to
the saint emerged throughout Europe.

El Greco kept strictly to the Byzantine canon in
the representation of the icon on the easel, but he
allowed himself greater freedom in the rest of the
depiction. *Saint Luke painting the Virgin and Child* is in
fact a transitional work that demonstrates how at
this stage in his career the artist was seeking to graft
Italianate Renaissance elements on to Byzantine
compositions. This attitude was not unique to
El Greco but is characteristic of several sixteenth-
century Cretan artists, including Theophanis (active
1520s, died 1559), Michael Damaskinos (1530/5–1592/3)
and Georgios Klontzas (1535/40–1608). The angel,
which is an iconographic interpolation of El Greco's,
is based on a victory figure crowning Tuccia in a print
by Giovanni Battista d'Angeli del Moro (1515–1573)
after a design by Bernardino Campi (1522–1519),
and Saint Luke, shown in a more natural pose than
in earlier, Byzantine versions of the subject, is an
amalgam of figures from two printed sources – an
Apostle in Marcantonio Raimondi's *Last Supper* (of
about 1515) and a figure of Minerva in a print by
Giulio Bonasone published in Achille Bocchi's
Symbolicarum quaestionum libri quinque (Bologna 1555).
The latter probably recommended itself to El Greco
as a model for Saint Luke because it shows Minerva
painting a portrait of King Francis I of France.

The artist's grasp of geometric perspective is
no more than rudimentary. He has imperfectly
understood Renaissance principles of spatial
recession, and has represented objects in the same
plane, notably the easel and the icon, in different
perspectives. El Greco's increasing competence in
the handling of perspective can be observed in the
series of *The Purification of the Temple* (see cat. 6–9).
He learnt Italianate perspective, however, only to
reject it at a later date. GF

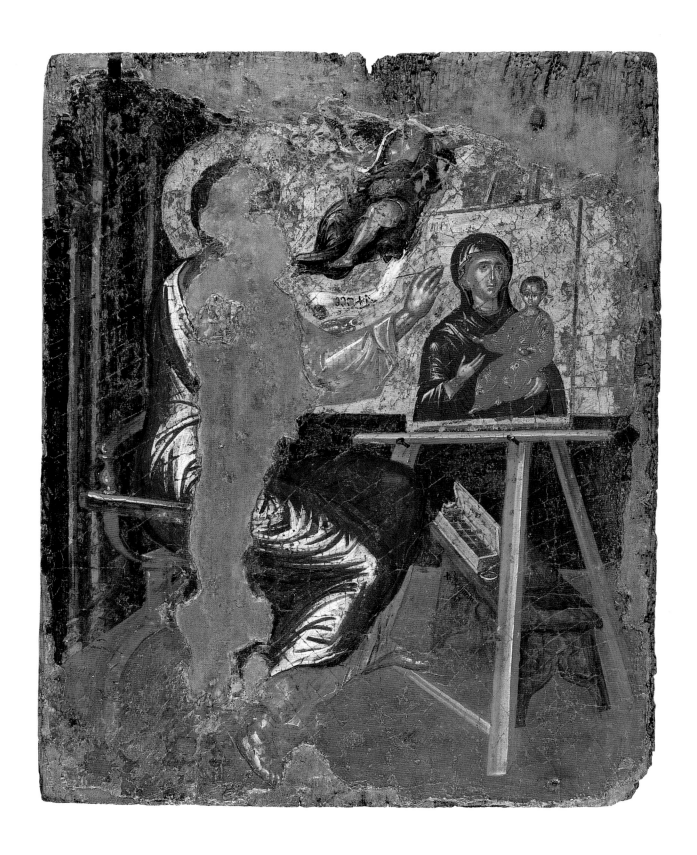

3 The Entombment of Christ, late 1560s

Oil (and tempera) on panel, 51.5 × 43 cm
National Gallery of Greece
Alexandros Soutzos Museum, Athens, inv. 9979

The Entombment of Christ, recently acquired by the National Gallery in Athens, is one of the most attractive pictures of El Greco's Venetian period. In spite of the pronounced curve of the wooden panel, it is in a remarkably good physical state.

According to the Gospel of Matthew, Jesus was buried in a tomb that Joseph of Arimathea, a secret disciple of Jesus, had had hewn out of the rock for himself (27: 59–60). He is perhaps the man on the left of the composition who looks on as Christ is lowered into the sepulchre. In his Gospel, Saint John – the young man in an orange robe on the right – says that Nicodemus, a member of the Jewish Sanhedrin, was also present at the burial of Christ (19: 39), but it is difficult to identify him as one of the two barefooted men who bear the body. Behind the tomb, the Virgin Mary swoons between the other two Maries. The crown of thorns and the nails of the crucifixion rest on the ground, as though waiting to be picked up and treasured as precious relics.

In designing the composition, El Greco drew heavily on Italian prints, as Milicua has demonstrated. The setting, with hillock and cavern on the left, and the group of Christ and the two men who carry his body are taken directly from a print of *The Entombment* by Battista Franco. The three Maries are quoted from a print of *The Entombment* by Parmigianino, an artist whom El Greco admired, as he himself stated in his annotations to Vitruvius' *Ten Books of Architecture*, for the grace and elegance of his figures. El Greco's barely disguised borrowings from Italian prints are a notable feature of his Cretan- and Italian-period

pictures and reflect his formation as a painter in the post-Byzantine tradition accustomed to working from established compositional patterns. They may also be interpreted as a sign that at this stage he had only limited confidence in his own powers of invention. The synthesis of the particular sources here employed has led El Greco into some compositional difficulties: the three Maries are too close to the figure of Christ to fit into the space behind the tomb, and in the central figure group there are problems of relative scale. These weaknesses arise from the attempt to elaborate a multi-figured composition in several planes on a scale larger than El Greco was used to. That said, *The Entombment of Christ* displays considerable sophistication in the handling of chiaroscuro, and the freedom of the brushstroke demonstrates how quickly he was adapting to a stylistic idiom that had very little in common with the post-Byzantine manner in which he was trained; furthermore, it is a painting with an impressive emotional range that effectively conveys the sense of tragic loss associated with the subject.

The underdrawing, executed in a dark liquid pigment with a fine brush, is apparent in several areas, notably in the orange cloak of Saint John and along the edge of the umber robe with a pinkish lining worn by the figure with his back to us. El Greco employs a rich and striking palette of intense hues, applied thinly in transparent layers in some areas, for example the small mound in the foreground, and more thickly in others, such as the highlit edge of the cavern above the Virgin's head. GF

PROVENANCE

Private collection in France in the 19th century, from which it passed to a Mexican collection; on the reverse of the painting is a seal with a crown and the initials *LF* (unidentified); sold at auction in Madrid, Edmund Peel & Asociados, 19 May 1992, lot 4; Christie's, New York, 11 January 1995, lot 59; with Stanley Moss, Riverdale-on-Hudson, New York; acquired by the National Gallery of Greece, 2000

ESSENTIAL BIBLIOGRAPHY

Athens 1995, no. 41 (entry by J. Milicua); Madrid-Rome-Athens 1999–2000, no. 10 (entry by J. Álvarez Lopera)

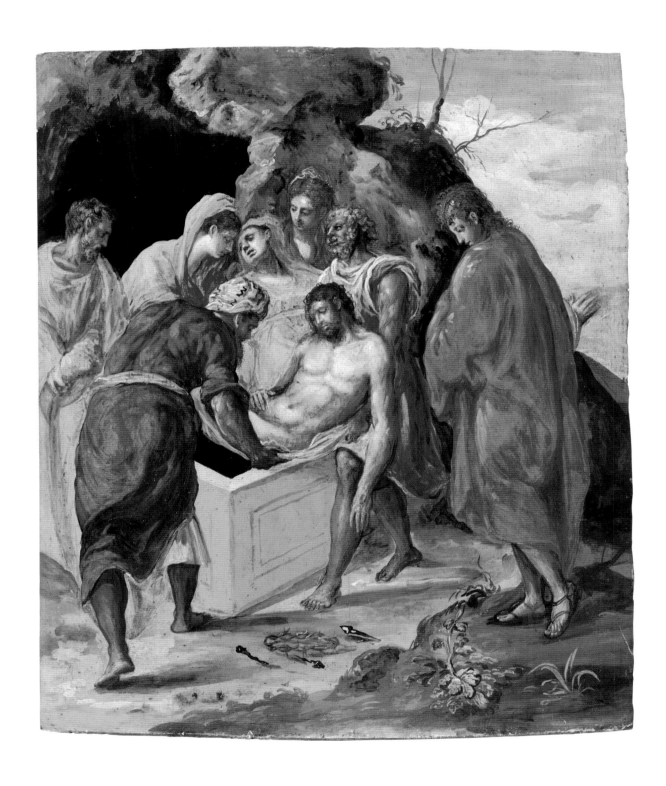

4, 5 Christ Healing the Blind

Christ's miracles were widely illustrated in early Christian and medieval art, and they enjoyed renewed popularity in the sixteenth century (see, for example, Goltzius's engraving of *Christ as Healer*, dated 1578).[1] The miracle of Christ healing the blind was associated with the prophecy of Isaiah (35: 5): 'Then the eyes of the blind shall be opened, and the ears of the deaf shall be unstopped', which, according to Isidore of Seville (*c.* 560–636) signified: 'We are called from the darkness into the light'. The miracle thus denoted spiritual enlightenment or revelation. The tendency during the late sixteenth century to interpret Christ's miracles in this spiritual vein was widespread,[2] though Puppi has ingeniously suggested that when El Greco first treated the theme he intended an allusion to his own conversion from the Orthodox to the Catholic faith.[3]

All four Gospels include an account of the miracle: Matthew 9: 27–34 and 20: 29–34, Mark 8: 22–5, Luke 18: 35–43 and John 9: 1–22. Each differs from the other in details: in both of Matthew's accounts there are two rather than one blind man; Mark situates the miracle in Bethsaida, Luke outside Jericho, while in John it occurs in Jerusalem, near the Temple. El Greco depicted the theme three times: on a panel now in the Gemäldegalerie, Dresden (fig. 25), on a small canvas in the Galleria Nazionale, Parma (cat. 5) and on a larger canvas in the Metropolitan Museum (cat. 4). In each he introduced differences, conflating aspects of the Gospel accounts. However, they all employ the same basic compositional formula of two groups of figures placed in the right and left foreground with a distant perspective of a city. There can be no question that, as in his depictions of *The Purification of the Temple* (cat. 6–9), El Greco seized an opportunity to demonstrate his skills in painting an *istoria* – a narrative painting of the kind first privileged by Leon Battista Alberti in his treatise on painting in 1435–6. One might indeed consider El Greco's depictions of *The Purification* and of *Christ healing the Blind* as contrasting sets – not only because of their related themes of religious purification and revelation, but because of the formal problems involved. One is set in an interior, the other in the open air; one is centred on a tightly packed group of figures being physically assaulted,

the other conveys through demonstrative gestures the responses of one group to the other. Did El Greco conceive them as pendants? The Washington *Purification* (cat. 6) and the Dresden *Christ healing the Blind* are both painted on panels of about the same size while the Minneapolis *Purification* (cat. 7) and the version of *Christ healing the Blind* in the Metropolitan (cat. 4) are on canvases of similar dimensions. Unfortunately, nothing is known about the early provenance of these pictures, and there is no record of their having once been together.

In conceiving the composition for *Christ healing the Blind* El Greco was inspired by Tintoretto, especially his large canvases of *Christ washing the Apostles' Feet* (versions in the Prado, Madrid and Newcastle-upon-Tyne) and *Christ and the Adulteress* (Gemäldegalerie, Dresden). From the first derives the bilateral placement of the figures and the distant urban view as well as the picturesque inclusion (in the Dresden version, fig. 25) of a dog in the centre foreground – like the water jug and sack, the dog must belong to the blind man. Tintoretto based his background city view on Sebastiano Serlio's celebrated design for a tragic stage set. El Greco's approach is freer, though he was certainly familiar with Serlio's architectural treatise, a copy of which is listed in the 1621 inventory of his library. From Tintoretto's *Christ and the Adulteress* derives the idea of two groups of figures, the one responding to the other, as well as the figure seen from the back at the right who strides into the space of the picture (this is a motif that both Tintoretto and El Greco knew from prints). The poses of some of the other figures have been shown to be taken from a variety of print sources, of which El Greco must have owned a large supply, using them very much like model-books (he would have begun amassing this material in Crete). There was nothing unusual in this. Indeed, it was part and parcel of Mannerist practice. Like Tintoretto, El Greco must have used prints to stimulate his imagination and develop his figural repertoire, to which end he also made clay models he could study from various points of view and under different lighting conditions. Marco Boschini records Tintoretto's practice of making wax figures, while Pacheco, when visiting El Greco in 1611, was shown a cupboard filled with clay figures.[4] Often

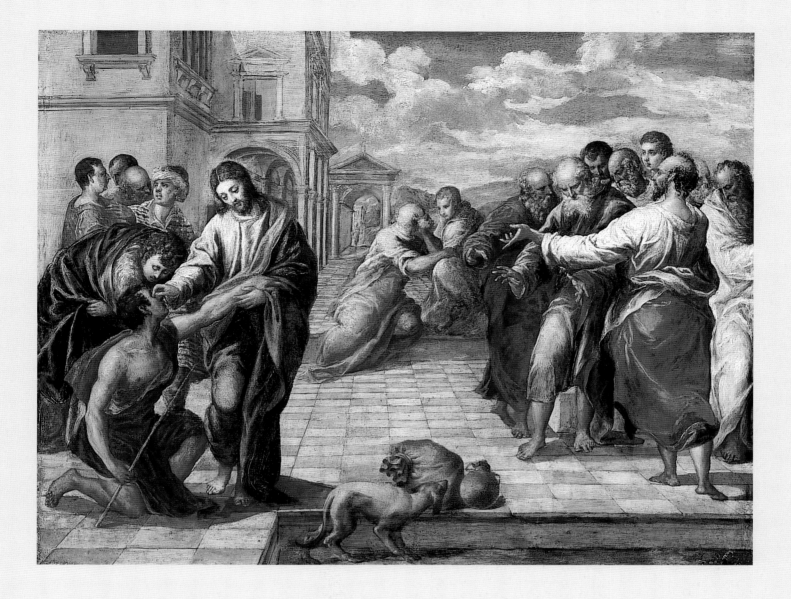

El Greco varied poses by merely reversing them, and it is thus not surprising that one of the two figures seated on the pavement in the middle ground of *Christ healing the Blind* is also found the other way round in *The Purification of the Temple* (the pose has been thought to derive from a figure in Cornelius Cort's engraving after Titian's *Gloria*).[5]

The *Christ healing the Blind* in Dresden was purchased in Venice in 1741 as the work of Leandro Bassano, and there is a presumption that it was painted there shortly before El Greco left for Rome in 1570. The Metropolitan canvas and the smaller version at Parma are later and adapt the Dresden composition to Roman standards. Although two copies of the Metropolitan canvas exist in Spain, the picture was certainly painted in Italy. In any event, he apparently never returned to the subject. Indeed,

the elaborate architectural setting bathed in sunlight with figures placed within a commensurable space became increasingly antithetical to his art, as, in Spain, he turned from the world of appearances to that of the imagination. His three depictions of Christ healing the blind exemplify the moment of his most intense engagement with Italian art. KC

1. The print, *Miracula Christi*, is from a series of allegorical sheets devoted to the life of Christ commissioned by Philips Galle of Antwerp: see Held in Hadjinicolaou 1999, p. 133. The prints after Perino del Vaga's *Christ healing the Blind* and Parmigianino's *Christ healing the Lepers* are particularly relevant to El Greco's paintings.
2. Held in Hadjinicolaou 1999, pp. 132–5.
3. Puppi in Madrid-Rome-Athens 1999–2000, p. 105.
4. See further in this catalogue, pp. 10, 52–3, 115, 176, 210, 236, 240.
5. Xydis 1964, p. 301.

4 **Christ healing the Blind**, about 1570?

Oil on canvas, 119.4 × 146.1 cm
The Metropolitan Museum of Art, New York
Gift of Mr and Mrs Charles Wrightsman, 1978, inv. 1978.416

NEW YORK ONLY

PROVENANCE

Martin H. Colnaghi, before 1876;
sold by William Rennie at Christie's,
London, 23 April 1888, (lot 88), as by
Tintoretto; to Eyles; the Bosanquet
family, Hengrave, Bury St Edmunds;
by whom sold at Christie's, London,
9 May 1958, (lot 14), as by Veronese;
Agnew's, London, by whom sold
in 1960 to Mr and Mrs Charles
Wrightsman as an early work by
El Greco; given to the Metropolitan
Museum in 1978

ESSENTIAL BIBLIOGRAPHY
Frankfurter 1960, pp. 36, 73; Wethey
1962, II, pp. 42–4, no. 63; Xydis 1964,
pp. 301, 303, 305f.; Fahy 1973, pp. 94–104;
Baetjer 1981, pp. 12–23; Vechnyak 1991,
pp. 177–82; Held in Hadjinicolaou 1999,
pp. 125–38; Vienna 2001, p. 134, no. 4
(entry by K. Schütz)

First recorded in 1888 as the work of Tintoretto and later ascribed to Veronese, this painting was only recognised as the work of El Greco in 1958: alone among his three versions of this subject it is not signed. It is the largest of the three, being more than twice the size of the painting in the Galleria Nazionale in Parma (cat. 5) and about the same size as *The Purification of the Temple* in Minneapolis (cat. 7), with which it must be more or less contemporary. It is also the most sketchy in execution and is, indeed, unfinished: note, in particular, the circular temple and the back row of heads at the left, two of which are no more than blocked in. The two seated figures in the middle ground were so thinly painted that the pavement is visible through them (while El Greco painted the pavement around the two principal figure groups, the secondary figures, including the two bust-length figures in the foreground, as well as parts of the architecture were painted over it).[1]

El Greco's interpretation of the miracle represents a synthesis of the three Gospel accounts of it. As Christ leaves the Temple (shown as a circular, colonnaded building), where he was threatened with stoning, he encounters two blind men (the Temple is mentioned in John; two blind men in Matthew rather than one in John). He restores their sight by touching their eyes. In the picture one is shown from the back, gesturing upwards in excitement, while the other kneels before Christ, who anoints his eye. To the right are the neighbours and Pharisees who, according to John, objected to Christ healing 'a man blind from his birth' on the Sabbath; the two bust-length figures in the foreground may be the parents of the blind man, summoned to confirm that their son had, indeed, been born blind (John 9: 18–23).[2] In effect, the picture transforms the biblical narrative into an exegesis of Christ's divine powers. In this it is very unlike earlier depictions or, indeed, such contemporary works as Livio Agresti's altarpiece of the same subject in Santo Spirito in Sassia, Rome.

By comparison to the version of the subject in the Gemäldgalerie, Dresden (fig. 25), the groups of figures are better articulated and the diminution of the figures in space is more accentuated. The figure of the gesturing blind man has been added, his pose evidently taken from an engraving by Giulio

Bonasone after a design by Perino del Vaga for *Saints John and Peter healing at the Golden Gate*, and a circular temple has been introduced (this detail may derive from Taddeo Zuccaro's fresco of *Saint Paul healing the Cripple* in San Marcello al Corso, Rome). The two bust-length figures in the foreground, who occupy a lower space, may reflect Francesco Salviati's fresco in the Oratory of San Giovanni Decollato in Venice (1538), though analogies for their poses have also been found in an engraving of *The Birth of the Virgin* from the school of Marcantonio Raimondi as well as in a print of *The Nativity* by Parmigianino. El Greco's interest in Salviati's work should not surprise us, as the Florentine artist had left a strong impression in Venice and was much admired by El Greco's friend and promoter in Rome, the Croatian miniaturist Giulio Clovio. In any event, this type of insertion was fairly common in Roman painting of the period.

Until recently there was a consensus of opinion that the Metropolitan canvas was the latest of the three treatments of the subject and possibly dated from El Greco's first years in Spain. The picture was certainly known there, as two Spanish copies of it exist. Moreover, the brilliant palette recalls that of *The Assumption of the Virgin* contracted in 1577 for the high altar of Santo Domingo in Toledo (fig. 12, p. 49; see cat. 17–20). However, in 1991 Vechnyak made a compelling case for dating the Metropolitan canvas between the Dresden and Parma pictures, and her arguments have been taken up by a number of scholars, notably Held and Schütz. Certainly, the Parma picture contains many more references to Roman pictorial and architectural traditions and also adopts a more subdued palette. Might we think of the Metropolitan canvas as El Greco's initial response to Rome – a response that was quickly superseded by a more intimate knowledge of Roman practice? That might explain why the picture was never brought to conclusion. In this case, the unfinished canvas might have been kept by the artist and taken to Spain, where the two copies were surely made. But there is another possibility, and that is that the absence of some of the most Roman features found in the Parma version denote a reaffirmation by El Greco of his sympathies for

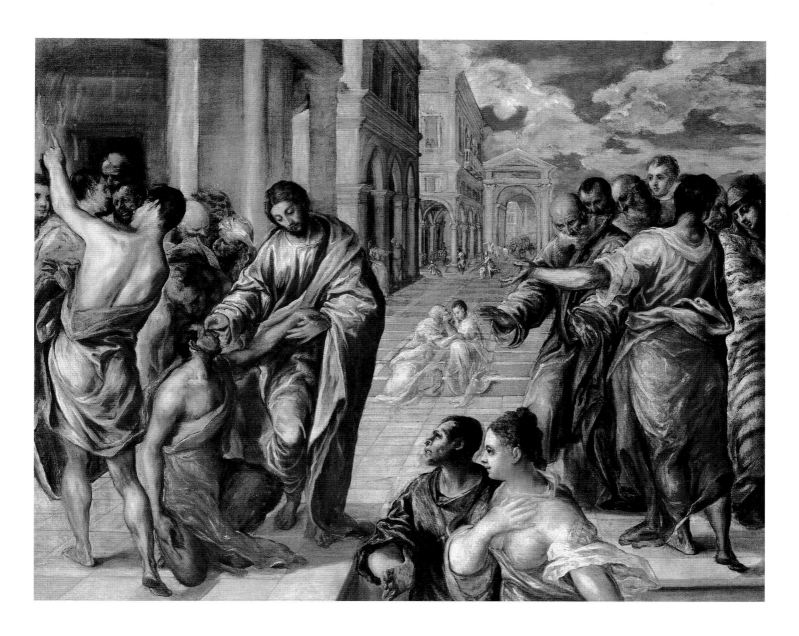

Venetian art and may reflect a return trip to Venice following an unsuccessful bid for patronage in Rome. Such a second Venetian trip, first proposed by Zottmann in 1906–7, has been repeatedly argued by Puppi.[3] There is no documentation either to support or to reject the idea. However, the contacts for his first major commissions in Toledo seem to have originated in the circle of Fulvio Orsini in Rome – not in Venice – and suggest El Greco's continued presence in the papal city. KC

1. In the Prado version of *Christ washing the Feet of the Apostles* Tintoretto painted in the pavement and then the figures: see Falomir Faus 2000, pp. 16–18.
2. Alternatively, Frankfurter (1960, p. 136) suggested that the bust-length male figure is the second blind man, while Wethey (1962, II, p. 42) supposed it was the deaf mute mentioned by Matthew. The figure at the extreme right, wrapped in a stripped robe, has sometimes been identified as the daughter of Jairus: in Matthew's account that story precedes the miracle of Christ healing the blind.
3. Puppi in Madrid-Rome-Athens 1999–2000, pp. 103–13, with previous bibliography.

5 Christl healing the Blind, about 1570–5

Oil on canvas, 50 × 61 cm

Signed on a step at lower left
ΔΟΜΗΝΙΚΟΣ ΘΕΟΤΟΚΟΠΟΥΛΟΣ ΚΡΗΣ ΕΠΟΙΕΙ
(Domenikos Theotokopoulos Cretan made)

Galleria Nazionale, Parma, inv. 201

NEW YORK ONLY

PROVENANCE

Recorded in the Farnese collection, Rome, in inventories of 1644 and 1653; transferred to the Farnese collections in Parma, where inventoried in 1662 and 1680; subsequently owned by Mariano Inzani, Parma, from whom it was acquired in 1862 for the Royal Gallery in Parma

ESSENTIAL BIBLIOGRAPHY

Du Gué Trapier 1958, pp. 78–80; Wethey 1962, II, pp. 41–4; Venice 1981, p. 265, no. 103 (entry by R. Pallucchini); Brown in Madrid-Washington-Toledo (Ohio)-Dallas 1982–3, pp. 88–90; Bertini 1987, pp. 213, 224, 237; Vechnyak 1991, pp. 177–81; Robertson 1992, p. 203; Joannides 1995, p. 202; Marías 1997, p. 109–10; Held in Iraklion 1990; Madrid 1998–9, pp. 604–5, no. 231 (entry by A. Pérez de Tudela); Madrid-Rome-Athens 1999–2000, pp. 367–8, no. 17 (entry by J. Álvarez Lopera); Vienna 2001, p. 134, no. 4 (entry by K. Schütz)

Whether the small painting at Parma (which has been cut at the right, giving it the appearance of a more centralised composition) precedes or follows the much larger one in the Metropolitan Museum (cat. 4) is uncertain, as both are closely related and adapt an earlier composition (fig. 25) to Roman standards. Of the two, however, the Parma painting is the more Roman and seems clearly to document El Greco's attempt to gain some footing in the highly competitive world of the papal city. The brilliant palette of the Dresden and Metropolitan paintings is subdued, the scale of the figures relative to the architecture is increased, and a number of details are introduced that firmly anchor this painting to Roman practice. Thus, instead of the simple pedimented arch that we find at the end of the perspective in the other two versions, here there are Roman ruins reminiscent of the Baths of Diocletian (their general form follows a plate in Serlio's treatise, Book III, f. XIXv); the first building of the enfilade on the left has the character of a three-bay Roman triumphal arch; the figure who bends over the kneeling blind man derives from one of the heroic nudes in Michelangelo's *Last Judgment* (El Greco reputedly criticised Michelangelo's great fresco, but its figures provided an unsurpassed repertoire of poses that he, like all his contemporaries, usually through the medium of prints, mined for ideas); and the poses of two further figures may derive from Roman sculptures: the nude man from the so-called Farnese *Hercules* and the turbaned figure to the left of Christ from the right-hand youth in the *Laocoön*. In all of these ways, El Greco signals his ambition to compete in the arena of Roman painting. It is worth noting Koshikawa's suggestion that his friendship with the leading painter in Rome, Federico Zuccaro, dates back to these years;[1] El Greco's friend and promoter, the miniaturist painter Giulio Clovio, admired Federico, who he recommended to Cardinal Alessandro Farnese in 1566.

The Parma *Christ healing the Blind* is one of three pictures by El Greco that are listed in a 1644 inventory of the Palazzo Farnese. In the 1644 and 1653 inventories it bears no attribution, while in 1662, after it had been moved to the Farnese collection in Parma, it is listed as by Tintoretto and then in 1680 as by

Veronese. Unlike the much larger Metropolitan version, the Parma painting is highly finished, and it is tempting to think of it as El Greco's introductory piece, painted in 1570 for Cardinal Alessandro Farnese after he had been given accommodation in the Palazzo Farnese. On the other hand, it may have been a gift to the cardinal from either Clovio or Fulvio Orsini, Alessandro Farnese's librarian. Certainly, the relatively small size and fine execution of the painting accords with what we know of the cardinal's tastes.[2]

Yet, if El Greco's object was to recommend his services to the cardinal, he was unsuccessful, for no Farnese commissions are known and the artist was expelled from Palazzo Farnese in the summer of 1572.[3] It was Fulvio Orsini who became El Greco's main patron in Rome: he owned seven works by the artist, including portraits of Cardinal Alessandro and of Ranuccio Farnese and of Giulio Clovio (cat. 70). It was as a portraitist that El Greco was most admired in Rome, and there are two portraits in the Parma picture, one at the extreme left edge of the painting and the other immediately behind the gesturing blind man. They have been variously identified as the future Duke Alessandro (1545–1592), son of Ottavio Farnese; Don John of Austria, the half-brother of Philip II and a relation as well as friend of Duke Alessandro's; and the young El Greco himself.[4] The issue is difficult to resolve. Although it was with a self-portrait that El Greco impressed Giulio Clovio in Rome, no certain examples survive (see cat. 75). Although the inclusion of contemporary portraits in a religious composition destined for Cardinal Alessandro Farnese has ample precedent in the work of Giulio Clovio, none of these or other identifications hitherto proposed is compelling. KC

1. Koshikawa in Hadjinicolaou 1999, pp. 357–72.
2. Robertson (1992, pp. 34–5) has discussed Cardinal Farnese's use of Clovio's miniature paintings as diplomatic gifts.
3. Robertson (in Hadjinicolaou 1995, pp. 215–27) suggests the various factors that may account for El Greco's lack of success with Cardinal Farnese.
4. For these identifications see especially Wethey 1962, II, pp. 43–4; Robertson in Iraklion 1990, p. 403; Puppi 1997, p. 289; and Puppi in Madrid-Rome-Athens 1999–2000, p. 111. Puppi argues that El Greco painted the picture in Parma in 1574, *en route* to Venice, but the painting is first recorded in the Farnese collection in Rome.

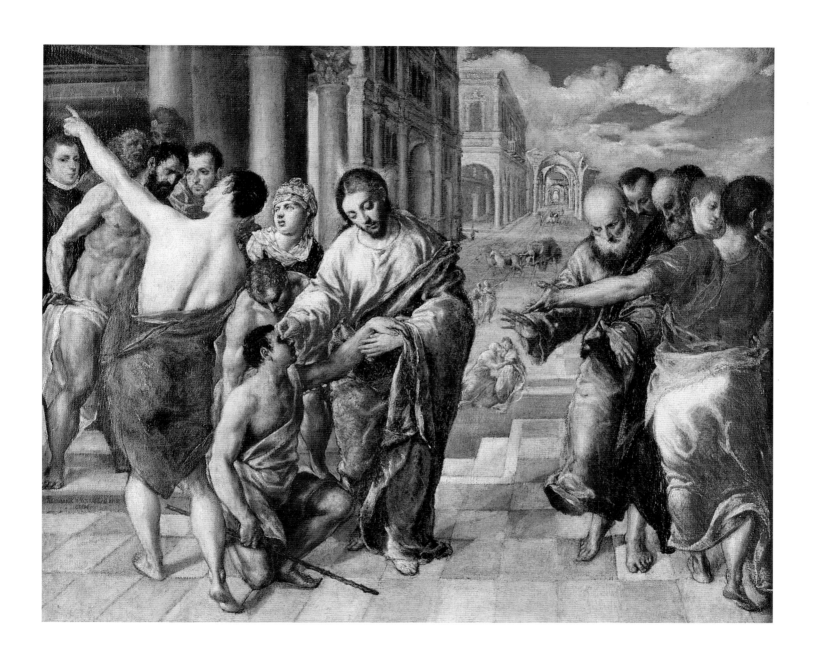

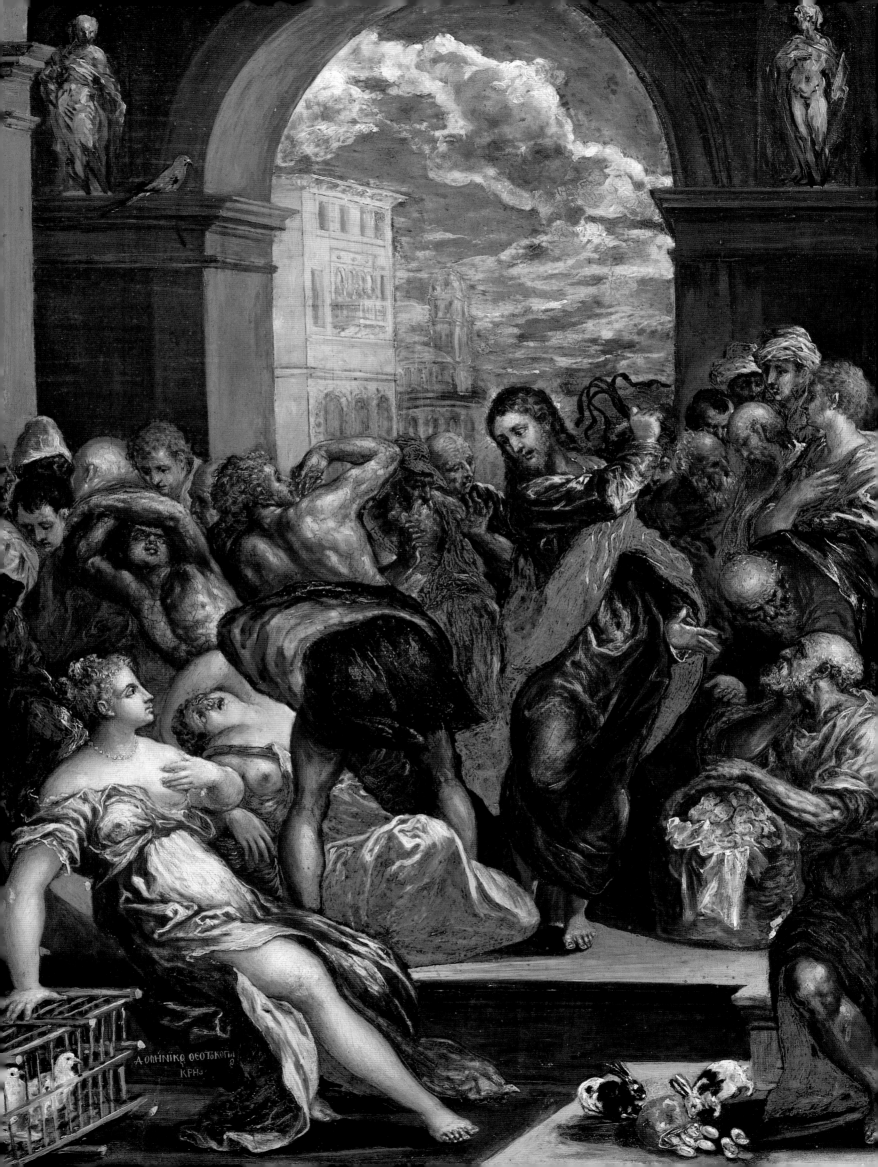

El Greco painted several pictures of *The Purification of the Temple*.[1] Four are listed in the inventory of his possessions drawn up by his son Jorge Manuel in 1614, immediately after his death, and probably the same four are listed in the inventory of Jorge Manuel's possessions drawn up in 1621 on the occasion of his second marriage.[2] The subject, which evidently held a deep fascination for El Greco, accompanied the artist throughout his career: he painted some versions in Italy (possibly even in Venice) and several more – dating from the 1590s onwards – in Spain. Many more were painted in his studio. Wethey's catalogue raisonné of El Greco's works lists four as autograph and eight as studio pictures or copies.

The episode of Christ driving the traders from the Temple in Jerusalem is described in all four Gospels but the fullest account is to be found in the Gospel of Saint John (2: 13–16):

> And the Jews' passover was at hand, and Jesus went up to Jerusalem, And found in the temple those that sold oxen and sheep and doves, and the changers of money sitting: And when he had made a scourge of small cords, he drove them all out of the temple, and the sheep, and the oxen; and poured out the changers' money, and overthrew the tables; And said unto them that sold doves, Take these things hence; make not my Father's house a house of merchandise.

The biblical exegetes had offered various interpretations of this episode. It was a warning against hypocrisy and simony (the commerce of holy things); it was an exhortation to spiritual purity among Christians – the third-century Church Father Origen, for example, likened the Temple to the soul that Christ cleanses of sin; clerical abuses and heretical beliefs were also seen as the target of Christ's wrath. As these last were particular concerns of the Counter-Reformation Catholic Church, several popes in the second half of the sixteenth century, including Paul IV (1555–9), Pius IV (1559–65) and Gregory XIII (1572–85), had medals struck with Christ cleansing the Temple represented on the reverse (fig. 26).[3]

In painting Purification of the Temple was usually part of Christological cycles, and only rarely an independent subject. But Michelangelo made several drawings of *Christ driving the Traders from the Temple*;[4] these became widely known through paintings and prints based on them (fig. 27), and El Greco seems to have taken Michelangelo's composition as the basis for his own. El Greco's devotion to the subject throughout his career reflects his concern with moral, spiritual and exegetical aspects, but it also testifies to his evolving artistic preoccupations. The *Purifications* in this exhibition (cat. 6–9), date from about 1570 to about 1600. GF

1. For a general discussion of El Greco's paintings of *The Purification of the Temple* see Harris 1944 and Wethey 1962, I, pp. 21–5; Davies 1984; and Brown's observations in New York 2001.
2. In the 1614 inventory the paintings correspond with items 84, 101, 127 and 155. The sizes are not given, but item 127 is described as small ('*chiquita*'); see San Román y Fernández 1910, pp. 192–5. In the inventory of 1621 sizes are given as follows: item 8 '*otro quadrito con su guarnizion negra, de quando christo echaba los Judios del tenplo, de dos terzias de alto y tres quartas de ancho*' (57 × 64 cm); item 20 '*una echada de los Judios del tenplo, de dos terzias de ancho y media bara de alto*' (43 × 57 cm); item 24 '*una echada de los Judios del tenplo, de bara y terzia de alto y bara y dos terzias de largo poco mas* [112 × 142 cm], *y es el original*'; item 217 '*una echada de los Judios del tenplo, de dos baras menos quarta de largo y bara y terzia de alto*' (43 × 57 cm): San Román y Fernández 1927.
3. On the significance of the theme see Waterhouse 1930, p. 70; Réau 1955–9, II, Part II, pp. 401–2; Harris 1944, pp. 11–12; Jordan in Madrid-Washington-Toledo (Ohio)-Dallas 1982–3, no. 2, p. 226.
4. Three are in the British Museum (Wilde 1953, nos. 76–8) and one in the Ashmolean Museum, Oxford (Parker 1956, no. 321).

Fig. 26 Medal of Paul IV (pope 1555–9) Reverse showing the Purification of the Temple with inscription 'My house shall be called the house of prayer' (Matthew 21: 13) The British Museum, London

6 The Purification of the Temple, about 1570–1

Oil on a single poplar panel, 65.4 × 83.2 cm

Signed lower left: *ΔΟΜ'ΗΝΙΚΟC ΘΕΟΤΟΚΌΠΟΥΛΟC ΚΡ'HC*
(Domenikos Theotokopoulos Cretan)

National Gallery of Art, Washington, DC
Samuel H. Kress collection, inv. 1957.14.4 (1482)

PROVENANCE

Probably in the collection of the
Marqués de Salamanca (died 1866),
Madrid; acquired in Paris (Hôtel
Drouot, 7 May 1868, lot 25) by John
Charles Robinson; Sir Francis Cook,
1st Bart (1817–1901), Doughty House,
Richmond, by 1894; by descent until
sold in 1955 to the Samuel H. Kress
Foundation in New York by Rosenberg
& Stiebel, New York

ESSENTIAL BIBLIOGRAPHY

Harris 1944, p. 7; Wethey 1962, I,
pp. 21–3; II, no. 104; Davies 1984, p. 63;
Brown and Mann 1990, pp. 67–72;
Madrid-Rome-Athens 1999–2000,
no. 12 (entry by J. Álvarez Lopera);
New York 2001

Fig. 27 After Michelangelo
(Marcello Venusti?, about 1512–1579)
The Purification of the Temple
(detail), after 1550
Oil on wood, 61 × 40 cm
The National Gallery, London,
inv. NG 1194

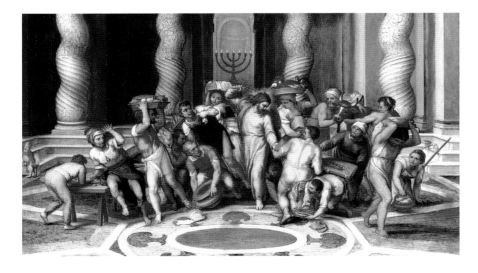

In this earliest known version of *The Purification* El Greco omits some of the details described in the Gospel texts, for example the oxen, while introducing other elements that suggest considerable erudition on his or his patron's part. These include the partridge, rabbits and oysters in the foreground, which were ritually unclean animals and signify the defilement of the holy place. In the cage at lower left the pigeons or doves (which are mentioned in the Gospels) were the offerings for sacrifice presented by the poor when they visited the Temple (Leviticus 5: 7) – the very kind that Mary and Joseph offered when they brought Jesus to the Temple (Luke 2: 21–4). The trussed lamb bound to a pole, together with the small cask of wine, has obvious Christological and Eucharistic symbolism.

This painting has usually been dated to El Greco's Venetian years, between 1567 and 1570,[1] though some scholars have placed it to his time in Rome, immediately after 1570. As in El Greco's earlier post-Byzantine works (cat. 1, 2), the support is a poplar panel and, although the picture is painted in oil, it emulates the effects of egg tempera. It is executed in short dense strokes, characteristic of an artist used to working on a small scale. There are traces of careful underdrawing, particularly in the architecture. By including a large group of figures in action in a complex architectural setting, El Greco was seeking to demonstrate his mastery of the Italian style. He borrowed extensively from High Renaissance visual models and did very little to disguise them. Thus the composition as a whole follows Michelangelo's design for *Christ driving the Traders from the Temple* (fig. 27); the *contrapposto* figure of Christ is probably based on Titian's *Transfiguration* (San Salvatore, Venice), and the woman with her hand on the birdcage is evidently inspired by figures of Veronese. The young man stepping over the recumbent woman (who is based on an ancient sculpture in the Vatican of a maenad or Ariadne) is taken from a figure in an engraving after Michelangelo's *Conversion of Saint Paul* in the Cappella Paolina in the Vatican. The woman and child on the right are based on figures in Raphael's tapestry of *The Healing of the Blind Man*, and the two sculptures flanking the arch are variants of the Minerva and the Apollo in his fresco of 'The School of Athens'. The use of receding floor tiles to define the space is typical of Tintoretto, and the buildings visible through the arch are based on an engraving in Sebastiano Serlio's treatise on architecture (1551). Many other sources have been identified and, since most of these are Roman, some scholars have argued for a later dating of the painting, to El Greco's period in Rome.[2]

El Greco's slightly naïve attitude to his sources, as well as the uncertainties in the handling of anatomy and space, are quite evident and confirm the painting's date early in his career. The elderly man seated in the foreground is a case in point: he does not appear to be properly sitting on the step and the upper part of his body seems to be in a different plane from the bread basket on which he is resting. This infelicity is resolved in the Minneapolis painting of the same subject (cat. 7), which is to be dated shortly afterwards. In his later treatments of the subject El Greco makes a clearer distinction between the groups of figures to the left and right – the traders and Christ's followers respectively – thereby seeking to clarify the interpretation of the Gospel episode. GF

1. Brown and Mann 1990, pp. 67–72.
2. Eisler 1977, p. 193; see the observations of Álvarez Lopera in Madrid-Rome-Athens 1999–2000, no. 12.

7 The Purification of the Temple, early to mid 1570s

Oil on canvas, 116.8 × 149.9 cm

Signed on the step to the left of centre
ΔΟΜΉΝΙΚΟΣ ΘΕΟΤΟΚΌΠΟΥΛΟΣ ΚΡΉΣ ἘΠΟΊΕΙ
(Domenikos Theotokopoulos Cretan made)

The Minneapolis Institute of Arts, Minnesota
The William Hood Dunwoody Fund, inv. 24.1

El Greco's second version of *The Purification of the Temple*, considerably larger than the first, represents a significant technical advance. Control of tone and contrast is such that the composition, which is almost identical to that of the first version (cat. 6), is considerably more legible. Skin tones are lighter and profiles more distinctive and there is a better sense of recession in the figure groups. By differentiating the tone of Christ's blue drapery, with its green-yellow lining, from the grey-blue robe of the man immediately to the left, El Greco has made the figure of Christ more dominant. The brushstrokes are more fluid than in the earlier work, signifying the artist's greater confidence in painting in the Venetian manner.

The prominent inclusion of half-naked women in both versions possibly has its basis in the text of *The Virgin's Profession* by Saint Jerome, 'Jesus entered into the temple and cast out those things which were not of the temple. . . . Where money is counted, where there are pens of doves for sale, where simplicity is slain, where a virgin's breast is disturbed by thoughts of worldly business. . .'. The presence of children is justified by the Gospel reference (Matthew 21: 15) to children who acclaimed Jesus in the Temple when he drove out the money-changers. The most significant iconographic feature is the introduction in the lower right-hand corner of four portraits of artists. They are, from left to right, Titian, Michelangelo, Giulio Clovio and Raphael (although it has also been suggested that this figure is El Greco himself, Giulio Romano or even Correggio). Their presence can be interpreted as a straightforward homage by El Greco to those artists to whom he felt indebted (and some of whose works he was quoting in the picture) and to whom he considered himself a worthy successor. In his annotations to Daniele Barbaro's edition of Vitruvius' *Ten Books on Architecture*, El Greco wrote admiringly of Michelangelo's sculpture, 'in which [he] displayed such admirable taste never seen in another sculptor' – although, according to Giulio Mancini, writing in about 1620, and informed about El Greco's stay in Rome, and to Francisco Pacheco, who met the artist in Toledo in 1611, El Greco was more critical of Michelangelo's painting. 'What words', El Greco added, 'would be sufficient to speak of the beauty of Titian's colours, so true in their imitation of nature?', and Raphael he described as 'among the first to show the way in painting'.[1] The image of Giulio Clovio closely resembles the independent portrait El Greco made of him (cat. 70).

The artists are not meant to be bystanders to the scene: their insertion is similar in character to a textual footnote crediting the sources employed in the main text. In relation to the subject-matter of the picture their presence is ambiguous, especially if El Greco regarded the Gospel episode as symbolic of the Counter-Reformation cleansing of the Church.
GF

1. Marías and Bustamante 1981, pp. 235–6.

PROVENANCE

George Villiers, 1st Duke of Buckingham, York House, London, 1635; by descent; acquired by Lord Yarborough; with Steinmeyer, Lucerne; with Henry Reinhardt & Co., New York; purchased by the Minneapolis Institute of Arts in 1924

ESSENTIAL BIBLIOGRAPHY

Waterhouse 1930, no. 14, pp. 76–7; Wethey 1962, II, no. 105; Gudiol 1973, no. 14, pp. 22–7, 333; Davies 1984, p. 63; New York 2001, pp. 31–2

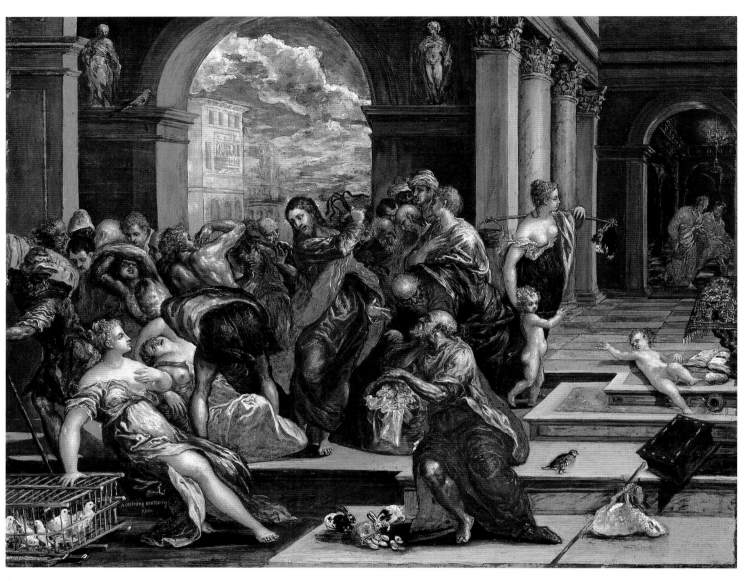

6

7

Oil on canvas, 106.3 × 129.7 cm
The National Gallery, London, inv. NG 1457

Slightly smaller than the Minneapolis painting (cat. 7), this work probably dates some twenty-five to thirty years after it. No autograph version of *The Purification of the Temple* appears to have been executed between these two, except possibly the small painting in the Frick collection in New York (fig. 28), which is sometimes said to be a *modello* in preparation for the National Gallery picture but is just as likely to be a repetition of it. It is not clear what, or what contemporary event, might have motivated El Greco to revive the composition at this later stage in his career.

Although the architecture remains broadly similar to that of the earlier works (though the Corinthian capitals have disappeared), it is now simply a backdrop to the foreground action. The arrangement of the floor has been radically simplified so that it is the figures that define the space rather than the sequence of steps and tiles. The still-life details and the quartet of artists are gone, and instead an overturned table fills the front of the picture space, endowing the composition with a skewed, unsettled quality. Thus the painting reflects a significant shift both in style and in the artist's intentions: whereas before he was concerned with conforming to the Italian model of ordered, perspectival composition, here he places much greater emphasis on the essential human drama. The figures are consequently much larger in relation to the picture space, the gestures are more eloquent and the colours more strident.

El Greco clarifies the figure groupings, placing the traders on the left and the Apostles, who comment on the significance of Christ's action, on the right. The money box formerly on the right side of the composition is now on the left, in the hands of a money-changer, who has replaced the female pigeon-vendor. His pose is perhaps derived from a figure in Tintoretto's *Marriage at Cana* in Santa Maria della Salute, Venice, but El Greco's borrowings are now properly digested. The old seated man resting on his basket is now unmistakably Saint Peter: he has the saint's characteristic physiognomy and wears the canonical colours of blue and yellow. The contrast between the figure groups is underscored

by the sculpted reliefs above them: on the left is the Expulsion of Adam and Eve from the Garden of Eden, signifying the fall of humanity, and on the right is the Sacrifice of Isaac, an Old Testament episode understood as foreshadowing the redeeming sacrifice of Christ on the cross. So the traders represent fallen humanity and the Apostles the redeemed. Christ chastises the sinners and profaners, whereas those who follow him receive his care and protection, as the gesture of his left hand implies. The composition, with Christ at the centre, his eyes and his rose-red robe flashing, recalls the imagery of the Last Judgment: 'When the Son of Man shall come in his glory . . . he shall separate them one from another, as a shepherd divideth his sheep from the goats: And he shall set the sheep on his right hand, but the goats on the left' (Matthew 25: 31–4) – and each shall have their proper reward.

The painting was acquired in 1877 by John Charles Robinson, a collector of Spanish painting and ceramics – among other things – and the first curator of the art collections of the Victoria and Albert Museum (1852–69). He already owned the Washington version of the subject (cat. 6). On 18 May 1895 Robinson wrote to the director of the National Gallery, Sir Edward John Poynter, stating his intention to offer the picture to the Gallery. Although its author was better informed than most about Spanish art, his letter illustrates a typical late nineteenth-century view of El Greco: 'The subject is the Expulsion of the money changers from the Temple consequently a "busy" composition of many figures, the "Temple" itself being a splendid Venetian interior with canals and palaces in the background seen through the arcades. The size 4ft 3 by 3ft 6 On the whole I think it is very much above the average of this most eccentric master's works and it has the advantage of being in splendid condition. At the same time you know the man was as mad as a hatter and his works must be taken with "all faults" of which there are plenty. However I have seen literally hundreds of El Greco's pictures in Spain and amongst them only very few up to the level of the present work.' GF

PROVENANCE

Possibly one of the paintings of the same subject listed in El Greco's (1614) and Jorge Manuel's (1621) inventories; Samuel S. Mira; sold anonymously by him at Christie's, London, 30 June 1877 (lot 63); bought by Sir John Charles Robinson and given by him to the National Gallery in 1895

ESSENTIAL BIBLIOGRAPHY

Harris 1944; Wethey 1962, II, no. 108; MacLaren and Braham 1970, pp. 24–7; Vienna 2001, no. 38 (entry by A. Wied)

9 The Purification of the Temple, probably after 1610

Oil on canvas, 106 × 104 cm

Signed on the leg of the table in the foreground
δομήνικος θεοτοκόπουλος ἐποίει
(Domenikos Theotokopoulos made)

Parish Church of San Ginés, Madrid

NOT IN EXHIBITION

PROVENANCE

Apparently given in 1700 by Don Juan Thomas to the Real Congregación del Santísimo Sacramento, Madrid, in lieu of debts owed by his father to Don Francisco Canesco (died 1682), a benefactor of the Congregación; first recorded in the Church of San Ginés in Madrid, in the sacristy of the Capilla del Cristo, in 1815

ESSENTIAL BIBLIOGRAPHY

Ortiz 1955; Wittkower 1957; Wethey 1962, II, no. 110; Davies 1984; Madrid-Rome-Athens 1999–2000, no. 88 (entry by J. Álvarez Lopera); New York 2001, pp. 32–3

Fig. 28 El Greco
The Purification of the Temple, about 1600
Oil on canvas, 41.9 × 52.4 cm
The Frick Collection, New York
inv. 09.1.66.

In his catalogue of the artist's works, Wethey argued that this version of *The Purification*, which dates from the last years of El Greco's career, was partly executed by Jorge Manuel.[1] Cleaning has since revealed the signature and, although this does not certify El Greco's sole authorship, has shown that the quality of the work is very high and its execution all of a piece.

The figure group is very close to that of the National Gallery picture (cat. 8), but perhaps even closer to the painting in the Frick Collection (fig. 28). It includes, on the right-hand side, a woman carrying a basket on her head and gesturing with her hand. Her identity and significance have not been satisfactorily explained. She is clearly not the same person as the bare-breasted woman with a child who appears in the early versions of the subject (cat. 6, 7). Her isolation, her gesture and her position on the side of the 'redeemed' suggest that she could be the poor widow who was observed by Christ and his disciples putting two small coins in the Temple treasury. Jesus contrasted her generosity with the painless largesse of the rich: 'Verily I say unto you, That this poor widow hath cast more in, than all

they which have cast into the treasury: For all they did cast in of their abundance; but she of her want did cast in all that she had, even all her living' (Mark 12: 43–4). If this identification is correct, her presence in the painting would bolster one of its central themes, Christ's abhorrence of religious commerce and hypocrisy. The figure running in from the left, an innovation of this composition, has been interpreted as a female trader who has recognised Christ and been converted.[2]

The most remarkable changes in the San Ginés painting, however, relate to the architectural setting. El Greco has shifted the action from the Temple porch to the inner sanctuary. At the centre of the structure supporting the altarpiece, which is almost identical to the one designed by the artist for the high altar of the church of the Hospital de la Caridad at Illescas and completed in 1605 (see cat. 48), is a tomb-like object with an obelisk, perhaps the Ark of the Covenant, which stood inside the Holy of Holies, or (less likely) the tomb of King David. On the left there is a relief of the Expulsion of Adam and Eve, similar to that in the London picture (cat. 8), and above it a statue of a naked male figure who has been variously identified as Adam, his son Seth or an unidentified idol. Saint Augustine had associated Adam closely with the Temple, drawing a parallel between Adam as the man of flesh who had to die to give birth to the 'new man' and the Temple in Jerusalem which Christ had said he would rebuild in three days after its destruction (actually referring to his death and bodily resurrection).

The changes introduced into this version of *The Purification* indicate El Greco's continuing reflection on the subject. He continued to add layers of interpretation to the end of his career. GF

1. Wethey 1962, II, no. 110.
2. Wittkower 1957.

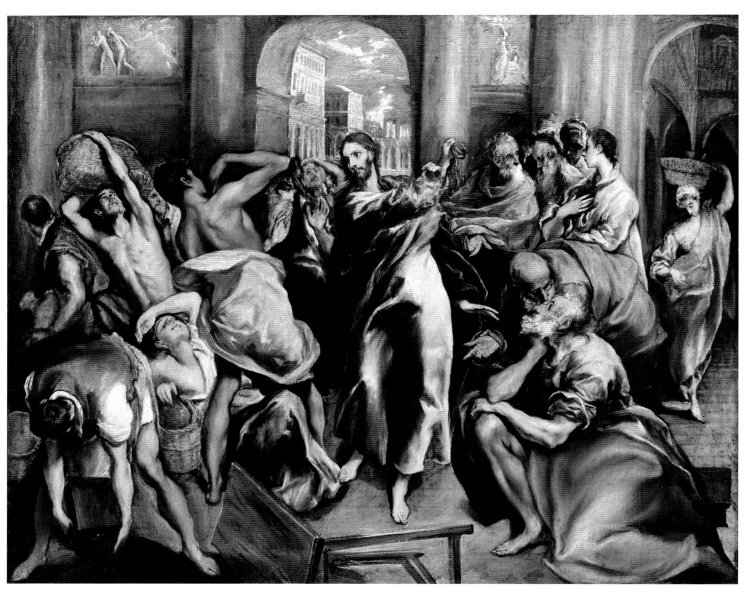

8

9

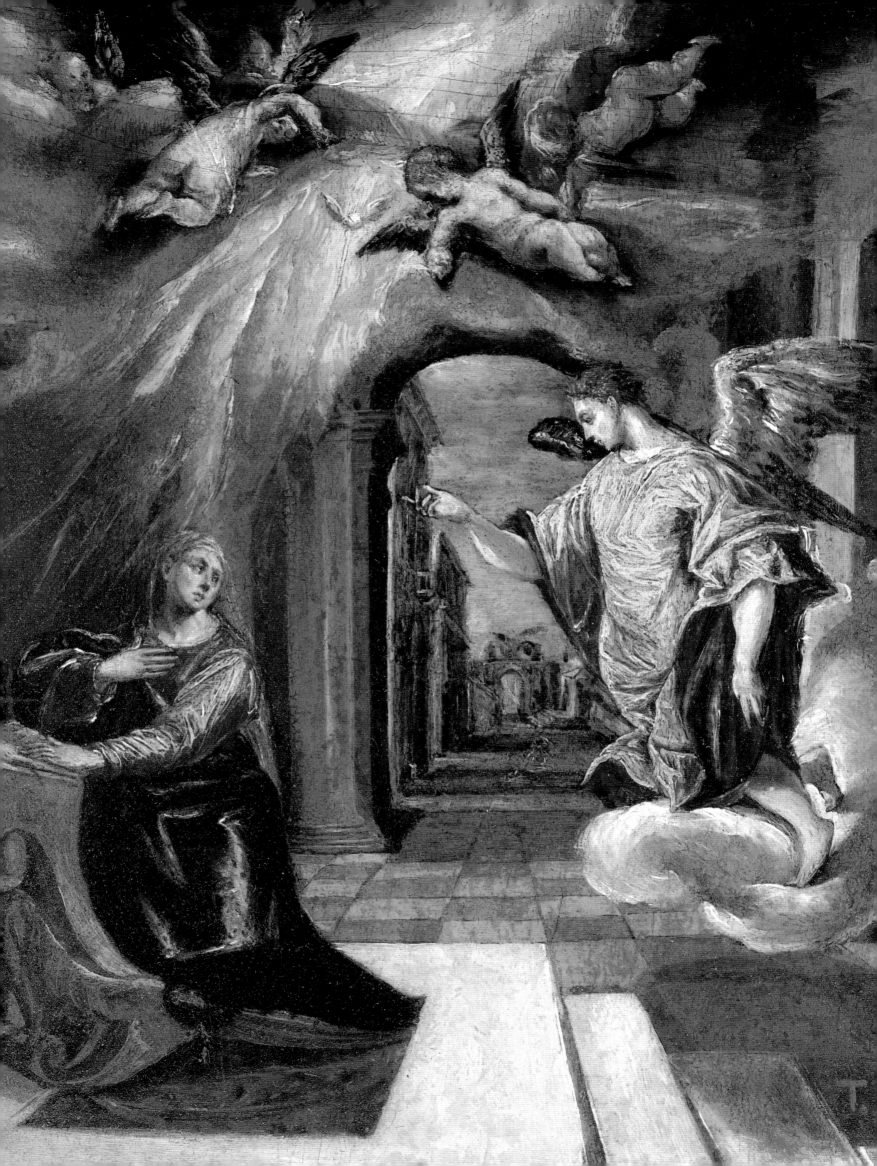

We know remarkably little about El Greco's activity in Rome. Even the duration of his stay is a matter of speculation. He arrived in the city shortly before 16 November 1570, when the Croatian miniaturist Giulio Clovio recommended him to Cardinal Alessandro Farnese. Yet less than two years later we find him appealing against being turned out of the quarters he had been given in Palazzo Farnese. He was inscribed in the painters' association in September 1572, evidently having decided to pursue a career in the papal city. The results of that venture were meagre indeed. It was for his capacities as a portraitist that Giulio Clovio recommended him and, although the Venetian manner he had mastered made a considerable impression, no public commissions came his way: with the exception of the life-sized, full-length portrait of *Vincenzo Anastagi* (fig. 56, p. 252), his activity was confined to modest-sized pictures destined for private collections ('*cose private*', in the words of the well-informed Sienese physician and critic Giulio Mancini, writing in 1617–21).[1] Of these, the bulk were devotional paintings showing such conventional subjects as *The Annunciation* (cat. 12, 16), the *Pietà* (cat. 14, 15) and *The Crucifixion* (cat. 25) – the stock-in-trade of artists, often executed in smaller and larger versions.

To understand the character of El Greco's early devotional paintings (which, curiously enough, include no depictions of the Madonna and Child), it is necessary to view them in their Roman context, dominated by the spectre of Michelangelo. In the years following completion of *The Last Judgment* in the Sistine Chapel in 1541 – which, because of its emphasis on the nude, became a firebrand for Counter-Reformation critics of the arts – Michelangelo created a series of devotional images remarkable for their formal purity and simplicity. They seem at once medieval in their suspension of time and place and their meditative character but assertively Renaissance in their insistence on the beauty of the human figure. Two – a drawing of *The Crucifixion* (fig. 40, p. 132) and another of the *Pietà* (fig. 33, p. 108) – were sent as personal gifts to the cultivated and pious Vittoria Colonna, who during the late 1530s and 1540s became a sort of spiritual mentor to Michelangelo. She wrote to him that her great faith

that God would grant him special Grace in making the image was more than met.[2] Both drawings were engraved and made a lasting impression on contemporaries: indeed, El Greco's *Crucifixion* in the Louvre (cat. 25) pays direct homage to Michelangelo's drawing at a distance of more than four decades. Versions of the *Pietà* exist in marble and bronze plaquettes as well as in small-scale paintings. Two further drawings by Michelangelo, both of *The Annunciation*, were translated into altarpieces and devotional paintings by Marcello Venusti, whose reputation was largely based on his practice of turning Michelangelo's designs into what Vasari described as 'an infinite number' of small-scale devotional paintings.[3]

El Greco would have been familiar with Michelangelo's compositions from an early date and he may also have been aware of the Neoplatonic ideas that informed their imagery.[4] However, these images would have become particularly important once he became part of the extended household of Cardinal Alessandro Farnese. Michelangelo had been closely associated with the Farnese family: it was under Pope Paul III Farnese that he frescoed *The Last Judgment* in the Sistine Chapel and the lateral walls of the Pauline Chapel; in 1549 a small copy of the *Last Judgment* was commissioned from Marcello Venusti to hang in their collection. They were, of course, also great admirers of Titian, who depicted various members of the family and for them painted two of his finest mythological canvases. Giulio Clovio's long affiliation with Cardinal Alessandro Farnese, which began around 1540, was predicated in part on his Michelangelesque style: Vasari famously christened him 'a new Michelangleo in miniature' (although he compared the naturalism of Giulio's portraits to those of Titian and Bronzino; like El Greco's, Giulio's initial training had been in Venice). Giulio also made copies of Michelangelo's drawings and interpolated Michelangelesque elements into his own compositions.[5]

We sense this same taste in Fulvio Orsini, the librarian and art advisor of Cardinal Alessandro Farnese and El Greco's most sustained Roman patron and possibly a promoter of his work. Orsini owned seven paintings by El Greco, who is designated

in the inventory of his collection as 'a Greek pupil of Titian's' – a depiction of *Mount Sinai* (cat. 10) and six portraits (four miniature in scale and painted on copper). His may also have been the mind behind the *Boy blowing on an Ember* (cat. 63).[6] It is of interest that he also possessed a conspicuous number of drawings ascribed to Michelangelo, including one of *Laocoön* that El Greco must have remembered years later (see cat. 69). Among those with religious themes was a fragment of Michelangelo's cartoon for *The Crucifixion of Saint Peter* (Capodimonte, Naples), two small drawings of *The Descent from the Cross* and a coloured drawing of *Christ and the Samaritan Woman* (a composition known from paintings by Venusti). Orsini also owned a version of Michelangelo's *Crucifixion* for Vittoria Colonna by Giulio Clovio. Clovio made devotional drawings as well as miniatures for Cardinal Alessandro, some inspired by Michelangelo's designs; these were used as diplomatic gifts – not least to Philip II.[7]

Although El Greco was later to express his low estimate of Michelangelo as a painter, and is even reputed to have scandalised the artistic establishment in Rome by declaring that he could replace *The Last Judgment* in the Sistine Chapel with something equally good and more decorous, it is inconceivable that his Roman work should not have responded to the inventions of the Florentine sculptor. It has long been recognized that his *Pietà* (cat. 14) draws in equal measure upon Michelangelo's sculptural group in Florence Cathedral and on the Vittoria Colonna drawing. Even in the Prado *Annunciation* (cat. 12), for which the compositional model is usually identified as an engraving after a lost painting by Titian (though no less important was Correggio's frescoed *Annunciation* for San Francesco, Parma, and a page in Giulio Clovio's *Farnese Hours*), he attempts to give the figures a physical weight and density that owes more to Rome than to Venice.[8] Michelangelo's influence went well beyond the issue of figurative vocabulary: El Greco strove for an intensity of effect comparable to that obtained by Michelangelo – but one achieved less through purity of form than through an emphasis on saturated colour and broad brushwork as well as on landscape setting.

There has been an understandable tendency to emphasise El Greco's debt to Titian and his criticism of Michelangelo. There can be no question that in Rome it was the Venetian style of his painting rather than his use of Michelangelesque motifs that struck artists and potential patrons: Mancini informs us that one of the Cretan's '*cose private*' in the collection of '*avocato* Lanciloti' was mistaken for the work of the great Venetian, and it was doubtless El Greco's mastery of a painterly technique that recommended him to Fulvio Orsini.[9] Yet it would be a mistake to take El Greco's dismissive comments about Michelangelo and his Roman followers at face value. They were penned into the margins of his copy of Vasari's *Lives* after his abortive attempt to secure the patronage of Philip II at the Escorial, where, instead, Michelangelesque artists were preferred.[10] Thus, although he was critical of Marcello Venusti, a *Crucifixion* El Greco painted in Rome (formerly in the Basha Johnson collection, Princeton, New Jersey)[11] seems to be based directly on Venusti's altarpiece in the church of Corpus Christi, painted in 1574–5.[12] Similarly, although he shocked Velázquez's teacher, Francisco Pacheco, who visited him in his studio in 1611, with his judgement that Michelangelo was a good man but did not know how to paint, he also noted that for drawing the nude Michelangelo was the model to follow, just as Raphael was for composition. When we consider El Greco's concentration on the figure as the primary means of conveying the spiritual, his deep affinity for Michelangelo's art and the Neoplatonic ideals that informed it become obvious.

The interest of El Greco's devotional paintings lies precisely in their tentative and not always successful negotiation of Venetian and Roman art – of the polar worlds of Titian and Michelangelo, the masters of *colore* and *disegno* respectively. What these images suggest is an artist in conflict, for there is an awkward, unresolved tension between the sensual world of Venetian art and the formal purity of Michelangelo's. Only later, in Toledo, was El Greco able to resolve this conflict by altering his palette, increasing the intensity of his colours and using his broken brushwork to dematerialise the figure. KC

1. Mancini 1617–21 (1956), p. 230. It is Mancini who also tells us that in his Venetian manner, based on the study of Titian, El Greco was very bold ('*pigliò grand-ardire*').

2. '*. . . Io ebbi grandissima fede in Dio che vi dessi una gratia soprannaturale a far questo Cristo: poi il viddi si mirabile che superò in tutti i modi ogni mia expettatione: poi facta animosa dalli miraculi vostri . . . cioè che sta da ogni parte in summa perfectione*' (. . . I had great faith in God that he would give you a supernatural grace to make this Christ. I then beheld this miraculous thing that surpassed in every way my expectations, made bold, moreover, by the miracles [you perform] . . . which is to say that it is of the highest perfection in every part): quoted in Tolnay 1953, p. 47.

3. On Venusti see Kamp 1993.

4. Among the poems Michelangelo sent to Vittoria Colonna around 1540 was the following (Saslow 1991, p. 322, no. 164):

 Per fido esemplo all mia vocazione
 nel parto mi fu data la bellezza,
 che d'ambo l'arti m'è lucerna e specchio.
 S'altro si pensa, è falsa opinione.
 Questo sol l'occhio porta a quella altezza
 c'a pingere e scolpir qui m'apparecchio.
 S'e giudizi temerari e sciocchi
 al senso tiran la beltà, che muove
 e porta al cielo ogni intelletto sano,
 dal mortale al divin non vanno gli occhi
 infermi, e fermi sempre pur là d'ove
 ascender senza grazia è pensier vano.

 As a trustworthy model for my vocation,
 at birth I was given the ideal of beauty,
 which is the lamp and mirror of both my arts.
 If any think otherwise, that opinion's wrong:
 for this alone can raise the eye to that height
 which I am preparing here to paint and sculpt.
 Even though rash and foolish minds derive
 beauty (which moves every sound mind
 and carries it to heaven) from the senses,
 unsound eyes can't move from the mortal to the divine,
 and in fact are fixed forever in that place
 from which to rise without grace is a vain thought.

 (Michelangelo's poems were first published in 1623 by his grand-nephew, but they circulated long before that and before he died Michelangelo had almost completed an edition of 105 poems for publication.)

5. See the inventory of his collection in Bradley 1891, pp. 355–7. Du Gué Trapier 1958, pp. 80–5, rightly emphasises the importance for El Greco of Clovio's drawing collection and of his access to his miniatures.

6. Crucial to the understanding of this picture is Orsini's interest not only in classical texts but in semi-genre pictures exploring a range of themes. He owned Sofonisba Anguissola's drawings of a child bitten by a crayfish and a girl laughing at an old woman trying to read.

7. See Robertson 1992, p. 35, for Cardinal Alessandro Farnese's practice of sending Giulio's miniatures as gifts.

8. See the *Annunciation* on f. 4v of the *Hours* in which there is an analogy for the gesture of the Virgin and the distant view found in El Greco's painting.

9. Mancini's '*avocato* Lanciloti' has been identified as a member of the Roman Lancellotti family, Orazio Lancellotti, who was close to Fulvio Orsini and, indeed, inherited from the scholar some of his Greek and Latin manuscripts: see Marias 1997, pp. 114, 302 n. 23, and especially Cavazzini 1998, pp. 8–9. However, Mancini would hardly have referred to this man, who was made a cardinal in 1611, as a lawyer. Patrizia Cavazzini kindly informs me that there was a Lancellotti family of lawyers from Perugia, one of whose members was named Orazio. As though to make matters more complicated, both Orazios studied law at Perugia, so that at more or less the same time there was a famous Perugian lawyer and university professor and a future Roman cardinal with the same name. The matter becomes more interesting in that on the back of the panel of El Greco's *Saint Francis* in the Istituto Suor Orsola Benincasa in Naples (see further cat. 11) is an inscription asserting that the picture belonged to a *Monsignor degli Oddi*. The Oddi were also a Perugian family.

10. El Greco's responses to Roman artists are reviewed by Marias 1997, pp. 99–105.

11. Sale, Christie's, New York, 31 January 2000, lot 217.

12. Kamp 1993, no. 23. Venusti's image was clearly derived from a drawing by Michelangelo and is also remarkably similar to a miniature by Giulio Clovio in the Uffizi, Florence.

Oil and tempera on panel, 41 × 47.5 cm
Historical Museum of Crete, Iraklion

The painting shows the peaks of Mount Sinai, a place sacred to Judaism and Christianity, of special significance for Eastern Orthodoxy, and revered by Muslims. At the centre is Mount Horeb, where Moses received the tablets of the Ten Commandments from God. In the similar scene on the reverse of the Modena Triptych (fig. 29), El Greco showed Moses receiving the Decalogue, but here the peak is deserted, albeit enveloped in a refulgent cloudburst that bespeaks its importance as the place where God revealed Himself (Exodus 19: 16–25). A long staircase leads up the rocky peak, which is dotted with small hermitages. On the left is Mount Epistene. The peak on the right is St Catherine's Mount, where the early Christian martyr Catherine had been buried, reputedly by angels (a scene also shown in the Modena Triptych), and the small citadel at the foot of Mount Horeb is the monastery that to this day bears her name. Founded by the Emperor Justinian and originally dedicated to Christ the Saviour, St Catherine's Monastery is venerated as the spiritual home of Byzantine Orthodoxy. It was

a centre of learning, housing, both in El Greco's time and today, a vast library and an enormous collection of icons.

Most importantly, from the point of view of the iconography employed by El Greco, the monastery was a great centre for pilgrimage. On the left are three Western pilgrims, dressed in the traditional short cape, with hat and staff, making their way towards it, and on the right is a group of Eastern pilgrims with camels. One has descended from his horse and kisses the hand of a bearded monk. To the left is a John the Baptist-like figure, presumably a hermit, and a little further to the left is a group of men in white turbans whose significance is not clear. Most of the figures in the foreground of the painting, as well as the straw hut on the extreme right, are adapted from a woodcut designed by Titian showing *Scenes from the Life of Saint Roch*.[1]

The view is not of course an accurate topographical rendering of the holy site, which anyway El Greco never saw. It is based on engravings of Mount Sinai which could be found in travel books and accounts of pilgrimages, and more specifically on a print of the site of 1569 by Giovanni Battista Fontana. El Greco, however, interprets the landscape in a highly dramatic key, with a decidedly animated brushstroke and an intense palette of ochres and umbers. The strong chiaroscuro effectively conveys the intense meteorological activity in the scene. Although it should be considered more a portrait of a holy place than an early independent landscape painting, El Greco's treatment presages the spectacular and highly atmospheric *View of Toledo* of a generation later (cat. 66).

The painting was probably made for the antiquarian Fulvio Orsini, librarian to Cardinal Alessandro Farnese, in whose palace the artist lived from 1570 to 1572. It is recorded in Orsini's inventory of 1600 as 'A painting with a walnut frame with a landscape of Mount Sinai by the hand of a Greek pupil of Titian' and it was valued at the relatively modest sum of 10 *scudi*.[2] Orsini, who would have been particularly interested in the historical-religious content of the picture, bequeathed it to Cardinal Odoardo Farnese (1573–1626), whose tutor he had been. GF

1. Constantoudaki-Kitromilidis 1995.
2. Nolhac 1884, p. 433.

PROVENANCE

Listed in the posthumous inventory of the collection of Fulvio Orsini, Rome, 1600; bequeathed to Cardinal Odoardo Farnese, Palazzo Farnese, Rome; recorded in the Palazzo Farnese inventories of 1653 and 1662–80; Alfonso Levi, Venice, by the end of the 19th century; Contini Bonacossi collection, Rome; collection of Baron Hátvany, Budapest, from 1921; private collection, Vienna, from 1974; London art market, 1988; acquired in 1990 by the A. and M. Kalokairinos Foundation; Historical Museum of Crete, Iraklion, 1991

ESSENTIAL BIBLIOGRAPHY

Byron and Talbot Rice 1930, pp. 195–8; Talbot Rice 1947; Wethey 1962, II, no. X-157; Wethey 1984, p. 174; Edinburgh 1989, no. 11 (entry by D. Davies); Iraklion 1990, no. 5 (entry by M. Constantoudaki- Kitromilidis); Robertson 1990; Gardner von Teuffel 1995; Cueto 1995, pp. 173 and 185, Dillon 1995; Madrid-Rome-Athens 1999–2000, no. 13 (entry by N. Hadjinicolaou)

Fig. 29 Detail of fig. 11

11 Saint Francis receiving the Stigmata, early 1570s

Tempera on panel, 28.8 × 20.6 cm

Signed at lower left: *ΔΟΜΉΝΪΚΟC ΘΕΟΤΟΚΌΠΟΥΛΟC ΈΠΟΙΗ*
(Domenikos Theotokopoulos made)

Private collection

NEW YORK ONLY

PROVENANCE

Possibly in the collection of Pedro
Salazar de Mendoza (died 1627;
inventory 1629) in Toledo; recorded in
the Nardiz collection, Bilbao; Ignacio
de Zuloaga, Paris, by 1908, till 1945; by
descent

ESSENTIAL BIBLIOGRAPHY

Cossío 1908, no. 326; Mayer 1926, no.
228; Waterhouse 1930, no. 3; Camón
Aznar 1950, no. 539; Soria 1954, no. 43;
Wethey 1962, II, pp. 117–18, no. 208;
Madrid-Rome-Athens 1999–2000, pp.
358–9, no. 9 (entry by N. Hadjinicolaou)

According to Thomas de Celano's biography, on
14 September 1224, feast-day of the Exaltation of the
Cross, Saint Francis retired into the wilderness of
Mount Alverna to contemplate Christ's Passion and
empathise with the suffering and emotional turmoil
of his Crucifixion. While deep in prayer, Saint Francis
had a vision of a seraphic figure with six wings and
outstretched arms, from whom rays of golden light
extended down to pierce his hands, feet and side
with the very wounds that Christ had suffered on
the cross. These marks, or stigmata, we are told,
remained on the saint's body until his death two
years later. Subsequent accounts of the event
modified some details. Saint Bonaventure, for
example, who may well be the literary source for
El Greco's rendition of the scene, identified the
seraphic figure with the crucified Christ.

El Greco ensures a full-frontal view of Saint
Francis's experience by positioning him in front
of a large rock. The palms of his open hands bear
the red marks of the stigmata, while the folds of his
grey habit reflect the brightness emanating from
the crucified Christ hovering among the clouds. As
a compositional device creating an uplifting sensa-
tion, perhaps in evocation of Francis's inner ecstasy,
El Greco has painted a sinuous oak tree rising up
into the sky. A drawing in the British Museum of
the same subject by Federico Barocci shows similar
attention to naturalistic detail and may have been
a source for El Greco's composition.[1] Francis's
companion, Brother Leo, unable to sustain the force
of the saint's ecstatic trance, lies on the ground with
his back to the viewer, in a pose that may have been
borrowed from a woodcut of the same subject by
Nicolò Boldrini after Titian. Behind, a path snakes
away into the distance towards a sunrise, which is
wonderfully rendered: with touches of reds, oranges
and yellows, El Greco simulates the early morning
rays of the sun blending with the hovering mist.

Like his other devotional paintings executed on
panel (cat. 10, 14), El Greco almost certainly painted
this picture as an image for private and intimate
contemplation. Its technique is similar to that of
icon painting, displaying a highly finished, enamel-
like surface. Details such as the head of Saint Francis
and the plants in the foreground are meticulously
executed with a fine brush. He superimposes
successive layers of paint; the whites and yellows, for
example, were applied last and protrude visibly from
the surface, for instance in the clouds around the
crucified Christ. The landscape is painted with
touches of red, yellow, green and blue, recalling the
swift and expressive brushstrokes of painters that
El Greco would have known in Venice, particularly
Titian.

Probably executed in the early 1570s soon after
his arrival in Rome, this painting demonstrates
El Greco's ability to fuse the lessons on the use
of colour that he had learnt there with his post-
Byzantine training, in order to impart emotional
charge to his image. Interestingly, the back of the
panel is prepared with gesso and painted over in
black with streaks of brown, perhaps in imitation
of wood (not unlike the reverse of *The Adoration of
the Name of Jesus*, cat. 23), suggesting that El Greco
wanted the picture to be seen as a completed object
from both sides. Another autograph version of the
composition is in the Istituto Suor Orsola Benincasa
in Naples.[2] This bears on the reverse a sixteenth-
century inscription indicating that the picture once
belonged to a Monsignor degli Oddi, a member of
one of the oldest families in Perugia. XB

1. British Museum, London, inv. Pp.3–203.
2. Madrid-Rome-Athens 1999–2000, pp. 358–9, no. 9
 (entry by N. Hadjinicolaou).

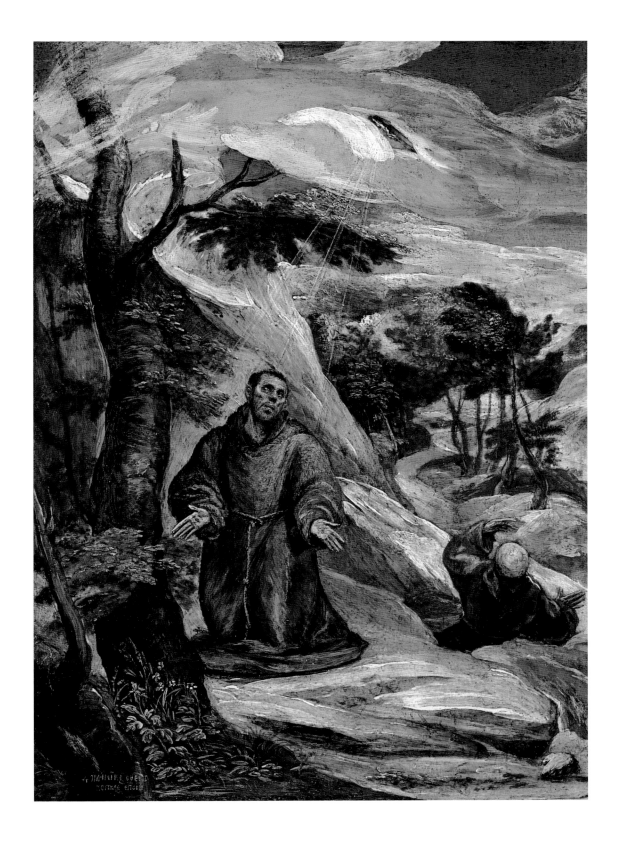

12 **The Annunciation**, early 1570s

Oil on poplar panel, 26.7 × 20 cm
Museo Nacional del Prado, Madrid, inv. 827

The Virgin is stationed at an elaborate winged prie-dieu, making her devotions. These are disturbed by the arrival on a cloud of the Archangel Gabriel, who has already addressed her with the salutation 'Ave Maria': as in his other early Annunciations (cat. 16 and fig. 30), El Greco represents a later moment in their dialogue. Having received the news that she shall conceive and bear the Son of God (Luke 1: 26–39), Mary, gesturing towards herself, asks of the angel: 'How shall this be, seeing I know not a man?' Gabriel responds, pointing in the direction of the dove descending in a blaze of glory: 'The Holy Ghost shall come upon thee, and the power of the Highest shall overshadow thee.' The Virgin's humble acceptance of the announcement makes possible Christ's incarnation and marks the beginning of the redemption of humanity. This is the reason why the subject is central to Christian iconography and to El Greco's own œuvre. The dimensions of the painting, the wooden support, and the precious quality of the execution suggest it is a work made for personal devotion.

The scene is set in an interior recalling that of a Venetian palazzo. The arch with the attached half-column is similar to that in the setting of the Minneapolis Purification of the Temple (cat. 7), to which this work is close in date. As in Christ healing the Blind in Parma (cat. 5) – which is again contemporary – the foreground scene is set up on a high level, thus raising the viewpoint so that the painter can include a distant perspective. The tiled floor defines the recession in the middle ground, and its two-tone arrangement is continued in the Renaissance piazza beyond, where the palazzi on the left cast large shadows across the ground. The octagonal fountain recalls the Virgin's title of 'Fons Signatus' (A Fountain sealed up), while the open arch at the end of the vista perhaps alludes to her appellation 'Ianua Coeli' (door of Heaven). The graceless proportions of the angel and the barely competent handling of the perspective contrast with the brilliant execution of the blaze of divine glory. Thick strokes of lead white over a yellow base define the centre of the glow; the edges of the clouds pushed apart by the explosion of divine radiance become trails of light falling on the Virgin. The foreshortening of the cherubs is effortlessly handled. The curious combination of great skill and striking awkwardness characterises several works of El Greco's Italian period and is indicative of the struggle it cost him to master the distinctive language of Italian Renaissance painting. Infrared reflectography has revealed detailed underdrawing of both the main figures and the architecture.

In iconography and style, the Prado Annunciation in particular is strongly marked by El Greco's efforts to emulate Venetian painting. The composition is based on Titian's Annunciation in Santa Maria degli Angeli, Murano, or rather perhaps on Caraglio's engraving of the picture, and the receding tiled floor recalls such floors in works by Tintoretto. By keeping to a minimum his blending of colours El Greco has sought to retain brilliance of hue.

A larger version of the painting, on canvas, is in a private collection in Madrid;[1] El Greco probably painted it very soon after this one. GF

PROVENANCE

Concepción Parody; acquired from her for the Museo del Prado in 1868

ESSENTIAL BIBLIOGRAPHY

Waterhouse 1930, no. 9, pp. 72 and 85; Pallucchini 1953, p. 20; Wethey 1962, II, no. 38; Madrid-Washington-Toledo (Ohio)-Dallas 1982–3, no. 1 (entry by W. B. Jordan); Garrido 1987; Athens 1995, no. 40 (entry by J. Álvarez Lopera); Garrido 1999

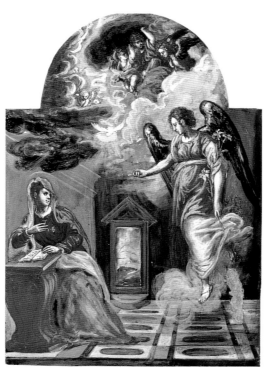

Fig. 30 Detail of fig. 11

1. Illustrated, following its recent cleaning, in Madrid-Rome-Athens 1999–2000 (Italian edn), no. 19.

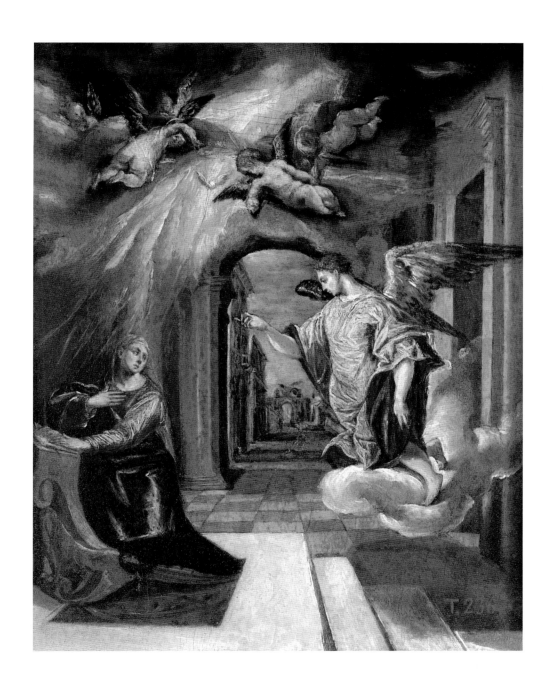

13 The Adoration of the Shepherds, early 1570s

Oil on canvas, 114 × 104.5 cm
Collection of The Duke of Buccleuch and Queensberry,
Boughton House, Kettering, Northamptonshire

The scene is set inside the stable in Bethlehem. Having heard the announcement from the angel that a saviour has been born in the town of David (Luke 2: 11–12), the shepherds have hurried to the crib to pay homage to the new-born king. One of them doffs his hat as he falls to his knees, another bears a lamb as a gift. To the left the Virgin kneels in adoration, her attention momentarily drawn to something outside the scene. Above the Child, who shines with light, are the ox and ass, and beyond the stable wall, to the left, a lone horseman and to the right the turbaned Magi, who approach with their retinue of horses, camels and attendants. The composition follows the scene of *The Adoration of the Shepherds* in the Modena Triptych (fig. 11, p. 47) of the late 1560s, a work that provided El Greco with a stock of ideas and compositional motifs for many years. Both that scene and, at one remove, this one are based on prints by Giovanni Britto after Titian (for the whole composition) and by Giulio Bonasone and Parmigianino (for individual figures and figure groups).

In the eighteenth century the Buccleuch *Adoration of the Shepherds* was attributed to Giovanni Lanfranco, the Parmese Baroque painter, and from 1820 it was considered to be by an otherwise unknown 'Girolamo' Bassano – bringing it, more accurately, into the orbit of the Bassano family. The attribution to El Greco was proposed by Waterhouse in 1951 and has found almost universal acceptance. He pointed out the similarities between the figure types of the shepherds and of the bystanders in the Dresden *Christ healing the Blind* (fig. 25, p. 81), which, incidentally, had been acquired for the Saxon royal collection in 1741 as a work by Leandro Bassano. Although El Greco was famously described by Giulio Clovio in 1570 as a disciple of Titian, on the evidence of his works his experience of Venetian painting would appear to have have been mediated principally by Jacopo

Fig. 31 X-radiograph of cat. 13

Tintoretto and the Bassano family of painters. This work, perhaps El Greco's first attempt at a nocturne, clearly owes a great deal to the nocturnal paintings of the Bassano.

The present appearance of the work is compromised by the complete repainting of the upper part of the canvas. The X-radiograph (fig. 31) shows that there were two angels, each holding a scroll, either side of a blaze of glory. They resemble two of the angels in the Prado *Annunciation* (cat. 12). The canvas has also been cropped at the top. A variant of the composition in vertical format was formerly in the collection of Carlo Brogio in Paris.[1] Another (oil on copper, 24.2 × 19 cm), almost certainly not autograph, is in the San Diego Museum of Art.[2] GF

1. See Davies in Hadjinicolaou 1999, pp. 149–61.
2. Athens 1995, no. 51; Marini 1999, pp. 137–8, fig. 1.

PROVENANCE

London, Montague House, by 1770; by descent

ESSENTIAL BIBLIOGRAPHY

Edinburgh 1951, no. 16 (entry by E. Waterhouse); Harris 1951, p. 313; Wethey 1962, II, no. 24; Pallucchini 1986, pp. 164, 166; Davies 1999–2000; Madrid-Rome-Athens 1999–2000, no. 18 (entry by J. Álvarez Lopera)

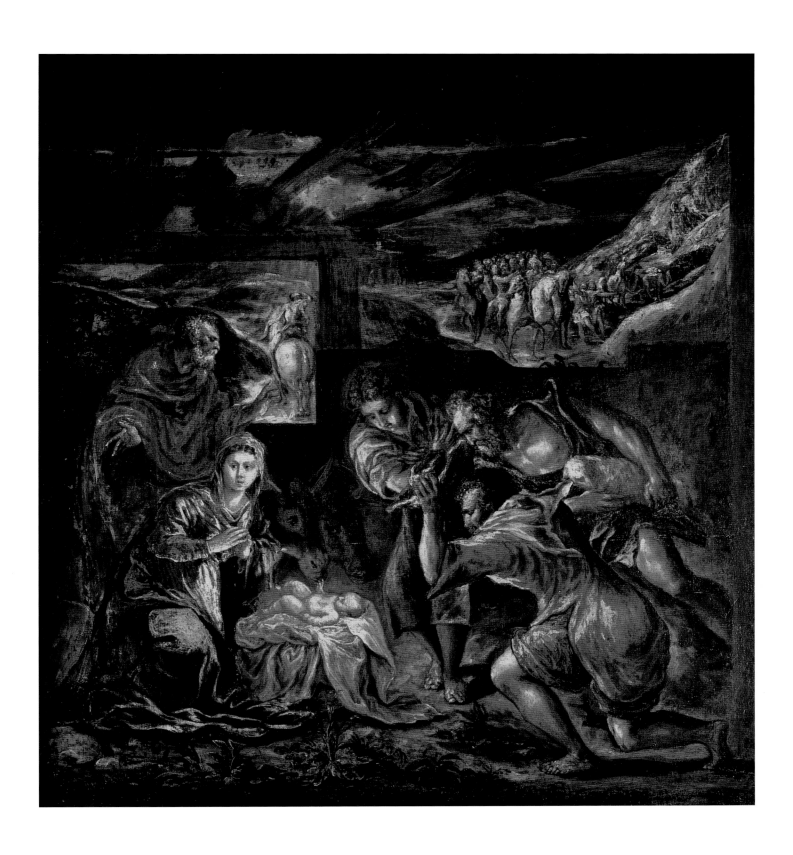

14 **Pietà**, early 1570s?

Oil on wood, 28.9 x 20 cm

Signed lower left: *ΔΟΜΗΝΙΚΟC ΘΕΟΤΟΚΟΠΟΥΛΟC*
(Domenikos Theotokopoulos)

The John G. Johnson Collection, The Philadelphia Museum of Art

Fig. 32 Michelangelo (1475–1564)
Pietà, about 1550
Marble, height 226 cm
Museo dell'Opera del Duomo, Florence

PROVENANCE

Chéramy, Munich; sold Paris, May 5–7
1908 (lot 78); Fischoff, Paris; John G.
Johnson Collection, Philadelphia,
from 1908

ESSENTIAL BIBLIOGRAPHY

Meier-Graefe and Klossowski 1908,
no. 22; Waterhouse 1930, pp. 68–9;
Tolnay 1953, p. 61; Du Gué Trapier 1958,
p. 82; Wethey 1962, I, pp. 24–5, II, p. 65;
Brown in Madrid-Washington-Toledo
(Ohio)-Dallas 1982–3, p. 88; Marías 1997,
p. 109; Koshikawa in Hadjinicolaou
1999, p. 364; Puppi in Madrid-Rome-
Athens 1999–2000, pp. 102–3; Fabianski
2002, pp. 32–4

Like the privately owned *Saint Francis receiving the Stigmata* (cat. 11) and the Prado *Annunciation* (cat. 12), the Philadelphia *Pietà* is painted on a small wood panel and must have been intended for private devotion (Waterhouse thought the *Saint Francis* might be its companion). As in the case of the *Annunciation*, there exists a larger version on canvas, now in the Hispanic Society, New York (cat. 15). The pattern established in these pictures of repeating compositions for the market, sometimes with only minor variations, was one El Greco followed throughout his career.

The composition of the *Pietà* is usually related to the sculptural group by Michelangelo (fig. 32) now in the Museo dell'Opera del Duomo in Florence (in El Greco's day it was in the Bandini collection in Rome). That group, mutilated by Michelangelo and partly restored by Tiberio Calcagni, shows the dead Christ supported by the Virgin and Mary Magdalen together with the standing figure of Joseph of

Fig. 33 Michelangelo (1475–1564)
Pietà, early 1540s
Black chalk on paper, 29.5 × 20 cm
Isabella Stewart Gardner Museum, Boston, Massachusetts

Arimathea (a self-portrait of the artist). In El Greco's painting the Virgin is behind Christ and the two supporting figures are usually identified as Saint John the Evangelist and Mary Magdalen. El Greco need not have known Michelangelo's sculpture first hand and, indeed, is more likely to have taken as his point of departure an anonymous engraving in which the group (with Christ's missing left leg restored) is placed in a landscape with Calvary in the distance.[1] The engraving also includes the three nails in the left foreground as a *locus* for meditation.

His sculptural group was not the only Michelangelo source on which El Greco drew: the arrangement of Christ's legs and his outspread arms, no less than the idea of viewing one of the two bearers of his body from the side and the other from behind, derive from Michelangelo's drawing for Vittoria Colonna (fig. 33), in which, as in El Greco's painting, the Virgin is placed behind and above Christ.[2] Both in the drawing and in the 1546 engraving after it the figures are placed directly beneath the cross and the Virgin looks upwards, raising her hands in a gesture of grief. In El Greco's picture, by contrast, the figures are some way away from Calvary, seen in the left distance, and are shown as though resting from the strain of carrying Christ's body to the tomb. A narrative element has been introduced. Strictly speaking, this is not a *Pietà* but a Lamentation on the way to the tomb. This idea, too, goes back to Michelangelo and was, interestingly enough, also developed in a drawing ascribed to Giulio Clovio that El Greco would presumably have known.[3]

El Greco's absorption of these various sources points to a complex response to the daunting, awesome talent of Michelangelo – one much harder to fight free of than that of Titian. Perhaps for this reason El Greco felt it necessary to adopt a highly vocal, hyper-critical stance towards the great Florentine in his declarations to Roman artists and in his comments penned in the margins of his copy of Vasari's *Lives*. Be that as it may, his interpretation of the *Pietà* theme is highly personal. Instead of that deeply affective yet meditative mood that Michelangelo achieves through a combination of physical weight, formal elegance, emotional restraint and abstraction, El Greco strikes a more

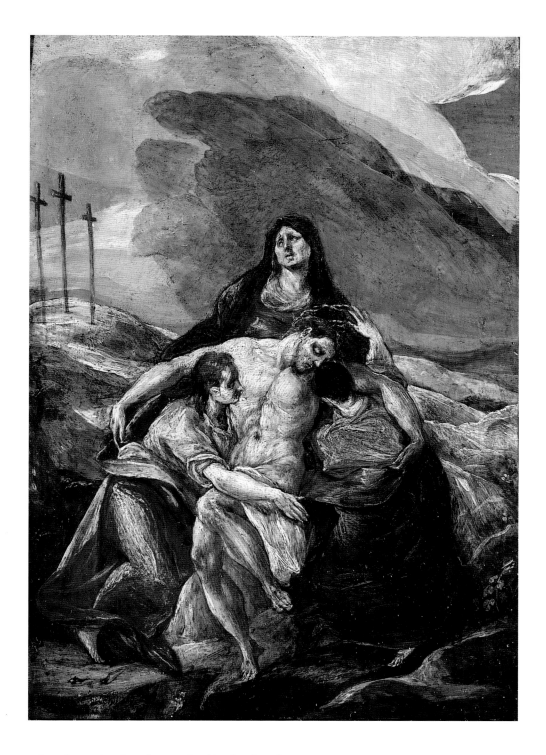

agitated, emotional mode, sustained by the play of dramatic light on the landscape and the turbulent cloud formations. In this way, the *Pietà* points the way to his first great triumph, the altarpiece of *The Assumption of the Virgin* for Santo Domingo in Toledo (fig. 12, p. 49; see cat. 17–20). The Philadelphia painting may date to the early 1570s while the Hispanic Society picture is probably a few years later.[4]

Catalogued as the work of El Greco when it was in the Chéramy collection in Munich, in 1908 the *Pietà* was sold to the Philadelphia lawyer–art collector John G. Johnson on the recommendation of Roger Fry. KC

1. The engraving was made during the papacy of Gregory XIII (1572–85).
2. See Tolnay 1953, p. 61.
3. See Nagel 2000, pp. 210–12; Monbeig-Goguel 1988, pp. 41, 46 note 44. Koshikawa in Hadjinicolaou 1999, p. 364, has noted analogies between El Greco's composition and a drawing by Taddeo Zuccaro in the Art Institute, Chicago, and uses this as evidence in the case he makes for El Greco's acquaintance with Taddeo's brother Federico.
4. See, however, Brown 2003 for the suggestion that the Philadelphia *Pietà*, together with the *Saint Francis* (cat. 11), should be re-considered among El Greco's earliest paintings in Venice and thus datable to around 1570.

15 **Pietà**, about 1575

Oil on canvas, 66 × 48 cm

The Hispanic Society of America, New York, inv. A69

NEW YORK ONLY

This is a version of the Philadelphia *Pietà* (cat. 14), varying the scale, colours and landscape. Although Wethey thought the Philadelphia painting a couple years earlier than the canvas in the Hispanic Society, which Cossío felt was painted in Spain (that is, no earlier than 1576), there is no reason to believe the two works very distant from each other. The Hispanic Society painting, which is on canvas, could easily have been rolled and brought by El Greco to Spain in 1576. The change in scale has magnified the artist's uncertainty in treating anatomical details (note, for example, the extended hand of the figure on the right), but the emotional impact is, if anything, even stronger. The Philadelphia and Hispanic Society works represent an important step towards El Greco's mature style, in which he was enabled by his experience of Venetian and Roman Renaissance art to leave behind forever the artistic values of his provincial post-Byzantine heritage (see cat. 14 for his compositional sources; here it may be added that Michelangelo's drawing of the *Pietà* now in the Isabella Stewart Gardner Museum, Boston (fig. 33, p. 108), was well known in Spain, as, for example, an altarpiece of about 1582 at Vallespinosa by Pietro Paolo de Montalbergo demonstrates). El Greco's contact with the great examples of ancient art at Rome also left their mark on the Philadelphia and Hispanic Society images: the tragic, grieving face of the Virgin, turned upwards and to the left, with a strongly modelled throat, was inspired by El Greco's study of the famous *Laocoön* group in the Vatican (fig. 54, p. 239). KC/MB

PROVENANCE

Acquired by the Hispanic Society from Don Luis Navas, Madrid

ESSENTIAL BIBLIOGRAPHY

Du Gué Trapier 1929, p. 81; Waterhouse 1930, p. 84; Tolnay 1953, p. 61; Du Gué Trapier 1958, pp. 82–3; Wethey 1962, II, pp. 65–6; Koshikawa in Hadjinicolaou 1999, p. 364; Fabianski 2002, pp. 32–4

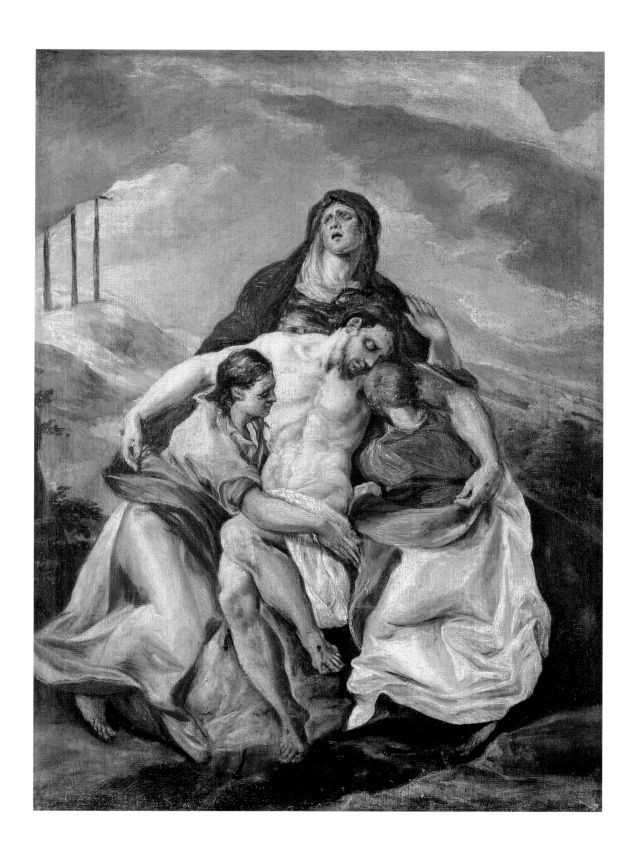

16 The Annunciation, mid 1570s

Oil on canvas, 117 × 98 cm
Museo Thyssen-Bornemisza, Madrid, inv. 1975-35

The style of the painting suggests that this work was painted towards the end of El Greco's period in Rome, shortly before his departure for Spain in 1576, and its provenance lends support to a dating in the Italian years. It is the finest of his Italian *Annunciations* (see cat. 12 and fig. 11), and in the clarity of its design, the elegance of its poses and proportions and the harmonious relationship of its figures and setting it is perhaps his most fully resolved picture in the Italian manner.

The painting represents a synthesis of El Greco's earlier treatments of the subject: the pose of the Virgin is virtually identical to that employed in the Modena Triptych *Annunciation*, while the Archangel Gabriel is a more classicising version of the Prado angel (cat. 12), his torso turned more towards the viewer and his left leg endowed with a more graceful profile. His draperies flutter lightly in the air while the Virgin's blue robe, with a lining of green shot with yellow, is more weighty and clings to her solid form. The light, which falls from upper left, emphasises the firmness of the anatomies, and a pool of shadow has formed beneath the angel's floating cloud. The setting has been simplified: the floor is on one level only, the perspective is centralised and there is no architectural backdrop, except what is possibly a plain parapet. The furniture is more sober than in the Prado picture and it is seen almost face on. In fact El Greco has intentionally avoided the use of diagonal planes and has even done away with the foreshortened cherubs of the Prado picture. The iconography has been clarified so that the angel's pointing gesture is unmistakably aimed at the dove. The gesture of the angel's left hand makes greater sense here than in the Prado painting because in this work he is carrying the rod of a messenger. The rod is almost parallel with the edge of the picture and it forms a right angle with the parapet, consolidating the orthogonal, planar design of the composition.

As in the Prado *Annunciation*, El Greco avoids blending his colours in order to preserve their vibrancy and to retain the lively character of the brushstrokes. Here the evidence of the influence of Tintoretto on El Greco's way of painting is incontrovertible. The increasingly Venetian character of his painting through the 1570s – when supposedly he was in Rome – has led some scholars to postulate that he returned to Venice before departing from Italy for Spain.

The dimensions of the painting suggest it was a work intended for domestic devotion, although conceivably it may have been intended for a small altar. GF

PROVENANCE

Corsini collection, Florence; Luigi Grassi, Florence; with Sulley, London, 1927; with Trotti & Cie, Paris; with Knoedler & Co., New York, 1929; Count Alessandro Contini-Bonacossi, Florence; with Stanley Moss, Riverdale-on-Hudson, New York; acquired in 1975 by Baron Thyssen-Bornemisza, Lugano; Museo Thyssen-Bornemisza, Madrid, from 1992

ESSENTIAL BIBLIOGRAPHY

Venturi 1927; Wethey 1962, II, no. 37; Madrid-Washington-Toledo (Ohio)-Dallas 1982–3, no. 6 (entry by W. B. Jordan); Madrid-Rome-Athens 1999–2000, no. 20 (entry by M. Borobia); Vienna 2001, no. 5 (entry by L. Ruiz Gómez)

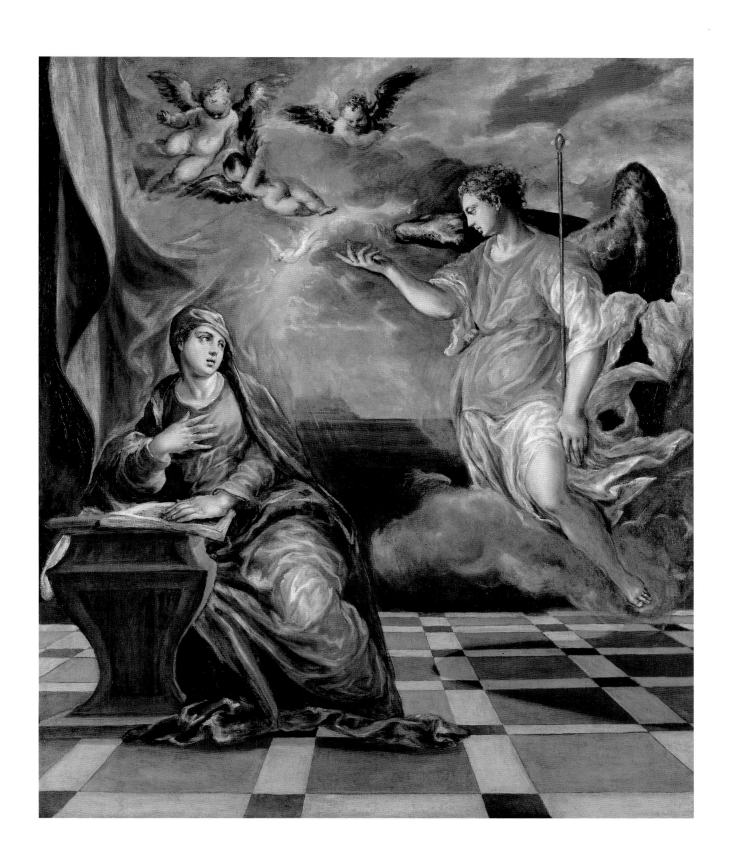

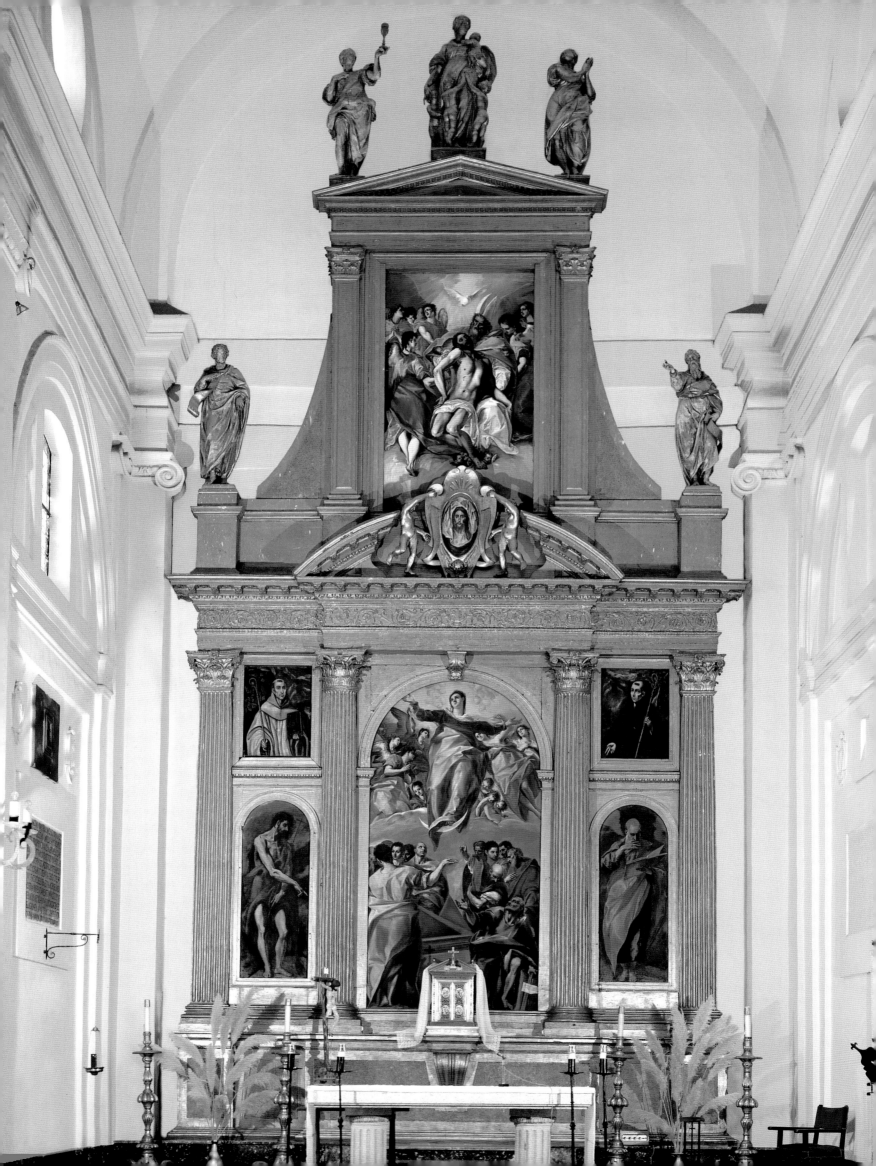

Having the previous month signed the contract for *The Disrobing of Christ* for the vestry of Toledo Cathedral (see cat. 21), in August 1577 El Greco was formally engaged by Diego de Castilla (1510/15–1584), dean of Toledo Cathedral, to paint three altarpieces for the Cistercian convent of Santo Domingo el Antiguo. The two side altars were to be decorated with *The Adoration of the Shepherds* and *The Resurrection* (still *in situ*; fig. 13, p. 49), while the main altar received an enormous, multi-tiered altarpiece with six canvases that had as its focus *The Assumption of the Virgin* (signed and dated 1577, now in the Art Institute, Chicago; fig. 12, p. 49) and *The Trinity* (Prado, Madrid; fig. 14, p. 50). The complex was among the most ambitious of El Greco's career and constituted one of his finest achievements. The missing canvases – *The Assumption of the Virgin*, *The Trinity*, and the half-length figures of *Saint Benedict* and *Saint Bernard* – have been replaced by copies, so that the character of the altarpiece can still be appreciated (see fig. 34).

Funding for the altarpieces, which were part of a vast project of reconstruction of the church, came from a bequest to the Toledan church of the Madre de Dios made by Doña María de Silva (died 1575), a Portuguese lady-in-waiting to the Empress Isabel.[1] The bequest was diverted to Santo Domingo by Diego de Castilla, who wanted a funeral chapel for himself, his son and Doña María. The programme for the altarpieces, which commemorate the Infancy of Christ, his death and Resurrection, and the Assumption of the Virgin, relate directly to this funerary theme as well as to Cistercian veneration for the Virgin.

El Greco's talents doubtless came to the attention of Don Diego through his illegitimate son Luis, whom the artist would have known in Rome in about 1571–5. It is possible that El Greco was approached for the commission in Rome and that his move to Spain was prompted by the prospect of this magnificent opportunity. Certainly, this commission initiated El Greco's career in Toledo in the most auspicious manner conceivable.

El Greco was supplied with plans of the church as well as designs for the frames of the lateral altarpieces drawn up by Juan de Herrera, Philip II's architect at the Escorial. El Greco had furnished drawings for the project (see cat. 18–19) and he promised to paint the specified scenes to the complete satisfaction of Don Diego and to remain in Toledo until the work was finished. Additionally, he was to superintend the design of the frames as well as of a tabernacle and five statues to adorn the main altarpiece – two of *Prophets* and three of *Virtues* (Faith, Charity and Hope). Like the frames, these statues were carved – with significant modifications – by Juan Bautista Monegro (c. 1545–1621), who was also responsible for the cherubs holding an escutcheon with the *sudarium* (see cat. 17).

This involvement with the frames of his altarpieces as well as with their sculptural adornment was to become typical of El Greco, who owned the architectural treatises of Vitruvius and Serlio and in Venice had learned to model figures in clay and wax to study elaborate poses. It was by means of his carefully articulated, almost rigorously classical frames that El Greco created a neutral foil for the agitated, spiritual world his paintings conjure up. In the great *Assumption of the Virgin*, the Apostle closest to the picture frame turns his back to the viewer, thus closing off the steep, notional space of the painting: the viewer is a distanced spectator. By contrast, in the smaller, lateral altarpiece of *The Adoration of the Shepherds*, a half-length figure of Saint Jerome seems to pose a book on the edge of the frame and turns to address the viewer, serving as a link between two worlds: he is painted in a distinctly more realistic style than the figures of *The Adoration*, positioned deeper in space, and he thus serves as a mediator between the real and the fictive.

The Santo Domingo altarpieces were a fitting debut for Toledo's greatest artistic genius, newly arrived from Italy, his mind filled with the most advanced ideas about the possibilities of art as a communicator of ideas and as a vehicle for the expression of spiritual values. The proposed fee for this immense task, completed in 1579, was 1500 ducats, which El Greco reduced to 1000. KC/XB

1. Doña Maria had wished to be buried in the church of Madre de Dios; Don Diego had Doña María's body removed to Santo Domingo. Doña María is conjectured to have been Don Luis's mother: see Mann 1986, pp. 2–3, 19–20.

Fig. 34 High Altar of the Church of Santo Domingo el Antiguo, Toledo

17 Escutcheon with Saint Veronica's Veil

Oil on wood, 90 × 130 cm
Private collection

According to legend, Veronica met Christ on the way to Calvary and wiped his face with a cloth. This cloth (or *sudarium*) retained his image and became venerated as a true image or *vera icon* (whence the name Veronica). Since the eighth century the *sudarium* has been in St Peter's, Rome. El Greco later made a number of independent paintings showing Saint Veronica displaying the image (see cat. 28). Here the *sudarium* is shown like a precious object, surrounded by an elaborate, carved frame that is held by two athletic cherubs or putti. The ensemble formed part of the elaborate frame of the main altarpiece for the Cistercian convent of Santo Domingo el Antiguo in Toledo.

The escutcheon was removed from its position above the central canvas of *The Assumption of the Virgin* (now in the Art Institute, Chicago; fig. 12, p. 49) and below *The Trinity* (Prado, Madrid; fig. 14, p. 50) in 1961. The 1577 contract with Juan Bautista Monegro provided for an 'escutcheon for figures' ('*un escudo para unas figuretas*') in this position on the frame but it makes no mention of a depiction of Veronica's veil, and the escutcheon was probably intended to receive the coat of arms either of Doña María de Silva, whose will specified that her family devices were to decorate the sanctuary of the church, or of Don Diego de Castilla, who intended to be buried in that portion of the church and whose coat of arms appears on the choir screen and in the main chapel. Certainly, the oval shape and curved surface of the escutcheon would serve this function perfectly. Presumably, it was only later decided to fill the central section with a depiction of Veronica's veil. Marías has suggested that a payment on 16 July 1579 could be for this work, though that document is usually associated with a painting in the Caturla collection, Madrid, which also comes from Santo Domingo. To judge from its style, this was the last part of the altarpiece El Greco painted. Perhaps, once the altarpiece was assembled in 1579, it was felt that the coat of arms was too conspicuously and indecorously juxtaposed with the canvas of *The Trinity*, in which the dead Christ is shown cradled by God the Father and adored by a circle of angels. It was, in any case, this iconography of salvation that the subject of Veronica's veil was intended to complement.

By substituting the *sudarium* for a coat of arms, an image of the living Christ was juxtaposed with one of the dead Christ and emphasis was given to redemption through his Passion and death. Significantly, in their original position the gaze of the two putti was directed towards the altar, so that the miraculous image of Christ's face related both to the dead Christ above and to the tabernacle housing the Eucharist below. For El Greco the change also presented the opportunity of using the real three-dimensionality of the frame to enhance the apparitional quality of the image – of insisting on art as revelation rather than mere description. Typically, he does not paint the *sudarium* as an object, in the way Zurbarán was later to do, but creates a hauntingly disembodied likeness, with Christ staring at the viewer in the fashion of a Byzantine icon. KC

PROVENANCE

Until 1961 part of the high altar of Santo Domingo el Antiguo, Toledo

ESSENTIAL BIBLIOGRAPHY

Cossio 1908, no. 231; Wethey 1962, II, p. 7, no. 6A; Pérez-Sánchez and Jordan in Madrid-Washington-Toledo (Ohio)-Dallas 1982–3, pp. 152–3, 229, no. 8; Mann 1986, pp. 43–4; Marías 1997, p. 144; Hadjinicolaou in Madrid-Rome-Athens 1999–2000, p. 372, no. 21

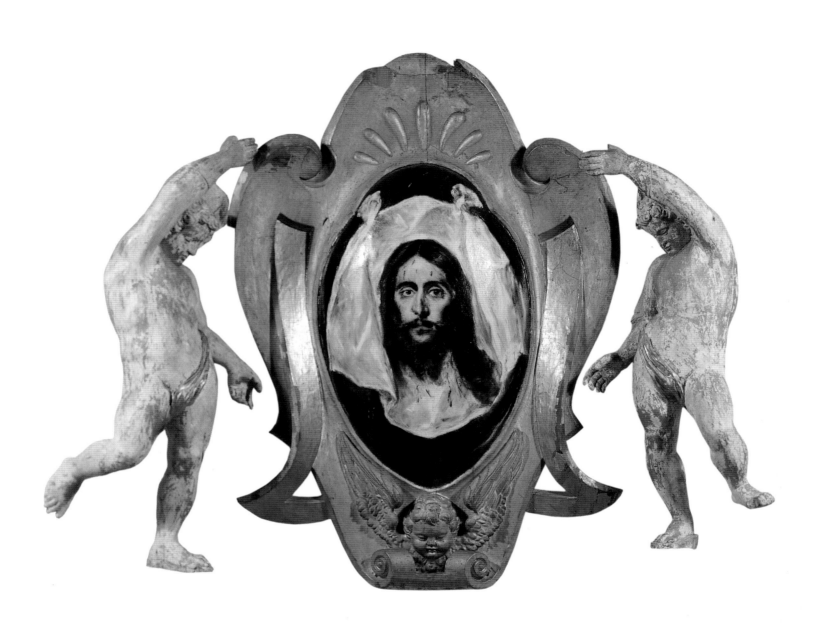

18 Saint John the Baptist, 1577

Pen and brown ink with brown and grey wash,
heightened with white on paper, 13.6 × 5.5 cm

Inscribed in ink in a hand which may be seventeenth-century: *Greco*

Private collection

LONDON ONLY

19 Saint John the Evangelist, 1577

Pen and brown ink with brown wash,
heightened with white on paper, 13.6 × 5 cm

Inscribed in ink in a hand which may be seventeenth-century: *Greco*

Private collection

LONDON ONLY

These two drawings probably once formed part of a much larger composition depicting the altarpiece commissioned by Diego de Castilla from El Greco for Santo Domingo el Antiguo. In its original state, the complete drawing would have served as a 'contract piece' which El Greco would have presented and discussed with his patron. That strict supervision was imposed on El Greco's artistic ideas is reflected in the memorandum attached to the original contract for Santo Domingo, to which the drawing was probably attached. It stressed that Diego de Castilla had the sole and complete authority to accept, reject or order alterations to the finished pictures: 'If any of these paintings are not satisfactory in part or in whole, the said Dominico is obliged to correct them, or remake them, so that the work is perfect and acceptable to Don Diego, canon, whose opinion will be submitted to said Dominico And whatever is said must be done, without any appeal except to that of the wishes of said dean.'[1]

Comparisons between these two drawings and the paintings of *Saint John the Baptist* and *Saint John the Evangelist* (figs. 35, 36), both still *in situ* to the left and right of the central large painting of *The Assumption* (see fig. 34), reveal much about El Greco's thinking and working methods. Initially, El Greco's idea was to set the figures of *Saint John the Baptist* and *Saint John the Evangelist* in niches forming part of the altarpiece that he had designed, recalling those he would have seen in Venice by Jacopo Sansovino. In the drawings, he has carefully defined the architectural lines with the aid of a ruler and compass. Using black and brown washes and white chalk, he suggests a space behind the figures into which their shadows are cast. Working in grisaille, El Greco seems to have been using the example of sculpture in order to understand the fall of light and the volume of the figures and to define the space they were to occupy. In the final paintings, the niches were discarded and instead both figures are shown standing on a clump of earth with blue sky and clouds behind them, probably to create a more direct visual connection with the sky in *The Assumption*.

This example shows how El Greco used drawings to try out poses and test the dynamics of his subjects so as to achieve visual harmony with other elements of a much larger complete composition. The subjects of his paintings needed to relate visually to each other so as to render the iconography of the altarpiece comprehensible to the viewer. Saint John the Baptist, for example, is shown pointing down to the tabernacle or crucifix on the altar placed before the centre of the polyptych, a detail which El Greco kept in the final painting. Instead of being accompanied by the Lamb that symbolises Christ in his sacrificial rôle, as usual, the Baptist is shown here referring indirectly to the Lamb by pointing to the altar where his sacrifice is re-enacted during Mass.[2]

In both the drawing and the painting Saint John the Baptist is shown standing three-quarters to the picture plane, his face turned in *profil perdu*, his body strongly illuminated on the right side, the left cast in deep shadow. In the drawing, this chiaroscuro modelling of form is realised by a deft use of brush and wash and delicate touches of white heightening. In representing his figures in this way, El Greco was

PROVENANCE

William Stirling-Maxwell; by descent to Lt.-Col. William Stirling of Keir; his sale, Sotheby's, London, 21 October 1963 (lot 12); sold at Bonham's, London, 9 December 2002 (lot 101)

ESSENTIAL BIBLIOGRAPHY

Harris 1951, p. 312; Wethey 1962, II, p. 152; Angulo Íñiguez and Pérez Sánchez 1975, I, nos. 157–8; Harris in Hadjinicolaou 1995, p. 486; Bonham's sale catalogue 9 December 2002, pp. 49–56, lot 101 (entry by M. Joannides)

Fig. 35 El Greco
Saint John the Baptist, 1577–9
Oil on canvas, 212 × 78 cm
High Altar, Santo Domingo el Antiguo, Toledo

Fig. 36 El Greco
Saint John the Evangelist, 1577–9
Oil on canvas, 212 × 78 cm
High Altar, Santo Domingo el Antiguo, Toledo

18

19

probably taking into account the natural lighting of the altarpiece from a window on the left. The whole conception looks back to examples El Greco had seen in Italy. The elongation and boniness of the Baptist's body in the drawing recall figures in drawings by Parmigianino, which El Greco may have seen when passing through Parma or in the collection of a fellow Cretan, Michael Damaskinos, who owned a collection of drawings by Parmigianino which he sold on to the sculptor Alessandro Vittoria. However, it is above all Titian's influence in the application of colour and light that is felt in El Greco's painting. Indeed, El Greco may have known Titian's treatment of the same saint in a painting sent from Venice to Philip II in 1574 and known to have been in the Escorial by 1577.[3]

Unlike Saint John the Baptist, the figure of Saint John the Evangelist was considerably altered between the drawing and the painting. The drawing shows the Evangelist symmetrically balancing the Baptist at a similar three-quarters angle to the

picture plane. However, rather than looking down, his head is thrown slightly back as he looks heavenwards. El Greco may have wanted to show him looking up towards the ascent of the Virgin but finally, perhaps after consulting Diego de Castilla, he abandoned this ecstatic posture for a more contemplative stance. A second drawing now in the Biblioteca Nacional, Madrid (cat. 20), shows the Evangelist standing parallel to the picture plane and directly facing the spectator, his head bent forward in rapt contemplation of the open book in his left hand. El Greco's initial idea for the Evangelist's pose was not wasted, however, as he adapted it in his representation of one of the Apostles witnessing the assumption of the Virgin (first from the right; see fig. 12, p. 49). XB

1. San Román y Fernández 1934, p. 3.
2. See Davies 1990.
3. London 2003, pp. 176–7, no. 42.

20 Saint John the Evangelist, about 1577

Black chalk with traces of white, on yellowish paper, squared for transfer
in black chalk, 25.5 × 15.5 cm

Inscribed at lower left, in a seventeenth-century hand
de mano de dominico Greco; and on the right *1.Rl* (1 *real*, the price of the drawing)

Biblioteca Nacional, Madrid, inv. BN. 105 (16–39)

LONDON ONLY

The drawing, now considerably faded, is a study for
Saint John the Evangelist, one of the six canvases that
El Greco painted for the altarpiece on the high altar
of Santo Domingo el Antiguo in Toledo (see figs. 35,
36 and cat. 18, 19).

Very few drawings by El Greco survive. One hundred
and fifty were listed in the inventory of the painter's
possessions after his death in 1614 and the majority
of these must have been by him. We know that
El Greco considered drawing an activity of funda-
mental importance for an artist. In his lively but not
especially lucid annotations to Daniele Barbaro's
edition of Vitruvius' *Ten Books on Architecture*, he wrote
that in order to know how to paint well it is not
necessary to know measurements and proportions
but 'to draw and draw some more [. . . because] to
conquer them [order and disposition] it is
necessary to draw more and more'.[1] He later quotes
Michelangelo who, when asked what was the
essential part of painting, would always reply,
'*dibujar e mas dibujar. . .*', 'to draw and draw some
more, and he never said anything different no matter
how often they asked him'.[2] El Greco held drawing
to be a speculative activity by which an artist could
acquire an understanding of the principles of beauty
and proportion and also a means to exteriorise the
disegno interno, a phrase used by Italian art theorists
to signify the artist's mental concept.

In addition to conveying El Greco's conception
of the saint as a deeply reflective classical sage, the
drawing of *Saint John the Evangelist* served a practical
purpose. The squaring of the sheet indicates that it
was used to transfer the design on to the full-scale
canvas. The small size of the squares indicates that
El Greco was very concerned to transfer the figure
accurately and it suggests that he was not yet used
to working on a large scale. Before receiving the
Santo Domingo commission, El Greco's largest
completed work had been the portrait of *Vincenzo
Anastagi* (fig. 56, p. 252), which measures 188 × 126 cm;
the finished painting for Santo Domingo is
212 × 78 cm. His care may also indicate that he
was very keen to make a good impression with his
debut commission in Toledo. In many respects the
painting (fig. 36) follows the drawing very closely:
the arrangements of the hands, feet and draperies are
virtually identical. The differences are very interesting,
however. El Greco elongated the proportions of the
head and altered the angle but, most significantly,
he did not include the eagle in the painting. The
absence of Saint John the Evangelist's emblem led
the eighteenth-century writer and critic Antonio
Ponz, as well as some modern art historians, to
misidentify the figure as Saint Paul. GF

1. Marías and Bustamante 1981, p. 227.
2. *Ibid.*, p. 236.

ESSENTIAL BIBLIOGRAPHY

Barcia 1906, no. 105; Cossío 1908,
no. 498; Kehrer 1911, pp. 415–16; Hind
1928, pp. 29–30; Sánchez Cantón 1930,
pl. 152; Wethey 1962, II, p. 152; Madrid
1980, no. 128 (entry by A.E. Pérez
Sánchez); Vienna 2001, no. 10 (entry
by U. Becker)

de mano de dominico greco

21 The Disrobing of Christ ('El Espolio'), 1577–9

Oil on panel, 55.6 × 34.7 cm

Signed in two lines on the paper at the lower right
δομήνικος θεοτο / κρής ἐποίει (Domenikos Theoto[kopoulos] Cretan made)

Bearsted Collection, Upton House, Warwickshire (The National Trust)

LONDON ONLY

PROVENANCE

First recorded in the collection of Don Gaspar Méndez de Haro y Guzmán, Marqués del Carpio (died 1687), as is indicated by the monogram *DGH* (Don Gaspar de Haro) on the back of the panel; inherited by his daughter Doña Catalina de Haro, Duquesa de Alba; sold at an unknown date in France and bought by the French painter Eugène Delacroix; at an unknown date in the collection of Baron Schwiter (whose portrait by Delacroix is in the National Gallery, London, NG 3286), until sold in Paris on 3 May 1886 (lot 10); bought by Chéramy, Paris; sold on to Ducrey on 5–7 May 1908

ESSENTIAL BIBLIOGRAPHY

Waterhouse 1930, no. 11; Camón Aznar 1950, no. 150; Wethey 1962, II, pp. 54–6; Upton House 1964, pp. 80–2; Nottingham 1980, p. 11; Massing 1988, pp. 76–81

This panel is probably a reduced autograph replica of one of El Greco's most celebrated works, his *Disrobing of Christ* or '*El Espolio*', measuring 285 × 173 cm, which now hangs in the sacristy of Toledo Cathedral (fig. 15, p. 51). The original painting was commissioned by the dean of the cathedral, Diego de Castilla, on 2 July 1577 to hang in the vestry there. Completed in 1579, it is one of the finest and most important paintings of El Greco's career. It was moved about 1612 from the vestry into the re-modelled sacristy, and in the 1790s was inserted into a new frame, in which it continues to impress visitors today (fig. 37).

Very close in its details to El Greco's original painting, the Upton House version shows Christ clad in a bright red robe and looking up to Heaven with an expression of serenity as he is being tormented by his captors. A figure in the background wearing a red hat points at Christ accusingly, while two others argue over his garments. A man in green to Christ's left holds him firmly with a rope and is about to rip off his robe in preparation for his crucifixion. At the lower right, a man in yellow bends over the cross and drills a hole to facilitate the insertion of a nail to be driven through Christ's feet. The clouds above Christ, painted in strong diagonals, provide a 'path' of uplifting communication between Christ and God the Father.

On the left-hand side of the composition, the three Maries contemplate the event with distress. Above them a soldier wearing a suit of armour reminiscent of those fabricated in sixteenth-century Toledo stares out directly at the viewer. El Greco may have intended this figure to be a contemporary portrait.[1] He may be intended to represent either the Roman centurion at the Crucifixion who exclaimed: 'Truly this man was the Son of God' (Mark 15: 39),[2] or the soldier later named in *The Golden Legend* (c. 1260) as Longinus. He was said to have been cured of his poor eyesight by Christ's blood and converted to Christianity.

The moment of the disrobing of Christ, immediately before his Crucifixion and known in Spanish as *el espolio*, is not specifically mentioned in the Gospels. As an imagined event it came to play a prominent rôle in medieval imagery of Christ's Passion. While the robe of Christ, for which the soldiers played dice after his crucifixion, receives mention in the canonical Gospels (John 19: 23–4), it is in the apocryphal Gospel of Nicodemus that fuller descriptions of the moment of his disrobing can be found: 'And when they [Christ and the two thieves] came to the place, they [the Jews] stripped him of his garments, and girt him about with a linen cloth.'[3] The popular fourteenth-century text attributed to Saint Bonaventure known as *Meditations on the Passion of Jesus Christ* is also a possible source. Details such as the inclusion of the three Maries at the lower left and the rope tied to Christ's wrist are mentioned in this account. The text relates that when Christ became too exhausted to carry the cross any further, it was given to someone else to carry, and he was pulled along by a rope, as a thief would have been. It goes on to describe how he was 'stripped, and now nude before all the multitude'.[4]

Drawing on Greek Passion cycles and especially motifs like *The Kiss of Judas* or *The Arrest of Christ* for his composition, El Greco brought together his post-Byzantine and Western artistic training to produce a masterpiece.[5] Clashing primary colours such as the carmine red of Christ's garment and the yellow clothes of the Magdalen and the figure bending over the cross electrify the violence of the scene. In contrast, the green worn by the Christ's tormentor to his left provides a cooler complement to the red of his clothes, both colours being echoed subtly in the reflection on the soldier's suit of armour. The composition is direct and simple: a crowd of heads behind Christ, two figures balancing each other at his side, and the three Maries arranged in a diagonal, echoing the diagonal formed by the bending man in front of the cross opposite. The lances in the background are set against a deep blue sky, accentuating the verticality of the composition.

The fact that the painting was originally commissioned to hang in the vestry, where priests would don their liturgical vestments before celebrating Mass, the moment in which the sacrifice of Christ was re-enacted, provides an additional dimension to the work's significance. El Greco chose as the main focus of his picture the garment worn by Christ, which is executed with tremendous energy, each fold being emphasised with a strong diagonal. Just

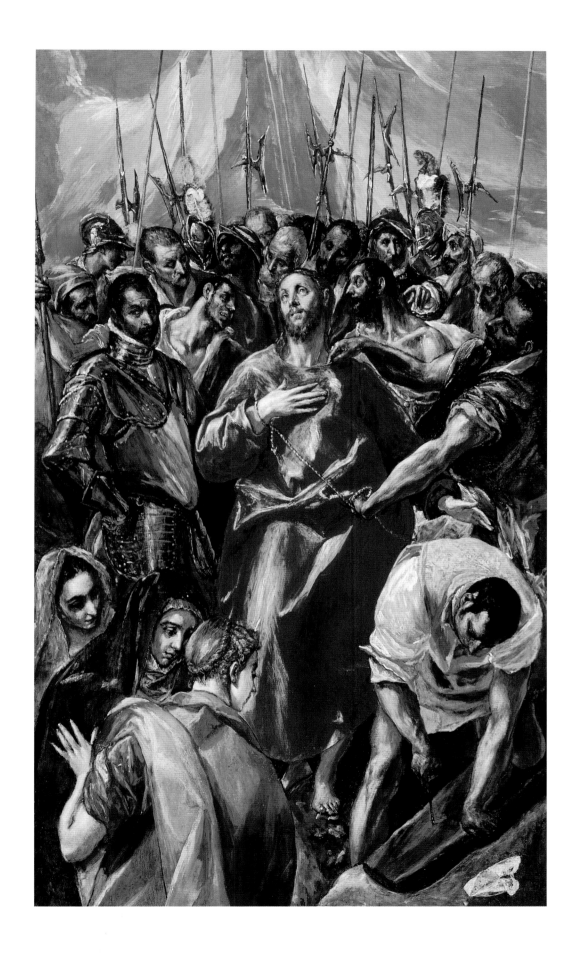

Fig. 37 The sacristy of Toledo Cathedral, with El Greco's **Disrobing of Christ ('El Espolio')** above the polychrome sculpture of **The Virgin presenting the Chasuble to Saint Ildefenso**

as Christ's robe is being removed in preparation for his sacrifice, the colour red being a symbol of his Passion, the priest is putting on his vestments in preparation for Holy Mass. The painting thus provided an ideal reminder of the importance of the ritual.[6] A further reminder of the significance of the priestly vestments is provided by El Greco's polychrome sculpture of *The Virgin presenting the Chasuble to Saint Ildefonso*, commissioned around 1581–5 for placement underneath the picture (see fig. 37). Saint Ildefonso (*c*. 606–667), who became archbishop of Toledo in 657, had a vision of the Virgin with attendant angels

seated on his episcopal throne in the Cathedral of Toledo and presenting him with a chasuble of celestial origin. A chasuble said to be the self-same garment was kept in the Cathedral as a holy relic.

Despite the skill with which it was executed, El Greco's painting met an unfavourable reception from the canons of the cathedral. They declared that the three Maries should not be present in this scene and that it was improper to place the heads of the crowd higher than Christ's. Therefore, when it came to obtaining payment for the painting on 15 June 1579, the customary process of evaluation by both

sides of the completed work set off a bitter dispute. El Greco's representatives set an ambitious price of 900 ducats while the experts on the cathedral's side valued the painting at 227 ducats. No doubt their objections were at least partly of a tactical nature, with the aim of reducing the price; in that case they had the desired effect, as El Greco was eventually obliged to take much less than he felt he deserved. A price of 317 ducats was set on 23 July 1579 and on 14 September 1579 El Greco finally agreed to deliver the picture.

The painting, however, was not installed in its intended location until 1587. Before that, a new contract had to be drawn up, on 9 July 1585, under which El Greco agreed to complete the design of the architectural framework of the altarpiece and provide the sculpture of *The Virgin presenting the Chasuble to Saint Ildefonso* for installation below the painting. The final evaluation for this contract was dispatched on 20 February 1587 by Esteban Jordán, a sculptor from Valladolid, and the cathedral authorities made payment of 535 ducats to the artist the following day. Even though the materials required, such as gold, were costly, it is interesting to note that the price for the gilded altar frame and the sculpture amounted to 218 ducats more than the painting that they were to accompany.

The Upton House painting is one of three existing versions. Another was formerly in the Stanley Moss collection,[7] while a third, considered a workshop copy by Wethey, was last recorded in Mrs Hugo Moser's collection in New York.[8] The first two are painted on pine panels of almost identical size. They may either have been preliminary studies for the

large painting or reduced versions executed for private patrons. The fact that both were at one time held in important seventeenth-century private Spanish collections, the present painting having been owned by Gaspar Méndez de Haro (along with cat. 23) and the other by the Duke of Benavente, suggests that they were considered precious autograph copies after the famous original, and, although the Moss collection picture is looser in handling and bears some minor differences from the original, it is unlikely that either picture would have been presented as sketches to the cathedral chapter. Had that happened, the canons would have had no grounds to object to El Greco's controversial composition. In addition, the prominent underdrawing, visible under natural and infrared light, of the Upton House picture suggests that the composition was copied and then filled in with colour. It is possible that the picture was among 'the originals of everything he had painted in his life painted in oil on smaller canvases' noted by Pacheco when visiting El Greco's studio in 1611.[9] But it has also been suggested by Davies that it may have been painted for Diego de Castilla, along with the replica of *The Adoration of the Name of Jesus* (cat. 23). XB

1. Oral communication, David Davies.
2. As suggested by Wethey (1962, II, p. 52).
3. Walker 1870, p. 186.
4. Saint Bonaventure (1961), p. 333.
5. Byron and Talbot Rice 1930, p. 188, n. 6.
6. Davies 1990, p. 219.
7. Jordan in Madrid-Washington-Toledo (Ohio)-Dallas 1982–3, pp. 232–3, no. 13.
8. Wethey 1962, II, pp. 55–6.
9. Pacheco 1649 (1956), II, pp. 8–9.

Oil on canvas, 140 × 110 cm

Signed at lower left: δομήνικος θεοτοκόπουλος κρής ἐποίει
(Domenikos Theotokopoulos Cretan made)

Monasterio de San Lorenzo de El Escorial,
Patrimonio Nacional, inv. 10014683

The Name of Jesus is represented by the trigram *IHS* with a cross above that appears in a burst of glory at the top of the composition. These three letters are an abbreviation in Latin of the Greek name of Jesus (*IHΣΟΥΣ*). The text on which this complex image is based (as was already recognised by Padre Francisco de los Santos in his description of the paintings in the Escorial of 1657) is from Saint Paul's Epistle to the Philippians: 'Wherefore God also hath highly exalted him [Christ], and given him a name which is above every name: That at the name of Jesus every knee should bow, of things in heaven, and things in earth and things under the earth; And that every tongue should confess that Jesus Christ is Lord, to the Glory of God the Father' (2: 9–11). The painting shows the angels, earthly authorities and the inhabitants of the Underworld submitting to the holy name. To the right the cavernous jaws of Leviathan open up to swallow those condemned to Hell and in the lower right corner a large devil is seen in profile spewing flames. Behind the mouth of Hell is an archway with a bridge from which small figures are being

Fig. 38 Style of Bernaert van Orley (active 1515–1542)
The Adoration of the Name of Jesus
Oil on panel(?)
Whereabouts unknown

flung into a fiery abyss under the direction of two riders on horseback. This scene has sometimes been interpreted as a visualisation of Purgatory, the realm of purification where the souls of those who have died in sin await entry to Paradise.

The painting has also been called *An Allegory of the Holy League* because of the presence in the foreground, kneeling on a carpet, of the main participants in the so-called Holy League that defeated the Turks at the battle of Lepanto in 1571. On the right, dressed in black, is King Philip II of Spain; the Doge of Venice with his back to us seen in *profil perdu* would therefore be Alvise I Mocenigo (died 1577) and in front of him, accompanied by two cardinals, Pope Pius V Ghislieri (died 1572). The military commander resting on a sword to the left of the pope has been said to be Don John of Austria (died 1578), the commander of the League's fleet at Lepanto. The two adjacent figures, one of whom points upwards in the general direction of the heavenly trigram, and the man in blue with arms crossed who kneels on a red cushion, have been tentatively identified as the commanders of the Venetian and papal troops at Lepanto, Sebastiano Venier and Marcantonio Colonna, respectively. With the exception of Philip II, none of the figures is represented in a sufficiently distinctive manner to make any of these identifications certain. The Holy League was established to defend Christendom, but also, as Philip II wrote on 12 April 1571 to his minister Cardinal Granvelle (sometimes thought to be recognisable as the older of the two cardinals in El Greco's painting), to 'defend the holy name' of Christ.[1]

Although it is a highly original work, El Greco's composition conforms to an iconographic tradition. One precedent is a small early sixteenth-century Netherlandish painting in the style of Bernaert van Orley (fig. 38).[2] It shows God the Father, a scroll inscribed with passages from Philippians 2: 9–10, the trigram IHS surrounded by an aureole and adored by the Church Triumphant (in Paradise) and the Church Militant (on earth); under the earth there are souls suffering in hell. The representatives of the Church Militant include three prominent figures, one of whom is a pope and another an emperor. An altarpiece by Martin de Vos of *The Adoration of the Name of Jesus*

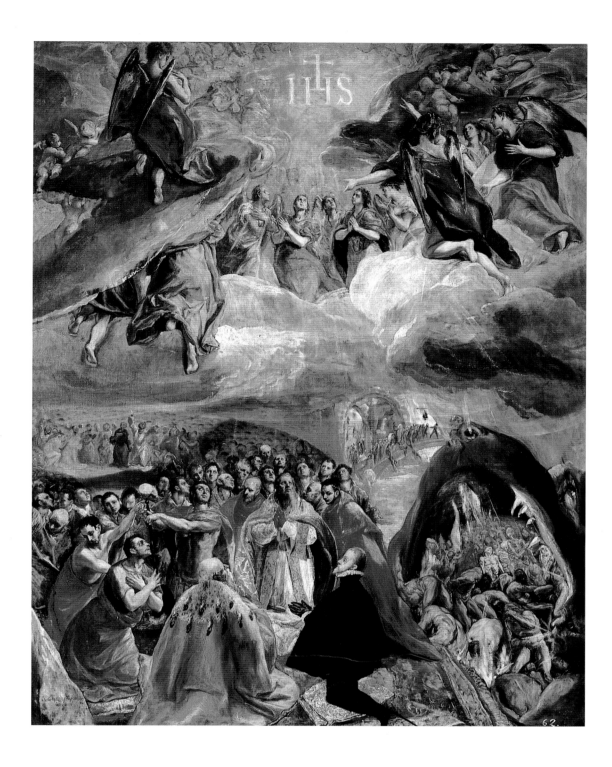

(before 1586) in the homonymous chapel in the church of Saint James in Antwerp contains similar elements, including a pope and an emperor. For certain iconographic elements of his composition, in particular the mouth of Hell and the scene in the middle distance behind it, El Greco seems to have drawn on an engraving of *The Last Judgment* by Giovanni Battista Fontana (published about 1578).[3] Rather than simply an illustration of the text of Saint Paul, the painting is a vibrant vision combining an Adoration of the Name of Jesus, a Last Judgment, and an Allegory of the Holy League.

The prominence of Philip II and the presence of the work in the Escorial monastery from an early date suggests that it may have been intended for Philip himself, and it must be among the earliest works that El Greco painted after his arrival in Spain in 1576. Recent cleaning of the painting, which is in very good physical condition, has shown it to have been executed with pigments of very high quality.

GF

1. Serrano 1914, IV, p. 248; Davies 1999–2000, p. 503, no. 156.
2. Davies in Madrid 1998–9.
3. Braham 1966.

23 The Adoration of the Name of Jesus, late 1570s

Oil and tempera on pine, 57.8 × 34.2 cm (the painted surface, excluding
the painted black border, measures 55.1 × 33.8 cm)

Signed at lower left: *ΔΟΜΉΝΙΚΟΣ ΘΕΟΤΟΚΌΠΟΥΛΟΣ ΚΡΉΣ ἘΠΟΊΗ*
(Domenikos Theotokopoulos Cretan made)

The National Gallery, London, inv. NG 6260

Fig. 39 Reverse of cat. 23

PROVENANCE

First recorded in the Madrid collection
of Don Gaspar Méndez de Haro y
Guzmán, Marqués del Carpio (died
1687), together with the small version
of the *Espolio* now at Upton House
(cat. 21); both paintings passed into
the Alba collection, probably through
Don Gaspar's daughter, Doña Catalina,
who married the 10th Duke of Alba
in 1688; removed from Spain at an
unknown date, probably during the
Peninsular War, and from 1838 to 1848
exhibited in King Louis-Philippe's
Galerie Espagnole at the Louvre; sold
after his death at Christie's, London,
7 May 1853 (lot 112); acquired by Sir
William Stirling-Maxwell; bought by
the National Gallery from his grandson,
Lt.-Col. William Stirling of Keir, in 1955

ESSENTIAL BIBLIOGRAPHY

Blunt 1939–40; Wethey 1962, II, no. 116;
MacLaren and Braham 1970, pp. 27–34;
Madrid 1998–9, no. 156 (entry by
D. Davies)

This is a reduced autograph version of the Escorial
painting (cat. 22) and the present exhibition
provides the first opportunity for the two works
to be seen together. The sequential relationship
between them is problematic and the arguments
in favour of the National Gallery painting being
preparatory for, or a repetition of, the Escorial painting
have been rehearsed by a variety of scholars. The
differences between the two paintings are small but
not insignificant. The National Gallery painting is
on panel, is considerably smaller and has narrower
proportions. The foreground figures are closer
together and the mouth of Hell has been compressed;
the fire-breathing devil that appears in the corner of
the Escorial picture is not present here. The kneeling
figure on the left with arms crossed has a yellow
cuirass rather than a blue one (the smalt blue of
his drapery is a fugitive pigment). Most notably, the
pointing figure at the left of the Escorial picture
does not appear in this work.

In his treatise on painting, Francisco Pacheco
stated that when he visited El Greco in Toledo in 1611
he was shown 'the originals of all that he had
painted in his life, painted in oils, on small
canvases'.[1] The inventory of the artist's possessions
made after his death (1614) lists many small-scale
works, presumably the very ones that Pacheco saw.[2]
The implication of Pacheco's statement is that these
'small canvases' were autograph *modelli* rather than
replicas or *ricordi*, but he may not have intended this
inference. El Greco's general practice may actually
have been to make small repetitions of his work as
the basis for subsequent copies. These would serve
as a record of successful paintings, which he and the
studio could repeat, and possibly also as a catalogue
to show potential clients.

Pacheco's ambiguous comment may be irrelevant
so far as this work is concerned since it is on panel
rather than on canvas, but the combination of icono-
graphic and technical evidence suggests that the
painting is a repetition rather than a *modello*. The
absence of the pointing figure is likely to be due
to the compression of space as a consequence of
the narrower format; the outstretched arms of the
commander to the left of the pope are only intelligible

with reference to the Escorial painting, where he is
resting on a sword. In spite of the sketchy character
of the painted execution, a quality that we know the
artist cultivated even in finished works, the infrared
photograph of the work shows that there is a careful
underdrawing, suggesting he was working from an
existing design rather than inventing a new compo-
sition. Some parts of the underdrawing, for example
the group of angels directly beneath the shining
trigram, are visible to the naked eye. In the Escorial
picture, the arrowhead-shaped bank of cloud on the
left conceals painted areas of the yellow- and green-
clad angels; by contrast, the equivalent passage in
this painting is dense and pentiment-free. The
presence in the National Gallery picture of a carefully
executed black border and a painted reverse (fig. 39),
apparently emulating a wood-grain effect, are addi-
tional elements that argue against the proposed
preparatory nature of this work.

From at least the later seventeenth century and
probably from much earlier, the work was a companion
piece to the Upton House *Disrobing of Christ* (cat. 21), a
small-scale version of the Toledo Cathedral sacristy
picture (fig. 15, p. 51). They share the same technique,
and the dimensions and date of execution of the two
works are approximately the same. The proportions
of the Upton House panel, however, conform quite
closely to those of the altarpiece, and it is possible
that the dimensions of the Upton House panel
determined the dimensions of the National Gallery
picture. Davies has suggested that the first recipient
of these disparate images (assuming that they did
form a pair from such an early date) may have been
Diego de Castilla, the friend and patron of El Greco
who as dean of Toledo Cathedral must have played
a rôle in obtaining for the artist the commission for
The Disrobing of Christ. *The Adoration of the Name of Jesus*
would also have been of direct interest to Diego
de Castilla since after the battle of Lepanto he was
instructed by Philip II to institute an annual feast
to commemorate the victory to which the paintings
of *The Adoration of the Name of Jesus* so evidently refer.
GF

1. Pacheco 1649 (1990), p. 440.
2. San Román y Fernández 1910, pp. 191–5.

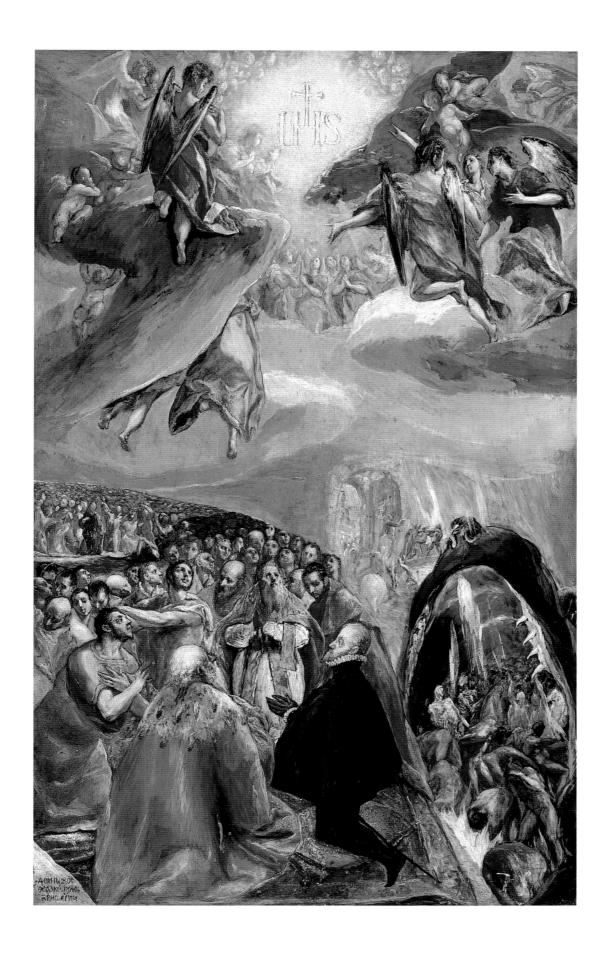

24 **Saint Sebastian**, about 1577–8

Oil on canvas, 191 × 152 cm

Signed on rock: *ΔΟΜΉΝΪΚΟC ΘΕΟΤΟΚΌΠΟΥΛΟC ἘΠΟΙΗ*
(Domenikos Theotokopoulos made)

Museo Catedralicio, Palencia

ESSENTIAL BIBLIOGRAPHY

Cossío 1908, pp. 156, 369, 578, no. 158;
Wethey 1962, I, pp. 38-9, II, p. 147,
no. 279; Madrid-Washington-Toledo
(Ohio)-Dallas 1982–3, p. 230, no. 10;
Kitaura 1987; Marías 1997, pp. 154, 304
n. 30; Trinidad de Antonio in Madrid
1998–9, p. 464, no. 135; Kitaura in
Hadjinicolaou 1999, p. 261; de la Plaza
Santiago in New York 2002, pp. 201–5

A victim of the persecution of Christians under Diocletian in the early fourth century, Sebastian was twice martyred: first by being tied to a tree or post and shot with arrows and then by being beaten to death and dumped in a Roman sewer. His survival of the first attempted killing – thanks to a group of women who found and nursed him – made Sebastian particularly popular during bouts of the plague. Traditionally, he is shown bound to a tree, standing, and El Greco's decision to show him in a more compressed pose, kneeling, is unusual.

The picture is one of the key works of El Greco's first years in Spain. Wethey suggested that the patron may have been Diego de Castilla, dean of Toledo Cathedral and responsible for the artist's first great commission in the city, the altarpieces in Santo Domingo el Antiguo (see cat. 17–20). Before becoming dean in 1551, Diego de Castilla had been a priest, canon and archdeacon at Palencia. His illegitimate son Luis almost certainly knew El Greco in Rome and may have been instrumental in the artist's move to Spain. On the other hand, San Martín Payo has suggested Bishop Zapata de Cárdenas or his protégé, Alonso de Córdoba, as the donor of the canvas. In the cathedral inventories the picture is listed in the Chapel of Saint Jerome, belonging to the Reinoso family, and this has suggested the possibility that Francisco de Reinoso, secretary to Pope Pius V, commissioned the picture. The matter of the identification of the patron remains necessarily conjectural and Marías has reminded us that another, though admittedly far less likely, possibility is that this is the *Saint Sebastian* painted for Bernardino de Mendoza which, around 1582, was placed in the Colegio de Nuestra Señora de Loreto or San Bernardo in Salamanca.[1]

The *Saint Sebastian* is El Greco's first life-size male nude. Throughout his life El Greco was haunted by the example and fame of Michelangelo – the metre by which every artist in Rome was judged. For an artist of El Greco's talent and ambition this must have proved galling. Mancini recounts that El Greco outraged his fellow artists in Rome by declaring that, were Michelangelo's *Last Judgment* in the Sistine Chapel to be demolished, he would replace it with something just as good and more decorous.[2]

Even at the end of his life he felt compelled to affirm to the painter-critic Pacheco that Michelangelo did not know how to paint, though he allowed that when it came to drawing the nude, the great Florentine was the model to follow.[3] The *Saint Sebastian* cannot be detached from this critical position, also involving the relative merits of *colore* versus *disegno* and the reputation of Titian (El Greco's model) and Michelangelo.

The pose of the figure has been thought to derive from Michelangelo's Adam in the *Last Judgment* or his sculpture of *Victory* in the Palazzo Vecchio, Florence. However, while Michelangelo's achievement provided the impetus for tackling the depiction of a life-size male nude, for the specific pose of Saint Sebastian El Greco turned to the sculpture of *Laöcoon* in the Vatican (see fig. 54, p. 239), as Kitaura recognised. The pose is reversed and the left leg bent back in a kneeling position, but in other respects it is reasonably close. The treatment of the right foot, with the toes pressing hard against the ground, attests to El Greco's close study of the statue itself, and not simply of one of the many prints and bronze reductions that populated artists' studios. This classical statue haunted El Greco almost as much as Michelangelo's legacy. The pose of the figure of Saint Peter in the great *Assumption of the Virgin* for Santo Domingo el Antiguo (fig. 12, p. 49) derives from one of Laocoön's sons, and the head of one of the angels in the *Trinity* from the same altarpiece (fig. 14, p. 50) derives from the other. Throughout his career El Greco continued to mine the celebrated sculptural group for formal or expressive ideas. It is quite clear from the *Saint Sebastian* that, like Titian in his polyptych for the church of Santi Nazaro e Celso in Brescia, El Greco translated the pagan priest into a Christian martyr by reference to a posed model, whose features the artist seems to have retained for the face of the young saint.

Yet, if the *Saint Sebastian* was intended to demonstrate El Greco's command of the nude, the results must be said to be equivocal. El Greco's understanding of anatomy was never more than superficial: he lacked the rigorous training of drawing from the nude that Italian artists received as a matter of course. Indeed, when judged by the standards of Michelangelo the figure must be considered a flawed performance.

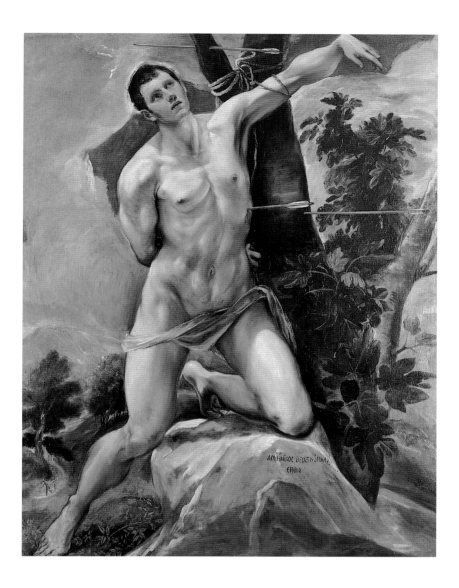

The left arm is poorly foreshortened, the wrist is folded rather than bent, the chest and abdomen implausibly constructed, and the head is far too small for the body. Nor does the picture suggest an artist with any great command of space. The foreground and background are improbably juxtaposed and the clouds skirt the silhouette of the figure in a way that flattens the sky. We need not wonder why a patron like Philip II, with his expectation of academic correctness, preferred the accomplished banality of Rómulo Cincinnato's art or the muscular, Michelangesque figures of Pellegrino Tibaldi to the imaginative licences of El Greco's.

By the same token, El Greco's dazzling painting of details explicitly recalls the work of Jacopo Bassano, whom he greatly admired[4] – for example the study of the light falling on the heel and toes of the left, retracted foot. The fig leaves (a traditional symbol of resurrection) are painted with extraordinary beauty, as are the plants around the saint's right foot and the sun-dappled landscape with executioners on a winding path. Remarkably, despite the awkwardness

in his treatment of anatomy, the painting remains enormously powerful and haunting. El Greco's strength lies in his ability to re-shape visual phenomena to express the spiritual significance of the event he is depicting. Paradoxically, it is not the lack of academic correctness that constitutes the weakness of this picture but the fact that the body of the saint has not been sufficiently distorted and re-cast so as to express the saint's spiritual release from the constraints of the body. Evidently driven by a desire to give a demonstration of what he had learned in Italy, El Greco has put himself at a disadvantage. But this very fact gives us a rare glimpse into his driving ambition as an artist. KC

1. De la Plaza Santiago in New York 2002 (pp. 201–4) gives the best discussion of the possible donors of the painting – including new information that may transform the presumptions underlying the various suggestions. See also de Andrés 1996, pp. 91–120.
2. Mancini 1617–21 (1956), I, pp. 230–1.
3. See Pacheco 1649 (1990), p. 349.
4. For El Greco's comments on Bassano in his copy of Vasari's *Lives*, see De Salas 1982, p. 83.

Oil on canvas, 260 × 178 cm

Inscribed at the head of the cross on a piece of paper
'Jesus of Nazareth the king of the Jews' in Hebrew, Greek and Latin
Signed at the foot of the cross
ΔΟΜΗΝΙΚΟC ΘΕΟΤΟΚΟΠΟΥΛΟC ΈΠΟΙΕΙ
(Domenikos Theotokopoulos made)

Musée du Louvre, Paris, inv. RF 1713

A priest and a nobleman, probably the patrons who commissioned the painting, are shown praying before Christ on the cross. The features and gestures of the man on the right, who has one hand placed against his chest and the other hand open with the palm upwards as if he is about to speak, recall El Greco's portrait of a *Nobleman with his Hand on his Chest* (fig. 58, p. 257). The white surplice of the priest, on the left, is similar to that worn by the priest in El Greco's *Burial of the Count of Orgaz* (fig. 17, p. 54). The two men contemplate Christ's sacrifice with compassion and sobriety, their gaze leading our eyes upwards to those of Christ, who in turn looks up to Heaven, seeking communication with God the Father, possibly at the moment when, according to the narrative of the Crucifixion, he cried out: 'My God, my God , why hast thou forsaken me?' (Matthew 27: 46; Mark 15: 34).

El Greco has included realistic details such as the drops of blood trickling from Christ's forehead,

hands and feet, while leaving his torso and legs unstained. Light and shadow model Christ's musculature, the elongation of his contorted body enhancing a sense of his suffering. Above his head a sheet of paper stuck to the cross informs us in Hebrew, Greek and Latin that he is Jesus of Nazareth, with the additional ironic words in Greek hailing him as the King of the Jews.

El Greco has set the scene in darkness, as recounted in Saint Luke's Gospel: 'And it was about the sixth hour, and there was darkness over all the earth until the ninth hour. And the sun was darkened . . .' (Luke 23: 44–5). To dramatise the sense of pain and turmoil, El Greco contrasts Christ's gracefully curved body with a tormented, almost abstract, clouded sky behind. The eclipsed sun creates zigzag patterns against the clouds, tinged with incandescent light. While representations of the Crucifixion with donors were not unusual in sixteenth-century Toledo, El Greco breaks with precedent by omitting

Fig. 40 Michelangelo (1475–1564)
The Crucifixion, about 1538–41
Black chalk on paper, 36.8 × 26.8 cm
The British Museum, London, P&D DW67

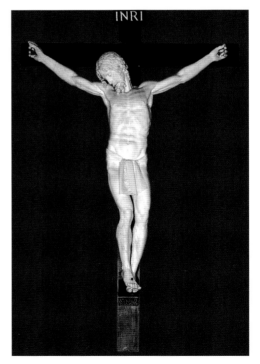

Fig. 41 Benvenuto Cellini (1500–1571)
The Crucifixion, 1556–62
Marble, height 145 cm
Monasterio de San Lorenzo de El Escorial,
Patrimonio Nacional

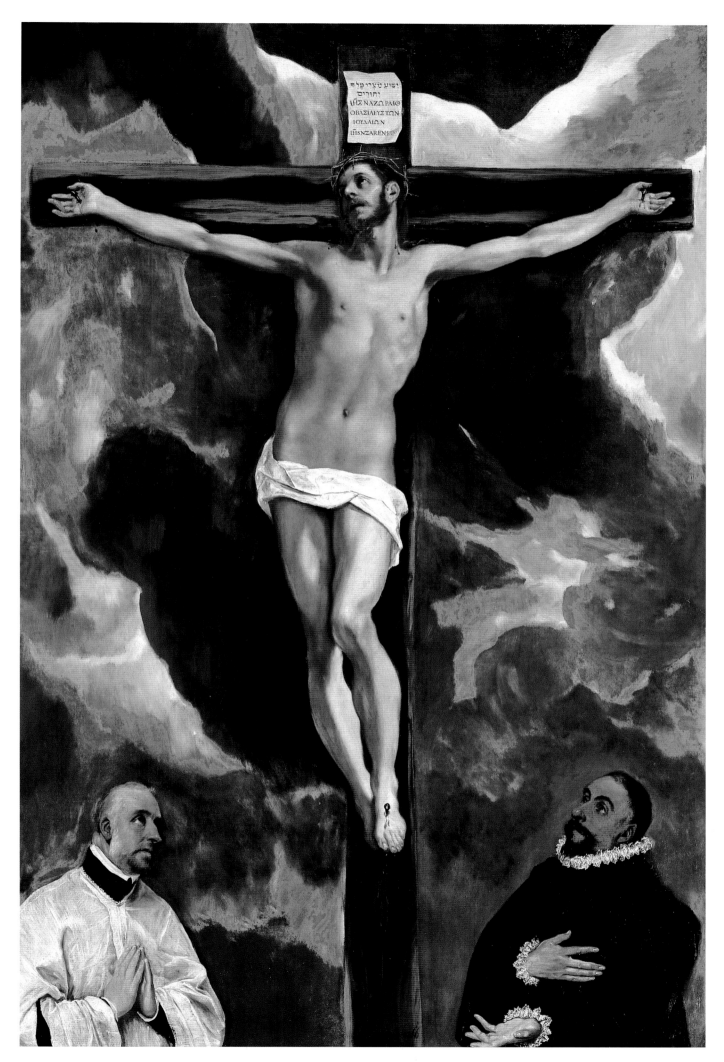

any indications of landscape or other physical context. In so doing, he suggests the duality of human existence, divided between the physical world of the two contemporary figures, the donors, who contemplate Christ's dying moments, and the spiritual world, in which Christ's sacrifice attains its full significance. In its original function as an altar-piece the painting would have presented the two donors at its base on the same level as the priest celebrating Christ's sacrifice during Mass.[1] In this way, the painting would have provided a theatrical backdrop to the consecration of the bread and wine and their transubstantiation into the body and blood of Christ, underpinning the central mystery of the Christian faith.

The date and original setting of this altarpiece are the subject of contention. Wethey suggested an early date, of around 1580, citing the apparent influence of Michelangelo – whose works El Greco would have known in Rome – in the depiction of the naked Christ. As long recognised, the posture and anatomy of El Greco's Christ echo in reverse Michelangelo's drawing of *The Crucifixion* (fig. 40, p. 132) for Vittoria Colonna, on which Vasari commented, 'One sees the body not abandoned to fall like one dead, but as if living, through bitter suffering arousing itself and writhing'.[2] El Greco may also have been inspired by the smooth and subtle anatomy of Benvenuto Cellini's beautifully carved *Crucifixion* (fig. 41, p. 132) given by Cosimo de' Medici to Philip II in 1576 for the Escorial, where it remains today, and which El Greco would have almost certainly seen. His treatment of the male nude is close to that of other compositions known to have

been executed soon after his arrival in Spain in 1577, notably the monumental dead Christ in *The Trinity* from Santo Domingo (fig. 14, p. 50) or the *Saint Sebastian* from Palencia Cathedral (cat. 24). El Greco's later treatments of the Crucifixion, such as that painted for the Collegio de Doña María de Aragón in 1596 (see fig. 21, p. 64), reveal a different approach, in which the body of Christ becomes flatter and less contorted. The Louvre *Crucifixion* is unlikely to be as late as this, but it is possible to suppose a slightly later date for it than that proposed by Wethey.

The first documentary reference to the painting is by the Spanish painter and biographer Antonio Palomino, who saw it in 1715 in a side chapel in the church of the Royal Convent of the Visitation in Toledo.[3] The convent was rebuilt between 1585 and 1593, under the supervision of a canon of the cathedral, Dionisio Melgar, who had reserved a burial site under the main altar.[4] If El Greco's painting was conceived as part of Melgar's decorative scheme, as suggested by Marías, the canon may be the ecclesiastical figure portrayed on the left. The precise realism with which El Greco executes both this figure and that of the donor on the right provides a further clue to the picture's date. In their expressions, dress and appearance, these two figures are reminiscent of the portraits in *The Burial of the Count of Orgaz* (fig. 17, p. 54), executed in 1586–8, a masterly work that similarly emphasises the complementarity of the terrestrial and the spiritual worlds. XB

1. Davies 1990, p. 222.
2. Quoted in Hartt 1971, p. 288.
3. Palomino 1715 (1947), p. 840.
4. See Marías 1983–6, pp. 129–32.

PROVENANCE

Recorded by Palomino in 1715 in the Royal Hieronymite Convent of the Visitation, Toledo; bought by Baron Taylor in March 1836; in the Galerie Espagnole, Musée du Louvre, Paris, January 1838–February 1848; in the reserve collection of the Louvre, February 1848–October 1850; with the heirs of Louis-Philippe, England, October 1850–May 1853; sold at the Louis-Philippe sale, Christie's, London, 7 May 1853 (lot 109); bought by Pearce for £10 on behalf of Isaac Pereire; given by Isaac Pereire to the town of Prades in the French Pyrenees, September 1863; hanging in the town hall of Prades until bought by the Musée du Louvre in March 1908

ESSENTIAL BIBLIOGRAPHY

Palomino (1715–24) 1947, p. 840; Wethey 1962, I, p. 92; II, p. 49, no. 74; Mateo Gómez 1984, pp. 121–3; Marías 1983–6, III, pp. 129–32; Baticle in Hadjinicolaou 1995, pp. 309–13; Marías 1997, pp. 157, 159; Gerard Powell and Ressort 2002, pp. 123–7

26 Mary Magdalen in Penitence, early 1580s

Oil on canvas, 108 × 101.3 cm

Signed at the left
XEIP ΔOMHNIKOY (hand of Domenikos)

Worcester Art Museum, Massachusetts, inv. 1922.5

Portrayed as a hermit saint, Mary Magdalen sits alone outside her cave, which according to legend was at St-Baume in southern France. With glistening eyes, she looks up to heaven pleading for forgiveness. Her elongated neck recalls works by Parmigianino that El Greco could have seen while in Italy. Despite her spiritual anguish, El Greco shows her as a beautiful young woman, her long flowing golden hair reaching down to her waist and her fingers neatly interlocked. Beside her, on a rock, a glass flask for scented oil reminds the viewer of the moment when, as a repentant prostitute, she wept before Christ as he was supping at the house of Simon the Pharisee, then wiped her tears from his feet with her hair, kissing and anointing them with oil of myrrh. Responding to the criticism of those present, Christ told them that her action proved her love, which made her worthy to be forgiven her sins (Luke 7: 36–50). The skull is a reminder of the brevity of life and here is probably intended as a prod to the viewer to confess and obtain forgiveness for past misdeeds before it is too late. The evergreen ivy growing on a rock behind is a symbol of immortality, alluding to the reward of everlasting life that can be reached through penance, as witnessed by Mary Magdalen.

As the archetype of the repentant woman, the Magdalen was a common subject in religious art from the Middle Ages onwards. Images of her became widespread after the Counter-Reformation, reflecting the efforts of the Catholic Church to popularise devotion to the Sacraments, particularly Penance, the value of which as a means of acceding to divine Grace was disputed by the Protestants. The wealthy citizens of Toledo who were El Greco's customers were keen to commission paintings on such themes as Saint Peter weeping (see cat. 27) or Saint Jerome in penitence, both subjects that he treated with originality.

During the course of his career El Greco developed five different compositions representing the Magdalen in penitence. This is an excellent example of the first of these, developed soon after his arrival in Spain. Demand for such images was so strong that El Greco had copies made in his workshop from his originals. In this painting, the refined execution of the drapery and of the still life indicate the hand of El Greco himself. A later version of the same composition in the Nelson Atkins Museum, Kansas City, thought to be of around 1580–5, shows the Magdalen in exactly the same position but with the landscape to the left and the still life to the right.

In conceiving this composition, El Greco drew on Titian's interpretation of the Magdalen in a painting now in the Hermitage (fig. 42), which he could have seen in Titian's studio when he was in Venice, or in a version now lost of the same image sent to Philip II in August 1561. El Greco follows Titian in showing his half-length figure of the Magdalen looking up to heaven, posed in the open air against a rocky background on one side, sprouting with vegetation, and an open landscape on the other. Like Titian, he exploits to sensual effect the long hair that, according to legend, she grew in the wilderness, showing it falling over her shoulders and around her neck. El Greco's rendition, however, is far more emotionally charged, both in the highly mannered depiction of her contorted body and in the effects of the contrasting blues and whites of her drapery echoed in the stormy sky behind. XB

PROVENANCE

First recorded in the Colegio de los Ingleses, Valladolid; then in the collection of R. Langdon Douglas, London; purchased by the Worcester Museum in 1922

ESSENTIAL BLIOGRAPHY

Wethey 1962, II, no. 259; Jordan in Madrid-Washington-Toledo (Ohio)-Dallas 1982–3, no. 9

Fig. 42 Titian (about 1487–1576)
The Penitent Magdalen, about 1561
Oil on canvas, 118 × 97 cm
The State Hermitage Museum, St Petersburg, inv. GE117

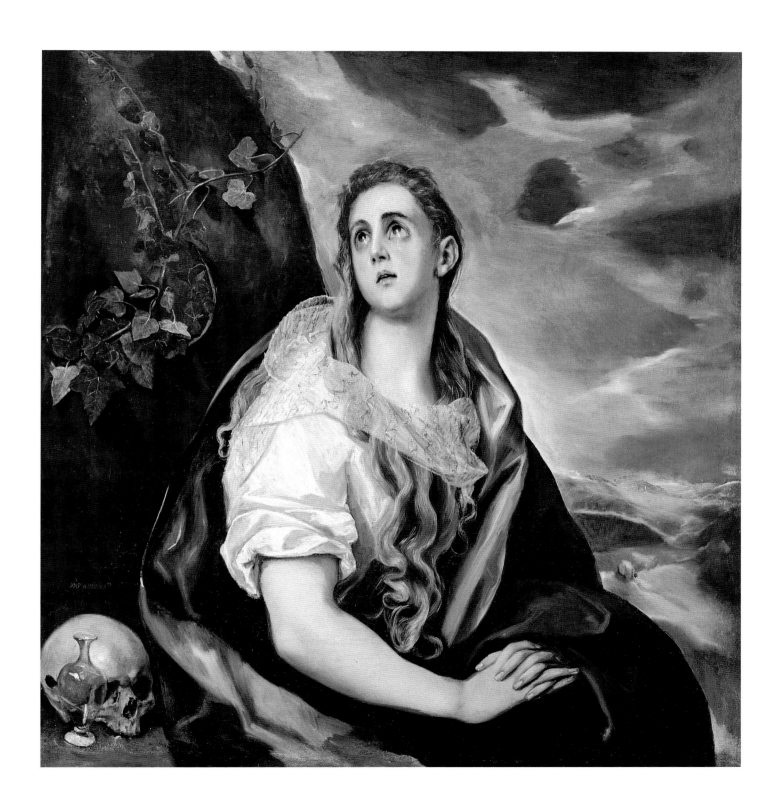

27 Saint Peter in Penitence, 1580s

Oil on canvas, 109 × 90.3 cm

Signed: δομήνικος θεοτοκόπουλος ἐποίει
(Domenikos Theotokopoulos made)

The Bowes Museum, Barnard Castle, County Durham, inv. BM 642

PROVENANCE

Conde de Quinto, Paris (1810–1860;
former Director of the Museo de la
Trinidad in Madrid); his widow,
Condesa de Quinto; sold through the
dealer Benjamin Gogué to John Bowes
for 200 francs, 16 April 1869

ESSENTIAL BIBLIOGRAPHY

López-Rey 1947; Wethey 1962, II, no. 269;
Young 1970, pp. 38–40; London 1981,
no. 5 (entry by A. Braham); Madrid-
Washington-Toledo (Ohio)-Dallas
1982–3, no. 15 (entry by W.B. Jordan);
Young 1988, pp. 83–4, no. 642; Madrid-
Rome-Athens 1999–2000, no. 33 (entry
by J. Álvarez Lopera); Vienna 2001,
no. 17 (entry by A. Wied)

Saint Peter wept tears of repentance after having disowned Christ. His betrayal had been prophesied by Jesus during the Last Supper: 'I tell thee, Peter, the cock shall not crow this day, before that thou shalt thrice deny that you knowest me' (Luke 22: 34). In spite of Peter's protestations of loyalty, after Christ's arrest Peter did deny him, and on hearing the cock crow remembered Jesus's words and 'went out, and wept bitterly' (22: 62). In the painting he raises his tear-filled eyes to Heaven, his hands joined in earnest prayer. This is El Greco's earliest version of a subject he painted in at least six different autograph variants (several of which gave rise to studio copies) over the course of his career in Spain. He made the subject, which was new in the Counter-Reformation period, one of his specialities.

The reasons for the subject's success reside in the fact that this episode of the 'flevit amare' – 'he wept bitterly' in the Vulgate – was associated with the Sacrament of Penance (or Confession), one of the Sacraments of the Catholic Church that had come under attack from the Protestant Reformers. According to Catholic teaching, if a person's sins were to be absolved by a priest, an attitude of contrition was required. Peter's tears demonstrated such contrition; and Christ forgave him and entrusted him with responsibility for the Church, making him the first pope. Thus the image of the weeping Saint Peter touches on two important areas of Catholic teaching, one sacramental and the other institutional – on the importance and validity of the Sacrament of Penance and the primacy of Peter.[1]

However, the devotional qualities of El Greco's painting are perhaps more striking. Several contemporary texts emphasised the importance of tears in devotional practice: Torquato Tasso (1544–1595), the Italian author of the Crusade epic Jerusalem Delivered, wrote poems entitled Le lagrime della beata Virgine and Le lagrime di Cristo (The Tears of the Blessed Virgin; The Tears of Christ), and in 1616 the Jesuit cardinal Robert Bellarmine published an exhaustive theological justification of the spiritual benefit of tears. El Greco, furthermore, shows the saint at the entrance to a cave or before a rock, suggesting physical and spiritual retreat, like that practised by the Magdalen, who appears in the background of the picture, and by Saint Francis (see cat. 45–7); such retreat was also much encouraged by Saint Ignatius Loyola and by Fray Luis de Granada, who in correspondence invited the Cardinal-Archbishop of Toledo, Bartolomé Carranza (died 1576), to retire to the 'yermo' or inner wilderness.[2]

The scene on the left represents the Magdalen returning from the empty tomb after receiving the announcement of Christ's resurrection from an angel. El Greco combines the account in Matthew, which speaks of a single angel sitting on the tomb (28: 1–3), with that in John, according to which the Magdalen runs to tell Peter the news (20: 1–2). The painting is particularly striking for the visionary qualities of the background scene with its incandescent light effects and flashing sky. GF

1. See Mâle 1951 and López-Rey 1947.
2. See Davies in Brown and Pita Andrade 1984.

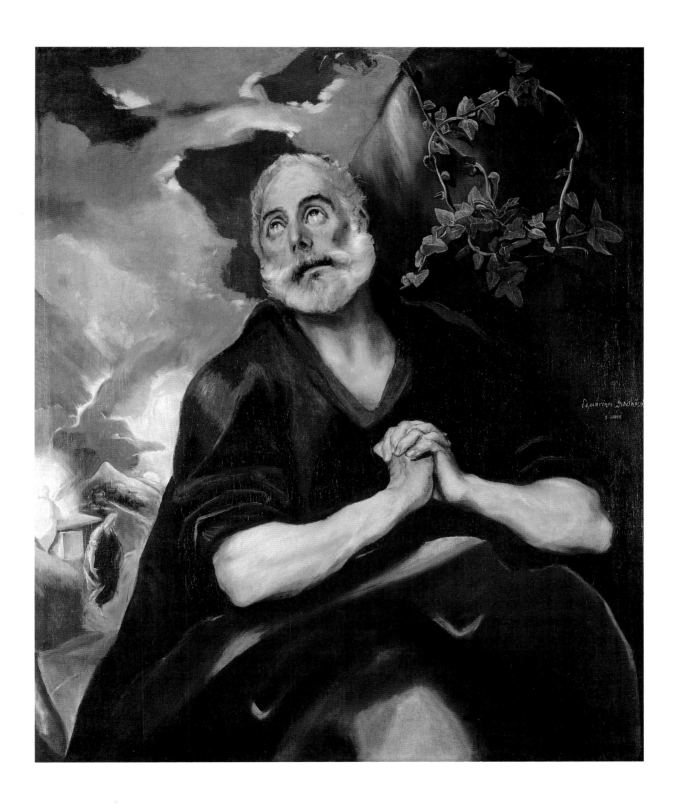

Oil on canvas, 51 × 66 cm

Signed at bottom right: *ΔΟΜΉΝΙΚΟC ΘΕΟΤΟΚΌΠΟΥΛC*
(Domenikos Theotokopoulos)

Private collection

PROVENANCE

According to the 1915 catalogue of
the E. Parès collection, Paris, in which
this painting is first recorded, it came
from a convent in Seville; auctioned
at the American Art Association,
New York, 8–13 December 1919 (lot 711);
bought for the Theodore Szarvas
collection, Chappaqua, New York; with
Wildenstein & Co., New York, until
sold in 1956 to the present private
collection, New York

ESSENTIAL BIBLIOGRAPHY

Mayer 1921, pp. 55–6; Camón Aznar
1950, no. 145; Wethey 1962, II, no. 284;
Madrid-Rome-Athens 1999–2000,
pp. 372–3, no. 22 (entry by
N. Hadjinicolaou)

El Greco reproduces illusionistically a simple piece of white cloth decorated with a geometric design, its two upper corners nailed to what is presumably a board forming the dark background. Imprinted on the cloth, the face of Christ wearing a crown of thorns stares out at the viewer, reminding us of his suffering prior to his crucifixion. His face, painted in a manner reminiscent of Byzantine iconography, is elongated, with high cheekbones accentuated by dark shadows on either side. The creases and folds of the cloth contrast with the serenity of the face of Christ, helping us to retain his image in our memory even when we avert our eyes.

El Greco treated the theme of the veil of Veronica several times. Another version (cat. 17) was executed to replace an escutcheon on the high altar of Santo Domingo el Antiguo in Toledo (see cat. 17). The present painting was probably completed earlier, perhaps for a client who wished to use it as a private devotional image.[1] In another painting that dates from around this time (fig. 43) El Greco shows Saint Veronica holding the veil and beckoning the viewer to come and contemplate it.

El Greco based his image on copies of the miraculous 'true likeness' of Christ preserved in St Peter's, Rome, as a holy relic and commonly known as 'the Veronica'. According to legend, Veronica was a woman of Jerusalem who witnessed Christ carrying the cross on the road to Calvary. Taking pity on him, she wiped his face with a cloth, on to which his features were miraculously transferred. From the eleventh century, images of the veil were widespread throughout Christendom, and the supposed original became one of the most famous relics in Rome. During the sack of Rome in 1527 by German Lutheran soldiers, the relic was removed from its shrine and, according to one contemporary, passed from hand to hand in the taverns of the city.[2] A similar image venerated from the 1530s onwards, although probably only a copy, continued to be a focus of popular enthusiasm. Michel de Montaigne, travelling through Rome in 1581, described how 'people throw themselves down before it upon their faces, most of them with tears in their eyes and with lamentations and tears of compassion'.[3] Such was the presumed power of the image, even in the form of a printed reproduction, that contemplation of it was held to reduce the time that a person's soul would spend in Purgatory.

During his stay in Rome, El Greco may well have seen a copy of the Veronica, but he would also have been familiar with a more ancient Eastern Orthodox version of the image, the Mandylion, or cloth, of Edessa. This miraculous image, the cult of which dates from the sixth century, was known in Greek as *acheiropoieton*, or 'not made by human hand'.[4] According to legend, Abgar, king of Edessa, afflicted by illness, heard of Christ's reputation as a healer and sent a servant to fetch him. Unable to come, Christ took a cloth and used it to wipe his face, leaving on it the imprint of his features and despatching it to the ailing monarch. The supposed original was housed in the imperial treasury of Constantinople from 944 to 1203, and copies of it were widely venerated, not least in El Greco's home territory of Crete. In the present, highly original interpretation of the Veronica, El Greco combines a realistic rendition of Christ's face with the iconic refinements found in images of the Mandylion such as the oval eyes, the elongated face and the serene expression. XB

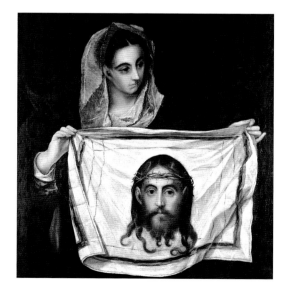

Fig. 43 El Greco
Saint Veronica Holding the Veil,
about 1580
Oil on canvas, 84 × 91 cm
Museo de Santa Cruz, Toledo

1. Davies believes the escutcheon was painted in the late
 1590s on stylistic grounds.
2. See London 2000, p 75.
3. *Ibid*.
4. See Cormack 1985, p. 124–5.

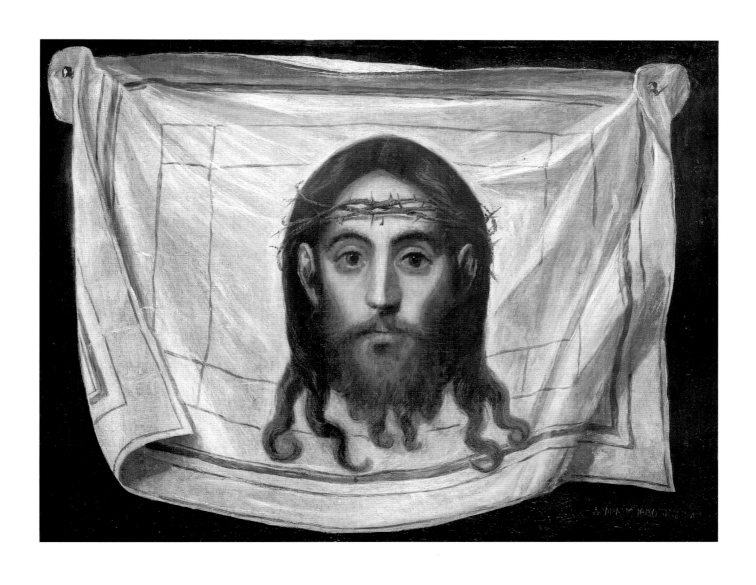

Oil on canvas, 106 × 87.5 cm
The Hispanic Society of America, New York, inv. A74

NEW YORK ONLY

It is curious that we have no devotional images of the Madonna and Child from El Greco's Italian period. Apparently it was only after he moved to Spain that he treated the theme in both half-length and full-length format; then he invariably included Saint Joseph, in keeping with the new prominence the saint was given in Counter-Reformation theology (Saint Teresa of Ávila was a proponent of the cult of Saint Joseph, as was Johannes Molanus, in his 1571 history of sacred images, *De historia sacrarum imaginum*). The Hispanic Society *Holy Family* is El Greco's earliest known treatment of the theme – it dates from the mid 1580s – and served as the point of departure for a larger canvas in the Hospital of Saint John the Baptist, Toledo, in which the composition is further enriched by the inclusion of Saint Anne to the left of the Virgin (fig. 44). Splendid though that picture is, it perhaps lacks the intimacy of the Hispanic Society painting, which Wethey rightly considered 'one of El Greco's finest paintings'.

The figures assert themselves not as physically present but as the embodiments of an ideal of beauty.

Especially the Virgin, who with her high forehead, large doe-like eyes beneath arching brows, bow lips and pale complexion, elegant hands and aristocratic bearing, is as artificially lovely as a Madonna by Parmigianino. As in Parmigianino, so here the con ditioning factors are to be found in conventions established by Petrarch's poetry, in which the individual features of the beloved are almost fetishistically singled out for elaborate description.[1] Any resemblance between this Virgin and the sitter of *A Lady in a Fur Wrap* (cat. 73) should be explained by the common poetic inspiration behind El Greco's ideal female types (we might think of the *Lady in a Fur Wrap* as the equivalent of Parmigianino's *Antea* in Naples).

Petrarchan poetry had biblical precedent and analogy in the Song of Songs – those voluptuous canticles in which the beloved Shulamite woman is described as having 'doves' eyes within thy locks' and 'lips . . . like a thread of scarlet . . . temples . . . like a piece of pomegranate . . . [a] neck . . . like the tower of David builded for an armoury. . .' (Song of Solomon 4: 1–4). The poem inspired a whole genre of mystical religious poetry, of which Saint John of the Cross is the greatest Spanish exponent. It is against this background that El Greco's paintings of the Madonna and female saints should be understood. At issue is an abstracting, conceptualising process that evolved throughout his career. For example, X-rays of *The Holy Family with Saint Anne* in the Hospital of Saint John the Baptist have revealed how the artist began with a more round-faced Virgin, which he then worked over to achieve an image of consummate elegance and refinement. In the present example, the X-radiograph offers a more direct match to the visible image, with El Greco working *alla prima* with whites to build up the Virgin's face, which he then refined less radically with glazes and shadows.

El Greco's approach to aesthetics was notably out of step with other trends that were transforming European art. His painting aspires neither to the placid naturalism and bland classicism characteristic of so much Counter-Reformation painting, nor to the elevated naturalism and warm humanity of Federico Barocci, El Greco's most advanced Italian contemporary. It is one of the paradoxes of El Greco's ideas about art – so far as they can be deduced from

ESSENTIAL BIBLIOGRAPHY

Cossío 1908, pp. 327, 600, no. 308; Du Gué Trapier 1929, pp. 79–80; Wethey 1962, I, pp. 42, 55; II, p. 57, no. 84; Gudiol 1973, p. 111, no. 69; Cossío and Cossío de Jiménez 1972, p. 358, no. 31; Caviró 1985, p. 220; Caviró 1990, p. 305; Kagan 1992, p. 155; Álvarez Lopera in Madrid-Rome-Athens 1999–2000, p. 396; Paris-New York 2003, pp. 446–7, no. 65 (entry by M. Burke)

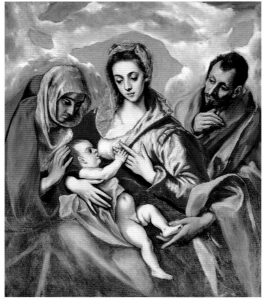

Fig. 44 El Greco
The Holy Family with Saint Anne, about 1590–5
Oil on canvas, 127 × 106 cm
Tavera Hospital (Church of the Hospital of Saint John the Baptist), Toledo

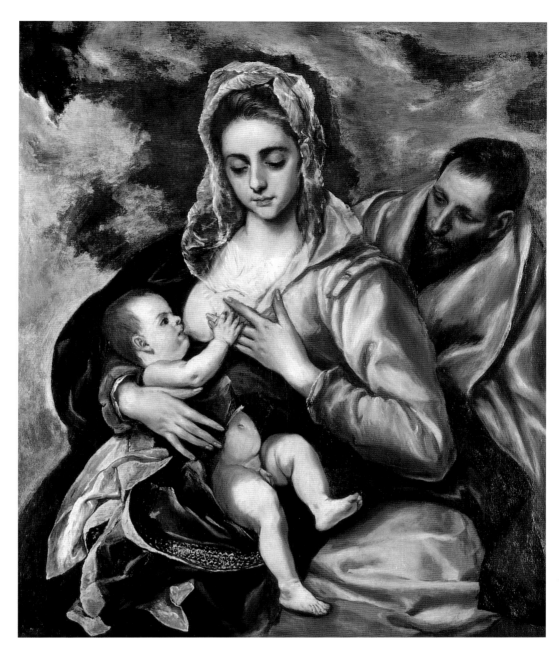

his often contradictory comments penned in the margins of Vasari's *Lives* – that, although he deeply admired the work of Titian and Correggio (other key figures in the creation of Baroque art), and while he was certainly a proponent of the brush over the pen and of *colore* over *disegno*, his devotional images have more in common with the ideals of Mannerism, with its emphasis on the imagination and its extreme, highly sophisticated ideal of grace and beauty.[2] Saint Joseph is no longer the doddering, elderly butt of medieval jokes but rather a powerful male in his prime, and therefore worthy of his rôle as protector of the newly invigorated Roman Catholic Church and as model for Christian family life.

This picture may be the '*Nuestra Señora de la Leche*' owned by Pedro Laso de la Vega, nephew of Cardinal Niño de Guevara: he owned eight paintings by El Greco, among them possibly the *Laocoön* (cat. 69),

the *View of Toledo* (cat. 66) and *A Cardinal (probably Cardinal Niño de Guevara)* (cat. 80). He installed his Madonna in an oratory in Batres. KC/MB

1. The classic treatment of the poetics of Parmigianino's female figures is Cropper 1976. See also Vaccaro in Ames-Lewis and Rogers 1998, pp. 134–42. Vaccaro notes that on one of Parmigianino's drawings for the Wise Virgins on the vault of Santa Maria della Steccata in Parma is a quote from Petrarch: '*Nova beleza in abito Gentile*'. It was a novel or extraordinary ideal of beauty – of divine beauty able to seduce the devout viewer – that both Parmigianino and El Greco pursued.

2. For El Greco's comments on Correggio and Titian see De Salas 1967 and 1982. It is worth noting that El Greco particularly singled out Vasari's passage lauding the figure of Saint Mary Magdalen in Correggio's '*Madonna of Saint Jerome*' (Gemäldegalerie, Dresden), which he qualified as '*la figura unica de Pintura*'. In other words, it was Correggio's ideal of beauty, far more than his naturalistic tendencies – so important to Barocci and the young Annibale Carracci – that especially attracted El Greco.

Oil on canvas, 178 × 105 cm

Signed on a piece of paper on the rock lower right: δομήνικος θεοτοκόπουλος ἐποίει (Domenikos Theotokopoulos made)

Santa Leocadia, Toledo; on loan to the Museo de Santa Cruz, Toledo

NEW YORK ONLY

PROVENANCE

Hospitalillo de Santa Ana, Toledo (on deposit with the Museo de San Vicente, and, after 1961, with the Museo di Santa Cruz, Toledo)

ESSENTIAL BIBLIOGRAPHY

Cossío 1908, p. 585; Camón Aznar 1950, I, pp. 581, 1369, no. 235; Wethey 1962, II, p. 62, no. 93; Gudiol 1973, pp. 197, 349, no. 148; Harris 1974, p. 104; Garrido and Cabrera 1982, pp. 93–101; Madrid-Washington-Toledo (Ohio)-Dallas 1982–3, pp. 234–5, no. 16; McKim-Smith, Garrido and Fisher 1985, pp. 67, 72–3; Marías 1997, p. 204; Madrid-Rome-Athens 1999–2000, p. 391, no. 38 (entry by J. Álvarez Lopera); Vienna 2001, p. 168, no. 21

Sometimes dated to the late 1590s but most probably painted in the mid 1580s – in the same period as *The Burial of the Count of Orgaz* – this is the earliest of El Greco's full-length depictions of the Holy Family. Two inferior paintings derive from it: a smaller version in the National Gallery, Washington, DC, that may be identified with a picture listed in the 1614 inventory of El Greco's possessions, and another in the Prado, Madrid.[1] The primary difference between the Santa Leocadia version and the others is the substitution in those works of a conventional image of Saint Joseph for the balding figure that appears in this one. The figure – in the writer's view unquestionably a portrait of the donor (unfortunately damaged in the proper right cheek and eye) – was painted out at one point and was only revealed by cleaning in 1981.[2] X-rays of the picture made at that time have demonstrated that he was originally shown in a more voluminous cloak and cross-sections have revealed that the cloak was yellow-orange rather than green. The face was also somewhat rounder. These changes should be interpreted as an adaptation of a portrait likeness towards non-specific features.

Conceivably, the picture was commissioned to commemorate the donor's association with the Hospitalillo de Santa Ana (Hospital of Saint Anne), a foundation that ministered to the poor.[3] This would explain both the presence of Saint Anne (the Virgin's mother) and her action of caring for the Christ Child. At the same time, the motif of the sleeping Christ Child adored by his mother has a long history and was traditionally associated with the Pietà and, by extension, with the Resurrection and salvation. Saint Anne's action of lifting the Christ Child's blanket as though it were a shroud reinforces the Pietà theme. Saint John the Baptist turns towards the viewer–worshipper and makes a gesture urging silence so that the child will not be awakened (X-rays show that the turn of the head and torso were modified by the artist – again indicating the primacy of this version). The Baptist holds a bowl of fruit that must allude to the Fall of Man and his salvation through Christ.

We owe to Harris our understanding of the genesis and meaning of El Greco's painting.[4] The idea, or *concetto*, informing it derives from a work by

Michelangelo, a drawing for the Holy Family with the infant Saint John the Baptist that was engraved by Giulio Bonasone. El Greco was not so much interested in Michelangelo's composition as in the motifs of the Christ Child asleep on his mother's lap and the silencing gesture of Saint John the Baptist. The sleeping child recalls a verse in the Song of Solomon (5: 2): 'I sleep, but my heart waketh' (i.e. Christ is ever vigilant). As Harris has observed, Saint John is shown 'not only guarding the Child's sleep but is commanding silence before the mystery of His future sacrifice. Perhaps the gesture [also] carries a reference to the silence that is associated with religious meditation, or even to liturgical silence. . . .' This silencing gesture, which, in the best syncretic tradition, Michelangelo adapted from the classical god of silence, Harpocrates, was taken up by a number of artists, including Annibale Carracci and Domenichino (where, however, it is the Virgin who shushes Saint John). Of special interest is Lavinia Fontana's adaptation in her *Holy Family*, dated 1589 (El Escorial). It was sent to the Escorial in 1593, and there was much admired by Philip II and his court for its beauty, colour and sweetness.[5] Harris suggests that the popularity of Lavinia's and El Greco's images may owe something to the Spanish devotion to 'Il Silenzio'. She remarks that the peaches in the bowl held by Saint John may reflect El Greco's awareness that this fruit was associated with Harpocrates, and of the origin of the motif in classical lore. KC

1. The Washington painting was long considered the model for the other paintings, but it is most probably a reduced variant–replica retained as part of El Greco's workshop stock. Garrido and Cabrera (1982, p. 98) have demonstrated by X-ray examination that the Saint Joseph in the Prado version originally resembled that in the Washington painting. See also McKim-Smith, Garrido and Fisher 1985. For other versions, see Wethey II, 1962, nos. X-105–9.
2. See Garrido and Cabrera 1982. Ruíz Goméz (in Vienna 2001) has tentatively identified the figure of Joseph as a self-portrait – unlikely in this writer's view.
3. See Marías 1983–6, III, p. 282. Nothing certain is known about the early history of the painting.
4. Harris 1974, pp. 103–11.
5. For Michelangelo's drawing see Langedijk 1964, pp. 3–18. Harris (1974, p. 108) quotes Fray Sigüenza's opinion of Lavinia Fontana's painting as well as the enormous price paid for it – 1000 ducats.

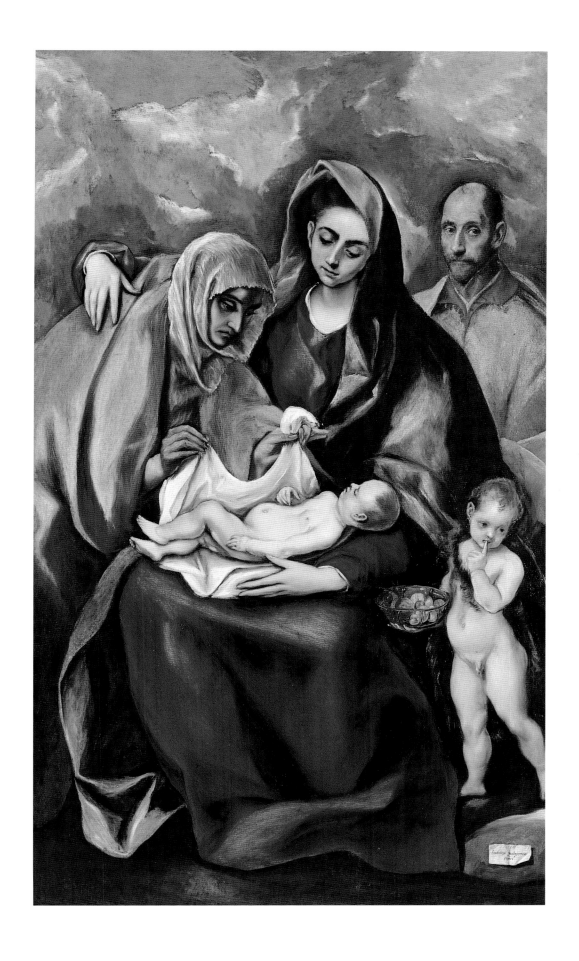

31 The Holy Family with Saint Mary Magdalen, about 1595–1600

Oil on canvas, 131.8 × 100.3 cm
The Cleveland Museum of Art, Cleveland, Ohio
Gift of the Friends of the Cleveland Museum of Art
in memory of J. H. Wade 1926, inv. 26.247

NEW YORK ONLY

This *Holy Family with Saint Mary Magdalen* (identified by the red cloak she wears) is one of El Greco's most appealing devotional images. It was a successful invention, repeated a number of times by his workshop and imitators.[1] The Madonna and Child are more or less repeated in the altarpiece in Washington, DC (cat. 39). The action is deceptively casual: Saint Joseph offers the Virgin a bowl of fruit from which she has selected two pieces to give to the Christ Child. The conceit turns on Mary as the second Eve and Christ as the second Adam: the fruit she offers him is the fruit of redemption that will set aright the Fall of Man. The presence of Mary Magdalen, who gazes with sorrowful intensity at the Christ Child, makes clear the future suffering of this contented baby. Only in El Greco's *Holy Family with Saint Anne* (cat. 30) do we find a similarly anecdotal approach to a religious theme. That picture, however, lacks the mood of warm domesticity that pervades this work, which is, unfortunately, not well preserved.

El Greco's approach to the theme is closely based on Venetian precedent, in which, however, the idyllic scene is usually set in a landscape. But, even if El Greco's more spare and concentrated composition dispenses with indicators of time and place, retaining only the sky, the informal mood is similar. Perhaps the most striking feature of the picture is the still-life detail of the clear glass bowl with fruit, a motif that introduces a contrast between painting as description or mimesis and painting as representation. El Greco was keenly aware of the hierarchies

of style that, in sixteenth-century critical thought, deemed mimesis appropriate for still lifes and portraits but not for religious figures, which should embody a higher realm of existence. He was no less aware of the still lifes of the Toledan painter Juan Sánchez Cotán, which, with their realistic, factual approach to the act of description, were at the opposite pole to El Greco's more 'optical' manner, deeply dependent on Venetian art. In the religious paintings of certain late Mannerist painters – Bartolomeo Passerotti in Bologna, Luis de Vargas in Seville – there is a disjunction between the descriptive treatment of the still-life details and the more abstracting, conceptual style of the figures. El Greco was adept at manipulating style in the interest of the effect he wished to achieve: his portrait style is notably different from that of his altarpieces. If in the late *Immaculate Conception* (cat. 55) the meticulously rendered still life of flowers at the base of the altarpiece contrasts with the abstract figural style and thus emphasises the ascent of the mind from the world of experience to that of divine revelation, in *The Holy Family* the still life sounds a note of actuality that greatly enhances the tender, informal mood of the painting. The picture is usually dated to around 1595–1600 and is said to have come from the Convento de Esquivias outside Toledo. KC

1. See Camón Aznar 1950, figs. 429, 434 and 435, for the versions in Montreal, Bucharest and the Flores collection, Madrid; and Wethey 1962, II, pp. 188–9, nos. X-99–104.

PROVENANCE

Convento de Esquivias, Torrejón de Velasco, near Toledo; Juan Gutiérrez, Torrejón de Velasco; Varga Machuca, Madrid; M. Albarrán, Madrid; Stanislas O'Rossen, Paris, 1908; Marczell von Nemes, Budapest; his sale, Galerie Manzi, Joyant, Paris, 17–18 June 1913 (lot 31); Gentile di Giuseppe, Paris; M. Knoedler & Co., New York, until 1926; from whom acquired by the Cleveland Museum of Art

ESSENTIAL BIBLIOGRAPHY

Cossío 1908, p. 601, no. 310; Milliken 1927; Camón Aznar 1950, I, p. 570; Wethey 1962, II, pp. 58–9, no. 86 ; Gudiol 1973, pp. 142, 345, no. 85; Madrid-Washington-Toledo (Ohio)-Dallas 1982–3, pp. 239–40, no. 27

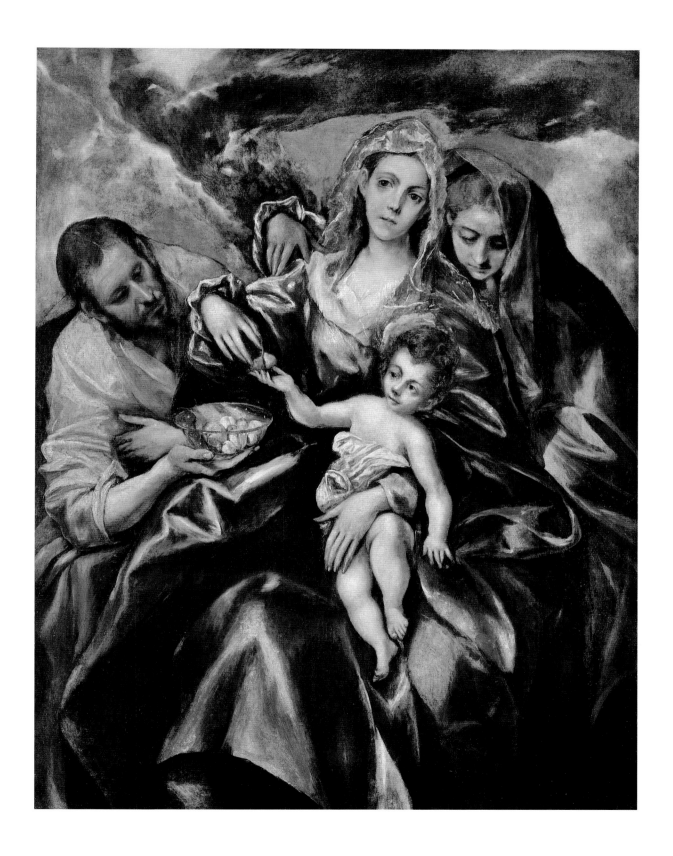

32 Christc carrying the Cross, 1580s

Oil on canvas, 105.1 × 78.7 cm

Signed on the cross above Christ's left hand (not very legible)
δομήνικος θεοτοκόπουλος ἐποίει
(Domenikos Theotokopoulos made)

The Metropolitan Museum of Art, New York
Robert Lehman Collection, 1975, inv. 1975.1.145

ESSENTIAL BIBLIOGRAPHY

Cossío 1908, p. 605, no. 338; Wethey 1962, II, p. 38, no. 50; Camón Aznar 1970, pp. 368, 1345, no. 131; Gudiol 1973, p. 347, no. 107; Baetjer 1981, p. 79; Madrid-Washington-Toledo (Ohio)-Dallas 1982–3, pp. 237–8; Brown in Sterling 1998, pp. 170–3; Vienna 2001, p. 172

Almost certainly painted in the same decade as *The Burial of the Count of Orgaz*, with which it shares the same exalted representational technique, the Lehman *Christ carrying the Cross* is among El Greco's most beautiful devotional images. Its success may be judged by the existence of no fewer than seven closely related versions, not counting another, somewhat different, type in which Christ is shown gazing upwards to the left, clasping an upright cross.[1] It is an image for private meditation and presents Christ not as the suffering Saviour but as transfigured by his Passion and submission to God's will. The picture is conceived as a means to lead the worshipper to that particular kind of mental prayer promoted by Church reformers such as Saint Teresa of Ávila that had as its goal transcendence of the physical world and, through contemplation, attainment through Grace of the union of the soul with Christ.

The special character of El Greco's painting is best perceived when it is compared to what has been recognised as its ultimate source, the two versions of *Christ carrying the Cross* by Sebastiano del Piombo, one in the Hermitage, St Petersburg, the other in the Prado, Madrid.[2] The earlier of these, the Prado picture, which was possibly painted in the 1520s for Luis Fernández de Córdoba, Charles V's ambassador to the papal court, shows Christ, his head bent under the weight of the cross, accompanied by two additional figures, one of whom is a soldier. The picture isolates a narrative moment from the Way to Calvary for the worshipper's contemplation. The idea of showing Christ moving towards us was without real precedent – almost all previous depictions show the movement parallel to the picture plane, with Christ turning his head to engage the viewer's gaze – and it understandably had an immense influence in Spain. In variants ascribed to the Flemish painter Michel Coxcie – an artist much esteemed by Philip II – one of the attendant figures in the background may be either Simon of Cyrene or Barrabas, thereby introducing a further meditation that we find taken up in the devotional writings of Fray Luis de Granada (his *Libro de la oración y meditación* of 1572).[3] Sebastiano re-considered the narrative implications of his first version in the second painting, executed in the 1530s

for Fernando de Silva, Conde de Cifuentes. In this work Sebastiano eliminated any narrative element: Christ is shown bearing his cross, making his inexorable way towards the viewer. As Hirst has noted, Sebastiano's pursuit of 'an ideal of pathos . . . is prophetic of the devotional art of [Luis de] Morales and . . . combined with a new hint of preciosity (as in the drawing of the elegantly abstracted single hand), may have been the painter's calculated response to Spanish taste'.[4] When, on a papal diplomatic mission in 1626, Cassiano dal Pozzo visited the Escorial, he remarked on the placement of Sebastiano's painting above the prior's seat in the choir of the church in the Escorial and noted that it was 'most dear' to Philip II.[5] The immense prestige of the work can thus easily be imagined: it was, in fact, repeated by the most important Spanish devotional painter of the sixteenth century, Luis de Morales.

Like Sebastiano's, El Greco's Christ and the cross he holds are angled towards the picture plane, at a slight diagonal. Unlike Sebastiano, El Greco does not isolate a narrative moment for contemplation. Rather, he abstracts the features from which the narrative was composed: the noble Christ, beautiful and conveying no pathos; the cross, rendered weightless; the crown of thorns, shown breaking above Christ's brow and drawing drops of blood from his forehead; and the elegantly drawn hands, which do not so much grasp as delicately embrace the cross and are expressive of Christ's ineffable spirituality. Most importantly, he eliminates any indicators of action and time. In these ways he shifts the character of Sebastiano's devotional image from empathetic to contemplative. As so often with El Greco, his artistic notion of physical beauty, or *grazia*, becomes the primary means for expressing divine Grace. KC

1. See Wethey 1962, II, pp. 37–41. The related type (Wethey's 'type III') was clearly inspired by Michelangelo's *Risen Christ* in Santa Maria sopra Minerva, Rome. El Greco's point of departure was an engraving (in the same direction as this image) after the celebrated marble statue.
2. On these see especially Hirst 1981, pp. 80–1, 133–5.
3. See González García in Madrid 1998–9, pp. 197, 508.
4. Hirst 1981, p. 135.
5. *Ibid.*, p. 135 n. 54.

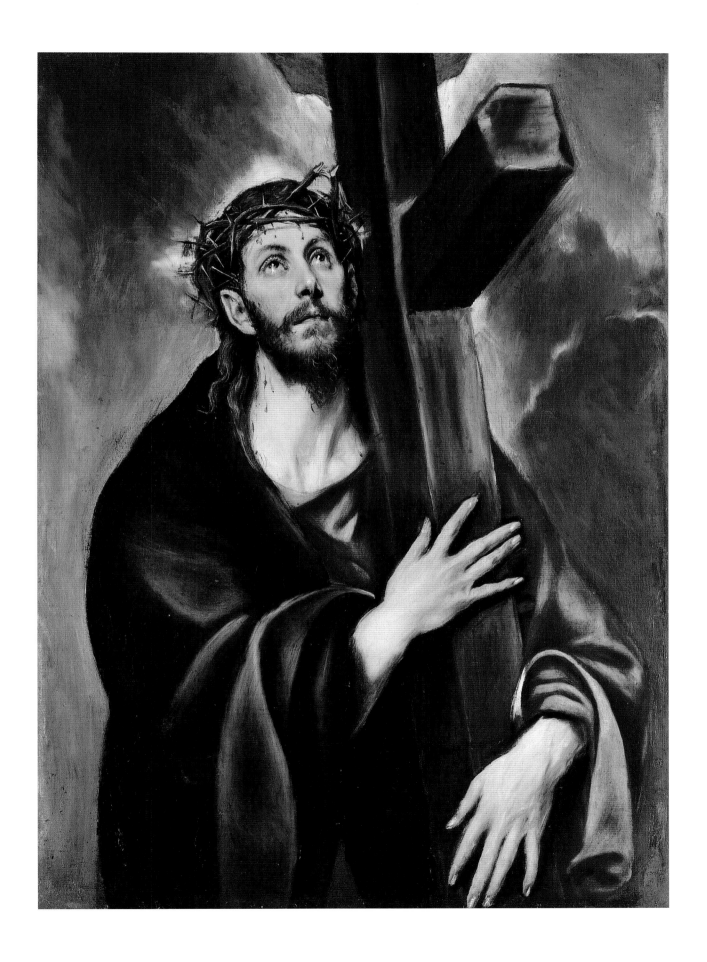

33 Saint Dominic in Prayer, about 1586–90

Oil on canvas, 118 × 86 cm

Signed on the rock at lower left: δομήνικος θεοτοκόπουλος ἐποίει
(Domenikos Theotokopoulos made)

Placido Arango Collection, Madrid

NEW YORK ONLY

Among the subjects mentioned in the 1614 inventory of El Greco's studio is *Saint Dominic holding a Cross*, a composition known from an engraving of 1606 by Diego de Astor. The picture catalogued here treats the same subject in a different, more novel manner. It shows the thirteenth-century founder of the Dominican order kneeling in isolation on a rocky plateau in prayerful devotion before a crucifix. Behind him is a landscape with one of El Greco's haunting skies filled with swirling, back-lit clouds that enhance the mood of spiritual agitation. The picture must have been painted during the time El Greco was working on *The Burial of the Count of Orgaz* and, within the genre of individual saints, is one of his finest inventions. The composition was repeated by his workshop over the next quarter century with little variation;[1] the versions in Toledo Cathedral and the Museum of Fine Arts, Boston, date from the first decade of the seventeenth century.

Both the individual features El Greco has given the saint and the depth of feeling communicated by the figure are remarkable. It is worth considering the possibility that the picture was based upon the features of a particular person. There was a tradition for such 'personified' portraiture, for example Giovanni Bellini's portrait of Fra Teodoro da Urbino as Saint Dominic (National Gallery, London) or Lorenzo Lotto's portrait of a Dominican friar as Saint Peter Martyr (Harvard University Art Museums, Cambridge, Massachussetts). Even more relevant is the report that the devout Augustinian friar Alonso

de Orozco (1500–1591) would allow himself to be portrayed only when the painter Juan de la Cruz proposed using him as a model for a depiction of Saint Augustine.[2] Perhaps indicatively, in later versions of the canvas El Greco made Saint Dominic's features more conventional, giving less emphasis to the finely shaped goatee and greater emphasis to the tonsure (curiously invisible in this painting).

None of the later paintings attains the same combination of expressive intensity and poignant humanity found in the Arango picture, which may owe its deeply affective character to this intersection of portraiture – the sitter being someone El Greco knew personally – and devotional image. To this possibility should be added Davies's proposal that the picture is in some sense a response to the dispute among contemporary Dominicans over the relative importance of mental prayer and penance and preaching, scholarship and education, which had been the traditional Dominican emphasis. The picture speaks clearly in favour of penance and an internalised form of spirituality.

The crucifix, viewed in strong foreshortening, propped against the rocks, is repeated by El Greco in a number of paintings showing saints in devotion: he must have created a drawn or painted model that he could refer to for replication. KC

1. See further Wethey 1962, II, pp. 112–3.
2. See Mann 1986, p. 51.

PROVENANCE

A. Sanz Bremón, Valencia, until 1924; Marqués de Amurrio, Madrid; by inheritance to Jaime Urquijo Chacón, until 1970; Madrid; Placido Arango, Madrid

ESSENTIAL BIBLIOGRAPHY

Cossío 1908, no. 273; Wethey 1962, II, pp. 112–3, no. 203; Gudiol 1973, p. 152, no. 95; Madrid-Washington-Toledo (Ohio)-Dallas 1982–3, pp. 235–6, no. 18; Davies in Madrid-Rome-Athens 1999–2000, p. 204

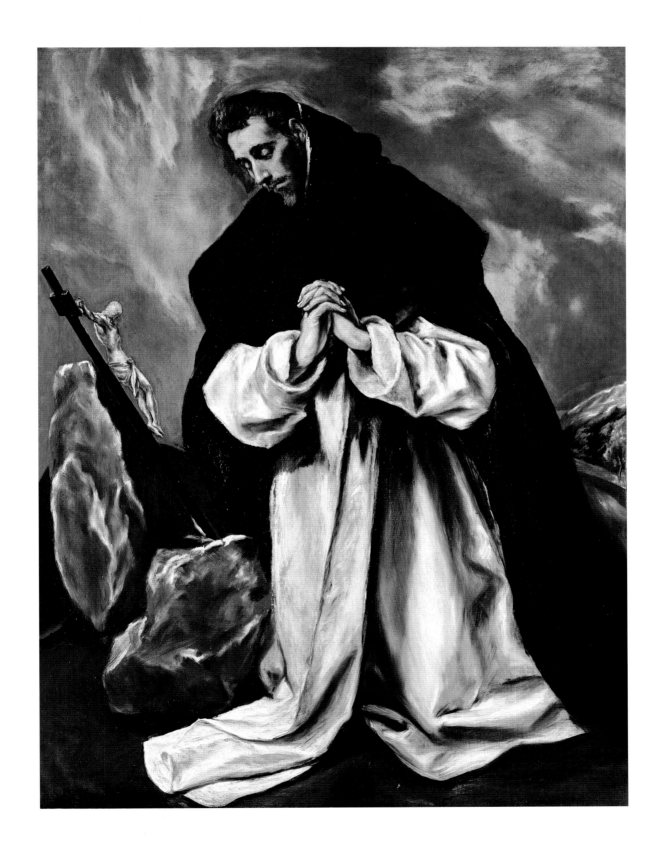

34 The Agony in the Garden, early 1590s

Oil on canvas, 102.2 × 113.7 cm
The Toledo Museum of Art, Toledo, Ohio, inv. 1946.5
Purchased with funds from the Libbey Endowment,
Gift of Edward Drummond Libbey

PROVENANCE

Cacho collection, Madrid, until about
1919; with Lionel Harris, London; with
Durlacher Brothers, New York; Arthur
Sachs, New York, by 1928; acquired by
the Toledo Museum of Art in 1946

ESSENTIAL BIBLIOGRAPHY

Wethey 1962, II, no. 29; MacLaren and
Braham 1970, pp. 37–9, under no. 3576;
Davies 1976, pp. 13–14; Madrid-
Washington-Toledo (Ohio)-Dallas
1982–3, no. 22 (entry by W.B. Jordan)

Fig. 45 Studio of El Greco
**The Agony in the Garden of
Gethsemane**, 1590s
Oil on canvas, 102 × 131 cm
The National Gallery, London
NG inv. 3476

Three paintings of this subject are mentioned in the inventory of El Greco's possessions drawn up at his death in 1614 by his son Jorge Manuel, identified in each case as 'Una orazion del guerto' (literally, A prayer in the garden). Five are listed in the 1621 inventory of Jorge Manuel's goods, and this probably includes versions by Jorge Manuel himself. If one allows for a certain number of paintings of the subject made for clients and sold directly by father and son, and therefore not listed in the inventories, *The Agony in the Garden* is one of the artist's most successful inventions. El Greco himself painted the subject both as a horizontal and as a vertical composition, and this painting is probably the prototype, or at any rate the best autograph version, of the horizontal type.

El Greco's representation is shot through with emotional and spiritual drama. The agitation experienced by Christ before the Passion is reflected in the way the different kinds of light, both real and supernatural, thrash around the scene. The moon shines through the clouds, investing them with a glassy three-dimensionality so that they appear about to crash into the rocky outcrop that frames the figure of Christ. The rock itself reflects the heavenly

beams that pour down on to Christ, which seem to turn the rock into flames; and on the left the cloud that bears the consoling angel is transformed by illumination into a transparent chrysalis that envelops the slumbering Apostles Peter, James and John. On a formal level, the treatment of light in the picture has a fragmenting rather than a unifying effect, but it thereby becomes a dramatic player in the narrative which focuses on Christ's spiritual state: 'My soul is exceeding sorrowful, even unto death', he says in the Gospel of Saint Matthew (26: 38), and Saint Luke adds, 'And being in agony he prayed more earnestly, and his sweat was as it were great drops of blood falling down to the ground' (Luke 22: 44). El Greco has avoided a literal rendition and shows Christ enwrapped in a mystical experience.

The artist introduces details contained in all four Gospel accounts but he also draws on established iconographic tradition. None of the Gospels, for example, states that the angel bore a chalice, but the motif is traditional and is an allusion to Christ's words: 'O my Father, if this cup may not pass away from me, except I drink it, thy will be done' (Matthew 26: 42). The tree stump in the left foreground is almost certainly a reference to the simile of Christ as a sapling cut down in its prime (see Isaiah 53: 2 and Luke 22: 31). Works by such painters as Carpaccio, Bassano, Titian and Tintoretto have been proposed as the models upon which El Greco based his interpretation of the scene. Some scholars have drawn attention to such Byzantine elements such as the rock behind Christ and the enclosure of the Apostles in a circle. Ultimately, El Greco's treatment of the theme remains a highly original one.

In the versions painted as upright compositions, of which the finest are the recently cleaned paintings in the parish church of Santa María in Andújar near Córdoba and in the cathedral at Cuenca (cat. 35), the handling of space and recession is more conventional, and the debt owed to engravings of the subject by Giulio Bonasone (after Titian's painting in the Escorial) and Cornelis Cort (after Federico Zuccaro) more obvious. A high-quality studio version of the Toledo, Ohio, painting is in the National Gallery in London (fig. 45). GF

35 The Agony in the Garden, about 1600–5

Oil on canvas, 86 × 50 cm

Signed lower right (fragmentary)

δομήνικος θεοτοκόπουλος ἐποίει

(Domenikos Theotokopoulos made)

Diocesan Museum, Cuenca

NEW YORK ONLY

PROVENANCE

Parish church of Las Pedroñeras
(Cuenca), before 1928

ESSENTIAL BIBLIOGRAPHY

Camón Aznar 1970, II, pp. 812–33, 1343,
no. 104; Wethey 1962, II, pp. 28–31,
no. 34; Gudiol 1973, pp. 204, 245, 354,
no. 210; Bermejo Díez 1977, pp. 349–50;
Tokyo 1986, p. 189; Monedero 1992,
pp. 134–5

The Cuenca painting is a fine example of the vertical composition of *The Agony in the Garden*, which is closer than the horizontal variation (see cat. 34) to its Venetian precedants, most famously represented by Titian's nearly square composition in the Escorial. The fact that El Greco's Venetian contemporary Francesco Bassano painted an *Agony in the Garden* in a vertical format almost identical to this (private collection, Florence) may suggest a common prototype or a source in a print as yet unidentified.[1]

In the Cuenca picture one finds almost the complete range of El Greco's brushwork. The hands of Christ reveal the flickering brushwork of his earlier Byzantine period. The rendering is more striated on Christ's face, characterised with sure touches on the eyes, eyebrows, nose and mouth that carry expression even at a considerable distance. Particularly impressive, epitomising El Greco's mature works of the 1590s, is the fluid, colourful, yet anatomically powerful rendering of the angel. The faces of James and John (the two Apostles to the left) are modelled tenderly, with delicate glazes, even as the treatment of their bodies exhibits a powerful sense of human anatomy, for example in the way the wrist of the central Apostle supports his head or in the way the yellow mantle of the Apostle to the left curves around the forms of his legs. At the upper right one has a foretaste of the feathery, highly abstract brushwork of El Greco's late works.

Overall, the picture offers a gentle progression into depth from left to right along the lower register. Whereas in some works by El Greco the space is discontinuous, jumping abruptly from foreground to middle or far distance, in Mannerist style, the Cuenca composition allows the movement from the Apostles to the area around Christ to be mediated by a fence made of recently cut wood and a grassy path. The fence functions iconographically as well, recalling, like the tree stump in the horizontal composition (see cat. 34), Luke 23: 31; but we also note how the fence separates the fallibly human, sleeping Apostles – and, by extension, the human viewer – from the divine person of Jesus. It was this gap between the human and the divine that the Counter-Reformation Church sought to bridge.

Wethey accepted as El Greco's own four versions of this 'type II' *Agony in the Garden*: a work at Andújar, Spain, which he considered autograph and the prime version; another at Budapest, which he also considered autograph; and a canvas at Buenos Aires and the present example, both of which he felt showed the intervention of El Greco's workshop. Other authors have proposed numerous other versions as autograph. What Wethey did not note is the fact, first commented upon by Camón Aznar, that the Cuenca version is not only smaller but also considerably more vertical than the other three in his group, with the sleeping Apostles compressed more tightly together and the rock behind Christ becoming extremely thin. The increased verticality yields a more heightened tension and, as Camón Aznar also realised, augments the emotional impact of the scene – which is far greater than the small scale of the work might suggest.

Wethey also spoke of 'weak' drawing and 'mechanical workmanship' in the Cuenca version, but he must have been focusing on the figure of Saint Peter at lower right, which has clearly been abraded and retouched (although there remains the possibility that the picture was here unfinished and was completed by an assistant or follower). A review of old photographs of the picture suggests that it has suffered overall abrasion: Christ's pink robe – so light that it reproduces as white in black and white photographs – seems formerly to have been darker, and it may have lost glazes in the course of cleaning during the past eighty years.[2] With the exception of the lower right area, the canvas appears to be largely autograph, and, *pace* Wethey, filled with extraordinarily effective brushwork. The date generally proposed for the picture, between 1600 to 1610, while acceptable for the other three versions, does not fit the fluid handling and more careful description of the angel, Christ and the faces of the two Apostles at the left. Allowing for the considerable variety of autograph brushwork within the work, we should perhaps allow for a wider range of dates, 1590–1605.

MB

1. See Tokyo 1986, p. 189, fig. 19e.
2. General Reference Photographs, Iconography Department, The Hispanic Society of America. The earliest photograph in the set was catalogued in 1929.

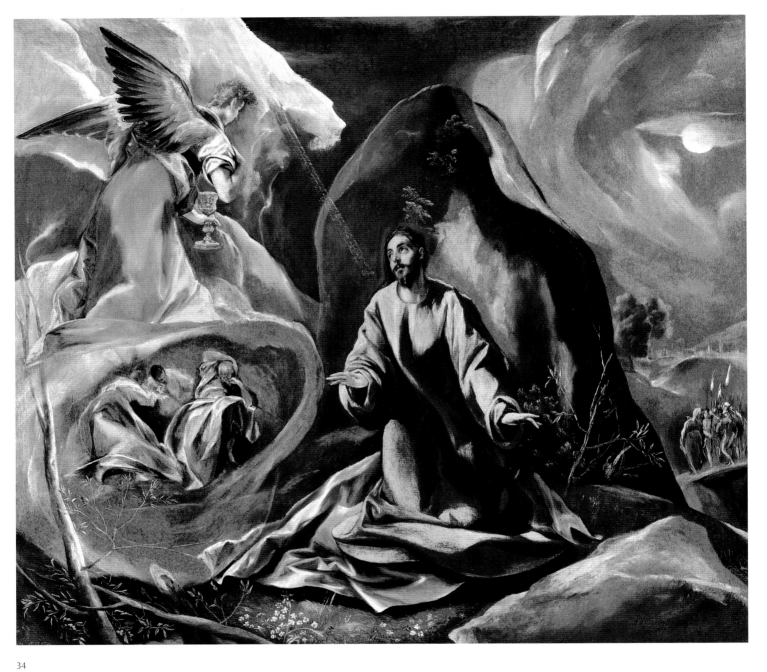

34

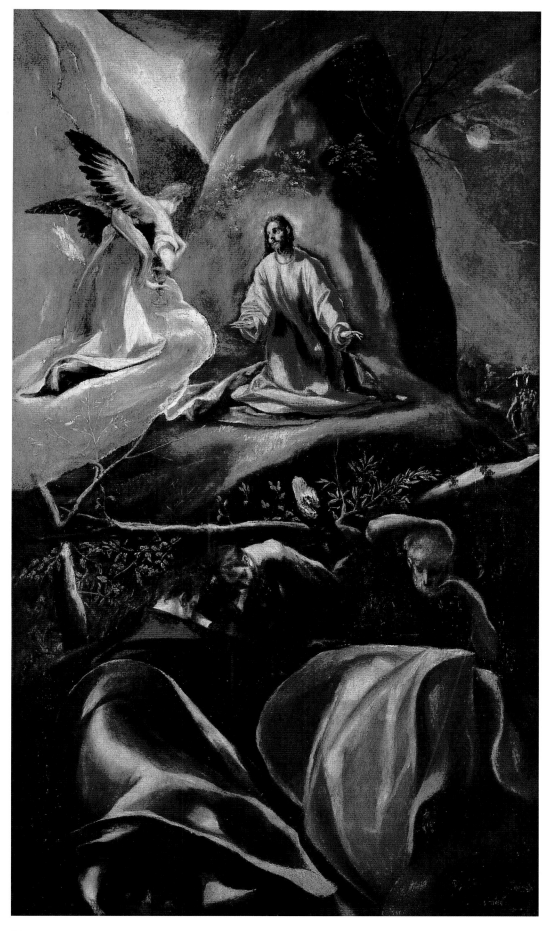

35

36 Saint Louis, King of France, with a Page, probably 1590s

Oil on canvas, 120 × 96.5 cm
Musée du Louvre, Paris, inv. 1507

PROVENANCE

In the collection of the Conde de
Quinto, Madrid, around 1843–54;
sold by the Countess of Quinto in
Paris in 1864 (lot 41, as *Saint Ferdinand*);
acquired by Mr Winterbottom, with
whom the painting remained until
it was sold on 27 April 1870; bought
for the collection of the Château de
Chenonceaux, where it remained
until around 1889; in the Michel Manzi
collection until 1903, when it was sold
via H. Glaenzer to the Musée du Louvre

ESSENTIAL BIBLIOGRAPHY

Wethey 1962, II, pp. 148–9, no. 256;
Marías 1997, p. 262; Madrid-
Washington-Toledo (Ohio)-Dallas
1982–3, p. 236, no. 19 (entry by W.B.
Jordan); Gerard Powell and Ressort
2002, pp. 118–23

El Greco depicts the French crusader king, Louis IX (1214–1270), clad in armour of a style made in Toledo in the sixteenth century and accompanied by his page wearing sixteenth-century courtly attire with an ornate ruff. The night landscape under moonlit clouds in the background, recently revealed during cleaning in 2000, is reminiscent of El Greco's representations of Toledo in the late 1590s (see cat. 66). Just visible are the cliffs that descend to the river Tagus. In presenting Louis in a contemporary Toledan context, El Greco may have been responding to the desire of the patron to establish a direct link between himself and the saintly French monarch.

A lay member of the Franciscan order, Saint Louis dedicated his life to the poor, inviting thirteen homeless people to his palace for a midday meal every day and distributing food in the streets. He founded hospitals for the blind and for lepers, built monasteries and created institutions such as a home for reformed prostitutes. In 1248, he led a crusade to liberate Jerusalem from the Saracens, returning to France in 1254 following his mother's death. In 1270, he set off again for the Holy Land but contracted typhoid on the way and died in Tunisia. He was canonised by Pope Boniface VIII in 1297.

In sixteenth-century Toledo, the virtues associated with Saint Louis were highly prized by the wealthy citizens who were El Greco's patrons. El Greco's portrait of *Capitán Julián Romero* (Prado, Madrid) shows the French king accompanying the kneeling donor in prayer. In 1620, El Greco's follower Luis Tristán (1576–1649) painted *Saint Louis giving Alms* (Louvre, Paris) for the cloister of the Church of Saint Peter the Martyr in Toledo.

Here El Greco alludes to Louis's military campaigns by presenting him in a suit of armour similar in design to that worn by Saint Martin of Tours in his picture (cat. 38) commissioned by a Toledan scholar in 1597. Louis's kingship is demonstrated by his large golden crown, decorated with points in the shape of the fleur-de-lys, the insignia of the French monarchy. In each hand, Louis bears a sceptre, one with a hand with two raised fingers as a symbol of justice and the other with a fleur-de-lys. A length of red drapery across his left shoulder and around his waist gives warmth and movement to the composition. The gold-damascened decoration of the armour, still a speciality of Toledan craftsmen today, is portrayed with thick impasto. A design of a small female figure holding a tablet is visible on the right-hand shoulder-plate.

Although this is a religious image, it is similar in composition to military portraits such as Titian's *Alfonso d'Avalos, Marchese del Vasto, with a Page* (1533, Marquis de Ganay, Paris). The model for the boy holding Saint Louis's helmet may also have posed for the figure of Jesus in El Greco's *Saint Joseph and the Christ Child* (1597–9), painted for the main altar of the Capilla de San José in Toledo (fig. 46). Behind, the base of a column provides an architectural complement to the scene, and possibly alludes to Louis's reputation for constancy and steadfastness.

We do not know who commissioned this painting, but we may suppose it to have been someone who wanted to show commitment to the noble ideals that he represented. Gerard Powell has suggested that it may have been painted for Luis de Castilla, to whom El Greco was closely linked (see cat. 17–20), in honour of his patron saint.[1] As regards the date of the painting, visual evidence, including the design of the armour, the features of the page and the detail of the landscape, argues in favour of the early to mid 1590s, rather than, as previously suggested, around 1585–90. XB

1. Gerard Powell and Ressort 2002, pp. 120–2.

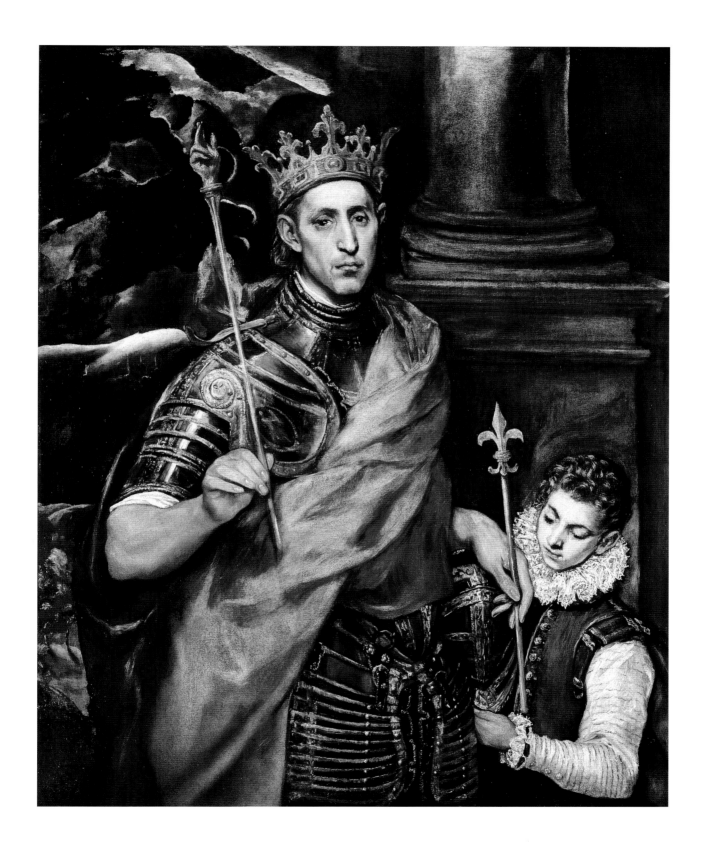

37 The Virgin Mary ('Mater Dolorosa'), 1590s

Oil on canvas, 52 × 36 cm

Signed: δομήνικος θεοτοκόπουλος ἐποίει (Domenikos Theotokopoulos made)

Musée des Beaux-Arts de Strasbourg, inv. MBA 276

Although sometimes referred to as a *Mater Dolorosa*, this is not strictly speaking an image of the anguished mother of Christ meditating upon his Passion. Rather it is a less specific devotional painting of the Virgin Mary, ultimately deriving from Byzantine prototypes, intended for private prayer. She looks directly at the viewer with large liquid eyes, with a gaze that is intended to convey maternal love and care, although it subliminally suggests a mild diffidence. As a religious image it is intended to function in a similar way to *Christ as Saviour* (cat. 49).

The image is one of great intensity, the tall and narrow picture-field almost completely filled with the life-size bust of the Virgin brought right up to the picture plane. She wears a white veil with small crisp parallel creases along the edge framing the elegant oval of her face. Over this she wears a cloak of ultramarine blue painted with remarkable freedom in long confident strokes. The arrangement is similar to that worn by the Virgin in *The Disrobing of Christ* in Toledo Cathedral sacristy (see cat. 21). The outer contour of the cloak has been refined with strokes of the same white paint that makes up her halo, and one can make out the underlying blue in several places. In Spain El Greco rarely painted conventional haloes; here the sacred nature of the Virgin is represented by means of an intense radiance that vibrates around her head and contains an outer ring of blue grey that breaks up into luminous radial rays.

The gaze of the Virgin, fundamental to El Greco's conception, is central, too, to one of the most widely recited devotional hymns to the Virgin, the *Salve Regina*: 'Eia, ergo, advocata nostra, illos tuos misericordes oculos ad nos converte...' (Turn then, most gracious advocate, thine eyes of mercy towards us). But the artist, raised in the Orthodox tradition, was also deeply aware that icons were not only looked upon by the devout but also contained a mystical presence: they, too, had eyes to look upon the faithful.

A version of the painting, usually described as autograph, and bearing a signature (retouched), is in the Prado (inv. 829). The Virgin's expression differs slightly there and she has a gentle smile on her lips.

GF

PROVENANCE

Sir John Charles Robinson, London, by 1868; acquired by Wilhelm von Bode and donated by him to the Strasbourg Museum in 1893

ESSENTIAL BIBLIOGRAPHY

Cossío 1908, no. 3; Haug 1929; Wethey 1962, II, no. 97; Gudiol 1971, no. 99; Madrid-Rome-Athens 1999–2000, no. 49 (entry by M. Borobia)

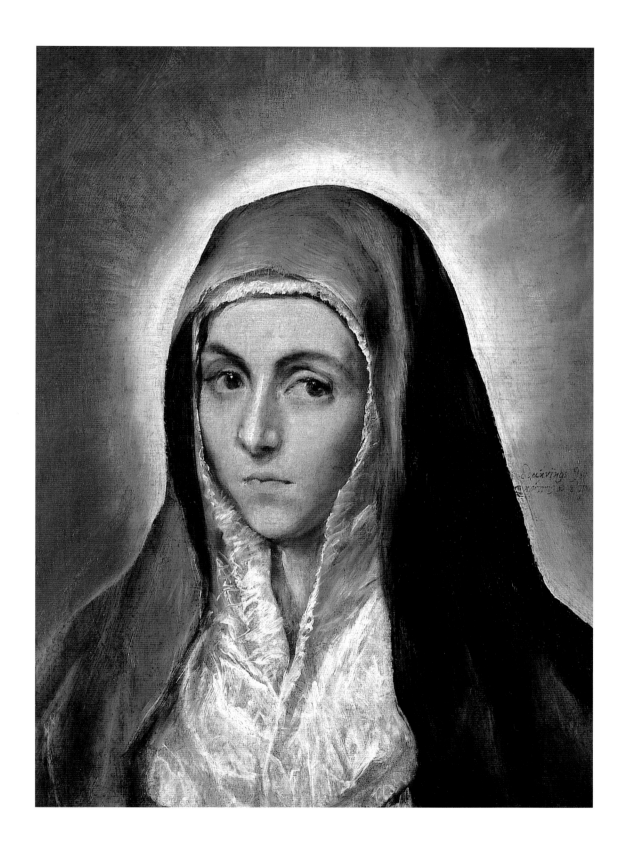

On 9 November 1597, El Greco signed a contract to execute a series of paintings for the newly built Capilla de San José (Chapel of Saint Joseph), Toledo. The contract specified that El Greco was to paint the altarpieces himself and design and gild the frames. The centrepiece of the decorative scheme was to be a painting of *Saint Joseph and the Infant Christ* with *The Coronation of the Virgin* above it. These two paintings, set in an altarpiece in a Palladian style designed by El Greco, though its surroundings were altered by Baroque additions around 1665, are still *in situ* (fig. 46); recent cleaning has revealed their masterly quality. In addition, El Greco was commissioned to paint two side altarpieces, the pictures exhibited here (cat. 38 and 39). *Saint Martin and the Beggar* hung on the left-hand side of the main altar, while *The Virgin and Child with Saints Martina and Agnes* was placed directly opposite, on the right-hand side of the altar, where they remained until they were sold in 1906 to the American collector Peter A. B. Widener.

The commission for the Capilla de San José was one of the most important undertaken by El Greco since Santo Domingo el Antiguo in 1577–9 (see cat. 17–20). Conceived on a much smaller scale than the Santo Domingo commission, it demonstrates his ability to execute pictorial schemes suited to his patrons' taste and religious aspirations. The chapel's visual harmony and complex religious iconography served as a prototype for later commissions such as those for the church of the Hospital de la Caridad at Illescas in 1603–5 (cat. 48) and the Oballe Chapel in the parish church of San Vicente in 1607 (cat. 55–8).

The background to the commission is complex, as the wishes of the chapel's original founder, Martín Ramírez (1499–1569), were considerably altered by his executors. A wealthy unmarried Toledan merchant, probably of Jewish extraction, known in Spain as a *converso* (having converted to the Christian faith), Ramírez wanted to be remembered as a devout Christian committed to good works. The inscription above his tomb in the chapel states that he gave money to the poor and to the Royal Hospital in Toledo. In his will, he expressed his desire to support the newly founded order of the Discalced Carmelites, led by Saint Teresa of Ávila, by providing

Fig. 46 The Capilla de San José (The Chapel of Saint Joseph), Toledo

them with part of his palace and with money to build a convent and a chapel dedicated to Saint Joseph in Toledo. However, the construction of the convent seems to have been deliberately delayed by his executors, who instead set out to transform the original project into a family burial chapel.

Building work began in 1588 and the chapel was consecrated on 24 December 1594. At a later date, possibly after the death of Ramírez's brother-in-law, Diego Ortíz de Zayas (1521–1611), who had married Francisca Ramírez (1540–1579), two sarcophagi were placed on either side of the main altar. Possibly designed by El Greco or his son Jorge Manuel, they are similar in design to the ark and the obelisk with a ball on top that appear in the background of El Greco's late *Purification of the Temple* from San Ginés (cat. 9). Martín Ramírez was buried to the left of the altar while Diego Ortíz and his wife were placed to the right, in each case with a plaque above stating that they were co-founders of the chapel.

The contract for the decoration of the chapel was signed on behalf of the Ramírez family by the son of Diego Ortíz and Francisca Ramírez, Dr Martín Ramírez de Zayas (1561–1625), a professor of theology at the University of Toledo and chaplain to the chapel.[1] A date of August 1598 was set for completion, but nothing more is heard about the commission until 13 December 1599, when Dr Martín Ramírez agreed to withdraw an action to have the appraisal of El Greco's work reduced and to pay a total of approximately 2850 ducats. Of that sum about 636 ducats was to be withheld and paid directly to the artist's creditors – 136 ducats to a linen merchant, who probably supplied material for canvases, and 500 ducats to the famous still-life painter Juan Sánchez Cotán, for a claim not specified.[2]

The choice of Saint Joseph as the patron saint of the chapel and subject of the main altarpiece reflects both its original founder's devotion to the saint and his respect for Saint Teresa, whose devotion to the husband of the Virgin Mary was well known. She dedicated the first convent that she founded in 1562 in Ávila to Saint Joseph, claiming he was 'the father of my soul'. The year in which El Greco received the commission for the chapel also saw the publication by the Carmelite priest Gracián de la Madre de Díos

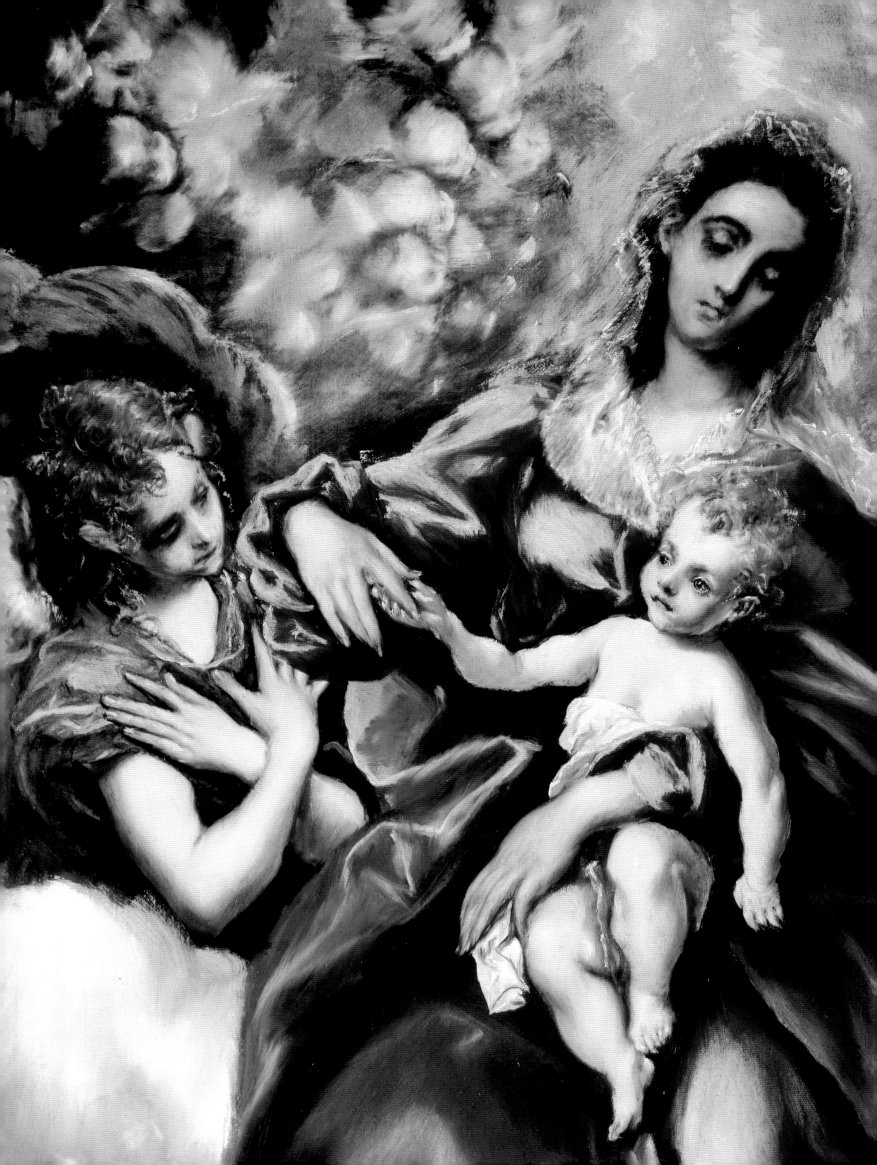

of his *Grandeza y excelencias del glorioso San José* (Greatness and excellences of the glorious Saint Joseph; Madrid 1597), one of the earliest and most successful formulations of the iconography of the saint as a strong and vigorous man, the earthly protector of the Virgin and the Christ Child (see also cat. 29). A few years later, in 1604, José de Valdivieso, prebendary of the cathedral of Toledo, composed his *Vida, excelencias y muerte del gloriosísimo patriarca San José* (Life, excellences and death of the most glorious patriarch Saint Joseph), a poetical work of exalted lyricism praising the virtues of Saint Joseph.

In his painting, El Greco shows Saint Joseph leaning towards the Christ Child, while the Child seeks his protection by nestling against him. In place of Joseph's traditional attribute of the rod in bloom, El Greco has substituted a shepherd's crook, thereby emphasising that he is protecting Jesus, clad in a blood-red garment, as the Lamb of God whose sacrifice is re-enacted during the celebration of the Mass.[3] Hovering above them are angels bearing flowers and a crown made of an olive branch, in recognition of Saint Joseph's patient and understanding rôle in fostering a son that was not his. Reflecting the influence of contemporary movements for spiritual reform, Joseph is shown emaciated and barefoot against the background of Toledo.

Two sculptures, of David and Solomon, situated on either side of the main altar and possibly also designed by El Greco, introduced an Old Testament father-and-son duo that mirrored Joseph's foster-father relationship with Jesus while at the same time underscoring Jesus's human ancestry, as a descendant, through his mother, of King David. An inscription beneath David's pedestal links Jesus directly to the city of Toledo, over which, it states, he will reign forever 'like a fruit filled with seed'. An inscription beneath Solomon alludes to Joseph's humility in accepting his rôle as foster-father of the Son of God.

In contrast to the earthly context in which El Greco presents Joseph and Jesus, *The Coronation of the Virgin*, above, is set in the celestial sphere. On either side of the painting, which shows the Mother of God being crowned by the Holy Trinity, sculptures (possibly designed by El Greco) depict two third-century martyr popes, Saints Pontius and Lucius. Below the Virgin in the painting saints such as James the Great, John the Baptist and Peter witness the scene while a young man who may be John the Evangelist looks back out at the viewer. This union of the earthly and the divine would have provided a fitting context for prayers at daily Mass on behalf of the souls of the chapel's patrons. The two paintings on the side altars, meanwhile, would have provided further reinforcement to the twin messages of charity and chastity that were the central themes of the commission. XB

1. San Román y Fernández 1910, pp. 57–8.
2. Cossío 1908. pp. 677–9.
3. Davies 1990, pp. 227–9.

38 Saint Martin and the Beggar, 1597–9

Oil on canvas, with a wooden strap added at the bottom, 193 × 103 cm

Signed at the lower right: δομήνικος θεοτοκόπουλος ἐποίει
(Domenikos Theotokopoulos made)

National Gallery of Art, Washington, DC
Widener Collection, inv. 1942.9.25

PROVENANCE

Commissioned (with cat. 39) for
the Capilla de San José, Toledo, on
9 November 1597; sold by the directors
of the chapel, in Paris, 1906, to Boussod
Valadon, Paris; purchased later the
same year by Peter A.B Widener, Elkins
Park, Pennsylvania; inherited from
the estate of Peter A.B. Widener by
gift through power of appointment by
Joseph E. Widener, Elkins Park; entered
the National Gallery of Art in 1942

ESSENTIAL BIBLIOGRAPHY

Lafond 1906, pp. 383–92; San Román y
Fernández 1910, pp. 157–8; Soehner
1961; Wethey 1962, I, p. 47, II, , pp. 12–13,
nos. 17, 18; Madrid-Washington-Toledo
(Ohio)-Dallas 1982–3, pp. 241–2, nos. 30,
31 (entry by W.B. Jordan); Mann 1990,
pp. 47–56; Marías 1997, pp. 221–4

Clad in gold-damascened armour with a ruff typical of fashionable Toledan dress in El Greco's day, Saint Martin is shown astride a white horse as he prepares to cut his bright green cloak in half in order to share it with the beggar who stands on the left. Below, a distant and freely painted view of Toledo shows the Alcántara bridge and the river Tagus, with what appears, on the right, to be a waterwheel, perhaps part of a system built in the 1560s by an Italian engineer, Juanelo Torriano, to bring water up from the river to the Alcázar. The gleaming whiteness of the horse and the shining gold-damascene work on Martin's armour contrast with the darkening sky behind. The horse stands alert, raising one hoof as if rearing to go forward. When the painting was in its original position above a side altar in the Capilla de San José, the horse and the two figures would have seemed to bear down on the viewer, emphasising the act of charity about to be performed by Saint Martin.

Born in the fourth century in Pannonia, now part of Hungary, Saint Martin showed an interest in Christianity as a child but was forced by his pagan father to enter the Roman army. As an officer in the imperial calvary under Constantine II, the son of Constantine the Great, he was stationed in France, near Amiens. One cold winter's day he came upon a beggar dressed in rags who was suffering from exposure. In an act of charity that was to become legendary, he divided his *paludamentum*, or military cloak, in two with his sword and gave half of it to the beggar. That night, he dreamed that Christ came to him wearing the piece he had given away, saying,

'What thou hast done for that poor man, thou hast done for me'. The vision inspired Martin to pursue an ecclesiastical career. In 372, he became bishop of Tours, where he remained until his death.

In El Greco's day, Saint Martin was widely venerated for his chastity, generosity and zealous propagation of the Christian faith as a preacher, founder of the first monasteries in France and destroyer of pagan shrines. As the patron saint of Martín Ramírez, he personified the virtues ascribed to the founder of the chapel of Saint Joseph, a childless bachelor whose generosity to the poor is recorded in the inscription above his tomb.

In designing his composition, El Greco linked the painting of Saint Martin to that of Saint Joseph on the main altar through a series of visual connections that reinforce their spiritual message. Along with the portrait of Saint Louis now in the Louvre (cat. 36), these are some of the earliest paintings by El Greco to include views of Toledo. In both paintings, the protagonists are confined to a narrow foreground ledge with the city of Toledo in the background. The figure of Martin is elevated above that of the beggar in much the same way as the elongated figure of Joseph towers over Jesus. Both Martin and Joseph have their heads inclined. By pointing his staff towards Saint Martin and physically guiding the Child in his direction, Joseph appears to direct Jesus's attention to Martin's act of charity. This emphasises Joseph's rôle in educating the Christ Child in such duties as care for the poor, echoing contemporary literature exalting Joseph as Christ's paternal teacher, preparing him for adulthood. XB

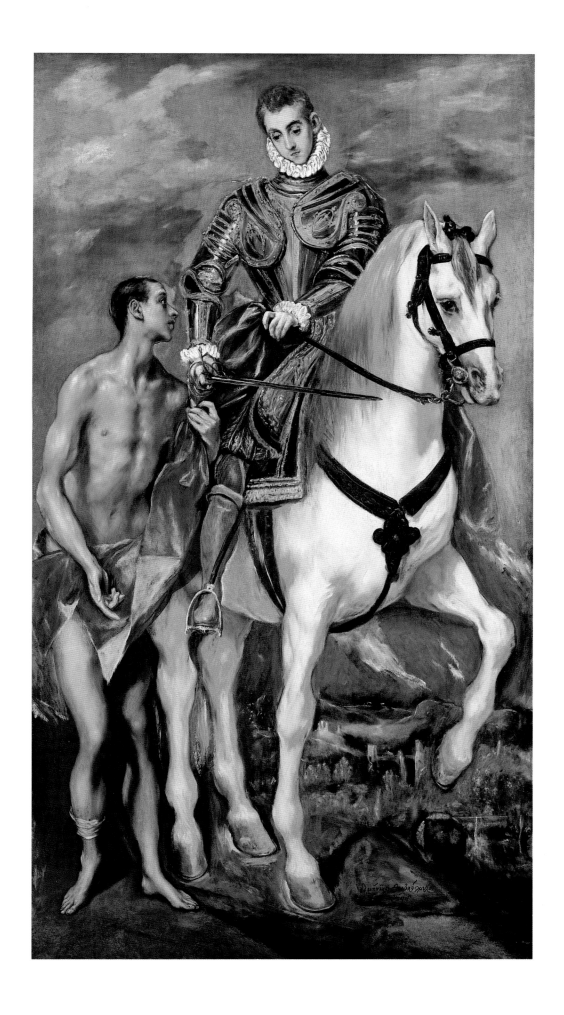

39 The Virgin and Child with Saints Martina (or Thecla?) and Agnes, 1597–9

Oil on canvas, 193 × 103 cm

Signed on the head of the lion: $\delta\theta$
(D[omenikos] T[heotokopoulos])

National Gallery of Art, Washington, DC
Widener Collection, inv. 1942.9.26

Originally located on the side altar opposite *Saint Martin and the Beggar* (cat. 38), this painting shows the Virgin Mary and the infant Jesus enthroned in the heavens, surrounded by angels and seraphim. The postures of the Virgin and Child are similar to those of the Virgin and Child in *The Holy Family with Saint Mary Magdalen* in Cleveland (cat. 31).[1] Below, two virgin martyrs are shown in adoration of the heavenly group. El Greco skilfully interweaves glances, gestures and drapery folds into a zigzag pattern that leads from Saint Agnes, on the right, across to her companion on the left and then up to the Virgin, presented here as the Queen of Virgins. When this painting was in its original location, the half-length saints would have appeared to be standing immediately behind the altar table – emphasising their rôles as intercessors for the patrons of the chapel.

Saint Agnes, shown with a lamb, her standard attribute, was one of the earliest Christian martyrs, venerated as a defender of chastity. She lived in Rome at the time of the persecutions under Diocletian (284–305). Her name, from the Greek word *agnos* meaning 'chaste', reflects her constant rejection of the amorous approaches of the son of a Roman prefect, whom she held at bay by declaring she was already espoused to her heavenly bridegroom. The attribute of the lamb is due to the similarity of her name to the Latin word *agnus*, or lamb.

The saint at the left, standing beside a lion on whose head El Greco has inscribed his initials in Greek characters, has traditionally been identified as Saint Martina, in a second allusion to the chapel's founder. Saint Martina is said to have been martyred

in the third century and was widely venerated especially after Pope Urban VIII revived her cult in 1634. However, she has also been identified as Saint Thecla,[2] which makes more sense within the context of El Greco's iconographic cycle. The lion and palm branch are the standard attributes of both saints. Saint Thecla was the first Christian female martyr of the Greek Church, converted by Saint Paul in the Phrygian city of Iconium. She was revered for enduring many torments in order to preserve her chastity for the sake of her devotion to God. After various ordeals, including being thrown to the lions, she retreated to a mountain cave near Seleucia, where she lived to a great age.

The identification with Saint Martina is supported by the appearance of a painting, possibly a sketch for the picture, in El Greco's inventory of 1614 and Jorge Manuel's of 1621: 'An Image [of the Virgin] with Child and Saint Agnes and Saint Martina.'[3] Nonetheless, there are several reasons for suggesting that El Greco actually represented Saint Thecla. As noted by Mann,[4] Thecla features in the legend of Saint Martin of Tours, who received frequent visits in his room from the Virgin Mary accompanied by Saints Agnes and Thecla.[5] Directly facing Saint Martin, who represents the virtue of Charity, the Virgin and the two martyrs would have been recognised as the principal exemplars of bodily chastity. XB

1. Mann 1990, p. 54.
2. Cossío 1908, p. 587–8.
3. San Román y Fernández 1910, p. 192.
4. Mann 1990, p. 54.
5. Réau 1955–9, III, part II, p. 911.

PROVENANCE

See cat. 38

ESSENTIAL BIBLIOGRAPHY

See cat. 38

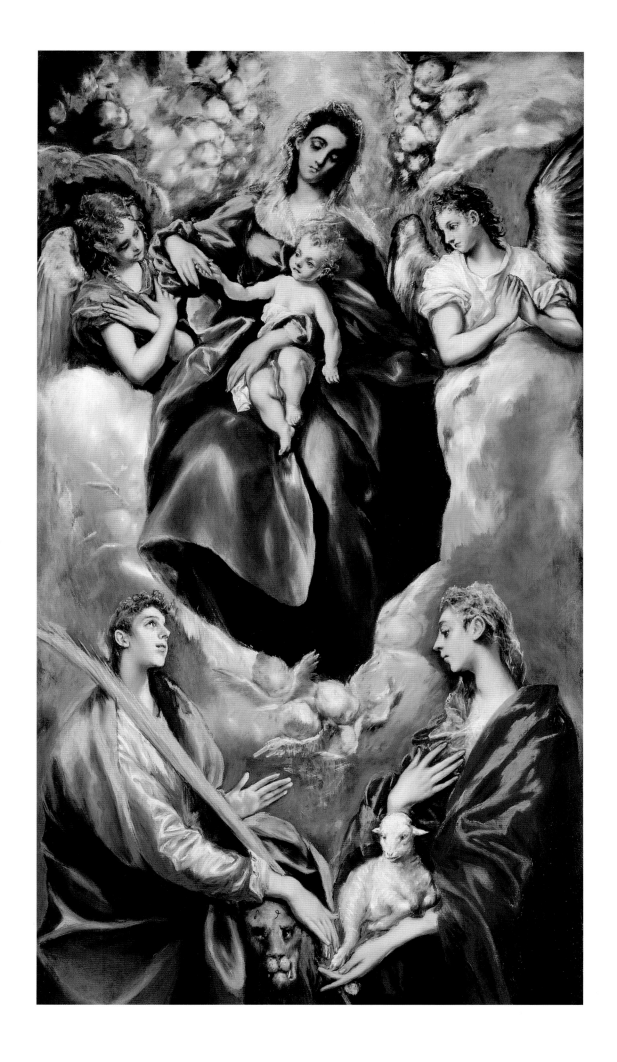

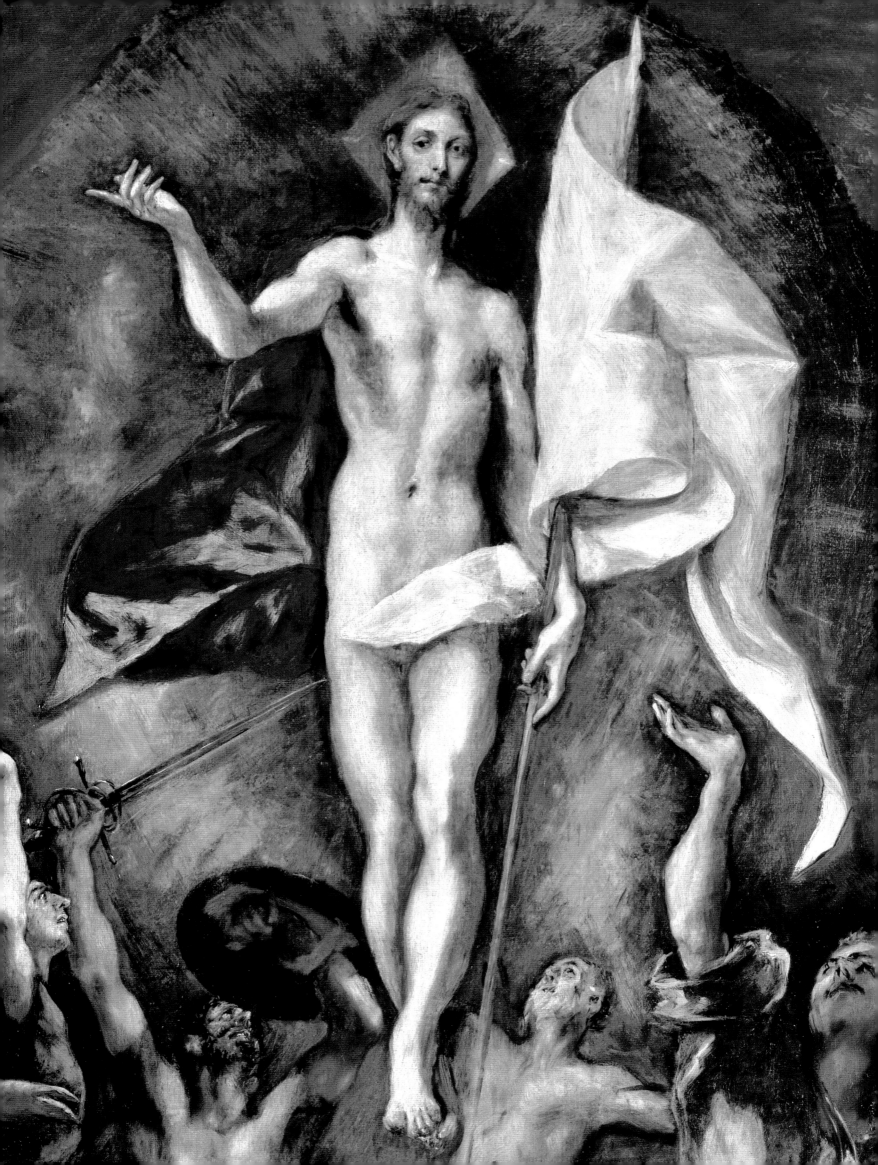

40–2 The Doña María de Aragón Altarpiece

The Colegio de Nuestra Señora de la Encarnación (College of Our Lady of the Incarnation), also known as the Colegio de Doña María de Aragón, was an Augustinian seminary in Madrid for the training of priests. Construction of the church began in 1581 and El Greco – who was resident in Toledo and had relatively few contacts in Madrid – was fortunate to obtain the contract for the main altarpiece. The agreement between the painter and the Council of Castile, which for legal reasons had temporarily taken over the administration of the foundation, was signed in December 1596 and required El Greco to deliver the altarpiece (including carpentry, sculptures and gilding) by Christmas 1599. Some legal proceedings initiated by the perennially litigious artist caused minor delays, and the altarpiece was eventually completed in July 1600. The Doña María de Aragón altarpiece was the most important commission El Greco received and he was paid just under 6000 ducats for it, a vast sum, and more than he earned for any other work. It was here that he first fully realised the traits of his late, 'mystical' style – elongated forms, flickering effects of light, colour combinations that verge on dissonance (copper-resinate green, rose-to-magenta, golden yellow and blue), and an emphasis on ecstatic gestures and expressions. It was the style of these paintings that famously led Palomino in the eighteenth century to dismiss 'the Greek's extravagant manner'.

The altarpiece was dismantled in 1810, following the suppression by Joseph Bonaparte of the religious orders in Spain. No detailed description of it survives, but according to a document of 1814 it comprised seven paintings and six sculptures. There has been much debate in recent years over the altarpiece's original appearance (see fig. 47), but there is considerable agreement that it comprised five paintings today in the Prado, *The Resurrection* (cat. 42), *The Crucifixion* (fig. 21, p. 64), *The Pentecost* (fig. 50), *The Baptism of Christ* and *The Annunciation* (see cat. 40), and a sixth, *The Adoration of the Shepherds*, in Bucharest. The seventh painting is presumed lost and it has been suggested that it may have been a *Coronation of the Virgin*.[1] GF

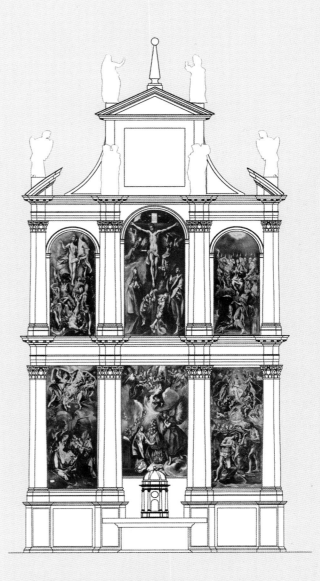

Fig. 47 Proposed reconstruction of the altarpiece in the church of the Colegio de Doña María de Aragón, by J.M. Pita Andrade and A. Almagro Gorbea (from Ruíz Gómez 2000, p. 87)

1. See, for example, Pérez Sánchez in Madrid-Washington-Toledo (Ohio)-Dallas 1982–3, pp. 156–64, and Mann 1986, pp. 72–9. The basis for a reconstruction was transformed by the discovery by Rincón (1985, pp. 322–3), of a nineteenth-century inventory listing the components. Seven paintings were involved, not three, four or six, as had previously been conjectured. For a good summary see Pita Andrade in Bilbao-Madrid 1997 and Álvarez Lopera 2000, and for a full discussion of many of the relevant questions, Ruíz Gómez 2000.

Oil on canvas, 114 × 67 cm
Museo Thyssen-Bornemisza, Madrid, inv. 171

NEW YORK ONLY

This picture is a remarkably fine reduced replica of one of El Greco's most haunting images, an *Annunciation* in the Prado, Madrid, that is almost three times as large (315 × 174 cm). The Prado *Annunciation* formed the centre of the elaborate altarpiece commissioned from the artist in 1596 for the Colegio de Doña María de Aragón. The church for which the *Annunciation* was painted was associated with the mystic Alonso de Orozco (1500–1591), and Mann has proposed that much of the imagery is directly related to the Blessed Alonso's visionary writings. In the case of *The Annunciation*, this involved a complete re-thinking of the subject as usually represented. As Mann explains, 'Most of Alonso's meditations did not concern the Annunciation, the transmission of God's message to Mary, but the Incarnation itself – i.e., the actual conception of Christ in Mary's womb . . .'.[1] Thus the Archangel Gabriel, his hands crossed over his breast, is shown adoring the Virgin, who looks up expectantly from her lectern, acknowledging her acquiescence (Luke 1: 38). The flaming rose bush – the rose is the Virgin's flower *par excellence* – signifies that Mary remained a virgin even after conception and refers to God's appearance to Moses in the form of a burning bush that was not consumed by the flames that engulfed it (Exodus 3: 2–5).[2] Alonso placed special emphasis on chastity and transferred this notion to the issue of spiritual purity, believing that the devout retained their purity through the intensity of God's love. The light-emanating dove corresponds with Alonso's idea that the Holy Spirit was literally inflamed by intense love as it approached the Virgin. In a similar fashion, by showing the cherubim as immaterial and light-reflective, El Greco was probably inspired by the *Celestial Hierarchy* of Pseudo-Dionysius the Areopagite, a key source for Alonso's thought (El Greco also owned a copy of the work). The music-making angels may refer to Alonso's description of the heavenly music that marked the Incarnation. The cloth in Mary's sewing basket is the veil of the Temple on which she was working; Alonso related these items to Communion and the Eucharist.

The picture is thus far more than a narrative: it is a meditation on the Incarnation of Christ. The absence of rational space, the unreal treatment of the light, and the invasion of the viewer's space by the weightless angel, whose cloud floats in front of the dais on which the Virgin kneels, has the effect of involving the viewer–worshipper in a dynamic, visionary experience. This style is at the farthest remove from the artist's Italian-inspired paintings of twenty-five years earlier (see cat. 12, 16).

As already noted, the quality of the Thyssen painting is extremely high. Indeed, Wethey did not hesitate to describe it as 'El Greco's original study' for the Colegio de Doña María altarpiece, noting that 'the brilliancy and freshness of the colour of this finished sketch are almost without parallel except in the final composition . . .'.[3] By contrast, he considered another version in the Museo de Bellas Artes, Bilbao, a workshop replica. The question how El Greco's oil sketches may be distinguished from reduced replicas of his work cannot be easily answered, but it seems doubtful that a preliminary oil sketch would have been as detailed as this picture, which differs only in minor details from the altarpiece (for example the pages of the open book on the lectern).[4] It is just possible that El Greco was obliged to present for approval a fully worked-out *modello* or drawing for the principal scene of this very important altarpiece – the church was dedicated to the Incarnation – but it seems doubtful that the Thyssen painting was this work. El Greco's habit of making reduced replicas is, of course, amply documented. In the 1614 inventory of his studio we find no fewer than five 'small' *Annunciations* listed. From the 1621 inventory of the studio of El Greco's son, Jorge Manuel, we learn that one of these Annunciations (no. 22) measured about 111 × 68 cm – the size of the Thyssen painting. KC

1. Mann 1986, p. 80; but see also Cruz Valdovinos 1998, pp. 113–24.
2. Titian painted a burning bush in his great *Annunciation* in San Salvatore, Venice, which El Greco surely knew and recalled. The depiction is accompanied by the inscription *ignis ardens non combvrens* (fire that burns but does not consume).
3. Wethey 1962, II, p. 33. Pérez Sánchez (in Madrid-Washington-Toledo (Ohio)-Dallas 1982–3) was of the same mind.
4. For a recent discussion of the problem of differentiating between oil sketches/*modelli*, reduced replicas/*ricordi* and copies, see Brown in New York 2001, pp. 16–25.

PROVENANCE

Pascual collection, Barcelona, by 1908, until 1954; Thyssen-Bornemisza collection, Lugano and Madrid

ESSENTIAL BIBLIOGRAPHY

Wethey 1962, II, pp. 11, 33, no. 40; Heinemann 1971, pp. 157–8; Pérez Sánchez in Madrid-Washington-Toledo (Ohio)-Dallas 1982–3, pp. 164, 242, no. 32 (entry by Pérez Sánchez); Bilbao-Madrid 1997; Madrid-Rome-Athens 1999–2000, pp. 148–9, 413, no. 61; Posèq 2000, pp. 22–3

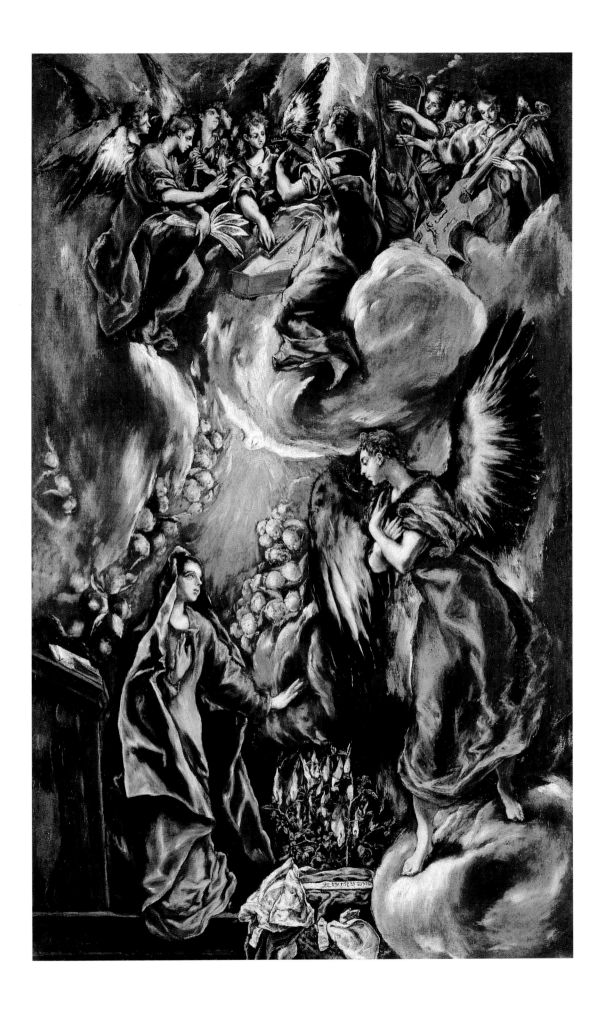

41 Study for Saint John the Evangelist and an Angel, late 1590s

Pen and pale-brown ink and grey-brown wash on off-white paper, 33.7 × 21 cm
The J. Paul Getty Museum, Los Angeles, inv. GA.166

One of only a very small number of drawings universally accepted as by the artist, this is a study for El Greco's *Crucifixion* in the Prado (fig. 21). It shows the figure of Saint John the Evangelist, who in the painting is stationed at the foot of the cross on the right side looking up at the crucified Christ. The pose and gestures are virtually identical and the indications of light and dark areas in the drawing, for example the patch of highlight on the saint's throat (where the paper is left untouched) and the shadows in the folds of the cloak, are also very close to the painting. The principal difference is in the figure of the angel, who in the drawing is very close to the saint, whereas in the painting the figures do not overlap at all. Another difference is the arrangement of the shadows on the extreme right of the cloak of the saint, from the shoulder to the waist, but the recent restoration has shown that this area of the painting is a complete reconstruction probably dating from the 1830s.[1]

The physical proximity of the saint and the angel in the sheet led the distinguished specialist in Spanish drawings Sánchez Cantón to wonder if the subject was Saint Matthew with the Angel. But the parallels between the angel's pose and that of the equivalent figure in the painting (even though the left arm and wing are yet to be defined) are such that there is little room for doubt that the drawing is associated with the painting.

The Prado *Crucifixion* is part of the altarpiece that the artist executed between 1596 and 1600 for the Augustinian Colegio de Doña María de Aragón in Madrid. In accordance with the late style of the artist, it is painted with great freedom and the forms are conceived – to make a broad distinction – in terms of colour rather than line. It comes as something of a surprise, therefore, to find that El Greco made a preparatory drawing which is essentially concerned with contours containing a form. The form is given depth and movement by the application of washes and hatching to make the shadows, but these are neatly enclosed within the outlines of the drawing. The outlines are executed with long strokes of the pen, free and confident. The head of the saint and the intense expression on his face are skilfully rendered with a few strokes and deftly applied wash. GF

1. Restoration documented by Alonso in Ruíz Gómez 2000

PROVENANCE

Mariano Fortuny (1838–1874), Rome; with Tomás Harris, London; Mark Oliver, Jedburgh, Scotland (who also owned cat. 65); with Wildenstein & Co., New York; acquired by the J. Paul Getty Museum in 1982

ESSENTIAL BIBLIOGRAPHY

Hind 1928, pp. 29–30; Sánchez Cantón 1930, II, no. 153; Wethey 1962, II, pp. 151–2; Angulo Íñiguez and Pérez Sánchez 1975, I, no. 160; Vienna 2001, no. 35 (entry by D. Carr)

Fig. 48 Detail of fig. 21

42 **The Resurrection**, late 1590s

Oil on canvas, 275 × 127 cm

Signed in the lower right corner: δομήνικος θεοτοκόπουλος ἐποίει
(Domenikos Theotokopoulos made)

Museo Nacional del Prado, Madrid, inv. 825

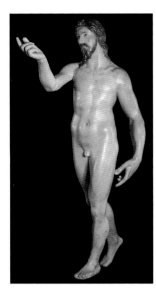

Fig. 49 El Greco
The Risen Christ, 1595–8
Polychrome wood, height 45 cm
Tavera Hospital (Church of the
Hospital of Saint John the Baptist),
Toledo

PROVENANCE

Colegio de Doña María de Aragón
until 1810; transferred in 1835 to the
Academia de San Fernando and then
to the Museo de la Trinidad, Madrid;
in the Museo del Prado from 1872

ESSENTIAL BIBLIOGRAPHY

Cossio 1908, no. 61; Mayer 1926,
no. 105; Wethey 1962, II, no. 111; Madrid-
Washington-Toledo (Ohio)-Dallas
1982–3, pp. 143, 161–3; Marías 1997,
pp. 286–90; Álvarez Lopera 2000,
pp. 109–11; Ruiz Gómez 2000, *passim*

The Resurrection was part of the *retablo* (altarpiece) that El Greco painted for the high altar of the church of the Colegio de Doña María de Aragón in Madrid. Christ is shown in a blaze of glory, striding through the air and holding the white banner of victory over death. The soldiers who had been placed at the tomb to guard it scatter convulsively. Two of them cover their eyes, shielding themselves from the radiance, and two others raise one hand in a gesture of

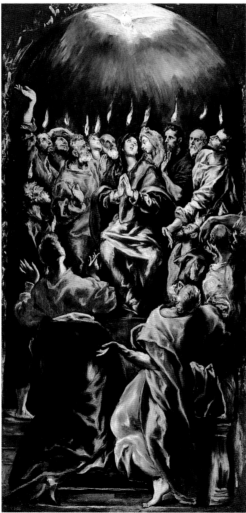

Fig. 50 El Greco
The Pentecost, about 1596–1600
Oil on canvas, 275 × 127 cm
Museo Nacional del Prado, Madrid, inv. 818

acknowledgement of the supernatural importance of the event.[1] Another, wearing a helmet decorated with brilliantly coloured plumes, rests his cheek on his hand – the traditional pose of melancholy – still unaware of Christ's resurrection. El Greco's skill in creating dramatically foreshortened figures is clamorously apparent in the soldier wearing a yellow cuirass sprawled in the foreground and in the adjacent soldier in green, who recalls Michelangelo's sculpture of *Night* in the Medici Chapel in Florence. Michelangelo's drawing of *The Resurrection* (Royal Collection, Windsor Castle), which belonged to Giulio Clovio and was certainly known to El Greco, has sometimes been cited as a source for the painting, but the debt is general rather than specific.[2] The figure of Christ is very similar in pose and design to the sculpted figure of the resurrected Christ which the artist had made a few years earlier to crown the tabernacle in the chapel of the Tavera Hospital (fig. 49). By excluding any visual reference to the tomb or to landscape, El Greco removed the scene from the realm of history; he articulated its universal significance through the dynamism of the nine figures that make up the composition and the intensity of the light and colours.

The X-radiograph of the painting shows a series of horizontal losses, caused by rolling up the canvas after its removal from the church. Comparison with a copy in the Saint Louis Art Museum suggests that the area around the figure of Christ was originally much more brilliant and has been overpainted.[3] The dimensions and arched top of *The Resurrection* correspond with the painting of *The Pentecost* (fig. 50) and the two pictures were probably positioned on the second storey of the altarpiece, possibly either side of the Prado *Crucifixion*. GF

1. Wittkower 1957, pp. 53–4.
2. Du Gué Trapier 1958, p. 10.
3. See Ruiz Gómez 2000, p. 102, fig. 1, and p. 123.

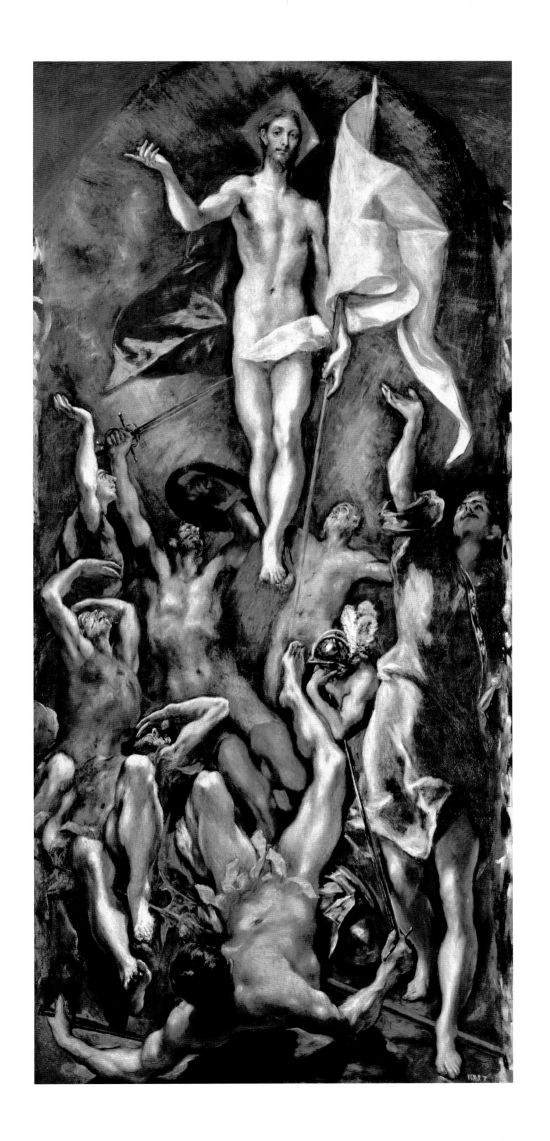

43 **Saint John the Baptist**, about 1600

Oil on canvas 111.1 × 66 cm

Signed on the rock at the lower right: δομήνικος θεοτοκόπολις ἐποίει
(Domenikos Theotokopolis made)

Fine Arts Museum of San Francisco
Museum purchase, funds from various donors, inv. 46.7

NEW YORK ONLY

Of the various canvases in which this figure of Saint John the Baptist appears, that at San Francisco is the finest. The attenuated figure, the agitated movement of the sky and the scintillating light on the landscape are characteristic of El Greco's work around 1600. The San Francisco painting is distinguished from related pictures by the placement of the lamb on the rock – a reference to Christ's sacrifice. The way in which the ascetic saint turns his head away from lamb, towards which he gestures, is especially poignant. Troutman identified the building in the landscape background as the Escorial.

What has been less commented upon is the sculptural quality of the figure, which reads as a small statuette placed against a landscape backdrop. It is well known that El Greco, like Tintoretto, made wax and clay figures from which he worked out the more complex poses of his figures, sometimes suspending them by strings: thirty such models appear in the 1614 inventory of his studio. The three-dimensionality of Saint John's pose, with the legs, hands and head positioned so as to emphasise their articulation in space, clearly derives from the study of a figurine, and so also does the study of the fall of the shadows. We find these same concerns in the canvases associated with El Greco's great altarpiece for the Colegio de Doña María de Aragón, which was commissioned in 1596 and delivered in 1600 (see cat. 40–2). As in those pictures, the elongation of the forms conveys a gracile artificiality that, for El Greco, was a formal expression of spiritual beauty. KC

PROVENANCE

Carmelitas Descalzas, Malagon (Ciudad Real), until 1929; Felix Schlayer, Madrid; Rudolph Heinemann, Lugano, until 1946: The De Young Museum, San Francisco

ESSENTIAL BIBLIOGRAPHY

Camón Aznar 1950, pp. 910, 1376, no. 405; Wethey 1962, II, p. 134, no. 250; Troutman 1963, p. 36; Gudiol 1973, p. 197, no. 151; Madrid-Washington-Toledo (Ohio)-Dallas 1982–3, p. 245, no. 37

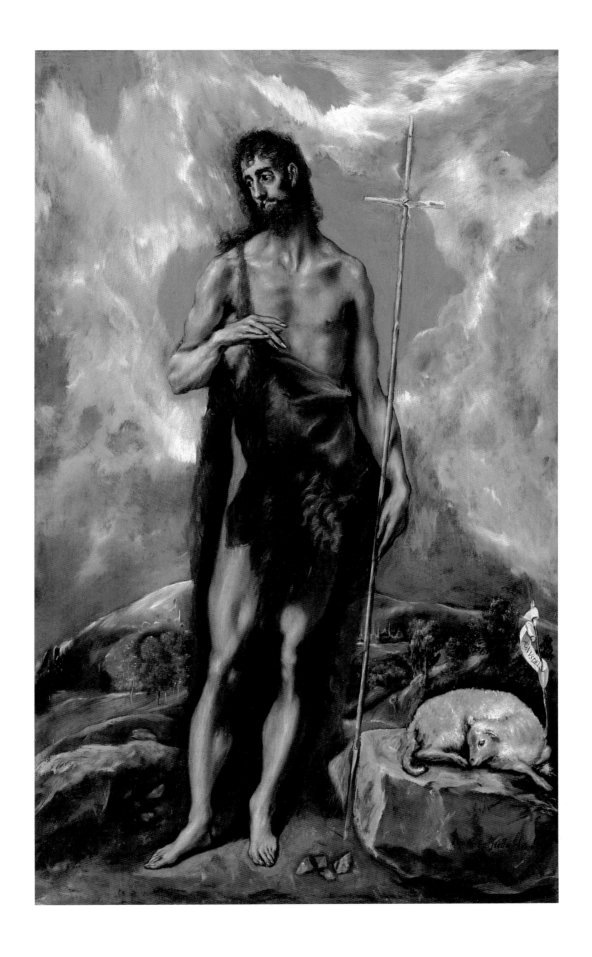

44 Allegory of the Camaldolese Order, about 1599–1600

Oil on canvas, 124 × 90 cm

Inscribed on the plinth: *S.BENEDICTVS*; *EREMITICÆ VITÆ DESCRIPTIO*; *S.ROMVALDVS*

Instituto de Valencia de Don Juan, Madrid

NEW YORK ONLY

PROVENANCE

Don Pedro Laso de la Vega, Conde de
los Arcos y Añover, Batres (died 1637;
inventory 1639); his grandson, Pedro
Laso de la Vega, Conde de Añover
(died 1674); by descent, to Don Carlos
de Guzmán y La Cerda, Conde de Oñate
(died 1880) and his wife Doña Maria
Josefa de la Cerda, Madrid (died 1884;
a 'lienzo de los Eremitas' is listed in the
division of her estate, no. 711); Don
José Reniero, Marqués de Guevara,
Oñate Palace, Madrid (died 1891);
Guillermo Osma, husband of the 24th
Condesa de Valencia de Don Juan,
co-founder of the Instituto Valencia
de Don Juan, Madrid (1891–1908);
given by her to the Instituto Valencia
de Don Juan, Madrid in 1908

ESSENTIAL BIBLIOGRAPHY

Cossio 1908, no. 118; Sánchez Cantón
1923, pp. 177–9; Wethey 1962, II, pp. 76–7,
no. 119; Gudiol 1973, pp. 203, 351, no. 166;
Madrid-Washington-Toledo (Ohio)-
Dallas 1982–3, p. 240, no. 28; Caviró
1985, pp. 216, 221–2; Caviró 1990, p. 305;
Kagan in Hadjinicolaou 1995, pp. 327,
336; Marías 1997, pp. 211–2; Madrid-
Rome-Athens 1999–2000, pp. 422–3;
Vienna 2001, p. 182, no. 28

Standing on a plinth to either side of a tabernacle containing two tablets with inscriptions are Saints Benedict (left) and Romuald (right). In the sixth century Saint Benedict drew up the rule that became the basis of Western monasticism: it is presumably the Benedictine rule in the book he holds. Saint Romuald (*c*. 950–1027) was the founder of the austere Camaldolese order – an offshoot of the Benedictines – so called from the monastery he established at Camaldoli, a mountainous place near Arezzo in Italy, of which he holds a model in his hand. The Latin poem on the two tablets extols Saint Romuald and is a sort of encomium of the monastic life. It was obviously intended to relate to the ideal monastic settlement depicted above, in which we see individual hermitages or cells, each with their own garden, built around a central chapel with a common building and fountain near the entrance gate. The community, sited on a mountainous plateau, is enclosed by a dense forest. The coats of arms on the plinth are those of the Conde de los Arcos y Añover and the Mendoza families and relate to Don Pedro Laso de la Vega, Conde de los Arcos, and his wife, Mariana de Mendoza, the daughter of the Conde de Orgaz.

The picture first appears in a 1632 inventory of the Arcos collection at the fortress at Batres ('*retrato del monasterio del gran camaldula*'). Together with El Greco's *View of Toledo* (cat. 66), it flanked a large canvas showing an angel appearing to Noah. *Noah* was possibly part of the series of paintings of *The Flood* copied after Bassano that hung nearby. The hanging thus paired two emblematic landscapes of roughly the same size by El Greco. But, whereas the *View of Toledo* presented an encapsulated depiction of a real city, clustering together its key monuments and topographical features, the *Allegory of the Camaldolese Order* sets forth an ideal establishment,

although it is apparently based on an engraving depicting Camaldoli. It is also suggestively similar to a description in Antonio de Yepes's *Cronica general de San Benito* (1615), in which the monastic community is said to be surrounded by mountains, pine forests and springs of water.

The picture must relate to the Conde de los Arcos's support of an initiative to establish a Camaldolese hermitage outside Madrid.[1] Two Camaldolese monks arrived in 1597 and Fray Juan de Castañiza published a history of Saint Romuald. Although land was set aside for the purpose, the project was opposed by the Royal Council of Castile and was abandoned. The project must have been important to the count, since he commissioned the picture today in the Instituto de Valencia de Don Juan for his own collection. One imagines him showing the painting to Philip III, who ascended the throne in 1598, to gain his support. Since Don Pedro became Conde de los Arcos only in 1599, the canvas must have been commissioned about this time. Another, larger version is in the Colegio del Patriarca in Valencia.[2] In it the coats of arms are those of Saint John of Ribera, who was Patriarch of Antioch and Archbishop of Valencia as well as a distant relative of Doña Mariana de Mendoza. His support must also have been sought.

Wethey considered both paintings to be by El Greco and his workshop, but the peculiar circumstances of their commission and function must be taken into account in evaluating their quality, which is of a high order and indicates El Greco's autograph authorship. KC

1. See Caviró 1985, and Kagan in Hadjinicolaou 1995.
2. For this picture see Álvarez Lopera in Madrid-Rome-Athens 1999–2000, pp. 422–3, no. 73.

45 Saint Francis meditating, about 1595–1600

Oil on canvas, 147.3 × 105.4 cm

Signed (?) on a piece of paper attached with a seal to the rock lower right

Fine Arts Museum of San Francisco
Gift of the Samuel H. Kress Foundation, inv. 61.44.24

NEW YORK ONLY

No saint enjoyed greater popularity in the Counter-Reformation period than Saint Francis of Assisi. His rigorous asceticism, meditational practices and spiritual union with Christ in the stigmatisation made him an important example for post-Tridentine spirituality. Favoured subjects represented in painting were his stigmatisation, his ecstasy and his meditation. El Greco treated all three and we find examples of each listed among the nine paintings of Saint Francis in the artist's studio in 1614. Wethey differentiated ten different compositions by the artist, some half-length, some full-length, some showing the saint alone, others with a companion.[1] El Greco's particular engagement with Saint Francis was recognised by contemporaries and earned him the praise of Pacheco in his treatise, *The Art of Painting*, of 1649.[2]

In the San Francisco painting, plausibly dated by Wethey to about 1595–1600, Saint Francis meditates not so much on mortality (signified by the skull) as on the sacrifice of Christ. Presumably the dark mass of rock behind him and the ivy are intended to suggest Mount Alverna, where he retreated and received the stigmata. In accordance with devotional practice, Francis has prepared his meditation by first reading from the Bible, shown lying on the ledge with a piece of paper marking the place. His hands, devoutly crossed on his breast, and his cowl-framed head are expressive of his sense of identification with Christ. KC

1. In addition to Wethey, see especially Gudiol 1962.
2. Pacheco 1649 (1990), p. 698.

PROVENANCE

Private collection, France;
H.F. Fankhauser, Basle; Rosenberg &
Stiebel, New York; Samuel H. Kress
collection, from 1953

ESSENTIAL BIBLIOGRAPHY

Suida 1955, pp. 70–1; Wethey 1962, II,
pp. 121–2, no. 219; Gudiol 1962, p. 202;
Gudiol 1973, p. 350, no. 163; Eisler 1977,
pp. 194–5

46 Saint Francis and Brother Leo meditating on Death, early 1600s

Oil on canvas, 168.5 × 103.2 cm

Signed on a piece of paper seemingly attached to the surface of the picture
δομήνικος θεοτοκόπουλος ἐποίει (Domenikos Theotokopoulos made)

National Gallery of Canada, Ottawa, inv. 4267

At the entrance to a cave on Mount Alverna, where towards the end of his life Saint Francis retired for fasting and prayer, the saint meditates upon a skull. Brother Leo, his faithful companion, joins his hands in prayer and he, too, from his lower position (notionally closer to that of the viewer) focuses his attention on the death's head. Saint Francis wears the habit of the order he founded, with a thick cord around his waist. His open right hand shows the stigmata, the wounds of Christ's crucifixion that were visited on his body shortly before he died in 1226. A shaft of light bursts through the clouds at upper left – a passage of brilliant colour that lights up the almost completely monochromatic setting – and illuminates the edge of the cave and the figure of Francis. The presence at upper right of a dark oval form surrounded by a ring of light (also apparent in many other versions of the composition) is suggestive of a heavenly eclipse, or some supernatural phenomenon, and it serves to intensify the mystical atmosphere of the scene.

El Greco's representations of Saint Francis all show him in meditation, receiving the stigmata or experiencing a vision. Devotion to Saint Francis was highly developed in Spain, and in El Greco's time there were in Toledo alone ten Franciscan religious institutions. Many ordinary Toledans were members of the Third Order of Saint Francis, established so that lay people could participate in the spiritual life of the Franciscans. All of this serves to explain the success of El Greco's images of the saint.

This particular composition enjoyed quite remarkable success. There exist some forty versions of it, consisting of autograph works, workshop paintings, early variants and copies, and an engraving by Diego de Astor of 1606 made under the artist's supervision (fig. 51). The composition seems to have been designed in the early 1580s (the version in Monforte de Lemos, recently cleaned, is one of the earliest),[1] but the present version, universally accepted as an autograph work, is datable on style to the early 1600s. It was almost certainly intended for personal devotion, and El Greco has placed the skull virtually in the centre of the composition, and frontally, so that it acts as the focus for the viewer's meditation. The skull is traditionally a symbol of death and the vanity of earthly pursuits. Saint Ignatius Loyola, one of the foremost saints of the Counter-Reformation, recommended using a skull for meditation in his *Spiritual Exercises*, to direct the mind and heart to a consideration of one's own mortality and thereby to repentance for sins. An image of a skull could clearly serve the same purpose.[2] GF

1. Rome 1999 (Italian edn), no. 36.
2. Mâle 1951, pp. 206–12.

PROVENANCE

In the parish church of Cristo de las Aguas in Nambroca, near Toledo, until sold *c.* 1927 to the Madrid dealer, Linares; with Tomás Harris, London; purchased by the National Gallery of Canada, Ottawa, in 1936

ESSENTIAL BIBLIOGRAPHY

Gudiol 1962, pp. 200–1; Wethey 1962, I, p. 49, II, no. 225; Laskin 1971; Madrid-Washington-Toledo (Ohio)-Dallas 1982–3, no. 38 (entry by W.B. Jordan); Davies in Hadjinicolaou 1995, p. 430

Fig. 51 Diego de Astor (about 1585–90–about 1650) after El Greco
Saint Francis and Brother Leo meditating on Death, 1606
Engraving, 23 × 14.8 cm
Biblioteca Nacional, Madrid, inv. 42.372

47 Saint Francis's Vision of the Flaming Torch, about 1600–5

Oil on canvas, 203 × 148 cm

Signed on the paper in the foreground

δομήνικος θεοτοκόπουλος ἐποίει (Domenikos Theotokopoulos made)

Church of the Hospital de Nuestra Señora del Carmen, Cádiz

NOT IN EXHIBITION

By the time El Greco painted this picture, in the early 1600s, he had established himself as the painter *par excellence* of Franciscan mystical imagery in Spain. His workshop was producing countless copies after his compositions of Saint Francis for a demanding devotional market. Those unable to afford a painting could purchase a print by Diego de Astor (fig. 51) after El Greco. The present painting from Cádiz, showing *Saint Francis's Vision of the Flaming Torch*, was probably the latest addition to his Franciscan repertoire, and certainly one of the most inventive. As in cat. 45 and 46, in an advertisement of his skills, El Greco has painted a piece of paper with his signature 'stuck' to the canvas with a red wax seal. Casting a shadow on the ground, it functions as a *trompe l'œil* simulation of a 'real' business card.

The subject of the picture is taken from *The Little Flowers of Saint Francis*, a popular medieval account of Saint Francis's life.[1] According to the story, one of his disciples, Brother Leo, set out in search of his master. Not finding him in the cave that he inhabited, Brother Leo went off into the woods by moonlight, to find him kneeling with his face and hands lifted towards Heaven in direct communication with God. He heard Saint Francis ask, '"Who art Thou, my God most sweet? What am I, Thy unprofitable servant and vilest of worms?" And these selfsame words he again repeated and said naught besides'. Brother Leo then 'lifted up his eyes and looked heavenward; and as he looked, he beheld a flaming torch coming down from heaven, most beautiful and resplendent, which descended and rested on the head of Saint Francis; and from the said flame

he heard a voice come forth which spake with Saint Francis, but the words thereof this Friar Leo understood not. . . .'.[2]

Using a palette of browns, greys and blacks, El Greco sets the scene against a rock in total obscurity. Ivy leaves are just visible at the upper left of the picture. In the right-hand top corner, a burst of light shines with dazzling intensity. Staring at it with an expression of inner peace, Saint Francis listens enraptured to the voice of the 'tongue of fire'. The play of light over the grey habit of Saint Francis and around the edges of the figure of Brother Leo, isolating his head, his hands and his habit, produces an extraordinary and eerie effect. What is particularly splendid about the picture is the way in which El Greco contrasts the front and back views of the two Franciscan brothers. Saint Francis's habit opens out to receive the full blast of divine light, while Brother Leo, struck by the intensity of its glare, falls backwards on to the ground, his back to us. His left arm and hand almost project into our space, while the rest of his body, particularly his right hand, is silhouetted against the light.

The Cádiz painting was copied several times. While Wethey counts five workshop copies, he notes that a slightly smaller version at the Museo Cerralbo, Madrid, although containing some studio participation, is largely by El Greco himself.[3] xb

1. The subject was identified by Robert Loescher. See Wethey 1962, II, p. 116.
2. Arnold 1908, pp. 178–9.
3. Wethey 1962, II, p. 126, no. 232; Madrid-Rome-Athens 1999–2000, no. 66, p. 416.

PROVENANCE

Possibly the painting recorded in Jorge Manuel's 1621 inventory as 'Saint Francis with the fallen companion'; Lorenzo Armengual de la Mota (1663–1739), bishop of Cádiz; donated by his nephew Bruno Verdugo Armengual de la Mota (1707–1751) in 1749 to the Hospital de las Mujeres, Cádiz, subsequently Hospital de Nuestra Señora del Carmen

ESSENTIAL BIBLIOGRAPHY

Cossío 1908, no. 39; Soehner 1958–9, I, p. 179, III, no. 82; Camón Aznar 1950, no. 643; Wethey 1962, II, p.126, no. 231; Sole 1966; Calavaris in Hadjnicolaou 1995, p. 386

48 **The Nativity**, about 1603–5

Oil on canvas, 128 cm in diameter

Signed in the centre, below the Infant Christ
δομήνικος θεοτοκόπουλος ἐποίει (Domenikos Theotokopoulos made)

Church of the Hospital de la Caridad, Illescas

LONDON ONLY

PROVENANCE

Painted for the vault of the main chapel of the Hospital de la Caridad, Illescas

ESSENTIAL BIBLIOGRAPHY

Cossío 1908, no 51; Mayer 1926, appendix, no. 20a; Harris 1938, pp. 154–64; Camón Aznar 1950, pp. 794–8, no. 16; Wethey 1962, II, pp. 13–15, no. 22; Barnes in Madrid-Washington-Toledo (Ohio)-Dallas 1982–3, pp. 45–55; p. 248, no. 42 (entry by W.B. Jordan); Davies 1999–2000, pp. 283–91

Surrounded by the darkness of the night, the naked Christ Child in the manger illuminates both the brilliant white linen on which he lies and the Virgin and Saint Joseph looking down upon him with tenderness and adoration. Although El Greco treated the subject of the Nativity frequently (see cat. 13, 29–31), this is the only known version by him depicting the Holy Family without other human participants. In the shadows to the left, an ass contemplates the scene. In the foreground the fore-shortened head of an ox, his horn echoing the curve of the circular format, looks up from below. Like so many features of the life of Christ as related in the New Testament, the traditional inclusion of these animals in the Nativity scene has an Old Testament antetype in a text from the prophet Isaiah: 'The ox knoweth his owner and the ass his master's crib' (Isaiah 1: 3).

El Greco's extraordinary treatment of the light emanating from the Christ Child may have been inspired by the visions of Saint Bridget of Sweden (died 1313). In her *Revelations* she describes a vision of the baby radiating 'such an ineffable light and splendour that the sun was not comparable with it, nor did the candle that Saint Joseph held there shine any light at all, the divine light totally annihilating the natural light of the candle'.[1] The crimson red of the Virgin's robe glows like a flame in the white light, while Saint Joseph's hands stand out against its brightness.

This roundel of the *Nativity* was part of one of the most ambitious and yet controversial decorative schemes of El Greco's career. On 18 June 1603 he signed a contract to make and decorate an altarpiece for a miraculous image of the Virgin of Charity belonging to the Hospital de la Caridad in the small town of Illescas halfway between Toledo and Madrid.[2] The carving, said to have been the work of Saint Luke, was believed to have belonged to the seventh-century archbishop of Toledo, Saint Ildefonso, a great devotee of the Virgin. The hospital church in which it was housed had been rebuilt in

the 1590s, and the church authorities wanted to create a worthy setting 'so that with all propriety the holy image of Our Lady could be shown'.[3]

According to a document relating to the contract, the main altarpiece and the decoration of the vault were to contain four canvases: *The Madonna of Charity* (fig. 64), *The Coronation of the Virgin*, *The Annunciation* and the present painting of *The Nativity* (all still in the church). El Greco completed the altarpiece by the stipulated date of 31 August 1604, but then found himself embroiled in an extended lawsuit after he rejected the sum initially offered to him as too low. For their part, the church authorities objected to the inclusion in his representation of *The Madonna of Charity* of portraits of contemporary figures wearing large ruffs, including one said to be of his son Jorge Manuel (see cat. 79). By then a fully fledged partner in El Greco's studio, Jorge Manuel is mentioned in the original contract for the commission and may have had a hand in the present picture.

The altarpiece was altered at the beginning of the twentieth century, but documentation relating to the lawsuit, which dragged on until 1607, helps us to reconstruct its original appearance. Harris suggested that the canvas of *The Madonna of Charity* was set high in the attic of the altarpiece, while the arches of the side walls of the chapel, to the left and right respectively, held tondi of *The Annunciation* and *The Nativity*. In the middle of the vault, crowning the iconographical programme, was the oval painting of *The Coronation of the Virgin*. Conceived as a whole, the four paintings depict Mary in different aspects of her being – as a mortal chosen to receive God's Grace (*The Annunciation*); as the mother of Christ (*The Nativity*); as the intercessor and merciful protector of humanity (*The Madonna of Charity*); and finally as the Queen of Heaven (*The Coronation*).
XB

1. Quoted in Snyder 1960, p. 123.
2. San Román y Fernández 1927, pp. 33–5.
3. Quoted in Harris 1938, p. 154.

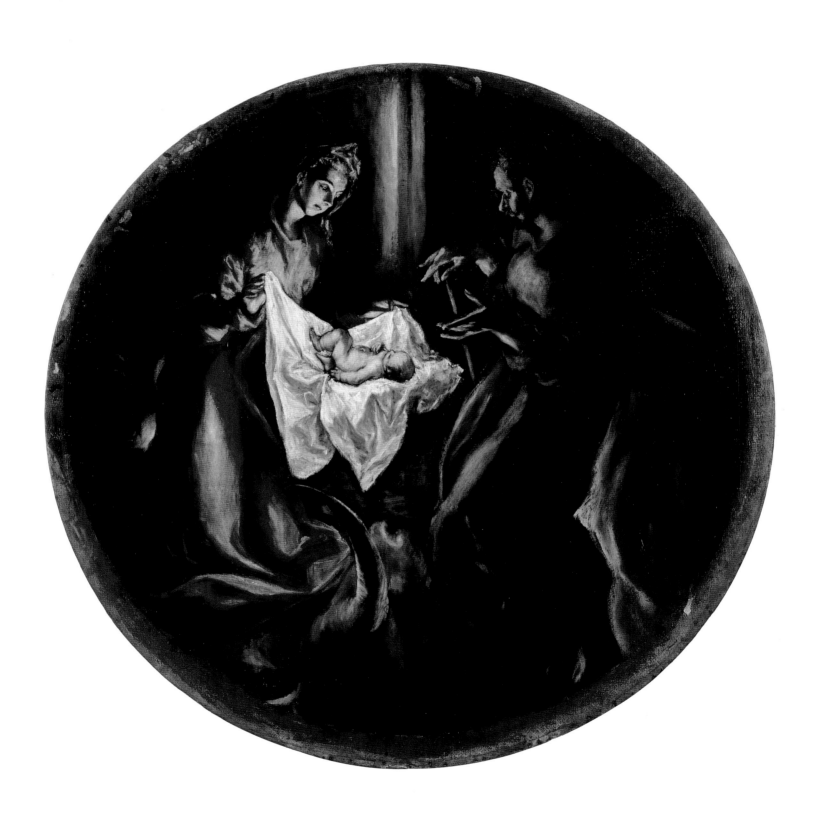

187

49 Christ as Saviour, about 1600

Oil on canvas, 73 × 56.5 cm

Signed on the right, above Christ's shoulder: $\delta.\theta.$
(D[omenikos] T[heotokopoulos])

The National Gallery of Scotland, Edinburgh, inv. NG 2160

The painting may originally have been part of a series of Christ with the Apostles (known in Spanish as an *Apostolado*), although it has not been possible to establish from the known works of El Greco a related group of paintings of the same format and date. Alternatively, it may have been painted as an individual work, and there are references in the inventory of El Greco's estate (1614) to 'A head of Christ' and to 'A head of the Saviour', which do not appear to be part of an *Apostolado*.[1] In the inventory of his son Jorge Manuel of 1621, there are listed two paintings of 'A Saviour' and 'Another Saviour', also unrelated to Apostle pictures, of which the dimensions are given as approximately 63 × 56 cm – corresponding reasonably closely with those of the Edinburgh picture.[2] It is not possible, however, to establish more certainly whether these references are connected with this painting.

Christ is shown with a rhomboidal halo, identifying him as the Godhead. Light also radiates from his face and tunic, as he imparts a blessing with his right hand. His left rests on a globe, signifying both the earth and the universe. The painting combines the imagery of Christ as Saviour of the World (*Salvator Mundi*) and Christ as the Light of the World: 'I am the light of the world: he that followeth me shall not walk in darkness, but shall have the light of life' (John 8: 12). The *Salvator Mundi* had a well established iconography in Italy in the fifteenth and sixteenth centuries but El Greco endowed the imagery with broader resonance. The long and narrow head of Christ, the frontal position and the hieratic quality of the representation – perhaps even more apparent in the taller versions of the painting in the Museo de El Greco (cat. 51) and in Toledo Cathedral[3] – are strongly reminiscent of Byzantine images of the Pantocrator (Christ as Ruler of All). El Greco was adapting a Byzantine prototype to the circumstances and necessities of Catholic Toledo at the end of the sixteenth century. This is a feature of his work that emerges more powerfully in the later years of his career.

The intense gaze of Christ, similar to that of the Strasbourg *Virgin Mary* (cat. 37), is remarkably potent. The artist conceived of the viewer as a devout believer who would have felt scrutinised by the loving eyes of the Saviour. The gaze of Christ is referred to several times in the Gospels: in his dialogue with the rich young man who questioned him about what he must do to inherit eternal life, Jesus 'beholding him loved him' (Mark 10: 21). Even more poignantly, right in the midst of the Passion drama when he is in the High Priest's house, Christ gazes at Peter, who had betrayed him three times: 'And Peter went out, and wept bitterly' (Luke 22: 61–2).

The painting is in remarkably good condition and, contrary to what most commentators have repeated (following Wethey), the artist's initials are not restored. The handling is fresh and brilliant and the rose glazes in the tunic of Christ are very well preserved. GF

1. San Román y Fernández 1910, pp. 193–4.
2. San Román y Fernández 1927, doc. XXXV, nos. 103–4.
3. Wethey 1962, II, no. 160.

PROVENANCE

Heirs of Juan de Ibarra, Madrid, before 1908; sold around that time to Luis María Castillo; sold to Trinidad Scholtz-Hermensdorff, viuda de Iturbe, later Duquesa de Parcent; her daughter Marquesa de Belvis de las Navas, who in 1921 married Prince Max Hohenlohe-Langenburg, Madrid, by whom sold to Tomás Harris, London, in 1951; bought from him in 1952

ESSENTIAL BIBLIOGRAPHY

Mayer 1926, no. 133; Wethey 1962, II, no. 113; Edinburgh 1989, no. 22 (entry by D. Davies); Brigstocke 1993, pp. 76–7, no. 2160

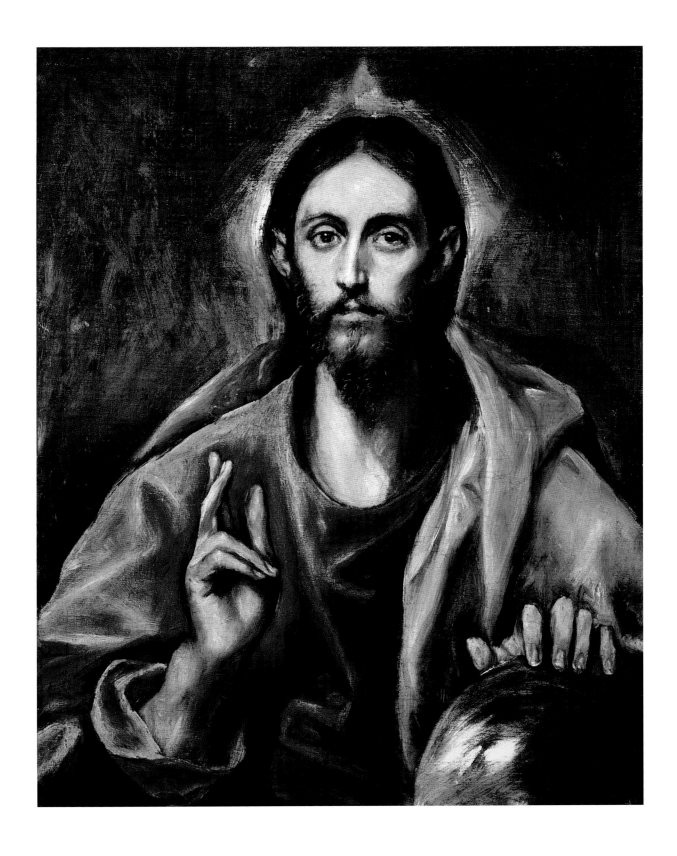

50 Saint Jerome as a Scholar, about 1600–14

Oil on canvas, 108 × 89 cm
The Metropolitan Museum of Art, New York
Robert Lehman Collection, 1975, inv. 1975.1.146

PROVENANCE

Marqués del Arco, Madrid; Durand-
Ruel, Paris and New York, from whom
acquired by Robert Lehman in 1912;
The Metropolitan Museum of Art,
from 1975

ESSENTIAL BIBLIOGRAPHY

Cossío 1908, p. 565, no. 85; Camón
Aznar 1950, pp. 881, 1381, no. 502;
Gudiol 1973, pp. 153–4, 346, no. 102;
Wethey 1962, II, pp. 130–1, no. 241;
Madrid-Washington-Toledo (Ohio)-
Dallas 1982–3, p. 247, no. 40; Brown
in Sterling 1998, pp. 173–7; Brown in
New York 2001, pp. 28–30

Endowed with an unsurpassed classical education, Jerome (c. 342–420) became an outstanding biblical scholar as well as the translator of the Bible into Latin (the Vulgate). During the Renaissance, paintings showing him either in his study or performing acts of penance in the wilderness adorned the walls of the homes of many humanists and scholars. El Greco painted both types. We might well imagine El Greco's depictions of the saint as destined for members of his close circle of scholar-friends – men like Antonio de Covarrubias (cat. 77), the theologian Martín Ramírez de Zayas (who awarded El Greco the commission for the Capilla de San José, see cat. 38–9), or the canon lawyer Pedro Salazar de Mendoza (see cat. 60). Indeed, El Greco's conception of the saint is entirely in line with the ideas expressed by Salazar de Mendoza in his *Monarquía*. Defending Jerome's status as a cardinal he wrote, 'The Holy Catholic Church holds many things which are affirmed by painting. Among them is [the fact] that Saint Jerome was a cardinal, [which is demonstrated] by painting him with the habit and insignia of a cardinal'.[1] We need not wonder at the success of El Greco's formulation of the cardinal–scholar standing behind his desk, marking his place with his thumb as he looks up, interrupted by an unexpected visitor. Five versions from El Greco's workshop and four copies are known, the two finest of which are in the Frick Collection, New York, and the Metropolitan Museum.[2]

The Frick painting, one of El Greco's masterpieces, is unquestionably his earliest formulation of the theme. The Metropolitan painting is a later replica. A comparison between the two, made possible by their exhibition together in 2001, confirmed that, however close they are in design, the colour harmonies and brushwork are strikingly different. The palette is paler, more brilliant, and the execution broader in the Frick version; darker, with a denser, descriptive brushwork in the Metropolitan painting. These same differences are found in El Greco's portraits. Thus, while the Frick painting perhaps dates from the 1590s and bears comparison to the portrait of an elderly gentleman in the Prado, Madrid (inv. 806), the Metropolitan version seems to date after 1600 and can, in certain respects, be compared with *Diego de Covarrubias* (cat. 78).

The portrait-like quality of Jerome's head has occasionally led to the suggestion that it is based on a specific sitter, possibly Cardinal Gaspar de Quiroga or even Cardinal Niño de Guevara (see cat. 80).[3] Certainly, in conceiving the picture El Greco resorted to portrait conventions: he used a similar compositional formula for *Francisco de Pisa* (cat. 82) and *Cardinal Juan de Tavera* (Hospital of Saint John the Baptist, Toledo). And he has invested Jerome with a psychological verisimilitude that is informed by his close association with Toledo's leading scholars and churchmen. But a comparison of Jerome's cardinal's robes with those of (the probable) Niño de Guevara reveals that the mimetic intention that is so conspicuous in the portrait has been relaxed. Gudiol has given a good description of the creative process behind this achievement: 'This [Saint Jerome] is depicted with all the spirit and force of a portrait. By this we mean that El Greco used a model whom he represented with objective realism, but whom he transferred, by a mysterious stroke of genius, to a higher plane, at the same time giving him that depth which transforms a person into a paradigm of a race and an age ...'.

In the 1614 inventory of El Greco's studio are listed two paintings of Saint Jerome as a cardinal. One is described as small, the other appears without qualification. What are probably the same two paintings recur in the 1621 inventory of the possessions of El Greco's son, Jorge Manuel. The measurements for the 'S. Jeronimo cardenal pequeno' (no. 162) are equivalent to 62 × 55 cm, while those for the larger painting (no. 131) are equivalent to 111 × 84 cm – about the size of the Frick and Metropolitan paintings. It is possible that the Metropolitan painting was part of El Greco's stock at the time of his death.[4] KC

1. For this see Mann 1986, p. 114. Brown (in New York 2001, p. 29) notes a similar line of defence taken by Fray José de Sigüenza in a publication of 1595 and suggests that the Frick painting may be related to this.
2. For the various versions see Wethey 1962, pp. 130–1, and Madrid-Washington-Toledo (Ohio)-Dallas 1982–3, pp. 247–8, no. 41.
3. The matter is discussed by Brown in Sterling. 1998, p. 174.
4. The smaller *Saint Jerome* may be that in the Várez-Fisa collection, Madrid: see Brown in New York 2001, p. 29.

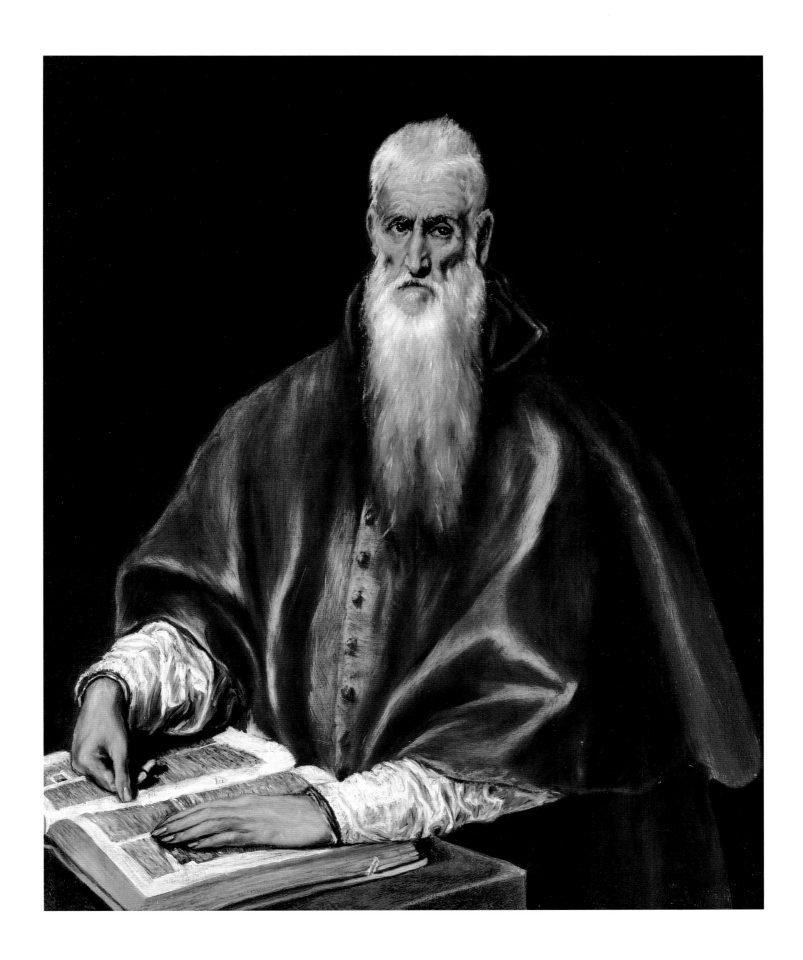

51 Christ as Saviour, about 1610–14

Oil on canvas, 99 × 79 cm
Museo de El Greco, Toledo, inv. 1

52 Saint Philip, about 1610–14

Oil on canvas, 97 × 77 cm
Museo de El Greco, Toledo, inv. 9

52 AND 53 NEW YORK ONLY

53 Saint Paul, about 1610–14

Oil on canvas, 97 × 77 cm

Inscribed on the piece of paper in the saint's
hand and signed on the sword blade
δομήνικος θεοτοκόπουλος ἐποίει
(Domenikos Theotokopoulos made)

Museo de El Greco, Toledo, inv. 3

PROVENANCE

The whole Apostolado was donated
in 1837 by Don Manuel Marceliano
Rodríguez, parish priest of the Church
of San Lucas, Toledo, to the Asilo de
los Pobres de San Sebastián, Toledo;
the Asilo was housed in the Hospital
de Santiago in Toledo, and in 1847
the series passed, together with the
relocated Asilo de los Pobres de San
Sebastián, to the Dominican convent
of San Pedro Mártir; in 1898 the
series was deposited in the Museo
Provincial de San Juan de los Reyes;
in 1909, following an exhibition of
the Apostolado in the Academia de
San Fernando in Madrid, it entered
the Museo de El Greco, Toledo. See
Mora del Pozo 1987

ESSENTIAL BIBLIOGRAPHY

Cossío 1908, nos. 201, 203, 204; Beruete
and Cedillo 1912, nos. 8, 10 and 14;
Byron and Talbot Rice 1930, pp. 192 and
217; Mayer 1926, nos. 161, 163 and 167;
Camón Aznar 1950, nos. 294, 296 and
300; Wethey 1962, II, nos. 173, 181, 183;
Gómez-Moreno 1968, nos. 1, 3 and 9;
Camón Aznar 1970, no. 307, 309 and 313;
Iraklion 1990, nos. 32 and 33 (entries
by J. Álvarez Lopera); Madrid-Rome-
Athens 1999–2000, no. 86 (entry by
J. Álvarez Lopera); Granada-Seville
2001, pp. 161–3; Pérez Sánchez 2002;
La Coruña 2002, nos. 13 and 15

These three paintings form part of a complete
series of Christ and the Apostles, known in Spanish
as an *Apostolado*, in the Museo de El Greco. Painted
by the artist in the last years of his life, it is one
of the most important of several such surviving
series by El Greco and his studio. The iconography
and format correspond to the Apostles series in
Toledo Cathedral, with the exception that Saint
Bartholomew appears in place of Saint Luke
and Saint Thomas carries a lance rather than his
carpenter's square. Other groups include the
Oviedo, Arteche, Almadrones and Henke series.
There are also individual *Apostles* of unknown
origin in various collections. The Edinburgh *Christ
as Saviour* (cat. 49) may once have formed part of
such a group.

The group of thirteen pictures was conceived as
a whole, with Christ looking directly at the viewer,
six of the Apostles turning to the right and six to the
left. El Greco must have intended it to be displayed
in a particular way. Wethey suggested that it was
planned for a room where Christ would occupy the
end wall and the Apostles would be arranged on the
two long walls, six on each side. Unfortunately the
original destination of this *Apostolado* is unknown.
The expressive, fragmentary brushwork has led some
to suppose that it was left unfinished at El Greco's
death. The inventory of works left in his studio
includes 'twelve heads of Apostles with Christ' and
several other paintings of individual saints, while
the 1621 inventory lists two paintings of the Saviour
and two of the Apostles among the unfinished works;
it is impossible to know whether any of these were
the Museo de El Greco paintings. The signature on
Saint Paul shows that El Greco considered at least
this work finished.

The *Christ as Saviour* in this series is one of El Greco's
most impressive treatments of the subject, taller in
format than the earlier Edinburgh *Christ as Saviour*
(cat. 49). Christ is shown here both as Saviour of the
World (*Salvator Mundi*) and the Light of the World.
Radiant with divine light, he rests his hand on a
globe enveloped in the folds of his cloak, recalling
vividly the Gospel of Saint John (8: 12): 'I am the light
of the world: he that followeth me shall not walk in
darkness, but shall have the light of life.'[1] The imagery
is particularly appropriate in the context of the
Apostolado as Christ sent his Apostles to spread
the Word of God throughout the World (Acts 1:8). It
brings to mind the Catholic sacrament of Ordination.
Christ's symmetrical frontal pose and physiognomy
recall Byzantine images of Christ as Pantocrator
(Ruler of All) but, as Wethey noted, Christ blesses
in the manner of the Roman Catholic Church (in
the Byzantine blessing the third finger touches the
thumb) and the *Salvator Mundi* was an established
theme in Italian and Spanish art.

Saint Philip became a disciple of Christ early on,
appearing frequently in the Gospels. Significantly,
it was he who helped Greeks wishing to meet Jesus
after he entered Jerusalem: 'And there were certain
Greeks among them that came up to worship at the
feast: the same came therefore to Philip, which was
of Bethsaida of Galilee, and desired him, saying, "Sir,
we would see Jesus"' (John 12: 20–1). Here he turns
towards the cross on which he was believed to have
been martyred; the short arm of the cross appears
at the top of the picture.

Although not one of the original twelve whom
Christ chose to be his closest followers, Paul became
the 'Apostle of the Gentiles' following his dramatic
conversion on the road to Damascus (Acts 9: 1–19),
founding Christian communities in many places,
including Crete. He appears in all of El Greco's
Apostolados, in place of Saint Matthias, the Apostle
chosen after Christ's ascension to replace Judas.
In this painting El Greco shows Saint Paul with a
sword, the instrument of his martyrdom, and a letter
inscribed in cursive Greek 'To Titus, ordained first
bishop of the church of the Cretans'. The painter,
no doubt, relished the close connection between the
saint and his native island, in spite of the fact that,
in his letter to Titus, Paul was very critical of the
Cretans, quoting the Cretan poet Epimenides of
Knossos who had said, 'Cretans are always liars,
evil beasts, slow bellies' (Titus 1: 12). LO

1. Edinburgh 1989, no. 22.

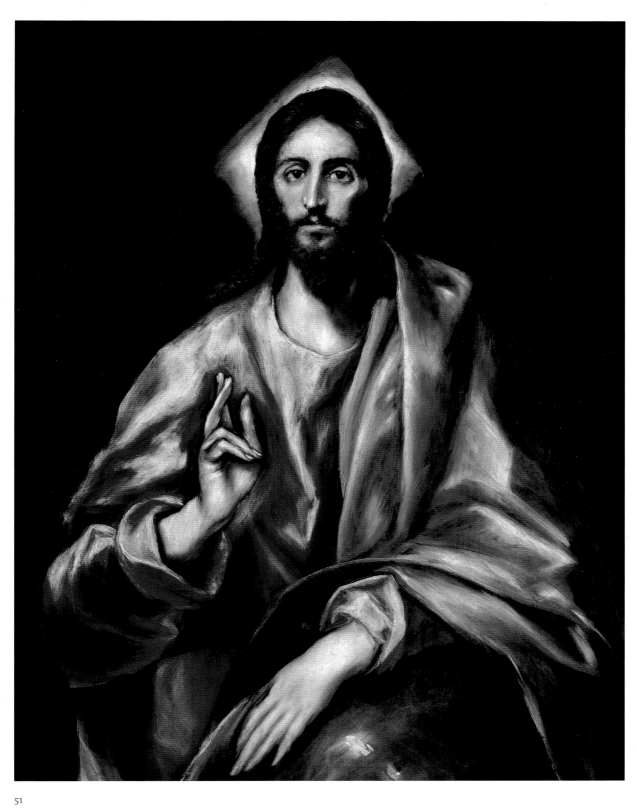

51

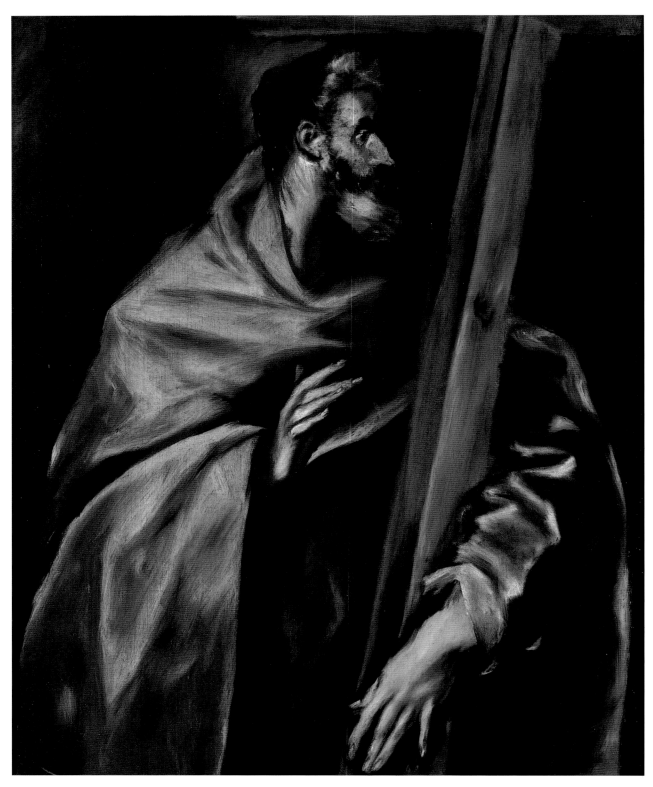

52

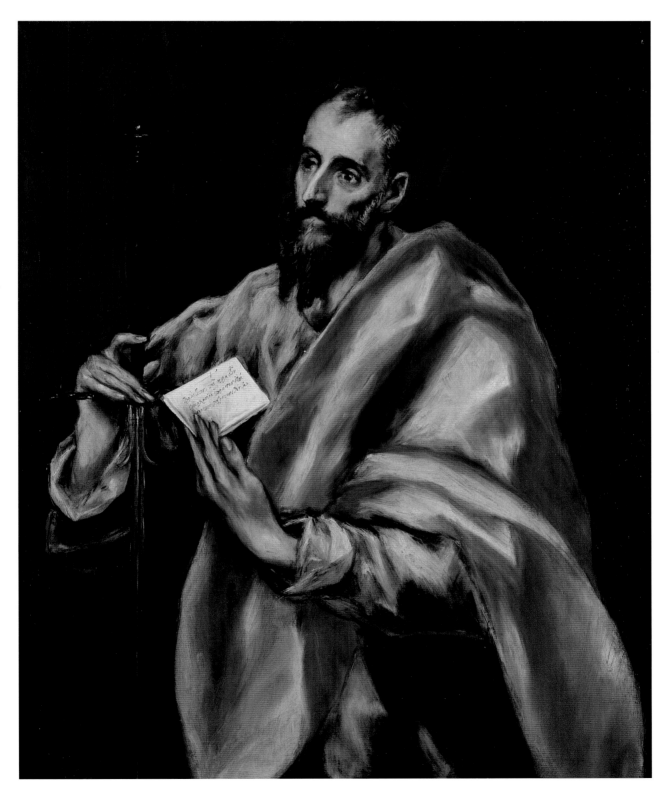

53

Oil on canvas, 124 × 93.5 cm
Nationalmuseum, Stockholm
Purchased with financial support from the Friends of the Museum, 1935, inv. NM 3077

Fig. 52 Diego de Astor (about 1585–90 – about 1650) after El Greco
Saints Peter and Paul, 1608
Engraving, 28.2 × 24.7 cm
Biblioteca Nacional, Madrid
inv. 41250

PROVENANCE

Vizcondesa de San Javier, Madrid; Marquesa de Perinat, Madrid, and her heir, Doña Soledad de Álvarez de Lorenzana, 1908; purchased by the Nationalmuseum, Stockholm, 1935

ESSENTIAL BIBLIOGRAPHY

Cossio 1908, p. 368, no. 120; Mayer 1926, no. 199; Camón Aznar 1950, nos. 426 and 427; Soehner 1957, p. 179; Wethey 1962, no. 277; Gudiol 1971, p. 245, no. 202; Pita Andrade 1981, no. 254; Iraklion 1990, no. 30 (entry by J. Álvarez Lopera); Álvarez Lopera 1993, no. 263; Barcelona 1996–7, no. 11, (entry by Milicua); Maurer 2001, no. 8

In this lifelike portrayal the two saints are shown engaged in an animated discussion. The older, white-haired Peter, wrapped in a golden-coloured cloak, inclines his head thoughtfully to one side as he looks towards the text being expounded. In his left hand he holds his attribute, the key to the kingdom of Heaven (Matthew 16: 19). His right hand is cupped as if weighing up an idea. Paul presses his left hand down firmly on the open volume on the table, his right hand raised in a gesture of explanation as he looks directly at the viewer. These two great preachers of the early Church appear to invite the onlooker to join in their debate.

Saint Peter and Saint Paul appear separately a great number of times in El Greco's œuvre and they are depicted with remarkable consistency. Peter is always shown with white hair and beard, and, following Italian iconography, he often wears his yellow cloak over a blue tunic (see also cat. 56). Paul is always shown slightly balding, with dark hair and beard, wearing a red mantle thrown over a blue or green tunic, which is here just visible at his neck.

The two saints were strongly associated with each other as the most influential leaders of the early Church. Peter was the first Apostle to be called to follow Jesus and the first to recognise Jesus as the Son of God (Matthew 16: 16). Christ gave him the name Peter, which means 'rock', telling him that he was the rock on which he would build his Church (Matthew 16: 18). Paul became a follower of Christ much later but was one of the most zealous evangelists of the new religion (see further cat. 53). Both were believed to have been martyred at Rome and to have died on the same day, 29 June, their joint feast-day.

El Greco had depicted the saints together previously, in a painting dating from about 1600 (Museu Nacional d'Art de Catalunya, Barcelona). In that painting Paul's right hand rests on Peter's wrist in a gesture symbolic of their union. The present painting, however, emphasises the difference in character between the two Apostles, Peter more reflective, Paul more energetic.

The spirit of debate embodied in this work and in an earlier version of the composition (Hermitage, St Petersburg) reflects contemporary concerns in Toledo. As Kagan suggested, the painting appears to represent the theological dispute between the Apostles at Antioch, where Paul rebuked Peter for placing too much importance on the old Jewish law (Galatians 2: 11–21).[1] This unique instance of a rift between the two Apostles took on great significance during the Reformation and Counter-Reformation. The questions faced by Peter, considered by Catholics to be the first pope, were seen as foreshadowing the questions now faced by the papacy, while Paul became a figurehead for reform. El Greco was closely associated with spiritual reformers in Toledo, some of whom were *conversos*.[2] Significantly, this picture embraces the new Christianity of the converted Paul.

The inventory of paintings left in El Greco's studio at his death includes a 'Saint Peter and Saint Paul', and the inventory made on the occasion of Jorge Manuel's marriage in 1621 lists 'a canvas with Saint Peter and Saint Paul in half-length' (no. 130); the entries have been variously interpreted as referring to the Stockholm or the St Petersburg version. The Stockholm painting was the model for an engraving signed *D.D. Astor sculp. Toleti anno 1608* (fig. 52); this shows the original format of the painting, which has been trimmed on the right, and the signature *domhnikos qeotokopoulos*, missing on the painting, on the edges of pages of the closed book. It is one of only four known prints after El Greco's compositions by Diego de Astor, who was employed by the artist between 1605 and 1608. The painter appears to have supervised the engraver closely as these prints are far superior to the rest of his output. It is significant that El Greco should have selected this composition for reproduction; two of the three other prints, *Saint Dominic in Prayer* and *Saint Francis and Brother Leo meditating on Death* (fig. 51), also reflect the interests of the reformers. LO

1. In Iraklion 1990, pp. 287–94.
2. See further Davies 1984, p. 63.

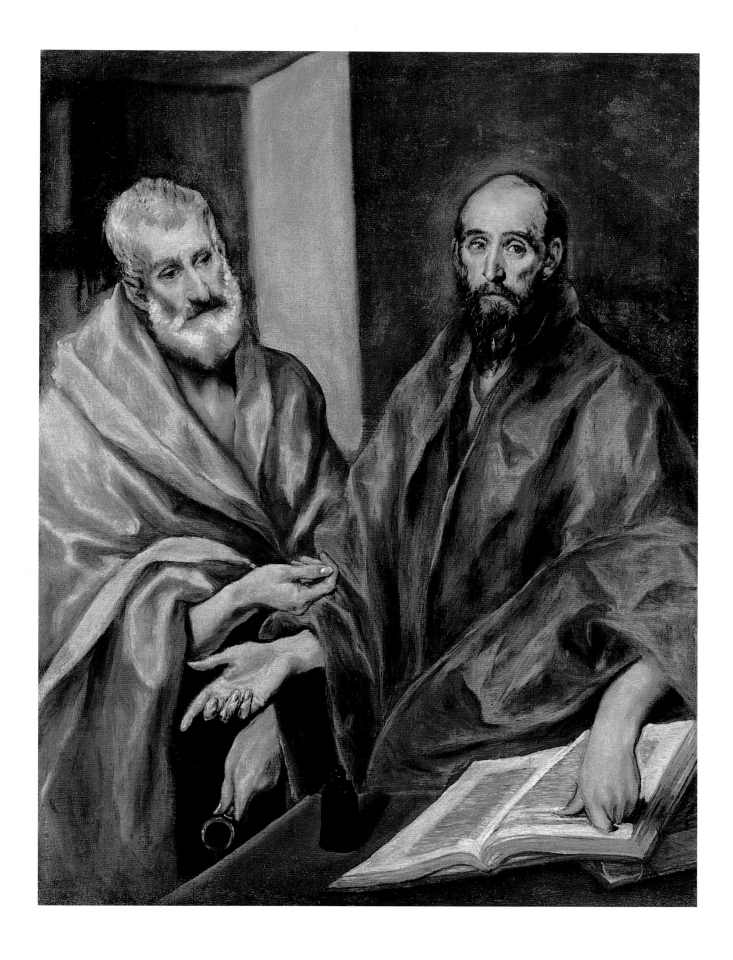

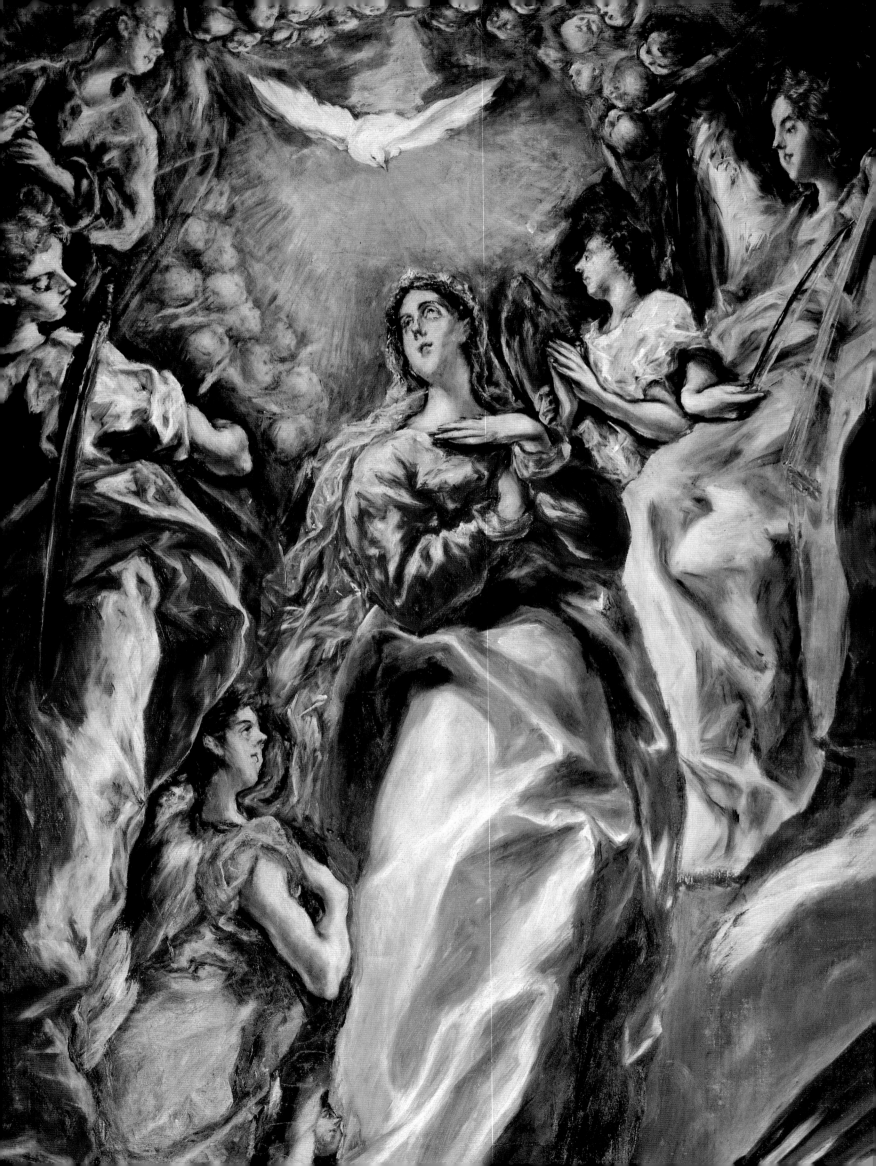

55–8 The Oballe Chapel in the Church of San Vicente, Toledo

Isabel de Oballe, the wife of a wealthy Toledan merchant, bequeathed funds for the foundation of a chapel in the parish church of San Vicente, Toledo, in her will of 1557, drawn up in Lima, Peru. Work on the chapel began in 1597, to the designs of the architect Juan Bautista de Monegro, and in 1606 the town council of Toledo, to whom the patronage of the chapel had passed, awarded the contract for the decoration to Alessandro Semini, a Genoese painter working in the city. Semini, however, died in 1607, having made a start only on some frescoes, and El Greco moved swiftly to take over the project, introducing some alternative proposals that included making the altarpiece taller, replacing the frescoed decoration with oil paintings on canvas, and placing a framed scene of *The Visitation* on the ceiling. Agreement was reached on 11 December 1607, and the painter was required to finish the work within eight months, presumably in time for the feast of the Assumption on 15 August 1608. On 13 August 1608, the painter declared in a petition to the council that the painting was well advanced, but it was clearly not finished. On 17 April 1613 he stated that the whole commission was completed and he requested a valuation, but only in March 1615, after his death, was his son Jorge Manuel able to declare that 'the altarpiece and the rest of the work of the Chapel of Isabel de Oballe which my father was contracted to do is finished and the said altar in place'.[1] The centrepiece of the scheme, over the altar, was *The Virgin of the Immaculate Conception* (cat. 55); in addition to *The Visitation* (cat. 58), the programme may have included the paintings of *Saint Peter* and *Saint Ildefonso* (cat. 56, 57). This exhibition offers the first occasion on which all four paintings can be seen together. GF

1. Cossío 1908, appendix 8.

55 The Virgin of the Immaculate Conception, between 1608 and 1613

Oil on canvas, 348 × 174.5 cm
Parish church of San Nicolás de Bari, Toledo,
now stored (together with the original frame) in
the Museo de Santa Cruz, Toledo, inv. 1277

The Virgin of the Immaculate Conception is one of
El Greco's most brilliant and celebrated paintings.
The Virgin Mary, of extraordinarily elongated
proportions, her blue cloak blazing with a white-hot
intensity, is being drawn up into Heaven, where the
dove of the Holy Spirit awaits her. She is surrounded
by cherubs and musician angels, spiritual presences
rather than real bodies, their draperies of yellow, acid
green, rose and blue-grey vibrating with an awesome
luminosity. The foremost angel, whose giant wing
flares out to the right – aptly described by Cossío,
referring to the sculpture in the Louvre, as a
'Christian Victory of Samothrace' – arches his back
as though to drive the Virgin up into the heavenly
realm. The spiritual excitement of the scene is
reflected in the meteorological effects: sun and
moon shine simultaneously while explosions
of light burst through the clouds like fire. Above

the city of Toledo the whole cosmos is heaving in
divine exultation.

El Greco took the distinctive characteristics of his
late style to their extreme conclusion in this work.
He appears to have worked rapidly with large brushes,
leaving many areas of the reddish ground visible,
and employing black pigment to help define contours.
Ordered scale and proportion, spatial recession and
anatomical accuracy have been subordinated to the
imperatives of a visionary experience. Colours are
unblended, forms have become dematerialised,
the logic of gravity and shadows is subverted; the
distinctions between near and far, open and enclosed,
physical and spiritual, are all dissolved. At the same
time, however, El Greco has included a passage of
naturalistic still life that seems to belong to the
earthly realm – the roses and lilies at lower right,
traditional emblems of the Virgin, which apparently
rise from the altar-table beneath the painting. Their
inclusion intensifies the visual transition from the
earthly to the mystical.[1] Brown has suggested that
El Greco was drawing attention to the contrast
between art and nature itself, in accordance with the
Mannerist notion of artful antithesis, or *contrapposto*.

The painting was usually described as an
Assumption of the Virgin until Wethey in 1962 catalogued
it as *The Immaculate Conception*, a title which has since
been widely adopted. The symbols that traditionally
accompany the Immaculate Conception – the ship,
the well, the fountain and the unblemished mirror
(imagery drawn from litanies of the Virgin), as
well as Eve's serpent – are shown at lower right.
The slightly more laboured execution of these
'Immaculist' emblems suggests that they may be
the work of Jorge Manuel. Be that as it may, the
upward thrust of the composition is so marked
that it is likely that El Greco was intentionally
conflating the iconographies of the Assumption
and the '*Inmaculada*'.

The picture was made for the Oballe Chapel in the
Church of San Vicente in Toledo (fig. 53). A reduced
replica of the painting, apparently signed, is in the
Fundación Selgas-Fagalde in Oviedo.[2] GF

PROVENANCE

Painted for the Oballe Chapel in San
Vicente, Toledo; moved to the Museo
de Santa Cruz, Toledo, in 1961

ESSENTIAL BIBLIOGRAPHY

Cossío 1908, no. 261, appendix 8;
San Román y Fernández 1927, pp.
13–14, doc. XXX, pp. 60–1; Wethey 1962,
II, no. 89; Brown in Madrid-
Washington-Toledo (Ohio)-Dallas
1982–3, p. 139; Stratton 1988, p. 47;
Marías 1995; Marías 1997, pp. 277–81

Fig. 53 **The Virgin of the Immaculate Conception** (cat. 55) in
its original frame in the Oballe Chapel in the Church of San
Vicente, Toledo.

1. Davies 1973, pp. 243–4.
2. Madrid-Rome-Athens 1999–2000, no. 84.

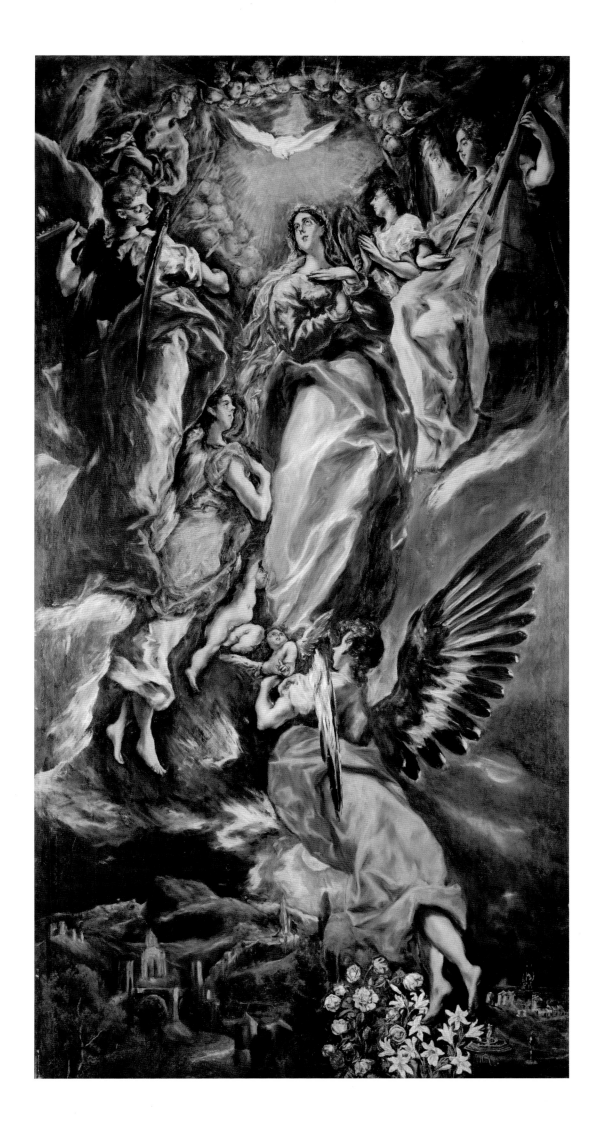

Oil on canvas, 209 × 106 cm
Monasterio de San Lorenzo de El Escorial,
Patrimonio Nacional, inv. 10014681

Executed with an astonishing freedom of handling and a self-confident virtuosity, this painting is a magnificent example of El Greco's late manner. In essence the painting is composed of a vast swathe of yellow drapery that fills the picture space, turning and flashing, hiding and revealing the figure it enfolds. The proportions of the saint are dramatically elongated, making him seem tall and dynamic. A sliver of ground with a low horizon line and an endless sky, thinly brushed in over the reddish preparation layer, enable him to tower over the viewer. In his hand Peter carries keys, signifying the authority entrusted to him by Christ. The arched top has been slightly reduced at some point.

This work and its companion piece, *Saint Ildefonso* (cat. 57), were probably intended for the Oballe Chapel in the Church of San Vicente in Toledo, where, hanging on the short lateral walls, they would have flanked El Greco's altarpiece of *The Virgin of the Immaculate Conception* (cat. 55). The evidence for this is essentially circumstantial. Old copies of these two pictures, although at that time they were thought to be originals by El Greco, were recorded in 1711 as having been removed from the Oballe Chapel to decorate the high altar (these are now in the Museo de Santa Cruz in Toledo).[1] Thematically the subjects fit in well: Saint Peter was the patron saint of Isabel de Oballe's second husband, Pedro López de Sojo, and we know that when making his bid for the commission El Greco had been keen to include a *Visitation* on the ceiling (cat. 58) so that he could depict the patron saint of the founder of the chapel, Saint Elizabeth. Saint Ildefonso was both a theologian of Marian themes and the patron saint of Toledo. Stylistically, they are very similar and clearly date from the last few years of El Greco's life.

In March 1615 the chapel was said to be complete with all the decorative elements finished and in place. This does not necessarily mean that these two paintings were part of the arrangement; they might well have been substituted with copies from the start. The *Saint Peter* and the *Saint Ildefonso* from the Escorial are almost certainly identical with two paintings of these subjects recorded in the inventory of the pictures belonging to Jorge Manuel in 1621: '27 A Saint Peter standing, 2⅔ *varas* high by 1⅓ wide, with a round headed top; 28 A Saint Ildefonso of the same width and height, and format.'[2] These dimensions correspond approximately to 224 × 112 cm, which is close to those of these two paintings before they were reduced in height. If they are indeed the same pictures, then they would have passed into the Spanish royal collection at some point in the seventeenth century, since they are recorded in Francisco de los Santos's 1698 edition of his description of the monastery of the Escorial. They do not appear in any of the earlier editions of the book, first published in 1657, and so may well have been acquired rather late in the century. GF

1. Ramírez de Arellano 1921, p. 287.
2. San Román y Fernández 1927, doc. XXXV.

PROVENANCE

Possibly intended for the Oballe Chapel, San Vicente, Toledo; probably identical with a picture listed in the inventory of Jorge Manuel, 1621; El Escorial, before 1698

ESSENTIAL BIBLIOGRAPHY

Santos 1698, quoted in Sánchez Cantón 1923–41, II, pp. 309, 312; Poleró 1857, no. 96; Cossío 1908, no. 43; Ramírez de Arellano 1921, p. 287; Wethey 1962, II, no. 274; Vienna 2001, no. 40 (entry by L. Ruíz Gómez)

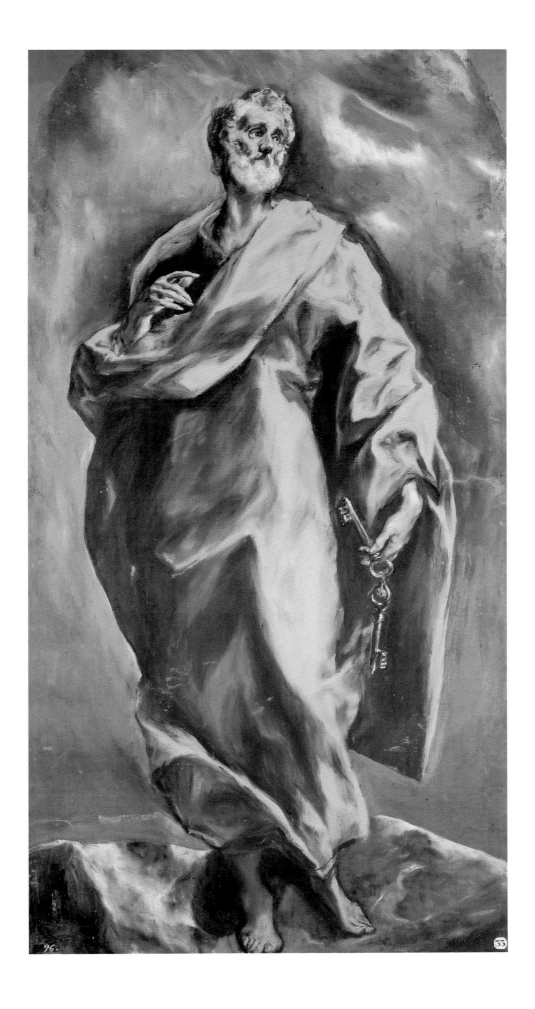

57 Saint Ildefonso, early 1610s

Oil on canvas, 219 × 105 cm
Monasterio de San Lorenzo de El Escorial,
Patrimonio Nacional, inv. 10014686

Saint Ildefonso, bishop of Toledo between 657 and 667, was the renowned writer of a treatise in defence of the virginity of Mary entitled *De virginitate perpetua Sanctae Mariae* (On the perpetual virginity of the Holy Mary). The Virgin herself appeared to him to signify her approval and on the feast-day of the Assumption in the cathedral of Toledo she appeared again and placed a chasuble on him. The latter apparition was the subject of a carved relief El Greco made for the cathedral vestry (see further cat. 21).

El Greco represents the saint, the patron saint of Toledo, in full episcopal regalia, holding an elaborate gilt crozier through its green velvet sleeve wearing white kid gloves. He is wearing a spectacular chasuble embroidered with floral arabesques and exotic birds, lined with pink silk, over a radiant white alb, and on his head an embroidered mitre. He reads a holy book with serious intensity while all around him the sky seems charged with high-voltage static. El Greco makes a play of diagonals and of axes that do not exactly align or are just off-centre, in order to create a dynamic image that is visually exciting.

The saint is illuminated from the left, in contrast to the companion piece of *Saint Peter* (cat. 56), who is lit from the right. This, and the arched top of both canvases (slightly reduced here, as in the *Saint Peter*), indicate that they were conceived to flank a window or central image. This was almost certainly *The Virgin of the Immaculate Conception* (cat. 55). The chapel has a window just above the frame of the altarpiece, as can be seen from an old photograph (fig. 53). Thus, *Saint Peter* would have been intended to hang to the left of the altarpiece and *Saint Ildefonso* to the right. As stated in the previous entry, it is unlikely that these paintings were ever hung in the chapel, having been substituted with copies from the start.

When the painting was first recorded in the Escorial monastery by Padre Francisco de los Santos in 1698, he described the saint as Eugene, the first bishop of Toledo, whose relics had been transferred to Toledo Cathedral from France in 1565. Mayer identified it as *Saint Ildefonso* on the basis of the description in the inventory of Jorge Manuel of 1621 (see previous entry). GF

PROVENANCE

As cat. 56

ESSENTIAL BIBLIOGRAPHY

Santos 1698, quoted in Sánchez Cantón 1923–41, II, pp. 309, 312; Poleró 1857, no. 90; Cossío 1908, no. 42; Ramírez de Arellano 1921, p. 287; Mayer 1926, no. 288; Wethey 1962, II, no. 275; Madrid-Washington-Toledo (Ohio)-Dallas 1982–3, no. 53 (entry by W.B. Jordan); Granada-Seville 2001, pp. 155–7 (entry by J. Álvarez Lopera)

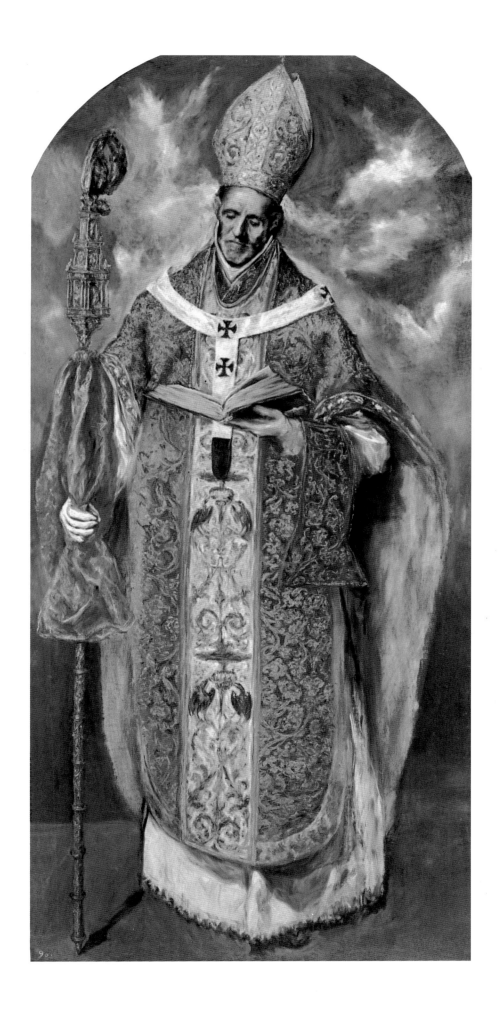

58 The Visitation, early 1610s

Oil on canvas, oval, 96 × 72.4 cm
Dumbarton Oaks, Washington, DC,
House Collection, inv. HC.P.1936.18(O)

PROVENANCE

Probably Oballe Chapel, San Vicente,
Toledo; reportedly in the convent
church of Santa Clara, Daimiel, near
Ciudad Real, Spain; possibly in the
collection of Mrs Horace Harding; with
Arthur Byne Medieval and Renaissance
Art, Madrid; acquired there in January
1936 by Mr and Mrs Robert Woods
Bliss, Washington, DC; donated by
them to Harvard University as part of
the Dumbarton Oaks Collection, 1940

ESSENTIAL BIBLIOGRAPHY

San Román y Fernández 1927, doc. XXX;
Plaut 1936; Wethey 1962, II, no. 115;
Madrid-Washington-Toledo (Ohio)-
Dallas 1982–3, no. 52 (entry by W.B.
Jordan)

The scene shows the meeting of Mary, on the right, pregnant with Jesus, and her cousin Elizabeth, who was in her sixth month awaiting the child who would become John the Baptist. 'And it came to pass that, when Elisabeth heard the salutation of Mary, the babe leapt in her womb; and Elisabeth was filled with the Holy Ghost: And she spake out with a loud voice, and said, "Blessed are thou among women, and blessed is the fruit of thy womb"' (Luke 1: 41–2). The meeting took place at the entrance to the house of Zachariah, the husband of Elizabeth, and El Greco shows a classicising doorway with a heavy cornice and consoles on the left.

The Visitation was made for the Oballe Chapel in the Church of San Vicente in Toledo. In 1607, when El Greco made his bid for the commission, he probably proposed to the municipal authorities of Toledo, to whom the patronage of the chapel had passed, that a painting of this subject should be included: '. . . and furthermore there is to be added on the ceiling a story of the Visitation of Saint Elizabeth because that is the name of the founder, and thus a tondo with its frame will be attached in the same manner as at Illescas'.[1] Illescas is mentioned because a few years earlier he had painted there a Coronation of the Virgin which was framed and attached to the ceiling (see cat. 48). The intended location of The Visitation explains the dramatic sotto-in-su perspective of the scene, the curved rendering of the floor, and the absence of a horizon line. Although The Visitation has usually been described as an oval, during the cleaning of the picture undertaken in 1950 it was established that no original tacking edges survived and that the painting had been reduced on all four sides: measurement of the composition's curve clearly indicated that it was originally circular rather than oval, with a diameter of about 96 cm.

Like the other works for the Oballe Chapel, The Visitation is painted with great force and dynamism. Mary and Elizabeth are 'enveloped in ample blue mantles upon which broad white highlights are liberally and brilliantly disposed like flashes of lightning', as Wethey described it.[2] Comparison has often been made with The Opening of the Fifth Seal (cat. 60), with reference to the handling of the draperies, the jagged outline of Mary and the flashing white lights everywhere in the painting.

Wethey, whose description of the painting has formed the basis of subsequent discussions, argued that the execution of the doorway was probably the work of an assistant, that the picture was unfinished, and that the painting was never installed in the Oballe Chapel. All three of these statements should be challenged, however. According to the agreement with the town council El Greco was required to execute all the paintings 'with his own hand and no other', while the architecture is summarily painted but not significantly inferior in quality to the rest of the picture. El Greco, knowing that it was to be placed on a vault, possibly felt he did not need to bring the painting to a high level of finish. In March 1615 Jorge Manuel declared that the chapel was finished in accordance with the agreement that his deceased father had signed.[3] This would imply that The Visitation, too, was in position. Although the painting was reportedly at some point in a convent near Ciudad Real, it may well have been in the Oballe Chapel for some time before its removal there. GF

1. San Román y Fernández 1927, doc. XXX, writer's translation.
2. Wethey 1962, II, p. 72.
3. Cossio 1908, p. 664.

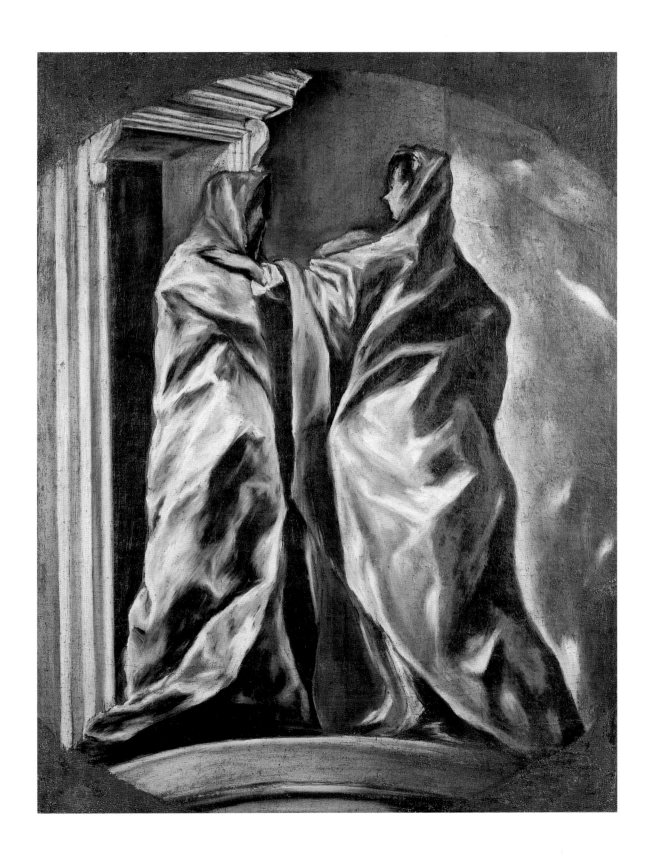

Oil on canvas, 110 × 83 cm
National Museum of Art of Romania, Bucharest

In this painting El Greco treats his subject in the manner typical of his late style. Drawing on his post-Byzantine roots, he opts for a simple symmetrical composition, painting the drapery of his protagonists' clothes in bright colours and elongating their figures to achieve an expression of religious intensity that recalls the visual impact of icons. The High Priest, with a large white beard and a mitre on his head, stands in the centre of the composition, with the Virgin Mary and Saint Joseph on either side. They are shown in the moment of their matrimonial union, represented by the locking together of their hands, which stand out against the background of the High Priest's white tunic. In the liturgy of the Latin Church, this moment is known as the *Dextrarum junctio* (Joining of right hands) or *Conjunctio manuum* (Joining of hands).[1]

The marriage of the Virgin, though not mentioned in the Gospels, was a familiar theme in Christian art, sometimes forming part of a cycle of scenes from the life of the Virgin. The story, as found in the Protevangelium (New Testament apocrypha) and in the thirteenth-century *Golden Legend*, recounts how Joseph was chosen as a husband for the fourteen-year-old Virgin from among a number of suitors after a sign, the miraculous flowering of his rod. Omitting such details, El Greco has concentrated instead on the moment when their vows are confirmed. Unlike earlier representations of the subject, in which he is shown as an old man, Joseph is depicted as a vigorous young man, enhancing his rôle as an intercessor (see further cat. 29, 38, 39).[2]

The trio create a perfect triangular composition, the symmetry of which is further emphasised by the grouping of the figures behind them. Two of the seven virgins who were Mary's companions during her upbringing in the Temple stand by her, while Saint Joseph is accompanied possibly by his unsuccessful rivals as suitors for Mary's hand. One of these, the bearded man dressed in black looking directly at us, resembles the man, thought by some to be a self-portrait, who appears in the background

of El Greco's *Pentecost* (1596–1600; fig. 50), probably painted for the Doña María de Aragon altarpiece.

To strengthen the visual impact of the composition, El Greco uses bright primary colours for the drapery. The vibrancy of the light blue of the Virgin's cloak and the yellow set against green of Joseph's clothing heightens the symbolic and spiritual nature of the event. The vertical lines of the elongated figures are echoed in the pilasters and columns in the background, which allude to the Temple of Jerusalem where the Virgin was brought up, with a dark patch behind the high priest bringing our eye towards the centre. To suggest a sense of space and perspective, El Greco has inserted a marble paved floor with clear lines of recession, similar to that which appears in his late *Purification of the Temple* (cat. 9).

We do not know for whom El Greco painted this picture. As a representation of Holy Matrimony, it may have been part of a series showing the seven Sacraments. Mayer suggested that it may have come from the Hospital de la Caridad at Illescas, where Fray Gaspar de Jesús de Santa María, writing in 1709, recorded the existence of a painting of the same subject on a side altar.[3] However, the frames on the altars at Illescas, measuring 187 × 102 cm, are considerably larger than this painting. Even though the picture was probably cut down after it was sold from the Condesa de Quinto's collection, where it is recorded as measuring roughly 150 × 80 cm, it seems unlikely it would ever have filled one of the Illescas frames. Since the present version is late in date and seemingly unfinished, it was probably painted for another location. Two versions of the subject appear in the posthumous inventories of El Greco's work, but the dimensions given for one of them are much smaller than this painting; the other is described simply as '*un despojo pequeño*' (a small marriage). XB

1. Réau 1955–9, II, p. 171.
2. Mâle 1957, pp. 315–6.
3. Wethey 1962, II, p. 63.

ESSENTIAL BIBLIOGRAPHY

Mayer 1926, no. 14; Wethey 1962, II, pp. 63–4

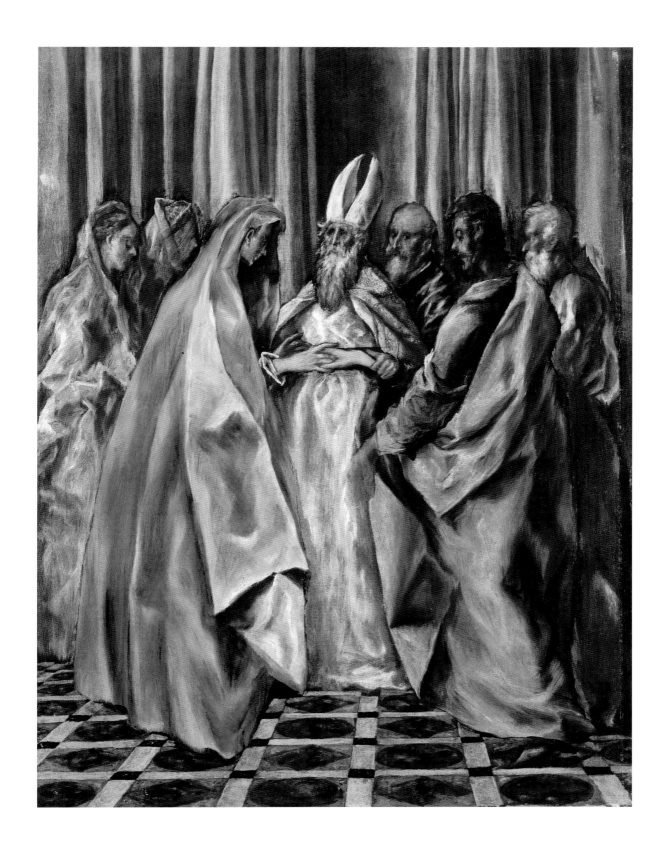

Oil on canvas, 222.3 × 193 cm
The Metropolitan Museum of Art, New York
Rogers Fund, 1956, inv. 56.48

ESSENTIAL BIBLIOGRAPHY

Cossío 1908, pp. 355–7, 680–1; Camón Aznar 1950, II, pp. 948–57, p. 1371, no. 266; Wethey 1962, pp. 19–24, 77, no. 120; Baetjer 1981, pp. 26–7; Mann 1982, pp. 57–76; Pérez Sánchez in Madrid-Washington-Toledo (Ohio)-Dallas 1982–3, pp. 174–5; Mann 1986, pp. 134–41; Richardson 1987, pp. 40–1, 44–7; Richardson 1991, pp. 429–31; Foundoulaki in Athens 1992–3, pp. 108–11; Joannides in Hadjinicolaou 1995, p. 214; Marías 1997, pp. 285–6; Hadjinicolaou in Madrid-Rome-Athens 1999–2000 (supplement for Greek edition), pp. 4–6

The Opening of the Fifth Seal is a large fragment of one of three altarpieces El Greco contracted to paint in 1608 for the church of the Hospital of Saint John the Baptist (the Tavera Hospital).[1] Located just outside the walls of Toledo, the hospital was founded in 1541 by Cardinal Juan Tavera (1472–1545), who is buried in the church. The administrator responsible for the commission was Pedro Salazar de Mendoza (c. 1550–1629), an admirer of El Greco with strong views about the function of works of art. He is known to have owned no fewer than six paintings by the artist, probably including the *View and Plan of Toledo* (fig. 9, p. 27), which gives prominence to the hospital (shown floating on a cloud). Thirteen years earlier, in 1595, El Greco had designed for the main altar a wooden tabernacle, or *custodía*, adorned with four small statues of the Fathers of the Church and another of the risen Christ. The tabernacle survives, though in a sadly dilapidated state, and the statuette of the risen Christ (fig. 49, p. 174) – of exceptional beauty and great importance, as it provides an idea of the appearance of the sculptural models in plaster, clay and wax that El Greco worked from – is normally displayed in the library.

Of the 1608 project for the altarpieces, three pictures survive: an *Annunciation* (Colección Santander Central Hispano, Madrid; the picture has been cut: the upper portion, showing a choir of angels, is in the National Gallery, Athens); a *Baptism* (installed on a side altar in the church; fig. 20, p. 58); and the picture in the Metropolitan Museum known today as *The Opening of the Fifth Seal* but perhaps best described as *Saint John the Evangelist witnessing the Mysteries of the Apocalypse* – the way a small replica or model for the picture was described in the 1614 inventory of El Greco's studio.[2]

This was El Greco's last large-scale undertaking, and he did not live to complete it: in the 1614 inventory we find its components described as 'the paintings destined for the hospital, begun', followed by 'the wood frames, not sculpted, for the lateral altarpieces', and 'the altarpiece of the high altar without its columns, tympana and sculptures'. Also listed are two canvases for the tympana (or pediments) of the lateral altarpieces. El Greco's son Jorge Manuel continued to work on the altarpieces

and by 1621 the frames of the lateral ones had been prepared for gilding and that for the high altarpiece had been finished.[3] Jorge had completed *The Baptism*, which was for the high altar, but not the paintings for the lateral altars, which remained only sketched in ('*bosqueados*'). Eventually, Jorge Manuel brought *The Annunciation* to completion, thereby spoiling with his pedestrian imagination and merely competent brush what his father had begun, just as he had spoiled the principal figures of *The Baptism*. Fortunately, *The Opening of the Fifth Seal* remained as El Greco had left it. Although cut down in 1880, when it was re-lined by a restorer of the Prado (as much as 175 cm may be missing from the top and as much 20 cm from the left side), and badly damaged, the Metropolitan's canvas remains the best testimony we have of the visionary heights of El Greco's late style.[4]

In the foreground is the incredibly elongated, ecstatic figure of Saint John, his head turned imploringly heavenward, his arms raised. Behind him are two groups of figures. The three on the right, seen against a green drapery, are male and reach upwards for white garments distributed by a flying cherub. The four on the left are shown in front of a mustard-coloured cloth. Two are male, two female, and they seem to be covering (or uncovering) themselves with the yellow drapery. It was Cossío who, in 1908, first proposed that these features suggested a visualisation of the Book of Revelation (6: 9-11), when Saint John the Evangelist witnesses the breaking of the Fifth Seal by the Lamb of God: '. . . I saw under the altar the souls of them who were slain for the word of God, and for the testimony which they held: And they cried with a loud voice, saying, "How long, O Lord, holy and true, does thou not judge and avenge our blood on them that dwell on the earth?" And white robes were given to every one of them; and it was said unto them, that they should rest yet for a little season, until their fellow servants also and their brethren, that should be killed as they were, should be fulfilled.' Unlike Dürer, who illustrated this passage in the upper register of one of his celebrated woodcuts of the Apocalypse, and Matthias Gerung, whose 1546 woodcut offers interesting analogies with El Greco's painting (it includes the

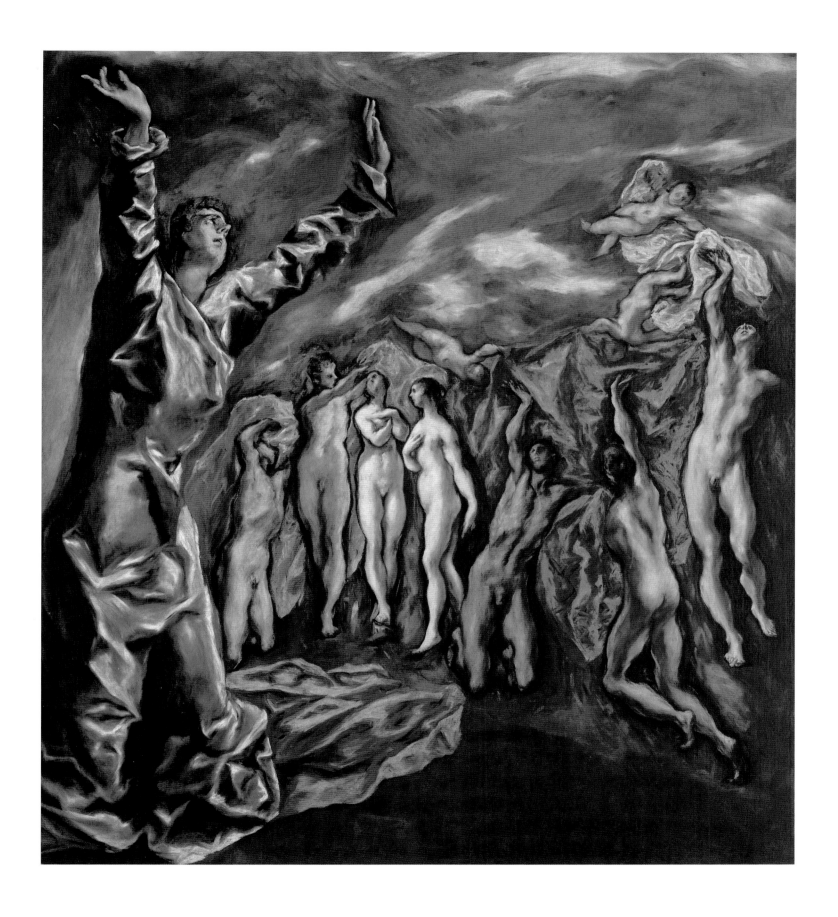

figure of Saint John in the foreground), El Greco shows no altar.[5] However, it is possible that an altar may have been represented above, in the sky, surrounded with angels, as in Dürer's and Gerung's prints. The towering figure of Saint John in the foreground shifts the emphasis from an illustration of an incident to Saint John and his vision.

Such a scene would have been important to the hospital, which offered spiritual consolation as well as physical care to patients, promising salvation to those who died within its walls. As Mann has shown, this aspect of the hospital's ministry was emphasised by Salazar de Mendoza, whose active interest in the altarpieces must be taken into account: in the contract it is stipulated that he had the right to inspect progress on them whenever he wished as well as to suspend work if he detected any slackness.[6] The hospital was empowered to grant indulgences that, in effect, enabled patients to join the ranks of the elect; this circumstance encouraged Mann to suggest that the Metropolitan's altarpiece actually shows *The Resurrection of the Elect*, a theme famously treated by Signorelli in his fresco cycle in the cathedral of Orvieto. Without the upper portion of the altarpiece, the precise identification of the event shown is bound to remain speculative – if, indeed, the intent was to illustrate a specific event rather then allude to the implications of John's apocalyptic vision. In this regard it is worth quoting from some notes on the painting by Meyer Shapiro, deposited at the Metropolitan Museum in 1957. 'In the colored stoles (or garments), El Greco perhaps follows the old French gloss on the Apocalypse, where it is said that the white stole is given to the martyred saints to signify that their souls and bodies are in the earth and they see Christ in the glorified flesh; their cry is for the last judgment and the resurrection of their bodies, when they will receive another stole and be above the altar If this gloss is pertinent here, it would appear to mean that El Greco represented not only the Opening of the Fifth Seal, but also its interpretation as a prophecy of the Last Judgment. Hence the figures rising from the ground as in images of the Last Judgment.'[7]

Mann also suggests that it was the Metropolitan's painting, rather than *The Baptism*, that was intended for the high altar since, according to the contract, the tympanum of the frame for the main altarpiece was to be decorated with a sculptural group of angels adoring the Lamb of God. That subject would, indeed, have been appropriate for a scene of the Apocalypse – but no less so for a *Baptism*. It is difficult to get around the very specific notice in the 1621 inventory of Jorge Manuel's possessions in which *The Baptism* is referred to as the principal altarpiece, and the fact that the hospital was dedicated to Saint John the Baptist, the patron saint of its founder. What cannot be doubted is that, when taken together, the three scenes offered a synopsis of God's plan of salvation by showing the incarnation of Christ, the manifestation of his divine mission, and a vision of the elect at the end of time.

In realising this hallucinatory scene, El Greco's imagination inevitably turned back to his memories of Rome and Michelangelo and the ceiling of the Sistine Chapel. The pose of one of the nude figures ultimately derives from the sculpture group of the *Laocöon* (a similar figure is found in El Greco's painting of this subject, cat. 69), while that of Saint John recalls Michelangelo's Hamen in one of the pendentives of the Sistine Chapel, although, as Joannides has remarked, 'it was the spiritual expressiveness of Michelangelo's figures that now fascinated El Greco' rather than the direct transcription of a motif.[8]

It can be only dimly imagined what the effect of El Greco's altarpiece would have been when the object of Saint John's upward gaze was depicted and the surface was brought to the degree of finish seen in *The Immaculate Conception* (cat. 55). Yet, despite its mutilated and much compromised state, the picture remains enormously powerful and has become a part of our shared visual culture. Indeed, its visionary treatment of space and dematerialisation of form have been shown to have played a crucial rôle in the genesis of that watershed of modernism, Picasso's *Demoiselles d'Avignon* (Museum of Modern Art, New York).[9] 'It is true,' Picasso remarked, 'that Cubism is Spanish in origin, and it was I who invented Cubism. We should look for Spanish influence in Cézanne. . . . Observe El Greco's influence on him. A Venetian painter, but he is Cubist in construction.' Picasso knew *The Opening of the Fifth Seal* from his visits to the

Paris studio of the painter Ignacio Zuloaga; Zuloaga had acquired the picture (which he insisted on interpreting as *Sacred and Profane Love*) in 1905. The painting also loomed large among the German Expressionists.[10] In the *Blue Rider Almanac* of 1912 Franz Marc wrote, 'Cézanne and El Greco are spiritual brothers, despite the centuries that separate them In their views of life both felt the *mystical inner construction*, which is the problem of our generation.'[11] The fact that almost three decades later *The Opening of the Fifth Seal* was sketched by Jackson Pollock reminds us how central El Greco has been to the modern imagination before Warhol, whose embrace of commercial culture stands at the opposite pole from El Greco and the artists he inspired. It also reminds us of the very different views that have been brought to El Greco's work.[12] KC

1. The contract was published by Cossío 1908, pp. 680–8, appendix 13. The fullest treatment of the altarpieces remains that of Mann 1986, pp. 111–46.
2. The subjects of the three canvases are not mentioned in the contract with El Greco but can be inferred from a document of 1635, when Félix Castelló was hired to paint replacements. In the 1635 document the subject of the Metropolitan's painting is referred to as '*una vision del apocalipsi*' and this confirms that the small picture listed in the inventory of El Greco's studio was related to the altarpiece: see San Román y Fernández 1910, p. 191, and 1927, pp. 119–20.
3. This information comes from the 1621 inventory of Jorge Manuel's possessions.
4. A detailed report and photographs of its restoration by Mario Modestini in 1958 are in the files of The Metropolitan Museum.
5. See the supplementary entry by N. Hadjinicolaou for the Greek edition of Madrid-Rome-Athens 1999–2000.
6. See Mann 1986, pp. 112, 136.
7. The French gloss referred to is Bibliothèque nationale fr. 403 (Delisle and Meyer 1901, p. 30).
8. Joannides in Hadjinicolaou 1995, p. 214.
9. See Richardson 1987, pp. 40–1, 44–7, and 1991, pp. 429–31. Some of the same observations were made in Laessøe 1987. See also Rubin 1988.
10. See Schroeder 1998, pp. 113, 120–1.
11. Quoted in Richardson 1987, p. 40.
12. For Pollock's sketches see Baetjer, Messinger and Rosenthal 1997, pp. 48, 51, 56. For the varying modern views of El Greco see Brown in Madrid-Washington-Toledo (Ohio)-Dallas 1982–3, pp. 26–30.

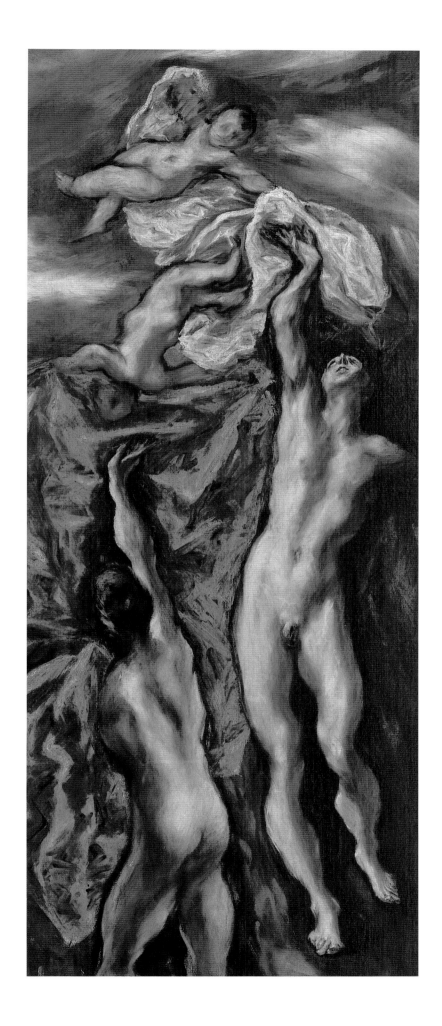

61 The Adoration of the Shepherds, about 1610

Oil on canvas, 144.5 × 101.3 cm

Inscribed on scrolls: *GLOR[IA] IN EXC[ELSIS D]EO / HOMI[NIBVS] / LAVDAMUSTE BENEDICIMV[STE]*
(Glory to God in the Highest [and on earth peace, good will towards] men; we praise you, we bless you)

The Metropolitan Museum of Art, New York
Rogers Fund, 1905, inv. 05.42

PROVENANCE

Duque de Hijar, Madrid; Don Luis de Nava, Madrid, 1892; E. Kerr-Lawson, Scotland, from 1895; D. McCorkindale, Lanarkshire, Scotland, by 1901; sold Morrison & Co., London, 6 November 1903 (no. 64); Eugene Glaenzer, New York 1904–5; The Metropolitan Museum of Art

ESSENTIAL BIBLIOGRAPHY

Cossío 1908, pp. 352, 595, no. 282; Camón Aznar 1950, pp. 729, 738; Wethey 1962, II, pp. 26, 27, no. 27; Lafuente Ferrari 1969, pp. 78, 130–1, 136; Baetjer 1981, pp. 30–2; Boime in Hadjinicolaou 1995, pp. 627, 642–3; Pita Andrade in Madrid-Rome-Athens 1999–2000, p. 411

In his 1962 monograph Wethey distinguished four basic compositions of *The Adoration of the Shepherds* by El Greco. The Metropolitan's canvas belongs to what he described as 'type III' and traces its descent from a picture now in the Colegio del Patriarca, Valencia. That work, conceivably commissioned by Don Pedro Laso de la Vega for Saint John of Ribera, Patriarch of Antioch and Archbishop of Valencia, was painted before 1605, when it was copied in an engraving by Diego de Astor.[1] The composition of the Metropolitan's picture is almost identical – the major change is the placement of the ox in front of rather than behind the Christ Child – but its effect is quite different. This is partly due to the increased emphasis on the enveloping darkness of the nocturnal setting, with the figures defined by the flickering radiance emanating from the Christ Child. It is also due to the use of a staccato-like brushwork that serves to dematerialise the forms still further. In all these respects the painting served as a sort of prelude to the great *Adoration of the Shepherds* El Greco planned for his own tomb (cat. 62). With reason, Wethey called the Metropolitan's canvas 'much the finest' of its type. It should, nonetheless, be noted that the picture almost certainly involved the workshop, and that this explains the discontinuity in some of the highlights as well as the variations in quality in the realisation of various features, for example the foreshortened hand of the pointing shepherd. X-rays show that in laying in the composition some alterations were made: most significantly, the head of Joseph was at first placed closer to the Virgin than it is. Yet, if the picture cannot bear comparison to the sublime *Adoration* for El Greco's tomb, it is vastly superior to the reduced replicas that were made as studio records of his altarpieces. (One such replica – of the late *Adoration* – is also in the Metropolitan Museum.)

The idea of a nocturnal Nativity certainly originated with El Greco's recollection of Correggio's celebrated altarpiece known as '*La Notte*' (now Gemäldegalerie, Dresden) and of certain paintings by the Bassano, both Jacopo and Francesco. The motif of the Virgin lifting the linen sheet on which the Christ Child lies, as though exposing him for veneration, is also found in Jacopo Bassano's treatment of the theme.

It is an action that underscores the sacral nature of the scene and reinforces the traditional allusion to Christ's death and to the manger as an altar.

The ruins in which the Nativity is set have been taken over from an illustration of the Baths of Diocletian in a publication of the ruins of Rome that El Greco probably owned.[2] In the Metropolitan's painting the vaults serve both to locate the Nativity and to frame the composition in a contained oval – far more pronounced than in the painting in Valencia. It was doubtless the desire to emphasise internal compositional rhythms that led El Greco to change the position of the ox, whose horns serve to bind the left-hand shepherd with the figure of Saint Joseph. This tendency towards abstraction and an almost dance-like, restless movement, with gestures indicating excitement and wonder, is characteristic of El Greco's late style – but so also is the insertion of a naturalistically observed detail, in this case the placid, homely features of the ass. All of these features mark a significant improvement on the painting at Valencia – a work that is not of the finest quality – and underscore the degree to which the Metropolitan's painting must be considered an independent production.

Nothing is known about the origins of the picture. Eight paintings of *The Nativity* are listed in the 1614 inventory of El Greco's studio – a clear indication of the popularity of the theme. It is impossible to say which were originals and which merely replicas. In the 1621 inventory of his son's possessions we do find a *Nativity* measuring $1^2/3$ by $1^1/3$ *varas* – the equivalent of 138 × 111 cm. This could be the Metropolitan's painting, but it cannot be demonstrated. KC

1. See Wethey 1962, II, p. 27, no. 26. That the work may have been commissioned by Don Pedro Laso de la Vega is suggested by the probable history of another painting by El Greco in the Colegio del Patriarca, the *Allegory of the Camaldolese Order* (cat. 44). Saint John of Ribera was a distant relative of Doña Mariana de Mendoza, the wife of Don Pedro. Although the painting is not mentioned in a 1611 inventory drawn up after the death of Saint John, it presumably was in the Colegio. See Álvarez Lopera in Madrid-Rome-Athens 1999–2000, pp. 422–3, nos. 73–4.
2. See further Bury 1987.

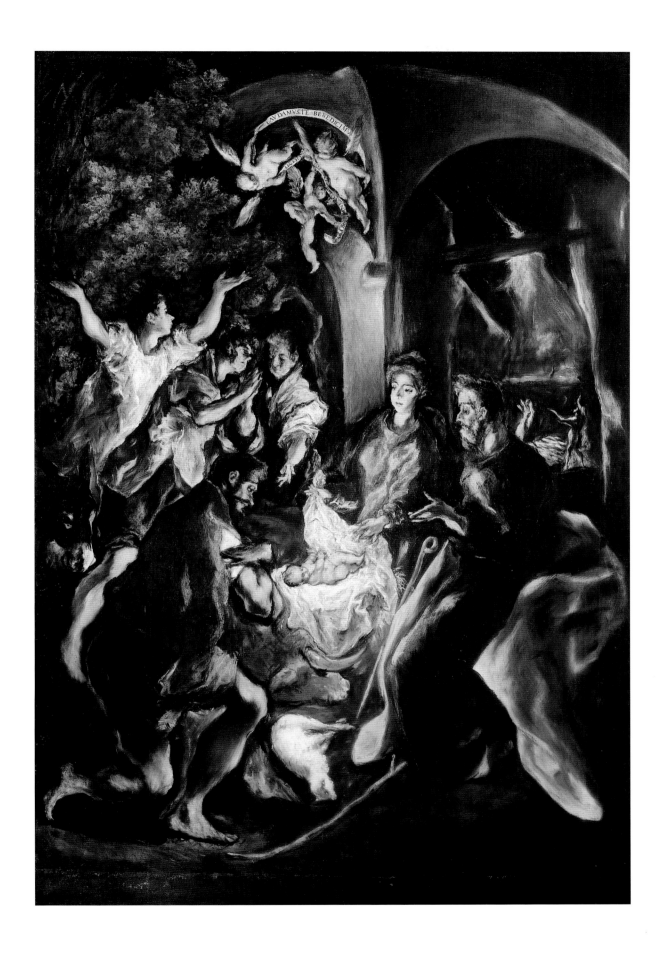

62 The Adoration of the Shepherds, about 1612–14

Oil on canvas, 319 × 180 cm

Inscribed on scroll: *Gloria in Excelsis. In terra pax*
(Glory [to God] in the highest, and on earth peace. . .)

Museo Nacional del Prado, Madrid, inv. 2988

PROVENANCE

Originally painted to hang above
El Greco's family tomb in the church
of Santo Domingo el Antiguo in Toledo
on the left side of the nave next to the
nuns' choir. When El Greco's bones
were exhumed in 1618 to be taken to
the new family tomb at San Torcuato,
Toledo, the picture was moved to
the chapel opposite the entrance of
the church. In 1827 the picture was
installed on the main altar in place of
The Trinity, which had been sold (Prado,
Madrid); the picture was eventually
sold in 1954 to the Prado.

ESSENTIAL BIBLIOGRAPHY

Cossío 1908, no. 232; Mayer 1926, no. 21;
Camón Aznar 1950, no. 53; Sánchez
Cantón 1956, pp. 86–8; Soehner 1960, I,
p. 194; Wethey 1962, II, pp. 27–8, no. 28;
Ruiz Gómez 2001, p. 114; Bray in Bailey
2001, p. 86

In this representation of *The Adoration of the Shepherds*, as in the Illescas *Nativity* (cat. 48), the Christ Child is the main source of light for the composition, illuminating the drapery worn by the figures around him in flame-like splendour. In contrast with his earlier interpretations of the same subject (see cat. 13), El Greco seems to forego any attempt to achieve balanced proportions, harmonious colouring and comprehensible space, transforming the scene into a transcendent and spiritual happening depicted in bright and contrasting colours. The bearded shepherd in the centre wears a bright orange-red jacket over yellow-green breeches, while Saint Joseph on the left appears in a purplish-blue tunic and yellow drapery. Blue and yellow recur in the garments of the standing shepherd to the right, whereas the man on his left wears green, contrasting handsomely with the rose tunic and blue mantle of the Virgin. Against the background of a sky composed of flashing whites and blues, a group of angels hovers above the scene. One holds a banderole with the words (probably added later) 'Glory to God in the Highest, and on earth peace'. Another crosses his arms in a pose similar to that of the shepherd below. Even the ox is kneeling before the Christ Child.

One of El Greco's last paintings, this is also one of his finest, painted specifically to hang above his tomb in the convent church of Santo Domingo el Antiguo in Toledo. Unlike other paintings of this period, it seems to have been entirely executed by his own hand, without the help of his son, Jorge Manuel. In devising the composition, El Greco drew on his treatment of the same subject in a slightly earlier painting now in the Colegio del Patriarca, Valencia. An engraving of this painting by Diego de Astor, which reversed the image, helped El Greco to rethink the composition, putting, for example, the figure of Saint Joseph with his arms and hands outstretched on the left rather than on the right, as in the Valencia painting. In the Prado version, El Greco eliminated most of the architectural features that appear in the Valencia painting, keeping only an arched tunnel behind the Virgin's head as a potential exit for the viewer's eye.

Surviving documents tell us that on 26 August 1612 Jorge Manuel signed a contract for a family burial vault with the Cistercian nuns of Santo Domingo el Antiguo, in which it was stated that El Greco and Jorge Manuel should fund the construction and decoration of the altarpiece.[1] While El Greco's altar-frame of gilded wood still exists today in the nave, on the left side next to the nuns' choir, his remains were exhumed in 1618 and taken to the parish church of San Torcuato in Toledo, where his son had bought a new family vault. It was probably around that date that the picture was moved to another part of the convent, where it remained until it was acquired by the Prado in 1954.

The original function of the picture explains its overtly spiritual character and the transcendental quality of the colours and composition. It is thought by some that El Greco may have portrayed himself as one of the shepherds, possibly the one in the foreground kneeling in a gesture suggesting eternal prayer for the forgiveness of his sins at the Last Judgment (see further cat. 75). As suggested by Davies, the painter's choice of subject may also have reflected the fact that the main part of his family name, Theotokopoulos, means 'Mother of God' in Greek.[2] Through his presence he wanted to invoke the intercession of the Virgin through Christ for the bestowal of God's grace, thereby reducing his time in Purgatory and hopefully gaining a place in Heaven.

El Greco may also have remembered the precedent of Titian, who painted a picture of the *Pietà* (Accademia, Venice) to hang above his tomb in the Frari monastery in Venice. In it, Titian portrayed himself as Saint Jerome kneeling in prayer and holding the hand of the dead Christ, who is laid to rest in the niche of a heavy classical stone archway. The Frari held a place in Titian's career similar to that of the convent of Santo Domingo el Antiguo for El Greco's. In 1519, Titian had established his reputation when his *Assumption* was unveiled in the Frari; in 1577, El Greco had marked the beginning of his successful career in Toledo with an altarpiece for Santo Domingo with *The Assumption* at its centre. Titian was working on the *Pietà* during the 1570s and it is possible that El Greco saw him doing so while he was in Venice. XB

1. San Román y Fernández 1910, doc. XXXXIX, pp. 180–2.
2. Davies 1999–2000, p. 199.

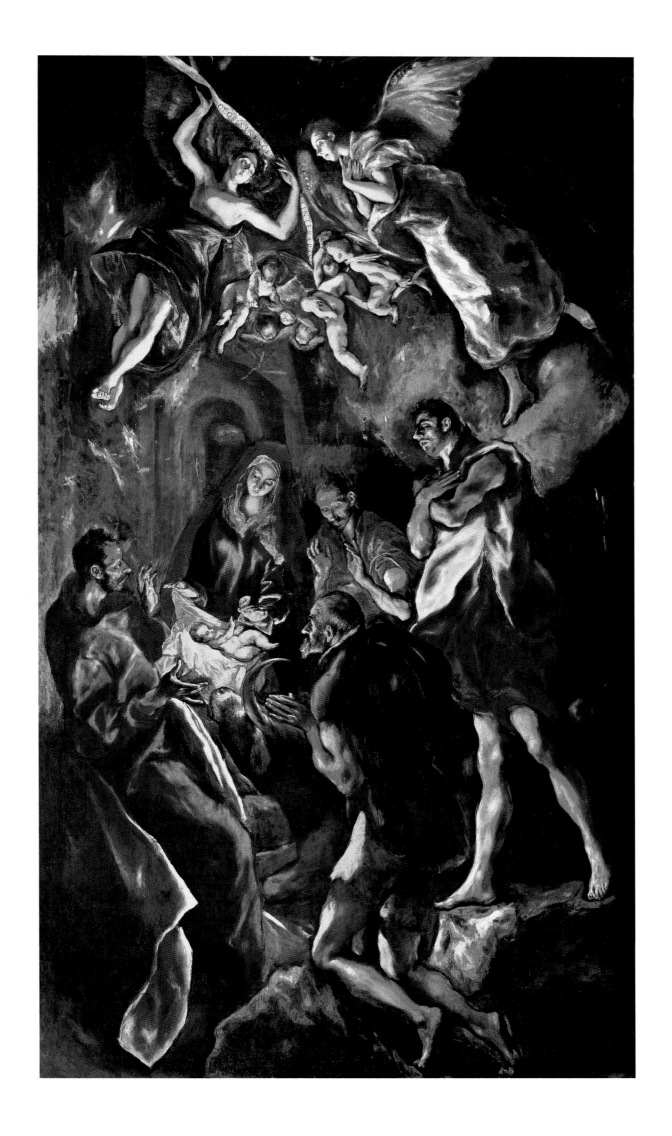

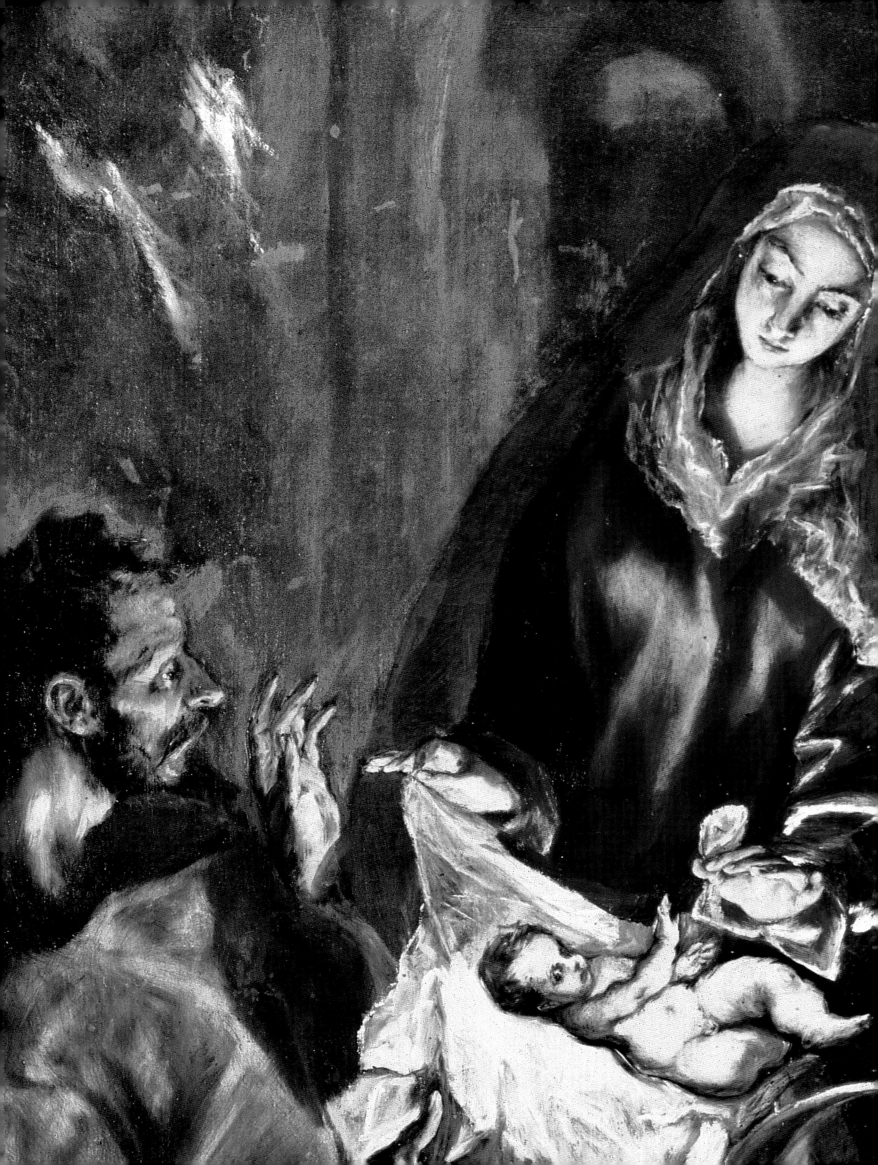

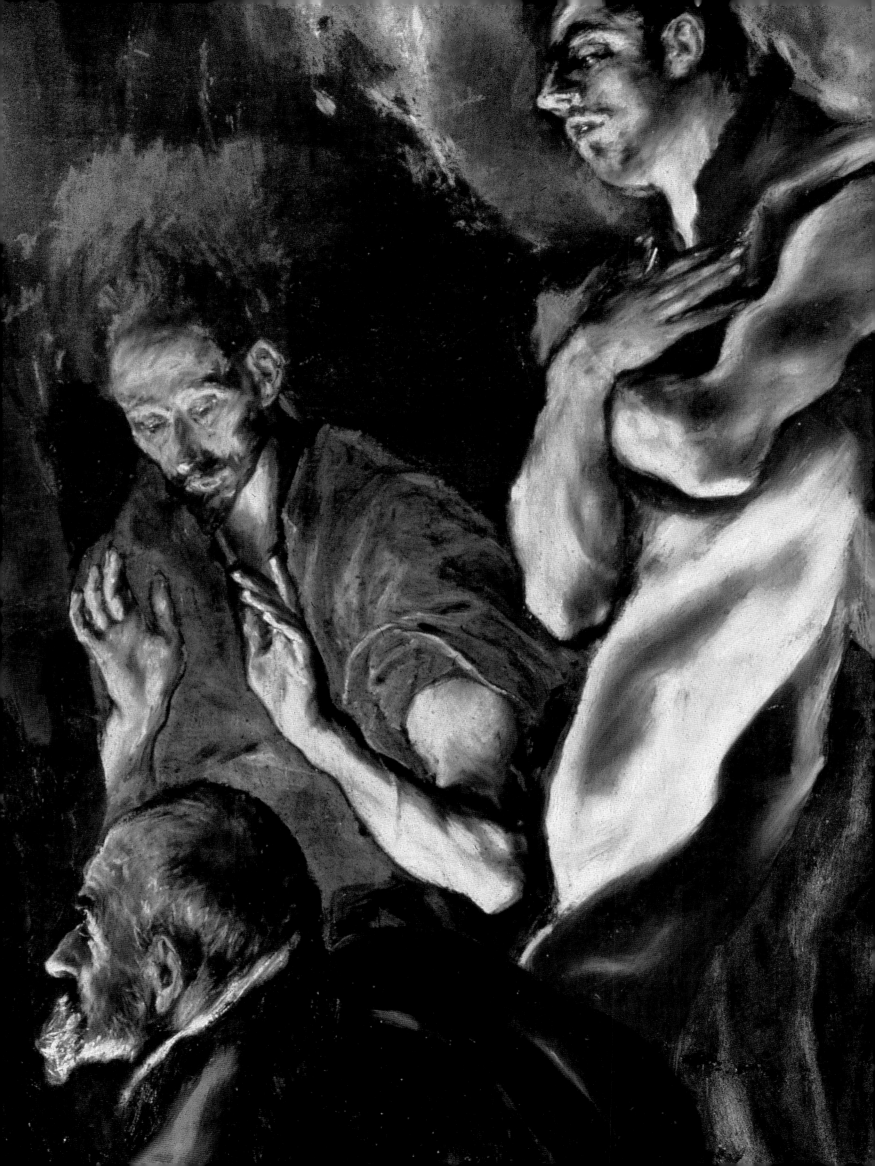

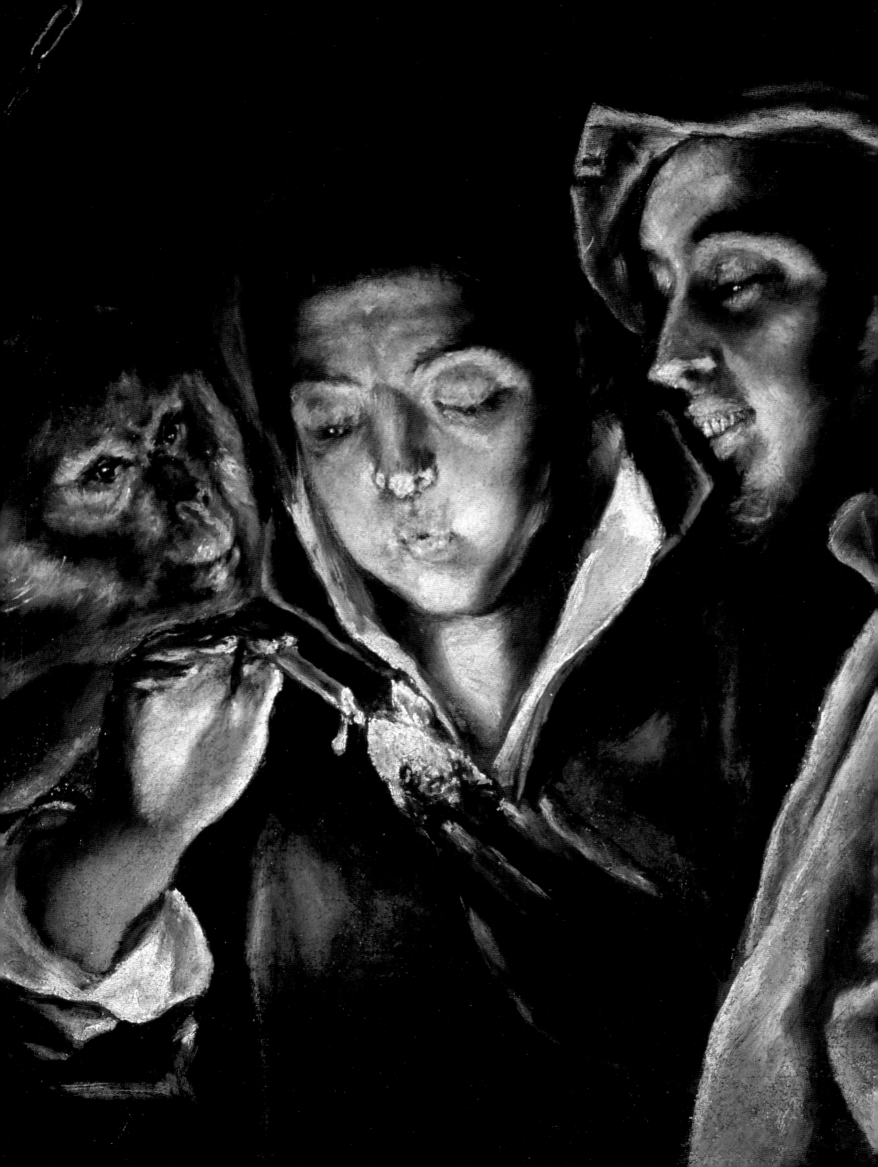

It is significant that El Greco's first essays in painting genre and landscape subjects as independent compositions were undertaken in the sophisticated circle, imbued with classical learning, of the Farnese Palace in Rome. Faced with the challenge of painting a *Boy blowing on an Ember* for Cardinal Alessandro Farnese (cat. 63), El Greco demonstrated great acuity and artistic sensibility.

In pitch darkness, an urchin intently and gently blows on an ember to light a small candle that he carefully holds in his other hand. Suddenly, the red-hot ember glows. Light irradiates his face, chest and the palm of one of his hands, but fails to penetrate the dark, indefinable space, thus accentuating its dramatic effect. The sensation of vibrating light is heightened by the striking contrasts between highlights of impasto and shadows of thick glazes, as well as the impenetration of the lights by the darks, owing to paint being brushed lightly over a dark ground. Irradiation is intensified by the light that flows along the sinuous folds of the drapery, thereby subtly creating a flame-like effect. The drama is heightened by the contrast between the complementary yellowish-green of the jacket and the orange-red of the ember. No wonder that the picture was once attributed to the Venetian painter Jacopo Bassano! In fact, the motif is derived from either one of Bassano's religious, narrative compositions, in which it figures as a detail, or, possibly, a lost independent composition.[1] Yet, whereas Bassano shows the boy in profile, as in many seventeenth-century variations on this theme, El Greco chose to present him in a frontal position and independent of any narrative and to make him the sole subject of the picture.[2]

The prevailing interest in nocturnes, which was to reach its climax in the paintings of the Caravaggisti, can be traced back to the work of artists such as Giorgione, Titian and Correggio. Indeed, in relation to El Greco's painting, one is particularly reminded of Correggio's miniature portrayal of *Judith with the Head of Holofernes* (Musée des Beaux-Arts, Strasbourg). Ultimately, such nocturnes would appear to have stemmed from Leonardo's treatment of chiaroscuro, and from northern painters' interest in depicting light effects. Genre-like scenes from northern Italy

were also known in Rome: Fulvio Orsini owned an *Old Woman and a Young Boy* by Giorgione.[3] The appeal of such subjects to these sophisticated and urbane clerics may appear curious. Yet genre was rooted in the classical literary traditions of comedy and satire,[4] and there was a strong medieval tradition, continuing into the Renaissance, of unelevated and plebeian subjects with a moral warning attached.

Aristotle had characterised comedy as 'representing men as worse than they are ... worse, however, not in the sense that it embraces any and every kind of baseness, but in the sense that the ridiculous is a species of ugliness or badness. For the ridiculous consists in some form of error or ugliness that is not painful or injurious; the comic mask, for instance, is distorted and ugly, but causes no pain'.[5] He also states: '...comic poets build up their plots out of probable occurrences, and then add names that occur to them; they do not ... write about actual people',[6] but use stock characters. Horace, noting that elevated language was not appropriate to comedy,[7] but terseness (rather like that of a proverb) was,[8] observed that low-life figures could be made the butt of satiric invective. Both he and Quintilian list these, as 'slaves, pimps, parasites, rustics, soldiers, harlots, maidservants, old men stern and mild, youths moral or luxurious, married women and girls'.[9] Clearly, what is known as 'genre' painting (a term of nineteenth-century origin)[10] corresponds to the comic and satiric models of antiquity. Its plebeian or low-life figures are nameless or bear stock names, as do the characters in certain prints by Dürer, or in paintings by Bosch or Bruegel, or in *bodegones* by Velázquez, or in the comic interludes of Shakespeare's plays. When the intention is satirical, a terse and incisive expression is fundamental, and much of this comic imagery derives from proverbs.

Imagery of the common people was not designed to gain the favour of the common people themselves. As Horace stressed,[11] it must appeal to the knowledgeable. Jerome Bosch, the author of such works as *The Cure of Folly* (Prado, Madrid), did not paint only to amuse. According to José de Sigüenza, librarian and prior of the Escorial:

[Bosch's] pictures are by no means absurdities but rather, as it were, books of great wisdom and artistic value. If there are any absurdities here, they are ours, not his; and to say it at once, they are a painted satire on the sins and ravings of man. One could choose as an argument of many of his pictures the verses of that great censor of the vices of the Romans, whose song begins with these words: 'All of man's desires, dreads, rages, vain appetites, pleasures, satisfaction, discourses I have made the subject of my painted work. But when there was such an abundance of vices...' [Juvenal, Satires, I, 85ff.].[12]

The known owners of El Greco's *Boy blowing on an Ember* and its later versions (cat. 64, 65) were highly educated, sophisticated and upholders of moral virtue (see below).

Significantly, in their ancient literary form, comedy and satire involved universal principles. According to Aristotle:

...poetry is something more philosophical and more worthy of serious attention than history; for while poetry is concerned with universal truths, history treats of particular facts.[13]

Thus comedy and satire, like art, was based on the imitation rather than the literal reproduction of everyday life. 'Literature is about life but must not be confused with it.'[14] Consequently, comedy and satire merited acceptance as subjects in their own right. Therefore, the emergence in the Renaissance of 'genre' subjects as independent compositions, in contrast to their relegation to the margins or their forming part of a series, as in the medieval Labours of the Months, would seem to have been profoundly influenced by the classical, literary traditions of comedy and satire. Moreover, classical art provided examples of 'genre' subjects as independent compositions.[15] In his *Natural History*, Pliny the Elder refers to works in sculpture, such as Myron's *Tipsy Old Woman*,[16] Pythagoras of Reggio's *Lame Man*,[17] Lysippus' *Tipsy Girl playing the Flute* and the paintings of Piraeicus, who, 'although adopting a humble line ... attained in that field the height of glory. He painted barbers' shops and cobblers' stalls, asses,

viands and the like, consequently receiving a Greek name meaning "painter of sordid subjects".'[18] Indeed El Greco's *Boy blowing on an Ember* is a re-creation of a painting by Antiphilus that was lauded by Pliny:[19]

Antiphilus ... is praised for his *Boy blowing a Fire*, and for the apartment, beautiful in itself, lit by the reflection from the fire and the light thrown on the boy's face...[20]

Pliny also records a sculpture by Lycius of a *Boy blowing a Dying Fire*[21] and a painting by Philiscus of a '*Painter's Studio*, with a boy blowing the fire'.[22]

This need not imply that El Greco's intention was only to paint a picture which would emulate the form and content of one recorded in antiquity. It is true that Pliny scarcely refers to the literary traditions of comedy or tragedy, and there is no mention of moralisation in the 'Notes' of the sixteenth-century collector Marcantonio Michiel, where examples of independent compositions of single, genre-type youths by Giorgione are cited,[23] or in the inventories in which *Boy blowing on an Ember* and its variants are listed.[24] But items in inventories are inevitably briefly recorded, and the presence of a monkey and a fool in El Greco's later versions (cat. 64, 65) is necessarily allegorical. One senses, furthermore, that some devilish mischief is afoot. The Harewood picture in particular (cat. 64) evokes the world of riff-raff, strolling players and confidence tricksters. The gaze of the monkey is so intense that it suggests that something more than the mere lighting of a candle is being contemplated. To the inanely grinning man (possibly the monkey's trainer) the prospect of the candle being lit gives mischievous delight. Secretly huddled together in some dark corner, these rascals seem to be hatching some diabolical plot.

For all the relation of El Greco's image to examples in Pliny, the young boy suggests an infamous literary character of the time, the *pícaro*.[25] The *pícaro* was a young delinquent who lived by his wits on the fringes of society. The escapades of these artful dodgers were notorious but, at times, amusing, which was part of their attraction.[26] In the 'picaresque' literature of the time, for example *Lazarillo de Tormes* (1554), the *pícaro* recounts the devilish tricks he has been up to, on one occasion deceiving his blind

master into jumping across a gutter headlong into a stone pillar[27] – a shocking scene but also comic. Another celebrated picaresque novel was *Guzmán de Alfarache* (1599–1604), by Mateo Alemán,[28] in which the intention of the author was to condemn immoral behaviour. The reader was to be dissuaded from aping these parasitic rogues, urged to assume responsibility for his or her actions, and save himself or herself by repentance. The novels are addressed not to the *pícaros* themselves or the humble, but to the educated, the literate, those who could appreciate the essential meaning of the subject.

It has long been suggested[29] that El Greco's painting may be an illustration of the Spanish proverb 'Man is fire and woman tow; the devil comes and blows'.[30] This proverb is virtually identical to that cited by Gonzalo Correas (1627): 'Fire near tow, the devil comes and blows'.[31] He pointed out that 'fire' is to be understood for man, and 'tow' for woman; that is to say, they should avoid being alone together. He means lust. The idea that lust was a flame was also common in religious writing,[32] In a famous address to a young woman (*Audi, filia*) Saint John of Ávila refers to the proverb, 'Man is fire and woman tow', and thereby warns how the devil tempts with the attraction of the flesh.[33] A sophisticated variation would be produced by Jacob Cats in his emblem book of 1632: in a section on 'Deceived and Dishonoured Lovers' there is an emblem entitled *O tinge o bruscia*, which means that a prostitute either makes one dirty or burns one. The accompanying text relates how a cavalier is offered a dish of hot and cold coals. If he picks up a coal, symbolic of the prostitute, he will either dirty or burn his fingers. The cavalier is aware of her deceit.[34] This and similar emblems have been cited as sources for Gerrit van Honthorst's painting in the Herzog Anton Ulrich-Museum, Brunswick,[35] in which a woman blows on an ember, held with tongs, to light a candle, indifferent to the cavalier who ardently fondles her breast – an unequivocal example of lust!

The extended imagery of the monkey and fool in El Greco's later versions (cat. 64, 65) would seem to reinforce the moralising intention. An ape, though sometimes a symbol of art – 'art is the ape of nature' (*Ars simia Naturae*) – generally has a derogatory symbolic meaning. Depending on its context, it can be emblematic of the devil, sin, deceit, folly, sexuality and the senses.[36] In the Harewood version (cat. 64) it is chained, implying that it is more than a household pet: it is probably a figure of man enslaved by the devil or one of the vices associated with the monkey.[37] (Because it is chained, it is unlikely to signify the devil himself.) The third member of the trio is a foolishly grinning man – a simpleton, no doubt: the image of a fool or jester with a chained monkey, reflecting court amusements, was popular in art and literature as an emblem of folly.[38] What seems to be of crucial significance to the meaning of El Greco's composition is that both monkey and fool were sometimes traditionally associated with an image of lust. In a fifteenth-century German engraving, sometimes ascribed to the Master of the Playing Cards, a female figure, astride an ass, holds a cuckoo in one hand and pulls along four roped monkeys with the other. In front of her stand four men wearing fool's hats. The inscription reads as follows:

> An ass I ride whene'er I will.
> A cuckoo is my hunting bird
> With it I catch many a fool and ape.[39]

This print was the source for a woodcut, attributed to Dürer, in the popular, moralising treatise by Sebastian Brant, the *Ship of Fools* (*Narrenschiff*), which was published in Basle in 1494.[40] It shows a winged Venus holding several ropes to which are tied an ass, an ape and three fools, one of whom is a friar; Cupid, who is blindfolded, draws his bow. Death, in the form of a skeleton, grins hugely. The meaning of the woodcut is clarified in Brant's text:

> My rope pulls many fools about,
> Ape, cuckold, ass, and silly lout,
> Whom I seduce, deceive, and flout . . .
> Dame Venus I, with rump of straw,
> Fools do regard me oft with awe,
> I draw them toward me with a thrill
> And make a fool of whom I will . . .
> Whom Cupid strikes, Amor ignites,
> So that the fire his vitals bites
> And he cannot put out the flame . . .[41]

With its references to the fettered monkey, fool and inflamed love, this text would appear to contain the basic elements of El Greco's composition. Although it is improbable that the subject was derived directly from Brant's *Ship of Fools*, it would seem likely that both derived from a common tradition.

Among the owners of these paintings by El Greco there figured eminent ecclesiastics and men associated with the reform of the Catholic Church: besides Cardinal Alessandro Farnese, they included Saint John of Ribera, Patriarch of Antioch and Archbishop of Valencia; García de Loaisa, Archbishop of Toledo; Pedro Laso de la Vega, the Conde de los Arcos, who was a supporter of the proposed establishment of the Camaldolese Order in Spain; and Juan de Borja, Conde de Mayalde y Ficallo, son of Saint Francis of Borja.[42] No doubt El Greco's paintings served to assuage their minds. On a literal level they would have derived much pleasure from them, but also they would have been acutely conscious of them being, especially in the case of the so-called *Fábula* (cat. 64), allegories of lust and moral satires.[43] El Greco has warned his patrons not to engage in the company of this rascally trio. He has not merely sought to imitate the natural reflections of light; but with vibrant light he has subtly and wittily exposed their secret and wicked machinations, thereby illuminating our darkness.

But you, brethren, are not in darkness, that that day should overtake you as a thief. For all you are children of light, and children of the day: we are not of the night, nor darkness.
(1 Thessalonians 5:4–5)[44] DD

1. Wethey 1962, I, pp. 25-7.
2. *Ibid.*
3. Nolhac 1884, p. 427.
4. See Aristotle (1965), p.33.
5. Aristotle (1965), p. 37.
6. Aristotle (1965), p. 44.
7. Horace (1965a), p. 82.
8. Horace (1965b), pp. 115, 117.
9. Quintilian (1933), IV, p. 285. See also Horace (1978), pp. 121, 123.
10. Oxford Dictionary 1977, I, p. 842.
11. Horace (1978), pp. 121, 123
12. Stechow 1966.
13. Aristotle (1965), pp. 43-4.
14. Jones 1971, p. 26.
15. Gombrich 1966, p. 107-121; Gombrich 1963, pp. 101-5.
16. Pliny the Elder (1938-62), X, p. 27.
17. *Ibid*, IX, p. 171.
18. *Ibid*, IX, p. 345.
19. Bialostocki 1966, I, pp. 591-5.
20. Pliny the Elder (1938-62), IX, pp. 361, 363.
21. *Ibid*, IX, p. 185.
22. *Ibid*, IX p. 365.
23. Pignatti 1971, p. 166.
24. Inventory (1662) of Farnese collection: '*Un quadro in tela con un giovine che buffa in un tizzone per accendere un lume, mano del Greco, segnato n.161*' (Rinaldis 1928, p.321); inventory of García de Loaisa: '*otro quadro de una figura con un animal a manera de bicho y otro allí soplando*' (I am most grateful to Prof. Fernando J. Bouza Álvarez for generously giving me this reference); inventory (1600) of Juan de Borja, conde de Ficalho: '*un muchacho que sopla un tízon*' (Pita Andrade 1985, p. 330); inventory (1611) of possessions in the '*casa de la Huerta*' of Saint John of Ribera: '*Un quadro al olio de dos palmos y medio de caída y quatro de ancho con dos figuras de hombre y un mono que están ensendiendo y soplando un tizón de fuego*'; '*Item. Un quadro al olio de tres palmos de caída y uno y medio de ancho con un Ninyo que está soplando un tizón de fuego con los marcos de dichos dos quadros de madera de nogal*' (Robres Lluch 1954, p. 254); inventory (1621) of possessions of Jorge Manuel: '*Un soplon, de casi una bara*', '*Otro soplon, del mesmo largo*' (San Román y Fernández 1927, p. 78, nos. 99, 100). Inventory of the Conde de los Arcos (1632): '*un mozo enceniendo una vela*' (Kagan in Hadjinicolaou 1995, p. 338. Kagan did not connect this painting with El Greco); inventory of the Conde de Monterrey (1653): '[No.] 237 *Un quadro de una mujer soplando la lumbre con dos figuras que es de mano del griego pequeñas [440 reales]*' (Pérez Sánchez 1977, p. 457).
25. Cossío 1908, p. 99.
26. Parker 1967. Jones 1971, ch. 6.
27. Resnick and Pasmantier 1958, p. 129.
28. Alemán 1962. Baez 1948.
29. Cossío 1908, p. 99.
30. Collins 1977, p. 126: '*El hombre es fuego, la mujer estopa, venga el diablo y sopla*'. Collins refers to a saying in Latin:
 Ignis vulcani est vir, stupaque femina sicca,
 Ecce venit flatus congeminare satan.
31. Correas 1967 (1967), p.95.
32. Carranza 1558 (1972) 1975, II, p. 93.
33. *Obras completas del Santo Maestro Huan de Avila* 1970, I, p. 440.
34. Cats 1632, p. 108. See also Brunswick 1978, pp. 91, 145. I am grateful to Elisabeth de Bièvre for this reference.
35. Brunswick 1978, no. 15.
36. Janson 1952, chs. 1-3, 7-9.
37. Scriptural references to the soul enslaved by sin are to be found in John, 8: 34; 2 Peter, 2: 4, 9-12, 19.
38. Janson 1952, p. 211.
39. Janson 1952, pp. 204, 206, 227 n. 29, pl. XXXVIc; Stewart 1977, p. 47, fig. 22.
40. Janson 1952, p. 206, fig. 10; Stewart 1977, pp. 47-9, fig. 21.
41. Stewart 1977, pp. 47-8.
42. See note 15.
43. Bury in Hadjinicolaou 1995, pp. 173-5. Bury renamed it *An Allegory of Lust*.
44. For a seminal study of the subject see Glendinning 1978, pp. 53-60. See also Davies in Edinburgh 1989.

63 A Boy blowing on an Ember to light a Candle ('Soplón'), early 1570s

Oil on canvas, 60.5 × 50.5 cm
Museo Nazionale di Capodimonte, Naples, inv. Q192

PROVENANCE

Recorded in the 'Stanza dei quadri' in
the Palazzo Farnese in Rome in 1644;
sent by the Farnese to Parma in 1662
and displayed first in the Palazzo del
Giardino and then from at least 1680
(with an attribution to Giulio Clovio)
in the ducal gallery in the Palazzo
della Pilotta; transferred to Naples in
1734, Palazzo Reale, and then to the
Palazzo di Capodimonte, before 1776;
in 1799 it was taken to Rome by French
commissars but returned to Naples
in 1800.[3]

ESSENTIAL BIBLIOGRAPHY

Du Gué Trapier 1958, pp. 85–7; Wethey
1962, I, pp. 25–26, II, no. 122; Bialostocki
1966, p. 592; Edinburgh 1989, no. 13
(entry by D. Davies); Spinosa 1995,
pp. 212–13 (entry by P.L. de Castris);
Pita Andrade 1995; Madrid-Rome-
Athens 1999–2000, no. 15 (entry by
N. Hadjinicolaou); Dal Pozzolo 1999,
pp. 336–43; Vienna 2001, no. 6 (entry
by W. Prohaska)

The painting is a *tour de force* of naturalistic representation. The boy purses his fleshy lips to blow on the ember in order to light the black wick of a candle, of which the wax is already melting on account of the heat. His face is brilliantly illuminated, as are his neck and right hand, by the light that emanates from the ember. The triangle of densely painted white pigment at the base of his throat and the heavy white strokes on the palm of his hand indicate the areas of the light's maximum impact; as one moves away from the epicentre of radiance the boy's form merges with the darkness of the night. The shadows on his face rise upwards, clustering around his nose and eyes, and the mottled effect of his skin is a reflection of the flickering of the glowing coal. Light bleeds through the fingers of his shadowed left hand, endowing it with a glassy translucency. The ember itself is executed with such a thick impasto that the ridges of paint create their own tiny shadows on the surface of the picture. There can be no doubt that whatever supplementary motivation lies behind El Greco's choice of subject, his primary intention in painting this work was to capture the appearance and effect of light in as convincing a manner as possible.

El Greco may have been seeking to emulate a lost work by the ancient Greek artist Antiphilus of Alexandria, described by the first-century Latin writer Pliny the Elder as having painted a boy blowing on fire whose face was illuminated by the flames. The difficulty of the task made Antiphilus' achievement more praiseworthy and El Greco, who never lacked ambition, took up the challenge of competing with a great classical forebear with enthusiasm. It has been suggested that the instigator of the work may

have been Fulvio Orsini, the librarian of Cardinal Alessandro Farnese, in whose palace in Rome El Greco resided between 1570 and 1572. Orsini was a renowned antiquarian, collector and bibliophile; he owned several works by El Greco and in the 1590s was responsible for spurring Annibale Carracci to produce some of his finest re-creations of classical subjects. *A Boy blowing on an Ember to light a Candle* may have been painted directly for Cardinal Alessandro, since it was not among the works listed in Orsini's collection. It is first recorded in the Palazzo Farnese in an inventory of 1644.

In mid-sixteenth-century Venetian painting the figure of a boy blowing on an ember appears not infrequently as a subsidiary element in subject pictures. There are examples in Titian's *Nativity* (Galleria Pitti, Florence) and Jacopo Bassano's *Adoration of the Shepherds* (Galleria Corsini, Rome). Jacopo and Francesco Bassano jointly signed a painting showing a boy in profile blowing on a flame (formerly Victor Spark, New York), a motif abstracted from their own larger work of *The Vision of Saint Joachim* formerly in Corsham Court.[1] The former work is dated 157[?], but since the last digit is not clear it cannot be ascertained whether it could have functioned as a specific precedent for El Greco's Naples *Soplón* (this was the title, meaning 'blower', which was given to paintings of this subject listed in Jorge Manuel's inventory of 1621).[2] GF

1. See Rearick 1968, figs. 14–17.
2. San Román y Fernández 1927, doc. XXXV, nos. 99 and 100.
3. A detailed provenance is given in Spinosa 1995, pp. 212–13 (entry by P.L. de Castris).

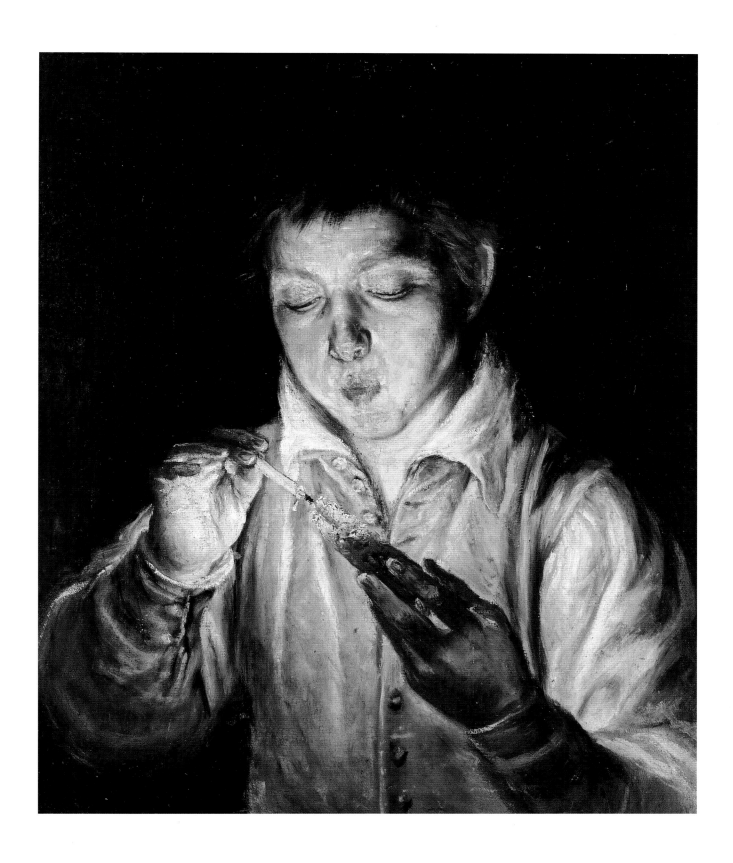

64 An Allegory with a Boy lighting a Candle in the Company of an Ape and a Fool ('Fábula'), late 1570s

Oil on canvas, 65 × 90 cm

Signed on the right: δομήνϊκος [θεο]τοκόπουλος ἐ[ποίει]
(Domenikos Theotokopoulos made)

Lent by kind permission of the Earl and Countess of Harewood and the Trustees of
the Harewood House Trust, inv. HHTP: 2001.1.10

The central figure is closely based on El Greco's earlier painting of *A Boy blowing on an Ember* in Naples (cat. 63), but the scene has been enlarged to include another male figure, wearing a yellow jacket and red cap, and a chained monkey, who emerges from the darkness on the left to look over the boy's shoulder. The composition, known in two other autograph versions (see cat. 65), has usually been interpreted as an allegory with some sort of moralising intent; it is very unlikely that it was conceived simply as a genre scene. It bears the traditional title 'Fábula', meaning fable or story.

Cossío, who wrote the first serious study of El Greco's work in 1908, took up the view, already current in the nineteenth century, that the painting illustrated the Spanish proverb which translates, 'Man is fire; woman is tow; the devil comes and blows'. According to this interpretation, the monkey would represent the devil and the middle figure the woman. Today this figure is taken to be male, but a description of what was probably another version of this painting by El Greco in the collection of the Conde de Monterrey in 1653 already described it as female: 'A painting of a woman blowing on a light with two figures which is by the hand of the Greek, small.'[1] As previous scholars have supposed, and David Davies has argued here (pp. 221–5) the painting may have been intended as a warning against the danger of fanning the flames of lust, or more generally the flames of discord. An alternative reading is suggested by the short-lived nature of flame and fire:

the painting could have been understood as a *vanitas*, an emblem of vanity drawing attention to the transitory nature of human life, which should not be wasted satisfying base passions (represented by the monkey) or seeking trivial pleasure (the grinning man on right) since youth (the boy in the centre) quickly gives way to old age.[2]

An allegorical interpretation of the subject, however, does not necessarily have to be moralising. It has been argued more recently that the motif of the boy blowing on the ember retains the same ekphrastic and antiquarian qualities that it has in the Naples painting, and that the addition of the monkey and the man simply extends them.[3] The presence of the monkey can be understood as an allusion to the classical dictum *ars simia naturae*, art is the ape of nature; in terms of the logic of the picture the monkey may simply be imitating the man who looks on as the boy light his taper.

Wethey dated the picture to shortly after the painter's arrival in Spain, principally on account of the similarity of the signature to the cursive Greek signature of the Chicago *Assumption*, painted in 1577 for the convent church of Santo Domingo el Antiguo (fig. 12, p. 49). It is likely to be the earliest of the three versions of the subject by El Greco. GF

1. Pérez Sánchez 1977, no. 237.
2. Glendinning has studied the literary context for this interpretation of the theme (Glendinning 1978).
3. As suggested by Jordan in Madrid-Washington-Toledo (Ohio)-Dallas 1982–3.

ESSENTIAL BIBLIOGRAPHY

Cossío 1908, no. 343; Rutter 1930, pp. 20–1; Borenius 1936, no. 85; Edinburgh 1951, no. 22 (entry by E. K. Waterhouse); Wethey 1962, II, no. 125; Edinburgh 1989, no. 16 (entry by D. Davies); Pita Andrade 1995, pp. 547–51

65 An Allegory with a Boy lighting a Candle in the Company of an Ape and a Fool ('Fábula'), late 1580s or early 1590s

Oil on canvas, 67.3 × 88.6 cm
The National Gallery of Scotland, Edinburgh, inv. NG 2491

This later version of the picture at Harewood (cat. 64), is unsigned. Painting with great freedom and remarkable economy, the artist has essentially limited himself to elaborating the highlit areas of the composition, leaving parts of the surface unworked – allowing the reddish ground to show – or painting in the dark tones in a very summary manner. The only iconographic difference from the Harewood picture is that the monkey here is not chained. The significance of this is difficult to gauge, but, in making the creature less obviously a pet, the possibility of interpreting the work as a genre picture would appear to be reduced yet further.

In addition to this painting and the one in Edinburgh, there is a third version accepted as by the artist, which was acquired by the Prado in 1993 (inv. 7657). That version is the smallest of the three, measuring 49 × 64 cm. Wethey, in his catalogue of El Greco's works of 1962, thought that the Prado picture, which was then in a private collection in Brazil, dated from El Greco's Italian years, because of its perceived Venetian qualities. However, the style and handling are such that the Prado painting

should probably be dated after, rather than before, the others. Pita Andrade has recently proposed a date of about 1600 for it.

It is often said that the Prado painting is identical to a work recorded in the 1611 inventory of the collection formed by Saint John of Ribera, Archbishop of Valencia. Listed there as 'Two figures of men and a monkey who are lighting and blowing on a firebrand', it measured 2½ by 4 *palmos*, which corresponds approximately to 52.5 × 84 cm. On the basis of these dimensions alone it is not possible to know which of the versions actually corresponds with the painting that belonged to the archbishop.

A picture described as '*Un lienzo grande de una fabula*' (A large canvas of a fable) in the 1621 inventory of Jorge Manuel's possessions has sometimes been thought to refer to a version of this composition;[1] this is almost certainly wrong since all three of the autograph versions and the known replicas are small pictures.[2] GF

1. San Román y Fernández 1927, doc. XXXV, no. 85.
2. See Wethey 1962, II, nos. X-147-51.

PROVENANCE

Féret collection, Paris; C. Cherfils, Paris, by 1908; Dr James Simon, Berlin; his sale, Amsterdam, 25–6 October 1927 (lot 149); Mark Oliver, Jedburgh, Scotland; acquired from his estate with the aid of the National Heritage Memorial Fund and the NACF in 1989

ESSENTIAL BIBLIOGRAPHY

Cossío 1908, p. 598; Wethey 1962, II, no. 126; Białostocki 1966; Glendinning 1978; Edinburgh 1989, no 16 (entry by D. Davies); Pita Andrade 1995; Brigstocke 1993, pp. 77–80, no. 2491; Madrid-Rome-Athens 1999–2000, no. 43 (entry by M. Borobia)

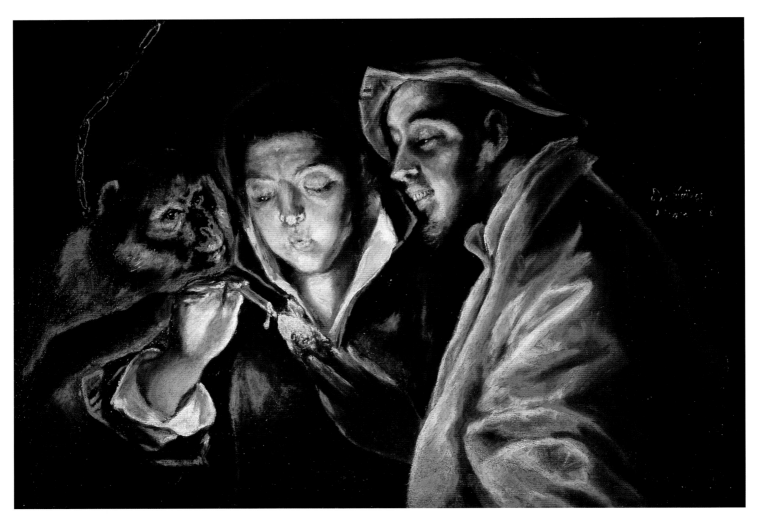

64

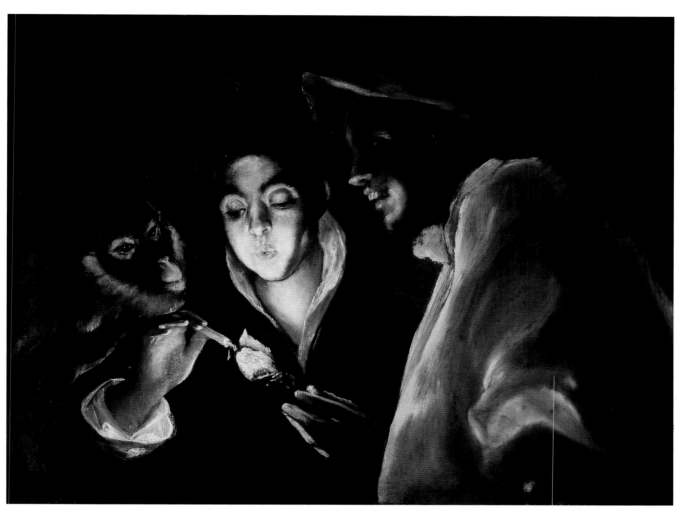

65

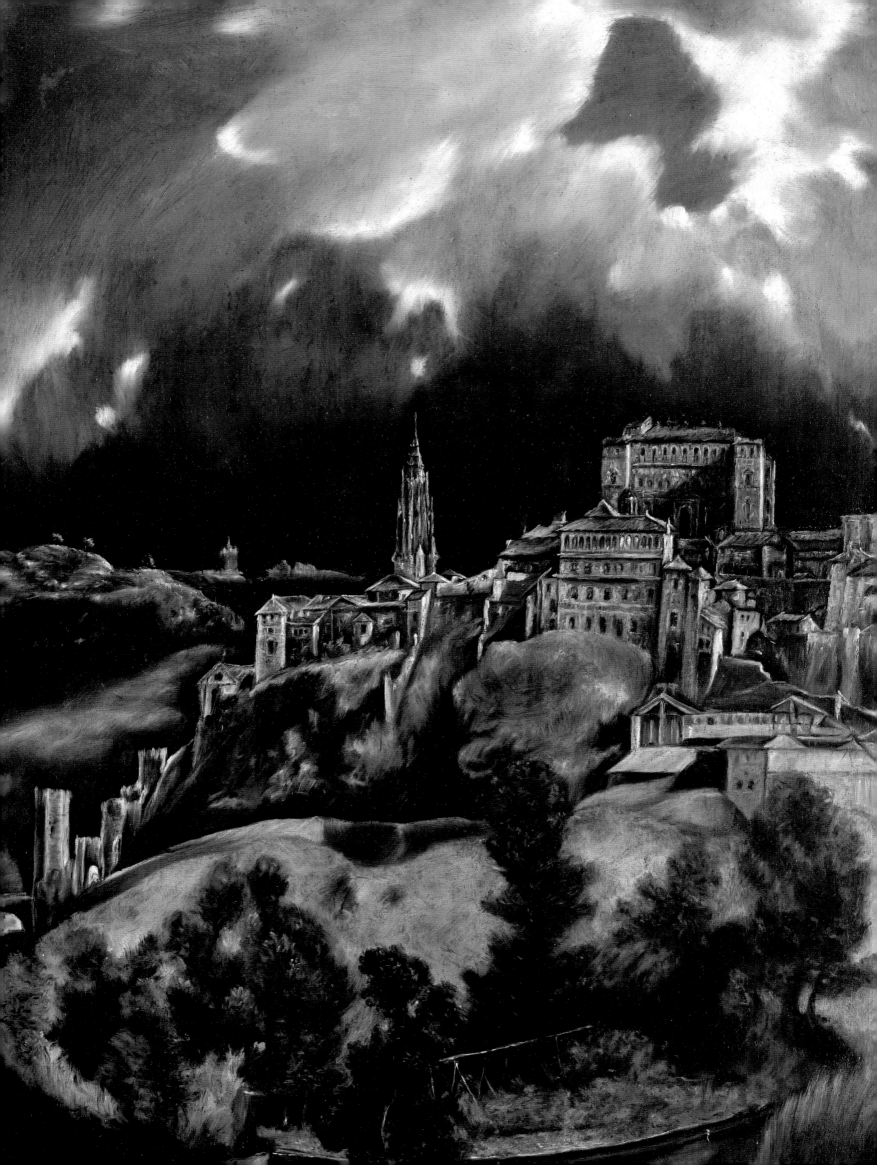

Oil on canvas, 121.3 × 108.6 cm

Signed at lower right: δομήνϊκος θεοτοκόπουλος ἐποίει
(Domenikos Theotokopoulos made)

The Metropolitan Museum of Art, New York
H.O. Havemeyer Collection,
Bequest of Mrs H.O. Havemeyer, 1929, inv. 29.100.6

PROVENANCE

Possibly still with El Greco when he died (1614 inventory); presumably inherited by his son, Jorge Manuel (1621 inventory); possibly Pedro Salazar de Mendoza, Toledo (died 1627; inventory 1629); probably Pedro Laso de la Vega, Conde de los Arcos, Batres (died 1637; inventory 1639); his grandson, Pedro Laso de Vega, Conde de Añover (died 1674); by descent to Don Carlos de Guzmán y La Cerda, Conde de Oñate (died 1880) and his wife Doña Maria Josefa de la Cerda, Madrid (died 1884; presumably the 'Vista de Toledo' listed in the division of her estate, no. 710); her son Don José Reniero, Marqués de Guevara, Oñate Palace, Madrid (died 1891; inventory 1892); by descent to Maria Pilar, condesa de Paredes de Nava, Oñate Palace, Madrid (died 1901);⁷ Condes de Paredes de Nava (1902–7); Durand-Ruel, Paris, 1907–9; Mrs H.O. Havemeyer, New York, 1909–29; The Metropolitan Museum of Art

ESSENTIAL BIBLIOGRAPHY

Cossío 1908, pp. 451–6, no. 83; Camón Aznar 1950, pp. 969–72, p. 1391, no. 699; Wethey 1962, II, pp. 85–6, no. 129; Gudiol 1973, pp. 187–8, no. 143; Baetjer 1981, p. 47; Brown and Kagan 1982; Madrid-Washington-Toledo (Ohio)-Dallas 1982–3, pp. 65–8, 244, no. 35; Caviró 1985, pp. 220–2; Edinburgh 1989, p. 63, no. 19 (entry by D. Davies); Caviró 1990, p. 305; Álvarez Lopera 1993, pp. 226–30; Marías 1997, p. 269; Madrid-Rome-Athens 1999–2000, pp. 157, 409–11 (entry by J. Álvarez Lopera); Vienna 2001, pp. 41, 180, no. 27

El Greco has left us one unforgettable landscape, his *View of Toledo* in the Metropolitan Museum, New York. It is a true expressionist work, a picture of El Greco's own mood, which, by the time this picture was painted, had become so much involved with the character of his adopted town, that we can understand how, for M. Barrès [the author of a book on El Greco], it seemed to represent the spirit of Toledo This extraordinary work is an exception to all rules, far removed from the spirit of Mediterranean art and from the rest of seventeenth-century landscape painting. It has more the character of nineteenth-century romanticism, though Turner is less morbid, and van Gogh less full of artifice; and to find analogies we must look in Romantic music, in Liszt and Berlioz.[1]

Kenneth Clark's vivid assessment of El Greco's greatest surviving landscape reminds us how central the *View of Toledo* is to the modernist vision (or distortion) of the artist. Yet we know remarkably little about the circumstances informing the creation of this masterpiece. There is a possibility that it was still in El Greco's studio when he died, for in the 1614 inventory of his possessions we find three landscapes listed: a 'Toledo' and 'two landscapes of Toledo'. What must be the same three paintings recur in the 1621 inventory of the possessions of El Greco's son (nos. 137–8, 172), in which the measurements for the first are indicated as '*dos baras de largo y bara 1 cuarto de alto*' (about 104 × 168 cm) and the other two are said to measure a '*bara y terzia en cuadrado*' (about 111 × 111 cm). (The 1621 inventory lists six further landscapes, either just begun or unfinished – but by whom, and of what subjects?) The larger, horizontal canvas is usually identified with the *View and Plan of Toledo* in the Museo de El Greco, Toledo (fig. 9, p. 27), though that work actually measures 132 × 228 cm. In 1629 we find two paintings of Toledo by El Greco listed in the collection of the artist's friend and patron Pedro Salazar de Mendoza (see cat. 60).[2] These are described as 'a picture of the city of Toledo with its plan' (possibly the *View and Plan* in the Museo de El Greco) and 'a landscape of Toledo looking towards the Alcántara bridge' – the

viewpoint of the Metropolitan's canvas. In 1632 we again find two landscapes by El Greco, in the collection of Pedro Laso de la Vega, Conde de Arcos, a major collector who owned at least seven paintings by El Greco, including the *Laocoön* (cat. 69), a *Holy Family* (see cat. 29) and, possibly, *A Cardinal* (*probably Cardinal Niño de Guevara*) (cat. 80). His landscapes are listed in his castle at Batres as a 'piece [showing] Toledo and the other a monastery of the Great Camaldolese'. There can be no question that the second is the *Allegory of the Camaldolese Order* (cat. 44). The other may well be the Metropolitan's painting, which belonged to a descendant of the Conde de Arcos, when Louisine and Harry Havemeyer were shown it (together with the *Cardinal*) in 1901; Louisine acquired it only in 1909, after her husband's death, from the French dealer Durand-Ruel.[3]

This fragmented information presents a number of problems, not least of which is the issue of how many landscapes with a view of Toledo El Greco painted and when and how the ones listed changed ownership. Because of these uncertainties, our understanding of the origin and meaning of the two surviving landscape paintings – the *View of Toledo* and the *View and Plan* – remains largely speculative. Certainly, they respond to very different objectives: one setting out to document the city in cartographic terms, the other evoking it through a selective arrangement of its most characteristic features. As Brown and Kagan noted, the Metropolitan painting belongs to a tradition of emblematic city views and derives its potency as an evocation precisely from the representational licence it takes. As with El Greco's finest portraits, its approach is interpretative rather than documentary: it seeks to portray the essence of the city rather than to record its actual appearance. In Aristotelian terms, it substitutes poetic for historic truth.[4]

Both here and in the *View and Plan* the city is shown from the north, except that El Greco has included only the easternmost portion, above the Tagus river. This partial view would have excluded the cathedral, which he therefore imaginatively moved to the left of the dominant Alcázar or royal palace. The identification of the palace building just to the left of the Alcázar remains something of a puzzle, though it appears in the *View and Plan* and

there can be no question but that the artist intended it to be recognisable. A string of buildings descends a steep hill to the Roman Alcántara bridge, while on the other side of the Tagus is shown the castle of San Servando. Another cluster of buildings is shown below the castle, on a cloud-like form. In his *View and Plan* El Greco shows the Hospital of Saint John the Baptist (the Tavera Hospital) raised on a cloud, and explains in an inscription that if he had not resorted to this device the hospital would have obscured a view of the city gate. Taking up this line of reasoning, Brown and Kagan have suggested that in this cluster of buildings in the Metropolitan's *View* El Greco may have wanted to represent the Agaliense monastery where Saint Ildefonso, the patron saint of Toledo, went on retreat. He may have felt that a depiction of this monastic complex was crucial to a spiritual portrait of the city. That the buildings are on a cloud has been questioned – note that figures are shown walking about – but there is really no other explanation for the form. The person Kagan identifies as crucial to the genesis of the two paintings is Pedro Salazar de Mendoza, who, as we have seen, either owned both paintings or ones similar to them. He was administrator at the Tavera Hospital and his interest in maps might explain the character of the *View and Plan*. Similarly, his interest in Saint Ildefonso and his attempt to determine the site of the Agaliense monastery used by the saint as a retreat could be equally important for the *View of Toledo*.

The same view appears in the background of El Greco's altarpiece in the Capilla de San José, Toledo, which was commissioned in 1597 (see cat. 38, 39). It also appears, without the Alcázar, in *The Virgin of the Immaculate Conception* (cat. 55), which was commissioned in 1607. The San José altarpiece shows Saint Joseph with the infant Christ and an inscription adjacent to it refers to the Christ Child as the ruler of Toledo: the city thus appears as his dominion. In the *Immaculate Conception* the city, significantly deprived of the building that served as the seat of secular power, is transformed into one of a number

of Marian symbols in the landscape. It has sometimes been conjectured that the *View of Toledo* is itself a fragment of a religious picture. Although this is incorrect, the impulse behind it – to create a spiritual portrait of El Greco's adopted city – is intimately linked with the altarpieces. Indeed, it seems likely that the *View* served as a model for the ecclesiastical works and thus dates to about 1597.

Countless visitors to Toledo can testify to the poetic truth of the picture, not least Louisine Havemeyer, who in her memoirs recalled how, on arrival, 'the high wind clouds gathered and rolled over the lofty city and darkened the Alcázar, making its outlines sharp as a silhouette against the sky. Toledo looked to me just as it did in El Greco's time, when he painted his only landscape which we own and which is called just Toledo.'[5] As Davies has pointed out, in representing this stormy sky El Greco may have intended to respond to a passage he knew from Pliny's *Natural History* (XXV, XCVII) in which Apelles is said to have painted 'things that cannot be represented in a picture – thunder, lightning and thunderbolts. . .'.[6] KC

1. Clark 1949 (1963), p. 49.
2. For Salazar de Mendoza see further Mann 1986, pp. 112–20.
3. The matter is succinctly summarised by Álvarez Lopera in Madrid-Rome-Athens 1999–2000, pp. 409–10. For Pedro Laso de la Vega see Caviró 1985.
4. Aristotle (1989), p. 18. See also p. 222 of this catalogue.
5. Havemeyer 1961 (1993), p. 139.
6. Davies in Edinburgh 1989, p. 63. Allen 1984, pp. 22–3, believed the reason for the stormy sky was that the *View of Toledo* derived from the landscape views that appear in two paintings of the Crucifixion, where a stormy or night sky would be appropriate. Suffice it to say that Allen has reversed the relationship: the Crucifixions that include a view of Toledo in the background are later products of El Greco's workshop, as Wethey (1962, X-57–60) noted.
7. José Raneiro's estate was divided into six lots, but the only list of paintings is that inherited by the Condesa de Valencia de Don Juan, which lists no works by El Greco. María de Pilar, condesa de Paredes, was the eldest sibling and is therefore listed here as the probable heir: in any event, the picture was acquired from the Oñate palace. The Oñate palace was sold in 1911 and its contents dispersed.

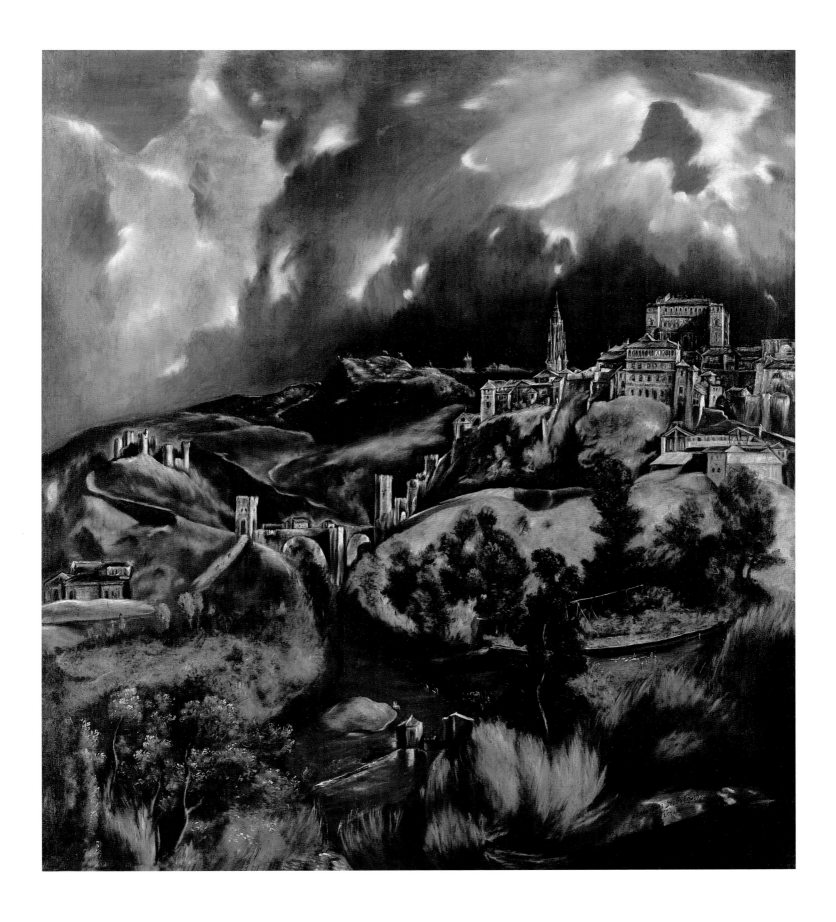

67 Epimetheus, 1600–10

Polychrome wood, 43 cm high
Museo Nacional del Prado, Madrid, inv. E 483

68 Pandora, 1600–10

Polychrome wood, 43 cm high
Museo Nacional del Prado, Madrid, inv. E 483

PROVENANCE

Acquired from a dealer in Madrid by Joaquín del Pulgary Campos, Conde de las Infantas, in about 1945; donated to the Prado by his widow in 1962

ESSENTIAL BIBLIOGRAPHY

Infantas 1945; Camón Aznar 1950, pp. 941–3, nos. 807–8; De Salas 1961; Wethey 1962, II, pp. 160–1; Madrid-Washington-Toledo (Ohio)-Dallas 1982–3 (Spanish edn. only), nos. 70–1 (entry by M. Estella); Coppel 1998, no. 8; Vienna 2001, no. 42 (entry by L. Ruíz Gómez)

El Greco's activity as a sculptor was marginal to that of his painting. He produced small models in clay, plaster and wax, which he employed as studies for figures in his paintings, a practice that he would have witnessed in Tintoretto's studio. Francisco Pacheco, who visited El Greco in 1611, wrote, 'Domenico Greco showed me a large cupboard filled with clay models made by him to use in his work'.[1] El Greco also produced models for some of the carvings on his altarpieces from which professional sculptors would work: the contract for the altarpiece of Santo Domingo el Antiguo of 1577 (see cat. 17–20) required him to make models for the two wooden *Prophet* figures and three *Virtues* that were to be carved by Juan Bautista Monegro 'so that they will come out better'.[2] In addition he produced some finished sculptures himself, notably the relief of *The Imposition of the Chasuble on Saint Ildefonso* (see cat. 21), *The Risen Christ* from the tabernacle of the Tavera Hospital (fig. 49, p. 174), and these two small figures of *Epimetheus* and *Pandora*.

Originally thought to represent Adam and Eve, or even Vulcan and Venus, they were correctly identified as representing Epimetheus and Pandora by de Salas in 1961. According to the Greek poet Hesiod, Pandora was the first woman, created from earth and water. She was brought to life with heavenly fire and married Epimetheus, the brother of Prometheus. Zeus gave her a beautiful box containing all manner of evils and calamities and Pandora or, according to some versions of the myth, Epimetheus, opened it, releasing them into the world.[3] El Greco would have been familiar with the account given in Erasmus's *Adages*, first published in Venice in 1508. The parallels between Pandora and Eve, who was likewise formed from the earth, and whose disobedience in the Garden of Eden brought sin and death into the world, were drawn from a very early date, for example by

Tertullian in his *De Corona Militis* (late second century).

These small statuettes are carved in wood and painted in oils, the traditional materials of Spanish polychrome sculpture. They are undocumented works but the attribution to the artist is universally accepted. They have survived in a reasonably good state, although *Epimetheus'* feet are modern, as are *Pandora's* left hand and the bases on which the two figures stand. There are small losses in the paint surface and *Epimetheus* is sometimes said to have been holding in his left hand the lid of the vessel in his right, although the position suggests that it may have been a rod or staff. The typology of the figures has parallels in some of El Greco's painted nudes, for example those in *The Opening of the Fifth Seal* (cat. 60), and the pose of *Epimetheus* in particular is close to the soldier with his back turned in the middle ground of *The Martyrdom of Saint Maurice* (fig. 16, p. 53) and to that of the foremost figure on the right of the *Laocoön* (cat. 69). The statuettes have similar long torsos and narrow hips, and a pronounced sternum and ribcage. Inevitably, though, these figures are more contained, their gestures less extreme; the proportions are more classicising and the skin tones of each figure more uniform.

The unabashed nudity is unprecedented in Spanish sculpture. This characteristic, the scale, and the nature of the subject-matter makes them akin to the small bronzes that were collected by refined and cultivated collectors in Italy and France. Nicholas Penny (in conversation) has noted the similarity between these works and bronzes by Pierino Da Vinci (c. 1530–c. 1553). Whom El Greco may have made them for remains a mystery. GF

1. Pacheco 1649 (1990), p. 440.
2. Quoted in Wethey 1962, II, p. 159.
3. For the myth see Panofsky 1956.

67

68

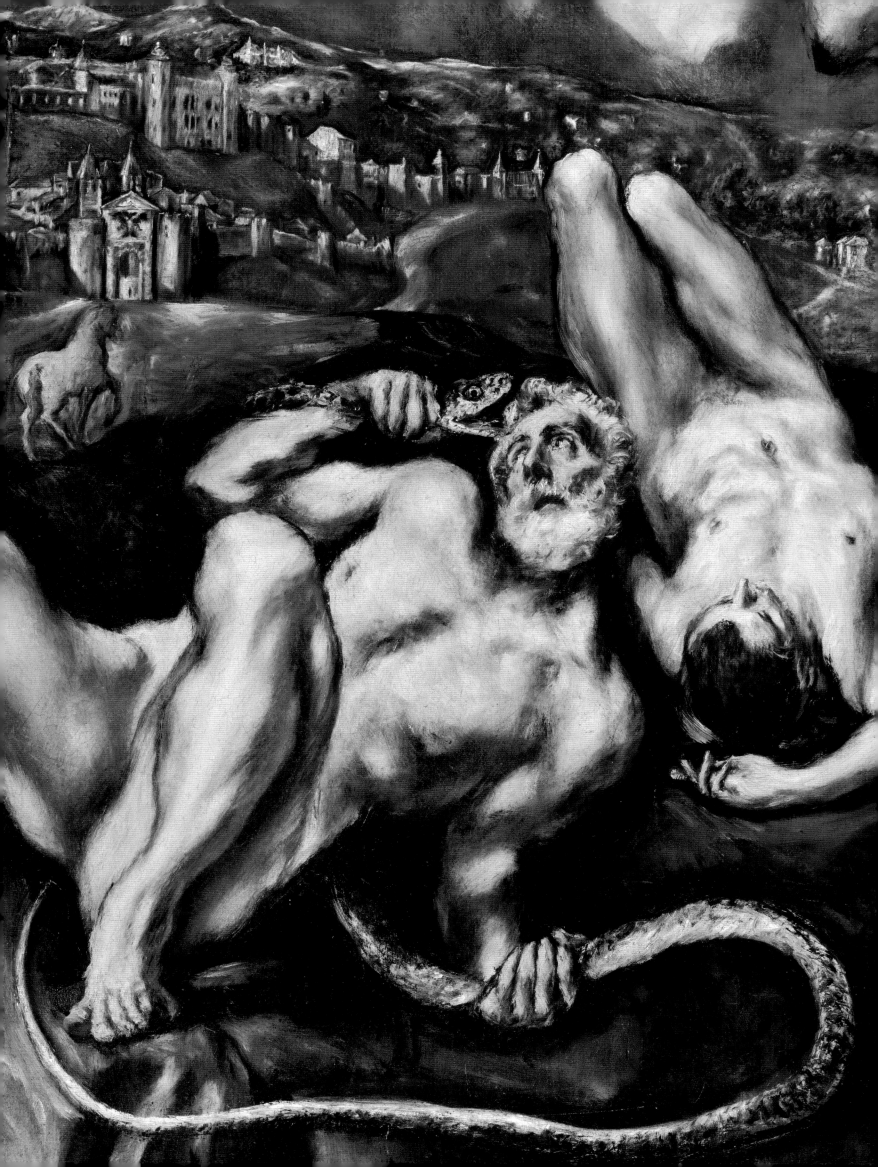

Laocoön was a priest of Troy who denounced the presence of the wooden horse outside the walls of Troy as an act of Greek treachery. He flung his javelin into its flank and implored the Trojans not to draw it into the city. To avenge his deed two serpents came from the sea and attacked him and his two sons as he prepared to sacrifice a bull at the altar of Neptune. In El Greco's awesome painting (cat. 69), Laocoön stares death in the face. Spreadeagled on the bare rocks, and with quivering flesh, he grimly grips the speckled snake in a vain attempt to keep at bay its gaping jaws. One of his sons lies dead. The other, with body arched and arm tautly stretched, desperately tries to hold off the venomous attack of the other snake. Yet he, too, is powerless. With irrepressible energy the deadly snake curves inwards to sink its fangs into his naked, lithesome body. The figures are stripped bare; the ground is upheaved; the horizon is tilted; the sky is rent with storm-clouds. In this elemental struggle the fate of Laocoön and his sons is sealed. Yet this calamity causes no distress to the two onlookers. They do not wail in despair but appear calm, dispassionate and disdainful. Beyond this scene of horror there is visible the diminutive image of the wooden horse. As in a weird dream it trots and ominously approaches not the gate of Troy but the Visagra Gate of Toledo. Toledo is the backcloth to this drama of death and impending destruction.[1]

The horrendous story had been stunningly rendered in a classical sculpture unearthed at Rome in 1506 (fig. 54) and subsequently housed in the Belvedere in the Vatican Palace. Its discovery had aroused enormous excitement and numerous copies were made after it.[2] Laocoön's suffering aroused particular interest.[3] The description under 'Pain' ('*dolore*') in Cesare Ripa's *Iconologia*, published in an illustrated edition in 1611, clearly reflects the Belvedere sculpture: 'A man half-naked with his hands and feet bound, and enveloped in a serpent which fiercely bites his left flank; he will appear very melancholy.'[4] El Greco is likely to have known a passage in Lomazzo's *Trattato dell'arte della pittura*,[5] where, during his discussion of 'Expression', Lomazzo cites the examples of Prometheus and Laocoön with specific reference to pain ('*dolore*'):

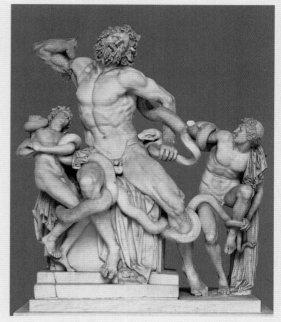

Fig. 54 **Laocoön and his Sons**
First century AD?
Marble, height 242 cm
Vatican Museums, Vatican City
inv. 1059

The first passion then is 'pain', according to which the torment of one so afflicted makes his body move in an anguished way. It was this sort of thing which Achilles Tatius was describing in the person of Prometheus tied to the rock with the vulture pecking at his liver, when he said that he drew back his belly and his ribcage, and to his own harm pulled up his thigh. For this only led the bird closer to his liver, and at this encounter he extended out his other foot with the veins standing up even into the extremity of his toes, and also showed anguish in the other parts of his body with the arching of his eyebrows, the tightening of his lips and the showing of his teeth. Beyond this, pain can be shown by contorting the body at the diverse joints, and by rolling the eyes in the way one does when poisoned, or when bitten by a snake. This was excellently expressed by the three ancient Rhodian masters Agesander, Polydorus and Athenodorus in the highly celebrated statue of Laocoön and his sons, in which one figure is seen in the act of anguish, another

in the act of dying, and the third in having compassion; and this can be seen nowadays in the Belvedere in Rome.[6]

El Greco must surely have had access to the original sculpture in the Vatican, for its legacy is discernible in his painting[7] – the large scale, the relief-like design, the symmetrical disposition and the nudity of the figures, the upturned head of the son on the left, and the type of Laocoön's head. Yet El Greco's dynamic is markedly different. He ingeniously conveys a sensation of upheaval by the see-saw design of the figures (lower left to upper right) and the horizon (upper left to lower right). He has also inventively drawn upon further classical models of suffering – the *Falling Gaul* (fig. 55) and either the *Dead Amazon* (Museo Nazionale, Naples) or the *Dead Niobid* (Glyptothek, Munich).[8] By contrast to other representations of Laocoön, the position and pose of El Greco's figure are remarkably similar to those of Titian's *Prometheus (Tityus?)* (Museo del Prado, Madrid),[9] who is similarly spreadeagled on the ground; Titian, too, had probably based the pose of his figure on the torso of the *Falling Gaul*.[10] El Greco would have known Titian's painting of *Prometheus (Tityus?)* either in the original in the Spanish royal collection or in Cort's engraving after it.[11] Indeed, Lomazzo's text may well have acted as a catalyst and caused El Greco to look

Fig. 55 **Falling Gaul**
First century BC?
Marble, height 73 cm
Museo Archaeologico Nazionale, Venice

at Titian's composition when he was conceiving the *Laocoön*. El Greco deliberately combined several precedents into his painting epitomising suffering.

Absent is any reference to the life model. Instead El Greco probably used plaster, clay and wax models of the kind reported in his studio: hence both the smooth, sinuous shapes of his figures and the repetition of certain of them: the standing figure at the right of *Laocoön* is identical in pose to a male nude in the background of *The Martyrdom of Saint Maurice* (fig. 16, p. 53), and Laocoön's standing son is repeated in the male nude on the right in *The Opening of the Fifth Seal* (cat. 60). Overall, the figures' three-dimensional form is drastically reduced by their lack of foreshortening, and the outlines of receding and advancing forms are conjoined so as to energise the surface plane of the picture. Contorted into taut, angular or arched shapes, they succumb nevertheless to the powerful arabesques of the irrepressible serpents. All these brightly lit shapes are accentuated by the very dark paint added round their edges. The harsh illumination ruthlessly exposes their tragic plight, and the free brushwork sets their flesh quivering in the vibrating light. Laocoön's head, which closely resembles that of his later version of *Saint Peter* (see cat. 56), is the most expressively modelled in the picture, and turned so that his feeling of dread is plainly visible: the viewer is compelled – because of the chosen viewpoint – to face Laocoön in his agony of death.

Although there were previous Greek accounts which provided a different context to Laocoön's death, Virgil's account in the *Aeneid* (II, 49ff.) was the one generally followed in the Renaissance.[12] In contrast to the Greek tradition, Virgil conceived Laocoön as a tragic hero, who had rightly warned the Trojans of the danger of accepting the wooden horse ('beware the Greeks bearing gifts'). The gods, who wished to destroy the Trojans, deceived them into thinking that Laocoön was killed because of his sacrilegious action against the wooden horse. Gulled by Sinon, left on the shore with the horse, and finally persuaded by Laocoön's horrible death, the Trojans breached their walls and wheeled the engine of doom into their city. El Greco may also have known a subsequent account, in Petronius' *Satyricon*

of the mid first century AD, in which there is a description, clearly assuming knowledge of Virgil's account, of a painting of Laocoön's death.[13] References here to Laocoön's 'grey locks unbound', especially, and to his being dragged to the ground accord with El Greco's work, which, like the *Boy blowing on an Ember* (cat. 63), might also have been seen as a re-creation of a classical painting.[14]

An ambience of classical learning is suggested further by the appearance in 1612, at approximately the same time as El Greco was painting the *Laocoön*, of a celebrated commentary on the *Aeneid* by Luis de la Cerda, a Jesuit and a Toledan.[15] Also referring to Petronius' *ekphrasis*, he comments on Laocoön:

> These lines [220–1] rouse great emotion, not only when we consider the wretched man's calamity, but also his piety, for not even his garlands, which are sacred, are saved from disaster.[16]

He characterises the Trojans' acceptance of Sinon's deceitful statements as an example of how superstitious people can be duped by specious religious arguments. The implication is that Laocoön is synonymous with the truthful priest who condemns not only imprudence but also falsehoods. Cerda's approach was typical of the Renaissance view, which followed Virgil's presentation and the subsequent medieval tradition in shifting from the Homeric viewpoint to that of the Trojans, regarded now as the victims of treachery and aggression.[17]

If, in Virgil's text, the acceptance of the wooden horse by the Trojans and the destruction of Troy are a consequence of the death of Laocoön, so in El Greco's painting the killing of Laocoön augurs the impending doom of Toledo, depicted behind Laocoön. Toledo is now the city from which 'Laocoön runs down' in Virgil's words (II, 41), and towards which the horse 'moves up' (II, 240). Quite how and why Toledo should be doomed, however, is a matter of interpretation and of specific associations. The wooden horse, for example, was a well-known symbol of deceit and of abuse. A notable example of its adaptation to a religious context is found in a papal report of 1537 criticising simoniacal practices, particularly the papal sale of benefices, 'the source, Holy Father, from which, as from the Trojan horse,

every abuse has erupted into the Church'.[18] Serpents were associated with all evil,[19] but particularly heresy. This was affirmed by Pius V in his Bull on the Rosary,[20] and manifested by Titian in his painting of *Religion succoured by Spain* (Museo del Prado, Madrid).[21]

One reasonable interpretation, based on the Virgilian epic, would be that Toledo is Troy, and that a priest of Toledo (in the guise of Laocoön) warned the Toledans about some threat or treachery (the wooden horse), as a consequence of which he was destroyed (by serpents). His destruction would have been designed by the protectors of his enemies (the gods who supported the Greeks) and it would have occurred during the performance of his duties (Laocoön was attacked while sacrificing a bull at the altar of Neptune). Since the Toledans ignored his caution, their ruin is imminent. Accordingly, the meaning of the picture would relate specifically to the city of Toledo and, particularly, to the destruction of an eminent member of its clergy.

One such figure might have been Bartolomé Carranza, consecrated Archbishop of Toledo in 1558.[22] As the priest of Toledo, he conscientiously undertook the pastoral care of his flock, warning of the dangers of simony and, particularly, the threat of heresy, which he invoked in a sermon by the image of a 'breach in the walls'. He vigorously combated these evils by the reform of abuses and the fostering of spirituality. This won him the admiration of Toledans, but his emphasis on spirituality, especially the primacy of mental prayer, aroused the enmity of certain fellow Dominicans. This primate of Spain was consequently accused by the Inquisition of heresy and imprisoned for no less than seventeen years. When judgement was eventually passed, he was cleared of heresy but had to abjure sixteen propositions as suspect. He emerged a broken man and died soon after his release. His supporters, however, among whom figured some of El Greco's most distinguished patrons and associates, continued to defend his reputation long after his death and support his spiritual reforms.[23] Perhaps El Greco intended to encourage such a reading by depicting Laocoön with an expression so similar to that of Saint Peter in his pictures of *Saint Peter in Tears*.

On the other hand no documentary or literary evidence has been found to associate Carranza with Laocoön.[24] The painting might be interpreted more broadly, as an allegory of the destruction not of a specific priest or priests but of the moral values exemplified in both their conduct and that of Laocoön. It might be a fervent plea to the viewer to uphold those values, to have the courage of one's convictions to condemn evil even if one has to suffer. In this vein the Habsburg minister, Cardinal Granvelle, owned a pendant with a motto, taken from the *Aeneid*, of '*Durate*... (Endure...) and with the head of Laocoön on the obverse.[25] Certainly his Stoic sentiment would have been applicable to Toledo. Witness the comments of the learned Toledan, Jesuit Juan de Mariana, in 1609 on the trial of the Augustinian biblical scholar Luis de León:

> The case made many people anxious, as they awaited its result. For men of learning and reputation were forced to defend themselves while in prison against something that was quite dangerous to their lives and good name. What a miserable situation is that of the virtuous man! As reward for his achievements he has to endure the hatred and accusations of the very people who should be his defenders The case in question disheartened many, as they saw the danger to others and the torment which threatened those who freely stated what they thought. In this way many changed over to the other side or decided to bow before the storm.[26]

The painting would serve as an exhortation to the contemporary Toledans to denounce these ills outright, otherwise the consequences for Toledo would be dire. To condone Laocoön's destruction and fail to protest, as did the Trojans, would result in the imminent destruction of the city.

El Greco's painting certainly might be read on various levels, in accord with contemporary practice.[27] It was established Renaissance tradition to expect to find in Virgil's epic a moral and allegorical meaning, a tradition echoed by Diego de Ayala in dedicating his edition of the *Aeneid*, printed in Toledo in 1577, to Philip II:[28]

I commend two things to those who may read this translation The other is that they should not content themselves merely with its literal understanding or with a simple enjoyment of its story, but that, going further, they should scrutinise and diligently examine its moral and philosophical meaning, where the greatest benefit is to be found.

On a literal level El Greco's painting is a gripping illustration of the destruction of Laocoön as recounted in either the *Aeneid* or the *Satyricon*. However, owing to the substitution of Toledo for Troy, the contemporary viewer would also have been compelled to relate the significance of the subject to a Toledan context. Furthermore, since the viewer, like the reader, knew the fateful consequences of ignoring Laocoön's advice, Laocoön would become an exemplar not only of suffering but also of prudence and fortitude. Laocoön spoke the truth. Unless the moral significance of Laocoön's suffering is recognised, Toledo is doomed. Accordingly, the painting might be interpreted on a moral level as well, or, further, as an allegory. A singular tragedy, such as that of Carranza, a priest of Toledo, might have motivated El Greco. Alternatively, the prevailing climate of apprehension, which was undoubtedly fuelled by such tragedies, may well have been the butt of the artist's powerful and highly emotive imagery.

Whatever its precise meaning, the effect is shocking. As in images of the Passion of Christ and the martyrdom of saints – and as in Goya's *Disasters of War* and Picasso's *Guernica* – the intention is not to indulge in the tragic suffering but to denounce it, to shock the viewer into action. It is an abhorrence of violence and the attitudes that gave rise to it. It is a condemnation not only of the wreck of their physical being, but also of the spoliation of their dignity. Yet it is also an exhortation to the viewer to imitate Laocoön since he had the wisdom and courage of his convictions to condemn those ills and endured his suffering, like a saint. There is a reek of despair, but there is also a passionate desire to restore the human condition. DD

1. For a discussion of El Greco and the Antique, see Marías 1993; Kitaura in Hadjinicolaou 1999, pp. 257–73. For a detailed analysis of the iconography of the Laocoön, together with translations of all the known classical texts relating to it, see Davies 1996, pp. 257–350.

2. Bieber 1967; Brummer 1970; Winner 1974, pp. 83–121; Haskell and Penny 1982; Bober and Rubinstein 1987; Rubinstein 1999, pp. 321–31; Brilliant 2000.

3. Ettlinger 1961, I, pp. 121–6. For a classic discussion of Laocoön's facial expression, especially his mouth, see Lessing (1910), chs. 1–3.

4. Ripa 1611, p. 125. (First, unillustrated edition published in Rome in 1593.)

5. Probably the item listed in the inventory of El Greco's books as 'Tratato del arte de la pintura'. See San Román y Fernández 1910, p. 197.

6. Lomazzo 1584, II, XVI. The translation is taken from Dempsey 1967, p. 424.

7. At that time it would appear that the right arm of Laocoön was restored such that it extended diagonally upwards, with a slight bend at the elbow. See Bober and Rubinstein 1987, p. 153; Rubinstein 1999, p. 34.

8. For the history of these sculptures during the Renaissance, see Bober and Rubinstein 1987, p. 140, no. 109; p. 179, no. 143; pp. 183–185, no. 149. Saxl was the first scholar to point out that the pose of Laocoön was similar to that of the Falling Gaul, Museo Archeologico, Venice (Saxl 1927–9, no. 1–2, pp. 86ff.). However, until its restoration by Tiziano Aspetti in 1587, that is after El Greco's move to Spain, the sculpture was in a fragmentary state. It lacked a nose, both arms, the entire right leg, and the left leg below the knee (Perry 1978, pp. 238–9, no. 12). Since there are numerous examples of this same pose in works prior to this restoration, it is conceivable that there was another antique version no longer extant, or that artists 'restored' the antique sculpture by adapting bodily members to it from other antique figures, such as a fallen Amazon or the dying Adonis in Roman sarcophagi reliefs. (For the Amazon, see Bober 1957, p. 74, fig. 94. For Adonis, see Bober and Rubinstein 1987, pp. 64–5, nos. 21–2).

9. It would seem reasonable to identify the subject of the picture in the Prado as Prometheus rather than Tityus. The figure is shown not in a cavernous underworld but outside, as is evident from the vegetation, and on a mound of rocks. He is also chained, as Prometheus was chained by Mercury to Mount Caucasus, and his liver is being torn out not by a vulture, as was the case with Tityus, but by an eagle, in accord with the fate of Prometheus. No painter who worked for the Spanish Habsburgs was likely to confuse a vulture, which eats carrion, with an eagle, which kills its prey, especially since a double-headed eagle was the emblem of the Holy Roman Emperor. For further discussion, see Davies 1996, n. 11, pp. 335–8.

10. See Brendel 1955, pp. 113–25.

11. Cort's print is dated 1566 (Reggio 1958, pl. 9c (facing p.57)). The Prometheus was also engraved by Rota in 1570 (Crowe and Cavalcaselle 1881, II, p. 187, note).

12. See Davies 1996, pp. 281–9. According to Euphorion (third century BC), fragments of whose writings were preserved in Serivus' commentary on the Aeneid (II, 201), Laocoön was killed by serpents because he had had sex with his wife before the image of Apollo. Hyginus (probably second century AD) essentially repeats this reason, stating that Laocoön 'took a wife and begat children against the will of the god [Apollo]' (Hyginus Augusti Liberti (1535), Fabula CXXXV). However, neither in Euphorion's nor Hyginus' accounts is there any reference to Laocoön's warning or Sinon's deceit, or to any description of Laocoön's epic struggle, or, most significantly, any connection with the subsequent entry of the wooden horse into Troy and the impending destruction of the city. Laocoön is not central to the story. Clearly, these flat and lifeless texts bear no relationship to El Greco's painting, in which the ominous horse and doomed city are integral to the story of Laocoön's suffering and death.

13. Petronius (1923), pp. 156–7.

14. Davies 1996, pp. 284–5, 298–9, Petronius' text is also discussed by Brilliant 2000, p. 47.

15. Ludovicus 1612.

16. Ludovicus 1612, p. 180 (Explicatio).

17. Buchthal 1971.

18. 'Ex hoc fonte, sancte pater, tanqum ex equo Troiano, irrupere in Ecclesiam Dei tot abusus & tam grauissimi morbi . . . Consilium delectorum Cardinalium et Aliorum Praelatorum de Emendanda Ecclesia'. See Dickens 1968, pp. 97–9.

19. Ripa 1611, p. 125.

20. Acta Sancta., Aug., p. 430. Mâle 1951, p. 38.

21. De los Santos 1667, f. 78v.

22. For Carranza, see Tellechea Idígoras 1968.

23. Pedro de Salazar y Mendoza, a friend and patron of the artist, wrote a biography of Carranza in which he eulogised his achievement and compared the tragedy of his life to those recounted in Greek and Latin literature. See Salazar de Mendoza 1613. Significantly it was written at a time approximately contemporary with El Greco's painting.

24. I am grateful to Professor Tellechea Idígoras for confirming this point.

25. London 1980–1, pp. 6, 52 (no.15). Clearly, Laocoön is here perceived in accord with the Virgilian tradition. El Greco may have seen the pendant. In Rome, Granvelle was an intimate of those men in the Farnese circle with whom El Greco was associated.

26. Lynch 1965, I, pp. 251–2.

27. See Pérez de Moya 1673, pp. 3–4 (first edition printed in Madrid in 1585). He interprets myths on various levels – literal, moral, allegorical and analogical. The moral interpretation is clearly reflected in the title of Book V, in which he exhorts men to flee from vices and follow virtue: 'Libro Quinto contiene fabvlas para exortar a los hombres, huir de los vicios, y seguir la virtud.'

28. Virgil (1577).

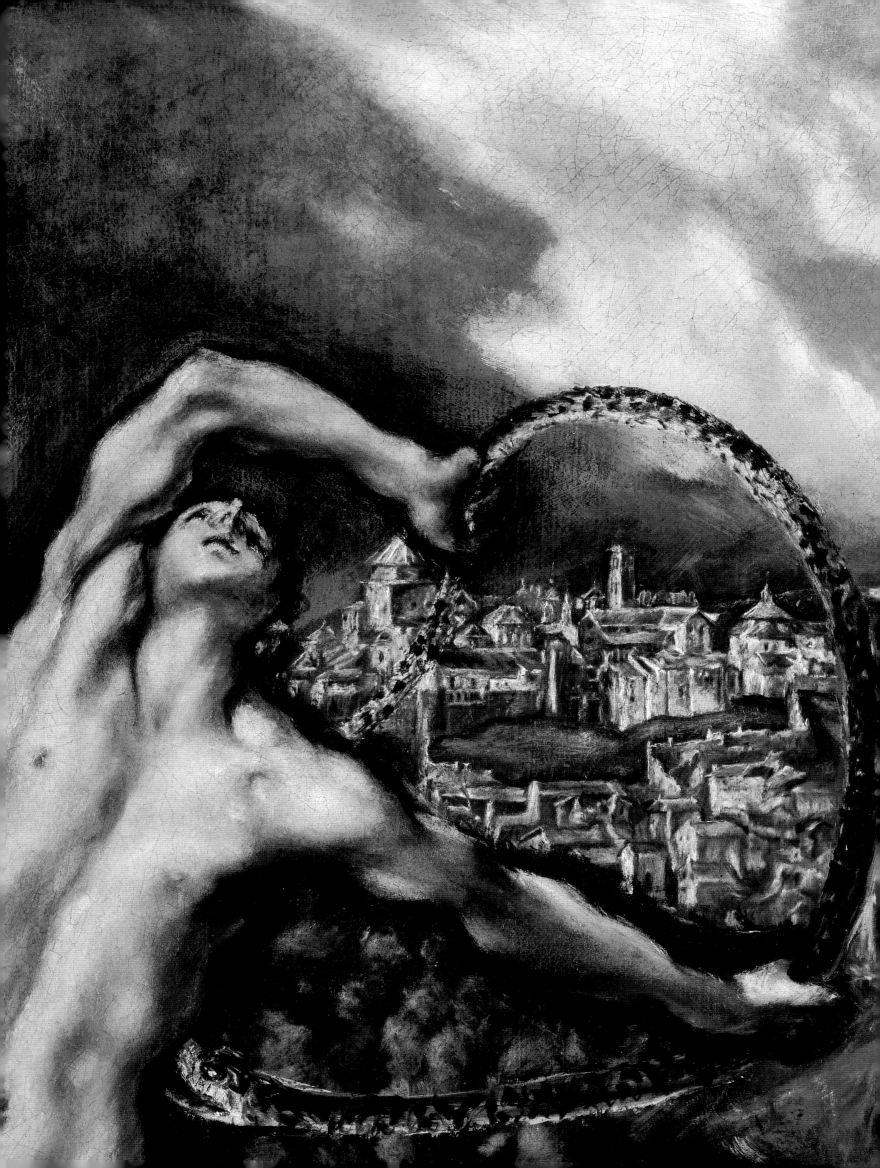

69 Laocoön, early 1610s

Oil on canvas, 137.5 × 172.5 cm
National Gallery of Art, Washington, DC
Samuel H. Kress Collection, inv. 1946.18.1

PROVENANCE

Possibly among El Greco's possessions
at his death in 1614; his son, Jorge
Manuel; possibly Pedro Laso de la Vega
(died 1637; inventory 1639); Infante
María Felipe Luis de Orléans, Duque de
Montpensier (1824–1890), Seville; his
son, the Infante Don Antonio de
Orléans, Duque de Galliera, Sanlúcar
de Barrameda, Cádiz; with Durand-
Ruel, Paris, by 1910; with Paul Cassirer,
Berlin, by October 1915; Edwin Fischer
(1886–1960), renowned pianist, Basle
and Berlin, by 1923; his wife (divorced),
Eleanora Irma von Jeszenski von
Mendelssohn, Berlin, by 1926; Prince
and Princess Paul of Yugoslavia,
Belgrade, Johannesburg and Paris, by
May 1934 (the painting was on loan
from them to the National Gallery in
London from May to December 1934);
with Knoedler & Co., London, Paris
and New York, 1946; acquired that
same year by the Samuel H. Kress
Foundation, New York

ESSENTIAL BIBLIOGRAPHY

Cossío 1908, pp. 357–63; Cook 1944;
Wethey 1962, I, pp. 50–1, 61, 63, II, no. 127;
Palm 1969; Vetter 1969; Davies 1976,
pp. 10 and 16 and note to pl. 41; Madrid-
Washington-Toledo (Ohio)-Dallas
1982–3, no. 56 (entry by W.B. Jordan);
Moffitt 1984; Brown and Mann 1990,
pp. 60–7; Davies 1996; Vienna 2001,
no. 43 (entry by C. Beaufort-Spontin)

The *Laocoön* is El Greco's secular masterpiece. It is a work of great compositional dynamism and pictorial virtuosity, offering a dense texture of cultural, historical and topical allusions. Painted late in his career, it is his only significant effort at a subject from ancient mythology. It reflects his interest, already apparent in *A Boy blowing on an Ember to light a Candle* (cat. 63), in re-interpreting an antique work of art, in this case the famous *Laocoön* sculptural group (fig. 54, p. 239). Unearthed in Rome a century earlier the sculpture had been enormously admired for its power, expression and technical skill.

According to Virgil's *Aeneid* (II, 56–80 and 284–313), Laocoön was the priest of Neptune at Troy. He warned the Trojans that the wooden horse which the Greeks had left outside their city, supposedly as a peace offering to the goddess Minerva, was an act of treachery. Minerva took her revenge on Laocoön by sending serpents to kill him and his two sons. The Trojans drew the horse into the city walls and when later the Greek soldiers who were hidden inside it emerged they laid waste to Troy. However, instead of showing Troy, the painter sets the scene outside the walls of Toledo; the wooden horse stands near the Visagra Gate, one of the principal entrances to the city. There was a tradition in Spain that Toledo had been founded by descendants of the Trojans Telemon and Brutus, who, like Aeneas, had escaped the flames of Troy. But in making Toledo the geographical setting for the story (he did the same with *Saint Martin and the Beggar* and *The Virgin of the Immaculate Conception*; see cat. 38 and 55) El Greco was seeking to universalise the story by drawing out its relevance for the contemporary world, and perhaps more specifically to contemporary Toledans.

In the commentaries both ancient and modern on Virgil and on the other ancient sources, Laocoön symbolised various and sometimes contradictory qualities: he was an *exemplum* of, among other things, prudence and courage, wise counsel, and of the prophetic voice that frequently goes unheeded. Some sources refer to his lack of chastity, and he became the symbol of the man who challenges divine ordinances and suffers retribution; likewise he was sometimes seen as a sort of pagan Job, upon whom unjust punishment is visited. Some scholars have

argued that the painting reflects the contemporary concern with the immoral or licentious behaviour of the clergy. Waterhouse proposed that Laocoön and his sons represent those Toledan ecclesiastics who, like the Trojan priest, warned their contemporaries of the dangers associated with reforms in the Catholic Church.[1] The analogy between the fate of Laocoön and the vicissitudes of the Cardinal-Archbishop of Toledo, Bartolomé Carranza (archbishop from 1558 until his death in 1576), who warned the Toledans of the dangers of heresy and immorality but himself fell victim to the Inquisition, was suggested by Davies, who, however, in his essay in the preceding pages, insists on the wide range of possible interpretations of the picture.

The main figures on the right who stand by as the horrid spectacle unfolds have been variously identified as Paris and Helen, Adam and Eve, Poseidon and Cassandra, Apollo and Artemis. Contributing to the difficulty of interpretation is the ambivalent physical state of the figure group. The main figures are usually said to be male and female but there can be no absolute certainty, owing to its condition, that the figure looking out of the painting to the right is female. When the picture was cleaned in 1955–6, there emerged the middle head and the fifth leg that appears between the two figures. El Greco may never have wanted this mysterious additional figure to be visible, perhaps intending that it should be replaced by the figure looking out of the painting. The execution of the picture may have been interrupted, perhaps by the artist's death, before he was able to cover up the leg and head, thus leaving the picture in its current, not quite finished state.

The inventory of El Greco's possessions made at his death in 1614 lists three paintings of Laocoön, possibly including this one. Jorge Manuel's inventory of 1621 also lists three *Laocoöns* but these may not be the same three. One of those in Jorge Manuel's possession may have passed into the Spanish royal collection, where it was described in several inventories as being about 3 by 3 *varas* (that is, about 250 × 250 cm). No other version of the *Laocoön* is known today. GF

1. Waterhouse 1978 and 1980, p. 10.

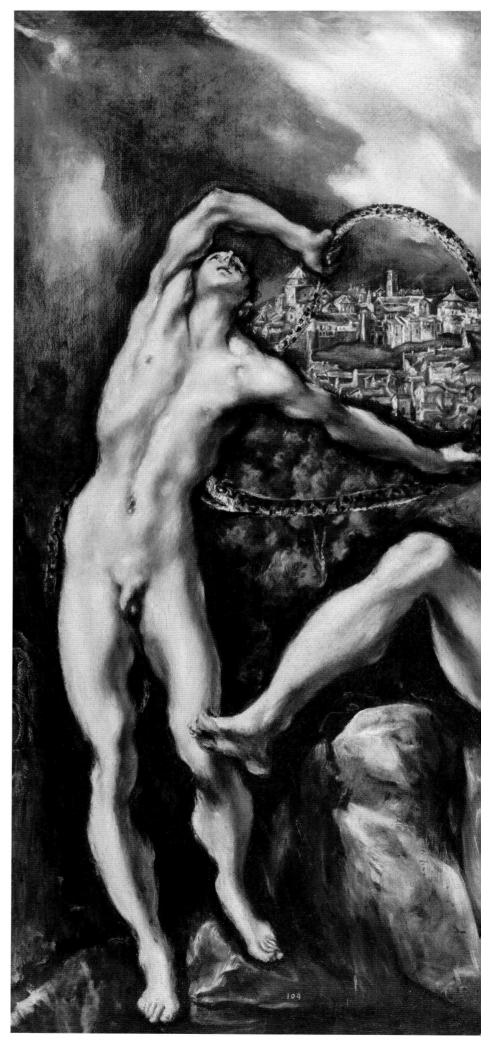

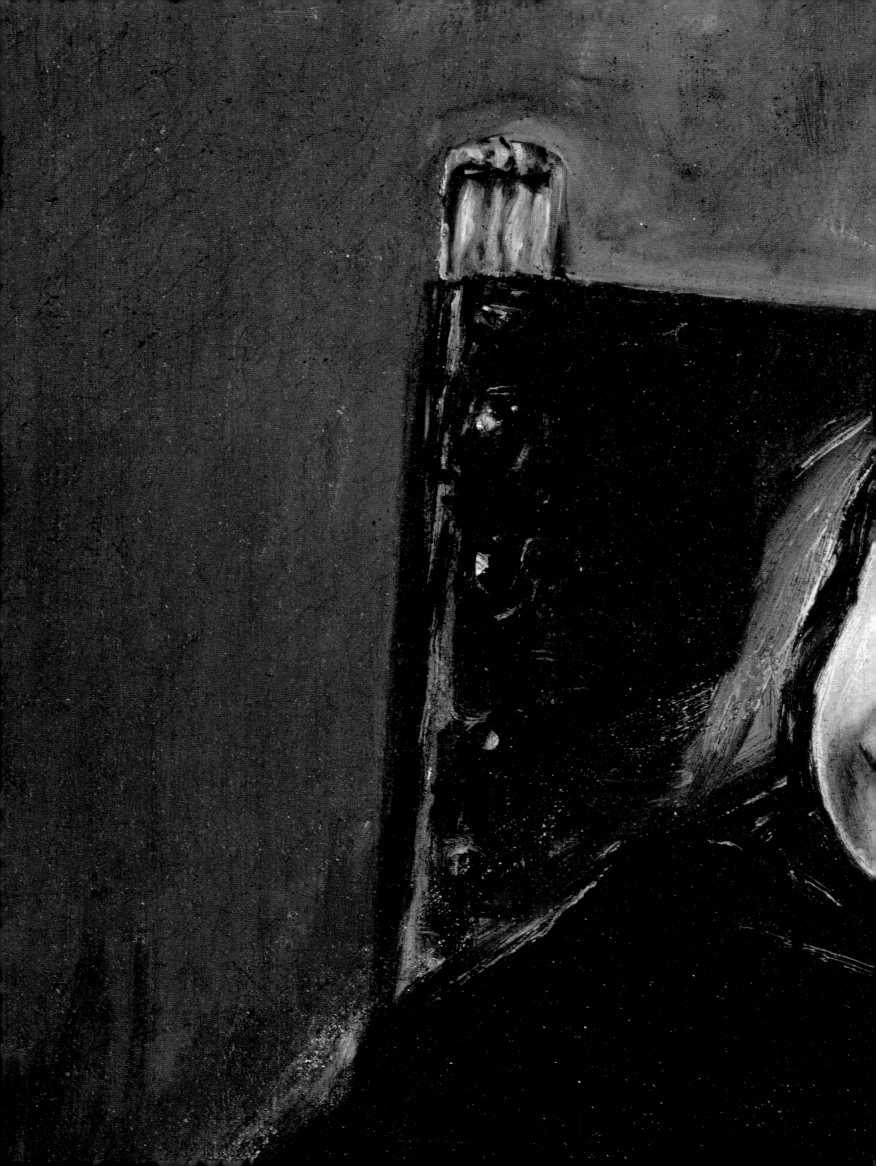

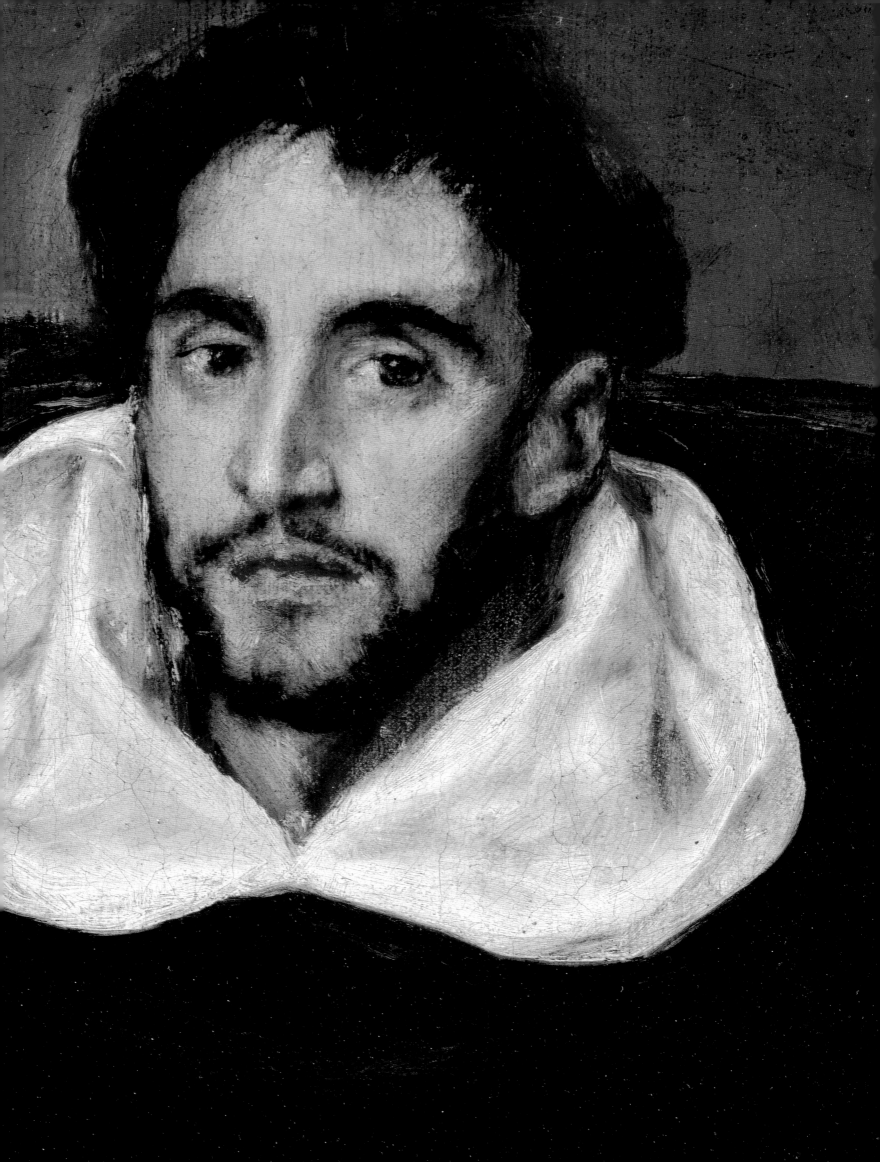

El Greco's Portraits:
The Body Natural and the Body Politic

What a piece of work is a man: how noble in reason; how infinite in
faculty; in form and moving how express and admirable; in action how
like an angel; in apprehension how like a god; the beauty of the world,
the paragon of animals.[1]

PORTRAITURE IN THE RENAISSANCE was motivated by a desire
to acknowledge the individual not simply for his or her own sake,
but as a creation 'in the image and likeness of God' (Genesis 1:
26–7). The idea is succinctly and beautifully expressed in Hamlet's
speech, quoted above. This Christian belief in the dignity of
man was reinforced by reference to the classical tradition,
especially to writers such as Plutarch and Suetonius, who had
provided biographies of illustrious men; Pliny had documented
the practice of making portraits to commemorate such men.[2]
Pliny had mentioned, among others, Aristides, who 'was the
first of all painters who depicted the mind and expressed the
feelings of a human being . . . and also the emotions'.[3]

Both to convey emotion and to enhance the illusion of the
sitter's reality, portraitists utilised the devices of rhetoricians,
for theirs was also an art of persuasion. Through gesture, for
example, the illusion of a dialogue or audience was established.
The rhetorician Quintilian had noted:

> Nor is it wonderful that gesture which depends on various
> forms of movement should have such power, when pictures,
> which are silent and motionless, penetrate into our inner-
> most feelings with such power that at times they seem more
> eloquent than language itself.[4]

Gesture included the whole language of the body. Cicero, one
of the greatest orators of antiquity, had prescribed:

> He [the orator] will also use gestures in such a way as to
> avoid excess: he will maintain an erect and lofty carriage
> There should be no effeminate bending of the neck, no
> twiddling of the fingers He will control himself by
> the pose of his whole frame, and the vigorous and manly
> attitude of the body, extending the arm in moments of
> passion, and dropping it in calmer moods.[5]

Inspired by such precedents, a Renaissance portraitist might
seek to record not only the sitter's physiognomy but also his

state of mind and at the same time the virtues and characteristics
appropriate to his station. Especially, but not exclusively, in
formal portraits, sitters might be represented not only in their
body 'natural' but also in their body 'politic'.[6] This might be the
aim of the 'liberal' artist of the Renaissance, in contrast to the
craftsman, who reproduced only literally and mechanically the
likeness of the sitter. This contrast was expressed in sixteenth-
century artistic theory by the distinction between *ritrarre* (to
replicate literally) and *imitare* (to imitate, to discern, select and
create the ideal from natural phenomena).[7]

It is against this backcloth that El Greco appears on the
artistic scene in Rome in 1570. The first encomium of his skill,
in a letter written in November 1570 by Giulio Clovio, recom-
mending El Greco to his patron Cardinal Alessandro Farnese,
was as a portrait painter: 'There has arrived in Rome a young
Candiot, a pupil [*discepulo*] of Titian, who in my opinion has a
rare gift for painting; and among other things, he has done a
portrait of himself which has astonished all these painters of
Rome.'[8] There is a glimpse here of El Greco's self-esteem and
calculated attempt to impress. The self-portrait signified his
social status as a liberal artist and enabled him to demonstrate
his skill. The painted portrait could be compared with the living
person. Clovio's reference to his ability as a portraitist and to
his being a 'discepulo' of Titian was undoubtedly calculated to
attract the attention of the Cardinal: Titian's portraits of his
family were some of his most psychologically penetrating. Clovio
himself, and particularly the Book of Hours which he illuminated
for Cardinal Farnese,[9] was especially admired by Vasari, who
ends his *Life* with this sympathetic picture of the miniaturist:

> And now, although Don Giulio is old . . . he is always at work
> on something in his rooms in the Farnese Palace, where he
> is most courteous and ready to show his productions to
> those who wish to go and see them among the other
> marvels of Rome.[10]

PREVIOUS PAGE Detail of cat. 81

It seems to be this courteous generosity that El Greco captures in his portrait of *Giulio Clovio* (cat. 70).[11] With an eloquent, rhetorical gesture, he engages and directs the viewer's attention to the cardinal's Book of Hours, open at the page showing God creating the Sun and the Moon.[12] Perhaps a conceit on creation – divine and artistic – was intended.

The distant view of a mountainous and windswept landscape, a figment of the painter's imagination, may be a foil to the restraint, calm and order that Clovio exemplifies in his person.[13] It may have been inspired by Titian, for example his portrait of *The Empress Isabella* in the Prado.[14] Certainly, the influence of Titian's style pervades El Greco's portrait. The composition, in which the sitter is positioned in the foreground and shown against a darker, neutral background, and with an object or objects set on one side with a window above, through which there is a view of a distant landscape, is a stock motif in Titan's portraiture.[15] As also in Titian's work, not all the forms are modelled in detail and with the same optical focus. The members are subordinated to the head, where paint is applied in small strokes to create the impression of an aged countenance. The free, but careful, brushwork animates the head, just as the strong light that shines on it makes it contrast dramatically with the dark wall behind. So strong is the reflection that it seems to emanate from Clovio's brow. Frail he may be, but mentally he is charged with energy.

Probably under Clovio's tutelage, El Greco also painted for Fulvio Orsini four portraits on copper roundels, no longer extant.[16] Clearly, their form would have related to Orsini's interest in classical coins. But El Greco's skill in painting portraits on a small scale is evident in his *Purification of the Temple* (cat. 7) and in the rather later miniature portrait (cat. 74), painted in Spain. In *The Purification* he inserted, in the lower right corner on a separate piece of canvas, bust portraits of Titian, Michelangelo, Clovio and (probably) Raphael.[17]

El Greco's association with intellectuals is also reflected in his *Portrait of a Man* in Copenhagen (cat. 71).[18] The only clues to his identity are the book and the drawing (writing?) instrument beside it.[19] He makes an eloquent gesture, one which is described by Quintilian as 'a most becoming gesture' for an orator, 'the fingers opening as the hand moves forward'.[20] 'The most

becoming attitude for the hand is produced by raising the thumb and slightly curving the fingers....'[21] Such hands 'may almost be said to speak'.[22] By this means the viewer is engaged in a dialogue, perhaps on the contents of the book. (In the later portrait assumed to be of *Rodrigo de la Fuente* (Prado, Madrid) the book is open and the sitter expounds on the text.) The viewer is bound to be impressed by the demeanour of his interlocutor, whose expression is serious and focused, his gesture meaningful and not mannered, his clothes sober in colour and devoid of decoration. He manifests modesty and calm reasoning. Visually he is also impressive. Just as the dark costume is silhouetted against the light background, so do the strongly lit hands and face stand out from the surrounding dark costume and hair respectively. Their three-dimensional form is more convincing and their outlines are strengthened. A tension is created between the body of the man, positioned at an angle to the picture plane, and his broad cloak, which forms a two-dimensional pyramidal shape. The result is a striking illusion of a 'speaking likeness'.

El Greco's portraiture developed dramatically during his Roman sojourn, reaching a peak in his portrait of *Vincenzo Anastagi* (fig. 56). The sitter was a distinguished Knight of Malta (Order of St John of Jerusalem), who had been appointed *sergente maggiore* of the Castel Sant'Angelo in Rome on 14 May 1575.[23] The portrait was probably painted to commemorate the appointment. For El Greco it was an important challenge, for he seems never previously to have painted a full-length or military or official portrait.

There is nothing literary, courtly or chivalric about this portrait. The man's stocky build and sturdy stance, with feet planted firmly on the ground and both arms akimbo, may well have been typical of him – the body natural. The armour, sword, helmet and, presumably, the green baldric and velvet breeches ornamented with gold thread, are the attributes of his station. Yet El Greco has not confined himself to replicating these particulars. He has sought to make manifest Anastagi's body politic as well – in particular the cardinal virtue of fortitude, comprising courage, endurance and physical strength.

Appropriately, the setting is spare. The bare floor, plain wall and high window bring to mind a guardroom in an army

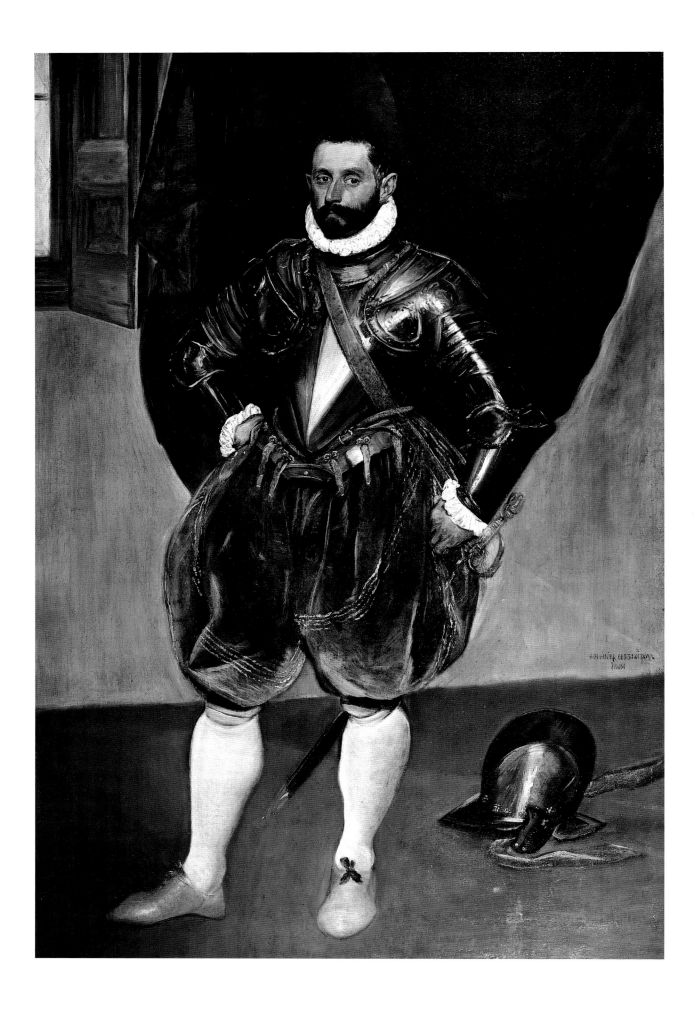

barracks. Anastagi's physical presence is emphasised by his size (he is shown full-length and life-size), scale (he dominates the picture space) and central position. His powerful calf muscles and broad shoulders are accentuated, and his stout arms assertively jut out at the elbows. Facing the front, and with feet firmly planted on the ground, he looks the viewer straight in the eye, eyeball to eyeball. The bold, geometric and curvilinear shapes of the design – from the verticals of the legs to the billowing shapes of the breeches to the diagonals of the arms which, like a pincer, direct attention to the head – heighten the visual impact. As in the earlier *Portrait of a Man* (cat. 71), the light background is used to accentuate the silhouette, but here the tonal and colour contrasts are more dramatic.

In spite of this achievement, the paucity of the extant and recorded portraits which El Greco painted in Rome suggests that commissions were not forthcoming. Perhaps his Titian-esque technique was not appreciated. The broad painting of the legs, the free brushwork of the green breeches and the summary treatment of the hands – in order to focus attention on the more detailed modelling of the head – are in striking contrast to the smooth and uniformly modelled forms in contemporary Roman portraits.

In making his decision to leave Rome and seek his fortune in Habsburg Spain, El Greco would have been aware of the keen interest of Philip II in portraiture for its dynastic and propagandist purposes. As well as learning this probably from Titian and, possibly, Cardinal Granvelle, it is also likely that Orsini, who owned portraits by Sofonisba Anguissola, would have told El Greco of her success at the Spanish court.

The earliest extant portrait which El Greco painted in Toledo was the *Lady in a Fur Wrap* (cat. 73). In the manner of Titian, the lynx fur is freely and vigorously painted. The dark tufts have been cleverly arranged so that they seem to splay out from the sitter, thereby enhancing and vivifying her. As such the fur acts as a visual and tactile foil to her delicate skin, which is smoothly and densely modelled. Indeed, the modelling of the face is reminiscent of contemporary Roman portraits, such as those painted by Scipione Pulzone for the Farnese.[24] This combination of Venetian and Roman stylistic elements is typical of El Greco's early work in Toledo (about 1577–9), although the

authorship of this picture has been disputed.[25] The identity of the sitter is not known,[26] but clearly the portrait is too informal and intimate for a sitter of royal or aristocratic blood: this woman fails to exude the dignity, sobriety and detachment high rank would require.[27] She is neither static nor frigid. Instead, she seems aware of the admiring gaze of the viewer, in reaction to which she draws her fur wrap across her bosom – though much more decorously than, for instance, Titian's *Girl in a Fur Coat* in Vienna, even if this is probably also a private picture. Settling her identity is not made easier by her high degree of red and white make-up, in conformity with the fashion of the day, making it difficult to discern her age.[28]

The problem of identification, but not attribution, also surrounds El Greco's *Portrait of a Sculptor* (cat. 72), usually identified as the famous sculptor Pompeo Leoni. Whatever his identity, El Greco has depicted him as a practitioner of a liberal art. Like Giulio Clovio, he is elegantly and modestly dressed in black. His dark, penetrating eyes and high brow imply his intellectual capacity. The hammer is poised to suggest his mental deliberation. El Greco has ingeniously applied the conventional formula of the self-portrait, in which the artist turns to face the viewer while working at the easel. Wittily, the viewer can imagine the sculptor looking at the sitter (Philip II) posing for his bust portrait. It is conceivable that El Greco is also subtly demonstrating the superiority of painting over sculpture, for the sculptor looks alive whereas his sculpture is a dead thing. Whether El Greco intended a '*paragone*' or not, there is a striking difference between his portrait of the sculptor and the bust. The former is animated through an appeal to the senses – the movement of the hands, the angular silhouette, the three-dimensional form of the head, and the play on textures. In contrast, Philip II looks dignified, grave and aloof. His eyes do not scrutinise a person but gaze into space – his mind is on higher things. Ironically, the bust portrait of the king is more typical of the ideals embodied in his person and society than the more naturalistic or life-like representation of the sculptor. It is the ideology represented by the bust that informs Spanish portraiture of the period, however, and it is one to which El Greco responds in the 1580s. His portraits of this period are

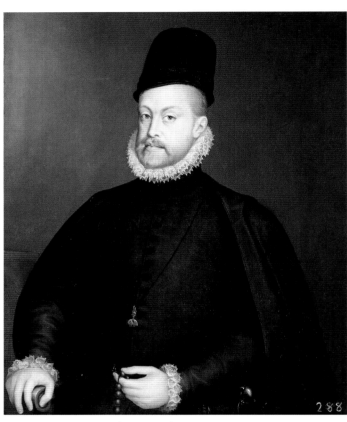

Fig. 57 Sofonisba Anguissola (1532/5–1626)
Philip II holding a Rosary, 1573
Oil on canvas, 88 × 72 cm
Museo Nacional del Prado, Madrid

marked by the hierarchical, élitist and pious sentiments of contemporary Spanish society.[29]

Certain distinctive features have long been discerned in Spanish portraiture of the Habsburg period. Sitters exude a sense of gravity, sobriety and formality. Men do not pose languidly against a classical column or velvet-draped table; nonchalance is not their style. They stand aloof and detached, motionless and impassive. Their reserve is striking and their modesty is proverbial. Men are usually dressed simply in black. There are no laughing cavaliers or boisterous groups of men in convivial company. Indeed, grimacing and overeating and inebriation – indecorous traits – seem to have been confined to the picaresque novel, the 'bodegón' and court buffoons.

These distinctive social mores and their reflection and promotion in Spanish portraiture were rooted in a society that was hierarchical, insular and élitist. Its code of honour was based on purity of faith, purity of blood ('limpieza de sangre') and legitimate birth, and was manifested in the practice of virtue. Philip II himself had introduced a fashion for shorter hair and shorter beards,[30] and for sober dress, particularly black evoking the scriptural image of 'black as sackcloth' (Revelation 6:12). The dignity, modesty and piety exemplified in his bearing is encapsulated in Sofonisba Anguissola's portrait of *Philip II holding a Rosary* (fig. 57). He put into writing the ideals governing such outward expression in a secret instruction written to his half-brother, Don John of Austria, upon his appointment as supreme commander of the armada of the Holy League against the Turks.[31] The letter is not about military tactics but moral conduct: ultimately, the success of the former will depend on the latter, since John must be devout in order to merit the bestowal of victory by God. Above all, Don John must be a good Christian, not only inwardly but also in his appearance and behaviour, that is, in his body politic, since a man of his elevated status has to set a good example. He must be prudent, always calm and reflective, never angry or impetuous, and he must distance himself and avoid familiarity in order to maintain his authority. He must exercise self-discipline – avoiding games of cards or dice, never swearing nor permitting those in his command to do so, never losing his temper, resisting the temptations of lust, greed or ostentatiousness of dress. He

OPPOSITE Detail of cat. 73

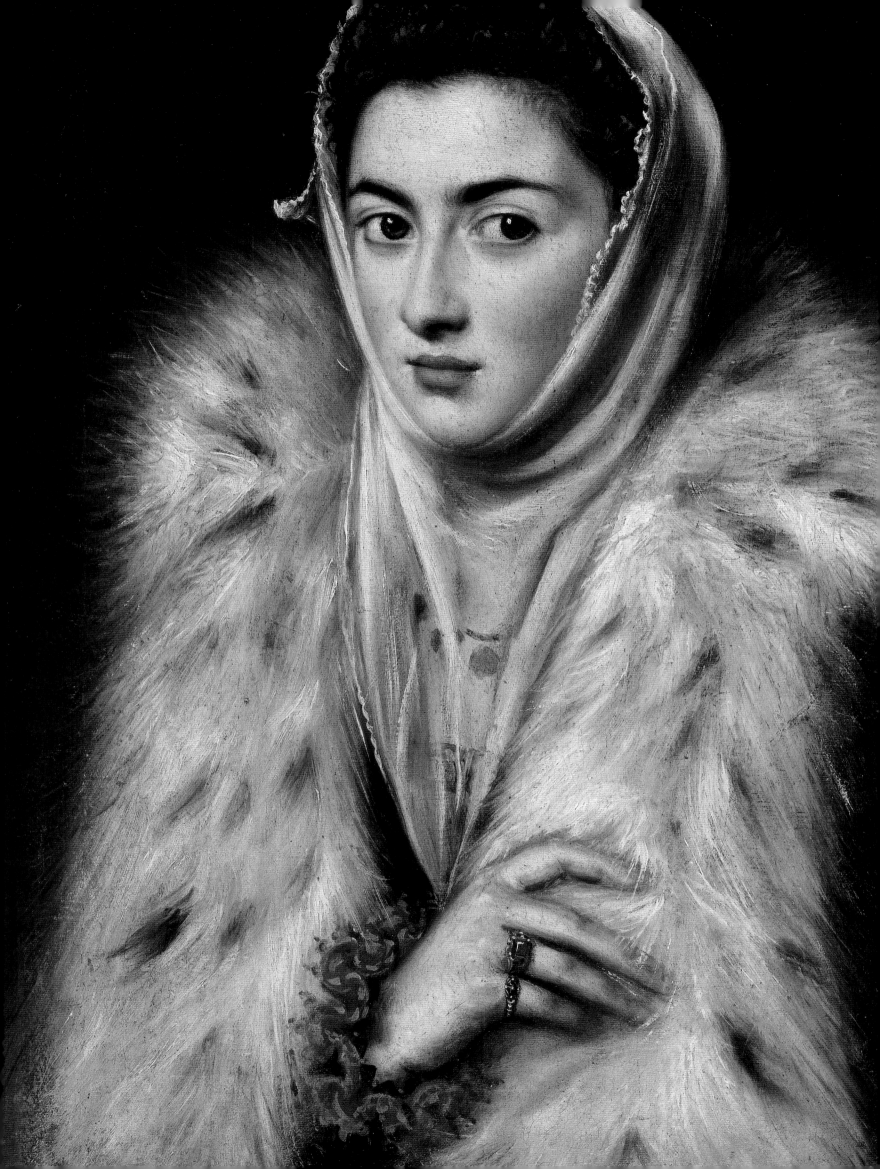

Fig. 58 El Greco
Nobleman with his Hand on his Chest,
about 1583–5
Oil on canvas, 81 × 66 cm
Museo Nacional del Prado, Madrid
inv. 809

must always keep decent company. He must be a paragon of virtue, and that will not only enhance the reputation of the Habsburg family and fulfil his duty to God, but also bring him success in his campaign.

Thus appearance and conduct were strictly determined by codes of decorum that were based on the perception of the Theological and Cardinal Virtues. The individual, like Don John of Austria, is exhorted to subordinate himself to these higher principles. Similarly, in formal portraiture of the period, it is characteristic that the individuality of the sitter is subservient to the manifestation of virtue. In imitating the king, the head of the Catholic Monarchy, an iconic stereotype was formed that rigidly embodied these abstract ideals.

They inform El Greco's portrait of an unknown knight with his hand on his breast (fig. 58). He is shown solemnly committing his whole being – body and soul – to a higher principle, for the gesture of placing the right hand on the left side of the chest – the heart – signalled not only pious respect but also a declaration of intent that would be upheld as a matter of honour. Since the knight directly faces and presents himself to the viewer, exactly as if he were making a vow,[32] the viewer becomes a witness to his solemn act.

His nobility is plain to see. In his bearing he exemplifies hauteur. His superiority is evident in his refined features and in the attenuated and sinewy fingers of his elegantly displayed hand – recalling those of the knights who marvel at the miraculous burial of the Count of Orgaz – and signify that he would most definitely not be excluded from the military orders because he had done menial work.[33] They are the fingers of one who handles a rapier rather than those of a peasant who wields a stout cudgel. In his person he is immaculate – his hair, moustache, beard and nails are neatly trimmed. His fine clothes, golden chain and pendant, as well as the finely wrought and gilded hilt of his sword, attest to his wealth and social superiority. Yet none of the conventional props, such as curtains or tables draped with velvet, or classical architecture, are included. Rather, their very absence proclaims his abnegation of vanity, his moral worth.

In the design, too, there is a pronounced emphasis on centrality and symmetry. The tuft of hair, nose and point of beard mark the central axis. The shoulders establish a triangular design, with the head at the apex. The diagonals formed by the top of the head are repeated by those of the moustache. Ovoid shapes are created by the head and ruff, and the cuff and tips of the fingers. The curve of the cuff is repeated in that of the curved guard of the hilt of the sword. Yet these curvilinear shapes are fixed and separate, not fluent and continuous. This rigid control is also evident in the relationship of the hand to the sword. The little finger is horizontally in line with the top of the pommel of the sword, and parallel to the cross-bar of the hilt. These strictly ordered elements of the design complement the ritual and impress upon the witness that here is a man who is prepared to grip the cold steel of his Toledan blade and face death coolly and disdainfully as a matter of honour.

In the years that follow (this work is probably datable to about 1583–5), El Greco increasingly refines and reduces the 'body politic' of his sitters to reveal the essence of their ideals. The magnificent portrait of the so-called *Duke of Benavente* (Musée Bonnat, Bayonne), and the astonishing group portrait in *The Burial of the Count of Orgaz* (fig. 17, p. 54) are testament to this achievement. For the latter, El Greco was commissioned to include around the miraculous burial 'many people watching'. In fact he carefully ordered the participants: the knights of Santiago are centrally placed and the regulars and the seculars, the pillars of the Church, are at either side. In this serried band El Greco conveys piety, dignity and social pride, so that they seem to typify the ideal Spanish nobleman or *hidalgo*. It is because he has revealed the essence of these virtues in their body politic that the commemoration of these men is vividly fixed in the mind.

The gravity and modesty that are ingrained in these men will be a constant in El Greco's portraits. Nevertheless there is a gradual change in his perception of their manifestation in the sitter. The workings of the mind increasingly preoccupy El Greco's attention. This is especially apparent in his bust-length portraits, which, by their very nature, establish an intimate rapport between the viewer and the sitter. El Greco's *Elderly Gentleman* (cat. 76) is a deceptively simple image. The grey-brown of the wall and the black of the dress not only accentuate the head, because they are darker and plainer in colour, but also evoke a mood of austerity. The delicately and thinly painted face not

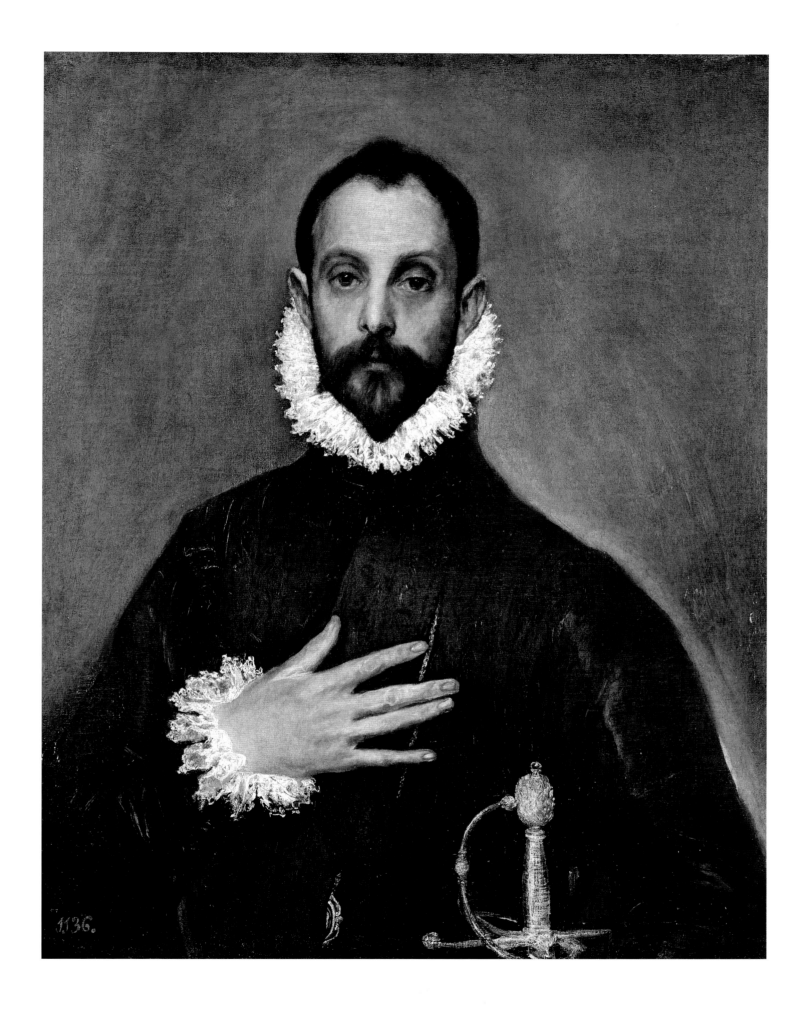

257

only conveys the softness of his skin but also suggests his gentleness. The flecks of silvery light in his hair and beard tell his age, but they also seem to hint at a mind that sparkles. The striking contrast between the stark white of the ruff and the black of the dress, the powerfully sinuous rhythm of the ruff, and the tension between the face and hair and beard, which incline to the left, and the gaze of the eyes to the front, endow the image with mental energy.

Yet he is quiet and still. His eyes are very slightly out of focus so that, although he looks at the viewer, his thoughts seem elsewhere, tinged with melancholy. The workings of his mind are also suggested by the lack of definition of his right eye and of the corners of his mouth. Benefiting from the legacy of portraits such as Leonardo's *Mona Lisa* and Raphael's *Baldassare Castiglione,* El Greco has given the sitter an enigmatic expression. As a result, the viewer can read into his thoughts, assume a closer relationship and even identify himself with the sitter. We do not know his name, but El Greco tells us that he is highly sensitive, full of thought and that his mind is on higher things than the matter of vanities.

In El Greco's moving portrait of his friend Antonio de Covarrubias, a distinguished jurist and celebrated Hellenist, (cat. 77),[34] all the props and attributes of his rank have been omitted. The head, not the body, is the focus of attention. It is true that more of the body is visible than in the *Elderly Gentleman* (cat. 76), and it is reported that Covarrubias was corpulent,[35] but the more vertical format, with more slanted shoulders and more space around it, lends the head greater presence. The head is dramatically isolated in light that is brighter and whiter than in earlier portraits. It is reflected off his hair and beard like frost. It sparkles. Similarly, the dark, clear eyes and high fore-head signal his keen intelligence. The impression of mental energy is heightened by the brushwork. Whereas the back-ground and dress are freely and broadly painted – the warm, red-brown ground is made visible – the face is freely but precisely painted with short, thin brush strokes. The modelling is less descriptive but more expressive. Together with the lack of definition, it allows us to speculate on his thoughts. Enclosed in his own world through deafness, he is oblivious of our presence. Yet we are conscious of his profundity.

Scarcely less vivid is El Greco's portrait of Antonio's elder brother Diego de Covarrubias (cat. 78), even though it is post-humous and based on a portrait by another artist (fig. 63, p. 278). In contrast to the bland description in the model, El Greco has brushed on the paint more freely, suppressed details of the face and surplice, and varied the shapes and outlines. The shape of the biretta is lively, even buoyant, and what is visible of the black cassock rises steeply. The profile on the left side of the face is interrupted by tufts of hair and beard, and that on the right by a clump of hair above the ear. Flecks of silvery light glisten on the hair and beard. Tension is accentuated by the asymmetry between the direction of the eyes, particularly that on the right, and the angle of the nose. The form of the head is narrower, compressed and elongated. Diego de Covarrubias looks not only more lively, but also more ascetic. His spiritual being is plain to see.

El Greco's insistent attempt to reveal the whole being of his sitters is brilliantly realised in his awesome portrait of the Grand Inquisitor, Cardinal Fernando Niño de Guevara (cat. 80).[36] The focus on the head is accentuated by its position at the juncture of the dark green and the yellow of the brocaded hangings, and by the diagonals of the cape and the ridge of the chair that point to it. The recession of the forearms and arms of the chair is masked by his silken robes, intensely red – most intense in the half tones, so that the strength of the colour is enhanced by the shadows and by the highlights that flash across it. Against the strong lines of the geometric design the crumpled folds and sharp-edged outlines of the drapery create restless patterns that flow into the brocade and flatten out the different spatial planes. The harsh brilliance of light, the intensity of the colour and the angularity of the folds of his dress create a dramatic impact and charge the sitter with vibrant energy. One might expect calm dignity from the holder of such a high ecclesiastical office, but that is not the mood of the portrait. The animated and intense painting of the dress forms an eerie contrast with the pensive – even apprehensive – expression on the face.

While his left hand is gracefully draped over the arm of the chair, his right hand claws the other. He seems to fidget in his chair, his feet askew. His black eyes, seemingly enlarged by

his black glasses, avoid our gaze. Is he nervous by nature or because of the thoughts in his mind (a Venetian ambassador commented that he was 'cunning and crafty').[37] He has let slip a piece of paper, which, from precedents in Sebastiano del Piombo's and Titian's papal portraits, the former of which was in the collection of the Farnese librarian Fulvio Orsini, one might expect to be a petition. But the paper that lies at the feet of Niño de Guevara bears the signature of El Greco. Perhaps it is the paper that has disturbed his thoughts. Cornered in his room, and fixed in his chair, it is he who is scrutinised by the artist. The certainties of his office seem to have been stripped away. In its penetration to the cardinal's inner character El Greco's portrait can only be compared to Titian's exposure of the pope in his portrait of *Paul III and his Grandsons* (fig. 65, p. 282). Here El Greco has gone beneath the surface of the body politic.

One of El Greco's finest portraits, demonstrating to the full his capacity to evoke the spirit or the motions of the mind, is that of the charismatic friar Hortensio Félix Paravicino y Arteaga (cat. 81).[38] The young friar, who was exceptionally intelligent and erudite, a poet both by inclination and in appearance, was a rising star at court. Philip III appointed him Royal Preacher in 1617;[39] people would flock to hear him, and there arose the popular refrain, 'If Hortensio has not yet preached, the service is not yet complete'.[40] Both his sermons and his sonnets reveal that he had a penchant for conceits and paradoxes, surprises and marvels.[41] By his own testimony, Fray Hortensio was an 'aficionado' of art.[42] For him, painting was superior to the other arts and, essentially, an intellectual process that appealed to the understanding.[43] Possibly influenced by El Greco, he also claimed the superiority of *colore* over *disegno*:

> The painter who draws the figure in lines and diameters, only paying attention to proportion, results in a work that is dead, lacking the life that colours give it.[44]

He had an acute understanding of Titian's technique, which may well be based on El Greco's tutoring. He writes about seeing pictures in their proper light:

> A painting by Titian not seen in its proper light is no more than a mêlée of sketch marks [*una batalla de borrones*],

a violent stroke of ill-defined reddish colours [*un golpe de arreboles mal asombrados*]. Yet seen in the light in which it was painted it is an admirable and fine harmony of colours, a lively picture which, simply judged by the eye, makes you doubt whether it is a painting or reality.[45]

Titian's bold and free brushwork depends on looking rather than measuring, and improvising rather than strictly copying an earlier drawing. Paravicino's description of the working method of the portrait painter may reflect not only Titian's but El Greco's procedure in this very portrait:

> When a great painter starts to paint a portrait, or any other work of art, he has to begin by drawing it in chalk, and then putting on colours with a brush. However, you would see how, having been very close to the canvas while painting, he would then draw back to see the effect, and he is not sure of the brushmarks until he examines from afar. As a result, devotees of this great art look and judge these boldly painted pictures [*valentías*] at a distance. Thus artists, when they paint, stand close to the painting, but when they want to be sure they stand far back.[46]

As in Paravicino's description, we can see that El Greco must have stood back and then returned to the canvas to make further adjustments to heighten the expressiveness of the image. Thus, he has reworked the left outline of the cowl, and deepened the shadows at either side of the white tunic, and energised the whole with vigorous brushstrokes – the '*borrones*' that Paravicino associated with Titian.

The formal design of the portrait contributes to the life-like effect. Paravicino's left eye – the one that looks directly at us – and the corner of the large book are aligned on the central vertical axis. At either side, and starting from the base, the outlines of the habit direct attention upwards. The movement is suddenly interrupted by the diagonals of the hand and book, which splay outwards, and then it continues along the diagonals of the cape to the head. The symmetry is not static. The geometry of the design is lit up by the flame-like folds of the white tunic, the sweeping curve of the cape and the billowing shape of the white lining of the cowl, and enlivened by the dramatic contrasts

between the dark and light tones and the black and white colours. Yet the contrast is not strident. It is muted by greys, browns and touches of red.

El Greco brilliantly conveys Paravicino's intelligence, charisma and distinguished ambience. His high broad forehead and bright eyes, especially the focused look of his left eye, signify this intelligence, as well as the books he holds with his left hand. His use of gesture in preaching is wittily indicated by his elegant right hand.[47] His pale skin and ascetic countenance attest to his religious vocation. As a learned prelate, he is shown seated, the high-backed chair adding to the authority of his presence. Yet El Greco has also subtly created a mood of informality. Paravicino's hair is tousled, and the ridge of the back of the chair is tilted, its joints loosened with use. It appears that we have interrupted him in his reading:[48] at our entrance he has closed his book and inserted his finger to mark the place. The action is suspended, and our exchange hangs on the moment. The subtly crafted relationship between sitter and spectator possibly would have called to mind the occasions when Paravicino was visited by court literati in his cell, where he was privileged to keep books.[49]

El Greco's ability to transcend the personality of his sitter to give expression to the character reached a peak in his powerful portrait of *Jerónimo de Cevallos* (cat. 83). Cevallos was a councillor (*regidor*) of Toledo, and a distinguished jurist and political theorist.[50] He, too, was knowledgeable about painting, and perfectly understood that the artist's function was not to copy the world of nature literally but to perfect it through imitation.[51]

His engraved portrait by Pedro Ángel of 1613 shows Cevallos standing in formal dress beside a table, holding one of his books in one hand and a piece of paper in the other. At the top right-hand corner is displayed his coat-of-arms. Although El Greco dispenses with these trappings, Cevallos is shown in his body politic, exuding gravity, sobriety and modesty. He is very much a civic dignitary in the Catholic Monarchy of the

Spanish Habsburgs. Nevertheless, the focus of El Greco's attention is on the face and ruff, where he transcends likeness to evoke the man's mental energy and strength of character.

The ruff is tilted so that it is almost like a plate behind the head and therefore accentuates the relief of the head. The slight turns of the head and body are magnified in the spade-like thrust of the beard to the left and the downward gaze and slant of the eyebrow of his left eye to our right. The profile of the right side of the face is a series of undulating curves from the temple to the beard, as if El Greco were kneading clay to invest the head with energy. A strong light falls only on the face and ruff so that it seems to emanate from the head. The sense of mental energy is heightened by the marked pleats of the ruff which seem to radiate from the head like spokes of light. The whole is animated by the free brushwork. In contrast to this pulsating energy, the eyes seem lost in thought. The reflection of light in the eyeballs is minimal. It is in this apparent contradiction that the force of the portrait lies, because the spectator seems to be able to read into Cevallos's thoughts.

Later in the seventeenth century, several portraits by El Greco, including that of Cevallos, entered the royal collection, where they would have been seen by Velázquez, painter to the king. Palomino tells us of Velázquez, 'In his portraits he imitated Domenico Greco, whose heads, he considered, could never be too highly praised...'.[52] Velázquez would seem to have imitated their lifelikeness, but he was an intense observer of natural phenomena who selected what was appropriate for the subject from what he saw. El Greco, by contrast, increasingly transcended the literal and relied on a conceptual approach to express the spirit of the sitter. As Paravicino perceptively and affectionately recalled in a sonnet:

Su estrañeza admirarán no imitarán edades

Future ages will admire his genius, but none will imitate it.

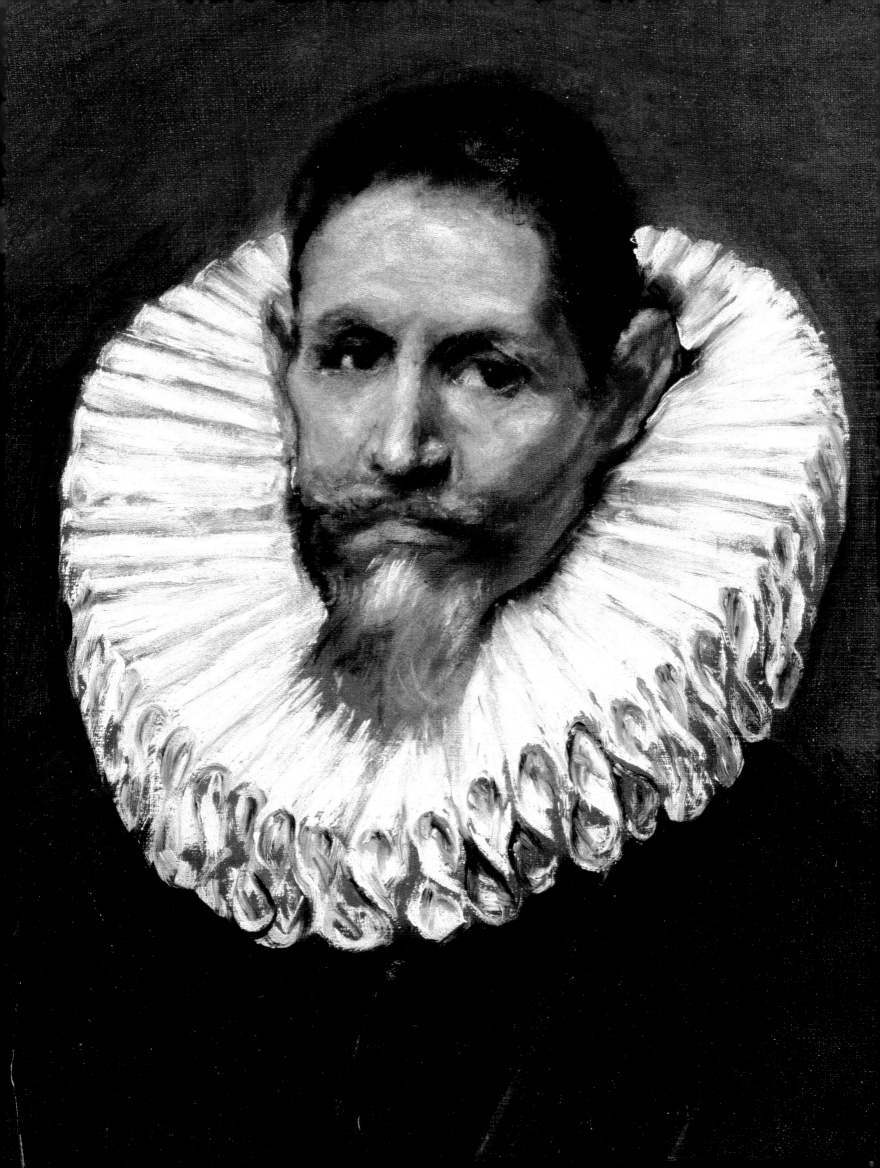

70 **Giulio Clovio**, about 1571–2

Oil on canvas, 58 × 86 cm

Signed on the left: *ΔΟΜΗΝΙΚΟC ΘΕΟΤΟΚΌΠΟΥΛΟC ΚΡΉC ἘΠΟΊΗ*
(Domenikos Theotokopoulos Cretan made)

Museo Nazionale di Capodimonte, Naples, inv. Q191

Giulio Clovio (1498–1578), a miniaturist painter of Croatian origin, was the friend and protector of El Greco in Rome. This is the earliest of El Greco's portraits to have survived and demonstrates both his technical ability and his originality as a portraitist. Painted on a canvas of exceptionally fine weave, it is a work in which the artist invested a great deal of thought and care.

Born in Grisone (or Grizane) in Croatia of a Macedonian family, Clovio first visited Rome in 1526 and soon afterwards took holy orders. He practised as a miniaturist in Mantua, Venice and Perugia and then in 1539 settled definitively in Rome, where he entered the service of Cardinal Alessandro Farnese.[1] He achieved great renown, being described in Vasari as 'this small and new Michelangelo'. He acted as artistic consultant to the cardinal, in 1566 recommending Federico Zuccaro to him and shortly afterwards the young Bartholomäus Spranger. On 16 November 1570, Clovio wrote to the cardinal about 'a young Candiot, disciple of Titian', requesting that he be put up for a time in the Palazzo Farnese. He remarked on a self-portrait El Greco had made (unfortunately now lost), which had greatly impressed the painters of Rome. The Cardinal acceded to the request and El Greco took up residence in the palace, only to be ejected a year and a half later in circumstances which remain unclear. In a letter from El Greco to the cardinal that has recently come to light, dated 6 July 1572, the painter asks why he is being expelled from the palace and protests his innocence of whatever accusations may have been levelled against him.[2] In spite of its relative brevity, his stay in the Palazzo Farnese was extremely important for him, giving him privileged access to one of the finest collections

in Rome and introducing him to a group of cultivated antiquarians, artists and churchmen including Fulvio Orsini, Pedro Chacón and Luis de Castilla, the natural son of the dean of Toledo Cathedral, Diego de Castilla (see further above pp. 66–7, 115).

El Greco's portrait of Giulio Clovio was probably executed as a token of friendship during the time El Greco resided in the palace. It shows the sitter, already in his early seventies, standing in front of a window through which one can see a hilly landscape with a threatening sky. There are some intriguing similarities with the landscape in Titian's portrait of *The Empress Isabela* (Prado, Madrid). Clovio points at his most famous work, an illuminated manuscript known as the *Farnese Hours* (Pierpont Morgan Library, New York), commissioned by Cardinal Alessandro and completed in 1546. It is shown open at folios 59v, showing *God the Father creating the Sun and the Moon*, and 60r, showing *The Holy Family*. Executed with a fluid brushstroke, El Greco's painting combines a high degree of finish in the head with a certain broadness of touch in the hands, the book and the landscape. The style is indebted to the late works of Titian and Jacopo Bassano, and the unusual use of a horizontal format has been associated with certain portraits by the Bolognese painter Bartolomeo Passerotti, which El Greco may have known.

El Greco paid a second tribute to his friend Clovio by including a small portrait of him, similar to this one, in the Minneapolis *Purification of the Temple* (cat. 7) in the exalted company of Titian, Michelangelo and (probably) Raphael, the artists he most admired. GF

1. On Clovio see Bradley 1891.
2. Pérez de Tudela 2000.

ESSENTIAL BIBLIOGRAPHY
Cossío 1908, no. 357; Wethey 1962, I, pp. 8, 20–1, 27, 89 n. 105, II, no. 134; Madrid-Washington-Toledo (Ohio)-Dallas 1982–3, no. 57 (entry by W.B. Jordan); Spinosa 1995, pp. 211–12 (entry by P.L. de Castris)

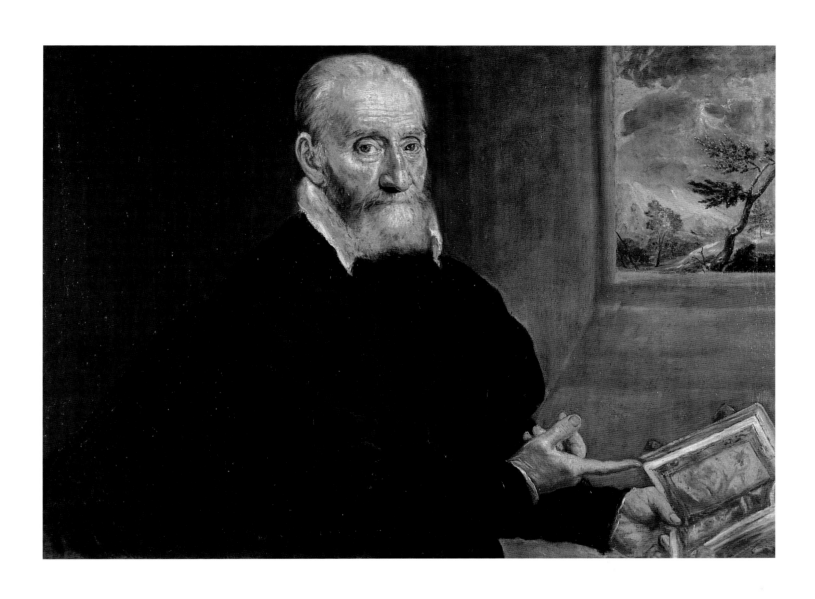

Oil on canvas, 116 × 98 cm

Signed on the table at the lower right-hand corner (fragmentary)

Statens Museum for Kunst, Copenhagen, inv. KMSsp146

ESSENTIAL BIBLIOGRAPHY

Wandel 1917, pp. 80–2; Willumsen 1927, p. 75; Waterhouse 1930, no. 24; Wethey 1962, II, p. 96, no. 154; Hadjinicolaou 1995, pp. 538–40; Vienna 1997, p. 30, no. 3 (entry by O. Koester)

A balding man with a dark beard looks out, his left hand resting on a book placed on what seems to be the arm of a chair with a carved motif. His right hand describes a graceful gesture, suggesting he is about to make a statement. Though who he is is not known, the importance of his social position is suggested by his sombre but sumptuous dress. With touches of white paint and greyish tones El Greco simulates the light reflecting off the black cloth and gives structure to the ample cut of the sitter's garments. The vellum-bound volume with red and white ribbons and the penholder beneath may allude to his intellectual activities.

As this portrait demonstrates, El Greco successfully assimilated the Venetian style of portrait-painting while working in the city between 1567 and 1570. Indeed, until his signature was rediscovered in 1898, the picture was thought to be a self-portrait by Tintoretto. Stylistic affinities can be found with portraits of male sitters by Titian, Tintoretto and Jacopo Bassano, particularly in the treatment of black tones and the way in which the figure is set against a greenish, grey-brown ground. A similar hand gesture can be found in Titian's portrait of *Cardinal Pietro Bembo* (1540; National Gallery of Art, Washington DC).

El Greco probably painted the portrait in Rome several years after moving there from Venice in November 1570. His talent as a portraitist had been hailed on his arrival in Rome by the miniaturist Giulio Clovio, who not only sat for El Greco (cat. 70) but commented that a self-portrait which El Greco had brought with him as a display piece caused 'wonderment among all the painters of Rome'. As a guest at the palace of Cardinal Alessandro Farnese between 1570 and 1572, El Greco painted four miniature portraits of the cardinal and members of his family on copper. These, now lost, and other works by El Greco featured in the collection of Cardinal Alessandro's librarian, the scholar Fulvio Orsini. El Greco was recognised as a talented portraitist by the mid 1570s, receiving commissions from such high-ranking persons as the Knight of Malta Vincenzo Anastagi, whose full-length portrait in military attire he painted in 1576 (fig. 56, p. 252).

It was first proposed that this portrait might represent the scholar and scientist Giovanni Battista Porta (1535–1615), on the basis of its (doubtful) similarities with an engraving of Porta published in his *De humana physiognomonia* (1586).[1] However, Porta resided mainly in Naples until 1579, two years after El Greco's departure for Spain. What is more, both this and another engraved portrait of Porta show him to have had a thinner and more pointed face and a beard and moustache of a different cut.

A second proposal was the Venetian architect Andrea Palladio (1508–1580), on the grounds of its similarity to an engraving of him of 1549.[2] However, El Greco's portrait contains no attributes referring to architecture, and shows a younger man – Palladio would have been in his late sixties by the mid 1570s.

The vellum-bound book, with its red ribbons with which to mark the pages, looks similar to the open volume of the *Farnese Hours* held by the miniaturist Giulio Clovio in his portrait by El Greco (cat. 70). Considering El Greco's close attachment to the Farnese household, it is possible that the sitter was part of that circle, perhaps Fulvio Orsini, Cardinal Alessandro's librarian, or Benito Arias Montano (1527–1598), the librarian of El Escorial, who visited the Farnese household in 1572 and the summer of 1575. Arias Montano may have been instrumental in bringing El Greco to the notice of Philip II of Spain. However, there is no record of Orsini having owned such a portrait by El Greco, which should anyway have shown him in clerical dress, and there is little in common between this portrait and an engraving of Arias Montano.[3] A final candidate is the lawyer Lancellotti, mentioned in Mancini's biography of El Greco as owning a painting that could be mistaken for a Titian.[4] The sober costume of El Greco's sitter would certainly have been suitable for a lawyer. But in the absence of documentary evidence, there is no basis for making any more definite identification of the sitter, even though the picture is a wonderful example of El Greco's mastery of portraiture, which he was to develop further in Spain. XB

1. Wandel 1917.
2. Willumsen 1927, p. 75.
3. Rekers 1972, preface.
4. Mancini 1617–21 (1956), p. 230; see further here pp. 98, 99 n.9.

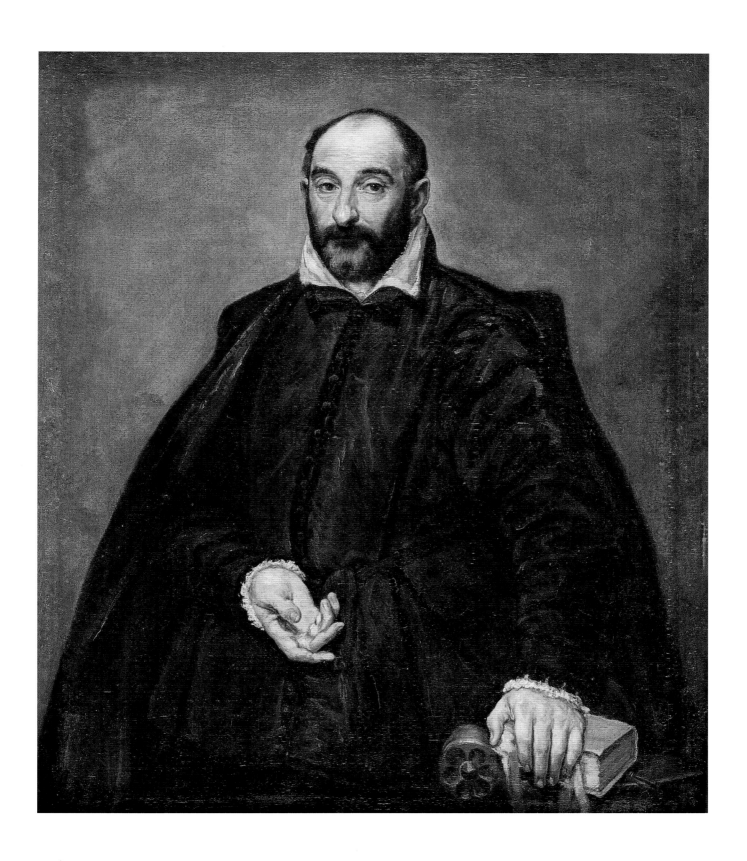

Oil on canvas, 94 × 87 cm
Private collection

Seldom seen but widely published, this is one of El Greco's most fascinating portraits – surely known to Velázquez, whose 1635 portrait of the great Seville sculptor Juan Martínez Montañes seems to reflect it. To judge from its strongly Venetian style – reminiscent especially of the work of Jacopo Bassano – the portrait must date from soon after 1576, when El Greco moved from Rome to Spain; the closest comparisons are with the *Portrait of a Man* in Copenhagen (cat. 71). Although the attribution has been questioned (most notably by Wethey), the picture fits well within El Greco's chronological development, once allowance is made for its somewhat compromised condition.

A persistent tradition identifies the sitter as the major sculptor at the court of Philip II, the Milanese Pompeo Leoni, the son of Leone Leoni, who had been employed in a similar capacity by Philip's father, Charles V. El Greco could certainly have known Leoni either in Madrid, where the sculptor resided on the Carrera de San Francisco, or in Toledo, where he came in 1578 to receive payments for his work on an elaborate reliquary urn for the cathedral. Leoni was later one of the arbiters in the contested payments for Greco's work at Illescas (see cat. 48) – though he was called in by the administrators of the hospital, not the artist. That he admired the Cretan's work is clear from an inventory of his collection drawn up after his death, where we find listed an unfinished painting of Christ by El Greco as well as 'a large, unfinished portrait of Pompeo in which is shown

a marble statue'. The author of the portrait is not given, but it could be the picture catalogued here.[1] Unfortunately, there is no documented likeness of Pompeo Leoni, so the identification must remain conjectural.

The most serious objection to the identification of the sitter as Pompeo Leoni has been raised by Proske, who has noted that the marble bust in the portrait, cut just below the shoulders, is significantly different from those attributable to Leoni. We do know of a portrait bust of Philip II of this type: it is described in a list of objects submitted for appraisal by Clemente Birago and Juan de Valenzuela, but the artist's name is not mentioned. Proske also notes that there were other Italian sculptors at Philip's court, though none of them acquired anything like Pompeo's reputation or standing, and most are merely names in documents. Quite clearly, the bust of Philip II is included to attest both to the occupation of the sitter and to his standing at court, and this really only makes sense if the sitter is Pompeo, whose services in 1579 were reserved for the king's vast project for the high altar of the Escorial. To carry out the seventeen life-size bronze statues Pompeo left for Italy in 1582 and only returned to Spain in 1589; this information coincides with the dating of the picture on grounds of style to 1576–8. KC

1. See Saltillo 1934 in Proske 1956, p.6. Proske suggests that a bust of the king would not be referred to as a statue, but this may be requiring more precision of an inventory than can be expected.

PROVENANCE

Galerie Espagnole, Louvre, Paris, 1838; Louis-Philippe's sale, Christie's, London, 1853 (lot 21); Stirling-Maxwell collection, Keir, Scotland, 1853–1957; Rosenberg & Stiebel, New York; private collection

ESSENTIAL BIBLIOGRAPHY

Camón Aznar 1950, pp. 1085–6; Proske 1956, p. 6; Wethey 1962, II, pp. 14, 94–5, no. 151; Madrid 1994, p. 47; Marías 1997, pp. 125, 303 n. 3; Falomir Faus in Madrid-Rome-Athens 1999–2000, p. 209

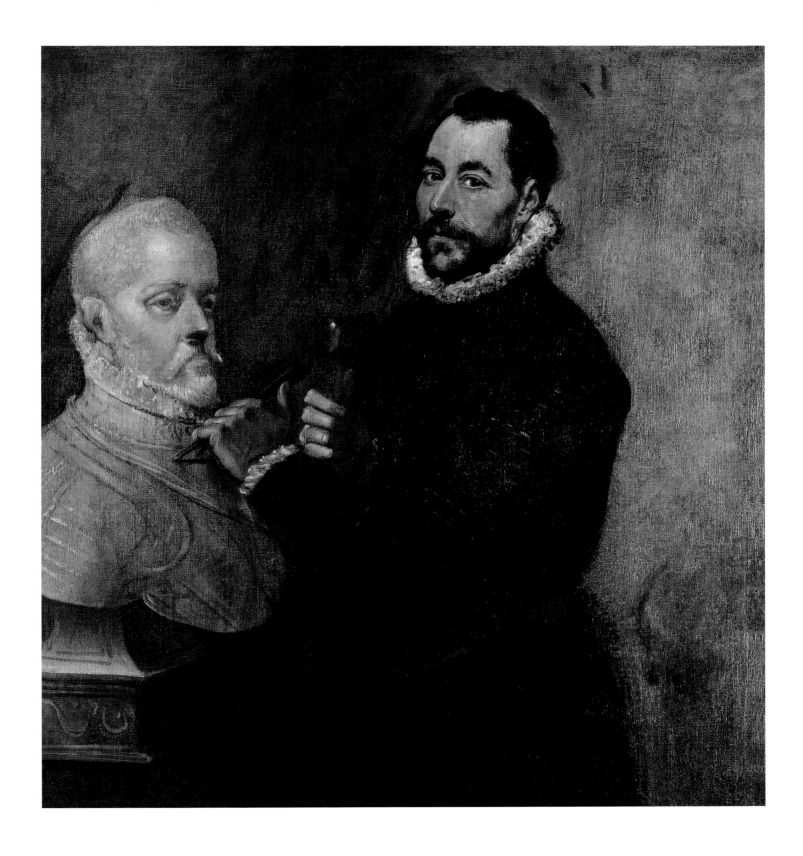

Oil on canvas, 62.5 × 58.9 cm (including additions)
Glasgow Museums, Art Gallery & Museums Kelvingrove
The Stirling-Maxwell Collection, Pollock House, inv. PC18

PROVENANCE

Serafín García de la Huerta, restorer
to the Spanish Royal collection and
the Museo del Prado, Madrid, 1830s,
by whom sold to Baron Taylor; Paris,
Galerie Espagnole, Louvre, 1838
(no. 259); sold with the Louis-Philippe
collection, Christie's, London, 1853
(lot 24); acquired by Sir William
Stirling-Maxwell; by descent until
given with much of the Stirling-
Maxwell collection to the city
authorities of Glasgow, 1967

ESSENTIAL BIBLIOGRAPHY

Cossío 1908, p. 395, no. 34; Edinburgh
1951, no. 14 (entry by E.K. Waterhouse);
Wethey 1962, I, p. 93, II, no. 148; Baticle
1984; Kusche 1989; Madrid 1998–9, no.
234 (entry by D. Davies); Madrid-Rome-
Athens 1999–2000, no. 27 (entry by
J. Álvarez Lopera)

This striking image of a dark-eyed, full-lipped, fur-clad woman with tightly curled black hair has intrigued historians for more than a century and a half. When it was exhibited in the Galerie Espagnole in the Louvre in 1838 it was called a 'portrait of the daughter of El Greco'; ever since it has been the subject of much discussion as regards both the identity of the sitter and indeed the identity of the painter.

Around her head the woman wears a transparent white veil with decorative edging, which comes down over her décolleté dress. Her right hand – somewhat ineptly drawn – emerges from a starched cuff and she fingers the soft and feathery texture of the lynx fur she wears over her shoulders, perhaps intending to draw it around her. She has precious rings on her fingers but the pendants on her necklace, visible through the veil, seem simple. The engaging gaze and the relative informality of the pose depart from Spanish court portraiture tradition, and it is not difficult to understand why earlier commentators perceived an intimate relationship between the sitter and the painter who portrayed her. El Greco did not have a daughter, but it has been suggested that the sitter may be Doña Jerónima de las Cuevas, El Greco's mistress and the mother of Jorge Manuel (see cat. 79). Waterhouse claimed to read the Greek letter 'Γ', Jerónima's initial, in the red stone on her ring,[1] but there is really no more there than a reflection. Cleaning in 1952 revealed the curious architectural moulding at top right.

Those who have accepted El Greco's authorship (including Tormo, Wethey, Harris, Davies and Álvarez Lopera) have argued for a date in the years immediately after the painter's arrival in Spain. The freedom of the brushstroke, particularly in the execution of the fur, indicates a familiarity with Venetian portraiture, and the smooth and dense modelling and luminosity of the face are reminiscent of the Roman portraits of Scipione Pulzone, with which El Greco would have been familiar. The uncertain grasp of the anatomy of hand and chin is comparable to other early works by El Greco, and the tall proportions of the portrait (when the narrow strips added at a later date to the left and right edges are discounted) combined with the high position of the head in the picture field correspond to the format of many of the artist's portraits (for example cat. 79). That said, several other attributions have been put forward. It has been proposed as a work of Tintoretto (de Beruete, Snr.), of an artist in the circle of the court portraitist Alonso Sánchez Coello (Lafuente Ferrari) and, most recently, of the Cremonese portrait painter Sofonisba Anguissola (Kusche, Bernis and Breuer). None of these is any more convincing, however, than the traditional attribution.

As for the identity of the sitter, evidence for Doña Jerónima's appearance is completely lacking, but there have been more reasoned proposals on the basis of comparison with other portraits. Several scholars (Tormo, Bernis) have identified the sitter as the Infanta Catalina Micaela, the daughter of Philip II (portraits in the Prado and El Escorial), but, although there are similarities, it is very difficult to see how Habsburg court etiquette would have permitted such a personage to be represented so informally. Furthermore, the Infanta was born in 1567, and this portrait of the late 1570s shows a mature woman. Other names put forward are Doña Luisa Isabel Enríquez de Cabrera, daughter of the Almirante de Castilla, and Doña Luisa's daughter, Doña Juana de Mendoza, the Duquesa de Béjar (Baticle). These identifications present problems of their own. GF

1. Edinburgh 1951.

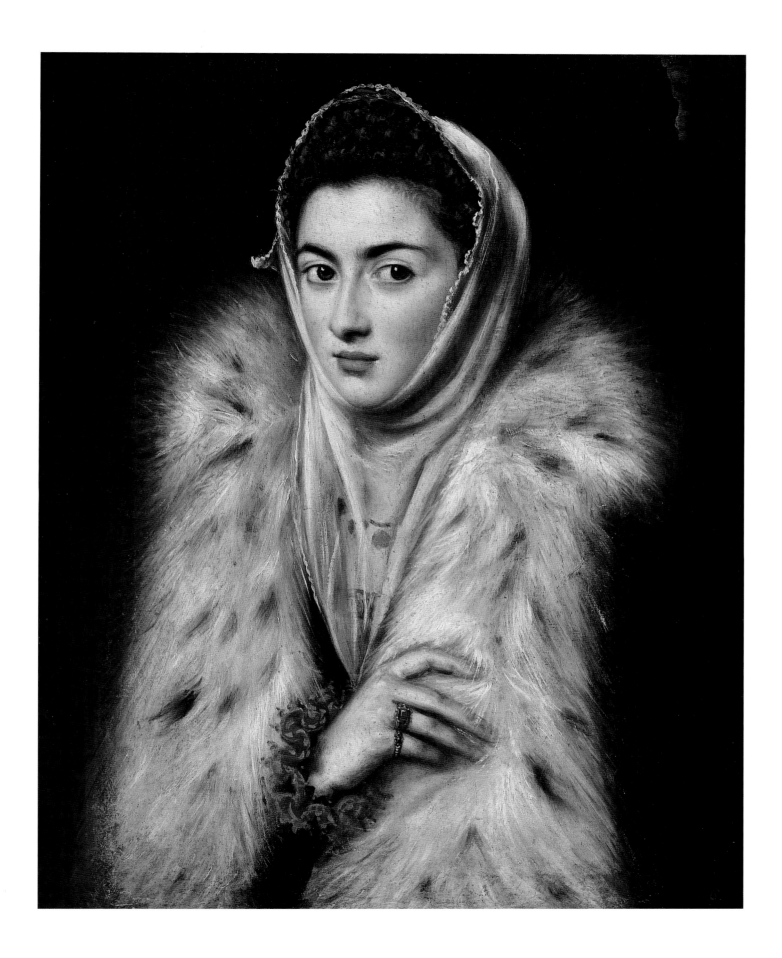

Portrait of a Man, about 1586–90

Oil on cardboard, 7.9 × 5.7 cm

Signed on the reverse: $\delta o\mu\acute{\eta}\nu\iota\kappa o\varsigma \ \theta\epsilon o\tau o\kappa\acute{o}[\pi o\upsilon\lambda o\varsigma] \ \acute{\epsilon}\pi o\acute{\iota}[\epsilon\iota]$
(Domenikos Theotokopoulos made)

The Hispanic Society of America, New York, inv. A311

NEW YORK ONLY

PROVENANCE

Said to have been owned by Martínez
Sobrano, Valladolid; apparently
purchased in Paris in 1911 by Archer
Milton Huntington, who presented
it to the Hispanic Society in 1922

ESSENTIAL BIBLIOGRAPHY

Du Gué Trapier 1929, p. 157; Mayer 1926,
no. 358; Du Gué Trapier 1929, p. 97;
Legendre and Hartmann 1937, p. 79;
Camón Aznar 1950, pp. 1173, 1396, no.
790; Wethey 1962, II, p. 209, no. X-205;
Cossío and Cossío de Jiménez 1972,
p. 396, no. 378; Stratton in New York
1988, p. 16; Ambler in Lenaghan 2000,
p. 246

Work by El Greco in small format, which includes miniatures, small-scale religious paintings and reduced versions of larger compositions, is well documented from the time of his residence in Italy onwards. Yet this highly interesting portrait miniature remains one of the few known in his œuvre. The picture seems to have been acquired by Archer Milton Huntington in Paris around 1911, along with a pendant miniature portrait of a woman. The male portrait bears a signature on the back, original to the work, while the female portrait is unsigned and shows little evidence of El Greco's hand. The two may not have been a pair originally, since all that is known of their provenance is that they were said to have come from a private collection in Valladolid. Both works were presented to the Hispanic Society in November 1922.

Scholarly assessment of the male portrait has been marked by confusion. For example, Mayer, who seems to have accepted the attribution to El Greco, thought the companion portrait of a woman bore the signature, while Wethey mis-copied the signature and rejected the attribution, perhaps assuming that the two works were in fact a pair. Legendre and Hartmann, Trapier, Cossío and Camón Aznar accepted the work, while Gudiol failed to mention it at all. Except for Trapier and Camón Aznar, none of these scholars discuss the work at any length.

In spite of the lack of attention afforded the Hispanic Society portrait, the sure touch, the palpable sense of space and tangible form, and the vivid presentation of the sitter indicate a work of a master artist, while the brushwork offers a perfect miniature version of that found in El Greco's larger works. All of this would argue for the acceptance of the portrait, even if it were not signed on the reverse. Trapier dated the miniature to El Greco's first decade in Spain, 1576–86, while other scholars have refined this to the years 1586–90. A date of around 1590 accords well with the costume and size of the sitter's ruff, which matches those found in *The Burial of the Count of Orgaz* (fig. 17, p. 54), painted in 1586, as well as in works from the 1590s. MB

Oil on canvas, 52.7 × 46.7 cm
The Metropolitan Museum of Art, New York
Joseph Pulitzer Bequest, 1924, inv. 24.197.1

PROVENANCE

First recorded in the collection of
the Marqués de Heredia; sold in 1892
to Areliano de Beruete y Moret,
Madrid, by Arteche; acquired by the
Metropolitan Museum in 1924

ESSENTIAL BIBLIOGRAPHY

Sanpere y Miquel 1900, p. 394; Camón
Aznar 1950, II, pp. 1108–9; Guinard 1956,
p. 30; Wethey 1962, II, pp. 96–7, no. 156;
Gudiol 1973, pp. 112, 344, no. 73; Marías
1997, pp. 224–5; Madrid-Rome-Athens
1999–2000, p. 409, no. 57 (entry by
M. Borobia); Vienna 2001, p. 186, no. 30
(entry by D. Carr)

When in the collection of Don Aureliano de Beruete in Madrid, this fine but somewhat worn picture was identified as a self-portrait. As such it became one of El Greco's most famous portraits. It appeared as the frontispiece to the catalogue of the landmark El Greco exhibition held at the Prado in 1902, and served as the model for Mariano Benlliure's 1934 monument to the artist in Crete; it has been reproduced on a postage stamp and, according to Lafond (writing in 1905), as a matchbox cover. Yet, as Lafond noted, the identification 'is only a plausible hypothesis, nothing more' – and based merely on the resemblance of the sitter to other figures in El Greco's paintings that have also been thought to record the artist's features (see overleaf).[1]

There are no certified portraits of the artist, although we know that he made a self-portrait in Rome and another appears in the 1621 inventory of Jorge Manuel's possessions: '189. a portrait of my father, in a carved frame'. This may be the picture later in the collection of Agustín de Hierro, a member of the Royal Council of Castile under Philip IV, and there described as a half-length self-portrait.[2]

Wethey attempted to clear the ground by noting that the most likely candidate for a portrait of El Greco was the figure of an old, balding man in Jorge Manuel's *Martyrdom of Saint Maurice* (Boulos Restelhueber, Paris), painted after February 1619 for the family burial chapel in San Torcuato, Toledo.[3] As he noted, a figure with similar features appears as one of the Apostles in *The Pentecost* (fig. 50; p. 174, for the complex to which this work belonged, see cat. 40–2); another similar head appears in the companion *Marriage of the Virgin* (cat. 59). It has also been suggested that the shepherd kneeling in the foreground of *The Adoration of the Shepherds* (cat. 62), which he painted to hang above his own tomb may be a self-portrait (see overleaf). To this writer's mind, the matter remains highly speculative. The picture is generally dated to about 1595–1600 (a date supported by the width of the ruff the sitter wears),[4] when El Greco was in his mid to late fifties.

Among the reasons that the Metropolitan painting gained such widespread credibility as a self-portrait is the soulful gaze of the figure, 'the impression of sincerity, of personal confession, of powerful emotion that emanates from the figure'.[5] Here, it seemed, must be the artist – 'his eyes aglow with an inner flame'[6] – whose works convey such a strong quality of spirituality. Viewer projection has played a large rôle in the interpretation of El Greco's art, and perhaps nowhere more than in this case.

Regardless of the identification of the sitter, this is a fine and particularly compelling portrait by the artist, with the features painted with great sensitivity. The canvas has been trimmed on all sides. The signature on the painting at the time it was first published proved to be false and was removed in 1947; an added strip of canvas at the bottom was folded under in 1974. KC

1. For illustrations see also Goldscheider 1938, p. 21.
2. For Jorge Manuel's inventory see San Román y Fernández 1927 (p. 303); for Agustín de Hierro's, see Marías 1993 (pp. 62, 70). In de Hierro's 1660 inventory (expertised by Antonio de Perreda) the painting is described as: '*Un retrato del Griego de si mismo y de su mano (retrato de medio cuerpo del Griego original de sí mismo) 300 reales*'.
3. Wethey 1962, I, pp. 19, 86–7 n. 84, II, pp. 251–2, no. X-422. His idea was followed by Gudiol 1971, p. 331. Next to the supposed portrait of El Greco is a younger figure who might be thought to be Jorge Manuel – a coupling we might expect from a picture destined for the family funerary chapel. Wethey went on to suggest other works in which he thought El Greco introduced his features. In so doing, he created a group no more coherent than the one he had discarded.
4. In a note in the Metropolitan's files, Ruth Anderson, Curator of Costume at the Hispanic Society, noted that the ruff worn by the sitter conforms to laws of 1586 and 1593 disallowing the use of starch and limiting the width to one twelfth of a *vara* (about 7 cm). In 160c Philip III relaxed the rules and permitted ruffs dressed with starch and measuring one eighth of a *vara* (about 10 cm).
5. Camón Aznar 1950, II, p. 1108: his phrase is '*lacerante emotividad*'. Camón Aznar rejected the idea that this was a self-portrait, but not that it showed an intimate of the artist – perhaps El Greco's older brother Manoussos Theotocopuli, who arrived in Toledo in 1590–1. On Manoussos see Panayotakis in Hadjinicolaou 1999, pp. 17–21.
6. Guinard 1956, p. 30.

Figs. 59–62 Possible El Greco self-portraits, from left to right, details from fig. 17, fig. 50, cat. 59 and cat. 62

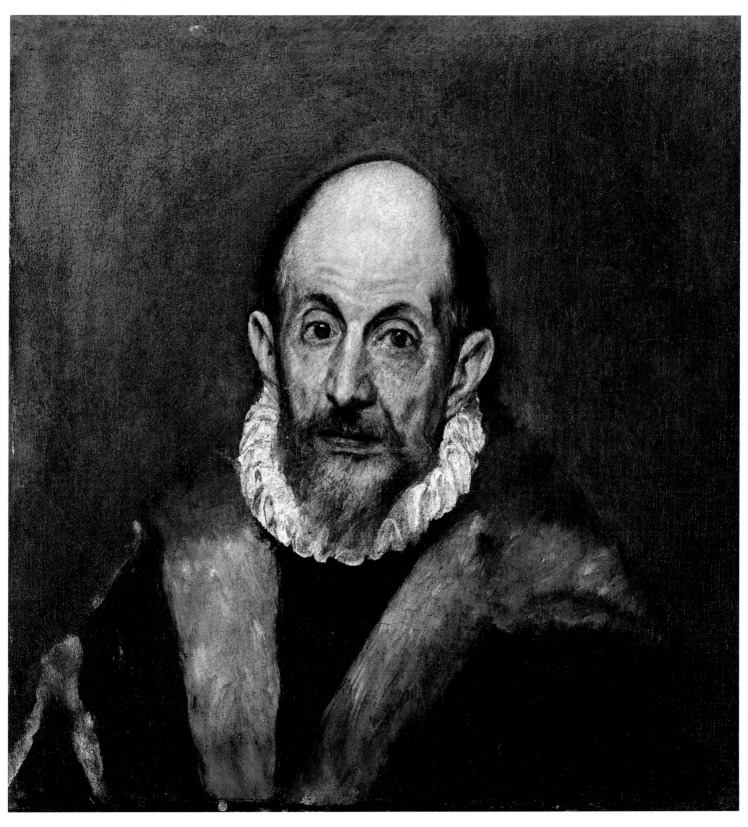

75

Oil on canvas, 44 × 42 cm

Signed: δομήνικος θεοτοκόπουλος ἐποίει
(Domenikos Theotokopoulos made)

Museo Nacional del Prado, Madrid, inv. 806

The apparent absence of any artifice or rhetoric makes this one of El Greco's most engaging portraits. The sitter is presented simply, against a grey background, close to the picture plane and looking directly at the spectator. The bust is terminated immediately beneath the shoulder and there is no detail or modelling in the costume, with the exception of the stiff white ruff. In spite of its unusual square format, there is no reason to think that this portrait has been reduced in height. When it was first listed in the Alcázar in Madrid, in 1666, it was already described as '*media vara en cuadro*' (half a *vara* square), that is about 41.7 × 41.7 cm. It was displayed there in a white frame.

El Greco deployed a variety of pictorial strategies to achieve the particular effect of personal engagement that we witness in this portrait. The two sides of the face convey slightly different expressions: the right side (to the viewer), with its big clear eye, large liquid highlight and faintly upturned lip, suggests a quizzical smile; the left side is more severe, and the combination of the two imparts a lively and interesting character to the face. The shoulders are apparently positioned diagonally to the picture plane but the head is turning towards the viewer,

subliminally suggesting the sitter's interest in us. The rightward movement of the head, gently tilted, and the leftward sweep of his hair and beard suggest poise and equilibrium. By lightening the area immediately around the head, the painter invests the sitter literally with an aura. The combination of these various devices and the large scale of the informal letters of the signature make it likely that the sitter was a personal friend of the artist.[1]

The colour is handled with great subtlety. Carmine pinks merge with blue-grey to define the attenuated, noble features of the face. For Cossío, who in 1908 wrote the first significant study of the work of El Greco, this portrait, like the *Nobleman with his Hand on his Chest* (fig. 58, p. 257), captured the essence of the Castilian *hidalgo*, as characterised in the Spanish literature of the period.

The dates proposed for the portrait range between 1584 and 1600, illustrating how much more difficult it is to date El Greco's portraits than his subject pictures. GF

1. Gómez Menor (1966, pp. 77–9) offered the completely gratuitous opinion that the sitter was Don Gaspar de la Fuente, the son of Dr Rodrigo de la Fuente, the presumed sitter of another of El Greco's portraits in the Prado (inv. 807).

PROVENANCE

Recorded in the Alcázar in Madrid in 1666; Spanish royal collections; entered the Prado before 1834

ESSENTIAL BIBLIOGRAPHY

Cossío 1908, no. 74; Wethey 1962, II, no. 139; Gómez Menor 1966; Pita Andrade 1981, no. 78; Madrid-Washington-Toledo (Ohio)-Dallas 1982–3, no. 59 (entry by W.B. Jordan); Madrid-Rome-Athens 1999–2000, no. 56 (entry by M. Borobia); Álvarez Lopera 2003, forthcoming

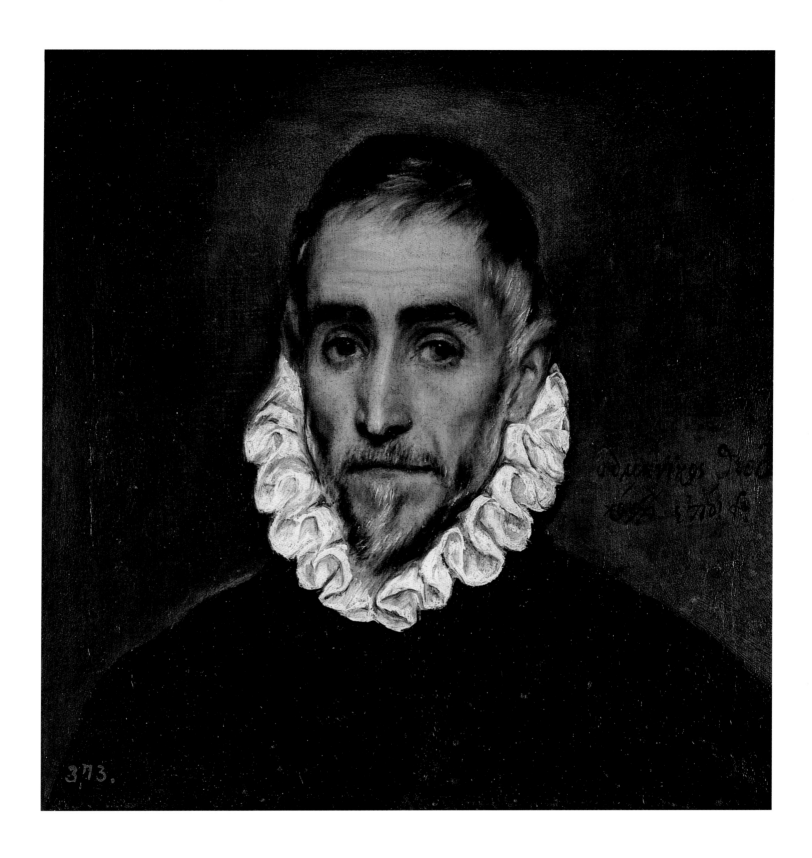

77 Antonio de Covarrubias, about 1600

Oil on canvas, 67.5 × 57.5 cm

Signed above the sitter's left shoulder

δομήνικος θεοτοκόπουλος ἐποίει

(Domenikos Theotokopoulos made)

Musée du Louvre, Paris, inv. RF 1941-32

PROVENANCE

Archiepiscopal Palace, Toledo; Museo Provincial, Toledo; Museo de El Greco, Toledo, until 1941, when given to the Louvre, in an exchange, by the Spanish government

ESSENTIAL BIBLIOGRAPHY

Madrid-Washington-Toledo (Ohio)-Dallas 1982–3, no. 61 (entry by W.B. Jordan); Marías 1997, pp. 167–8; Madrid-Rome-Athens 1999–2000, p. 418, no. 68 (on the copy in the Museo de El Greco, Toledo); Gerard Powell and Ressort 2002, pp. 127–30

In this austere yet sensitive representation of one of the key intellectual figures of Toledo in the late sixteenth century, once again El Greco demonstrates his skills as a portraitist. The sitter's black costume contrasts with his soft white beard and the light flesh tones of his face. He seems lost in thought, his watery eyes looking into the void. Antonio de Covarrubias y Leiva (1524–1602), the sitter, was a close friend of El Greco's and reputedly one of the most learned men of his time. The portrait was probably painted around 1600, when Covarrubias had become completely deaf.

A son of the Toledan architect Alonso de Covarrubias, the master of works at Toledo Cathedral, who also designed the façade of the Alcázar, or royal palace, in the city, Antonio studied law at the University of Salamanca and served as a royal magistrate in Granada and Valladolid. In 1563 he attended the final session of the Council of Trent in the company of his brother Diego, a distinguished canonist and adviser to Philip II (see cat. 78). A noted jurist, antiquarian, philosopher, poet, humanist and Hellenist, Antonio was appointed a member of the Royal Council of Castile in 1573. Such were his intellectual qualities that in 1580 Philip II called upon him to articulate the Spanish monarch's right to the crown of Portugal. In 1581, however, increasing deafness compelled him to resign and return to Toledo, where he became *maestrescuela* (rector) to the cathedral, an office that gave him control of the university and which he held until the end of his life. Following his wife's death, he was ordained in 1581 and made a canon of Toledo Cathedral.

It was probably at about this time that El Greco met Covarrubias. His admiration for him is reflected in one of his annotations in his copy of Daniele Barbaro's edition of Vitruvius: 'That Antonio de Covarrubias (I would say that he is a miracle of nature) in whom live not only eloquence and Ciceronian elegance and a perfect knowledge of the Greek language, but also an infinite kindness and patience, which is so splendid that it disturbs the gaze and prevents me from going forward.'[1] No doubt the two men felt at ease with each other, possibly speaking together in Greek. That they discussed Greek literature is demonstrated by the fact that Covarrubias gave El Greco a Greek edition of Xenophon, recorded in the artist's library at his death. As a tribute to his friend, El Greco included Covarrubias in his *Burial of the Count of Orgaz* (fig. 17, p. 54), where he is seen in profile towards the right.

In the intellectual life of Toledo, Covarrubias provided a link between the university and the city's other great centre of learning, the cathedral chapter. He may have helped El Greco to meet other scholars who were then in Toledo, such as Rodrigo de La Fuente (died 1589), a professor of medicine whom El Greco lauded in his annotations on Vitruvius. A possible portrait of him by El Greco is in the Prado, Madrid.

Here El Greco combines thick impastos with light touches of the brush skimmed over a pale brown ground, following the technique described by the Sevillian painter–theorist Francisco Pacheco, who visited El Greco's studio in 1611. As Pacheco records, El Greco would repeatedly leave and then return to his canvases, retouching the dry paint in order to ensure that his colours remained distinct and unblended.[2] Here, strokes of black and white over Covarrubias's gown re-create reflections of light, while the eyes, lips and beard are painted with a meticulous application of the brush.

Soon afterwards El Greco produced a copy of the Louvre portrait, which he paired with a posthumous portrait of Antonio's brother Diego de Covarrubias (cat. 78). Now in the Museo de El Greco, Toledo, these two portraits feature in the 1629 inventory of Pedro Salazar de Mendoza (for whom see further cat. 60), a friend of both Covarrubias brothers; he may have commissioned them as a homage to the two great Toledan intellectuals. XB

1. Marías and Bustamente 1981, p. 168.
2. Pacheco 1649 (1990), II, p. 79.

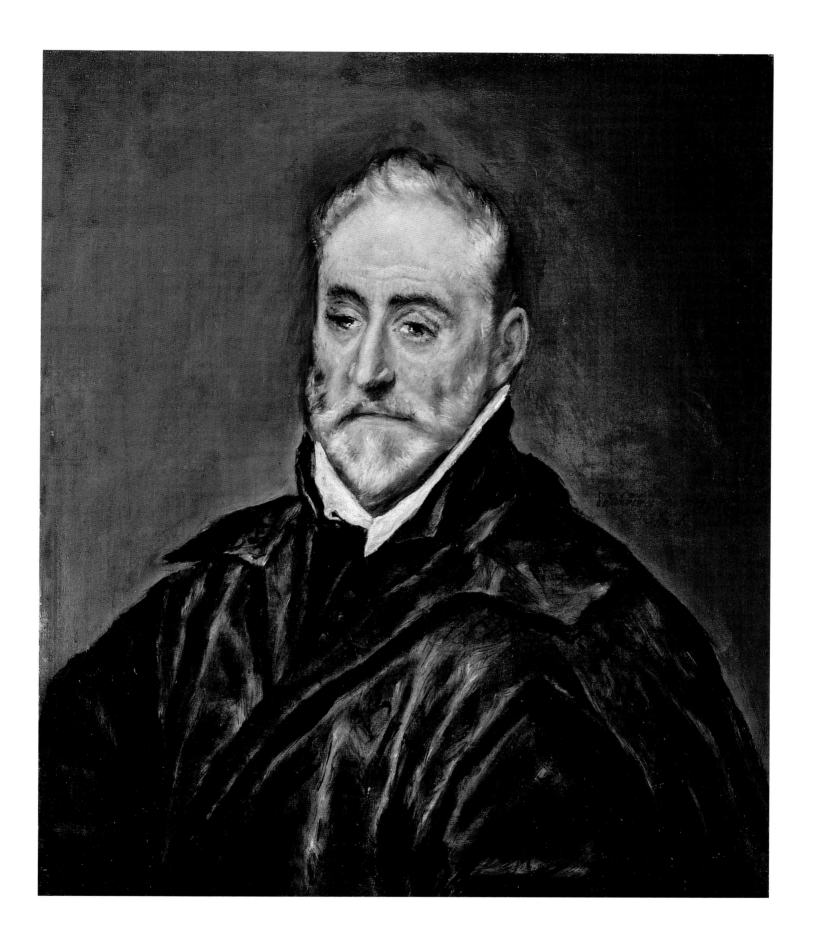

78 Diego de Covarrubias, about 1600

Oil on canvas, 67 × 55 cm

Signed above the shoulder on the right (fragmentary)

Museo de El Greco, Toledo, inv. 14

The elder brother of Antonio de Covarrubias (cat. 77), Diego de Covarrubias y Leiva (1512–1577), whom El Greco almost certainly never met, was a distinguished churchman, canon lawyer and administrator. Professor of Canon Law in the University of Salamanca, in 1560 he was charged by Philip II with the reorganisation of the university's curriculum. Consecrated bishop of Ciudad Rodrigo in 1559, he was appointed, together with his brother Antonio, to the Spanish delegation that attended the last session of the Council of Trent in 1563. He collaborated with Ugo Buoncampagni, the future Gregory XIII, in drafting some of the final decrees of the Council, and shortly after his return to Spain, in 1565, he was made bishop of Segovia. In 1572 he was appointed President of the Council of Castile, the most important administrative office in the kingdom. He died in Madrid in 1577. A complete edition of his writings was published in Antwerp in 1638.[1]

Despite its lively character, El Greco did not paint the portrait from life but based it on one by, or after, Alonso Sánchez Coello (fig. 63) showing

PROVENANCE

Almost certainly one of a pair of paintings listed in the inventory of the collection of Pedro Salazar de Mendoza, Toledo, 1629; Biblioteca Provincial, Toledo, until 1910, after which the picture entered the newly constituted Museo de El Greco

ESSENTIAL BIBLIOGRAPHY

Cossío 1908, pp. 444–5, no. 190; Beruete and Cedillo 1912, no. 3; Wethey 1962, II, no. 137; Gómez-Moreno 1968, no. 18; Madrid-Washington-Toledo (Ohio)-Dallas 1982–3, no. 62 (entry by W.B. Jordan); Iraklion 1990, no. 26 (entry by J. Álvarez Lopera); Granada-Seville 2001, pp. 139–41 (entry by J. Álvarez Lopera)

Fig. 63 Alonso Sánchez Coello (about 1531–1588) and Studio
Diego de Covarrubias, 1574
Oil on canvas, 61 × 50 cm
Museo de El Greco, Toledo

Covarrubias when sixty-two years old (it is inscribed ETATIS SVE 62), which would date it to 1574. El Greco followed quite closely both the format and the sitter's dress of black biretta, white surplice with embroidered edges, and gold cross mounted with six green stones on a white ribbon. But the dry execution of the prototype, though it was no doubt a very good likeness, could hardly be more different from El Greco's quivering rendition of a physical and psychological presence. El Greco used the portrait as though it were the sitter himself. He reproduces the physiognomy – the high forehead, the long eyebrows and hooded eyes and the slightly bulbous nose with a mole on it – thereby capturing the likeness, but in addition he invests the sitter with a sense of lively and engaging intelligence. Jordan has rightly pointed out that, despite its being posthumous, this portrait holds its own alongside El Greco's most insightful representations of living sitters.

The painting has a pendant, also in the Museo de El Greco, showing Diego's younger brother Antonio – an autograph copy of El Greco's portrait now in the Louvre (cat. 77), probably made from the life in about 1600. The two pictures were possibly made for Pedro Salazar de Mendoza (see cat. 77 and further cat. 60). An inventory of his estate lists a series of portraits of notable Toledan churchmen and scholars (some of whose biographies he had written), including '*dos retratos de los Covarrubias*', which are likely to be El Greco's pair.[2] GF

1. On the Covarrubias see Fernández Montaña 1935.
2. Kagan in Brown and Pita Andrade 1984, pp. 85–92; Andrés 1988.

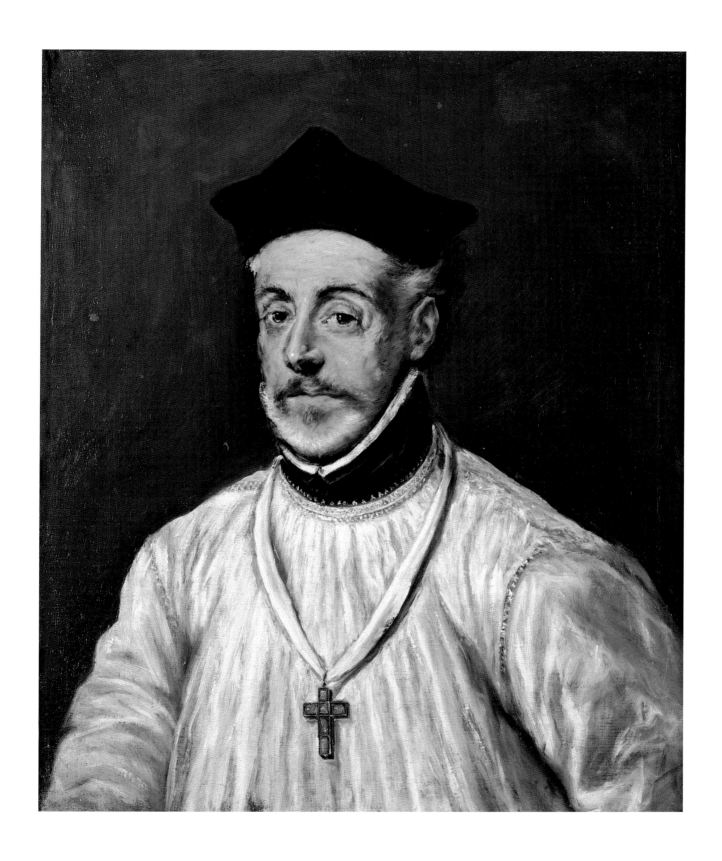

Oil on canvas, 74 × 51.5 cm

Signed above the left shoulder of the sitter
δομήνικος θεοτοκόπουλος ἐποίει
(Domenikos Theotokopoulos made)

Museo de Bellas Artes, Seville

PROVENANCE

In the collection of Serafin García de la Huerta, Madrid; in the Galerie Espagnole, Louvre, Paris, 1838 (no. 260); sold with other works from the Louis-Philippe collection at Christie's, London, 1853 (lot 24); collection of the Duque de Montpensier, Seville; given to the Museo de Sevilla by the Duquesa de Montpensier in 1897

ESSENTIAL BIBLIOGRAPHY

Wethey 1962, I, pp. 119–22, II, p. 97, no. 158; Marías 1997, p. 251; Álvarez Lopera 1999, pp. 405–6, no. 67

Long thought to be a self-portrait by El Greco, this painting is now generally agreed to represent the painter's son, Jorge Manuel Theotokopoulos (1578–1631), who worked alongside him in his thriving studio. Named after El Greco's father and elder brother, Jorge Manuel was born in 1578 in Toledo, where El Greco had met his mother, Jerónima de las Cuevas, on his arrival in the city the previous year. Such was El Greco's affection for his son that he included his portrait in his *Burial of the Count of Orgaz* (fig. 17, p. 54), executed in 1586 for the church of San Tomé, where he and his family were parishioners. The eight-year-old child is shown staring at the spectator and pointing at the scene unfolding before the viewer. El Greco signed the painting on a handkerchief in the boy's pocket with the date 1578, the year of Jorge Manuel's birth, an unusual but eloquent expression of paternal love.

El Greco trained Jorge Manuel as a painter, sculptor and architect with the idea that he would assist him in the running of his studio. We first hear of him in

this context in a contract dated 1597 for an altarpiece for the monastery of Guadalupe, which he and Francisco Prevoste, El Greco's other assistant, who had come with him to Spain from Rome, were required to complete in the event of El Greco's death. From 1603 onwards Jorge Manuel's name appears regularly in documents concerning the studio, suggesting that he had become his father's chief assistant. He was delegated to carry out inspections and to review proposals for the refurbishment and modernisation of parish church interiors.

One of the most important such projects in which Jorge Manuel was involved was the controversial commission for the chapel decoration in the Hospital de la Caridad at Illescas, for which the contract, signed on 18 June 1603, includes his name. The paintings, once completed, became the objects of a lengthy dispute, after complaints by the hospital's representatives about their iconography, particularly in relation to the painting of *The Madonna of Charity* (fig. 64). The hospital objected to El Greco's insertion of numerous portraits of recognisable individuals 'wearing ruffs', among them, on the right, a portrait of Jorge Manuel. It is probable that he painted his son's independent portrait about this time. It reflects his view that artists, architects and sculptors were the equal of poets, philosophers and rhetoricians, rather than mere craftsmen. The fashionable ruff in this portrait, in a style known as *lechuguillas de a ochava [octava de vara] y con almidón* introduced to Spain in 1600 by Philip III, emphasises the sitter's refinement, while the brushes that he holds are the tools that he uses to communicate higher ideals.[1]

Jorge Manuel was not to become as great an artist as his father, although he painted his own compositions and received a solo commission in 1607 for a scheme of decoration in the parish church of Titulcia. Many of his works were based on his father's pictures, and it was mainly these that enabled him to keep the studio going after El Greco's death. In 1618, he was responsible for re-designing the upper stories of Toledo's city hall, designed by Juan de Herrera in the 1570s. His death in 1631 brought El Greco's artistic legacy to an abrupt end. XB

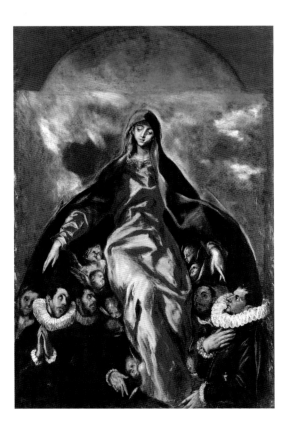

Fig. 64 El Greco
The Madonna of Charity, 1603–5
Oil on canvas, 184 × 124 cm
Church of the Hospital de la Caridad, Illescas

1. Madrid 1999, p. 405–6, pl. 67.

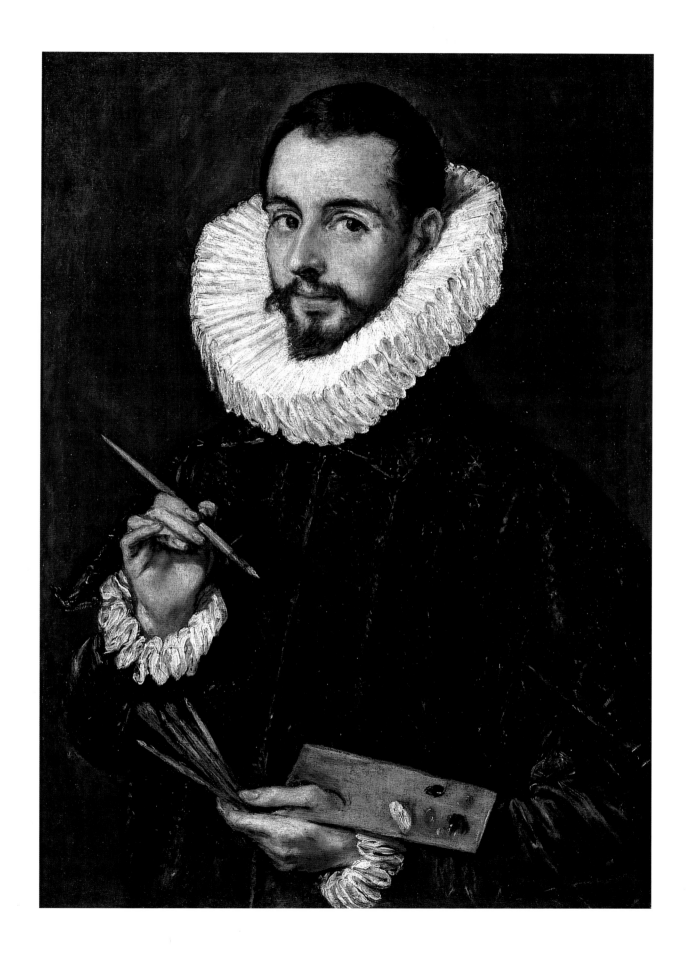

A Cardinal (probably Cardinal Niño de Guevara), 1600–1

Oil on canvas, 170.8 × 108 cm

Signed on the creased paper on the floor

δομήνικος θεοτοκόπουλος ἐποίει

(Domenikos Theotokopoulos made)

The Metropolitan Museum of Art, New York
H.O. Havemeyer Collection
Bequest of Mrs H.O. Havemeyer, 1929, inv. 29.100.5

PROVENANCE

Possibly Pedro Laso de la Vega, Conde de los Arcos, Madrid (died 1637; inventory 1632; his grandson, Pedro Laso de la Vega, Conde de Añover (died 1674); by descent to Don Carlos de Guzmán y La Cerda, Conde de Oñate (died 1880) and his wife Doña María Josefa de la Cerda, Madrid (died 1884); presumably the picture listed in the division of her estate; her son Don José Reniero, Marqués de Guevara, Oñate Palace, Madrid (died 1891; inventory 1892, no. 747); by descent to Maria Pilar, Condesa de Paredes de Nava, Oñate Palace, Madrid (died 1901); Condes de Paredes de Nava (1902–4); Durand-Ruel, Paris, 1904; Mr and Mrs H.O. Havemeyer, New York, 1904–29; Metropolitan Museum of Art

ESSENTIAL BIBLIOGRAPHY

Cossío 1908, pp. 423–4; Wethey 1962, II, p. 95, no. 152; Brown in Brown and Carr 1982; Brown in Madrid-Washington-Toledo (Ohio)-Dallas 1982–3, pp. 68–9; Caviró 1985, pp. 222–4; Caviró 1990, pp. 305–6; Kagan in Hadjinicolaou 1995, pp. 330, 335; Scholz-Hansel in Hadjinicolaou 1995, pp. 295–307; Marías 1997, p. 262; Madrid 1998–9, p. 469, no. 138; Carr in Vienna 2001, p. 92

This celebrated picture – a landmark in the history of European portraiture – has become synonymous not only with El Greco but with Spain and the Spanish Inquisition. His finely wrought features framed by a manicured, greying beard and crimson biretta, the sitter is perched like some magnificent bird of prey in a gold-fringed chair, his dazzling watered-silk robes, *mozzetta* and lace-trimmed *rochet* flaring out like exotic plumage. The round-rimmed glasses confer on his gaze a frightening, hawkish intensity as he examines the viewer with an air of implacable, even cruel detachment, his right hand impatiently – almost convulsively – grasping the armrest. Although a description such as this may seem too subjective, even arbitrary, to merit serious consideration, ever since the portrait was first exhibited in 1902 and identified as Cardinal Don Fernando Niño de Guevara (1541–1609), Inquisitor General and Archbishop of Seville, it has been impossible to separate our responses from the dreaded institution this figure headed with notable inflexibility between 1599 and 1602.[1] Schiller's drama and Verdi's sublime opera

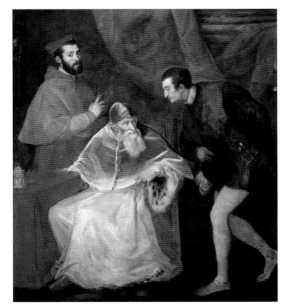

Fig. 65 Titian (about 1487–1576)
Pope Paul III with his Grandsons Alessandro and Ottavio Farnese, 1545–6
Oil on canvas, 210 × 174 cm
Museo Nazionale di Capodimonte, Naples, inv. Q 129

about Don Carlos doubtless frame our responses even more than history. (In a stroke of brilliant poetic licence, Verdi made his 'Grand Inquisiteur' blind and not merely near-sighted.)[2]

Easy though it is to dismiss this sort of response, it is not without some basis, for the modernity of El Greco's extraordinary picture resides precisely in the way he has re-defined portraiture as characterisation rather than mere description. We may appreciate the degree to which El Greco manipulated visual fact for expressive effect simply by noting the distorted perspective of the marble-inlaid floor, which introduces a feeling of uneasiness, and the rigid, bilateral division of the background between a rich brocade hanging and the rectangular panels of a wooden door, tightly shut; or the effect of the creased paper bearing El Greco's signature that the cardinal has apparently dropped, or discarded. The American artist Mary Cassatt commented on precisely this detail when she first reported on the 'magnificent portrait by El Greco' to its future owners, the Havemeyers, in 1901: 'I believe [the sitter] had something to do with the Inquisition, and he has let fall a letter he has just been reading.'[3]

Identity is clearly crucial to understanding the work and the proposal made by Brown and Carr (1982) that the sitter is not Niño de Guevara but Bernardo de Sandoval y Rojas, Cardinal Archbishop of Toledo (1546–1618), a dedicated Church reformer, patron of the arts, and Niño de Guevara's successor as Inquisitor General (1608), thus assumes more than passing interest. Ultimately, the identification is based on the (undeniable) resemblance of the sitter to two documented portraits of Sandoval, one, by Luis Tristán, in the chapter house of Toledo Cathedral (dated 1619) and the other an engraving bearing the date 1599.[4] However, in neither does Sandoval wear glasses, which seems curious for someone who chose to be portrayed wearing them in a formal portrait; in El Greco's picture they are fashionably attached by strings around the ears.[5] Also, Sandoval preferred to trim his beard straight across rather than taper it meticulously to a point, as in El Greco's portrait. The question of resemblances is further complicated by the fact that at some time in its history the Metropolitan portrait was seriously

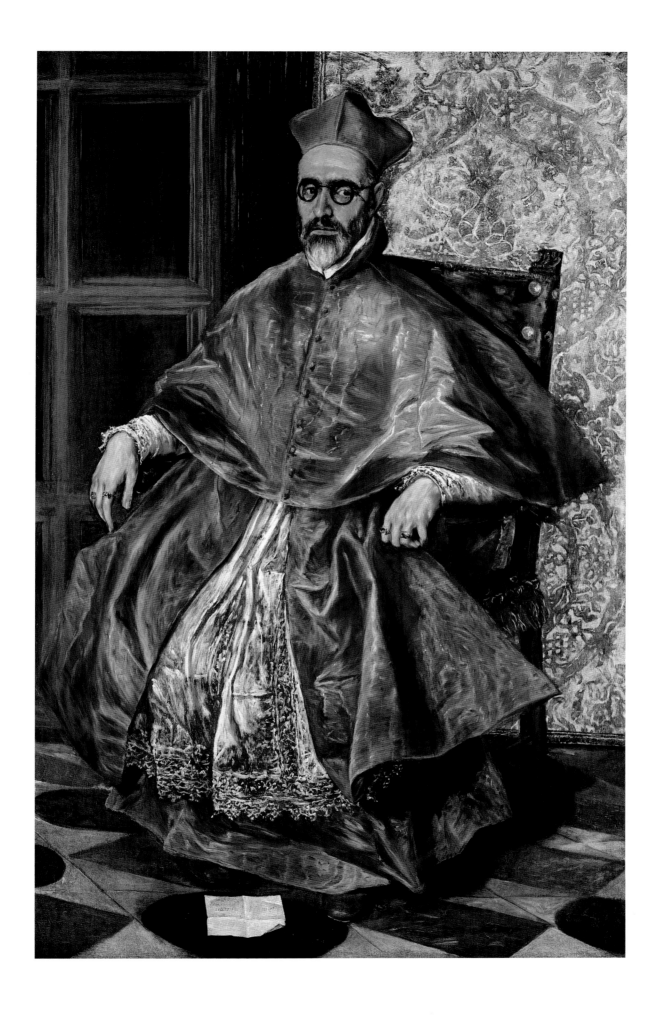

vandalised: the current shape of the bridge of the nose is a reconstruction, based in part on a copy of the painting in the Museo de El Greco, Toledo.[6] That painting, in turn, has been very tentatively identified with a portrait of Niño de Guevara attributed to Luis Tristán that is said to have hung in Guevara's funerary chapel in San Pablo, Toledo.[7]

When Brown and Carr first advanced their re-identification, the earlier provenance of the picture was not known, and since by the nineteenth century both the Sandoval and Guevara lines of descent had converged in the Oñate family, the picture could, in principle, have been inherited from either family.[8] However, another avenue of investigation has traced the picture through the Condes de Añover de Tormes back to Don Pedro Laso de la Vega, the first Conde de los Arcos (died 1637). The Conde de los Arcos was a known patron and collector of El Greco, and a cultural figure of considerable importance in Toledo. At the peak of his career in Madrid he held the post of majordomo to Philip IV.[9] He belonged to El Greco's inner circle of intellectual friends and in 1596 stood surety for the artist for the commission to provide an altarpiece for the Colegio de Doña María de Aragón in Madrid (see cat. 40–2). An inventory of his collection drawn up in 1632 or 1639 (by the Caravaggesque painter Juan Bautista Maino) lists no fewer than seven paintings by El Greco, including a *Laocoön* (see cat. 69), 'Virgin nursing' (*The Holy Family*; cat. 29), and *A View of Toledo* (cat. 66). In his Madrid residence Don Pedro also had a portrait of '*Fernando Niño, Arzobispo de Sevilla, inquisidor general, sentado en silla*'. Niño de Guevara was his maternal uncle and he could have inherited the painting from his mother.[10] In the inventory no attribution is given. This is troublesome, but the inventory lists the names of hardly any artists and the picture carries a very high valuation (100 ducats). According to Caviró (1985 and 1990), the picture was sold in 1632 for 880 *reales*, but what is presumably the same picture reappears in a 1712 inventory of the Arcos fortress at Batres. This is significant, for it was the collection at Batres that Don Pedro entailed, and there is thus a presumption that, like the *View of Toledo*, this portrait remained with the family and is the one listed in an 1894 inventory of the Condesa de Oñate (again, without attribution). The Oñate picture was shown to the Havemeyers in 1901 and acquired by them in 1904.

A member of a noble Toledan family, Niño de Guevara rose to prominence under Philip II. He was a member of the Council of Castile and President of the Cancilleria de Granada before being made cardinal in 1596 at the instance of Philip II. Philip III made him a member of the Royal Council and Inquisitor General. As such he had charge of the Consejo de la Inquisición (the Inquisition) and its tribunals, though he was forced to resign the post in 1602. In 1601 he was made archbishop of Seville. Despite his reputation today for rigidity, he lent his support to the Dominican theologian Agustín Salucio, who had written against the laws governing racial and religious purity (*limpieza de sangre*).[11] As Inquisitor General Guevara was in Toledo in February and March 1600, and visited the city again in 1601 and 1604. If, as seems increasingly likely, the portrait shows Niño de Guevara, it would probably have been painted in 1600 or 1601.

It has frequently been noted that the most important models for El Greco's conception were the two splendid portraits by Titian of Pope Paul III Farnese (Museo di Capodimonte, Naples). The unfinished full-length portrait in particular (fig. 65, p. 282) appears to have been crucial to El Greco's understanding of portraiture as characterisation. Like El Greco, Titian shows the old, stooped pope grasping the armrest of his chair with his left hand, and he gives the pontiff a wily expression quite at odds with the conventions of state portraiture. Just as remarkable as the conception of the portrait is El Greco's rapid, abbreviated technique, with highlights obtained by painting wet into wet. In the case of the white *rochet* the brown primer is left exposed as shadow. It has sometimes been suggested that Velázquez, who deeply admired El Greco's portraits, consciously referred to this masterpiece in his *Innocent X* (Galleria Doria Pamphilj, Rome), but, if the painting was at Batres, this is unlikely. What is certain is that no one else before Velázquez achieved such opulent effects so economically. KC

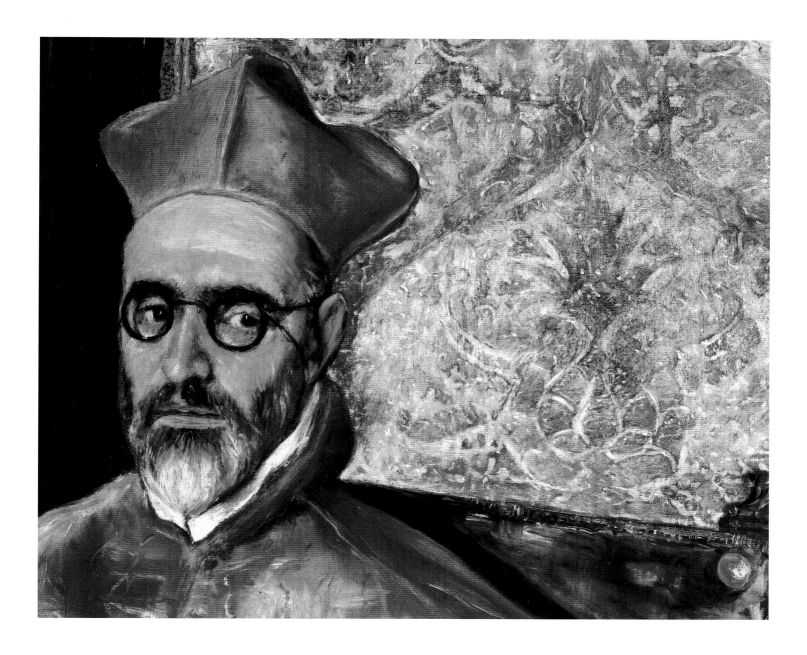

1. Although most scholars have cast their descriptions in advisedly general terms, lauding above all the use of colour, ever so often – usually in 'popularising' writing – a hint of the sort of response suggested here emerges. For example, Villar (1928, p. 148) writes of the sitter's '*afectada majestad*' and the '*expresión de un inexorable legalismo y una inquisitorial intransigencia, consideradas como un deber dentro del alto concepto de la dignidad propria*'. Leo Bronstein (1950, p. 84) set out to rectify what seems to have become a popular interpretation of the picture by asserting, 'If this man was lacking charity, El Greco gave it to him. The magnificent portrait . . . is not an image of pomp and rigid authority, but one of insecurity.' Among noted El Greco specialists, Camón Aznar (1950, II, p. 1159) gives perhaps the most extensive and penetrating analysis.

2. Verdi's historical inquisitor would have been Fernando de Valdés, Inquisitor General from 1547 to 1568. Verdi had visited Spain in 1863 to stage a production of *La Forza del Destino*. The Escorial impressed him as 'severe, terrible, like the ferocious ruler who built it'; see Phillips-Matz 1993, p. 459.

3. See Havemeyer 1961 (1993), p. 152. Mary Cassatt acted as an adviser as well as travelling companion to the Havemeyers, who had been deeply impressed by *The Burial of the Count of Orgaz*. The portrait was first brought to their attention by Cossío, who was gathering material for his groundbreaking monograph on El Greco.

4. An engraving asserting that it is a likeness of Niño de Guevara dating from the late seventeenth century is of questionable usefulness, as it may be an invented likeness.

5. On the glasses in El Greco's painting and the fashion for them in Spain, see Scholz-Hansel in Hadjinicolaou 1995, pp. 295–307.

6. See Pérez Sánchez and Navarrete Prieto 2001, pp. 245–6.

7. The burial chapel in San Pablo was established in 1613: see Kagan in Hadjinicolaou 1995, p. 330 n. 31; Ramirez de Arellano 1920, pp. 309–10; and Caviró 1985, p. 224.

8. See Brown and Carr in Brown 1982, p. 38.

9. See Caviró 1985 and Kagan in Hadjinicolaou 1995.

10. For Pedro Laso de la Vega's family tree see Caviró 1985, p. 226, and Caviró 1990, pp. 299ff.

11. See Kamen 1997, pp. 247–9.

Fray Hortensio Félix Paravicino, about 1609

Oil on canvas, 112 × 86.1 cm

Signed on the right: δομήνικος θεοτοκόπουλος ἐ[ποίει]
(Domenikos Theotokopoulos made)

Museum of Fine Arts, Boston
Isaac Sweetser Fund 1904, inv. 04.234

Hortensio Félix Paravicino y Arteaga (1580–1633) was a Trinitarian friar who came to know El Greco during the painter's last years. His family was of Italian origin but he was born in Madrid. Already Professor of Rhetoric at the University of Salamanca at the age of twenty-one, he was a figure of great intellectual brilliance and authority in the Spain of Philip III and Philip IV. He was a prolific poet and a renowned orator and in 1616 he was appointed Preacher to the King. He was a close friend of the poet Luís de Góngora and both were practitioners of a rhetorical style that was brilliantly inventive, dense in visual images and rich in learned references: it came to be known as the *culterano* style and was much imitated in Spain, although it also had its distinguished critics, for example the playwright Lope de Vega. Paravicino lavished praise on El Greco, dedicating four sonnets to his memory in a volume of poems published in 1641, the *Obras postumas, divinas y humanas*. These include the sonnet with the oft-quoted lines, 'Crete gave him life, Toledo his brushes and a better homeland...'. Another of the sonnets was dedicated to the portrait exhibited here:

The conceit of the soul not knowing whether it should inhabit the portrait or the person himself conveys effectively the sense of vibrant and living presence that the picture communicates. Although he is seated, Paravicino seems to be looking down at the viewer, engaging our gaze with an expression tinged with hauteur. His eyes are quick and bright and different aspects of his pose suggest both repose and activity, a life both contemplative and active: his right hand rests loosely but authoritatively on the arm of the chair, but his left holds two books, one a large folio volume and the other a smaller book, of poetry perhaps, in which the page is marked with his middle finger. El Greco may have wanted to allude to the varied nature of his polymath sitter's achievement. The extraordinary liveliness of the execution, quick and free, and the contrasting diagonals in the composition invest it with a mobility and pulse. At the same time the range of colours is strictly limited, except for the flashes of red in the Trinitarian crosses and the sitter's lips, so that all these effects are achieved within an almost monochromatic scale. GF

O Greek divine! We wonder not that in thy works
The imagery surpasses actual being,
But rather that, while thou art spared, the life that's due
Unto thy brush should ever withdraw to Heaven.
The sun does not reflect his rays in his own sphere
As brightly as thy canvases. Thou dost
Essay, and like a god succeed. Let Nature try:
Behold her vanquished and outdone by thee!
Thou rival of Prometheus in thy portraiture,
Mayst thou escape his pain, yet seize his fire:
This does my soul for thee most ardently desire;
And after nine and twenty years of life,
Betwixt thy hand and that of God she stands perplexed,
And doubts which is her body, where to dwell.[1]

Divino Griego de tu obrar, no admira,
que en la imagen execeda al ser el arte,
vino que della el cielo por templarte
la vida, deuda a tu pinzel retira.

No el sol sus rayos por su esfera gira,
como en tus lienços, basta el empeñarse [sic]
en amigos de Dios, entre a la parte
nauraleza que vencer se mira.

Emulo de Prometheo en vn retrato
no afectes lumber, el hurto vital dexa,
que hasta mi alma á tanto ser ayuda.

Y contra ceinte y nueve años de trato,
entre tu mano, y la de Dios, perpleja,
qual es e! cuerpo en que ha de viuir duda.[2]

PROVENANCE

Duque del Arco, Madrid, 1724; Fray Javier de Muguiro, Madrid; Isaac Sweetser Foundation, Boston, 1904; acquired by the Boston Museum of Fine Arts in 1904

ESSENTIAL BIBLIOGRAPHY

Palomino 1715–24 (1947), p. 842; Cossio 1908, no. 278; López-Rey 1943, pp. 86–8; Camón Aznar 1950, pp. 1136–42, no. 751; Wethey 1962, I, pp. 62–3, II, no. 153; Davies 1976, pp. 9, 15; Madrid-Washington-Toledo (Ohio)-Dallas 1982–3, no. 63 (entry by W.B. Jordan); Marías 1997, pp. 258–60; Carr in Vienna 2001, English edn. p. 50, no. 32 (entry by D. Carr)

1. Translation from Boston 1907, p. 22.
2. Paravicino cited in Cossio 1908, p. 660.

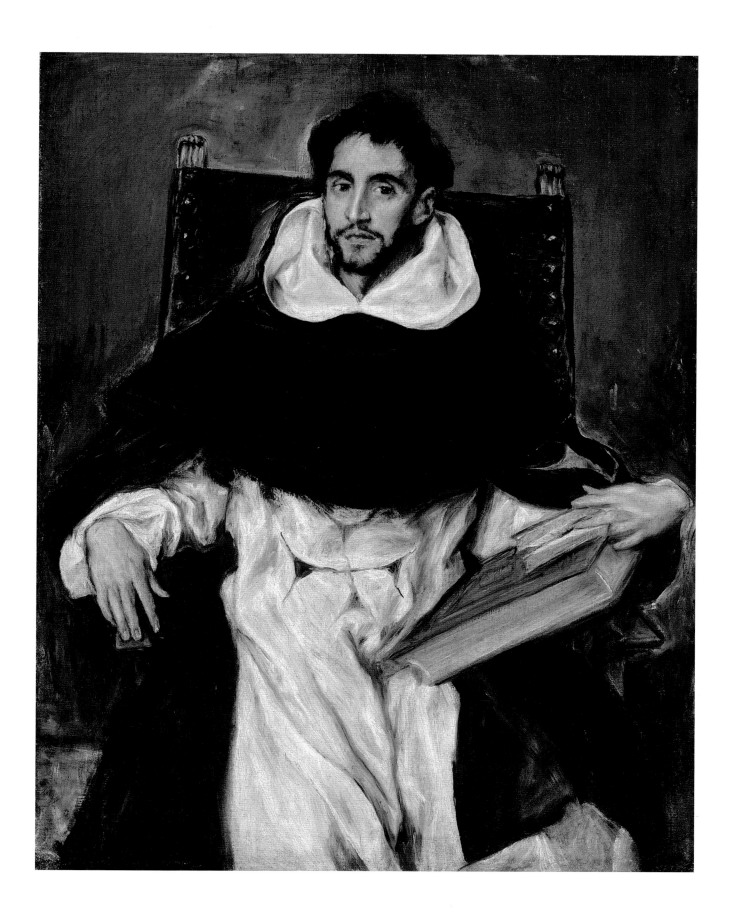

Oil on canvas, 107 × 90 cm

Inscribed on the pages of the book: *BOSIVS CANONICI*

Kimbell Art Museum, Fort Worth, Texas, inv. AP 1977.05

NEW YORK ONLY

Remarkably, until fifteen years ago there was no plausible identification of this imperious sitter, despite the fact that the portrait is one of El Greco's most ambitious and must record a prominent figure. However, in 1988 Martínez Caviró made a convincing case for identifying him with Francisco de Pisa (*c.* 1537–1616), Professor of Holy Scripture at Toledo University, the author of a major history of Toledo and a prominent figure in ecclesiastical affairs in the city. He founded a *beaterio* – a house for pious women – near the church of Santa Ana (the Beaterio De Pisa) and was chaplain of another one in the parish of San Pedro (later known as Las Benitas de la Purisima Concepción).[1] Additionally, he served as parish priest at Santa Justa y Rufina and as chaplain of the Capilla Mozárabe in the cathedral; it was there that he was buried.[2] In addition to his history of Toledo, published in 1605, he was the author of saints' lives and devotional and ceremonial texts as well as a commentary on Aristotle's *De anima* (On the soul). His views on religion were rigidly orthodox. Perhaps not surprisingly, he was no admirer of Saint Teresa of Ávila, who in 1596 he described as 'an unlettered woman', voicing his opposition to the publication of a new edition of some of her writings.

The case for identifying the sitter of the Fort Worth portrait with the Toledan scholar rests, in the first place, on the striking resemblance between his features and those of a documented miniature of Francisco de Pisa in a private collection that was, at one time, ascribed to El Greco himself.[3] That miniature portrait has been thought to have a provenance from the Beaterio founded by Pisa and to be the work referred to by an inscription on the reverse of a nineteenth-century portrait of the scholar in the municipal archives of Toledo.[4] Further, Pisa left a number of items to the Beaterio de San Pedro, including his portrait, which is recorded in a 1623 inventory of the Beaterio. The frame – but not the picture – was evidently still there about 1940 or 1942, re-used for an image of Christ, and seems to have been of a size suitable for the Fort Worth portrait. The 1623 inventory does not mention the author of the portrait of Pisa, but it does list a large painting by El Greco of *The Martyrdom of Saint Maurice* as well

as paintings of Christ and the Virgin. As an aside, it should be noted that Pisa mentions the artist in his history of Toledo, noting that no visitor to the city left without seeing the artist's *Burial of the Count of Orgaz*.

The open book displayed on the table is identified by lettering on its pages as *BOSIVS CANONICI* – presumably an edition or commentary on the corpus of canon law (*Corpus iuris canonici*). The job of codifying canon law following the reforms of the Council of Trent was begun under Gregory XIII (1572–85) by a review board of cardinals and experts. An official Roman edition was published in 1580–2.[5] It has been universally assumed that the Bosius referred to in the inscription was Giacomo Bosio (1544–1627), but this is extremely unlikely. There is nothing to suggest his interest or participation in the codification of canon law. For a time Giacomo Bosio was even thought to be the sitter. However, since he never went to Spain, this can be excluded out of hand.[6]

A more likely candidate as author of the text is Francesco Bossi, or Bosio (*c.* 1500/10–1584), who specialised in law.[7] In Rome Bossi was closely associated with Carlo Borromeo, one of the key figures of the Catholic reform. Among other books, his *Decreta generalia . . .* was first published in 1582 and enjoyed a certain success. Among the issues it discussed was the preservation and defence of orthodoxy. We might imagine this kind of work to have interested Francisco de Pisa.

This portrait is likely to date from the last decade of El Greco's career. The similarity of the compositional formula to that already employed for *Saint Jerome* (cat. 50) illustrates the way in which El Greco enriched his work by cross references. KC

1. On the Benitas see Marías 1983–6, III, pp. 117–8.
2. *Ibid.*, pp. 213–5. El Greco's son Jorge Manuel was involved in the repairs to the Capilla Mozarabe following the damage sustained from fire in 1620.
3. See Lafond 1916 and Wethey 1962, II, p. 209.
4. The inscription indicates that the prototype is a painting by '. . . *Dominico Greco, que existe en el Beaterio de Pis junto a Santa Ana . . .*': see Martinez Caviró 1988, p. 116.
5. See the entry on canon law in the *New Catholic Encyclopedia*, III, p. 47.
6. See De Caro 1971, pp. 261–4.
7. See Prosperi 1971, pp. 303–4.

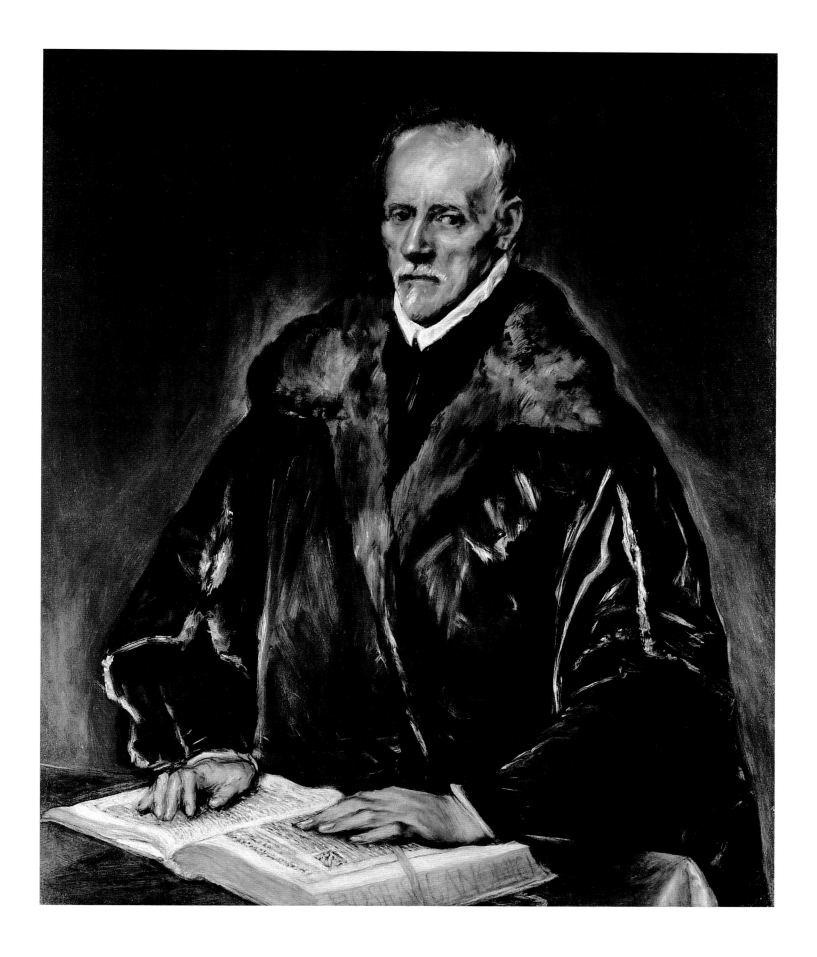

83 Jerónimo de Cevallos, about 1610

Oil on canvas, 70.8 × 62.7 cm
Museo Nacional del Prado, Madrid, inv. 812

Jerónimo de Cevallos was born in the town of Escalona, near Toledo, in 1562. He studied law at Salamanca University and in about 1600 settled in Toledo to practise as a lawyer. He became a member of the city council in 1605 and, following his wife's death, a priest. In 1639 he was nominated the president of the governing council of the archbishopric during the tenure of the Cardinal Infante Fernando de Austria, brother of Philip IV. He acquired fame for his writings on legal questions and he frequented the literary circle that met in the house of Francisco de Rojas y Guzmán, Conde de Mora, which included the poet and playwright Lope de Vega, the historian Tamayo de Vargas, the poet Baltasar Elisio de Medinilla and the dean of Toledo Cathedral, Francisco de Céspedes. In 1623 he published a book entitled *Arte real para el buen gobierno* (The royal art of good government), advising the new king, Philip IV, how to halt the decline of Spain. He died in 1644.[1] His posthumous inventory mentions a *Saint Francis* by El Greco and a portrait of 'Senor Cevallos when he was married', which might be this one by El Greco.[2]

The identification of the sitter as Cevallos is based on the comparison with a print of 1613 by the engraver and silversmith Pedro Ángel, active in Toledo between 1583 and 1617 (fig. 66). There Cevallos is shown holding a book inscribed *Communes contra communes*, referring to his publications on institutional jurisprudence. The similarity is general rather than specific, however, and Roteta has argued against the commonly accepted identification of El Greco's sitter. That said, Pedro Ángel, who was not a highly gifted engraver, was probably working from a rather poor portrait of Cevallos, a version or copy of which is in the Biblioteca Provincial in Toledo. Whether it is Cevallos or not, El Greco's portrait could certainly be the image of a man in his mid to late forties, which is what Cevallos would have been if the portrait dates from either side of 1610.

This is undoubtedly one of El Greco's portrait masterpieces, demonstrating not only his technical skill but also his great sensitivity to his sitter. While the enormous ruff might seem a little pretentious, the face, with its tremulous outline and slightly drawn features, conveys dignity and serenity. The sitter's gaze suggests thoughtfulness and even a touch of modish melancholy. The range of colours is limited essentially to black, white and grey, but the reddish-brown ground imparts a warm tonality to the whole. Particularly striking is the execution of the ruff: dense strokes of white are applied directly on the ground, which is left showing, especially around the edge, to indicate shadows. The ground showing around the sitter's beard functions miraculously as beard, shadow and ruff. Velázquez was clearly very attentive to El Greco's methodology in late portraits like this one. GF

PROVENANCE

One of several portraits by El Greco that belonged to Don Alonso Maurique de Lara, Duque del Arco, *caballerizo mayor* of Philip V; his widow, Condesa de la Puebla del Maestre; donated by her, with all the contents of the Quinta del Duque del Arco, a country residence close to the royal palace of El Pardo, to Philip V in 1745; Spanish royal collection; passed to the Museo del Prado

ESSENTIAL BIBLIOGRAPHY

Cossio 1908, no. 79, pp. 429–30; Allende Salazar and Sánchez Cantón 1919, p. 175; Wethey 1962, I, p. 62, II, no. 133; Roteta 1976, pp. 226–7; Marías 1997, p. 227; Vienna 2001, no. 31 (entry by L. Ruiz Gómez); Álvarez Lopera 2003

Fig. 66 Pedro Ángel (about 1588–about 1617)
Jerónimo de Cevallos, 1613
Engraving, 13.5 × 21.5 cm
From *Tractatus de cognitione per viam violentiae in causis ecclesiasticis*, Toledo 1613
Biblioteca Nacional, Madrid

1. For Cevallos's biography see Gómez Menor 1966, pp. 81–4; Kagan 1982, pp. 50–2; Gómez Menor 1983; Rodríguez de Gracia 1988.
2. Allende Salazar and Sánchez Cantón 1919, p. 175; Rodríguez de Gracia 1988, p. 160, n. 29.

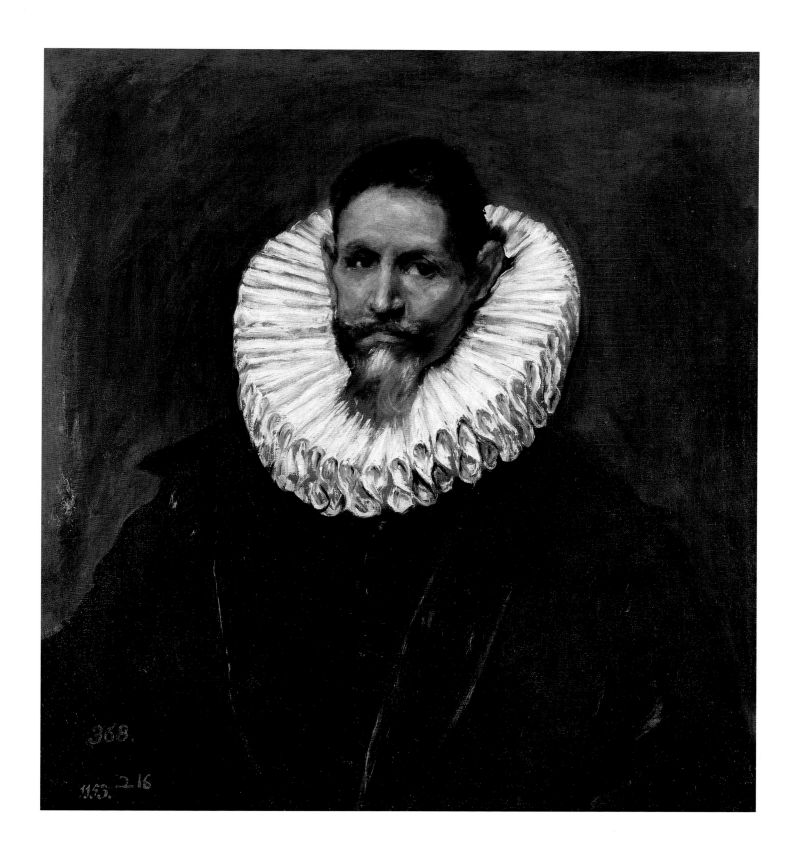

368.

1153. 2.16

References

EDITOR'S NOTE ON EL GRECO'S SIGNATURES

As far as possible, El Greco's signatures as given here have been checked against transparencies of the paintings. In the signatures that he gives, in transliterated form, Wethey tends to give a standard signature, which is not always what El Greco wrote. El Greco does not always provide accents, for instance; these have not been given here where they do not seem to occur. In addition to Wethey's notes on signatures (1962, I, pp. 111–14), the following remarks may be made:

El Greco often uses combined letter forms or abbreviations, for example *MH* in *ΔOMΉNIKOC*, *τo* and *ov* in *θεοτοκόπουλος*, final *ος*, *ει*. Because the s is reduced to a mere flourish the variant *θεοτοκόπολι* Wethey notes may in fact be *θεοτοκόπολις*. El Greco also often places two dots over the *ι* of *δομήνïκος*. He sometimes writes the final *ει* of *ἐποίει* as *η* instead, for instance in the very clear signature on the portrait of Giulio Clovio (cat. 70).

EL GRECO'S MEDITERRANEAN:
THE ENCOUNTER OF CIVILISATIONS

1. The 'normal' sailing time from Candia in the sixteenth century was thirty-three days: Braudel 1972–3, I, p. 362.
2. For Cretan society and culture in this period, see especially Holton 1991.
3. In spite of intensive work in recent years, very little information has been found about El Greco's family or his early years. See the catalogue essay by José Álvarez Lopera in Madrid-Rome-Athens 1999–2000, pp. 47–8. For the fortunes and misfortunes of his brother, see Nikolaos M. Panayotakis in Hadjinicolaou 1999, pp. 17–21.
4. Maltezou in Holton 1991, pp. 33 and 44.
5. See Maria Constantoudaki-Kitromilides in Madrid-Rome-Athens 1999–2000, pp. 85–95.
6. Marías 1997, pp. 62–73.
7. Pullan 1971, p. 289.
8. See McNeill 1974.
9. Braudel 1972–3, II, iii, provides an extensive narrative of the origins and formation of the Holy League and the movement of the conflict towards its climax at Lepanto, as also does Setton 1984, IV, chs. 19–24. For a summary account of the confrontation between the Spanish and Ottoman empires, set in a general European context, see Elliott 2000, especially ch. 6.
10. For El Greco in Rome, see Lionello Puppi in Madrid-Rome-Athens 1999–2000, pp. 97–106. For Cardinal Farnese and his circle, see Zeri 1957, and Robertson 1992; also Clare Robertson in Iraklion 1990, pp. 215–27.
11. Dandelet 2001, p. 120.
12. The battle and its implications are well described in Guilmartin 1974, pp. 221–52.
13. See Setton 1984, IV, pp. 1060–3, for the impact of the news in Venice and the papal court; Dandelet 2001, p. 70, for the celebrations in Rome.
14. Andrés 1999, p. 67.
15. Andrés 1999, p. 66.
16. The story is told by Panayotakis in Hadjinicolaou 1999.
17. Puppi in Madrid-Rome-Athens 1999–2000, p. 105.
18. Marías 1997, p. 117.
19. José Manuel Pita Andrade, 'El Greco in Spain', in Madrid-Rome-Athens 1999–2000, pp. 119–51, at p. 119.
20. Mulcahy 1994.
21. For this painting, see cat. 22.
22. Mulcahy 1994, p. 65. There is a considerable literature on the unfavourable reaction of the king to this work.
23. Various possible reasons for Philip's selection of Madrid are discussed in Alvar Ezquerra 1985.
24. For El Greco's move to Toledo, see Pita Andrade Madrid-Rome-Athens 1999–2000, p. 122, and Jonathan Brown, 'El Greco and Toledo', in Madrid-Washington-Toledo (Ohio)-Dallas 1982–3, ch. 2, pp. 94–5.
25. For the Santo Domingo el Antiguo commission, see Mann 1986, ch. 1.
26. Pita Andrade in Madrid-Rome-Athens 1999–2000 p. 150.
27. Andrés 1999, p. 101.
28. A general account of Spain in this period is to be found in Elliott 1963.
29. For a succinct and up-to-date account of the Church and religious policy in Spain in this period, see Rawlings 2002.
30. Tellechea Idígoras 1968, I, p. 80; Mann 1986, pp. 6–8.
31. Kagan in Madrid-Washington-Toledo (Ohio)-Dallas 1982–3, ch. 1, pp. 54–6.
32. Vincent and Domínguez Ortiz 1978.
33. Martz 1988, pp. 117–96.
34. Sicroff 1960, chs. 3 and 4; Martz 1994, pp. 83–107.
35. Martz 1983, pp. 98–9.
36. Kagan 2003.
37. Kagan 2003; Marías 1997, ch. 5.
38. Andrés 1999, pp. 32 and 36.
39. Marías 1997, pp. 166–8; Kagan 1982, p. 64.
40. Marías 1997, p. 178.
41. Kagan 1982, p. 40.

EL GRECO'S RELIGIOUS ART:
THE ILLUMINATION AND QUICKENING
OF THE SPIRIT

1. Paravicino 1641, f.74. Contrary to the assertion of some scholars, there is a comma after 'vida', so that Paravicino does not state that Crete gave him life and brushes.
2. While in Crete, he is known to have painted an icon of the Passion of Christ. Although it is lost, the reference to a gilded background suggests that it was painted in the contemporary, post-Byzantine style. Constantoudaki-Kitromilidis 1975, pp. 292–308.
3. Davies 1995, pp. 425–45.
4. Acheimastou-Potamianou 1990, pp. 329–30.
5. See Acheimastou-Potamianou 1990; Fatourou-Hesychakis in Hadjinicolaou 1995, pp. 45–68; Constantoudaki-Kitromilides in Hadjinicolaou 1995, pp. 97–118; Mastoropoulos 1999–2000, pp. 340–2.
6. The Canons and Decrees of the Council of Trent, 'Decree concerning Justification', pp. 29–46. See, also, Miesel Jr. 1953, pp. 205–14; Rogelio Buendía 1984, pp. 36–7; Rogelio Buendía 1999, pp. 275–89; Cueto 1995, pp. 173–85.
7. For the sources of this composition, see Palluchini 1937; Hadermann-Misguich 1965, pp. 355–8; Vassilaki in Iraklion 1990, pp. 341–3; Vassilaki in Hadjinicolaou 1995, pp. 119–32; Constantoudaki-Kitromilides 1995, pp. 110–16.
8. Wethey 1962, II, p. 65, no. 101.
9. Waterhouse 1978, p. 7.
10. Wilde 1978, p. 181.
11. Harris 1944, pp. 11–12.
12. Alberti (1991), II, no. 40, p. 76.
13. Maclaren 1952, p. 13.
14. Harris 1945, p. 7; Maclaren 1952, p. 13.
15. Mundy 1989, no. 55, pp. 180–1.
16. For an illustration, see Mundy 1989, p. 293, fig. 48.
17. Wilde 1953, pp. 106–7, no. 67.
18. For the fundamental importance of this tradition for the art of El Greco, see the forthcoming article by José Álvarez Lopera and David Davies.
19. The dark background might refer to contemporary practice of night burials, which was intended to signify the dead person's rejection of pomp and circumstance.
20. According to Ridolfi, Tintoretto made small figures in wax and clay, and dressed them in scraps of cloth. 'He also hung some models by threads to the roof beams to study the appearance they made when seen from below, and to get the foreshortenings of figures for ceilings.' Ridolfi (1984), p. 17.
21. San Román y Fernández 1910, p. 195.
22. Pacheco 1649 (1990), III, ch. I, p. 440.
23. Du Gué Trapier 1943, pp. 3, 5.

24. As recorded by Boschini, see Hope 1980, p. 163.

25. Pacheco 1649 (1990), III, ch. V, p. 483.

26. Brenan 1973, p. 163.

27. Saint John of the Cross (1978), I, bk III, ch. XVI, p. 242.

28. The Oxford Book of Spanish Verse 1925, pp. 99, 108–9.

29. Green 1965, III, p. 148.

30. It appears that El Greco was recorded in Madrid on 21 October, 1576. Andrés 1996, p. 95.

31. I am grateful to Professor Joseph Leo Koerner for making me aware of this fact.

32. Documents of the Christian Church 1967, pp. 231, 233.

33. Council of Trent (1978), p. 30.

34. Council of Trent (1978), pp. 144–52.

35. Council of Trent (1978), pp. 160–63.

36. Council of Trent (1978), pp. 214–17.

37. Bataillon 1966.

38. Bataillon 1966, chs. I, IV, XI, XIII.

39. A.A. Parker, *The Spanish Mystics*, Open University Tape, no. A201.26.

40. 'Tercera parte de la Obras del P. Mtro. Juan de Ávila,' 2nd edn., Seville, 1603. Reproduced in Balust 1952–3, p. 32.

41. Saint Teresa of Jesus (1978), I, p. 188.

42. Huerga 1950, pp. 297–335.

43. Saint John of the Cross (1978), pp. 144–5

44. Saint John of the Cross (1978), pp. 162–3.

45. Oxford Dictionary of the Christian Church 1957, p. 402.

46. Saint Thomas Aquinas (1963), vol. 58, 3a.75,5, pp. 73–7; vol. 45, 2a.2ae.175,2, p. 99. Saint Bonaventure (1953), p. 45.

47. It will suffice to name a few of El Greco's distinguished contemporaries: the Augustinians, Alonso de Orozco, Cristóbal de Fonseca and Pedro Malón de Chaide; the Jesuits, Antonio Cordeses and Antonio Sobrino; the Benedictine, Antonio de Alvarado; the Discalced Carmelites, Jerónimo Gracián, Tomás de Jesús and San Juan de la Cruz; the Franciscan Juan de los Ángeles, and Fray Diego de Jesús, the nephew of Cardinal Gaspar de Quiroga. Allison Peers 1960, I–III (see Indices: 'Dionysius').

48. Dionysius the Areopagite (1965), p. 22.

49. San Román y Fernández 1910, p. 185.

50. Davies 1999–2000, p. 199.

51. Mâle 1951, ch. II. For a fundamental study of the influence of the Council of Trent on sacred images in Spain and in relation to the censures of El Greco's religious paintings, see Ceballos 1984, pp. 153–8.

52. Although Pacheco praises El Greco's portrayal of Saint Francis for the historical accuracy of the Saint's physical appearance, he also states that El Greco shows him in the habit of a Recollect, whereas it should have been that of a Capuchin: '*pero dexaremos esta gloria a Domenico Greco, porque se conformó mejor con lo que dice la historia; mas, aunque lo vistió, ásperamente, de xerga basta como recoleto, no fue éste su hábito como veremos con puntualidad . . . Sabemos, de cierto, que el hábito primitivo que usó San Francisco fue Capuchino*', Pacheco 1649 (1990), p. 698. '. . . but we will leave this glory to Domenico Greco, because he conformed better to that which history tells [us]; furthermore, although he dressed him austerely, in coarse cloth as a Recollect, this was not his habit as we shall see . . . We know, for certain, that the primitive habit that Saint Francis wore was [like that of a] Capuchin.' By depicting the saint in the habit of a Recollect, that is, a member of the reformed branch of the Franciscan Observants, El Greco reflected and promoted the austere asceticism of the saint and the reformers.

53. Beltrán de Heredia 1941.

54. Schroth 1982, pp. 1–17; Davies 1984, pp. 69–70.

55. Schroth perceptively recognised the importance of the Office for the iconography of the painting, Schroth 1982, p. 7ff.

56. The presence of Saint Paul, who was not one of the original twelve Apostles, but who is included among them in the Canon of the Mass, may indicate a liturgical context.

57. Council of Trent (1978), p. 160.

58. Haemerken à Kempis 1908, pp. 106–7.

59. Parker 1968, pp. 60–1.

60. Council of Trent (1978), p. 23.

61. Stirling-Maxwell 1891, III, p. 1074

62. In this context it is relevant to quote Saint Basil, whose *Homilies* and *Ascetic Treatises* El Greco possessed. 'For instance, whenever the Lord is called the Way, we are carried on to a higher meaning, and not to that which is derived from the vulgar sense of the word. We understand by the Way that advance to perfection which is made stage by stage, and in regular order, through the works of righteousness and "the illumination of knowledge"; ever longing after what is before, and reaching forth unto those things which remain, until we shall have reached the blessed end, the knowledge of God, which the Lord through Himself bestows on them that have trusted in Him. For our Lord is an essentially good Way, where erring and straying are unknown, to that which is essentially good, to the Father. For "no one" He says, "cometh to the Father but through me." Such is our way up to God "through the Son."' (*Letters and Select Works, The Treatise De Spiritu Sancto, A Select Library of Nicene and Post-Nicene Fathers of the Christian Church* 1895, p. 12).

63. See Mann 1986.

64. Schroth 1982 p. 13; Davies 1984, pp. 69–70. It is likely that this motif was derived from either Titian's *Gloria* (Schroth 1982, p. 13) or Giulio Clovio's *Last Judgment* (Towneley Lectionary) in which Cardinal Alessandro Farnese appears among the heavenly throng.

65. The fundamental study of this theme in El Greco's œuvre is by Harris 1944.

66. Pacheco 1649 (1990), p. 537.

67. Pacheco 1649 (1990), pp. 349, 404.

68. Pacheco 1649 (1990), p. 422.

69. Pacheco 1649 (1990), p. 349.

70. Pacheco 1649 (1990), p. 349.

71. For the intellectual background to El Greco's activity in Italy, see the seminal paper by Maria Calì, Calì 1999, pp. 291–313.

72. Pérez de Tudela 2001, pp. 175–89.

73. Recorded in Robertson 1992, p. 13.

74. Robertson 1992; Parma-Napoli-Munich 1995.

75. Pérez de Tudela 2001.

76. Pérez de Tudela 2001, p. 179.

77. Nolhac 1884, p. 433; Du Gué Trapier 1958, pp. 73–90; Robertson 1992, p. 226; Hochmann 1993, I, pp. 49–91.

78. The cartoon of the 'Epifania' (British Museum) was included among them. Wilde 1953, p. 115.

79. Nolhac 1884, pp. 431–6.

80. Robertson 1992, p. 40.

81. Nolhac 1887, p. 227.

82. Ferrary 1993, p. 31 ff.

83. Nolhac 1884, pp. 25–6.

84. Waterhouse 1930, pp. 65–6.

85. For Chacón, see A. Orive's entry in *Diccionario de Historia Eclesiástica de España* 1972–87, II, p. 673; Ruiz 1976, pp. 189–247.

86. Nolhac 1887, p. 29.

87. Saint Teresa of Jesus (1978), I, pp. 311, 376. His acquaintanceship with Doña Luisa de la Cerda, a patroness of Saint Teresa, is also implied in this correspondence.

88. Tellechea Idígoras 1968, I, p. 80.

89. García Rey 1923; Andrés 1983.

90. Pinta Llorente 1961, p. 165.

91. San Román y Fernández 1928, pp. 543–66.

92. Andrés 1983, p. 95, n. 24.

93. Ruiz 1976, appendix 6, pp. 207–11.

94. San Román y Fernández 1928.

95. Andrés 1989, no. 11, p. 169.

96. Vegue y Goldoni 1928, p. 136.

97. Pepe Sarno 1979, p. 217. Andrés 1989, pp. 169, 172.

98. Andrés 1989, pp. 169, 172.

99. Marías and Bustamante 1981, p. 242.

100. Andrés 1988, pp. 297–307.

101. San Román y Fernández 1941, pp. 235–8.

102. El Greco painted his portait (Boston, Museum of Fine Arts); Paravicino lauded it in a sonnet: '*Al mismo Griego, en un retrato que hizo del Autor*',

which began with the words: '*Divino Griego . . .*' *Obras Postumas, Divinas y, Humanas, de Don Felix de Arteaga* 1650, f.63,r.

103. Pérez Pastor 1971, p. 205, number 515. Pisa, *Apuntamientos*, p. 12.
104. Madrid 1982, p. 53ff.
105. Wethey 1962, II, p. 79.
106. Davies 1984, p. 60.
107. Davies 1984, pp. 60–1.
108. Andrés 1988, p. 262.
109. Andrés 1988, pp. 271–2.
110. Andrés 1988, pp. 270–1.
111. Andrés 1988, p. 271.
112. Andrés 1969.
113. Wethey 1962, I, p. 13.
114. Marías and Bustamante 1981, p. 242.
115. Marías and Bustamante 1981, pp. 58, 238; Bouza Álvarez 1992, p. 63.
116. Martínez Caviró 1985, pp. 216–26; Martínez Caviró 1990, pp. 305–6. For a useful list of the paintings in that collection, see Kagan 1990, pp. 325–39.
117. Martínez Caviró 1985, pp. 121–2.
118. Saint Teresa of Jesus (1978), I, p. 45; II, p. 902.
119. Wethey 1962, II, pp. 117, 134, 137.
120. Saint Teresa of Jesus (1978), I, pp. 80, 83.
121. Robres Lluch 1954, pp. 254–5.
122. San Román y Fernández 1910, pp. 185–8.
123. San Román y Fernández 1910, p. 188; Andrés 1989, p. 174.
124. Sigüenza 1963, p. 385.
125. San Román y Fernández 1910, pp. 195–7.
126. A work by the famous, sixteenth-century Christian Neoplatonist, Francesco Patrizzi, was also listed, but it was not one of Patrizzi's philosophical tracts. (Yet it has been reported that the late Xavier de Salas found, in the University Library at Salamanca, a copy of Plotinus's *Enneads* which, allegedly, once belonged to El Greco.)
127. Such as Plutarch's *Lives* and *Moralia*, the works of Boethius and especially those of Pseudo-Dionysius the Areopagite.
128. The item listed in the 1621 inventory of his son's possessions as '*zinco libros de arquitetura manue-scriptos, el uno con trazas*', may refer to the treatise on architecture. See San Román y Fernández 1927, p. 309. It may also be identified with his lost work on Vitruvius, which was cited by his son. See Martín González 1959, pp. 86–8.
129. Discovered by Xavier de Salas. See Salas and Marías 1992.
130. Discovered by Fernando Marías and Agustín Bustamante. See their publication, Marías and Bustamante 1981.
131. See Davies 1999–2000, p. 215, n. 128.
132. Xavier de Salas in Salas and Marías 1992, p. 42.

133. Robertson 1992, p. 35.
134. Taddeo Zuccaro's altarpiece was originally intended for the chapel in Cardinal Farnese's villa at Caprarola (for an illustration, see Milwaukee 1990, p. 294, fig. 48). After Taddeo's death, however, Federico acquired it and made a copy after it, in fresco, for the same chapel (Robertson 1992, pp. 108–9). A similar pose of Christ, but in reverse, is also found in a drawing by Federico (Milwaukee-New York 1989–90, colour plate 56; pp. 182–3). It is a depiction of the *Dead Christ being lifted heavenwards by an Angel*, and relates to the liturgical moment when the Sacrificial Victim is taken by an angel to God the Father. The stylistic influence of these images on El Greco's painting of the *Trinity* has also been noted by Michiaki Koshikawa, Koshikawa 1999, pp. 364–5.
135. Domínguez Bordona 1927, pp. 77–89.
136. The annotations on El Greco's copy of Vitruvius' *Ten Books* have been dated to *c.* 1592–3 on the grounds that the artist states that he was fifty years of age (he was born in 1541) and refers to Dr Rodrigo de la Fuente in the past tense, that is, as dead (he died in 1589, see Marías and Bustamante 1981, pp. 59, 62). Both statements are incorrect. In fact El Greco speaks of Fuente in the present tense (see transcript, Marías and Bustamante 1981, p. 242) and for himself states that, because he has gained a reputation and authority as a painter, some people are persuaded that he may be about fifty years of age (see preface, p. 9). These annotations must in fact have been written before 1589, the date of Fuente's death (I am especially grateful to Professor Ángel García and Dr Ronald Cueto for checking and confirming these observations). Furthermore, since those in Vitruvius reveal less knowledge of Spanish than those in Vasari, it is probable, as Salas suggested, that the former were earlier. See Xavier de Salas in Salas and Marías 1992, p. 55. In this context, it is also to be noted that El Greco used more Italianate words in his annotations on Vitruvius' text. Thus he wrote (see Marías and Bustamante 1981) 'grazia' (pp. 226, 232, 235, 236); 'San Pieto' (p. 240); 'Titiano' (p. 236); 'Micael Angelo (pp. 226, 235, 236), Micael Anjelo (p. 240), Miguel Anjelo (p. 237). Only once did he omit the final 'o': Micael Angel (p. 226). In his annotations on Vasari's *Lives*, these words were spelt (see Salas and Marías 1992): 'gracia' (pp. 128, 130, 134); 'San Piedro' (p. 131); 'Tiçiano' (pp. 127, 128, 129, 130, 132, 133), 'Ticiano' (p. 133), 'Tiziano' (p. 133); 'Micael Angel' (Sometimes the first name is indecipherable, pp. 126, 127, 128, 133), 'Micael Angelo' (pp. 126, 129). This preponderance of

more Italianate words in his annotations on Vitruvius' work, lends support to Salas' observation. The annotations in Vasari are generally assumed to have been made in 1586 or soon after, but if he had acquired his copy of Vasari's *Lives* in Italy, as opposed to the time when Zuccaro visited Toledo, in 1586, they may have been done earlier. On account of the language of those in Vitruvius, it would be reasonable to assume that they were done in the early 1580s.
137. Alberti (1991), II, no. 53, p. 88.
138. Vitruvius (1960), pp. 5–6.
139. Marías and Bustamante 1981, p. 87: '*este salir fuera de los términos de la arquitectura hallo yo que es la mayor verdad y la cosa que más se sigue de cuanto ha escrito Vitruvio y io que se debe entender que más ilumina (aun) cuando no hubiese escrito otra cosa.*'
140. In this vein, Cicero had stated, 'that men should leave nothing untried if they have aspired to great and ambitious undertakings'. Cicero (1952), p. 309.
141. Vitruvius (1960), I, ch. II, 2, p. 14.
142. Shearman 1967, pp. 21–2.
143. Marías and Bustamante 1981, pp. 80, 227: '*el Arte que tenga más dificultades será la más agradable y por consecuencia mas intelectual.*'
144. Marías and Bustamante 1981, pp. 131, 235: '*. . . los hombres eminentes en cualquier arte es en la dificultades donde hacen que parezca la facilidad.*'
145. Marías and Bustamante 1981, p. 165, 241: '*la pintura es la única que puede juzgar todas las cosas, forma, color, como la que tiene por objecto la imitación de todas; en resumen, la pintura tiene un puesto de prudencia . . . la pintura, por ser tan universal, se hace especulativa, donde nunca falta el contento de la especulación, puesto que nunca falta algo que se pueda ver, pues hasta en la mediocre oscuridad se ve y se goza y tiene que imitar.*' It is relevant to note that, according to the *Diccionario de Autoridades* 1990, II, p. 597, '*especulación*' means: '*contemplación grande y aplicación del entendimiento para saber y conocer las cosas.*' As an example, Saavedra is cited: '*El arte de reinar no es don de la naturaleza, sino de la especulación y de la experiencia.*' One of the meanings of '*especular*' is '*considerar despacio y con reflexión alguna cosa, meditandola y contemplandola para entenderla*'.
146. Aristotle (1957), II, ch. ii, 194a 21 (pp. 121–3); II, ch. viii, 199a 15–20 (p. 173). Two copies of the *Physics* are recorded in El Greco's library, see San Román y Fernández 1941, p. 196.
147. Butcher 1899, p. 116.
148. Davies 1973, II, pp. 242–9.
149. Cicero (1952), III, 7–9, p. 311; III, 9–10, p. 313. See also XXIX, 101, p. 379.
150. Plotinus (1969), pp. 422–3 (v.8.1). See also p. 441 (v.9.11).

151. *Ibid.*, pp. 400 and 63.
152. *Dionysius the Areopagite, Mystical Theology and the Celestial Hierarchies* 1965, p. 12, Compare Plotinus (1969), I.6.9, p 63.
153. See Grabar 1945, pp. 15–31; Davies 1995, pp. 425–45.
154. Lindberg 1970, p. 87 (John Pecham, 'Perspectiva communis', Part I, Proposition I. II(13)); it was also observed by Leonardo, see Richter 1970, vol. 1, p. 217, no. 249: 'To prove how it is that luminous bodies appear larger, at a distance, than they are' (A.64b). I am most grateful to B.A.R Carter for the reference to Pecham.
155. Lindberg 1970, p. 20.
156. Wethey 1962, I, p. 50; II, p. 27, no. 28.
157. The assertion that the contrary was true, which is supposedly revealed in one of his annotations to Daniele Barbaro's Vitruvius, is erroneous. See Marías and Bustamante 1981, p. 204 ff. 'Cristus' does not mean 'Credo'. According to the *Diccionario de Autoridades* 1980, p. 335: 'Christus: *La Cruz que precede al abecedario o alphabeto en la cartilla. Estar en el Christus: Phrase metaphórica. Es hallarse uno mui al principio de alguna arte o ciencia, o no saber los primeros passos y modos para dirigir algún negocio. No saber el Christus: Phrase con que se da a entender que alguno es del todo ignorante y rústico.*' I am most grateful to Professor Ángel García for elucidating the meaning of this annotation.
158. Legendre 1947, p. 26.
159. Council of Trent (1978), p. 147. ('Doctrine concerning the sacrifice of the Mass'). As in El Greco's imagery the function of the ceremonies and rites is to elevate the mind 'to meditation on divine things'.

EL GRECO'S PORTRAITS:
THE BODY POLITIC AND THE BODY NATURAL

1. Hamlet (Act II, scene II). See Tillyard 1972, p. 11.
2. Pliny the Elder (1938–62), IX, p. 139.
3. Pliny the Elder (1938–62), pp. 333, 335.
4. Quintilian (1933), IV, p. 281.
5. Cicero (1952), pp. 349, 351.
6. For a magisterial treatment of the history of this concept see Kantorowicz 1957. See also Aristotle (1965), p. 44. Since they are not merely physiognomic records, but about the essence of the sitter's persona, they relate to Aristotle's conception of the imitation of Nature, and to his perception of poetry as opposed to history, which he regarded as annalistic. As he stated in his Poetics, 'poetry is concerned with universal truths, history treats of particular facts'.
7. Panofsky 1968, p. 81. Carr in Vienna 2001, p. 47.

8. Wethey 1962, I, p. 7, n. 8. 32. 'Discepulo' may mean pupil or follower. See Jonathan Brown, citing John Shearman in Madrid-Washington-Toledo (Ohio)-Dallas 1982–3, p. 78. According to Vasari, Titian was disinclined to teach pupils, preferring them to learn by his example, Vasari (1927), IV, pp. 211–2
9. The Pierpoint Morgan Library (M.69), New York.
10. Vasari (1927), IV, p. 249.
11. Voelkle in London-New York 1994–5, p. 247.
12. See Du Gué Trapier 1958, pp. 73–90.
13. The type of landscape is reminiscent of Vitruvius' description of the stage set for satyric scenes, which 'are decorated with trees, caverns, mountains. . .' (Vitruvius (1960), p. 150). It was illustrated by Serlio in his *Five Books on Architecture* (II, ch. 3, f. 26r).
14. According to Wethey, the landscape view is of Cadore, Titian's homeland (Wethey 1971, II, 'The Portraits', p. 110, no. 53). This does not invalidate the idea that it may also be a foil to the Empress' temperance. In portraiture, references were often made to this virtue, and a common symbol of it was the clock. It signified not transience but order and regularity.
15. For example, *Eleanora Gonzaga della Rovere, Duchess of Urbino* (Uffizi Gallery, Florence), *The Doge Francesco Vernier* (Thyssen-Bornemisza Museum, Madrid), *Antonio Palma* (Staatliche Gemäldegalerie, Dresden) and *Cardinal Bembo*, (Museo e Gallerie Nazionale di Capodimonte, Naples).
16. Nolhac 1884, p. 433, no. 45. They were portraits of Cardinals Alessandro Farnese, Ranuccio Farnese, Bessarion and Marcello Cervini (Pope Marcellus II).
17. See Willumsen 1927, II, p. 421ff; Wethey 1971, II, p. 68–9.
18. The identification of the sitter as Giovanni Battista Porta is untenable because he would only have been in his thirties when the portrait was painted (Hadjinicolaou in Athens 1995, no. 48, pp. 368–73; 538–40). The sitter is also unlikely to be Palladio. The conventional attributes of an architect – plan, compass and set square – are absent. Moreover, in comparison with Maganza's almost contemporary portrait (for an illustration, see Tavernor 1991, p. 10, fig. 1). The sitter in El Greco's painting looks younger, has predominantly dark rather than grey hair, lacks the distinctive side-whiskers, and his head appears broader.
19. The same instrument is visible in Vasari's *Saint Luke painting the Virgin* (SS. Annunziata, Florence), in which it is shown on a shelf attached to the easel, and in Lavinia Fontana's *Self-Portrait* (Uffizi Gallery, Florence). For illustrations of both, see Woods-Marsden 1998, pp. 26, 219.
20. Quintilian (1933), IV, p. 289.

21. Quintilian (1933), IV, p. 321. The gestures is shown in Titian's portrait of *Cardinal Bembo* (National Gallery of Art, Washington). See also Brown in Venice-Washington 1990–1, p. 238.
22. Quintilian (1933), IV, p. 289.
23. Wethey 1984, pp. 175–6.
24. See Parma-Naples-Munich 1995, pp. 251–4.
25. In recent years it has been attributed by some scholars to Sofonisba Anguissola and to the circle of Sánchez Coello (Kusche 1989, p. 415; Bernis 1990, p. 95, fig. 55; Breuer-Hermann 1990, p. 29. On p. 146 the latter attributes it to the circle of Sánchez Coello, probably by an Italian painter.) The traditional attribution to El Greco would seem to be well founded, despite the awkward modelling of chin and hand, because of the style and the sheer quality of the painting.
26. The similarity of her appearance to that of the Infanta Catalina Micaela (Real Monasterio de El Escorial; Prado, Madrid) has long been recognised. However, if the *Lady in a Fur Wrap* was painted by El Greco (c. 1577–80), it cannot be a portrait of the Infanta because she would only have been 10–13 years old. She has also been identified with Doña Juana de Mendoza, the Duquesa de Béjar, on the basis of a portrait of the Duquesa as a child with a dwarf (Private collection). Since her date of birth is not known, the identification is problematic. Even if the Duquesa is the sitter of the portraits said to be of the Infanta (see Baticle 1984, p. 16, fig. 6.), there remains the apparently insurmountable problem of decorum in identifying her as the *Lady in a Fur Wrap*.
27. Baticle 1984; see also Davies in Edinburgh 1989, p. 60. E. Harris concurs with this view, Hadjinicolaou 1995, p. 484.
28. In 1594, Camillo Borghese, the Papal Nuncio, reproted that '. . . all the women using as a rule the rouges whereby they alter their naturally brown complexions and they put on so much that they really seem painted'. Perhaps such excess was to associate themselves with the 'purity' of the Virgin Mary and to distance themselves from the 'moriscos' who were regarded as having 'impure' blood. See Thomas 1988, p. 344.
29. For a fuller discussion of the subject, see Davies 1998.
30. Porreño 1627 (1923), p. 98.
31. Díaz-Plaja 1958, pp. 593–603. I am most grateful to Prof. Mía Rodríguez-Salgado for drawing my attention to this document many years ago in connection with my research on El Greco's *Allegory of the Holy League*.
32. Márquez Villanueva 1959, pp. 193–7.
33. Admission into a military order would have been

prohibited for those engaged in such work. See Izquierdo 1992, p. 98.

34. On Covarrubias, see Gutiérrez 1951, pp. 129–135; Andrés 1988, pp. 237–313.

35. Gutierrez 1951, p. 125.

36. The ingenious suggestion that the sitter is the contemporary Archbishop of Toledo, Bernardo de Sandoval y Rojas (Brown and Carr 1982, pp. 33–42), is untenable. A portrait of Fernando Niño de Guevara (though not the name of the portraitist) is recorded in the collection in Madrid of Pedro Laso de la Vega, when it was valued prior to its sale in 1632: 'el retrato del Cardenal don Fernando Niño, arzobispo de Sevilla, sentado en silla'. (Caviró 1985, pp. 216–226; Caviró 1990, pp. 299–313). Other paintings from his residence in Batres, such as A View of Toledo and the Camaldolese Monastery were sold in 1639. Yet the portrait of the cardinal must have remained in the family since it is recorded in an early eighteenth-century inventory of the collection in Batres (Kagan 1995, pp. 330, n. 31; 333, n. 44). Perhaps it was brought by other members of the Guevara family. Since the portrait, as well as the View of Toledo, in the Metropolitan Museum, and the Camaldolese Monastery in the Instituto de Valencia de Don Juan (Madrid), were acquired from descendants of the Laso de la Vega and Guevara branches of the family (Caviró 1985, p. 224) it is probable that the sitter of the portrait in the Metropolitan Museum is Niño de Guevara. Physiognomic evidence supports this identification. In the inscribed portrait of Cardinal Niño de Guevara in the Archbishop's Palace in Seville, the shape of the head and beard are similar to those of El Greco's sitter. In contrast, in portraits of Sandoval y Rojas, as in the Chapter-House of the Cathedral, the Convent of Sto. Domingo el Real, and the Convent of San Clemente, the forehead would seem to be broader, and the shape of his beard is distinctly different. The latter is spade-like and composed of light grey hairs at either side of a pointed tuft of dark hair.

37. Goñi 1987, p. 521.

38. See Cossío 1908, p. 12ff., 659–61. Alarcos 1940–1. Camón Aznar 1950, II, pp. 1136–42. Cerdan 1978, pp. 8–13. Kitaura 1994. Thomas 1995.

39. Paravicino (1994), p. 12.

40. Paravicino (1994), p. 30.

41. Paravicino (1994), p. 22ff. See, also, Jones 1971, ch. 7. I am most grateful to Peter Thomas, my former postgraduate student, for drawing my attention to the bibliography on Paravicino's literary work.

42. Paravicino 1638–41. Hererro García 1943, p. 201.

43. Paravicino 1638–41. Hererro García 1943, p. 199.

44. 'El pintor que trazó en lineas y diámetros la figura, sólo atendiendo a la proporción, eso tiene la obra muerta, fáltale la vido toda de los colores'. Paravicino 1638–41. Hererro García 1943, p. 203.

45. Paravicino 1638–41. Hererro García 1943, p. 103.

46. Paravicino 1638–41. Hererro García 1943, p. 205. This is consistent with Pacheco's observation that El Greco retouched his paintings many times to leave the colours distinct and separate (Pacheco 1649 (1990), p. 483).

47. I am grateful to Peter Thomas for this perceptive observation.

48. This device had been employed by Titian in his informal portrait of Lodovico Beccadelli (Palazzo Pitti, Florence).

49. Paravicino (1994), p. 12.

50. For example, his Arte real para el buen govierno de los Reyes, y Príncipes, y de sus vassallos, Toledo, 1623.

51. Ceballos 1623, f. 18r.

52. Palomino 1715–24 (1947). Harris 1982, p. 198.

Bibliography

ACHEIMASTOU-POTAMIANOU 1990
M. Acheimastou-Potamianou, 'The Dormition of the Virgin' (with reference to its discovery by Georgios Mastoropoulos), in Iraklion 1990

ALARCOS 1940-1
E. Alarcos (writing under the pseudonym P.G. Millán), 'Paravicino y El Greco', Castilla (1941), pp. 139-42

ALBERTI (1991)
L. Battista Alberti, On Painting, trans. C. Grayson, ed. M. Kemp, London 1991

ALEMÁN 1962
M. Alemán, Guzmán de Alfarache, ed. S. Gili y Gaya, 2 vols, Madrid 1962

ALLEN 1984
G. Allen, El Greco: Two Studies, Philadelphia 1984

ALLENDE SALAZAR AND SÁNCHEZ CANTÓN 1919
J. Allende Salazar and F.J. Sánchez Cantón, Retratos del Museo del Prado. Identificación y rectificaciones, Madrid 1919

ALLISON PEERS 1960
E. Allison Peers, Studies of the Spanish Mystics, 3 vols, London 1960

ALVAR EZQUERRA 1985
A. Alvar Ezquerra, Felipe II, la Corte y Madrid en 1561, Madrid 1985

ÁLVAREZ LOPERA 1993
J. Álvarez Lopera, El Greco, Madrid 1993

ÁLVAREZ LOPERA 2000
J. Álvarez Lopera, El retablo del Colegio de Doña María de Aragón de El Greco, Madrid 2000

ÁLVAREZ LOPERA 2003
J. Álvarez Lopera, 'El Greco en las colecciones reales. Los retratos del Prado', in El Greco, forthcoming, Fundación Amigos Museo del Prado, Madrid 2003

AMES-LEWIS AND ROGERS 1998
F. Ames-Lewis and M. Rogers, Concepts of Beauty in Renaissance Art, Totton 1998

ANDRÉS 1969
G. de Andrés, El Cretense Nicolás de la Torre, Copista Griego de Felipe I, Madrid 1969

ANDRÉS 1988
G. de Andrés, 'El helenismo del camónigo toledano Antonio de Covarrubias. Un capítulo del humanismo en Toledo en el siglo XVI', Hispania Sacra, 40 (1988), pp. 297-307

ANDRÉS 1989
G. de Andrés, 'El helenismo en Toledo en tiempo del Greco', Cuadernos para Investigación de la Literatura Hispanica, Madrid 1989

ANDRÉS 1996
G. de Andrés, 'Perfil artístico del palatino Francisco de Reinoso Obispo de Córdoba', Institucion Tello Téllez de Menezes, 67 (1996)

ANDRÉS 1999
G. de Andrés, Helenistas del renacimiento en Toledo. El copista cretense Antonio Calosinás, Toledo 1999

ANGULO ÍÑIGUEZ AND PÉREZ SÁNCHEZ 1972
D. Angulo Íñiguez and A.E. Pérez Sánchez, Pintura toledana. Primera mitad del siglo XVII, Madrid 1972

ANGULO ÍÑIGUEZ AND PÉREZ SÁNCHEZ 1975
D. Angulo Íñiguez and A.E. Pérez Sánchez, A Corpus of Spanish Drawings, 1400-1600, I, London 1975

ARISTOTLE (1965)
Aristotle, On the Art of Poetry, in Classical Literary Criticism, trans. T.S. Dorsch, Harmondsworth 1965

ARISTOTLE (1989)
Aristotle, On Poetry and Style, trans. G.M.A. Grube, Indianapolis and Cambridge 1989

ARNOLD 1908
The Little Flowers of Saint Francis of Assisi, trans. T.W. Arnold, London 1908

ATHENS 1992-3
From Greco to Cézanne, exh. cat., National Gallery-Alexandros Soutzos Museum, Athens 1992-3

ATHENS 1995
El Greco in Italy & Italian Art, exh. cat., National Gallery-Alexandros Soutzos Museum, Athens 1995

AZCÁRATE 1955
J.M. Azcárate, 'La iconografía de El Espolio del Greco', Archivo Español de Arte, 28 (1955), pp. 189-97

BAETJER 1981
K. Baetjer, 'El Greco', The Metropolitan Museum of Art Bulletin, XXXIV, 1 (1981)

BAETJER, MESSINGER AND ROSENTHAL 1997
K. Baetjer, L.M. Messinger and N. Rosenthal, The Jackson Pollock Sketchbooks in The Metropolitan Museum of Art, New York 1997

BAILEY 2001
The Folio Society Book of the 100 Greatest Paintings, ed. M. Bailey, London 2001

BALUST 1952-3
S. Balust, Obras completas del P. Mt. Juan de Ávila, 2 vols, Madrid 1952-3

BARCELONA 1996-7
El Greco. Su revalorizacion por el modernismo catalán, exh. cat., Museo Nacional d'Art de Catalunya, Barcelona 1996-7

BARCÍA 1906
A.M. Barcía, Catálogo de la colección de dibujos originales de la Biblioteca Nacional de Madrid, Madrid 1906

BARNES 1982
S.J. Barnes, 'The Decoration of the Church of the Hospital of Charity, Illescas', in Brown 1982, pp. 45-55

BATAILLON 1966
M. Bataillon, Erasmo y España, Mexico 1966 (1991 edn)

BATICLE 1984
J. Baticle, 'A propos de Greco portraitiste: Identification de la Dame à la fourrure', Studies in the History of Art, 13 (1984)

BELTRÁN DE HEREDIA 1941
V. Beltrán de Heredia, Las corrientes de espiritualidad entre los dominicos de Castilla durante la primera mitad del siglo XVI, Salamanca 1941

BERMEJO DÍEZ 1977
J. Bermejo Díez, La Catedral de Cuenca, Cuenca 1977

BERNIS 1962
C. Bernis, Indumentaria española en tiempos de Carlos V, Madrid 1962

BERNIS 1990
C. Bernis, 'La Moda en la España de Felipe II a través del Retrato de Corte', in Madrid 1990

BERTINI 1987
G. Bertini, La galleria del duca di Parma: storia di una collezione, Bologna 1987

BERUETE AND CEDILLO 1912
A. de Beruete and Conde de Cedillo, Catálogo del Museo del Greco de Toledo, Madrid 1912

BIAŁOSTOCKI 1966
J. Białostocki, 'Puer sufflans ignes', in Arte in Europa: Scritti di storia dell 'arte in onore di Edoardo Arslan, 2 vols, 1966, pp. 591-5

BIEBER 1967
M. Bieber, Laocoön. The Influence of the Group since its Discovery, Detroit 1967

BILBAO-MADRID 1997
El retablo del Colegio de Doña María de Aragón, exh. cat., eds. J.M. Andrade and A. Sánchez-Lassa, Museo di Bellas Artes, Bilbao, and Museo del Prado, Madrid, 1997

BLUNT 1939-40
A. Blunt, 'El Greco's Dream of Phillip II: An Allegory of the Holy League', Journal of the Warburg and Courtauld Institutes, III (1939-40), pp. 58-69

BOBER 1957
P.P. Bober, Drawings after the Antique by Amico Aspertini, London 1957

BOBER AND RUBENSTEIN 1987
P.P. Bober and R.O. Rubenstein, *Renaissance Artists and Antique Sculpture*, London 1987

BORENIUS 1936
T. Borenius, *Catalogue of the Pictures and Drawings at Harewood House and elsewhere in the Collection of the Earl of Harewood*, Oxford 1936

BOSTON 1907
Museum of Fine Arts Bulletin, v, 26, 1907

BOUZA ÁLVAREZ 1992
F. Bouza Alvarez, *Del Escribano a la Biblioteca*, Madrid 1992

BRADLEY 1891
J.W. Bradley, *The Life and Works of Giorgio Giulio Clovio*, London 1891

BRAHAM 1966
A. Braham, 'Two notes on El Greco and Michelangelo', *The Burlington Magazine*, CVIII (1966), pp. 307–10

BRAUDEL 1972–3
F. Braudel, *The Mediterranean and the Mediterranean World in the Age of Philip II*, English trans., 2 vols, London 1972–3

BRENAN 1973
G. Brenan, *Saint John of the Cross*, trans. L. Nicholson, Cambridge 1973

BRENDEL 1955
O.J. Brendel. 'Borrowings from Ancient Art in Titian', *Art Bulletin*, XXXVII (1955)

BREUER-HERMANN 1990
S. Breuer-Hermann, 'Alonso Sánchez Coello. Vida y Obra', in Madrid 1990

BRIGSTOCKE 1978
H. Brigstocke, *Italian and Spanish paintings in the National Gallery of Scotland*, Edinburgh 1978

BRIGSTOCKE 1993
H. Brigstocke, *Italian and Spanish Paintings in the National Gallery of Scotland*, revised edn, Edinburgh 1993

BRILLIANT 2000
R. Brilliant, *My Laocoön. Alternative Claims in the Interpretation of Artworks*, Berkeley and London 2000

BRONSTEIN 1950
L. Bronstein, *El Greco*, New York 1950

BROWN 1982
Figures of Thought, El Greco as Interpreter of History, Tradition, and Ideas, ed. J. Brown, *Studies in the History of Art*, 11, Washington, DC 1982

BROWN 2003
J. Brown, *The Modena Triptych*, forthcoming publication, 2003

BROWN AND CARR 1982
J. Brown and D. Carr, 'Portrait of a Cardinal: Niño de Guevara or Sandoval y Rojas?', in Brown 1982, pp. 33–44

BROWN AND KAGAN 1982
J. Brown and R.L. Kagan, 'View of Toledo', in Brown 1982, pp. 19–32

BROWN AND MANN 1990
J. Brown and R.G. Mann, *Spanish Paintings of the Fifteenth through the Nineteenth Centuries*, National Gallery of Art, Washington, DC 1990

BROWN AND PITA ANDRADE 1984
El Greco – Italy and Spain, eds. J. Brown and J. Manuel Pita Andrade, *Studies in the History of Art*, 13, Washington, DC 1984

BRUMMER 1970
H.H. Brummer, *The Statue Court in the Vatican Belvedere*, Stockholm 1970

BRUNSWICK 1978
Die Sprache der Bilder, exh. cat., Herzog Anton Ulrich-Museum, Brunswick 1978

BUCHTHAL 1971
H. Buchthal, *Historia Troiana. Studies in the History of Medieval Secular Illustration*, London 1971

BURY 1984
J. Bury, 'A Source for El Greco's Saint Maurice', *The Burlington Magazine*, CXXVI (1984), pp. 144–8

BURY 1987
J. Bury, 'El Greco's Books', *The Burlington Magazine*, CXXIX (1987), pp. 388–91

BUSUIONCEANU 1934
A. Busuionceanu, 'Les tableaux du Greco de la collection royale de Roumanie', *Gazette des Beaux-Arts*, Séries 6, 2 (1934), pp. 302–4

BUTCHER 1899
S.H. Butcher, *Aristotle's Theory of Poetry and Fine Art*, London 1899

BYRON AND TALBOT RICE 1930
R. Byron and D. Talbot Rice, *The Birth of Western Painting*, London 1930

CALÌ 1999
M. Calì, 'Il Greco fra Venezia e Roma: cultura e orientamenti religiosi. Dalla linea neoplatonica a Venezia all'umanesimo farnesiano', in Hadjinicolaou 1999, pp. 291–313

CAMÓN AZNAR 1950
J. Camón Aznar, *Dominico Greco*, 2 vols, Madrid 1950

CAMÓN AZNAR 1970
J. Camón Aznar, *El Greco*, revised edn, Madrid 1970

CARR 2001
D.W. Carr, 'Regarding El Greco's Portraits', in Vienna 2001 (English edn), pp. 47–52

CARRANZA 1558 (1972)
B. Carranza, *Comentarios sobre el Catechismo Christiano*, ed. J.I.Tellechea Idigoras, 2 vols, Biblioteca de Autores Cristianos, Madrid 1972

CATS 1632
J. Cats, *Spiegel van den Ouden en Niewen Tydt*, Graven-Hage 1632

CAVAZZINI 1998
P. Cavazzini, *Palazzo Lancellotti ai Coronari*, Rome 1998

CAVIRÓ 1985
B.M. Caviró, 'Los Grecos de don Pedro Laso de la Vega', *Goya*, 184 (1985), pp. 216–26

CAVIRÓ 1990
B.M. Caviró, *Conventos de Toledo*, Madrid 1990

CEBALLOS 1623
Ceballos, *Arte real para el buen govierno de los Reyes, y Príncipes, y de sus vassallos*, Toledo 1623

CEBALLOS 1984
A.R.G. de Ceballos, 'La repercusión en España del decreto del Concilio de Trento acerca de las imágenes sagradas y las censuras al Greco', in Brown and Pita Andrade 1984

DE LA CERDA 1612
I. Ludovicus de la Cerda, *P. Virgilii Maronis Priores Sex Libri Aeneidos Argumentis, Explicationibus notis illustrati*, Lyons 1612

CERDAN 1978
F. Cerdan, 'La Passión según Fray Hortensio', *Criticon*, 5, University of Toulouse 1978

CHATZIDAKIS 1990
M. Chatzidakis, *Doménikos Theotokópoulos, Keímena 1950–1990*, Athens 1990

CICERO 1952
Cicero, *Orator*, trans. H.M. Hubbell, (Loeb edn), Cambridge, Mass., and London 1952

CLARK 1949
K. Clark, *Landscape into Art*, London 1949 (edn 1963)

COLLINS 1977
J. Collins, *A Dictionary of Spanish Proverbs*, London 1977

CONSTANTOUDAKI-KITROMILIDIS 1975
M. Constantoudaki-Kitromilidis, 'Dominicos Théotocopoulos (El Greco) de Candie à Venise. Documents Inédits (1566–1568)', *Thesaurismata*, 12 (1975)

CONSTANTOUDAKI-KITROMILIDIS 1995
M. Constantoudaki-Kitromilidis, 'Italian
Influences in El Greco's Early Work. Some New
Observations', in Hadjinicolaou 1995, pp. 97–118

CONSTANTOUDAKI-KITROMILIDIS 1999–2000
M. Constantoudaki-Kitromilidis, 'La pintura
en Creta durante los siglos XV y XVI. El largo
camino hacia Doménikos Theotokópoulos y su
producción temprana', in Madrid-Rome-Athens
1999–2000, pp. 85–95

CONSTANTOUDAKI-KITROMILIDIS 2002
M. Constantoudaki-Kitromilidis, 'Saint-Luc par
Théotocopoulos au Musée Bénaki: Nouvelles
remarques', in Topics in Post-Byzantine Painting
in Memory of Manolis Chatzidakis, Athens 2002,
pp. 271–86

COOK 1944
W.S. Cook, 'El Greco's Laocoön in the National Gallery',
Gazette des Beaux-Arts, Séries 6, 26 (1944), pp. 261–72

COPPEL 1998
R. Coppel, Museo del Prado. Catálogo de la Escultura de
época moderna, Madrid 1998

CORMACK 1985
R. Cormack, Writing in Gold: Byzantine Society and its
Icons, London 1985

CORMACK 1997
R. Cormack, Painting the Soul: Icons, Death Masks and
Shrouds, London 1997

CORREAS 1627 (1967)
G. Correas, Vocabulario de Refranes y Frases Proverbiales
(compiled in 1627, but unpublished during his
lifetime), Bordeaux 1967

COSSÍO 1908
M.B. Cossío, El Greco, Madrid 1908

COSSÍO AND COSSÍO DE JIMÉNEZ 1972
M. Cossío and N. Cossío de Jiménez, El Greco,
Barcelona 1972

COUNCIL OF TRENT 1978
The Canons and Decrees of the Council of Trent, trans.
Rev. H.J. Schroeder, Illinois 1978

CROPPER 1976
E. Cropper, 'On Beautiful Women. Parmigianino,
Petrarchismo, and the Vernacular Style', Art Bulletin,
LVIII (1976), pp. 374–95

CROWE AND CAVALCASELLE 1881
J.A. Crowe and G.B.Cavalcaselle, The Life and Times
of Titian with some account of his family, 2 vols,
London 1881

CRUZ VALDOVINOS 1998
J.M. Cruz Valdovinos, 'De Zarzas Toledanas',
Archivo Español de Arte, 282 (1998), pp. 113–24

CUETO 1995
R. Cueto, 'Mount Sinai and El Greco's Spirituality',
in Hadjinicolaou 1995

DAL POZZOLO 1999
E.M. Dal Pozzolo, 'El Greco e Jacopo Bassano', in
Hadjinicolaou 1999, pp. 331-43

DANDELET 2001
T.D. Dandelet, Spanish Rome, 1500–1700, New Haven
and London 2001

DAVIES 1973
D. Davies 'The Influence of Philosophical and
Theological Ideas on the Art of El Greco', in
Proceedings of the XXIII International Congress of
History of Art, 3 vols, Granada 1973

DAVIES 1976
D. Davies, El Greco, Oxford and London 1976

DAVIES 1984
D. Davies, 'El Greco and the Spiritual Reform
Movements in Spain', in Brown and Pita Andrade
1984, pp. 57–74

DAVIES 1990
D. Davies, 'The Relationship of El Greco's
Altarpieces to the Mass of the Roman Rite', in
The Altarpiece in the Renaissance, eds. Peter Humfrey
and Martin Kemp, Cambridge 1990

DAVIES 1995
D. Davies, 'The Byzantine Legacy in the Art of
El Greco', in Hadjinicolaou 1995, pp. 425–45

DAVIES 1996
D. Davies, 'Unravelling the meaning of El Greco's
Laocoön', in Recognition: Essays presented to Edmund
Fryde, Aberystwyth 1996

DAVIES 1998
D. Davies, 'El desnudo en El Greco', in El desnudo en
el Museo del Prado, Fundación de los Amigos del
Museo del Prado, Barcelona 1998, pp. 133–62

DAVIES 1998
D. Davies, The Anatomy of Spanish Habsburg Portraits,
'The Ramón Pérez De Ayala Lecture', Embajada de
España and University of Portsmouth,
Portsmouth 1998

DAVIES 1999–2000
D. Davies, 'The Ascent of the Mind to God:
El Greco's Religious Imagery and Spiritual Reform
in Spain', in Madrid-Rome-Athens 1999–2000

DE CARO 1971
G. De Caro, entry on 'Giacomo Bosio' in the Dizionario
biografico degli italiani, XIII, Rome 1971, pp. 261-4

DE SALAS 1961
X. De Salas, 'Sobre dos esculturas del Greco',
Archivo Español de Arte, 34 (1961), pp. 297–301

DE SALAS 1967
X. De Salas, 'Un exemplaire des 'Vies' de Vasari
annoté par Le Greco', Gazette des Beaux-Arts, 69
(1967), pp. 177–80

DE SALAS 1982
X. De Salas, 'Las notas del Greco a la 'Vida de
Tiziano' de Vasari', Boletin del Museo del Prado, III, 8
(1982), pp. 78–86

DE SALAS AND MARÍAS 1992
X. De Salas and F. Marías, El Greco y el arte de su
tiempo: Las notas de El Greco a Vasari, Madrid 1992

DELISLE AND MEYER 1901
L. Delisle and P. Meyer, L'Apocalypse en français au
XIIIe siècle, Paris 1901

DEMPSEY 1967
C. Dempsey, 'Euanthes Redivivus: Rubens's
Prometheus Bound, Journal of the Warburg and
Courtauld Institutes, XXX (1967)

DÍAZ-PLAJA 1958
F. Díaz-Plaja, La Historia de España en sus documentos.
El siglo XVI, Madrid 1958

DICCIONARIO DE AUTORIDADES 1990
Diccionario de Autoridades, 3 vols, Madrid 1990

DICCIONARIO DE HISTORIA ECLESIÁSTICA
DE ESPAÑA 1972–87
Diccionario de Historia Eclesiástica de España, 5 vols,
Madrid 1972–87

DICKENS 1968
A.G. Dickens, The Counter Reformation, London 1968

DILLON 1995
G. Dillon, 'El Greco e l'incisione veneta. Precisazioni
e novità', in Hadjinicolaou 1995, pp. 229–49

DIONYSIUS THE AREOPAGITE (1965)
Dionysius the Areopagite, Mystical Theology and the
Velestial Hierarchies, trans. the Editors of the Shrine
of Wisdom, 2nd edn, Godalming 1965

DOCUMENTS OF THE CHRISTIAN CHURCH 1967
Documents of the Christian Church, ed. H. Bettenson,
2nd edn, Oxford 1967

DOMÍNGUEZ BORDONA 1927
J. Domínguez Bordona, 'Federico Zuccaro in
España', Archivo Español de Arte, 40 (1927)

DON FELIX DE ARTEAGA 1650
Don Felix de Arteaga, Obras Postumas, Divinas y
Humanas, de Don Felix de Arteaga, Alcalá 1650

DU GUÉ TRAPIER 1925
E. Du Gué Trapier, El Greco, New York 1925

DU GUÉ TRAPIER 1929
E. Du Gué Trapier, Catalogue of Paintings in the
Collection of the Hispanic Society of America (16th, 17th,
and 18th Centuries), New York 1929

DU GUÉ TRAPIER 1943
E. Du Gué Trapier, 'The Son of El Greco', *Notes Hispanic*, New York 1943

DU GUÉ TRAPIER 1958
E. Du Gué Trapier, 'El Greco in the Farnese Palace, Rome', *Gazette des Beaux-Arts*, 51 (1958), pp. 73–90

EDINBURGH 1951
Catalogue of an Exhibition of Spanish Paintings from El Greco to Goya, exh. cat., ed. E.K. Waterhouse, Edinburgh Festival Society and the Arts Council of Great Britain, Edinburgh 1951

EDINBURGH 1989
El Greco: Mystery and Illumination, exh. cat., ed. D. Davies, National Gallery of Scotland, Edinburgh 1989

EISLER 1977
B. Eisler, *Paintings from the Samuel H. Kress Collection: European Schools Excluding Italian*, Oxford 1977

ELLIOTT 1963
J.H. Elliott, *Imperial Spain, 1469–1716*, London 1963 (reprint 2002)

ELLIOTT 2000
J.H. Elliott, *Europe Divided, 1559–1598*, 2nd edn, Oxford 2000

ETTLINGER 1961
L.D. Ettlinger, 'Exemplum Doloris. Reflections on the Laocoön Group', in *Essays in Honor of Erwin Panofsky*, ed. M. Meiss, New York 1961

FABIANSKI 2002
M. Fabianski, 'El Greco in Italian: precisazioni su due quadri', *Paragone*, LIII, 46 (2002), pp. 33–8

FAHY 1973
A. Fahy, *The Wrightsman Collection*, V, 1973

FALOMIR FAUS 2000
M. Falomir Faus, *Un obra maestra restaurada. El lavatorio de Jacopo Tintoretto*, Madrid 2000

FATOUROU–HESYCHAKIS 1995
K. Fatourou-Hesychakis, 'Philosophical and Sculptural Interests of Domenicos Theotocopoulos in Crete', in Hadjinicolaou 1995, pp. 45–68

FERNÁNDEZ MONTAÑA 1935
J. Fernández Montaña, *Los Covarrubias*, Madrid 1935

FERNANDO 1997
M. Fernando, *Greco: biographie d'un peintre extravagant*, trans. Marie-Hélène Collinot, Paris 1997

FERRARY 1993
J.L. Ferrary, 'La Genèse du *De legibus et senatus consultis*', ed. M.H. Crawford, *Antonio Agustín. Between Renaissance and Counter-Reform*, Warburg Institute Surveys and Texts XXIV, London 1993

FRANKFURTER 1960
A. Frankfurter, 'El Greco: an autobiography in paint', *Art News*, 59, no. 4 (1960)

GARCÍA REY 1923
Verardo García Rey, 'El deán Don Diego de Castilla y la reconstrucción de Santo Domingo el Antiguo', *Boletín de la Real Academia de Bellas Artes de Toledo*, XVI–XVII (1923)

GARDNER VON TEUFFEL 1995
A. Gardner Von Teuffel, 'El Greco's *View of Mount Sinai* as Independent Landscape', in Hadjinicolaou 1995, pp. 161–72

GARRIDO 1987
M.C. Garrido, 'Estudio técnico de cuatro *Anunciaciones* de El Greco', *Boletín del Museo del Prado*, VIII (1987), pp. 85–108

GARRIDO 1999
M.C. Garrido, 'La *Anunciación de la Virgen* del periodo italiano de El Greco en el Museo del Prado: examen de su técnica de ejecución', in Hadjinicolaou 1999, pp. 139–48

GARRIDO AND CABRERA 1982
M.C. Garrido and J.M. Cabrera, 'Estudio técnico comparativo de dos Sagrada Familias del Greco', *Boletín del Museo del Prado*, III, 88 (1982), pp. 93–101

GERARD POWELL AND RESSORT 2002
V. Gerard Powell and C. Ressort, *Ecoles espagnole et portugaise: Catalogue Musée du Louvre*, Paris 2002

GLENDINNING 1978
N. Glendinning, 'El Soplón y la Fábula de 'El Greco'. ¿Imitaciones de los clásicos? ¿Cuadros de género o pinturas emblemáticas?, *Traza y Baza*, 7 (1978), pp. 53–60

GOLDSCHEIDER 1938
L. Goldscheider, *Art without Epoch*, London 1938

GOMBRICH 1963
E.H. Gombrich, *Meditations on a Hobby Horse*, London 1963

GOMBRICH 1966
E.H. Gombrich, *Norm and Form*, London 1966

GÓMEZ MENOR 1966
J. Gómez Menor, 'En torno a algunos retratos del Greco', *Boletín del Arte Toledano*, I (1966), pp. 78–88

GÓMEZ MENOR 1983
J. Gómez Menor, 'Nuevos datos biográficos sobre el licenciado Jerónimo de Cevallos', *Anales Toledanos*, XVI (1983), pp. 187–93

GÓMEZ–MORENO 1968
M.E. Gómez-Moreno, *Catálogo de las pinturas del Museo y Casa de El Greco en Toledo*, Madrid 1968

GOÑI 1987
J. Goñi, 'Niño de Guevara', *Diccionario de Historia Eclesiástica de España*, 'Supplemento I', Madrid 1987

GRABAR 1945
A. Grabar, 'Plotin et les origines de l'esthétique médiévale', *Cahiers Archéologique* (1945), pp. 15–31

GRANADA–SEVILLE 2001
El Greco, Últimas Expresiones, exh. cat., eds. R. Sánchez Mantero *et al.*, Centro Cultural Puerta Real, Granada; Museo de Bellas Artes de Sevilla, Seville 2001

GREEN 1965
O.H. Green, *Spain and the Western Tradition*, Madison and Milwaukee 1965

GUDIOL 1962
J. Gudiol, 'Iconography and Chronology in El Greco's Paintings of St. Francis', *Art Bulletin*, XLIV (1962), pp. 195–203

GUDIOL 1971
J. Gudiol, *Doménikos Theotokópulos El Greco. 1541–1614*, Barcelona 1971 (English trans., *Domenikos Theotokopoulos El Greco. 1541–1614*, New York 1973)

GUDIOL 1973
J. Gudiol, *The Complete Paintings of El Greco*, New York 1973

GUILMARTIN 1974
J.F. Guilmartin Jr., *Gunpowder and Galleys*, Cambridge 1974

GUINARD 1956
P. Guinard, *El Greco: Biographical and critical study*, trans. J. Emmons, Skira 1956

GUTIÉRREZ 1951
C. Gutiérrez, *Españoles en Trento*, Valladolid 1951

HADERMANN-MISGUICH 1965
L. Hadermann-Misguich, 'Deux nouvelles sources d'inspiration du Polyptique de Modène', *Gazette des Beaux-Arts*, 63 (1965)

HADJINICOLAOU 1995
El Greco of Crete. Proceedings of the International Symposium Held on the Occasion of the 450th Anniversary of the Artist's birth, Iraklion, 1–5 September 1990, ed. N. Hadjinicolaou, Iraklion 1995

HADJINICOLAOU 1999
El Greco in Italy and Italian Art. Proceedings of the International Symposium, Rethymo, Crete, 22–24 September 1995, ed. N. Hadjinicolaou, Rethymo 1999

HAEMERKEN À KEMPIS 1908
T. Haemerken à Kempis, *Prayers and Meditations on the Life of Christ*, trans. W. Duthoit, London 1908

HARRIS 1938
E. Harris, 'A Decorative Scheme by El Greco', *The Burlington Magazine*, LXXII (1938), pp. 154–64

HARRIS 1944
E. Harris, *The Purification of the Temple [By] El Greco: in the National Gallery*, London 1944

HARRIS 1951
A. Harris, 'Spanish Painting from Morales to Goya in the National Gallery of Scotland', *The Burlington Magazine*, XCIII (1951), pp. 310–7

HARRIS 1982
E. Harris, *Velázquez*, Oxford 1982

HARRIS 1974
E. Harris, 'El Greco's *Holy Family with the Sleeping Christ Child and the Infant Baptist*: an Image of Silence and Mystery', in *Hortus Imaginum: Essays in Western Art*, eds. R. Enggass and M. Stokstad, Lawrence 1974, pp. 103–11

HARTT 1971
F. Hartt, *The Drawings of Michelangelo*, London 1971

HASKELL AND PENNY 1982
F. Haskell and N. Penny, *Taste and the Antique*, New Haven and London 1982

HAUG 1929
H. Haug, 'Une Vièrge du Greco', *Bulletin des Musées de France*, I (1929), pp. 108–11

HAVEMEYER 1961 (1993)
L.W. Havemeyer, *Sixteen to Sixty: Memoirs of a Collector*, New York 1961 (1993 edn)

HEINEMANN 1971
R. Heinemann *et al.*, *Sammlung Thyssen–Bornemisza*, Castagnola 1971

HERERRO GARCÍA 1943
M. Hererro García, 'Contribución de la Literatura a la Historia del Arte', *Revista de Filología Española*, XVII (1943)

HIND 1928
A.M. Hind, 'El Greco', *Old Master Drawings*, 3 (1928)

HIRST 1981
M. Hirst, *Sebastiano del Piombo*, Oxford 1981

HOCHMANN 1993
M. Hochmann, 'Les dessins et les peintures de Fulvio Orsini et la collection Farnèse', *Mélanges de l'Ecole française de Rome*, CV, 1 (1993), pp. 49–91

HOLTON 1991
D. Holton (ed.), *Literature and Society in Renaissance Crete*, Cambridge 1991

HOPE 1980
C. Hope, *Titian*, London 1980

HORACE (1965a)
Horace, 'On the Art of Poetry', in *Classical Literary Criticism*, trans. T.S. Dorsch, Harmondsworth 1965

HORACE (1965b)
Horace, 'Satires, Epistles and Ars Poetica', in *Classical Literary Criticism*, trans. T.S. Dorsch, Harmondsworth 1965

HORACE (1978)
Horace, '*Satires, Epistles and Ars Poetica*', trans. H. Rushton Fairclough (Loeb edn), Cambridge, Mass., and London 1978

HUERGA 1950
A. Huerga, 'Fray Luis de Granada en Escalaceli. Nuevos datos para el conocimiento histórico y espiritual de su vida', *Hispania*, 10 (1950)

HYGINUS AUGUSTI LIBERTI (1535)
Hyginus Augusti Liberti, *Fabularum Liber*, Basle 1535

INDEX LIBRORUM EXPURGATORUM 1584
Index Librorum expurgatorum, Illustrissimi ac Reverendis, D.D. Gasparis Quiroga, Cardinalis & Archiep. Toletani Hispan. generalis Inquisitoris iussu editus, Madrid 1584

INFANTAS 1945
Conde de las Infantas, 'Dos esculturas del Greco', *Archivo Español de Arte*, 18 (1945), pp. 193–200

IRAKLION 1990
El Greco of Crete, exh. cat., ed. N. Hadjinicolaou, Iraklion 1990

IZQUIERDO 1992
F. Izquierdo, *La Orden Militar de Calatrava en el siglo XVI*, Madrid 1992

JANSON 1952
H.W. Janson, *Apes and Ape Lore in the Middle Ages and the Renaissance*, London 1952

JOANNIDES 1995
P. Joannides, 'El Greco and Michelangelo', in Hadjinicolaou 1995

JONES 1971
R.O. Jones, *A Literary History of Spain. The Golden Age: Prose and Poetry*, London and New York 1971

KAGAN 1982–3
R.L. Kagan, 'The Toledo of El Greco', in Madrid–Washington–Toledo (Ohio)–Dallas 1982–3, pp. 35–73

KAGAN 1992
R.L.Kagan, 'The Count of Los Arcos as Collector and Patron of El Greco', *Anuario del Departamento de Historia y Teoría del Arte*, IV (1992), pp. 151–9

KAGAN 1995
R.L. Kagan, 'The Count of Los Arcos as Collector and Patron of El Greco', in Hadjinicolaou 1995

KAGAN 2003
R.L. Kagan, 'El Greco y se entorno humano en Toledo', in *El Greco. Obras maestras*, Madrid 2003

KAMEN 1997
H. Kamen, *The Spanish Inquisition: A Historical Revision*, New Haven and London 1997

KAMP 1993
G.W. Kamp, *Marcello Venusti: Religiöse Kunst im Umfeld Michelangelos*, New York 1993

KANTOROWICZ 1957
E.H. Kantorowicz, *The King's Two Bodies. A Study in Medieval Political Theology*, Princeton 1957

KEHRER 1911
H. Kehrer, 'Die einzige Zeichnung von Greco in der Madrider National Bibliothek', *Monatshefte für Kunstwissenschaft*, IV, (1911)

KITAURA 1987
Y. Kitaura, 'El *San Sebastián* de El Greco de la catedral de Palencia. Un estudio morfológico', *Archivio Español de Arte*, 239 (1987), pp. 307–21

KITAURA 1994
Y. Kitaura, 'Sonetos de Góngora y Paravicino dedicados a El Greco', *Boletín Camón Aznar*, LVII (1994)

KOSHIKAWA 1999
M. Koshikawa, 'El Greco and Federico Zuccari', in Hadjinicolaou 1999

KUSCHE 1989
M. Kusche, 'Sofonisba Anguissola en España retratista en la corte de Felipe II junto a Alonso Sánchez Coello y Jorge de la Rúa', *Archivo Español de Arte*, 72 (1989), pp 391–420

LA CORUÑA 2002
El Greco: Apostolados, exh. cat., La Coruña 2002

LAESSØE 1987
R. Laessøe, 'A Source in El Greco for Picasso's Les Demoiselles d'Avignon', *Gazette des Beaux–Arts*, 10 (1987), pp. 131–6

LAFOND 1906
P. Lafond, 'La Chapelle San José de Tolede et ses peintures du Greco', *Gazette des Beaux–Arts*, 36 (1906), pp. 383–92

LAFOND 1916
P. Lafond, 'Le Portrait du Docteur Pisa', *Revue Hispanique*, XXXVI (1916), pp. 308–10

LAFUENTE FERRARI 1969
E. Lafuente Ferrari, *El Greco: The Expressionism of His Final Years*, New York 1969

LANGEDIJK 1964
K. Langedijk, 'Silentium', *Nederlands Kunsthistorisch Jaarboek*, XV (1964), pp. 3–18

LASKIN 1971
M. Laskin, *Saint Francis and Brother Leo Meditating on Death, Masterpieces in the National Gallery of Canada*, No. 1 (in English and French), Ottawa 1971

LEGENDRE 1947
M. Legendre, *El Greco*, New York 1947

LEGENDRE AND HARTMANN 1937
M. Legendre and A. Hartmann, *Domenico Theotocopouli dit El Greco*, Paris 1937

LENAGHAN 2000
P. Lenaghan *et al.*, *The Hispanic Society of America/Tesoros*, New York 2000

LESSING (1910)
G.E. Lessing, *Laocoön*, trans. R. Phillimore, London and New York 1910

LINDBERG 1970
John Pecham and the science of optics: Perspectiva communis, ed. and trans. D.C. Lindberg, Madison 1970

LOMAZZO 1584
G.P. Lomazzo, *Trattato dell'arte della pittura, scoltura et architettura*, Milan 1584

LONDON 1980-1
Princely Magnificence. Court Jewels of the Renaissance, 1500-1630, exh. cat., ed. A. Somers Cocks, Victoria and Albert Museum, London 1980-1

LONDON 1981
El Greco to Goya, exh. cat., ed. A. Braham, The National Gallery, London 1981

LONDON–NEW YORK 1994-5
The Painted Page. Italian Renaissance Book Illumination 1450–1550, exh. cat., London and New York 1994-5

LONDON 1987
From Byzantium to El Greco. Greek Frescoes and Icons, exh. cat., ed. M. Acheimastou-Potamianou, Royal Academy of Arts, London 1987

LONDON 2000
The Image of Christ, exh. cat., ed. G. Finaldi, National Gallery, London 2000

LONDON 2003
Titian, exh. cat., ed. C. Hope *et al.*, National Gallery, London 2003

LÓPEZ-REY 1943
J. López-Rey, 'El Greco's Baroque Light and Form', *Gazette des Beaux-Arts*, Series 6, 24 (1943), pp. 73–88

LÓPEZ-REY 1947
J. López-Rey, 'Spanish Baroque: A Baroque Vision of Repentance in El Greco's *Saint Peter*', *Art in America*, 35 (1947), pp. 313–8

LYNCH 1965
J. Lynch, *Spain under the Habsburgs*, 2 vols, Oxford 1965

MACLAREN 1952
N. Maclaren, *The Spanish School*, National Gallery Catalogues, London 1952

MACLAREN AND BRAHAM 1970
N. Maclaren, *The Spanish School*, revised edn by A. Braham, National Gallery, London 1970

MADRID 1980
El dibujo español de los Siglos de Oro, exh. cat., A.E. Pérez Sánchez, Madrid 1980

MADRID 1990
Alonso Sanchez Coello, exh. cat., Museo del Prado, Madrid 1990

MADRID 1994
Los Leoni (1509–1608): Escultores del Renacimiento italiano al servicio de la corte de España, exh. cat., Museo del Prado, Madrid 1994

MADRID 1998-9
Felipe II: Un monarca y su época. Un Principe del Renacimento, exh. cat., ed. F. Checa Cremades, Museo del Prado, Madrid 1998-9

MADRID-ROME-ATHENS 1999–2000
El Greco. Identidad y trasformación. Creta, Italia, España, exh. cat., ed. J. Álvarez Lopera, Museo Thyssen-Bornemisza, Madrid 1999 (also shown in Palazzo delle Esposizioni, Rome, and National Gallery and Museum Alexandros Soutzos, Athens)

MADRID-WASHINGTON-TOLEDO (OHIO)-DALLAS 1982-3
El Greco of Toledo, exh. cat. (English edn), ed. J. Brown *et al.*, Museo del Prado, Madrid; National Gallery of Art, Washington; The Toledo Museum of Art, Toledo (Ohio); Dallas Museum of Fine Art, Dallas, 1982-3

MÂLE 1932
É. Mâle, *L'Art religieux du Concile de Trente*, Paris 1932

MÂLE 1951
É. Mâle, *L'Art religieux de la fin du XVIe siècle du XVIIe siècle et du XVIIIe siècle*, Paris 1951

MANCINI 1617–21 (1956)
G. Mancini, *Considerazioni sulla pittura*, ed. A. Marucchi, Rome 1956

MANN 1982
R.G. Mann, 'The Altarpieces for the Hospital of Saint John the Baptist, Outside the Walls, Toledo' in Brown 1982, pp. 57–78

MANN 1986
R.G. Mann, *El Greco and His Patrons. Three major projects*, Cambridge 1986

MANN 1990
R.G. Mann, *Spanish Painting of the Fifteenth through Nineteenth Centuries*, National Gallery of Art, Washington, DC 1990

MARÍAS 1983-6
F. Marías, *La Arquitectura del Renacimiento en Toledo (1541-1631)*, 4 vols, Madrid 1983-6

MARÍAS 1993
F. Marías, 'El Greco y los usos de la antigüedad clásica', *La Visión del Mundo Clásico en el Arte Español*, *Jornada de Arte*, VI (1993)

MARÍAS 1993
F. Marías, 'Reflexiones sobre una colección de pinturas de El Greco y *La Gloria de Felipe II*', *Anuario del Departamento de Historia y Teoría del Arte*, 5 (1993), pp. 59–70

MARÍAS 1995
F. Marías, 'El Greco y el punto de vista: La Capilla Ovalle de Toledo', in Hadjinicolaou 1995, pp. 357–69

MARÍAS 1997
F. Marías, *El Greco. Biografía de un pintor extravagante*, Madrid and Paris 1997

MARÍAS AND BUSTAMENTE 1981
F. Marías and A. Bustamente, *Las ideas artísticas de El Greco (Comentarios a un texto inédito)*, Madrid 1981

MARINI 1999
M. Marini, 'Creta gli diede la vita e i pennelli, Toledo una patria migliore dove cominciare a ottener con la morte, l'eternità', Rome 1999, pp. 131–43

MARTÍN GONZÁLEZ 1984
J.J. Martín González, 'El Concepto de retablo en El Greco', in Brown and Pita Andrade 1984, pp. 115–18

MARTÍN GONZÁLEZ 1959
J.J. Martín González, 'El Greco arquitecto', *Goya*, 26 (1959)

MÁRQUEZ VILLANUEVA 1959
F. Márquez Villanueva, 'En torno al caballero de la mano al pecho', *Archivo Español de Arte*, 32 (1959)

MARTÍNEZ CAVIRÓ 1985
B. Martínez Caviró, 'Los Grecos de Don Pedro Laso de la Vega', *Goya*, 184 (1985)

MARTÍNEZ CAVIRÓ 1990
B. Martínez Caviró, *Coventos de Toledo*, Madrid 1990

MARTÍNEZ CAVIRÓ 1988
B. Martínez Caviró, 'El Convento Toledano de Las Benitas, Don Francisco de Pisa y El Greco', *Archivo Español de Arte*, 242 (1988), pp. 115–30

MARTZ 1983
L. Martz, *Poverty and Welfare in Habsburg Spain*, Cambridge 1983

MARTZ 1988
L. Martz, 'Converso Families in Fifteenth- and Sixteenth-Century Toledo: the Significance of Lineage', *Sefarad*, XLVII (1988)

MARTZ 1994
L. Martz, 'Pure Blood Statutes in Sixteenth-Century Toledo: Implementation as Opposed to Adoption', *Sefarad*, LIV (1994)

MASSING 1988
A. Massing, 'The examination and restoration of El Greco's *El Espolio*', *The Hamilton Kerr Institute*, I (1988)

MASTORÓPOULOS 1983
G. Mastorópoulos, 'Ena ágnosto ergo tou Theotokopoulou' (An unknown work by Theotokopoulos), *Tríto Sympósio Byzantinés kai Metabyzantinés Archaiologías kai Téchnes (Christianiké Archailogiké Etaireía). Programma kai perilepseis*, Athens 1983

MASTORÓPOULOS 1995
G. Mastorópoulos, 'To chronikó tes evréseos tes eikonas tou Domenikou Theotokópoulou sti Syro' (Chronicle of the discovery of the icon by Doménikos Theotokópoulos in Syros), *Epetiris Eterías Kiladikón Meletón*, 12 (1995), pp. 405–24

MASTOROPOULOS 1999–2000
G. Mastoropoulos, 'The Dormition of the Virgin', in Madrid-Rome-Athens 1999–2000, pp. 340–2

MATEO GÓMEZ 1984
I. Mateo Gómez, 'Consideraciones iconográficas sobre la Crucifixión con donantes del Greco, para la Iglesia de Las Monjas Jerónimas de Toledo', in Brown and Pita Andrade 1984, pp. 121–3

MAURER 2001
G. Maurer, *Spanish Paintings at the Nationalmuseum*, Stockholm 2001

MAYER 1921
A.L. Mayer, 'Einige Gemälde und seine Zeichnung von Greco', in *Zeitschrift für bildende Kunst*, XXII (1921), pp. 55–60

MAYER 1926
A.L. Mayer, *Dominico Theotocopuli El Greco*, Munich 1926

McKIM–SMITH, GARRIDO AND FISHER 1985
G. McKim–Smith, M. del C. Garrido and S. Fisher, 'A Note on Reading El Greco's Revisions: a Group of Paintings of the Holy Family', *Studies in the History of Art*, XVIII (1985), pp. 67–77

McNEILL 1974
W.H. McNeill, *Venice. The Hinge of Europe, 1081–1797*, Chicago and London 1974

MEIER-GRAEFE AND KLOSSOWOSKI 1908
J. Meier-Graefe and E. Klossowoski, *La Collection Cheramy*, Munich 1908

MIESEL JR. 1953
V.H. Miesel Jr., 'La tabla central del tríptico de Modena del Greco', *Archivo Español de Arte*, 26 (1953)

MILLIKEN 1927
W.M. Milliken, '*The Holy Family* by El Greco', *Bulletin of The Cleveland Museum of Art*, 14 (1927), pp. 3–6

MILWAUKEE–NEW YORK 1989–90
E.J. Mundy, *Renaissance into Baroque. Italian Master Drawings by the Zuccari, 1550–1600*, exh. cat., Milwaukee Art Museum, Milwaukee, and National Academy of Design, New York, 1989–90

MOFFITT 1984
J.F. Moffitt, 'A Christianization of Pagan Antiquity', *Paragone*, XXXV (1984), pp. 44–60

MONBEIG-GOGUEL 1988
C. Monbeig-Goguel, 'Giulio Clovio "nouveau petit Michel-Ange" à propos des dessins du Louvre', *Revue de l'Art*, 80 (1988), pp 37–47

MONEDERO 1992
M.Á. Monedero, *Guía ilustrada de la Catedral y del Museo Diocesano de Cuenca*, 2nd edn, Cuenca 1992

MORENO BAEZ 1948
E. Moreno Baez, 'Lección y Sentido del Guzmán de Alfarache', *Revista de Filología Española*, XL (1948)

MORA DEL POZO 1987
G. Mora del Pozo, 'Origen del Apostolado del Museo del Greco', *Anales Toledanos*, 14 (1987), pp. 161–6

MULCAHY 1994
R. Mulcahy, *The Decoration of the Royal Basilica of El Escorial*, Cambridge 1994

MULLER 1989
J. Muller, *Rubens: The Artist as Collector*, Princeton 1989

NAGEL 2000
A. Nagel, *Michelangelo and the Reform of Art*, Cambridge 2000

NEW YORK 1988
The Spanish Golden Age in Miniature: Portraits from the Rosenbach Museum & Library, exh. cat., The Spanish Institute, New York 1988

NEW YORK 2001
El Greco: Themes & Variations, exh. cat., J. Brown et al., The Frick Collection, New York 2001

NEW YORK 2002
Time to Hope, exh. cat., Cathedral of Saint John the Divine, New York 2002

NOLHAC 1884
P. de Nolhac, 'Une Galerie de Peinture au XVIe siécle. Les collections de Fulvio Orsini', *Gazette des Beaux-Arts*, 29 (1884), pp. 427–36

NOLHAC 1887
P. de Nolhac, *La Bibliothèque de Fulvio Orsini*, Paris 1887, p. 29

NOTTINGHAM 1980
The Golden Age of Spanish Art from El Greco to Murillo and Valdés Leal: Paintings and Drawings from British Collections, exh. cat., Nottingham University Art Gallery 1980

OBRAS COMPLETAS DEL SANTO MAESTRO HUAN DE AVILA 1970
Obras completas del Santo Maestro Huan de Avila, ed. L. Sala Balust and F. Martin Hernandez, 6 vols, Madrid 1970

ORTIZ 1955
A. Ortiz, 'Un Greco, "redescubierto" en Madrid', *Ya*, Madrid, 13 December 1955

OXFORD BOOK OF SPANISH VERSE 1925
The Oxford Book of Spanish Verse, Oxford 1925

OXFORD DICTIONARY 1977
The Shorter Oxford English Dictionary, 2 vols, Oxford 1977

OXFORD DICTIONARY OF THE CHRISTIAN CHURCH 1957
The Oxford Dictionary of the Christian Church, ed. F.L. Cross, London 1957

PACHECO 1649 (1990)
F. Pacheco, *Arte de la pintura*, Seville, 1649, ed. B. Bassegoda I Hugas, Madrid 1990

PALLUCCHINI 1937
R. Pallucchini, *Il polittico del Greco della R. Galleria Estense e la formazione dell' artista*, Rome 1937

PALLUCCHINI 1953
R. Pallucchini, 'La vicenda italiana del Greco', *Paragone*, 4, no. 45 (1953)

PALLUCCHINI 1986
R. Pallucchini, 'Una nuova giovanile "Adorazione dei pastori" di El Greco', *Arte Veneta*, 40 (1986)

PALM 1969
W.E. Palm, 'El Greco's *Laocoön*', *Pantheon*, 27 (1969), pp. 129–35

PALOMINO 1715–24 (1947)
A. Palomino, *El museo pictórico y escala óptica. El Parnaso español pintoresco laureado* (Madrid 1715–24), Madrid 1947

PANOFSKY 1956
D. and E. Panofsky, *Pandora's Box. The Changing Aspects of a Mythical Symbol*, London 1956

PANOFSKY 1968
E. Panofsky, *Idea. A Concept in Art Theory*, trans. J.J.S. Peake, Columbia 1968

PARAVICINO 1638–41
Fray Hortensio Félix Paravicino y Artega, *Oraciones evangélicas*, Madrid 1641

PARAVICINO 1641
Fray Hortensio Félix Paravicino y Artega, *Obras posthumas divinas y humanas*, Madrid 1641

PARAVICINO (1994)
Fray Hortensio Félix Paravicino y Artega, *Sermones cortesanos*, ed. F. Cerdan, Madrid 1994

PARIS 1937
Domenico Theotocouli, El Greco: Exposition organisée par la 'Gazette des Beaux-Arts', exh. cat., Paris 1937

PARIS 2002
Ecoles espagnole et portugaise, exh. cat., eds. V. Gerard Powell and C. Ressort, Musée du Louvre, Paris 2002

PARIS-NEW YORK 2003
G. Tinterow and G. Lacambre, *Manet/Velásquez: The French Taste for Spanish Painting*, exh. cat., The Metropolitan Museum, New York 2003

PARKER 1956
K.T. Parker, *Catalogue of the Collection of Drawings in the Ashmolean Museum*, Oxford 1956

PARKER 1967
A.A. Parker, *Literature and the Delinquent; The Picaresque Novel in Spain and Europe, 1599–1753*, Edinburgh 1967

PARKER 1968
A.A. Parker, *The Allegorical Drama of Calderón*, Oxford 1968

PARMA-NAPLES-MUNICH 1995
I Farnese. Arte e colezionismo, exh. cat., ed. L.F. Schianchi and N. Spinosa, Parma, Naples and Munich 1995

PEPE SARNO 1979
I. Pepe Sarno, *Alvar Gómez de Castro, 'Sonetti'*, Rome 1979

PÉREZ DE MOYA 1673
J. Pérez de Moya, *Filosofia Secreta, donde debajo de Historias Fabulosas, se contiene mucha doctrina provechosa a todos estudios*, Madrid 1673

PÉREZ PASTOR 1971
C. Pérez Pastor, *La Imprenta en Toledo 1483–1886*, reprint Amsterdam 1971

PÉREZ SÁNCHEZ 1970
A.E. Pérez Sánchez, *Gli spagnoli dal Greco a Goya, I disegni dei maestri*, Milan 1970

PÉREZ SÁNCHEZ 1977
A.E. Pérez Sánchez, 'Las colecciones de pintura del conde de Monterrey (1653)', *Boletín de la Real Academia de la Historia*, CVXXIV (1977)

PÉREZ SÁNCHEZ 2002
A.E. Pérez Sánchez, *El Greco. Apostolado de Oviedo*, Madrid 2002

PÉREZ SÁNCHEZ AND NAVARRETTE PRIETO 2001
A.E. Pérez Sánchez and B. Navarrette Prieto, *Luis Tristán*, Madrid 2001

PÉREZ DE TUDELA 2001
A. Pérez de Tudela, 'A proposito di una lettera inedita di El Greco al Cardinale Alessandro Farnese', *Aurea Parma*, 2001, pp. 175–89 (first published, with a brief analysis, in *Archivo Español de Arte*, no. 291 (2000), pp. 267–8)

PERRY 1978
M. Perry, 'Cardinal Domenico Grimani's Legacy of Ancient Art to Venice', *Journal of the Warburg and Courtauld Institutes*, XLI (1978)

PETRONIUS (1923)
Petronius, *The Satyricon*, trans. J.M. Mitchell, 2nd edn, London and New York 1923

PHILLIPS-MATZ 1993
M.J. Phillips-Matz, *Verdi: A Biography*, Oxford and New York 1993

PIGNATTI 1971
T. Pignatti, *Giorgione*, Venice 1971

PIGNATTI 1991
T. Pignatti et al., *L'Histoire de Venise par la peinture*, Paris 1991

PINTA LLORENTE 1961
M. de la Pinta Llorente, *Aspectos históricos del sentimiento religioso en España*, Madrid 1961

PITA ANDRADE 1981
J.M. Pita Andrade et al., *El Greco*, Milan 1981, and Barcelona 1985

PITA ANDRADE 1985
J.M. Pita Andrade, 'Sobre la presencia del Greco en Madrid y de sus obras en las colecciones madrileñas del siglo XVII', *Archivo Español de Arte*, 58 (1985)

PITA ANDRADE 1995
J.M. Pita Andrade, 'Sobre los "soplones" o "sopladores" del Greco', *Homenaje al professor Martín González*, Valladolid 1995

PLAUT 1936
J.S. Plaut, 'The Visitation by El Greco', in *Bulletin of the Fogg Art Museum, Harvard University*, 5 (1936), pp. 21–4

PLINY THE ELDER (1938–62)
Pliny the Elder, *Natural History* (Loeb edn), 10 vols, Cambridge, Mass. and London 1938–62

PLOTINUS 1969
Plotinus, *The Enneads*, trans. S. Mackenna, 4th edn, London 1969

POLERÓ 1857
V. Poleró, *Catálogo de los cuadros del Monasterio de San Lorenzo llamado de El Escorial, en el que se comprenden los del Real Palacio, Casino del Príncipe y Capilla de la Fresneda*, Madrid 1857

PONZ 1772–94 (1947)
A. Ponz, *Viaje de España*, Madrid 1772–94, Madrid 1947

PORREÑO 1627 (1863)
B. Porreño, *Dichos y Hechos del Rey Don Felipe II*, Madrid 1627; edn Valladolid 1863

POSÈQ 2000
A.W.G. Posèq, 'El Greco's Annunciations from the Right and the Left', *Source*, XIX (2000), pp.18–28

PROSKE 1956
B.G. Proske, *Pompeo Leoni*, New York 1956

PROSPERI 1971
A. Prosperi, entry on 'Francesco Bossi' in the *Dizionario biografico degli italiani*, XIII, Rome 1971, pp. 303–4

PULLAN 1971
B. Pullan, *Rich and Poor in Renaissance Venice*, Oxford 1971

PUPPI 1997
L. Puppi, '*I testimoni impassibili, Ritratti di spettatori nei drammi evangelici dipinti dal Greco in Italia*', Rome 1997

QUINTILIAN (1933)
Quintilian, *Institutio Oratoria* (Loeb edn), 4 vols, trans. H.E Butler, Cambridge, Mass. and London 1933

RAMÍREZ DE ARELLANO 1920
R. Ramírez de Arellano, *Catalogo de Artifices*, Toledo 1920

RAMÍREZ DE ARELLANO 1921
R. Ramírez de Arellano, *Las parroquias de Toledo*, Toledo 1921

RAWLINGS 2002
H. Rawlings, *Church, Religion and Society in Early Modern Spain*, Basingstoke 2002

REARICK 1968
W.R. Rearick, 'Jacopo Bassano's Later Genre Paintings', *The Burlington Magazine*, CX (1968), pp. 241–9

RÉAU 1955–9
L. Réau, *Iconographie de l'art chrétien*, 3 vols, Paris 1955–9

REGGIO 1958
O. Reggio, 'The Myth of Prometheus', *Journal of the Warburg and Courtauld Institutes*, XXI (1958)

REKERS 1972
B. Rekers, *Benito Arias Montano (1527–1598)*, London and Leiden 1972

RESNICK AND PASMANTIER 1958
S. Resnick and J. Pasmantier, *An Anthology of Spanish Literature in English Translation*, London 1958

RICHTER 1970
J.P. Richter, *The Literary Works of Leonardo da Vinci*, 2 vols, London 1970

RICHARDSON 1987
J. Richardson, 'Picasso's Apocalyptic Whorehouse', *The New York Review*, 23 April 1987

RICHARDSON 1991
J. Richardson, *A Life of Picasso*, 2 vols, New York 1991

RIDOLFI (1984)
Carlo Ridolfi, *The Life of Tintoretto*, trans. and intro. by C. Enggass and R. Enggass, Pennsylvania State University 1984

RINALDIS 1928
A. de Rinaldis, *Pinacoteca del Museo Nazionale di Napoli. Catalogo*, Naples 1928

RINCÓN 1985
W. Rincón, 'Un manuscrito con inventarios artísticos de conventos madrileños en 1814', *Academia: Boletín de la Real Academia de Bellas Artes de San Fernando, Madrid*, LX (1985), pp. 299–372

RIPA 1611
C. Ripa, *Iconologia*, Padua 1611

ROBERTSON 1990
C. Robertson, *El Greco and Roman Mannerism*, in Iraklion 1990, pp. 397–403

ROBERTSON 1992
C. Robertson, *Il Gran Cardinale. Alessandro Farnese, Patron of the Arts*, New Haven and London 1992

ROBRES LLUCH 1954
R. Robres Lluch, 'El Beato Ribera y El Greco', *Archivo Español de Arte*, 27 (1954)

RODRÍGUEZ DE GRACIA 1988
H. Rodriguez de Gracia, 'El inventario *post mortem* del Licenziado Geronimo de Ceballos', *Toletum*, LXXI (1988), pp. 149–64

ROGELIO BUENDÍA 1984
J. Rogelio Buendía, 'Humanismo y simbología en El Greco: el tema de la serpiente', in Brown and Pita Andrade 1984

ROGELIO BUENDÍA 1999
J. Rogelio Buendía, 'Consideraciones sobre el "miles Christi". Del políptico de Módena al Martirio de San Mauricio', in Hadjinicolaou 1999, pp. 275–89

ROTETA 1976
A.M. Roteta, 'El retrato–grabado español en Pedro Angel', *Goya*, 130 (1976), pp. 220–7

RUBIN 1988
W. Rubin, *Les Demoiselles d'Avignon*, 2 vols, Musée Picasso, Paris 1988

RUBINSTEIN 1999
R.O. Rubinstein, 'El Laocoonte y su influencia en la pintura del siglo XVI', *Summa Pictoria. Histórica Universal de la Pintura*, 5 (1999)

RUÍZ 1976
E. Ruíz, 'Los años romanos de Pedro Chacón: vida y obras', *Cuadernos de Filolgía Clásica*, X (1976), pp. 189–247

RUÍZ GÓMEZ 2000
Actas del Congreso sobre el retablo del Colegio de Doña María de Aragón del Greco, ed. L. Ruíz Gómez, Museo Nacional del Prado, 16–17 October 2000, Madrid 2000

RUÍZ GÓMEZ 2001
L. Ruíz Gómez, *El Greco y la pintura española del Renacimiento*, Madrid 2001

RUTTER 1930
F.V.P. Rutter, *El Greco (1541–1614)*, New York 1930

SAINT BASIL (1895)
Saint Basil, *Letters and Select Works, The Treatise De Spiritu Sancto, A Select Library of Nicene and Post-Nicene Fathers of the Christian Church*, Oxford and New York 1895

SAINT BONAVENTURE (1953)
Saint Bonaventure, *The Mind's Road to God*, trans. by G. Boas, New York 1953

SAINT BONAVENTURE (1961)
Saint Bonavature, *Meditations on the Passion of Christ*, New Haven 1961

SAINT JOHN OF THE CROSS (1978)
The Complete Works of Saint John of the Cross, trans. by E. Allison Peers, Wheathampstead 1978

SAINT TERESA OF JESUS (1951)
The Letters of Saint Teresa of Jesus, trans. E. Allison Peers, 2 vols, London 1951

SAINT TERESA OF JESUS (1978)
The Complete Works of Saint Teresa of Jesus, trans. by E. Allison Peers, London 1978

SAINT THOMAS AQUINAS (1963)
Saint Thomas Aquinas, *Summa Theologiae*, 60 vols, Blackfriars edn, 1963

SALAZAR DE MENDOZA 1613
Salazar de Mendoza, *Vida succesos prosperos y adversos de Fray Don Bartolome de Carrança y de Miranda Arzobispo de Toledo Primado de Espana*, 1613 (lot 1325, Bibliotheca Phillipica, Sotheby's, 16 June 1970)

SALTILLO 1934
Marques del Saltillo, 'La Herencia de Pompeo Leoni', *Arte Espanol*, 42 (1934), pp. 95–121

SAN ROMÁN Y FERNÁNDEZ 1910
F. de B. San Román y Fernández, *El Greco en Toledo o Nuevas investigaciones acerca de la vida y obras de Domingo Theotocopuli*, Madrid 1910

SAN ROMÁN Y FERNÁNDEZ 1927
F. de B. de San Román y Fernández, 'De la vida del Greco. Nueva serie de documentos inéditos', *Archivo Español de Arte*, 3 (1927)

SAN ROMÁN Y FERNÁNDEZ 1928
F. de B. de San Román y Fernández, 'El testamento del humanista Alvar Gómez de Castro', *Boletín de la Real Academia Española*, 15 (1928)

SAN ROMÁN Y FERNÁNDEZ 1934
F. de B. de San Román y Fernández, 'Documentos del Greco, referentes a los cuadros de Santo Domingo el Antiguo', *Archivo Español de Arte*, 10 (1934), pp. 1–13

SAN ROMÁN Y FERNÁNDEZ 1941
F. de B. de San Román y Fernández, 'Dos libros de la biblioteca del Greco', *El Jenofonte De Florenica* (1516), *Archivo Español de Arte*, 44 (1941)

SÁNCHEZ CANTÓN 1923
F.J. Sánchez Cantón, *Catálogo de las pinturas del Instituto de Valencia de Don Juan*, Madrid 1923

SÁNCHEZ CANTÓN 1923–41
F.J. Sánchez Cantón, *Fuentes literarias para la historia del arte español*, 5 vols, Madrid 1923–41

SÁNCHEZ CANTÓN 1930
F.J. Sánchez Cantón, *Dibujos Españoles*, 5 vols, Madrid 1930

SÁNCHEZ CANTÓN 1956
F.J. Sánchez Cantón, 'Adquisiciones del Museo del Prado 1954–1955', *Archivo Español de Arte*, 29 (1956), pp. 85–8

SANPERE Y MIQUEL 1900
S. Sanpere y Miquel, 'Domenikos Theotokopoulos', *Revista del la Asociación artístico-arqueológica-barcelonesa*, IV, 18 (1900), pp. 369–98

DE LOS SANTOS 1667
Fray Francisco de los Santos, *Descripción breve del Monasterio de San Lorenzo el Real del Escorial*, Madrid 1667

DE LOS SANTOS 1698
A. de los Santos, *Descripción breve del Monasterio de San Lorenzo el Real del Escorial*, Madrid 1698

SASLOW 1991
J.M. Saslow, *The Poetry of Michelangelo: An Annotated Translation*, New Haven and London 1991

SAXL 1927–9
F. Saxl, *Kritische Berichte zur Kunstgeschichtlichen Literatur*, Leipzig 1927–9

SCHROEDER 1998
V. Schroeder, *El Greco im frühen deutschen Expressionismus*, Frankfurt am Main 1998

SCHROTH 1982
S. Schroth, 'Burial of the Count of Orgaz', *Studies in the History of Art*, 11 (1982), pp. 1–17

SERRANO 1914
L. Serrano, *Correspondencia diplomatica entre España y la Santa Sede durante el pontificado de S. Pio V*, 4 vols, Madrid 1914

SETTON 1984
K.M. Setton, *The Papacy and the Levant, 1204–1571*, 4 vols, Philadelphia 1984

SHEARMAN 1967
J. Shearman, *Mannerism*, Harmondsworth 1967

SICROFF 1960
A.A. Sicroff, *Les Controverses des Statuts de "Pureté de Sang" en Espagne du XVe au XVIIe Siècle*, Paris 1960

SIGÜENZA (1963)
Fray J. de Sigüenza, *Fundación del Monasterio de El Escorial*, Madrid 1963

SNYDER 1960
J.E. Snyder, 'The Early Haarlem School of Painting, II: Geertgen tot Sint Jans', *The Art Bulletin*, 42 (1960), pp. 113–32

SOEHNER 1957
H. Soehner, 'Greco in Spanien. Tiel I: Grecos Stilentwicklung in Spanien', *Münchner Jarhbuch des bildenden Kunst*, VIII (1957), pp. 123–94

SOEHNER 1958–9
H. Soehner, 'Greco in Spanien. Teil II: Atelier und Nachfoge Grecos', in *Münchner Jahrbuch der bildenden Kunst*, IX–X (1958–9), pp. 147–242

SOEHNER 1960
H. Soehner, 'Greco in Spanien. Teil IV: Die retabel Grecos', in *Münchner Jahrbuch der bildenden Kunst*, XI (1960), pp. 173–217

SOEHNER 1961
H. Soehner, *Una obra maestra de El Greco – La Capilla de San José de Toledo*, Madrid 1961

SOLE 1966
P.A. Sole, 'El Greco en El Hospital de Mujeres de Cadiz', *Archivo Hispalanse*, 138 (1966), pp. 85–90

SORIA 1954
M. Soria, 'Greco's Italian Period', *Arte Veneta*, 8 (1954), pp. 213–21

SPINOSA 1995
N. Spinosa, *I Farnese: arte e collezionismo/ a cura di Lucia Fornari Schianchi*, Milan 1995

STECHOW 1966
W. Stechow, *Northern Renaissance Art 1400–1600. Sources and Documents*, ed. H.W. Janson, Englewood Cliffs, New Jersey 1966

STERLING 1988
C. Sterling et al., *The Robert Lehman Collection, II, Fifteenth- to Eighteenth-Century European Paintings*, New Haven 1998

STEWART 1977
A.G. Stewart, *Unequal Lovers: a Study of Unequal Couples in Northern Art*, New York 1977

STIRLING-MAXWELL 1891
W. Stirling-Maxwell, *Annals of the Artists of Spain*, 4 vols, London 1891

STRATTON 1988
S. Stratton, *La Immaculada Concepción en el Arte Español*, Madrid 1988

SUIDA 1955
W.E. Suida, *The Samuel H. Kress Collection*, San Francisco 1955

TALBOT RICE 1947
D. Talbot Rice, 'Five Late Byzantine Panels and El Greco's Views of Sinai', *The Burlington Magazine*, LXXXIX, 529 (1947), pp. 93–4

TAVERNOR 1991
R. Tavernor, *Palladio and Palladianism*, London 1991

TELLECHEA IDÍGORAS 1968
J.I. Tellechea Idígoras, *El Arzobispo Carranza y su tiempo*, 2 vols, Madrid 1968

THOMAS 1988
H. Thomas, *Madrid. A Travellers' Companion*, London 1988

THOMAS 1995
P. Thomas, 'Extrañeza': *Aesthetic and Stylistic Parallels in Paravicino and El Greco*, M.A. Dissertation, University College, London 1995

TILLYARD 1972
E.M.W. Tillyard, *The Elizabethan World Picture*, Harmondsworth 1972

TOKYO 1986
Gureko ten: El Greco Exhibition, exh. cat., Tokyo 1986

TOLNAY 1953
C. de Tolnay, 'Michelangelo's Pietà Composition for Vittoria Colonna', *Record of the Art Museum*, XII, 1 (1953), pp. 44–62

TOLNAY 1969–71
C. de Tolnay, *Michelangelo*, 5 vols, Princeton 1969–71

TROUTMAN 1963
P. Troutman, *El Greco*, London 1963

UPTON HOUSE 1964
Upton House: the Bearsted Collection: Pictures, The National Trust 1964

VASARI (1927)
G. Vasari, *The Lives of the Painters, Sculptors and Architects*, trans. A.B. Hinds, London and New York 1927

VASSILAKI 1990
M. Vassilaki, 'The Modena Triptych', in Iraklion 1990, pp. 341–2

VASSILAKI 1995
M. Vassilaki, 'Three Questions on the Modena Triptych', in Hadjinicolaou 1995, pp. 119–32

VECHNYAK 1991
I.B. Vechnyak, 'El Greco's Miracle of Christ Healing the Blind: Chronology Reconsidered', *The Metropolitan Museum Journal*, 26 (1991), pp. 177–82

VEGUE Y GOLDONI 1926–7
A. Vegue y Goldoni, 'En torno a la figura del Greco', *Arte español*, 8 (1926–7)

VEGUE Y GOLDONI 1928
A. Vegue y Goldoni, 'El Cardenal Quiroga, retratado por El Greco', *Archivo Español de Arte*, 4 (1928)

VENICE 1981
Da Tiziano a El Greco: Per la storia del Manierismo a Venezia, exh. cat., Venice 1981

VENICE–WASHINGTON 1990–1
Titian, Prince of Painters, exh. cat., Venice and Washington 1990–1

VENTURI 1927
L. Venturi, 'Una nuova *Annunziazione* del Greco', *L'Arte*, 30 (1927), pp. 252–55

VETTER 1969
E. W. Vetter, 'El Greco's Laokoön "reconsidered",
Pantheon 27 (1969), pp. 295–9

VIENNA 1997
*Meisterwerke des Kopenhagener Statens Museum for
Kunst im Kunsthistorischen Museum Wien*, exh. cat.,
Vienna 1997

VIENNA 1995
*Sofonisba Anguissola, la prima donna pittrice: die erste
Malerin der Renaissance (um 1535–1625)*, exh. cat., eds.
S. Ferino-Pagden and M. Kusche,
Kunsthistorisches Museum, Vienna 1995

VIENNA 2001
El Greco, exh. cat., eds. S. Ferino-Pagden and F.
Checa Cremades, Kunsthistorisches Museum,
Vienna 2001 (there is an unillustrated English edn)

VILLAR 1928
E.H. del Villar, *El Greco en España*, Madrid 1928

VINCENT AND DOMÍNGUEZ ORTIZ 1978
B. Vincent and A. Domínguez Ortiz, *Historia de los
Moriscos*, Madrid 1978

VIRGIL (1577)
La Eneida de Virgilio, trans. G. Hernádez de Velasco,
Toledo 1577

VITRUVIUS (1960)
Vitruvius, *The Ten Books On Architecture*, trans.
M.H. Morgan, New York 1960, pp. 5–6

WALKER 1870
Apocryphal Gospels, Acts, and Revelations, trans.
A. Walker, Edinburgh 1870

WANDEL 1917
S. Wandel, *Kunstmuseetso Åarsskrift*, III (1917),
pp. 80–2

WATERHOUSE 1930
E.K. Waterhouse, 'El Greco's Italian Period', *Art
Studies*, 8 (1930), pp. 61–88

WATERHOUSE 1978
E. Waterhouse, *El Greco*, New York 1978

WATERHOUSE 1980
E. Waterhouse, *El Greco: The Complete Paintings*,
London 1980

WETHEY 1962
H.E. Wethey, *El Greco and his School*, 2 vols,
Princeton 1962

WETHEY 1971
H.E. Wethey, *The Paintings of Titian*, 3 vols, London
1971

WETHEY 1984
H.E. Wethey, 'El Greco in Rome and the Portrait of
Vincento Anastagi', in Brown and Pita Andrade
1984

WILDE 1953
J. Wilde, *Italian Drawings in the British Museum,
Michelangelo and his Studio*, London 1953

WILDE 1978
Johannes Wilde, *Michelangelo*, Oxford 1978

WILLUMSEN 1927
J.F. Willumsen, *La Jeunesse du peintre El Greco*, 2 vols,
Paris 1927

WINNER 1974
M. Winner, 'Zum Nachleben des Laokoon in der
Renaissance', *Jahrbuch de Berliner Museen*, 16 (1974)

WITTKOWER 1957
R. Wittkower. 'El Greco's Language of Gesture',
Art News, 56 (1957), pp. 45–54

WOODS-MARSDEN 1998
J. Woods-Marsden, *Renaissance Self-Portraiture*,
New Haven and London 1998

XYDIS 1964
A.G. Xydis, 'El Greco's *Healing of the Blind*, Sources
and Stylistic Connections', *Gazette des Beaux-Arts*,
64 (1964), pp. 301–6

YOUNG 1970
E. Young, *The Bowes Museum, Barnard Castle, County
Durham: Catalogue of the Spanish and Italian Paintings*,
Barnard Castle 1970

YOUNG 1988
E. Young, *Catalogue of the Spanish Paintings in
the Bowes Museum*, revised edn and intro. by
E. Conran, Barnard Castle 1988

ZERI 1957
F. Zeri, *Pittura e Controriforma*, Turin 1957

ZOTTMANN 1906–7
L. Zottmann, 'Zur Kunst von *El Greco*' in *Die
Christliche Kunst*, 3 vols, Munich 1906–7

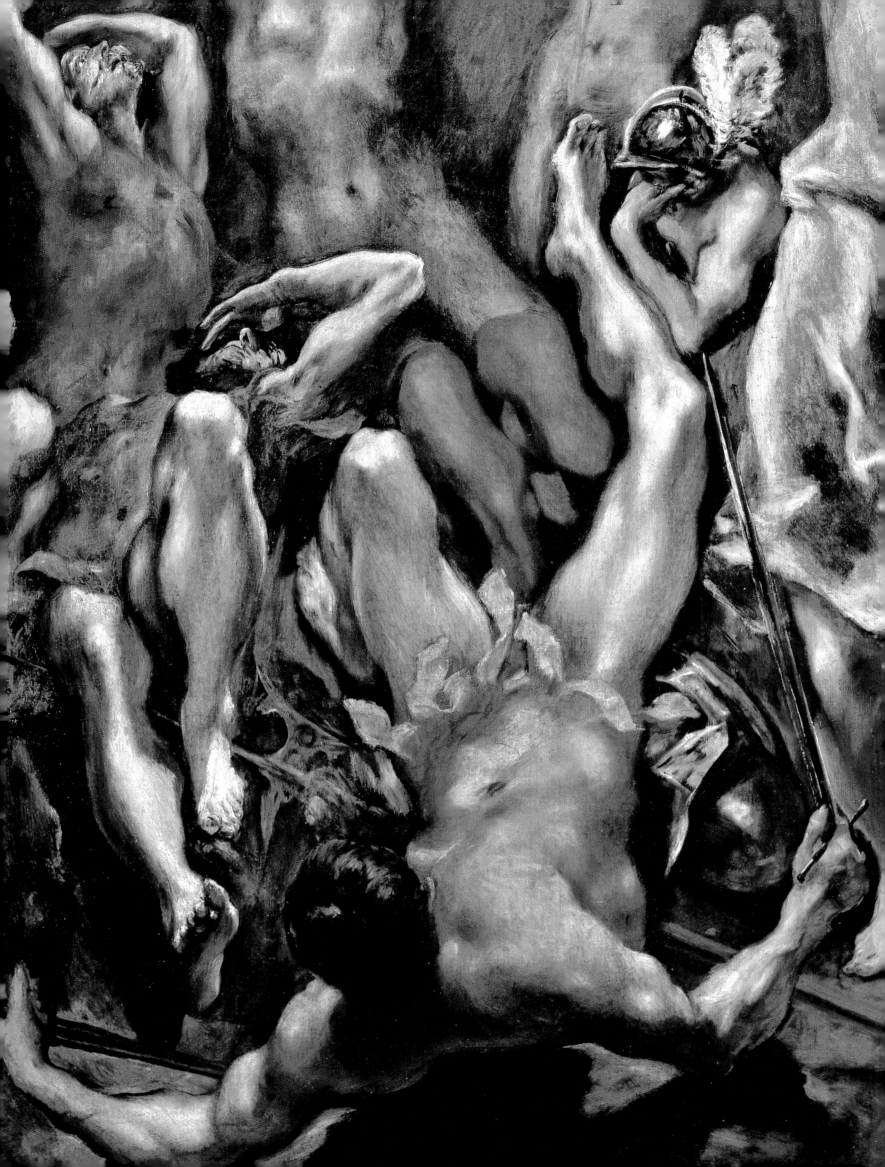

List of Lenders

ATHENS
Benaki Museum
National Gallery of Greece,
　Alexandros Soutzos Museum

BOSTON, MA
Museum of Fine Arts

BUCHAREST
National Museum of Art of Romania

CÁDIZ
Church of the Hospital de Nuestra
　Señora del Carmen

CLEVELAND, OH
The Cleveland Museum of Art

COPENHAGEN
Statens Museum for Kunst

COUNTY DURHAM
The Bowes Museum, Barnard Castle

CUENCA
Diocesan Museum

EDINBURGH
The National Gallery of Scotland

EL ESCORIAL
Monasterio de San Lorenzo,
　Patrimonial Nacional

ERMOUPOLIS, SYROS
Holy Cathedral of the Dormition of
　the Virgin

FORT WORTH, TX
Kimbell Art Museum

GLASGOW
Glasgow Museums, Art Gallery and
　Museums, Kelvingrove

ILLESCAS
Church of the Hospital de la
　Caridad

IRAKLION
Historical Museum of Crete,
　Hellenic Ministry of Culture

KETTERING, NORTHAMPTONSHIRE
Boughton House, the Duke of
　Buccleuch and Queensbury

LEEDS
The Earl and Countess of Harewood
　and the Trustees of the Harewood
　House Trust

LONDON
The National Gallery

LOS ANGELES
The J. Paul Getty Museum

MADRID
Biblioteca Nacional
Instituto de Valencia de Don Juan
Museo Nacional del Prado
Museo Thyssen-Bornemisza
Parish Church of San Ginés
Placido Arango collection

MINNEAPOLIS, MN
The Minneapolis Institute of Arts

NAPLES
Museo Nazionale di Capodimonte

NEW YORK
The Hispanic Society of America
The Metropolitan Museum of Art

OTTAWA
National Gallery of Canada

PALENCIA
Museo Catedralicio

PARIS
Musée du Louvre

PARMA
Galleria Nazionale, Ministero per i
　Beni e le Attività Culturali

PHILADELPHIA
The Philadelphia Museum of Art

SAN FRANCISCO, CA
Fine Arts Museum of San Francisco

SEVILLE
Museo de Bellas Artes

STOCKHOLM
Nationalmuseum

STRASBOURG
Musée des Beaux-Arts de
　Strasbourg

TOLEDO
Museo de El Greco
Museo de Santa Cruz
Parish Church of San Nicolás de Bari
Church of Santa Leocadia

TOLEDO, OH
The Toledo Museum of Art

UPTON, WARWICKSHIRE
Upton House (The National Trust)

WASHINGTON, DC
National Gallery of Art
Dumbarton Oaks

WORCESTER, MA
Worcester Art Museum

Index

Numbers in **bold** refer to catalogue illustrations; those in *italics* refer to figures

Sigüenza, Fray 68, 144 n. 5, 221
Siliceo, Cardinal-Archbishop 27
de Silva, Fernando, Conde de
 Cifuentes 148
de Silva, Doña María 115, 116
Suetonius 250
Sulaiman the Magnificent 21

Tasso, Torquato 138
Tavera, Juan 210
Teresa of Ávila, Saint 28, 60, 67, 68, 142,
 148, 161–2, 288
Tertullian 236
Theophanis 76
Theotokopoulos, Gabriel 38, 40, 41
Theotokopoulos, Georgios 20, 32
Theotokopoulos, Manoussos 20, 23,
 32, 33, 38
 see El Greco; Jorge Manuel
Thomas à Kempis 63
Thomas Aquinas, Saint 61
Tibaldi, Pellegrino 131
Tintoretto, Jacopo 55, 80, 82, 84, 88, 92,
 104, 106, 152, 236, 264, 268; see also
 El Greco, and Tintoretto

Titian 66, 81, 88, 97, 98, 100, 102, 104,
 106, 119, 130, 152, 153, 156, 170 n. 2,
 221, 226, 241, 250, 251, 253, 262, 264;
 see also El Greco, and Titian
 discussed by Palma Giovane 55
 discussed by Paravicino 259
 Christ carrying the Cross 22, 65
 Isabella, Empress 251, 262
 Farnese, Cardinal Alessandro 22, 5
 Mary Magdalen 136, 42
 Paul III Farnese 259, 65
 *Philip II offering Don Fernando to
 Victory* 24, 6
 Pietà 216
 Prometheus (Tityus?) 240, 243, n. 9
Toledo, cultural climate of 28, 59
de la Torre, Nicolás 67
Trechello, Thomasso 38
Trent, Council of, and Tridentine
 decrees 22, 26, 60, 62, 65, 67, 278,
 288
Tristán, Luis 10, 38, 40, 156, 282, 284
Tsafouris, Nikolaos 20, 3

de Ubeda, Juan Bautista 38

de Valdés, Fernando 285 n. 2
de Valdivieso, José 163
de Valenzuela, Juan 266
de Vargas, Luis 146
de Vargas, Tamayo 290
Vasari, Giorgio 68, 97, 135, 250, 262
de Velasco, Luis 34
de Velázquez, Diego 9, 10, 66, 221
 and El Greco's portraits 9, 260, 266,
 284, 290
Venier, Sebastiano 126
Venusti, Marcello 88, 97, 98, 27
de Vergara, Juan 67
de Vergara, Nicolás 34
Veronese 10, 82, 84, 88
 Allegory of the Battle of Lepanto 25, 7
Vignola, Giacomo 48
de Villegas, Isabel 41
de Villena, Marqués 35, 36, 38, 39, 68
de Villena, Marquesa 68
Virgil (Virgilus Maro) 240–2, 245
Virgin Mary, cult of 65
Vitruvius 69; see El Greco, books in
 library, annotations to Vitruvius
Vittoria, Alessandro 119
de Vos, Martin 126

Warhol, Andy 213
van Wyngaerde, Anton 28–9, 10

Xenophon 67

de Yepes, Antonio 178
yermo 61, 62

Zuccaro, Federico 33, 35, 48, 69, 84, 109
 n.3, 152, 262
Zuccaro, Taddeo 48, 69, 82, 109 n.3
Zuloaga, Ignacio 9, 213
de Zúñiga, Diego 67
Zuqui, Demetrio 37
de Zurbarán Francisco 116

Photographic Credits